# DICTIONARY OF AMERICAN ART

# DICTIONARY OF AMERICAN ART

_____

## Matthew Baigell

ICON EDITIONS

**Harper & Row, Publishers**

_New York / Hagerstown / San Francisco / London_

FIRST EDITION

*Designer: Sidney Feinberg*

Library of Congress Cataloging in Publication Data

Baigell, Matthew.
  Dictionary of American art.
  (Icon editions)
  Bibliography: p.
  1. Art, American—Dictionaries. I. Title.
N6505.B34 1979    709′.73      78-24824
ISBN 0-06-433254-3

79 80 81 82 83 10 9 8 7 6 5 4 3 2 1

# General Articles

In addition to biographical entries, essays will
be found on the following subjects.

Abstract Expressionism
American Abstract Artists
American Academy of the Fine Arts
American Artists Congress
American Art-Union
American Scene Painting
Armory Show
Art Students League (see also NATIONAL ACADEMY OF DESIGN)
Assemblage
Barbizon, American
Bayou School
Biomorphism
Centennial Exposition, Philadelphia
Color-Field Painting (see MINIMAL ART)
Columbianum (see PENNSYLVANIA ACADEMY OF THE FINE ARTS)
Computer Art
Conceptual Art
Currier & Ives
Dada (see NEW YORK DADA)
Düsseldorf Gallery
Earth Art
Eight, The
Farm Security Administration Photographs
Federal Art Projects
Folk Art
F .64 Group
Funk Art
Gift Books
Happenings
Hudson River School
Impressionism, American
Independent Exhibitions (1902–16)
Kinetic Art

# Abbreviations Used in This Book

| | |
|---|---|
| AAFA | American Academy of the Fine Arts, New York, N.Y. |
| Acad. | Academy |
| Addison Gall. | Addison Gallery of American Art, Andover, Mass. |
| Adirondack Mus. | Adirondack Museum of the Adirondack Historical Association, Blue Mountain Lake, N.Y. |
| AIC | Art Institute of Chicago, Chicago, Ill. |
| AK | Albright-Knox Art Gallery, Buffalo, N.Y. |
| Albany Inst. | Albany Institute of History and Art, Albany, N.Y. |
| Amon Carter Mus. | Amon Carter Museum of Western Art, Fort Worth, Tex. |
| ASL | Art Students League, New York, N.Y. |
| Assoc. | Association |
| Baltimore Mus. | Baltimore Museum of Art, Baltimore, Md. |
| Brooklyn Mus. | Brooklyn Museum, Brooklyn, N.Y. |
| Butler Inst. | Butler Institute of American Art, Youngstown, Ohio |
| Calif. Hist. Soc. | California Historical Society, San Francisco |
| Carnegie Inst. | Museum of Art, Carnegie Institute, Pittsburgh, Pa. |
| Chouinard Inst. | Chouinard Art Institute, Los Angeles, Calif. |
| Chrysler Mus. | Chrysler Museum at Norfolk, Norfolk, Va. |
| Cincinnati Mus. | Cincinnati Art Museum, Cincinnati, Ohio |
| Cleveland Mus. | Cleveland Museum of Art, Cleveland, Ohio |
| Coll. | College, Collection |
| Columbus Gall. | Columbus Gallery of Fine Arts, Columbus, Ohio |
| Cooper-Hewitt Mus. | Cooper-Hewitt Museum, New York, N.Y. |
| Corcoran Gall. | Corcoran Gallery of Art, Washington, D.C. |
| CPLH | California Palace of the Legion of Honor, San Francisco |
| Crocker Gall. | E. B. Crocker Art Gallery, Sacramento, Calif. |

| | |
|---|---|
| CSFA | California School of Fine Arts, San Francisco (since 1960, San Francisco Art Institute) |
| Dallas Mus. | Dallas Museum of Fine Arts, Dallas, Tex. |
| Denver Mus. | Denver Art Museum, Denver, Colo. |
| Detroit Inst. | Detroit Institute of Arts, Detroit, Mich. |
| de Young Mus. | M. H. de Young Memorial Museum, San Francisco, Calif. |
| EBA | Ecole des Beaux-Arts, Paris, France |
| Fogg Mus. | William Hayes Fogg Art Museum, Harvard University, Cambridge, Mass. |
| Fort Worth Mus. | Fort Worth Art Museum, Fort Worth, Tex. |
| Gall. | Gallery |
| GEH | International Museum of Photography, George Eastman House, Rochester, N.Y. |
| Gibbes Gall. | Gibbes Art Gallery, Charleston, S.C. |
| Guggenheim Mus. | Solomon R. Guggenheim Museum, New York, N.Y. |
| Hirshhorn Mus. | Hirshhorn Museum and Sculpture Garden, Washington, D.C. |
| Hist. | Historical |
| Hist. Soc. of Pennsylvania | Historical Society of Pennsylvania, Philadelphia |
| Houston Mus. | Museum of Fine Arts, Houston, Tex. |
| Indianapolis Mus. | Indianapolis Museum of Art, Indianapolis, Ind. |
| Inst. | Institute |
| LACMA | Los Angeles County Museum of Art, Los Angeles, Calif. |
| Maryland Hist. Soc. | Maryland Historical Society, Baltimore |
| Massachusetts Hist. Soc. | Massachusetts Hist. Soc., Boston, Mass. |
| MCNY | Museum of the City of New York |
| MFAB | Museum of Fine Arts, Boston, Mass. |
| Minneapolis Inst. | Minneapolis Institute of Arts, Minneapolis, Minn. |
| MMA | Metropolitan Museum of Art, New York, N.Y. |
| MOMA | Museum of Modern Art, New York, N.Y. |
| Montclair Mus. | Montclair Art Museum, Montclair, N.J. |
| Mus. | Museum |
| MWPI | Munson-Williams-Proctor Institute, Ithaca, N.Y. |
| NAD | National Academy of Design, New York, N.Y. |
| NCFA | National Collection of Fine Arts, Washington, D.C. |

| | |
|---|---|
| Nebraska Art Assoc. | Nebraska Art Association, Lincoln |
| Nelson Gall. | William Rockhill Nelson Gallery of Art–Atkins Museum of Fine Art, Kansas City, Mo. |
| Newark Mus. | Newark Museum, Newark, N.J. |
| New Britain Mus. | New Britain Museum of American Art, New Britain, Conn. |
| New Hampshire Hist. Soc. | New Hampshire Historical Society, Concord, N.H. |
| New Mexico Mus. | Museum of New Mexico, Santa Fe |
| New York State Hist. Assoc. | New York State Historical Association, Cooperstown |
| NGW | National Gallery of Art, Washington, D.C. |
| North Carolina Mus. | North Carolina Museum of Art, Raleigh |
| Norton Simon Mus. | Norton Simon Museum, Pasadena, Calif. |
| NPG | National Portrait Gallery, Washington, D.C. |
| NYHS | New-York Historical Society, New York, N.Y. |
| NYPL | New York Public Library, New York, N.Y. |
| Oakland Mus. | Oakland Museum, Oakland, Calif. |
| PAFA | Pennsylvania Academy of the Fine Arts, Philadelphia |
| Parrish Mus. | Parrish Art Museum, Southampton, N.Y. |
| Peabody Mus. | Peabody Museum, Harvard University, Cambridge, Mass. |
| Pennsylvania Hist. Soc. | Historical Society of Pennsylvania, Philadelphia, Pa. |
| Philadelphia Mus. | Philadelphia Museum of Art, Philadelphia, Pa. |
| Phillips Coll. | Phillips Collection, Washington, D.C. |
| Portland (Maine) Mus. | Portland Society of Art, Museum of Art, Portland, Maine |
| Portland (Oreg.) Mus. | Portland Art Museum, Portland, Oreg. |
| RISD | Museum of Art, Rhode Island School of Design, Providence |
| St. Louis Mus. | St. Louis Art Museum, St. Louis, Mo. |
| San Francisco Mus. | The Fine Arts Museums of San Francisco, San Francisco |
| Santa Barbara Mus. | Santa Barbara Museum of Art, Santa Barbara, Calif. |
| Soc. | Society |
| Speed Mus. | J. B. Speed Art Museum, Louisville, Ky. |
| Springfield Mus. | Museum of Fine Arts, Springfield, Mass. |

| | |
|---|---|
| Stony Brook Mus. | Museums at Stony Brook, Stony Brook, N.Y. |
| Taft Mus. | Taft Museum, Cincinnati, Ohio |
| Timken Gall. | Timken Art Gallery, San Diego, Calif. |
| Toledo Mus. | Toledo Museum of Art, Toledo, Ohio |
| UCLA | University of California, Los Angeles |
| Univ. | University |
| Valentine Mus. | Valentine Museum, Richmond, Va. |
| Virginia Mus. | Virginia Museum of Fine Arts, Richmond |
| WA | Wadsworth Atheneum, Hartford, Conn. |
| Walker Art Center | Walker Art Center, Minneapolis, Minneapolis, Minn. |
| Walters Gall. | Walters Art Gallery, Baltimore, Md. |
| WMAA | Whitney Museum of American Art, New York, N.Y. |
| Worcester Mus. | Worcester Art Museum, Worcester, Mass. |
| WPA-FAP | Works Progress (later, Works Projects) Administration, Federal Art Project |

# *Preface*

The purpose of this dictionary is to provide in a conveniently sized volume essential information about important American painters, sculptors, printmakers, and photographers, as well as about the topics and movements central to American art from the 16th century to the present day. It is intended to serve as a useful reference book for museum and gallery visitors, for students, and for all others interested in the subject. Although the dictionary offers a well-rounded picture of all periods and aspects of American art, without favoring one century or movement to the detriment of others, there are comparatively more entries on painters and sculptors than on printmakers and photographers, and on artists whose works are derived from western European sources. Obviously, in a volume of this size, selection is necessary. I have tried to include all the significant names and topics, but there may be omissions that disappoint some readers.

The emphasis in the dictionary is placed on artistic achievement and stylistic development rather than on biographical detail. Only as much personal data as seemed necessary to illuminate each artist's growth is included in the biographical entries. Throughout the book, I have cited individual works that contribute to an understanding of an artist's career or a general topic and have dated them whenever possible. Most of the American works mentioned are in public collections, and the whereabouts of these are indicated. Examples in private collections, on the market, or lost at this writing are only named and dated. When they exist, major collections of an artist's work are also indicated. At the end of all the longer entries and, in the shorter ones when an important book or article exists on the subject, a bibliographical reference is given.

Names that appear in capital and small-capital letters within an entry indicate cross references to other entries. These references are made only when consulting another article will cast significant light on the subject; thus, we include an entry on folk art in the dictionary, but the reader may not be referred to it from an entry in which the subject is only mentioned in passing. A List of General Articles and a List of Abbreviations precede the alphabetical listing.

I have tried to be as accurate as possible about facts, but the task has not been easy. For example, in the same book I have found different

dates given in different places for the same painting or trip to Europe, and information found in two equally reliable sources has often been in distinct disagreement. My publisher and I want to make this volume as useful as possible and we welcome corrections, which will be incorporated into subsequent editions, as well as suggestions for additional entries.

I owe a special debt of gratitude to Professor William Gerdts, who, in addition to preparing the basic lists of 17th-, 18th-, and 19th-century artists and general topics, also wrote a number of articles. Patricia Leighton assumed responsibility for the photography entries, and Andrew S. Arbury, Dr. Jack Bornstein, Maria Chamberlain-Hellman, Susan Cooperman, Frank Cossa, Nancy Heller, Phoebe Lloyd, Professor Joan Marter, Jennifer A. Martin, Barbara Mitnick, Margaret O'Neill, Joyce Rodgers, Wayne Roosa, Ellen Rusinow, Mary Jo Viola, Sara Webster, Jeffrey Wechsler, Julia Williams, and Susan Fillin Yeh all contributed articles. I am most grateful to them. I also want to thank Ferris Olin, head of the Rutgers University Art Library, for her patient help in locating many articles and books. Finally, I want to state as forcefully as possible that my appreciation knows no bounds for the support, sympathy, and understanding that Cass Canfield, Jr., of Harper and Row, has given me from the inception of the project and for the care with which he and Ellyn Childs Allison treated the dictionary during all stages of its development and completion.

—MATTHEW BAIGELL
*Rutgers University*
*January 1, 1979*

DICTIONARY OF AMERICAN ART

# A

ABBEY, EDWIN AUSTIN (1852–1911), a noted illustrator, painter, and muralist. Born in Philadelphia, Abbey studied at PAFA in 1868 and entered the Philadelphia publishing industry before joining the publishing company of Harper & Brothers in New York City in 1871. Sent to England by the firm in 1878, he became an expatriate, making numerous return visits to America, however. Abbey steeped himself in all the pictorial aspects of historic England, which became the special subject of his illustrations and, after 1889, of his oil paintings. In 1887 he began a long-term project for Harper's to illustrate Shakespeare, and many of his easel paintings also have Shakespearean themes. Beginning in the late 1890s, his work lost much of its earlier naturalism, strong chiaroscuro, and ample space, becoming more stylized, with flattened space often achieved by crowding the outer edges of the canvas with large forms. Abbey's figures are often arranged in a processional manner across the picture, and, formally at least, his art is related to both the contemporary Art Nouveau and Symbolist movements. In 1902 he was appointed official court painter of the coronation in Westminster Abbey by Edward VII. In the same year, he received the commission to decorate the new State Capitol in Harrisburg, Pa., having already achieved success with his series of historicizing murals in the Boston Public Library, The Quest for the Holy Grail, completed the year before. *Lit.:* E. V. Lucas, *The Life and Works of Edwin Austin Abbey, R.A.*, 1921.

ABSTRACT EXPRESSIONISM, a movement that flourished, primarily in New York City, from about 1943 to about 1955. It was the first significant American contribution to transatlantic art after JAMES A. M. WHISTLER's. The artists usually considered part of this movement, (who are also often described as the NEW YORK SCHOOL), did not always have similar stylistic interests and similar attitudes toward subject matter. One group, which included JACKSON POLLOCK, WILLEM DE KOONING, and HANS HOFMANN, favored a gestural expressionism in which accident and chance seemed to play significant roles in determining the final appearance of a painting. It was the vigorous nature of their attack that inspired critic Harold Rosenberg to coin the term *Action Painting*, which is often used to describe the movement as a whole. The second major group, which included MARK ROTHKO and BARNETT NEWMAN, preferred the patient exploration of carefully meditated color relationships. Within both groups—loose alignments at best—artists chose subject matter evocative of myth and ritual or of primitive life-forms (see BIOMORPHISM) until about 1947, when some, including Pollock, Rothko, and Newman, eliminated representational elements in favor of complete nonobjectivity. Others, among them WILLIAM BAZIOTES, continued to paint biomorphic shapes during the 1950s; de Kooning never relinquished his interest in the human form. Within both wings of Abstract Expressionism, artists found ways from about 1947 to extend their art beyond the flattened three-dimensionality of Cubism to what may be called a "post-Cubist" space, in which suggestions of depth are almost completely eliminated. Thus, the movement progressed through two chronological phases.

Abstract Expressionism probably had its genesis in a generation's desire to make an appropriate response to a world in which it spent its youth mired in a major economic depression and its young adulthood engaged in a barbaric world war. Rather than develop an art

based on rational thought, as did the followers of Piet Mondrian among the AMERICAN ABSTRACT ARTISTS, the Abstract Expressionists preferred to create a style more personal and self-revelatory, which, at the same time, would evoke timeless human emotions, fears, and beliefs.

Their specific sources of inspiration and influence were many and varied and included individuals as well as earlier European movements. The cosmopolitan artist JOHN GRAHAM, who became friendly with several New York artists during the 1930s, among them ARSHILE GORKY and de Kooning, helped the Americans gain an appreciation of abstract art and primitive art and an awareness of the role the unconscious might play in artistic creation as well as of the theories of Carl Jung, the Swiss psychologist, concerning primordial images and memories. In the late 1930s and early 1940s, several European artists settled in the New York City area and, of these, the Surrealists were the most important to the Abstract Expressionists. They included André Breton, Surrealism's founder, André Masson, and the Chilean painter Roberto Matta Echaurren. The Americans responded most profoundly to the mode of Surrealism concerned with automatic gestures and improvisation. These European artists helped reestablish, after a decade of AMERICAN SCENE PAINTING, the private engagement between imagination and materials as the central experience of the modern artist.

Several exhibitions at MOMA were of seminal importance—African Negro Art (1935); Prehistoric Rock Pictures in Europe and Africa (1937); Indian Art of the United States (1941); and the retrospective of the Spanish Surrealist Joan Miró (1941)—as was also the retrospective of the Russo-German abstractionist Wassily Kandinsky at the Mus. of Non-Objective Painting (now the Guggenheim Mus.) in 1945. Peggy Guggenheim's Art of This Century Coll. was another important exhibition space, for European artists as well as for the Abstract Expressionists.

Such avant-garde magazines as *Dyn*, *VVV*, *Tiger's Eye*, and *Possibilities* also served as sources of communication and vehicles of expression. Throughout these years, the art of Pablo Picasso, especially works such as *Girl Before a Mirror* (1932), also provided clues as to how one might use the irrational, improvised gesture and the unconscious and find nontraditional ways of arranging compositional elements.

From this miscellany of sources, ranging from personal doodling to primordial and archetypal images, from primitive art to modern abstract art, and from a psychological interest in the personality to postulated deep-seated memories of the entire human race, the artists evolved their personal styles and subject matter. (There is no way to determine who made the first Abstract Expressionist painting or precisely how Abstract Expressionism separated itself from Surrealism.) Gorky was among the first to hammer out a coherent style—in his case, Miró, Kandinsky, and Matta were among the most important influences. His imagery, charged with sexual overtones (as in *The Liver Is the Cock's Comb*, 1944, AK), often appears on the verge of metamorphosis into another state of being. Natural forms whipped by improvisational gestures, but often constrained by taut linear enframements, his images float on the picture surface, reflecting the Abstract Expressionist paradox of rational control (and systematic artistic training) guided by automatist responses. Pollock, more sympathetic to the notion of Jungian archetypes, created such ritualistic and mythic works as *Guardians of the Secret* (1943, San Francisco Mus.), with its allusions to priests and priestesses who "guard" a mysterious central area of amorphous, chaotic matter. Rothko, who with Newman and ADOLPH GOTTLIEB wrote a famous letter to the *New York Times*, published on June 13, 1943, asserting the importance of tragic and timeless subject matter, floated primitive organisms on veils of color (*Vessels of Magic*, 1946, Brooklyn Mus.). Gottlieb

created new hieroglyphs distantly based on primitive art (*Forgotten Dream,* 1946, Herbert F. Johnson Mus. of Art, Ithaca, N.Y.), while de Kooning avoided Biomorphism in favor of a loosely woven Cubism, best seen in his black-and-white paintings of the late 1940s (*Painting,* 1948, MOMA).

After World War II, when the European Surrealists returned to the Continent, many Americans abandoned representation altogether and, with it, Surrealist investigations of vaguely allusive forms. Harold Rosenberg dramatically overstated but nevertheless recorded the transition when he observed (primarily of such "action" artists as Pollock and de Kooning), "At a certain moment the canvas began to appear to one American painter after another as an arena in which to act—rather than as a space in which to reproduce, re-design, analyze or 'express' an object, actual or imagined" (*Art News,* Sept., 1952). In a manner analogous to the Existentialist ideal of Jean-Paul Sartre (*Existentialism,* English trans. 1947), each artist became responsible for his actions; his work was the sum total of his life. A painting, therefore, was intended to be a revelation of the artist's authentic identity, his personal signature unlike that of any other individual.

At this time, artists also developed strategies to bypass the restrictions of Cubist space, some reducing their palettes to black and white paint from about 1947 to about 1951. De Kooning tried to shatter it in his previously mentioned black-and-whites by using the outlines of randomly scattered bits of torn paper to suggest compositional arrangements. These energy-filled, splashy paintings have been considered by many his best. Rothko no longer chose to superimpose wriggly organisms on horizontal veils but allowed the latter, now large, soft-edged bands, to become his principal subject matter (*Light Cloud, Dark Cloud,* 1957, Fort Worth Mus.). Pollock's colorful drip paintings, such as *Cathedral* (1947, Dallas Mus.), marked the major stylistic breakthrough, how-

ever. Dripping and flinging paint on canvases placed on the floor, he created dense, often impenetrable webs of pigment that seemed to be continuous skins rather than forms created in traditional relational units. Suggestions of depth, however shallow, were effectively curtailed. At first, these works appeared to be barbaric attacks on the art of painting, but over the decades they have "grown in grace" and even in reserve, assuming their place as probably the most significant American paintings of the century. Newman, who had made biomorphic works in the mid-1940s, also turned to complete abstraction in 1948 and created a body of work that was as advanced as Pollock's drip paintings. In his *Vir Heroicus Sublimis* (1950–51, MOMA), Newman painted widely spaced, thin lines of intense color between large fields of blander color in such a way that the lines did not appear to advance or recede in relation to the large fields.

By 1950 earlier realists FRANZ KLINE, BRADLEY WALKER TOMLIN, and PHILIP GUSTON had developed Abstract Expressionist styles ranging between the gestural and contemplative extremes maintained by Pollock and de Kooning, on the one hand, and Rothko and Newman, on the other. Of the "later" Abstract Expressionists, Kline, whose imagery of black bars set against sections of white paint (*Mahoning,* 1956, WMAA), was perhaps the most powerful. By the mid-1950s, as the heroic and existential stance of these artists—their desire to free their work of European references, their self-searching, their devotion to art as a way of life and to the art-making process—lost its original urgency, the stylistic advances of Pollock and Newman came to assume the greatest consequence. In his development of improvisational techniques, Pollock had an especially important influence on such later manifestations as ASSEMBLAGE, HAPPENINGS, and PERFORMANCE ART. By eliminating depth cues, which resulted in the recognition of the canvas as a painted object rather than as a surface

upon which objects are reproduced, Pollock and Newman influenced the direction MINIMAL ART would take, especially in the work of FRANK STELLA. Other younger artists, including SAM FRANCIS, HELEN FRANKENTHALER, and GRACE HARTIGAN created their own variations of Abstract Expressionism, forming, in effect, a second generation. The wide-ranging influence of Pollock, Newman, and the other key figures of the original movement indicates that virtually every important artist of the 1960s and 1970s, regardless of the style in which he worked, was, in some way, affected by Abstract Expressionism. *Lit.:* Irving Sandler, *The Triumph of American Painting: A History of Abstract Expressionism*, 1970.

**ACADEMIES AND SCHOOLS.** See AMERICAN ACADEMY OF THE FINE ARTS, ART STUDENTS LEAGUE, NATIONAL ACADEMY OF DESIGN, and PENNSYLVANIA ACADEMY OF THE FINE ARTS.

**ACCONCI, VITO** (b. 1940). See PERFORMANCE ART.

**ACTION PAINTING.** See ABSTRACT EXPRESSIONISM.

**ADAMS, ANSEL** (b. 1902), a founding member of the F.64 GROUP and an influential landscape photographer. Born in San Francisco, Adams was a professional pianist when he met PAUL STRAND in 1930 and turned to photography, deeply impressed with the possibilities of the "straight" or "purist" technique (see STIEGLITZ, ALFRED; WESTON, EDWARD). In 1936 Stieglitz showed Adams's work at An American Place Gall., and in 1941 Adams was appointed photo-muralist to the Department of the Interior, for which he created the landscape portraits of various regions that made him famous. Beginning in 1954 he undertook a series of exhibitions and books with Nancy Newhall, including *This Is the American Earth* (1960).

A conservationist and nature lover, Adams has specialized in interpreting the American landscape in the purest and most direct manner possible. His famous "zone system"—in which he groups tone values into ten groups, or zones, ranging from dark to light—has enabled him to achieve a high degree of precision and control. Trusting in the scientific basis of picture making, Adams feels he is certain to arrive at a subjective interpretation of a scene simply by seeking the most exact equivalent of what he sees. He thus shares with Stieglitz and MINOR WHITE the belief that the most purely mechanical means produces the most expressive result. MOMA has a collection of his photographs. *Lit.:* Nancy Newhall, *Ansel Adams: The Eloquent Light*, 1963.

**ADAMS, HERBERT** (1858–1945), a leading sculptor of the Renaissance revival. Born in Concord, Vt., Adams studied at EBA, in Paris, in 1885, at a time when American artists were turning from the emulation of the sculpture of antiquity to more lively surface modeling. Among Adams's early works is a series of frontal and symmetrical busts, of attractive women, often in vaguely historical costume and sometimes polychromed, which recall the work of the Italian Renaissance sculptor Francesco Laurana (*Primavera*, 1893, Corcoran Gall.). The delicate low-relief modelling of such Renaissance artists as Desiderio da Settignano was the inspiration for Adams's relief *Singing Boys* (1894, MMA). As a leading sculptor of his time, Adams executed numerous portrait busts and received commissions for allegorical works of a commemorative nature. Perhaps his finest public commission was the set of bronze doors for St. Bartholomew's in New York City. Adams's work perfectly illustrates the academic spirit under the influence of the Renaissance, and it was in the same vein that his wife, Adeline Adams, wrote about the history of American sculpture in *The Spirit of American Sculpture* (1923). *Lit.:* Ernest Peixotto, "The Sculpture of Herbert Adams," *American Magazine of Art*, May, 1921.

AGOSTINI, PETER (b. 1913), a sculptor. From New York City, he is self-taught except for a year spent at the Leonardo da Vinci School of Art, in New York City. During the 1930s, he worked for WPA-FAP. His early work was influenced by a number of sculptors, including Alberto Giacometti and ELIE NADELMAN. By the late 1950s, he had developed a personal style dependent on a brilliant handling of plaster, which he molded and cast from found objects—cans, tubes, tires, plants, thin sheets of metal, and even paper. Pieces were often very elaborate, filled with complicated ridges, grooves, and projections and with baroque profiles. Themes, usually hidden by surface bravura, suggested the sea, the horse-and-rider, or, as in *Hurricane* (1962), the weather. Throughout the early 1960s, Agostini explored the everyday world more closely, creating such pieces of "frozen life" as clotheslines and punched-in pillows. These, though humorous, had surrealistic overtones because of their convoluted forms and implied meanings. During the rest of the decade, he produced forms molded from squeezed inner tubes, often piled capriciously on each other. Agostini colored some works; in those left unpainted, he allowed a tension to build between the voluptuousness of the pneumatic forms and the purity of white. In the 1970s, he exhibited figure studies made of clay, in which folds, dabs, and lumps were emphasized. He has also made many watercolors and monoprints.

AKERS, BENJAMIN PAUL (1825–1861), a talented but short-lived neoclassical sculptor from Westbrook, Maine. Akers received his early training in Boston, Mass., then sailed for Italy in 1852 and settled in Florence for a year. Back in America in 1853, he was primarily occupied with the creation of portrait busts and medallions. In 1855 he returned to Italy, this time to Rome, where he became an intimate of the Anglo-American colony, which at that time included Robert and Elizabeth Browning and Nathaniel Hawthorne as well as many fellow sculptors. In Rome Akers was able to turn his hand to the ideal themes favored by the neoclassical artists. Most of these sculptures have disappeared, though his *Saint Elizabeth of Hungary* (c. 1856), of which several examples were carved, still exists in a Portland, Maine, collection. Akers is best known for his *Dead Pearl Diver* (1857, McLellan-Sweat House, Portland, Maine), a beautifully carved and pathetic representation of ideal youth, drowned at sea. With its virtuoso carving (of the fishnet drapery), the statue brought the artist admiration and success. However, Akers's health had so deteriorated that a return trip to America and then another to Rome did him no good. Akers is remembered today as a one-sculpture artist, but it still affords him fame. Kenyon, hero of Hawthorne's *The Marble Faun*, is partly modelled upon Akers: He is the sculptor of a dead pearl diver and of a bust of Milton, as was Akers. *Lit.:* William B. Miller, "A New Review of the Career of Paul Akers, 1825–1861," *Colby Library Quarterly*, Mar., 1966.

ALBERS, JOSEF (1888–1976), one of the generation of European emigré artists (including HANS HOFMANN, the painter, and Walter Gropius and Ludwig Mies van der Rohe, the architects) who contributed to the domestication of modern art in America through their work and teaching. Albers was especially concerned with problems of perception and used both the graphic and painting media to probe them. Born in Westphalia, Germany, he was a schoolteacher intermittently from 1908 to 1918. During those years, he also studied at the Royal Art Acad., Berlin (1913–15), and at the School of Applied Arts, Essen (1916–19). Working primarily in graphics at the time, he reflected the influence of Paul Cézanne and of Cubism, particularly in his urban views, but in the series entitled Sandpit (linoleum cuts) he responded to the style of the Die Brücke artists. In this series, he studied the same subject repeatedly, a practice characteristic of his subsequent career.

Between 1920 and 1923, he studied at the Weimar Bauhaus, at a time when it was still oriented toward the romantic reunification of the arts and crafts. After creating a series of freeform collages composed of bottle shards, tin cans, and wire screens, he was invited to reorganize the glass workshop in 1922. In 1923, however, reflecting the influence of the De Stijl artist Theo van Doesburg, Albers's glass pieces grew increasingly geometrical (his change of style also reflected a change in emphasis at the Bauhaus favoring engineering and Constructivist aesthetics). He also began to use opaque milk glass with colored overlays, creating, in effect, "glass wall paintings." Appointed to the Bauhaus faculty in 1923, he took over the elementary courses. He remained at the Bauhaus until 1933.

About 1931 he began to explore perceptual problems in the Step series, whose principal image consisted of step-like shapes that could not be read according to the rules of linear perspective. Questions of depth and surface relationships remained purposely unresolved. This type of experiment, the leitmotif of the remainder of his career, Albers continued in America, first, in 1933, at Black Mountain Coll., then, at various other institutions, and finally in the Department of Design at Yale Univ., from 1950 to 1960. His earliest American works marked both the termination of an earlier improvisational manner and the development of a rigid geometrical mode. Some individual works assumed a lyrical cast as he experimented with the texture of woodcut blocks and with seemingly random linear arrangements. But, at the same time, he completed his first American series, the Treble Clef (initially conceived in Europe), in which the same format was used repeatedly with different value combinations. In such works, Albers was clearly illustrating his conviction that "an element plus an element must yield at least one interesting relationship over and above the sum of those elements." He felt that individual works in a series should be studied not in isolation but in comparison with each other so that different types of combinations might better be understood. Albers analyzed elemental pictorial problems in this and subsequent series by using illusionistic modulations of forms to create apparent but not actual changes in volumetric and positional relationships. This also involved considering the interrelationships of depth sensation and surface tension. Using simple linear constructions, avoiding personal flourishes and marks, Albers also explored ways in which forms and shades of color can produce different optical stimuli. In short, he investigated that area lying between reality and visual effect, between actual and apparent fact. The various media he used through the 1940s and 1950s were zinc lithographs, woodcuts, engravings, and linocuts; the series titles included Graphic Tectonics (lithographs, 1942) and Structural Constellations (engravings, c. 1957–64). He discontinued his experiments in graphics about 1965. Similar effects were also pursued in such paintings as the various Two Center pieces (late 1960s works composed of small rectangular slabs of unmodulated color in which two clear centers of focus compete for attention) and the famous Homage to the Square series, begun in 1949.

In his important book *The Interaction of Color* (1963), Albers indicated that color was not subordinate to form in his works but rather the chief medium of pictorial language. This statement reveals Albers's increasing concern with aesthetic experiences evoked by the interactions of color rather than of form, and this new preoccupation is perhaps best seen in the Homage to the Square series. The series also reflects Albers's great concern with economy of means. Choosing the simplest of formats—squares contained within squares—Albers also restricted himself as to color. Each square is an unmodulated color area, and all the colors in a given painting are of equal intensity (the squares are mathematically related in size and position). Each central square appears either to be superimposed on the other squares or to be a square hole in a field of rectangles; similarly, sections near

edges within each color area appear lighter or darker depending upon the strengths of the neighboring colors. Consequently, each painting in the series yields different spatial effects based on a purely coloristic means of organization. As in his previous series, Albers used different combinations within restricted formats, but here, no definitive solutions are suggested for color combinations. All of these works challenge the notion of holding a picture stable in the mind's eye and emphasize the ambiguities of perception, particularly of color perception.

Albers expanded his ideas to a monumental scale in murals made of brick, glass, and bronze, alone and in combination: the brick fireplace wall in the Graduate Student Center, Harvard Univ. (1950) and the large bronze-and-glass piece in the Time-Life Building, New York City (1961). He was an influential figure in the development of Op Art (see MINIMAL ART). *Lit.:* Eugen Gomringer, *Josef Albers*, 1968.

ALBRIGHT, IVAN LE LORRAINE (b. 1897), a painter of meticulously detailed images often reminiscent of viscera, whose work is representative of the style called MAGIC REALISM. Born near Chicago, he began studying art with his artist father in 1905. In the army during World War I, he drew medical illustrations. Deciding to become an artist, he studied at AIC from 1920 to 1923 and at PAFA and NAD in 1923–24. Probably the art schools taught very little to Albright, already profoundly influenced by his father, a strict disciplinarian who favored detailed drawing. Albright's paintings of the 1920s exhibit, beyond a broad realism, an obsessive concern for such details as creases in clothing and skin folds (*Maker of Dreams*, 1928, WA). This attitude, which has characterized his work up to the present time, is exaggerated, stylistically, by abrupt tonal contrasts and, psychologically, by the isolation of figures within neutral backgrounds. Pictorial objects appear as though set apart from human space, like exhibits on display.

As the decades progressed, Albright's rendering of flesh simulated decay and rot. Nervous and continuous light-dark contrasts evoked images of yeast rising and falling, but without the pleasant odors associated with baking. At times, lighting effects grew gaudy as forms appeared almost to palpitate. In his figural works, he seems to attack human vanity, leaving no room for joy, pleasure, or individual salvation. Nonfigural works, such as the image of a door in *That Which I Should Have Done I Did Not Do* (1931–41, AIC) have a poetic gloss that mitigates the aura of age and decay. Still lifes especially are filled with a bewildering display of forms and objects. *Lit.:* Michael Croydon, *Ivan Albright*, 1978.

ALEXANDER, COSMO (c. 1724–1772), a Scottish portraitist working in the colonies between 1768 and 1772. Alexander's father, John, was the creator of the unique surviving example of Scottish Baroque painting, *The Rape of Proserpine* (1720/21), and Cosmo called himself a history painter, but only his portraits survive. He was in Rome by 1749 and, after returning to Scotland (by 1754), went to Holland and London before his sojourn in the colonies. Alexander's known European paintings are stiff and quite simplified, and his style did not mature or change appreciably during his years in America. Indeed, his emphasis upon solidity of form and material goods was consistent with the intuitive classical realism of the far more masterly JOHN SINGLETON COPLEY, which dominated late colonial aesthetics. Alexander's principal significance in American art was his role as the teacher of the young GILBERT STUART, who became Alexander's pupil and assistant in Newport, R.I., in 1769, and who accompanied the Scottish painter on a tour of the South and then, in 1771, to Edinburgh, where Alexander died, leaving Stuart in the care of his brother-in-law and fellow artist, Sir George Chalmers.

ALEXANDER, FRANCIS (1800–1880), a leading New England portrait painter

during the early 19th century. From Killingly, Conn., Alexander settled in Boston, Mass., after studying in New York City with Alexander Robertson. In Boston, he received the friendship and guidance of the aging GILBERT STUART. Alexander's style was modelled upon Stuart's (as were those of most of the portraitists in Boston at the time), though his work lacked the vivacity and sparkle of Stuart's. His portraiture is more frankly sentimental, and he was at his most appealing in studies of attractive women. Here he may have been influenced also by Boston's other major romantic artist, WASHINGTON ALLSTON. Alexander achieved particular notoriety in 1842, when he painted a portrait of Charles Dickens, who was visiting Boston during his trip to America. He is reported to have badgered Dickens so persistently that the term "to be alexandered" came into vogue.

Alexander had visited Italy from 1831 to 1833, and in 1853 he returned, settling in Florence, where he became an intimate of the sculptor HIRAM POWERS, the leader of the American art colony there. He died in Florence.

ALEXANDER, JOHN WHITE (1856–1915), a major American portrait and mural painter. From Allegheny City, Pa., he began working as an illustrator for the publishing firm of Harper & Brothers in 1874; three years later, he went to Europe, studying in Munich with the many American artists who had been attracted to the Bavarian capital and art center. He was associated with J. FRANK CURRIER in Polling, Bavaria, and became one of the "Duveneck Boys," painting with the group in Florence and Venice in 1879 (see DUVENECK, FRANK). He returned to New York City in 1881 and worked there as an illustrator, but a decade later began a ten-year stay in Paris. It was particularly during his years in France that Alexander achieved his greatest prominence, and in both his portraiture and his more ideal figure painting, he became the leading American exponent of the aesthetic principles of the Art Nouveau movement. His masterpiece is *Isabella; or The Pot of Basil* (1897, MFAB) after the poem of that name by Keats. In this painting, as in his fashionable female portraits, Alexander worked with a fluid, sweeping line, combining an almost abstract, decorative rhythm of shape with a graceful and voluptuous expressiveness. Some of his portraits are painted in transparent colors on roughly woven canvas, an attempt at increased textural emphasis investigated by such other American painters of the period as WILLIAM MERRITT CHASE. Alexander's work as a muralist may be found at the Carnegie Inst. and at the Library of Congress (1895).

ALLSTON, WASHINGTON (1779–1843), the greatest of the American romantic painters. Allston came from a wealthy family in Georgetown, S.C., and was sent in 1787 to Newport, R.I., where he may have been inspired, perhaps even taught painting, by the portraitist Samuel King. In 1800 he graduated from Harvard Coll. where he had formed a strong friendship with the fine miniature painter EDWARD GREENE MALBONE, with whom he traveled to London to study in 1801. Malbone remained only a few months, but Allston studied for several years with BENJAMIN WEST and with Henry Fuseli at the Royal Acad. Thus, in these formative years as an artist, Allston was embued with the spirit of romantic classicism.

In England he met JOHN VANDERLYN. Though Vanderlyn's training was French, not English, the two Americans shared the ambition to create great historical canvases in the tradition of the old masters. Allston and Vanderlyn travelled through the Low Countries to Paris, and it was in Paris that Allston created his first major canvas, *The Rising of a Thunderstorm at Sea*, in 1804 (MFAB). This painting was the first great American seascape, and the first great romantic nature drama by an American, though its inspiration was a group of seascapes by the English artist Joseph M. W. Turner. Allston not only endowed his

work with the European romantic appreciation of the empty vastness of the sea and the helplessness of the storm-tossed boat but borrowed the swirling forms and chevron shapes in the sky from Turner's paintings.

Allston travelled on through Switzerland and arrived in Rome late in 1804, via Venice, Florence, and Siena. He impressed the important art community in Rome, which then consisted primarily of German artists, by a series of landscapes, classical both in subject and in their sense of order and harmony. He also painted in a manner derived from the Venetian Renaissance artists, a style that many of the German expatriates adopted, and Allston was given the appellation the "American Titian." In Rome, too, he undertook a number of portraits and pictures with classical subjects and formed close friendships with the English poet Samuel Taylor Coleridge and the American writer Washington Irving.

Allston returned to Boston in 1808 but three years later went back to London, this time with his pupil SAMUEL F.B. MORSE. During the years 1811 to 1818, Allston was recognized as one of the important history painters in England, specializing particularly in biblical themes rather than in the classical subjects he had painted in Italy. His friend and former teacher, West, had renewed his own popularity with vast religious paintings that taught moral lessons, tremendously successful in their great public showings, and Allston was one of the leading painters in London to follow his example, with *The Dead Man Restored to Life by Touching the Bones of the Prophet Elisha* (1813–14; PAFA), *Saint Peter in Prison* (1814, MFAB), and *Jacob's Dream* (1817). In 1817 he began his great *Belshazzar's Feast* (unfinished, Detroit Inst.), which became both his masterpiece and his albatross.

Allston returned to America in 1818, hailed as the nation's finest artist; nevertheless, there was still little demand there for great historical works, though his were admired by connoisseurs. Allston attempted smaller paintings, there-fore, both figural works and landscapes. The dramatic intensity of his English paintings was at first maintained in America, in such pictures as *Saul and the Witch of Endor* (1821, Amherst Coll.), but gradually, in the absence of the inspiration of British painting and examples in the old-master tradition, Allston retreated from the dramatic to the lyrical. This as much as anything may also account for his inability to finish *Belshazzar's Feast,* despite the subscription of a dozen wealthy Americans who together pledged a sum of $10,000 toward the great picture. This act of generosity nevertheless committed Allston to the completion of a work he might otherwise have been willing to abandon. Efforts were also made by Congress to interest Allston in the production of historical works for the Rotunda of the U.S. Capitol, but he did not undertake these works.

Allston's later pictures were painted in a very different spirit from those done in England. The finest of them show the solitary figures of young women, sometimes in outdoor settings—*The Spanish Girl* (1831, MMA), *The Evening Hymn* (1835, Montclair Mus.)—or indoors—*Roman Lady Reading* (1831, Newark Mus.). There are also several idyllic paintings of shepherd boys. These are wistful, intimate pictures of soft and fragile figures communing with nature, often echoing the pastoral mood of Allston's Italian landscapes and the tradition of Claude Lorrain. At this time, Allston also painted a number of poetic landscapes, whose forms are far softer and less monumental than those done on his early Italian trip, but which often were painted in a spirit of reminiscence and nostalgia for Italy. If his earlier landscapes suggest an ultimate derivation from Poussin, these later ones are more closely related to Claude. They also look forward to the late landscapes of GEORGE INNESS.

Allston's precise position in the history of American art is difficult to pinpoint. The works he created are uncommonly poetic and so somewhat alien to the

American tradition of art; yet he stimulated many painters and sculptors, including Morse, CHARLES LESLIE, and HORATIO GREENOUGH. Many other artists sought him out, and he inspired through contact or reputation the more intellectually ambitious art of the next generation. He became an arbiter of artistic taste and more than anyone else changed the public's conception of the artist from one as artisan to one as creative genius. His work was admired and when, on his death, his still-unfinished *Belshazzar's Feast* was put on exhibition in Boston, it created a great stir and in itself became a source of inspiration. A delicate, poetic, and intensely admirable person, his own character added to the stereotype of the quintessential romantic figure, as did his poetry and prose writings. At the same time, he was recognized as the antithesis of the typical American artist, whether in the role of successful portraitist, as JOHN SINGLETON COPLEY, or recorder of the native landscape, as THOMAS COLE. He was considered a cosmopolitan, intrinsically Europe-inspired artist, rather than a truly American painter. Allston's work is best represented in MFAB. *Lit.:* Edgar P. Richardson, *Washington Allston: A Study of the Romantic Artist in America,* 1948.

AMERICAN ABSTRACT ARTISTS, an association established in New York City in 1936 to unite abstract artists living in America, to promote their works, and to foster increased understanding among abstract artists as well as between artists and the public. BALCOMB GREENE was the first chairperson elected; the group's first exhibition was held in April, 1937. Catalogues published in that year and irregularly afterward have chronicled the association's history as well as bespoken the need for modern nonfigurative manipulations of color, form, and content. Initially, the members disavowed representationalism, expressionism, and Surrealism, but, over the years, elements of the latter, at least in its abstract form, appeared in many of their paintings. Most of the original members—painters

and sculptors included—worked in hard-edged and nonobjective styles based on Constructivism and Neoplasticism. International in outlook, the American Abstract Artists regarded themselves as in the vanguard of the new art of the 20th century. The organization reached its peak artistic strength about 1940, when the Dutch Neoplasticist Piet Mondrian lived in the United States. *Lit.:* Ruth Gurin, *American Abstract Artists, 1936–1966,* 1966.

AMERICAN ACADEMY OF THE FINE ARTS, an institution founded in New York City in 1802 as the New York Acad. of the Fine Arts. Its name was changed to the American Acad. of Arts when incorporation took place in 1808, and finally to the American Acad. of the Fine Arts in 1817. Virtually moribund in its last years, AAFA never recovered from a fire in 1839 that destroyed the building that housed it. By 1841 it had ceased to exist. Organized and run by merchants, it was founded to display copies of classical works, to cultivate the public taste for art, and to make examples of art accessible to artists. Exhibitions, instituted on a regular basis in 1816, included older works as well as copies, to the chagrin of contemporary artists. JOHN TRUMBULL, president between 1817 and 1836, modelled the institution upon England's Royal Acad. His resistance to change and his imperious dealings with artists helped provoke the establishment of a splinter group in 1825, which, three years later, became the NATIONAL ACADEMY OF DESIGN. *Lit.:* Mary Bartlett Cowdrey and Theodore Sizer, *American Academy of Fine Arts and American Art Union,* 1953.

AMERICAN ART-UNION, an organization involved between 1839 and 1851 in promoting American art. Initially (in 1838) named the Apollo Gall. and conceived as an exhibition space for artists, it was reorganized as the Apollo Assoc. in 1839 for a distinctly different purpose. The public was invited to join: Each year, members received an engraving of a

painting by an American artist as well as a chance to win an original painting or statue at an annual lottery. Artists were also invited to exhibit and sell works at the gallery. Purchasers included the general public as well as the assoc. Until 1842 the distributed reproductions were of Europe-inspired works, but in 1843, with its choice of WILLIAM SIDNEY MOUNT's *Farmers Nooning* (1836), the association began to favor works that were particularly American in theme and character. Renamed American Art-Union in 1844, the organization grew so popular that by 1849 it had 18,960 members. Dedicated to "cultivating the talent of artists" and to "promoting popular taste," the Art-Union helped further the careers of GEORGE CALEB BINGHAM, whose *Jolly Flatboatmen* (1846) was engraved in 1847, as well as those of RICHARD CATON WOODVILLE, GEORGE INNESS, and EMANUEL GOTTLIEB LEUTZE.

Although no lottery was held in 1851 for business reasons, a suit claiming the illegality of lotteries was pressed and won by the State of New York in 1852, effectively halting the Art-Union's operations. Similar art unions were established in Cincinnati in 1847 (the Western Art-Union), in Philadelphia in 1848 (the Philadelphia Art-Union), in Boston, Mass., and Newark, N.J., in 1850 (the New England Art-Union and the New Jersey Art-Union), and in Sandusky, Ohio, in 1854 (the Cosmopolitan Art Assoc.). *Lit.:* Mary Bartlett Cowdrey and Theodore Sizer, *American Academy of Fine Arts and American Art-Union*, 1953.

AMERICAN ARTISTS CONGRESS, one of the most important left-wing artistic organizations of the 1930s, in part because its policies were immediately and vigorously promoted by STUART DAVIS, its national secretary. Prompted in great measure by the inauguration of the Popular Front in 1935, the American Communist Party urged the formation of nationwide literary and artistic organizations to aid in its struggle against fascism. These organizations were to be broadly based and of politically diverse composition. The American Artists Congress first met from February 14 to 16, 1936, in New York City and numbered about four hundred delegates, including representatives from Mexico, Cuba, Peru, and Canada. The congress endorsed government art programs and government support for art unions, for a museum rental policy, and for an exhibition boycott of the 1936 Olympic Games in Berlin. Concern was also expressed for minority rights. The congress promoted symposia and exhibitions and also published books of social-realist art aimed at the average person (see AMERICAN SCENE PAINTING). The executive committee supported the Stalinist position during the Spanish Civil War and the Russo-Finnish War as well as Poland's dismemberment as a result of the Hitler-Stalin Pact, which opened it to charges of Communist party domination. In the spring of 1940, many initial supporters abandoned the congress, including Stuart Davis. By June, two new groups had formed: the Soc. of Modern Artists, composed of independent progressive artists; and the nonpolitical Federation of Modern Painters and Sculptors, which included among its membership some future Abstract Expressionists. The congress was defunct by 1943.

AMERICAN SCENE PAINTING, traditionally a term synonymous with Regionalism, a grassroots, nonpolitical art movement of the 1930s, which may now be used to describe all interwar movements devoted to the realistic recording of various aspects of American life. It thus includes social realism, a point of view rather than a specific style adopted by urban-oriented artists interested in political change, sometimes by revolutionary means. Regionalists thought that art should grow from the environment. Social realists wanted art to reflect social concerns and to be used as an instrument for social change. Both groups believed that artists should play a vital role in their society, and, together with independent realists like EDWARD HOPPER,

rejected modern European art and theory.

Regionalism: Most closely identified with midwesterners THOMAS HART BENTON, GRANT WOOD, and JOHN STEUART CURRY, and with easterner REGINALD MARSH because of the propagandizing of the xenophobic critic Thomas Craven, Regionalism was, in fact, a nationwide art movement in which artists turned to local themes presented in realistic styles. Hopper and CHARLES BURCHFIELD are considered the founders though they never identified themselves with it. Propelled into prominence among artists and into popularity with the public by the Depression, Regionalism took on a nationalistic and jingoist gloss, especially after it became the approved mode of representation for the various FEDERAL ART PROJECTS. No distinctive, local—and thus truly *regionalist*—art styles ever emerged, nor did artists try to develop them. The leading figure, Benton, actively sought to create a national American style rather than one associated specifically with the Middle West. The term, in fact, is better used to describe the work of a group of southern writers of the period associated with Vanderbilt Univ., as well as sociologists of the period concerned with economic, political, and cultural regionalization as opposed to centralization of American life. As an art movement, Regionalism encompasses attitudes ranging from nostalgia for the past, to depictions of the past and present, to interest in recording the passing scene. Major works include Wood's *American Gothic* (1930), Benton's *Boomtown* (1928), and Curry's *Mississippi* (1935).

Social realism: Found primarily in New York City, this aspect of American Scene Painting emerged in the early 1930s, encouraged especially by such leftist literary organizations as the John Reed Club. Most social realists, humanitarians rather than ideologues, found little pleasure in the American scene. BEN SHAHN, RAPHAEL SOYER, and PHILIP EVERGOOD, among the most successful artists

of this point of view, portrayed the downtrodden and the economically and racially disadvantaged, as in Shahn's *Scott's Run, West Virginia* (1937) and Evergood's *Through the Mill* (1940). At the same time they also painted, especially in their murals, idyllic hopes for a future free from physical want and psychological pain.

During the 1940s, American Scene Painting lost its vitality and purpose. In the light of global conflict and the principles at stake, art in the service of politics seemed completely compromised; in face of new worldwide American responsibilities, the American countryside no longer offered provocative thematic material. The American Scene movement may also be viewed within the larger context of American art independent of European influences, a recurrent theme in the history of American art. *Lit.:* Matthew Baigell, *The American Scene: American Painting of the 1930s,* 1974.

AMES, EZRA (1768–1836), the leading painter in Albany, N.Y., in the early 19th century. Ames came from Framingham, Mass., and worked first in Worcester but settled in Albany in 1793, remaining there for the rest of his life. He was an extremely prolific artist, undertaking all types of subjects, but the vast majority of his pictures are portraits, many of which depict local political figures. Ames's masterpiece is his portrait of Vice-President George Clinton (1813) for the New York State Capitol, in Albany, done to balance his copy of GILBERT STUART's full-length *George Washington.* Stuart, indeed, provided the inspiration for the pose and style of the Clinton portrait. The direct gaze, the impasto highlights, the pearly flesh tonalities, and the general coloration of all Ames's pictures are directly inspired by Stuart, who was the dominant figure in American portraiture during Ames's early maturity. But Ames's style is a simplified, provincial version of Stuart's, lacking the latter's painterly, stylistic verve and

sparkling likeness. *Lit.:* Theodore Bolton and Irwin Cortelyou, *Ezra Ames of Albany,* 1955.

**ANDERSON, ALEXANDER** (1775–1870), the first significant wood engraver in America. Born in New York City and trained as a doctor, he was inspired by the revival of the art of wood engraving in the hands of the British artist Thomas Bewick. In Bewick's style, the lines cut into the wood block are allowed to form the design, rather than define the dark areas around it. In 1798 Anderson completely abandoned medicine and devoted his life to wood engraving, producing thousands of designs. He made both small vignettes similar in manner and size to Bewick's engravings, many of which he copied, and large illustrations of the Bible and of the works of such authors as John Bunyan. Though Anderson produced some original designs, the majority of his wood engravings are after the work of such famous artists as BENJAMIN WEST. His engravings number many thousands, and he was active until the last years of his long life. Anderson dominated the field of wood engraving in America until the 1840s, inspiring such artists as Abel Bowen in Boston, Mass., and George Gilbert in Philadelphia. His approach to the art was superceded then by the freer and livelier style of F.O.C. DARLEY and, a decade later, by the more sophisticated art of WINSLOW HOMER. *Lit.:* Frederick Burr, *Life and Works of Alexander Anderson,* 1893.

**ANDRE, CARL** (b. 1935), an important Minimalist, whose strategies for creating sculpture during the mid-1960s were perhaps more important than the objects themselves. From Quincy, Mass., he studied with Patrick Morgan at Phillips Acad., Andover. There, he met FRANK STELLA, whose paintings and ideas, central to MINIMAL ART, furthered Andre's own developing theories during the late 1950s. Andre's work, at this time made primarily from Plexiglas and wood, retained blocklike features. Geometrical and saw-toothed repetitive patterns were incised, drilled, or cut into them. These pieces without bases reflected Andre's interest in Constantin Brancusi's sculpture in general, and in his *Endless Column* in particular because of its suggestion of continuity. In *Cedar Piece* (1959), Andre created two identical units that could be rearranged to form new configurations, offering extended possibilities for combinations of forms. Made from lumber, such works stressed the architectural and structural features of design, traditional concerns from which Andre had departed by the mid-1960s. After working for a railroad company between 1960 and 1964, he wanted his sculpture to become "more like roads than like buildings." This involved interrelating each piece with the environment in nontraditional ways. As he said, "Up to a certain time I was cutting into things. Then I realized that the thing I was cutting was the cut. Rather than cut into the material, I now used the material as the cut into space." In other words, Andre began to use the object to model the environment, and the environment became, in effect, the sculpture. In 1965 he decided to make his objects hug the ground, and this added a measure of negative volume—the space above the objects—to the total ensemble. Materials used were common industrial products—bricks, Styrofoam slabs, metal strips and squares standard in size and measurement. These products could be arranged in single file (as a cut into space) or in the shape of a rug. Each piece could be dismantled and stored, its artistic identity reappearing when reformed and exhibited. As a result, a piece by Andre documents only its own existence and its impermanent relationships with its site. With these pieces, Andre considered himself a "post-studio artist" in that he attacked the conception of sculpture as a precious and unique object without eliminating references to the object entirely, a step taken by some creators of Conceptual Art. More consciously than many sculptors, Andre

works with the essential properties of mass, location, and weight—placing the strips, slabs, and bricks in arrangements rather than compositions. The viewer is invited to observe the pattern from different positions, but common notions of centering and balance have been assiduously eliminated. Andre does not paint his objects, preferring that time and history alter their surfaces, nor does he use more than one type of material in each piece. His work reflects a violent reaction to the concern of ABSTRACT EXPRESSIONISM for individual and unique creations; he is very much a part of the subsequent search for basic vocabularies of form and the relationship of forms to environments, materials, and gravity. *Lit.:* Diane Waldman, *Carl Andre,* 1970.

ANDREW, BENNY (b. 1930), a painter whose works comment on racial and economic injustice in American society. From Madison, Ga., he graduated from AIC in 1958. Not a propagandist, he uses both personal and public symbols in his portrayal of victims of oppression and exploitation. He has adopted elements of Cubism and the weapons of caricature and has combined painting with collage and subtle with crude coloration to emphasize his points.

ANSHUTZ, THOMAS POLLOCK (1851–1912), an important painter and teacher in Philadelphia. Born in Newport, Ky., Anshutz studied in New York City at NAD from 1872 to 1876 and then enrolled at PAFA, becoming assistant to THOMAS EAKINS there. When Eakins resigned, Anshutz took his place as teacher of painting, in 1886. Anshutz maintained Eakins's emphasis upon the study of anatomy and, though not nearly so innovative as his illustrious predecessor, he was less demanding and dictatorial, and thus better liked. More of Anshutz's pupils at the academy became leaders of the next generation of American art than Eakins's; they included ROBERT HENRI and other painters associated with The EIGHT, as well as some of the more Europe-oriented American modernists.

The majority of Anshutz's oils show the female figure, in a combination of interpretative figure painting and portraiture. The isolated figure is usually seen either in a contemplative attitude or as a coquette, or as both. Figure construction is sharp and solid, though less vigorous than Eakins's work, and more glossily academic. Somewhat exceptional is Anshutz's most famous canvas, *Steelworkers—Noontime* (c. 1882), a rare example of industrial genre at that period. In this small canvas, Anshutz pursued Eakins's interest in the display of the human body in a range of positions, yet in a naturalistic and believable setting: His subject here is partially stripped workingmen at temporary leisure. Anshutz was also a masterful watercolor painter. His works in this medium (frequently beach scenes with young children) demonstrate a far greater interest in outdoor light and bright color than do his oil paintings. His watercolors also demonstrate the technical analogies between that medium and the newly popular one of pastel in the late 19th century. *Lit.:* Sandra Denny Heard, *Thomas P. Anshutz,* exhib. cat., PAFA, 1973.

ANUSZKIEWICZ, RICHARD (b. 1930), the most prominent painter associated with Op Art (see MINIMAL ART). From Erie, Pa., he studied at the Cleveland Inst. of Art from 1948 to 1953 and then with JOSEF ALBERS at Yale Univ., where he received a M.F.A. degree in 1955. He travelled abroad in 1958. Although Albers excited his curiosity about the effects of color on perception, Anuszkiewicz did not directly concern himself with such problems until about 1960. During the early and mid-1960s, his works contained repeated, concentric, geometrical shapes that emanated in wavelike movements from a center, as in *Water from the Rock* (1961–63, AK). In other paintings, forms radiated more strictly or as parts of expanding rectangles. In 1966–67 he reduced his palette to black and white, as in *One Quarter* (1966, New Jersey State Mus., Trenton). One pattern used recurrently in the 1970s looks like a

computer printout on graph paper. "My work," he has said, "is of an experimental nature and has centered on an investigation into the effects of complementary colors of full intensity when juxtaposed and the optical changes that occur as a result." Taken altogether, his surfaces are impersonally smooth; his systems of juxtaposed color areas are consistent and unbroken throughout a painting. Unlike other Op artists, he appears less concerned with indicating spatial jumps of color (at the edges of forms where two colors meet) than with suggesting an expansive glow of color from radiant forms that wants to extend beyond the framing edges. Unlike the wavy-lined paintings of Bridget Riley, his works can be looked at painlessly, and, unlike Victor Vasarely's paintings, which often contain three-dimensional suggestions, Anuszkiewicz's usually remain relatively flat. *Lit.: Anuszkiewicz*, exhib. cat., La Jolla Mus. of Contemporary Art, 1976.

**ARBUS, DIANE** (1923–1971), a photographer. Born in New York City, she became a successful fashion photographer, working for such magazines as *Vogue*. EDWARD STEICHEN chose one of her pictures from this period for the *Family of Man* exhibition at MOMA in 1955. In 1959 she took a photography course with Lisette Model, a bold and sensitive photographer, and subsequently gave up commercial work to pursue photography as an art. In 1963 and 1966 she was awarded Guggenheim Fellowships, and in 1967, her reputation was established in an important three-person show at MOMA with Lee Friedlander and Garry Winogrand entitled New Documents. Her suicide in 1971 was followed by a major retrospective exhibition at MOMA in 1972.

The major part of Arbus's work concerns social outcasts—midgets, transvestites, nudists—who confront the viewer with their social, and, more important, their private realities. She was usually able to inspire her subjects with a great desire to be photographed; they thus became collaborators in the pictures she took of them. Arbus avoided the usual sneaking glance or pathetic (because distanced) documentary study. MOMA has a collection of her photographs. *Lit.:* Diane Arbus, *Diane Arbus*, 1972.

**ARCHIPENKO, ALEXANDER** (1877–1964), a Europe-born and -trained, pioneer modernist sculptor who settled in this country in 1923. From Kiev, he studied art in that Russian city between 1902 and 1905. Arriving in Paris in 1908, he worked with Amedeo Modigliani and Henri Gaudier-Brzeska. By 1909 he had begun to abstract the human form by means of volumetric simplification. Soon afterward, he suggested negative masses by hollowing out parts of bodies, leaving voids where one normally anticipates ample curving forms. In 1912 he became a member of the Section d'Or. In that same year he made one of the first multimedia sculptures, *Medrano I*, composed of wood, glass, and wire. After moving to America, he simplified his Cubist style. His subsequent principal subject was the Torso in Space, created in the round, in relief as well as in collage materials. By the 1950s his work once again contained a mix of positive and negative volumes as in his earlier pieces. *Lit.:* Donald Karshan, *Archipenko*, exhib. cat., UCLA, 1969.

**ARMORY SHOW**, the popular name given to the first great show of modern art in America, the International Exhibition of Modern Art. Sponsored by the Assoc. of American Painters and Sculptors, it took place at the 69th Infantry Regiment Armory, New York City, between February 17 and March 15, 1913. Smaller versions of the exhibition travelled to AIC (March 24 to April 16) and to Copley Hall, Boston, Mass. (April 28 to May 19). Of the approximately 1300 European and American paintings, sculptures, and prints shown, about a third were foreign. The show encapsulated the development of major 19th- and 20th-century movements from neoclassicism and romanticism through Cubism, Fauvism, and the

various expressionist styles. The Italian Futurists did not exhibit at the show. Among the American works shown, pictures by Impressionists, such mystics as ALBERT PINKHAM RYDER, such realists as ROBERT HENRI and his circle, and such modernists as MAX WEBER were included. Modernist European and Europe-inspired pieces, especially Marcel Duchamp's *Nude Descending a Staircase, II* (1912, Philadelphia Mus.) provoked great hostility among the insular, conservative, and nationalistic Americans (among both the public and artists) and contributed markedly to the exhibition's notoriety. Its immediate importance was in calling to the attention of the public developments in the art world previously known only to a small audience of dedicated internationalists and cosmopolitans associated primarily with ALFRED STIEGLITZ. The sponsoring organization, secessionist in spirit like similar organizations abroad, persisted in the antitraditionalist tendencies evident in American art at least since the Macbeth Gall. exhibition of The EIGHT in 1908 and the exhibition of Independent Artists of 1910 (see INDEPENDENT EXHIBITIONS).

The Armory Show initially grew from discussions held late in 1911 by JEROME MYERS, WALT KUHN, Elmer MacRae, and Henry Fitch Taylor. All had had difficulties exhibiting their works and all were concerned with what they felt to be the moribund state of American art. On December 16, 1911, they helped form the Assoc. of American Painters and Sculptors, devoted to showing the best contemporary American and foreign art as well as to promoting American art activities. The majority of the original members were antiacademic but not very radical and probably not very familiar with recent European developments. They were most interested in advancing American art and improving the status of the American artist. JULIAN ALDEN WEIR, the Impressionist, was elected president (he immediately resigned), GUTZON BORGLUM, the sculptor, vice-president, and Walt Kuhn, the secretary.

The Armory Show, the only exhibition staged by the association, might not have become such a radical exhibition (and therefore the most important of all the independent exhibitions in America), had ARTHUR B. DAVIES not become its president early in 1912. Although best known as a painter of idyllic nudes, he organized the show with authority and competence and was chiefly responsible for emphasizing the work of radical European artists. After seeing the catalogue of the large and varied Cologne Sonderbund show, which took place in the summer of 1912, he communicated his excitement to Walt Kuhn. The latter left immediately for Europe to see the exhibition, which surveyed modernist developments. After borrowing a large number of works for the New York exhibition from the Sonderbund, he travelled through western Europe, rounding up additional pieces. Davies joined Kuhn in Paris, where they met artist-critic Walter Pach, who introduced them to many avant-garde figures. Davies and Kuhn also visited London, where they saw the Second Post-Impressionist Exhibition (the second Grafton Gall. show), organized by critic Roger Fry, a former curator of painting at MMA and an early advocate of modern art. The London show reinforced Davies's and Kuhn's intention to exhibit the still largely unknown modernists.

As part of their program to present a coherent survey of recent art and to explain it to a bewildered public, the organizers of the Armory Show published pamphlets on Paul Cézanne, Odilon Redon, and Raymond Duchamp-Villon, as well as excerpts from Paul Gauguin's *Noa-Noa*. Despite hostile responses from critics, artists, and the general public to the show, about 175 works were sold, including pieces to Lillie P. Bliss, John Quinn, Arthur Jerome Eddy, Albert C. Barnes, Walter Arensberg, A. E. Gallatin, and Stephen C. Clark, who developed the earliest substantial American collections of the new art and who subsequently gave various museums important examples. In fact, one of the major

results of the Armory Show was the development of a group of enlightened patrons who, in addition to buying the works of European modernists, supported American artists.

For American artists, the importance of the Armory Show has always remained ambiguous. MAURICE PRENDERGAST, then dean of American modernists, remained largely unaffected. Davies tried to absorb the new developments too quickly and so achieved only a superficial understanding of modernism. Realists JOHN SLOAN and GEORGE BELLOWS might have done better to have rejected modernism since it conflicted with their traditional styles. Many young Americans had already become familiar with modernism when abroad and were probably more greatly influenced by the European artists in this country during World War I than by the show. Upon a few, such as STUART DAVIS, the exhibition did have a profound effect. Perhaps the major consequences of the show were its contribution to a new climate of opinion that favored experimentation in the arts and support of those experiments by a handful of dealers and patrons, and the general sense of encouragement it gave American artists. *Lit.:* Milton W. Brown, *The Story of the Armory Show,* 1963.

**ARMS, JOHN TAYLOR** (1887–1953), a printmaker, best known for his etchings of medieval architecture. Born in Washington, D.C., he studied architecture at M.I.T., from which he graduated in 1912. For the next five years, he worked for Carrère and Hastings, a stylistically conservative architectural firm, then as a partner with Clark and Adams. He made his first etching in 1913. Although he came to prefer that medium to all others, he also worked in aquatint, often combining the two media, especially in the early 1920s. He made some lithographs in 1921 but, unlike STOW WENGENROTH, did not care for that technique. He turned seriously to printmaking in the 1920s. Early in the decade, he made prints of Maine scenes and a series on American cities, but increasingly he turned his attention to medieval, especially French, architectural subjects, which he etched with compelling virtuosity. At first he concentrated on sections of a building, but then reproduced entire facades, or, as in *Venetian Mirror* (1935), a number of buildings and even their reflections in water. Although he emphasized detail, his meticulous realism was modified by an underlying quest for spiritual grandeur. Of his various series of prints of Gothic monuments he said, "It is my mission to make bits of paper, covered with etched or penciled lines, express my deepest sense of beauty in the effort to recreate the glory which, though of another age, endures throughout the centuries." His *Handbook on Printmaking and Printmakers* was published in 1934. NYPL owns copies of all of his work.

**ART STUDENTS LEAGUE**, probably the country's most important art school during the early part of the 20th century. Founded in New York City in 1875, when the NATIONAL ACADEMY OF DESIGN closed its art schools for the season, ASL had to compete with at least thirteen other institutions in New York City, including one at the Cooper Union for the Advancement of Science and Art, established in 1859. Student controlled and managed, the league offered more progressive teaching procedures than other schools. Under its first important teachers WALTER SHIRLAW and WILLIAM MERRITT CHASE, the newly imported tonal and brushy styles of the Munich and related schools were emphasized instead of the precise drawing techniques favored by many Paris-trained Americans. Subsequently, many diverse figures, including THOMAS EAKINS, AUGUSTUS SAINT-GAUDENS, MAX WEBER, and JOSEPH PENNELL, taught there.

**ASHCAN SCHOOL.** See EIGHT, THE.

**ASSEMBLAGE,** a term used to describe mixed-media art objects. First suggested as a rubric by French artist Jean Dubuffet to include all types of composite art,

the term became popular when in 1961 MOMA held an exhibition entitled The Art of Assemblage. The show reflected and responded to the increased use of mixed-media during the 1950s, both in this country and abroad.

An assemblage is made up of two or more elements and is "predominantly assembled rather than painted, drawn, modelled, or carved. Entirely or in part, [its] constituent elements are preformed natural or manufactured materials, objects, or fragments not intended as art materials." Assemblage has also been described as the art of a junk culture, usually urban, in which bits and pieces of the environment, transformed or not, become the content of a work. Materials may be ephemeral or substantial. Meaning may be prosaic or profound, personal or public. Forms may be permanently fixed or alterable. Presentation may range from the exquisitely crafted to the randomly assembled. Such manipulation of nonartistic materials in indeterminate contexts has attracted many artists and influenced many movements since the late 1950s, especially in the medium of sculpture, so that even if Assemblage is associated with that period its influence is still profoundly felt two decades later. Major centers of work in assemblage have been New York City and southern California.

The history of Assemblage reaches back at least to the earliest experiments in collage by Pablo Picasso and Georges Braque in 1912, and can be traced through Futurism, Dada, and Surrealism. In this country, immediate sources are diverse. Marcel Duchamp's interest in found materials has been of great consequence. Surrealist juxtapositions of carefully arranged forms with potentially labyrinthine meanings influenced such figures as JOSEPH CORNELL (*Lunar Level No. 1*, 1958, Hirshhorn Mus.). ROBERT RAUSCHENBERG (*Collection*, 1953, San Francisco Mus.), the major assemblage-maker, and others divested objects of personal meaning, perhaps in response to the subjective and emotional cargo of Abstract Expressionist painting, thus allowing works to remain within the continuum of life, to maintain overtones of their own past history, even as their forms were manipulated in "artistic" contexts. At the same time, Assemblage carried ABSTRACT EXPRESSIONISM's improvisational tendencies well beyond the canvas surface. Some artists, such as EDWARD KIENHOLZ, used found objects to make sardonic observations about American life.

Virtually all assemblages provoke a series of questions concerning modern art: What is the nature of art? What is appropriate subject matter? What are appropriate materials? Should the artist form materials or use already formed ones? *Lit.*: William C. Seitz, *The Art of Assemblage*, exhib. cat., MOMA, 1961.

**AUDUBON, JOHN JAMES** (1785–1851), AND FAMILY. John James Audubon, the greatest American naturalist-artist, was born in Les Cayes, Santo Domingo (now Haiti), of French and Creole parentage, and was educated in France. He studied there for a short time with Jacques-Louis David, and the severity of line and classical purity of David's large forms, particularly at just this period, seem to have been transmitted to the young Audubon. He came to America, first in 1803 and then again to stay in 1806, and began pursuing his naturalist interests in Kentucky, hunting and collecting specimens. In 1808 he turned to portrait painting but continued his interest in wildlife, and about 1820 he began to note in watercolor the appearance of the different species of North American birds. The next six years were spent travelling widely in the United States, after which he went to England in search of engravers and publishers for his planned book on this subject and for financial support. This was raised by individual subscription, much of it in Great Britain, some in the United States.

Audubon's great publication *The Birds of America* contained 435 hand-colored aquatints copied from his own

drawings in their original size on copper plates and subsequently colored by hand. It appeared between 1827 and 1838 in four volumes. The prints included representations of 1065 birds of 489 species. A smaller, less complete edition was also published. The British artist Robert Havell, Jr., was responsible for most of the graphics, and his artistry is admired almost as much as Audubon's. He was later to emigrate to America and live near Washington Irving on the Hudson River, where he became a significant landscape artist.

Audubon's bird prints often contained more than one example of each species. They were depicted in life size, often in a setting appropriate in terms of both the habits of the birds and the geography of their habitat. Smaller birds were often displayed against decorative foliage; even camouflage was delicately suggested, though the birds themselves were never obscured. The larger birds are often shown in action, and Audubon was able to bring a sense of drama to these prints without lessening their accuracy. Audubon did not have a scientific education, and it was rather his ability to infuse life into his subjects that made his work superior to that of his predecessor and rival in the sphere of ornithological artistry, Alexander Wilson. Audubon's work was primarily in watercolor, though he occasionally created oil replicas of his orginals. Most of the watercolors are in the collection of NYHS.

After *Birds of America* was published, Audubon returned to America and soon embarked upon a companion project, *The Viviparous Quadrupeds of North America*, a less ambitious collection of 150 plates, reproduced by the newer and cheaper process of lithography. They do not have quite the finesse and sensitivity of Havell's great aquatints. *The Viviparous Quadrupeds* appeared in two volumes between 1845 and 1848. Audubon used assistants in his first publication, particularly for the foliage and backgrounds. For *The Viviparous Quadrupeds*, he relied extensively upon the

artistry of his two sons, whom he had trained, Victor Gifford Audubon (1809–1860) and John Woodhouse Audubon (1812–1862). Victor Gifford Audubon, primarily a landscape specialist, provided the backgrounds; John Woodhouse Audubon executed almost half of the original designs, often illustrating the smaller animals. He was an artist of distinction, though not quite of the quality of his father. John James was the greater designer and ornithologist. He is recognized as the originator of the greatest artistic publication in early American art. *Lit.:* Alice Ford, *John James Audubon*, 1964.

**AUGUR, HEZEKIAH** (1791–1858), one of America's pioneer professional sculptors. In the early 1820s Augur turned from mercantile pursuits to woodcarving in his native New Haven, Conn., where he lived his entire life. Augur had some training with SAMUEL F. B. MORSE, who, though a painter, had had experience with modelling figures as part of his classical training in England. With Morse as inspiration, Augur turned to marble carving, and in 1827 he executed a posthumous bust of Professor Alexander Fisher (Yale Univ.). In this, and in his later bust of Chief Justice Oliver Ellsworth for the Supreme Court, Augur's style—broad, flat planes of drapery with sharp edges—reveals his training as a woodcutter. He was generally unfamiliar with correct anatomical modelling. He carved several now-lost ideal pieces, but his best-known sculpture is the rather melodramatic *Jephthah and His Daugher* (1828–30, Yale Univ.). This is a two-figure group, full-length though only half life-size, created as two figures, separate but conceived together. In a way that is melodramatic yet faithful to the biblical source, Augur depicted the resoluteness of the daughter greeting her horrified father, who must sacrifice her for the military victory he sought. Here, Augur revealed himself a woodcarver working in stone. The columnar forms and general mood of high heroics ally

him with contemporary neoclassicism, whereas the attempt at archaeological accuracy, as seen particularly in Jephthah's armor, must be due to a study of European prints.

AULT, GEORGE (1891–1948), usually considered a Precisionist painter (see PRECISIONISM). From Cleveland, Ohio, he moved with his family to London in 1899. There, Ault attended the Slade School and St. John's Wood Art School. Frequent trips to Paris, as well as visits to the regions of Brittany, Normandy, and Picardy in France, introduced him to the advanced art movements of the time. He returned to the United States in 1911, eventually settling permanently in Woodstock, N.Y., in 1937. After early explorations of the modern styles, including a thickly brushed technique resembling late Neoimpressionism, Ault developed his mature style about 1920. He painted scenes that are primarily architectural, usually urban, sometimes rural, focusing on the geometry of structures and exhibiting a pronounced sense of design (*From Brooklyn Heights*, 1926, Newark, Mus.). The stark lines of his subjects were emphasized by extremely precise paint application, smooth and nearly textureless. Ault sometimes simplified his images, accentuating abstract design by leaving out details (such as windows), and employing a dark, muted palette of browns, grays, blacks, and greens, with lighter accents. Unlike the work of other Precisionists, Ault's is distinguished by a romantic, even poetic, quality. A great admirer of Giorgio de Chirico, Ault often placed objects in spare settings—a plow in the middle of a field or a figure on an empty rooftop—to create an unusual mood. His romantic side is best seen in his many Nocturnes—night scenes, in which glimmering skies with rippling cloudbanks and dramatic lighting turn mundane architectural themes into shadowy, rather mysterious vignettes.

After some experimentation in 1946 with abstract forms derived from natural effects (shadows cast by stacked cups, for example), he rejected reality for a fantasy world based on these random shapes, to which he added imaginary landscapes. Still executed with crystalline crispness, the painting of Ault's last two years is a personal variant of Surrealism—a geometer's dreamscape, filled with both linear and vaguely organic objects.

AVERY, MILTON (1893–1965), a painter. Avery's use of color and handling of composition were among the most sophisticated of the 20th century, and, even though his subject matter was limited primarily to figure studies and seaside scenes, it was charged with the same type of controlled emotional tension felt in the work of MARSDEN HARTLEY. In the hands of both artists, even ordinary scenes are memorable. Born in Altmar, N.Y., Avery studied in Hartford, Conn., before moving to New York City in 1925. He never went abroad as a young man (he did not travel there until 1952) and learned about modern art at home. Primarily an oil painter, he also made drawings throughout his career. In 1933 he began making drypoints, and in 1950 he undertook the first of some two hundred monotypes. In Avery's work, there was always a studied dialogue between line and shape. His early drypoints seem influenced by the angularities and abrupt tonal contrasts of German Expressionism. But in his paintings of the same period, even though edges of forms are clearly delineated, the luminous fields of color emphasize the supremacy of shape (*Harbor at Night*, 1932, Phillips Coll.). Because of the way he allowed color to define form, and because of his subtle combinations of hue and tone, Avery must be considered one of the nation's supreme colorists. Henri Matisse, rather than Paul Cézanne or Pablo Picasso, offered him the most important lessons. But Avery was not an abject imitator. Unlike Matisse's, his colors were invariably muted. Because of his habit of varying the amounts of white paint across a field of color, each shape appeared to have translucent

thickness regardless of what it represent-
ed. In figural works, this quality can sug-
gest bulk even if figures are not mod-
elled. In landscapes, it provides volume
without necessarily suggesting depth.
During the mid-1950's, Avery increas-
ingly controlled suggestions of volume,
in part by compositional simplification,
so that his late canvases, such as *Spring
Orchard* (1959, NCFA), appeared quite
flat. Though never associated with major
artistic groups, he was nevertheless an
influential figure. His use of color was
important for ADOLPH GOTTLIEB and

MARK ROTHKO, and, through them, the
Color-Field painters of the 1960s (see
MINIMAL ART). But unlike these later art-
ists, Avery never abandoned representa-
tional images, even when he merely in-
dicated them by economical detail and
kept them secondary to patterns created
by color masses. In this respect, his art
shows close ties to such earlier emotional
and mystical painters as Hartley and AL-
BERT PINKHAM RYDER. *Lit.*: Adelyn Brees-
kin, *Milton Avery*, exhib. cat., NCFA,
1969.

# B

**BABCOCK, WILLIAM P.** (1826–1899), a sig-
nificant expatriate painter. Babcock,
born in Boston, Mass., was one of the
earliest Americans to study with Thomas
Couture in Paris, in 1847. Like so many
of his fellow countrymen, he moved on
to Barbizon, the small French town
where many distinguished romantic
landscapists and figure painters had set-
tled (see BARBIZON, AMERICAN). There he
formed a friendship with Jean-François
Millet. It was Babcock who introduced
WILLIAM MORRIS HUNT to that great
French artist. Although Babcock execut-
ed some well-received still lifes, in a po-
etic manner not dissimilar from that of
JOHN LA FARGE, he was noted as a figure
painter, particularly of traditional classi-
cal and biblical scenes. They also have a
strong poetic strain and what may be de-
scribed as a Venetian feeling for form,
color, and light, in a manner reflecting
Couture and Titian, but also akin to the
fine studies of the nude that Millet
painted in the 1840s, before turning to
his better-known peasant subjects. Al-
though Babcock lived most of his profes-
sional life in France, and died there, his
work was appreciated in his native Bos-
ton, and MFAB has a large collection of
his painting.

**BACON, PEGGY** (b. 1895), a printmaker,
but also a poet and author of children's
books. Her work is typically satirical,
whether her subject was a fellow artist
(*Kenneth Hayes Miller,* 1927) or a
group of ordinary people characteristi-
cally occupied (*Antique Shop,* 1943).
From Ridgefield, Conn., she studied at
ASL and other schools from 1915 to
1919. Her first important works in dry-
point, a medium she first used in 1917,
are related in theme to the realistic
prints of JOHN SLOAN and GEORGE BEL-
LOWS, but her style was more modern
than theirs in that she emphasized flat-

tened, unmodelled forms. At first, these
forms were bound by taut, dark lines,
but about 1920 she occasionally softened
contours and modelled features, depend-
ing upon the subject and the effects she
wanted to produce. In the late 1920s, she
began to explore lithograph, etching,
and pastel, but drypoint remained her
favored medium. Only in the 1950s did
she concentrate on oils. In many works
she recorded the New York art world.
Her observations, gentle rather than
mordant, are of ordinary events in the
lives of her subjects, but her ability to ex-
aggerate a turn of the neck, a withering
glance, or a baggy dress and pair of
pants often flavors her sallies with a wry
twist. A large collection of her work is in
Guild Hall, East Hampton, N.Y. *Lit.:*
Roberta Tarbell, *Peggy Bacon,* exhib.
cat., NCFA, 1975.

**BADGER, JOSEPH** (1708–1765), a New
England portraitist. From Charlestown,
Mass., one of the earliest native-born art-
ists, Badger began his career as a house
painter in Boston, turning to portraiture
about 1740. To judge from the large
number of likenesses we know he paint-
ed, Badger had abundant patronage.
This is somewhat surprising, for of all
the professionals known to have worked
during the colonial period in Boston,
Badger was the least sophisticated. His
pictures are flat, labored, and character-
less, without the sense of design or at-
tractive color that often animates primi-
tive or naive art. We can only suppose
that Badger had a brief moment of pros-
perity about 1750, when more talented
figures were absent from the artistic
scene (JOHN SMIBERT became blind in
1749 and died two years later; ROBERT
FEKE left the colonies about 1750, as did
JOHN GREENWOOD two years afterward).
The arrival in 1754 from England of the
talented Rococo artist JOSEPH BLACKBURN

and the rise of Badger's infinitely abler fellow Bostonian JOHN SINGLETON COPLEY must have dimmed Badger's popularity, their work making his appear not only inadequate but outmoded in style. There are, however, some later paintings by Badger that suggest the influence of the young Copley. As with many so-called primitive artists, Badger's most attractive paintings are often those of children, for example, that of his grandson, *James Badger* (1760, MMA), in which the naiveté of his youthful subject matches his own innocent vision. *Lit.:* Lawrence Park, "An Account of Joseph Badger . . .," *Proceedings of the Massachusetts Historical Society* 51 (Dec., 1917).

**BAIZERMAN, SAUL** (1889–1957), a sculptor, born in Vitebsk, Russia. He came to America in 1910 and, soon after, studied at ASL and at the Beaux-Arts Inst. of Design, New York City, until 1920. About 1920 he developed a technique of hammering metal sheets into shapes, and he used this technique for the remainder of his career. As a result, his work must always be viewed from the front. Primarily a realist, he chose urban themes in the early 1920s, notably for his City and the People series. Subsequently, he simplified forms by creating chunky squared-off volumes. These evolved into monumental figures whose softened arabesques and stippled surfaces provide a note of lyricism. *Lit.:* Thomas Messer, *Saul Baizerman*, exhib. cat., Inst. of Contemporary Art, Boston, 1958.

**BALL, THOMAS** (1819–1911), a sculptor of historical figures. Ball, born in Charlestown, Mass., began his artistic career as a painter in Boston and, when he turned to sculpture, he alternated between the neoclassical aesthetic and a more naturalistic one. He spent much of his life in Florence, becoming a close friend of HIRAM POWERS, and he produced a good many smooth, sentimental works in marble, some of which were funeral monuments in Boston cemeteries. His most vigorous sculptures, however, are bronze figures of historical American leaders, beginning in the 1850s with his popular statuettes *Daniel Webster* and *Henry Clay* (1858, North Carolina Mus.). In these he avoided traditional symbolism and classical costume, though he emphasized the strong oratorical personalities of his subjects. These bronzes were cast by the Ames Foundry in Chicopee, Mass., the first foundry to produce art sculpture in the United States. *Daniel Webster* was enlarged in 1876 for the heroic statue in New York City's Central Park.

One of Ball's finest sculptures is his equestrian statue *George Washington*, installed in Boston's Public Gardens in 1869. The slow, cadenced movement and the aura of sureness and steadfastness in the poses of horse and rider make the work one of the major bronze monuments of the third quarter of the century. Even more famous is Ball's *Emancipation Group; or, Lincoln Freeing the Slaves*, erected in Lincoln Park in Washington, D.C., in 1876 and paid for by contributions from freed slaves. The symbolism is restrained, as a paternal Lincoln gestures above a counterbalanced crouching black man, anatomically strong and well observed. A replica of this monument was commissioned by the City of Boston. *Lit.:* Thomas Ball, *My Threescore Years and Ten*, 1891 (reprint, 1976).

**BANNARD, WALTER DARBY** (b. 1934), a painter, and a writer on the effects of color. From New Haven, Conn., he began to paint seriously at Princeton Univ., from which he graduated in 1956. His early paintings evoke memories of WILLIAM BAZIOTES and THEODOROS STAMOS. In 1958–59 CLYFFORD STILL's close-valued paintings became influential. Through the early and middle 1960s, Bannard painted hard-edged works with centralized circular and rectangular motifs in close-valued, pastel colors. Primarily concerned with color relationships, Bannard created forms that lacked movement and seemed to float in a thin veil of color. Yet, their location in the

pictorial field was clear and easy to read. After 1965 Bannard began to loosen forms, and by the end of the decade amorphous areas stretched across the canvas surface, often in superimposed layers of pigment (*China Spring No. 3,* 1969, Baltimore Mus.). In the early 1970s, he began to thicken surfaces so that the drag of the brush became much more evident, as if he were asserting the importance of the surface rather than of the arrangements of forms or the sheer visuality of color alone. *Lit.:* Jane Harrison Cone, *Walter Darby Bannard,* exhib. cat., Baltimore Mus., 1973.

**BANVARD, JOHN** (1815–1891), the most successful and important of the panorama artists (see PANORAMAS). Banvard came from New York City but settled in Louisville, Ky. That city became his base of operations while he travelled the Mississippi and Ohio rivers for material he later incorporated in his Mississippi panorama, begun in 1840. Seven or eight similar panoramas were created in the late 1840s and early 1850s by other artists, including, John Rowson Smith, Henry Lewis, Leon Pomarede, Samuel Hudson, and John J. Egan. All of these men competed with one another to achieve the greatest accuracy of description, variety of scene, and length for their panoramas. Banvard's was originally twelve feet high and over thirteen hundred feet long, but, as with most of the panoramas, it was continually enlarged. Banvard began to travel with his panorama in 1846 from city to city, accompanying the presentation with lectures, music, and pamphlets. In 1847 more than a quarter of a million people viewed it. Later, Banvard toured Europe. In London, more than six hundred thousand people saw the attraction, and he exhibited it to Queen Victoria at Windsor Castle. He also duplicated the panorama so that one version could tour the English provinces while another was shown in France. A form of popular entertainment and a forerunner of the cinema, Banvard's panorama nevertheless captured the interest of such distinguished authors as Longfellow, Thoreau,

Whittier, and, in England, Dickens. While abroad, Banvard conceived, and created a panorama of the Holy Land and the Nile, but he is remembered best for his now-lost Mississippi panorama.

**BARBIZON, AMERICAN,** a style that intermeshed with TONALISM and Impressionism (see IMPRESSIONISM, AMERICAN) as well as with the MUNICH SCHOOL style. Fundamentally based on the proto-Impressionist landscape and figural art of the painters who, under the leadership of Théodore Rousseau and Jean-François Millet, settled in the French village of Barbizon earlier in the century, American Barbizon paintings also reflected the general late 19th-century interest in enriched surfaces, intimate scenes, and bucolic subject matter. The Boston, Mass., painter Winkworth Allen Gay was the first American to take lessons from a French Barbizon artist, (Constant Troyon), in 1847, and WILLIAM P. BABCOCK was perhaps the first to become friendly with Millet and to move (about 1849) to Barbizon, but it was WILLIAM MORRIS HUNT who became the most significant early American exponent of the Barbizon style. He spent two years (1852–54) with Millet and was instrumental as a teacher and a painter in popularizing the mode after he returned to New England in 1854. Of greater ultimate significance, however, was GEORGE INNESS because of the high quality of his work and the followers he attracted. After 1855 Inness began to work in the Barbizon idiom, creating a landscape of mood and poetry, based on summary form rather than specific detail and with muted tones dispersed across the picture surface. ALEXANDER WYANT was attracted to the style in the late 1860s and DWIGHT TRYON had developed a related one by 1880. The creative peak of American Barbizon was reached in the 1880s and 1890s, though significant figures continued to work in the style into the 1920s.

For the most part, American Barbizonists preferred the lower-keyed paintings of Camille Corot and Charles Dau-

bigny to Rousseau's richly colored and vibrantly textured works. They also neglected the example of Millet's heroic peasants. Figures, when included in the landscape, are small in scale. Trees and bushes tend to have blurred and softened edges; streams meander rather than rush between their banks. In the work of some artists, such as Daniel Ridgeway Knight and even William Morris Hunt, an academic attention to detail and clarity of parts in figures contrasts with the muted and indistinct background forms. A few artists, including Carleton Wiggins, concentrated on animal scenes. Most paintings portray agrarian life as pleasant and tranquil. Although skies are often cloudy, it rarely storms in a Barbizon landscape, and farmers toil without fatigue. The landscape does seem to be shrouded in perpetual mourning, however, but the source of gloom is never disclosed; one must surmise it lay in the heart of the painter. In any event, the desire to commune with nature and to project human feelings upon nature suggests that a residue of Barbizon influence made itself felt on the art of such early modernists as JOHN MARIN and ARTHUR G. DOVE. A large collection of Barbizon works is in NCFA. *Lit.*: Peter Bermingham, *American Art in the Barbizon Mood*, exhib. cat., NCFA, 1975.

BARD, JAMES (1815–1897), and JOHN (1815–1856), "ship portraitists." Born in New York City, the Bard brothers were twins who collaborated in painting ships, occasionally sailing vessels but most usually steam-sidewheelers. They worked in New York City, and their careers developed apart from the general course of American art. Their painting is closely allied in style to the work of naive or primitive artists, with sharp, tight, meticulous drawing, flat patterning, and bright coloration (see FOLK ART). It is believed that one brother, probably James, did the drawing and the other provided the coloring, though after John's death, James continued to produce an enormous number of paintings. Accurate visual descriptions of individual vessels, they are also rather monumental. The boats are always placed parallel to the picture plane and shown on the water, with many attractively painted small figures of sailors and passengers. The work of the Bard brothers has special significance for the historian of sailing and navigation, and their work is to be seen primarily in the numerous seaport and marine museums in America. *Lit.*: Harold Sniffen and Alexander Brown, "James and John Bard: Painters of Steamboat Portraits," *Art in America*, Apr., 1949.

BARNARD, GEORGE GREY (1863–1938), the most original American sculptor of his generation. From Bellefonte, Pa., Barnard grew up in the Middle West and, after attending classes at AIC, went to Paris in 1883. He studied there at EBA and succeeded in winning the patronage of Alfred Corning Clark. It was Clark who commissioned Barnard's earliest works, in which can be found the influences of both Michelangelo and Auguste Rodin.

Barnard's major sculpture for Clark was *Struggle of the Two Natures in Man* (1894, MMA), a powerful group of two nude male figures, one prone, the other tensely rising. The expressiveness communicated by the human form here recalls Michelangelo; the only other American sculptor to have been similarly inspired was WILLIAM RIMMER. *Struggle of the Two Natures* was shown in 1894 at the Paris Salon and made Barnard's reputation. In 1896 Barnard's sculpture was exhibited in New York City. Other works of these years included *Pan* (1896–1902, Columbia Univ.) and *The Hewer* (1896–1902), the latter a representation of primitive man, strong of body, yet at the same time filled with fears and doubts. The most important commission of Barnard's career was the decorations for the Pennsylvania State Capitol, at Harrisburg, created in France between 1904 and 1910. The original scheme called for a vast panorama of figures allegorically expressive of

virtues and vices, including law, labor, love, brotherhood, and parenthood. A scandal over the misuse of funds in Harrisburg in 1906 brought payments to an end, but Barnard was able to continue to work on the project by collecting and selling French antiquities. He also accumulated a collection of his own, which became the basis of the medieval collection at the Cloisters, in New York City. The unveiling of the sculpture in Harrisburg took place on October 4, 1911—Barnard Day, as it was called—and the state finally awarded him a substantial sum for the heavy burden of expenses he had assumed.

The only major historical monument that Barnard produced was the bronze *Lincoln* for Cincinnati. The statue was cast in 1917 and set up in Lytle Park. It created a furor, for Barnard had deliberately avoided the more conventional dignity of Lincoln representations by AUGUSTUS SAINT–GAUDENS and DANIEL CHESTER FRENCH, and critics found the crude features, the staring eyes, the expressive, oversized hands and feet, and the unpressed costume undignified and unworthy of the subject. Nevertheless, replicas of the sculpture were ordered for Louisville, Ky., and Manchester, England, and the sculptor also created separate marble heads of Lincoln, including a colossal one sixteen feet high. In later years, Barnard's style changed somewhat. His earlier work is characterized by undulating surfaces in an impressionistic manner; some of his later figures are smoothly stylized and simplified in a manner not unlike that of PAUL MANSHIP. No other sculptor of his day created works of such personal expressiveness and none of his sculpture can be considered academic or formularized. *Lit.:* Harold E. Dickson, *George Grey Barnard, Centenary Exhibition, 1863–1963,* exhib. cat., Penn State Univ., 1964.

BARNARD, GEORGE N. (1819–1902). See PHOTOGRAPHY, CIVIL WAR.

BARNET, WILL (b. 1911), a printmaker and painter from Beverly, Mass. After studying at MFAB from 1928 to 1930, he concentrated on lithography at ASL from 1930 to 1934. In 1934 he became ASL's printer. Throughout his career, Barnet's lithographs have tended to exploit the full range of tones, whereas the differentiations in his woodcuts are more starkly black and white, in the manner of German Expressionism. Until about 1939, Barnet maintained a realistic style, and, as in *Conflict* (1934), the content of his work reflected the currently popular social realism (see AMERICAN SCENE PAINTING), although, he also often explored family themes. During the 1940s, more imaginative forms and subtler ranges of color or tone pervaded both his painting and prints. Toward the end of the decade, Barnet increasingly abandoned "realistic space and substituted a painting space based purely on the rectangle: the vertical and horizontal expansion of forms." But even when images became completely abstract, they rarely departed from the organic. Through the 1960s and 1970s, Barnet's work has swung from nonobjective to realistic extremes. Of his abstract work he has said, "[It] is never concerned with amorphous feelings but always with visual images of very real experiences which demand [that] each form exist in its own sharply defined character." To that end, Barnet's forms retain a firm sense of shape, and their spatial relationships, when not logical from the point of view of perspective, are carefully coordinated (*Big Grey,* 1962). *Lit.:* Una E. Johnson, *Will Barnet: Prints 1932–1964,* exhib. cat., Brooklyn Mus., 1965.

BARTHOLOMEW, EDWARD SHEFFIELD (1822–1858), a significant but short-lived neoclassical sculptor. Bartholomew came from Colchester, Conn., and studied at NAD. On finding he was colorblind, he turned from painting to sculpture. Bartholomew began carving marble busts and medallions in Hartford, Conn., and New York City and in 1850 went to Rome. His sculpture in the round, based on traditional classical and religious subjects, culminated in *Eve Repentant,* one

replica of which (1858–59) is in WA. The figure is monumental but suitably tragic in expression, a seated woman weighed down by grief. (The subject was sculpted by many of Bartholomew's American contemporaries in Italy.) At his best and most personal when working in bas-relief, Bartholomew interpreted classical subjects, such as Homer and Belisarius, and religious ones, such as Hagar and Ruth. Together, the pieces prove that he was one of the finest relief sculptors of the period. Unlike the medallions of his contemporaries ERASTUS DOW PALMER and MARGARET FOLEY, Bartholomew's reliefs are narrative pieces and convey a sense of tragic sincerity, in stylized but very beautiful terms. He died young, as did his contemporary BENJAMIN PAUL AKERS, and was buried in Naples, where he had gone for his health. Collections of his work are in WA and the Maryland Hist. Soc. *Lit.:* William Wendell, "Edward Sheffield Bartholomew, Sculptor" *Wadsworth Atheneum Bulletin*, Winter, 1962.

**BARTLETT, PAUL WAYLAND** (1865–1925), one of the more illustrious of the American Beaux-Arts sculptors. Born in New Haven, Conn., he was the son of the minor neoclassical sculptor Truman Bartlett. In 1874 he went to Paris to study, and was thus one of the early Americans to turn away from the neoclassical sculptural tradition practiced in Italy to the more vital, fluid, and progressive art of EBA. He studied in Paris with one of the leading French masters of the period, Emmanuel Frémiet. Bartlett began his career as a specialist in animals, a respected theme in contemporary French sculpture, and, though he soon turned away from this, the skill he had achieved stood him in good stead in the execution of many of his major works. The first of these was *Bear Tamer* (1887, Corcoran Gall.), whose Indian subject matter reflected his American background. The surfaces are varied and textured, assuming great vitality as light passes over them. Bartlett's forms turn naturally and are open, allowing for varying view-

points and contrasts of solid form and voids. Facial types are markedly unclassical, and poses are deliberately awkward, gaining in spontaneity what they lack in grace. Such qualities can also be found in the work of Bartlett's teacher Frémiet and in that of such contemporary Italian masters as Victor Gemito. Bartlett spent most of his career in France and, appropriately, was the sculptor of the bronze equestrian *Lafayette* (1899–1908), donated by the United States to France and installed in the court of the Louvre Mus. His most ambitious sculpture was the pediment for the Senate Wing of the U.S. Capitol, in Washington, D.C.

**BASKIN, LEONARD** (b. 1922), a sculptor, printmaker, and draftsman, for whom "man and his condition have been the totality of my artistic concern." From New Brunswick, N.J., he studied sculpture with Maurice Glickman at the Educational Alliance, New York City, from 1937 to 1939, and art at New York Univ. and Yale Univ. from 1939 to 1943. During these years, his sculpture reflected the influences of Ossip Zadkine, Henri Laurens, and ALEXANDER ARCHIPENKO. After World War II, Baskin allowed social concerns and political beliefs to color his work. When, in 1949, he began to make wood engravings, his attitude toward the nature of man grew more generalized, but no less moralistic or didactic. In style these works are closest to German *Die Brücke* prints. A trip abroad at this time, with study at the Académie de la Grande Chaumière, Paris, and the Accademia di Belle Arti, Florence, as well as extensive familiarization with the great European collections, helped release in him the sculptural images he has since used—large, heroic, but flawed human beings who at times recall photographic images of concentration-camp victims *(Youth: Oak,* 1956, Univ. of Nebraska); and birds with human bodies that suggest mythical forms *(Crow Man: Walnut,* 1962). Whether working with bronze or wood, in the round or in relief, or using the

graphic media (and especially in his enormous woodcuts, some over five feet in height), Baskin employs an expressionist touch. Forms are neither smoothed nor rounded off. He is also editor of Gehenna Press. *Lit.: Baskin: Sculpture, Drawing and Prints,* 1970.

**BAYOU SCHOOL,** a group of artists who painted the Louisiana landscape from the 1860s into the 1880s. It is subject matter rather than style that gives unity to this group: bayou scenes showing swamp oaks, cypresses, Spanish moss, and other elements characteristic of that southern landscape. In some paintings, a sense of quiet is pervasive. Some have a palpably moisture-laden atmosphere reminiscent of the landscapes of LUMINISM. Many reflect the diverse European training of the individual artists. Best-known of this group were RICHARD CLAGUE, and Joseph Rusling Meeker, a pupil of ASHER B. DURAND, whose most important Louisiana landscapes were painted from sketches made there during the Civil War. Also a key figure was Everett D. B. Fabrino Julio, who studied with WILLIAM RIMMER. Julio worked in both St. Louis and New Orleans. The term Bayou School has also been used in reference to Art Nouveau pottery produced at Newcomb Coll. in New Orleans (between about 1895 and 1918), in which Louisiana landscape motifs are a distinctive feature of the design. Examples of Bayou landscapes are located primarily in museums and private collections in New Orleans. *Lit.:* H. Parrott Bacot, *The Louisiana Landscape: 1800–1969,* exhib. cat., Anglo-American Art Mus., Louisiana State Univ., Baton Rouge, 1969.

**BAZIOTES, WILLIAM** (1912–1963), a painter associated with the first phase of ABSTRACT EXPRESSIONISM. Born in Pittsburgh, he worked for a stained-glass company in Reading, Pa., about 1931. His serious art study began when he attended NAD from 1933 to 1936, studying especially with LEON KROLL. Between 1936 and 1941, he was employed by WPA-FAP, first as a teacher then in the Easel Painting Division. He became the first Abstract Expressionist to gain wide attention when he won a prize at the AIC exhibition of abstract and Surrealist art in 1947. His mature style began to emerge in 1942 through his interest in automatism. Prompted by Roberto Matta Echaurren and Joan Miró, he broke the Cubist strictures containing his work. As in the works of several contemporaries, biomorphic forms began to spread across his increasingly loose Cubist grids (see BIOMORPHISM). By 1946 monumental amoebalike forms had begun to dominate his canvases (*Cyclops,* 1946, AIC). They were set off by either squiggly shapes or linear webs bathed in translucent colors and softened as if seen through thin veils. Baziotes said that he did not follow a system to evoke images. "Each beginning suggests something," he remarked in 1947. "Once I sense the suggestion, I begin to paint intuitively." For Baziotes, "the act of doing it [painting] becomes the experience." Nevertheless his forms and subtle color arrangements appear to be the result of careful calculation—even if opted for on the spur of the moment—rather than of violent outbursts of passion or prolonged self-definition. His late paintings assumed a breadth of scale and airiness that suggest he might have developed, had he lived longer, a willingness to emphasize the palpability of the canvas surface itself (*Opalescent,* 1962, Walker Art Center). *Lit.:* Lawrence Alloway, *Baziotes,* exhib. cat., Guggenheim Mus., 1965.

**BEAL, GIFFORD** (1879–1956), a painter and etcher. Beal was one of the last American artists to receive Impressionism directly from those who brought it over from France (see IMPRESSIONISM, AMERICAN), and he remained faithful to it all his life. A native of New York City, Beal studied at ASL for two years and also with WILLIAM MERRITT CHASE on weekends and during summers from 1891 to 1900. During this period, Beal also attended Princeton Univ. from which he graduated in 1900. He went

abroad for the first time in 1908 and later also visited the West Indies, Central America, and the east and west coasts of Africa. Working principally in gouache, watercolor, and pastel, Beal concentrated on scenes of New York City, the circus, and the coastal areas of New England. He also painted a number of Hudson River Valley landscapes from 1901 to 1908. Brilliant light and color characteristically pervade his works. In his later years, his mature Impressionist style became increasingly looser and freer (The Albany Boat, MMA; A Puff of Smoke, AIC). Beal also liked to draw, and the influence of Raoul Dufy can be seen in his work in this medium.

BEARD, JAMES HENRY (1812–1893), a leading animal-painting specialist. Beard was born in Buffalo but grew up in Ohio and began his artistic career as an itinerant portrait painter, settling in Cincinnati and remaining there until 1870, when he moved to New York City. His early works were, for the most part, straightforward, uninspired, but competent portraits. He was also an early genre specialist; his initial pieces in this vein, dating from 1840, are gently humorous paintings of small figures in dark, humble mercantile establishments. Though lacking the vivacity of a WILLIAM SIDNEY MOUNT, the compositional sureness of a GEORGE CALEB BINGHAM, and the pungent satire of a DAVID GILMOUR BLYTHE, these early genre pictures have historical significance. And one picture at least, The North Carolina Emigrants, of about 1845, in the poignant sense of hopelessness and despair it conveys is a truly memorable achievement. Nor did Beard ever entirely abandon genre. But he gained his earliest real success with portraits of children with animals, and this encouraged him to abandon portraiture for animal painting in which his subjects mirrored the follies and vanities of human beings. In this specialization he was followed by his younger brother, WILLIAM HOLBROOK BEARD, though James's work is distinguished by a predilection for indoor settings and overscaled animals, such as in The Parson's Pets (1874). In a sense, these are modern allegories; the tradition is founded in the work of such old masters as David Teniers and Jean-Baptiste Siméon Chardin. In some of these pictures, Beard introduces a very real violence, a sense of chaos and destruction that may be characterized as Victorian "black humor."

BEARD, WILLIAM HOLBROOK (1824–1900), a leading specialist in animal painting. Beard was born in Painesville, Ohio, but maintained a studio in Buffalo during the 1850s, becoming a leading artist of the emerging art community there. In 1861 he settled in New York City. Both he and his older brother, JAMES HENRY BEARD, practiced a form of humorous, sometimes satirical animal painting in which the follies and weaknesses of man are attributed to animals. One of Beard's finest works, replicated several times, is Susannah and the Elders (1865), where the biblical beauty is represented as a swan and the two lecherous elders by two owls. More topical are Beard's The Bears of Wall Street Celebrating a Drop in the Market (NYHS) and, far more savage and violent, The Bulls and Bears of Wall Street, (c. 1880, NYHS). William Beard's works differ from those of his brother in their outdoor landscape settings, which are so emphasized that the animals usually remain fairly small and are seen from a distance. He occasionally made small models of his animals and at least twice designed large sculptural monuments, never executed. One of these was a plan for a vast, subterranean entrance to an art gallery lined with gigantic statues of animals, proposed for New York City's Central Park by the millionaire Henry Keep about 1870. Beard occasionally painted fantastic human genre pictures, among them a sprightly Santa Claus (early 1860s, RISD).

BEARDEN, ROMARE (b. 1914), a painter of the black experience in America. From Charlotte, N.C., he studied with George Grosz at ASL in 1936–37. About that

time he became active in the Harlem-based 306 Group, which also included JACOB LAWRENCE. From 1950 to 1954, he lived abroad and studied at the Sorbonne in Paris. His paintings of the early 1940s combine a stylized realism with African elements, notably masks used as portrait heads. Scenes derived from the Bible and from ancient legend include black figures as the principal characters, as in *The Annunciation* (1942). During the 1950s, Bearden's work turned decidedly abstract, as he substituted for figural images both thickened bars of loosely woven color and layered washes indistinct in shape. He also used oil paint as if it were watercolor. Forms hug the picture surface, but, because of their softened edges and subtly related tones, they appear to float rather than to be anchored to the surface. In the early 1960s, he turned to collage, bringing together images of faces and masks in landscape and interior settings. Spaces and objects are oddly juxtaposed: Parts of faces are taken from different sources, often producing a nightmarish aura; bodies are superimposed on a jumble of street images. These phantasmagorical montages describe the passage of blacks through contemporary America. A theme Bearden has used, "The Prevalence of Ritual," may describe a baptism (an example of 1964 is at Williams Coll.), a "conjur woman," or a funeral. Placing people and objects in indefinite environments, he combines the specific with the general in order to create archetypal images. Bearden wrote *The Painter's Mind* (1969) with CARL HOLTY. *Lit.:* M. Bunch Washington, *The Art of Romare Bearden: The Prevalence of Ritual,* 1972.

**BEAUX, CECILIA** (1855–1942), a portrait painter. Born in Philadelphia and associated with that city for much of her life, Beaux was an artist whose style changed from an early realism to a more international, painterly, and fluid style, often compared with that of JOHN SINGER SARGENT. Although she later denied it in her autobiography, *Background with Figures* (1930), Beaux studied at PAFA in the 1870s, when THOMAS EAKINS taught there. She also studied with William Sartain (see SARTAIN, JOHN) before going abroad in 1888 and enrolling at the Académie Julian in Paris. Her first major composition, *Les Derniers Jours d'Enfance* (1885), derived from JAMES A. M. WHISTLER's well-known portrait of his mother, (1871), was shown at the Paris Salon in 1887. After returning to the United States, she began to attract attention as a portrait painter. While a member of the PAFA faculty from 1895 to 1915, she continued to travel and work abroad at frequent intervals, associating with many of the leading artists of the day, including CHILDE HASSAM, ABBOTT THAYER, and WILLIAM MERRITT CHASE. A recipient of many honors, she, like Chase, was asked to paint her self-portrait for the Uffizi Gall. in Florence. Beaux was frequently ranked with MARY CASSATT as an outstanding woman painter. Such public figures as Henry James, Theodore Roosevelt, and Georges Clemenceau sat for her, as did many members of her own family. *Lit.:* Frank Goodyear, Jr., *Cecilia Beaux: Portrait of an Artist,* 1974.

**BECK, GEORGE** (1748/50–1812), among the earliest professional landscape painters in America. Beck was one of four English-trained landscapists who came to America between 1790 and 1795 (the others were WILLIAM WINSTANLEY, William Groombridge, and FRANCIS GUY). He exhibited in London in the early 1790s and may have been the best trained of the four. He worked for a few weeks in Norfolk, Va., two years in Baltimore, and seven years in Philadelphia, before moving on to Kentucky about 1804–5. English works by Beck are known, but his strongest paintings are two acquired by George Washington for "Mount Vernon" and still on view there. These are of the falls and rapids of the Potomac River (c. 1796), very dramatic and powerful, and suggest the influence of the Dutch 17th-century tradition, then popular in Beck's native England. He also provided the designs for six

views of America published as engravings in London between 1800 and 1808, topographical prints of scenic beauties and natural wonders of America. Beck's wife, Mary, was a teacher who conducted academies in Baltimore, Philadelphia, Cincinnati, and Lexington, Ky., but is reputed to have been a landscape painter also. The Becks were among the first professional artists to work west of the Appalachians. *Lit.:* J. Hall Pleasants, *Four Late Eighteenth-Century Anglo-American Landscape Painters*, 1942.

BELL, LARRY (b. 1939), a sculptor, born in Chicago. After attending the Chouinard Art Inst., in Los Angeles, from 1957 to 1959, he created shaped canvases (see MINIMAL ART). Turning to sculpture about 1961, Bell worked in a mode associated with a distinctive southern California school that includes ROBERT IRWIN, DeWain Valentine, and Craig Kauffman. Bell's primary materials have been coated glass and plastics derived from recent technological developments. By 1964 he had begun making framed cubes containing mirrored and transparent glass. Precisely tooled, their coated surfaces are exquisitely surfaced and—paradoxically—transparent, translucent, and, on occasion, opaque. They exist in space yet do not prevent the eye from passing through them. In 1966 Bell placed the vacuum-coated glass boxes at eye level, often on transparent bases so that light could travel through all parts of a work. About this time, he also experimented with freestanding glass panels coated to achieve varying degrees of reflection and opacity. When placed within a room, these become nonisolatable as the viewer walks around them, gazes through them, and sees reflections in them. In effect, they create ever-changing room-sized environments. These works exist in states of continuing metamorphosis, an industry-related analogue to the biomorphic paintings of such artists as MARK ROTHKO and WILLIAM BAZIOTES. *Lit.:* Barbara Haskell, *Larry Bell*, exhib. cat., Norton Simon Mus., 1972.

BELLOWS, GEORGE (1882–1925), a realist painter associated with The EIGHT, who did not, however, participate in their famous exhibition in 1908. He arrived in New York City in 1904 from Columbus, Ohio, his birthplace, and, while studying at the New York School of Art, was befriended by ROBERT HENRI. Bellows developed a style notable for vigorous brushwork in either broad strokes or small touches of pigment. Initially, he favored a tonal palette, preferring creams and browns scumbled by streaks of white. Like others in Henri's circle, Bellows painted urban scenes, ranging in theme from excavations to dockside swimming. Even though he occasionally sought a quiet, even lonely, vantage point, he especially favored dynamic interpretations that reflected the exuberance of urban life. A notable example is *Steaming Streets* (1908, Santa Barbara Mus.), which shows horses drawing trolley cars. He painted crowded neighborhood streets as he painted athletes at moments of great physical stress, perhaps to suggest the state of visual and physical excitement a modern city can generate. Bellows realized these sensations in concrete rather than spiritual terms, in realistic rather than abstract imagery.

Although Bellows found the city to be a wonderful middle-class spectacle, he was sympathetic to the poor and to radical causes. In 1912 he joined the art staff of *The Masses* under JOHN SLOAN, providing illustrations until the magazine was forced to cease publication in 1917. During World War I, he created a series of paintings and lithographs (a medium he began to use in 1916) about wartime atrocities, including his famous *The Murder of Edith Cavell* (1918, Springfield Mus.).

Throughout his career, Bellows painted portraits and landscapes. After 1909 they revealed the influence of Hardesty Maratta's lively color schemes and, after 1918, the geometrical compositional theories of Jay Hambidge (see HENRI, ROBERT). Perhaps the ARMORY SHOW of 1913 also inspired Bellows with an obsessive desire to provide his art with a sound un-

derlying structural and coloristic basis. However, his new "scientific" interests inhibited his earlier, more personal responses to his subject matter. Yet his sympathetic portrayals of the human face, into which he poured his emotions, remain among the best portraits of the immediate postwar years.

In the early 1920s, Bellows occasionally attempted to paint landscapes infused with fantastical elements, as in *The White Horse* (1922, Worcester Mus.), which might have developed into a landscape art of poetry rather than of fact had Bellows not died soon after. Compared in his lifetime to Walt Whitman for his robust and democratic embrace of the mass of Americans, Bellows was viewed as the personification of the new American artist—vigorous, athletic, eager to explore themes and to experience life. Never programmatic, his art reflects the impressions of an intensely responsive individual. *Lit.:* Charles H. Morgan, *George Bellows: Painter of America,* 1965.

**BENBRIDGE, HENRY** (1743–1812), a portrait painter. Benbridge came from Philadelphia and studied briefly with JOHN WOLLASTON in 1758. Enabled by an inheritance to travel to Europe, he left for Italy in 1764, thus joining his distant relative BENJAMIN WEST in becoming one of the first colonial artists to study the grand manner at first hand. The highlight of his European years was a commission to paint an "official" military likeness of the Corsican patriot General Pascal Paoli for James Boswell. In London, Benbridge met West and painted Benjamin Franklin; he returned to Philadelphia with letters of recommendation from both of them. There he met the miniaturist Letitia Sage, whom he married, and soon after they settled in Charleston, S.C. (Sage apparently abandoned painting after their marriage).

Benbridge's work is extremely uneven. The best of it is stylistically neoclassical: sharply outlined, with a fascinatingly metallic drapery treatment. The early historian of the arts in America WILLIAM DUNLAP later was to complain of Benbridge's hard outlines and dark shadows. Often the heads and bodies of his figures are wildly disproportionate (*Sarah Flagg,* c. 1775, Gibbes Gall.). Yet he was a most ambitious artist and painted numerous group portraits combining monumental figures in interlocking geometrical relationships. Though these may be classified as "conversation groups," they are stiff and serious, displaying none of the relaxed informality that usually characterizes that genre. There still exist several ambitious classical works in the manner of Peter Paul Rubens by Benbridge. Dunlap also mentions a category of "small fulllength" portraits, and several of his group portraits of cabinet size are extant, done in a scale that suggests his proficiency as a miniature painter. In this last category, he was one of the best artists of his day (a number of miniatures by Benbridge are on display in the Gibbes Gall.). Benbridge apparently retired about 1790 because of ill health, but at the turn of the century he gave lessons to young THOMAS SULLY in Norfolk, Va., *Lit.:* Robert L. Stewart, *Henry Benbridge,* exhib. cat., NPG, 1971.

**BENGELSDORF, ROSALIND** (b. 1916), a painter and charter member of the AMERICAN ABSTRACT ARTISTS. Born in New York City, from 1930 to 1934 she studied painting at ASL, where George Bridgeman's anatomy classes were groundwork for her evolution of a nonobjective idiom. In 1936, at HANS HOFMANN's private school, she began to produce abstract paintings reflecting an aesthetic philosophy based on a belief in the interdependence of all matter, which drew upon the art of Paul Cézanne and Pablo Picasso, as well as upon insights gained in high-school science classes. Bengelsdorf lectured on her philosophy, which she called "The New Realism," at meetings of the American Abstract Artists. Later, she found pure geometrical abstraction too reductive; her mature personal style includes biomorphic forms abstracted from actual objects and is

similar in approach to ARSHILE GORKY's Newark Airport murals (begun in 1935). Bengelsdorf was part of WPA-FAP, Mural Division, from 1936 to 1939, and Easel Painting Division in 1939–40. Bengelsdorf ceased full-time painting in the early 1940s and in 1947 began a second career as art critic and teacher. Until 1972 she was editorial associate for *Art News* magazine. *Lit.:* Karal Ann Marling and Helen A. Harrison, *Seven American Women: The Depression Decade*, exhib. cat., Vassar Coll., 1976.

BENGSTON, BILLY AL (b. 1934), a painter associated with art in southern California. From Dodge City, Kans., he studied briefly at the California Coll. of Arts and Crafts, Oakland, in 1955–56 and at the Otis Art Inst., Los Angeles, in 1956. He also studied with ceramist PETER VOULKOS. From about 1960 until the mid-1970s, his paintings (and ceramics) invariably had a central image—a cross, an iris, chevrons (*Humphrey,* 1963, LACMA). With the exception of the motorcycle in *Skinny's 21* (1961), these emblems appear as shapes without volume. In the late 1960s, Bengston often used dented aluminum sheets as his "canvas." Like other southern California artists, such as LARRY BELL and Craig Kauffman, in the late 1950s Bengston began to explore the ways modern materials affected surface finishes. In addition to oils, he used, lacquers, epoxies, and acrylics, as well as spray guns. Colors were often applied in successive thin layers so that the central emblem exists in an indefinable, textureless, translucent space, while the surrounding rectangular fields often contain richly brushed areas for contrast. The aluminum pieces were painted smoothly, but the dents suggest textures they do not actually possess. In the mid-1970s, Bengston abandoned the central image and the glossily finished surface for a style that reexamines the overlapping planes of Cubism. But at the same time, he remains very much concerned with creating a well-crafted surface. *Lit.:* James Monte, *Billy Al Bengston,* exhib. cat., LACMA, 1968.

BENSON, FRANK WESTON (1862–1951), a leading Boston, Mass., Impressionist painter, also known for his etchings and aquatints. He was born in Salem, Mass., and, like his good friend EDMUND C. TARBELL, was educated at the school of MFAB. There, he later taught extensively, beginning in 1889, when he returned from study at the Académie Julian, in Paris. Some of Benson's earliest work consists of subtle, tonal figure painting that reflects the influence of JAMES A. M. WHISTLER and probably of the short-lived Boston painter DENNIS MILLER BUNKER. Benson's work is very much like that of Tarbell. His indoor figure painting combines solid figure construction with subtle modulations of light, in the manner of the Dutch old master Vermeer, then just recently "rediscovered." His outdoor paintings, especially those of vibrant, lovely young women, were painted in the full spectrum of colors, in bright sunlight. His subjects were taken from the wealthy classes: idealized women in a world never made ugly or harsh. Like Tarbell, too, Benson was a member of the TEN AMERICAN PAINTERS. His subjects are often somewhat more active and more monumental than Tarbell's (*In a Garden,* Milwaukee Art Center), and his paintings reflect a love of children. Benson was responsible for some of the murals in the Library of Congress. In his later years, he combined still-life painting with figure subjects but was principally occupied with sporting pictures: etchings and paintings of duck hunting. *Lit.:* Patricia Jobe Pierce, *The Ten,* 1976.

BENTON, THOMAS HART (1889–1975), the major exponent of AMERICAN SCENE PAINTING, who, in the 1920s, tried to create a style and range of subject matter that would be distinctly American and as meaningful to as many of his fellow countrymen as possible. Born in Neosho, Mo., Benton studied at AIC in 1907–8, before departing for Paris, where he remained until 1911. Like others initially attracted to the conservative Académie Julian and Académie Colarossi, Benton

discovered modern art independently. For the next several years, he was influenced by Paul Cézanne, Henri Matisse, and the Cubists, as well as by SYNCHROMISM after he returned to America. Until 1918 or 1919, he was a dedicated modernist and was included in the Forum Exhibition in 1916 (see INDEPENDENT EXHIBITIONS). Unfortunately, a fire in 1913 destroyed most of his early work.

After serving in the navy in 1918–19, Benton was inspired to develop a modern American art free of European taint. Influenced by French critic and historian Hippolyte Taine and, in the late 1920s, by American historian Frederick Jackson Turner, Benton believed that art should grow from the environment rather than from abstract ideas and that relevant American art would spring from artists who lived in sympathetic interaction with their environment and heritage. Since Benton believed that the common person was primarily responsible for the development of the nation, he was most responsive to subject matter based on the common experiences of the average individual. This belief also accorded with the Populist political ideas he inherited from his father, who served in the House of Representatives from 1897 to 1905.

Through the 1920s, Benton developed his Americanist style in mural studies for an American historical epic, first planned about 1920. In these, he developed his characteristic jerky-figured, broken-spaced style, which was intended to represent the constantly changing, dynamic aspects of American life. For emphasis, he developed a stipplelike technique, vaguely Neoimpressionist in effect, and the many individually discernible colors add a note of energy. His later murals *America Today* (1930, New School for Social Research), *The Arts of Life in America* (1932, now New Britain Mus.), and *The Social History of the State of Indiana* (1933, now Indiana Univ.) popularized mural painting and thereby encouraged federal support for mural programs (see FEDERAL ART PROJECTS). Benton's paintings at the Missouri

State Capitol, Jefferson City, 1935, are the major American Scene murals.

After World War II, when nationalistic concerns diminished in importance, Benton became a chronicler of America's past rather than an advocate of enriching American traditions in the present. *(Independence and the Opening of the West*, 1959–62, Truman Library, Independence, Mo.). He also painted intimate landscape and portrait studies. One might consider him as the last in a line of artists, reaching back to JOHN TRUMBULL and SAMUEL F. B. MORSE, who sought to create an American art and who tied their art to their country's past, present, and future.

A prolific writer, Benton authored two autobiographies, *An Artist in America* (1937) and *An American in Art* (1969). *Lit.:* Matthew Baigell, *Thomas Hart Benton*, 1974.

BERTOIA, HARRY (1915–1978), a sculptor, born in San Lorenzo (Udine), Italy, who was brought to this country in 1930. After studying at the Detroit Soc. of Arts and Crafts in 1936, he attended Cranbrook Acad. of Art, in Bloomfield, Mich., where, in 1939, he set up the metalworking department. In 1943 he moved to southern California, where he worked with designer Charles Eames. In 1950 he joined Knoll Associates as a furniture designer. Aware of the desire of architects and designers to create integrated environments, Bertoia developed into a prolific architectural sculptor. His first commission, a screen for the General Motors Technical Center, Warren, Mich. (1953), was followed by many other commissions in major cities and airports. They included screens composed of small, slightly irregular metal rectangles welded in slightly different depth planes; mazes of thin rods, brushlike in appearance, whose contours are formed not by continuous lines but by closely juxtaposed rod ends; and occasional experiments with forms that move and emit sound. His smaller pieces are stylistically similar. For Bertoia, "One prevailing characteristic of sculpture is the

interplay of void and matter, the void being of equal value to the component material units." *Lit.:* June K. Nelson, *Harry Bertoia, Sculptor*, 1970.

**BIDDLE, GEORGE** (1885–1973), a social-realist painter and muralist (see AMERICAN SCENE PAINTING). Born in Philadelphia, he prepared for a career in law at Harvard Univ. and passed the bar examination, but in 1908 decided to become a painter and enrolled at PAFA. Between 1911 and 1914 he studied in Munich and in Paris at the Académie Julian. The most important influences on his work were Diego Velázquez and Peter Paul Rubens, and, later, Edgar Degas and MARY CASSATT (the two Philadelphians were close friends until Cassatt's death in 1926). In 1932, after painting genre scenes in Paris, Polynesia, and Italy, Biddle settled permanently in the United States, where he helped popularize mural painting. He is credited with having persuaded Franklin D. Roosevelt in 1933 of the need for a government project to employ artists (see FEDERAL ART PROJECTS). Biddle's first and best-known government mural commission is *Tenement* (c. 1935, now Univ. of Maryland). *Lit.:* George Biddle, *An American Artist's Story*, 1939.

**BIERSTADT, ALBERT** (1830–1902), the best-known painter of the western landscape. Born in Solingen, Germany, he and his family came to America in 1832, settling in New Bedford, Mass. In 1853 he went to Düsseldorf to study. Düsseldorf was then the leading European center for young American artists, who went to learn the craft of landscape, genre, and history painting. There, Bierstadt became close to EMANUEL GOTTLIEB LEUTZE and to T. WORTHINGTON WHITTREDGE. Of the three, Bierstadt was to become the foremost practitioner of Düsseldorf landscape-painting techniques. He and Whittredge went to Rome for a year, and in 1857 Bierstadt returned to America. The works he painted in Germany, though characterized by Düsseldorf meticulousness and drabness of palette, are much more painterly and generalized than most German landscapes of the period, and his Italian scenes are surprisingly luminous—considering both the artist as he was to develop and the period.

Back in America, Bierstadt visited the White Mountains, where he experimented with outdoor photography, and then in 1858 made his first trip to the West, joining Colonel Frederick W. Lander's expedition to the Wolf River and Shoshone Indian country. On his return, he began to paint the series of western landscapes for which he is best known and justly famous. In 1863 he made a second trip to the West, and the paintings that resulted from this journey brought Bierstadt to the height of his career. He began to turn out enormous panoramas of western scenery, exploiting the magnificent Rocky Mountain ranges and filling his scenes with a variety of landscape elements—lofty crags and cascading waterfalls, plateaus and plains—as well as buffalo and Indians. His western scenes are the northern visual counterparts of the famous tropical landscapes of FREDERIC EDWIN CHURCH. Both artists conceived of the New World as an unspoiled Eden (for Bierstadt, the Indian was both noble savage and primitive innocent). But, compared to the work of his colleague and rival Church, Bierstadt's is thin in color and uninteresting in the handling of paint, despite its topographical accuracy and care in the manipulation of line and form. Bierstadt's western masterpieces are *The Rocky Mountains* (1863, MMA) and *Storm in the Rocky Mountains* (1866, Brooklyn, Mus.). Germanic coolness and dryness still dominate the 1863 canvas, but the later painting (newly rediscovered) is a very vital work, and it benefits from a Turneresque, elliptical, vortextual composition, which pulls the spectator's eye into a whirlpool of movement. Joseph M. W. Turner's influence was appreciable at this period in America, reflected also in the works of Church and SANFORD ROBINSON GIFFORD, but seldom is it found in Bierstadt's art.

The public responded favorably in the 1860s to Bierstadt's grandiose "machines," but by the end of the decade critics were beginning to find these great paintings bombastic, as more lyrical and intimate Barbizon painting began to appear in America (see BARBIZON, AMERICAN). In the early 1870s, Bierstadt made a third visit to the West, this time to San Francisco, where he lived for several years, considered by the Californians as practicing the finest cosmopolitan landscape techniques. He also travelled frequently to Europe and to the Bahamas; his European Alpine scenes are still often mistaken for western American ones, especially since demand today for his painting relates very much to the present preference for American scenery.

By the 1880s, Bierstadt's reputation had become much downgraded, and, with the rejection of *The Last of the Buffalo* (1888, Corcoran Gall.) from the Paris Universal Exposition of 1889 by a professional artist-jury, he became an anachronism in American art. His *Landing of Columbus* for the Chicago WORLD'S COLUMBIAN EXPOSITION in 1893 destroyed; versions in the Newark Mus. and Perth Amboy Public Library) did nothing to ameliorate this situation. By the time of his death, he and his reputation were in total obscurity. In recent years, however, his popularity has grown considerably. *Lit.:* Gordon Hendricks, *Albert Bierstadt: Painter of the American West,* 1974.

BINGHAM, GEORGE CALEB (1811–1879), one of America's greatest genre painters. Bingham was born in Augusta County, Va., but grew up in Franklin, Mo., and that area was the scene of all his major work. He began as a portraitist, in 1833, creating simplified and linear paintings that have a strength and an intensity of modelling that make them greatly superior to the work of most provincial artists. In 1838 he studied briefly at PAFA and between 1840 and 1844 was painting portraits in Washington, D.C. Undoubtedly due to his Philadelphia training, his portraits of this period are much more sophisticated, though not especially individual.

In 1845 Bingham began the series of scenes of life in the Middle West (then the West) upon which his reputation rests. Almost without exception, these fall into three thematic categories, all related to the Missouri and Mississippi rivers and to St. Louis. The earliest of these masterworks is still considered his best: *Fur Traders Descending the Missouri* (1845, MMA). It is also the simplest of his multifigure scenes, depicting a quizzically smiling youth, a grizzled old trader, and a strange tethered animal outlined against a misty background that is as flat as a stage set. These figures are arranged in a boat parallel to the picture plane; they glide silently by and will shortly be out of sight.

Fur traders were exotic figures in then quite cosmopolitan St. Louis. Riverboatmen, though a wild, rough company, were a more familiar sight, and in his first depiction—*The Jolly Flatboatman* (1846)—Bingham appropriately showed them not gliding out of view but with their boat perpendicular to the picture plane, the symmetrical compositional lines directed toward the spectator. No 19th-century American artist created a more conscious geometrical structure of forms. In Bingham's work, horizontals and diagonals were carefully balanced; multiple diagonals were parallel or symmetrically crossed, and figures were positioned to form right angles that reinforce fundamentally cubical arrangements. Each year Bingham increased the structural complexity of his rearrangements of these flatboatmen, whom he depicted engaged in all sorts of activities—dancing, playing music or cards, or just lounging (never working !). Gradually, the flatboatmen moved onto the land and, gradually, too, Bingham's compositions moved from formal symmetry to asymmetry, so that one side or the other of the painting began to open up vast vistas of river landscape, while figures, still geometrically arranged, occupied the other side. He also began painting near-replicas of his in-

creasingly famous works, and, though the variations he introduced often included a skillful depiction of moonlight, the later versions are usually less effective than the originals.

Tentatively, in a now-lost picture of 1847 but then again in the early 1850s, Bingham went on to his third and most powerfully treated subject, political campaigning and elections. These pictures involved dozens of figures, and for them he made painstakingly complete preliminary drawings, carefully differentiating facial features and expressions and physical types and ages. In creating an election series, Bingham's most famous predecessor was William Hogarth, prints after whose works he might have known. While Bingham's pictures do not have the satirical overtones of Hogarth's, they have political import, reflecting Bingham's own interest in politics (he was elected to the Missouri legislature in 1848) and relating to his aversion to universal male suffrage (some, such as *The County Election* [1852, St. Louis Mus.], show precinct workers providing free liquor at polling places). Of the hundreds of figures that fill Bingham's genre pictures, only a few are women. This is due in part to the nature of the subjects he painted but in part also to the general 19th-century relegation of women to private life. For his election pictures, Bingham sought engravers in Europe, dissatisfied with the skill of those in his native land. This is the principal reason why so many of his political pictures exist in duplicate: He wished to have one copy available for exhibition while a second was in the hands of an engraver.

Bingham's genre scenes became well known in the East, thanks to support by the influential AMERICAN ART-UNION, which distributed his pictures, and engravings after them, to their membership by lottery. Bingham was the first great artist from the West, and the popularity he enjoyed must be related to the great popularity in the East, and even abroad, of the vast travelling PANORAMAS of the Mississippi that appeared in large numbers about 1848.

In 1856 Bingham went to Düsseldorf, primarily to undertake several historical portraits (destroyed). Düsseldorf was then a famous art center that had attracted such aspiring American artists as EMANUEL GOTTLIEB LEUTZE and ALBERT BIERSTADT. Bingham differed from them, however, in that he was already a mature and established painter. For him, Düsseldorf represented the conclusion of an artistic career, rather than its beginning. Upon his return to St. Louis in 1859, he became increasingly active in politics, and most of his diminishing artistic production thereafter consisted of portraits, with only an occasional genre and history painting.

In his own time, Bingham's art was admired as a faithful record of a nationalistic American way of life that was, at the same time, to many Americans, exotic. Today, we appreciate his compositional skills and his talent for solid figural construction. Most of his works are still in Missouri, principally in St. Louis (St. Louis Mus. and the Boatmen's National Bank). *Lit.:* E. Maurice Bloch, *George Caleb Bingham*, 2 vols., 1967.

**BIOMORPHISM,** a rubric associated with early ABSTRACT EXPRESSIONISM that includes the work of WILLIAM BAZIOTES, ADOLPH GOTTLIEB, CLYFFORD STILL, JACKSON POLLOCK, MARK ROTHKO, THEODOROS STAMOS, and ARSHILE GORKY. It developed from the Surrealist art of André Masson, Joan Miró, and Jean Arp as well as from the works of Constantin Brancusi and Wassily Kandinsky. Characteristics of this type of painting include organic rather than geometrical forms, and tendrillike lines. Shapes often seem to be in the process of metamorphosis from amoebalike configurations, which may appear to be water- or airborne. Automatism as a means of access to the unconscious is basic to Biomorphism. Content may range from the erotic, to the prehistorical, to the primitive, to the vegetal and floral. *Lit.:* Lawrence Alloway, *Topics in American Art Since 1945*, 1975.

BIRCH, THOMAS (1779–1851), the earliest marine-painting specialist. Birch arrived in America from England in 1794, settling in Philadelphia with his father, William Birch, a miniature painter (the leading artist in this popular genre to produce baked-enamel miniatures and an engraver of note). Thomas began his artistic career assisting his father with a series of engraved topographical views of Philadelphia, which provide an extremely important documentation of the city in the post colonial era and constitute some of the finest cityscapes done in America in the late 18th century.

About 1806, Birch began to paint large oil and miniature watercolor portraits; the latter, usually quickly done profile miniatures on cardboard, are similar to some by his friend the artist JOHN WESLEY JARVIS. He was also attracted at this time to marine subjects during trips he made to the mouth of the Delaware River. He began to paint seascapes and found his first real success depicting American naval victories in the War of 1812. He painted certain battles over and over again, often showing the vessels from slightly different viewpoints or at different moments in the struggle. His best-known pictures in this series are The "Constitution" and the "Guerrière" and The "United States" and the "Macedonian" (1812, 1813; both Hist. Soc. of Pennsylvania) and The "Wasp" and the "Frolic" (NYHS). Often Birch's patrons were the officers of the successful warships, though in order to benefit from patriotic fervor on the part of the general public, Birch turned out these canvases as soon as possible after the battles. They were put on view in PAFA exhibitions and were successfully engraved by one of the leading Philadelphia specialists of the period, Alexander Lawson.

Birch continued to produce his battle scenes but also painted marine pictures of other kinds, including many ship portraits, commissioned by their owners and officers, and numerous harbor and river views, usually of Philadelphia but also of New York City. Whether he travelled much farther afield is not known, though there exist New England and even foreign views by him, which may have been drawn from verbal descriptions or from his imagination. There are also paintings of dramatic shipwrecks derived from the accounts of survivors, and some of Birch's finest and most moving paintings are romantic and imaginary—for example, Shipwreck (1829, Brooklyn Mus.), in which he contrasts man's pitiful insignificance with the power and hostility of natural forces.

In his marine pictures, Birch worked in a tradition of the 18th-century England of his youth, ultimately derived from 17th-century Dutch traditions: In dramatic presentation, vessels are shown far out at sea against a low horizon with rough water below and sky above. He was also inspired by the seascapes of Joseph Vernet, the 18th-century French artist, at least one of which he copied.

At the same time, Birch also painted landscapes and, in the 1830s, took up a second specialty, winter scenes that focus on the activities of the inhabitants of rural locales: skating, sleigh riding, and so forth. In this, he was a precursor of GEORGE HENRY DURRIE.

Birch was active in local Philadelphia art affairs, beginning with his youthful participation in the 1795 Columbianum exhibition, and he exerted important influence at PAFA (see PENNSYLVANIA ACADEMY OF THE FINE ARTS.) Lit.: William Gerdts, Thomas Birch, exhib. cat., Philadelphia Maritime Mus., 1966.

BISHOP, ISABEL (b. 1902), a painter. Born in Cincinnati and raised in Detroit, she came to New York City in 1918 to study illustration. Deciding to become an artist, she worked at ASL with KENNETH HAYES MILLER from 1922 to 1924 and again in 1926. As with Miller, her preferred subject matter, for paintings as well as graphics, is the urban landscape peopled by women shoppers, strollers, and, occasionally, the unemployed. She also paints studio subjects, especially the nude, and sometimes interiors. She is an observer of life on lower-middle-class streets, but her art rarely, if ever, makes social commentary. Although her figures do not move briskly, she tries to create,

as she has said, the "implication of unfix-
ity." Her early style—tonal, realistic,
and insistent in its emphasis on bodily
volumes—did not suggest movement so
much as the momentary suspension of
movement in figures caught between
poses (*Encounter*, 1940, St. Louis Mus.).
During the mid-1930s, after reading
Max Doerner's *The Materials of Art*
(1934), Bishop developed a style in
which forms coalesced through touches
of color, as if seen through a broken
wire-mesh screen. Bodies appeared
ghostlike and iridescent. Spaces grew in-
definite as if all forms were in a perpet-
ual state of flux. Hers is an image, albeit
a quiet one, of a city in constant, but not
entirely definable, movement (*Subway
Scene*, 1958, WMAA). *Lit.:* Karl Lunde,
*Isabel Bishop*, 1975.

BLACKBURN, JOSEPH (active in America
1754–1763/64s), a master of Rococo por-
traiture. Blackburn was trained in Eng-
land, where he may have begun his ca-
reer painting draperies and accessories
in the pictures of better-established art-
ists. He worked independently from
1752 to 1754 in Bermuda, where por-
traits by him still can be found. He then
came to Newport, R.I., moved to Boston,
Mass., in 1755, and worked there and
also later in Portsmouth, N.H., returning
to England in 1763. During his decade
in America, he was the finest practition-
er of Rococo portrait painting in the
colonies, replacing the heavy severity of
form of the Baroque artist JOHN SMIBERT
with more graceful, thinner, and elegant
figures, more stylish costumes, brighter
colors, and a greater sense of movement.
His portraits, however, suggest the adop-
tion of formulas; they are all character-
ized by a slight smirk and heavily
rouged cheeks, and no attempt was
made at character interpretation. Black-
burn was, in fact, markedly more suc-
cessful in painting satins, silks, and laces
than in re-creating individuals. Never-
theless, about 1756–57, his influence on
young JOHN SINGLETON COPLEY was
marked.

It is believed that competition with
Copley's phenomenal talent ultimately

drove Blackburn back to England,
where a small number of works are
known to have been painted by him in
provincial areas. His American paintings
are concentrated in public and private
collections in New England; his finest
picture is *Isaac Winslow and His Fam-
ily* (1757, MFAB), and a group of works
of quality are in the Warner House in
Portsmouth.

BLAKELOCK, RALPH ALBERT (1847–1919),
one of the greatest visionary artists of the
late 19th century. Blakelock was born
and studied in New York City and began
his career as a late HUDSON RIVER
SCHOOL landscape painter, though even
the works from this early period have a
unique melancholy and were executed
in a rough, somewhat painterly manner.
These qualities are accentuated in a se-
ries of pictures of New York City shan-
ties, glowing in jewellike impastos, but
markedly unbeautiful in subject matter
(*Shanties, New York City*, Milwaukee
Art Center).

Blakelock spent the years 1869–72 in
the West; there, he painted a number of
topographical scenes (*Western Land-
scape*, Newark Mus.), though even in
these he did not choose the grandiose
forms of ALBERT BIERSTADT. On his re-
turn to the East, he evolved the aesthetic
that was to dominate his art—quiet eve-
ning scenes, large oak trees silhouetted
against a sunset or moonlight glow, often
with Indian camps sparkling in the dark
beneath. He made no attempt in these
pictures to transcribe scenery; his aim
clearly was to express moods of haunting
reverie and to reflect memories of inno-
cent tranquillity, and the results are the
product more of his imagination than of
his experience. His technique was labori-
ous—he built up layer upon layer of
thick paint with sensuous textures—akin
to that of the French painter Adolph
Monticelli. While Blakelock's work bears
some similarity to Barbizon landscape
paintings (see BARBIZON, AMERICAN), it
was too individual and too unacademic
to win contemporary approval. Finan-
cial distress led to mental breakdown
and hospital confinement in 1899. Ironi-

cally, he was no longer able to profit from the recognition and appreciation that finally came to him after 1900; moreover, the demand for his work, coupled with his incapacity to produce more, led to widespread forgery of his very individual art. Even today, despite much scientific study of his technique and the pigments he used, it is more difficult to authenticate his work than that of any other American artist. *Lit.:* Norman A. Geske, *Ralph Albert Blakelock*, exhib. cat., Nebraska Art Assoc., 1974.

BLANCH, ARNOLD (1896–1968), a realist painter. From Mantorville, Minn., he studied at the Minneapolis Inst. of Arts in 1916–17, and at ASL from 1919 to 1921. He moved to Woodstock, N.Y., in 1923 and, with his wife, DORIS LEE, became part of the art colony there. He painted federally sponsored murals during the 1930s at post offices in Fredonia, N.Y., Norwalk, Conn., and Columbus, Wis. One of many artists whose works reflect the realistic styles favored by his teachers KENNETH HAYES MILLER, BOARDMAN ROBINSON, and JOHN SLOAN, Blanch produced informal portraits and studio and landscape paintings. During the 1930s, moved by the nationwide economic distress, he painted scenes in the vein of social realism with his own nightmarish overtones (see AMERICAN SCENE PAINTING). For effect, he enriched textures, blurred forms, and used eerie lighting techniques. The *Third Mortgage* (1935), in which skeletons are seen hanging from a farmer's tree, was part of a series demonstrating the failed promise of New England. Through the 1940s and later, his touch lightened, at times growing feathery. Spaces grew contrived and controlled as occasional fantastical elements appeared. But the general tone tended to be pleasant and lighthearted. A longtime teacher, he wrote *Methods and Techniques of Gouache Painting* (1946) and *Painting for Enjoyment* (1947).

BLASHFIELD, EDWIN HOWLAND (1848–1936), a leading mural painter, born in New York City. Like most of the American artists of his generation, Blashfield studied with the French academic masters, in his case, Léon Bonnat and Jean-Léon Gérôme, beginning in 1867. His early works, painted in Paris, were historical costume pieces, anecdotal in nature, a particularly popular genre in the 1870s. Blashfield was perhaps the most significant mural painter involved with the revival of painting at the WORLD'S COLUMBIAN EXPOSITION in Chicago in 1893 (see MURAL PAINTING MOVEMENT). He also provided decorations for the Library of Congress and the Appellate Courthouse in New York City. Blashfield's mural art is characterized by shallow space with symmetrical, friezelike arrangements of figures, intense expressiveness, and, frequently, rich, brilliant colors. He concentrated upon the monumental female form, often in active movement. Blashfield became the most notable and most popular muralist of his time, decorating public and commercial buildings throughout the East and the Middle West. *Lit.:* Edwin Blashfield, *Mural Painting in America*, 1914.

BLOCH, LUCIENNE (b. 1909), a muralist. Daughter of the composer Ernest Bloch, she was born in Geneva, Switzerland, and moved with her family to the United States in 1917. Bloch studied at the Cleveland School (now Inst.) of Art in 1924–25, and, until 1929, in Paris with Antoine Bourdelle and André Lhote, and at EBA. In 1931, after a promising career as a sculptor was cut short by the Depression, she became an assistant to Diego Rivera and worked with him on murals in the Detroit Inst. and in Rockefeller Center and the New Worker's School, in New York City. Like Rivera, she held that "the artist is a creature of social responsibility." Bloch's murals, commissioned by WPA-FAP, of 1935–39, depict scenes of daily life. Her design for a playground scene for the Women's House of Detention, New York City, 1935 (destroyed), was based on lengthy consultations with prisoners and staff. Since 1948 Bloch and Stephen Dimitroff, another former Rivera assistant, whom

Bloch married in 1936, have collaborated on seventeen mural cycles, working in mosaic, acrylic, assemblage, and oil, in addition to fresco. *Lit.:* Karal Ann Marling and Helen A. Harrison, *Seven American Women: The Depression Decade*, exhib. cat., Vassar Coll., 1976.

**BLOOM, HYMAN** (b. 1913), a painter. Born in Brunoviski, Lithuania, Bloom moved with his family to Boston, Mass., in 1920. At about the age of fourteen, he was encouraged in art by a high-school teacher and soon started study with Harold Zimmerman. Zimmerman showed Bloom drawings by one of his pupils, JACK LE-VINE, who would become a close friend. Bloom has confirmed his indebtedness to Zimmerman as a teacher who aided him by encouraging an imaginative approach to subject matter and technique. Bloom's inherent attraction to spiritual and expressionistic imagery was early attested by his admiration for William Blake. On visiting MOMA shortly after its opening, he was also impressed by Georges Rouault and Chaim Soutine. Bloom's religious and visionary bent was further strengthened by an Orthodox Jewish upbringing, an interest in philosophy (Spinoza, Kant, Plato, Ouspensky), study of astrology, and time spent as a Rosicrucian.

A number of themes were taken up and repeated in his mature period, which began about 1940: scenes of Judaic religious life (*Synagogue*, 1940, MOMA), imaginative scenes of allegorical or symbolic content, and a series of rather gruesome anatomical subjects, including skeletons, slaughtered animals, and human corpses and limbs. All of these were developed simultaneously, and all were executed in an individual technique of vigorously applied pigment alternately defining and obscuring the objects depicted. In paintings of religious or visionary content, the rapid brushwork and high-keyed palette produce an exultatory mood of heightened emotionalism. The flesh and corpse paintings also display a color range of calculatedly spectacular effect, the minerallike glitter of the rainbow hues nearly denying the macabre subject matter. *Lit.:* Frederick S. Wight, *Hyman Bloom*, exhib. cat., AK, 1954.

**BLUEMNER, OSCAR** (1867–1938), an early modernist painter initially trained as an architect in his native Germany. Born in Preuzlau, Bluemner won a royal medal for a painting of an architectural subject in 1892, before emigrating to Chicago in search of work at the WORLD'S COLUM-BIAN EXPOSITION of 1893. His Beaux-Arts design won the competition for the Bronx, N.Y., County Courthouse in 1900. After moving to New York City, he started sketching urban views, some in the style of MAURICE PRENDERGAST. After a trip abroad in 1912, Bluemner's style changed radically (*Old Canal Port*, 1914, WMAA). Colors turned bright and harsh, details grew sharp, forms became emphatic and developed sharp angles and stern outlines. Space, although never denied, turned claustrophobic. Occasionally, but especially around 1916, Cubist and Futurist planar fractures interrupted the solidity of his forms. Through these years, Bluemner's preferred subjects were buildings in landscape settings. His hard-edged, unpopulated landscapes look forward to the rise of PRECISIONISM in the 1920s. During that decade, Bluemner allowed mystical elements—large suns and moons, evocative night views—to enter his art, tempering his harsh forms with an element of fantasy. Shapes began to appear that could not easily be anchored to his usually architectonic understructures. Before he died, a suicide, his forms grew simpler and more expansive, but remained always bound by the spatial constrictions inherited from his early work. *Lit.: Oscar Bluemner*, exhib. cat., New York Cultural Center, 1970.

**BLUM, ROBERT FREDERICK** (1857–1903), a major figure painter and illustrator. Blum emerged from the active artistic milieu of mid-century Cincinnati, where he was born, but his true inspiration came from viewing the works of the leading artists of the Romano-Spanish school at the CENTENNIAL EXPOSITION in

Philadelphia in 1876. Blum became the most significant American follower of the then highly thought-of Giovanni Boldini and Mariano Fortuny—so much so that he was referred to as "Blumtuny." He joined FRANK DUVENECK, also from Cincinnati, and his "Duveneck Boys" in Venice in 1880, when the group was associated with JAMES A. M. WHISTLER. Whistler's influence upon Blum was significant for the development of Blum's interest in both etching and pastel, which were Whistler's own principal interests in Venice, and of his concern with the impressionistic rendering of figures enveloped in light and atmosphere. Back in New York City, Blum was associated with his good friend WILLIAM MERRITT CHASE in the Soc. of Painters in Pastel during the 1880s, an organization of which Blum was president. Chase and Blum were the principal and most highly respected pastelists of the period, and the society was instrumental in hastening the acceptance of the Impressionist aesthetic in America (see IMPRESSIONISM, AMERICAN). Blum's finest and most important paintings are his *Venetian Lace Makers* (1887, Cincinnati Mus.) and *Italian Bead Stringers* (1887/88, Otesaga Hotel, Cooperstown, N.Y.), both vibrant, sunlit pictures of contemporary women workers, reflecting the international popularity of Venetian subject matter during the late 1870s and 1880s. In 1890 Blum became one of the earliest American artists to travel and paint in Japan, and from there he sent back popular illustrations for *Scribner's* magazine. In 1893, back in New York City, he began his most monumental paintings, the murals for the Mendelssohn Glee Club (Brooklyn Mus.). Later, he worked on murals for the New Amsterdam Theatre (destroyed).

BLUME, PETER (b. 1906), a painter noted for enigmatic works. Born in Russia, he was brought to New York City in 1911. He studied at the Educational Alliance, New York City, the Beaux-Arts Inst. of Design, New York City, and ASL after 1921, but, preferring to teach himself,

he began painting alone in 1925. He gained fame with *South of Scranton* (1931, MMA), a prizewinner at the Carnegie International Exhibition of Painting in 1934. It is semisurrealistic, a description based on both fantasy and memory of a motor trip Blume took from Scranton, Pa., to Charleston, S.C. Subsequent works also combined, in a sharply focused manner, hallucinatory visions with precise, realistic descriptions of objects. Perhaps his most famous work, *The Eternal City* (1937, MOMA), developed from his aversion to Mussolini's Italy, which he visited in 1932–33. Blume designed government-sponsored murals for post offices in Canonsburg, Pa. (1936), and Geneva, N.Y. (1941), as well as for the Rome, Ga., Courthouse (1941). A visit to Mexico in 1949 inspired paintings based on his observations there. In 1956 he became artist-in-residence at the American Acad. in Rome and proceeded to make extraordinarily detailed paintings based on Italian themes. About 1950 Blume's manipulations of form and space grew more logical and realistic even when meaning remained elusive (*Hadrian's Villa*, 1958, Cleveland Mus.). *Lit.:* Charles Buckley, *Peter Blume: In Retrospect*, exhib. cat., Currier Gall. of Art, Manchester, N.H., 1964.

BLUMENSCHEIN, ERNEST L. (1874–1960), the most widely known artist associated with the TAOS COLONY. Born in Pittsburgh, he studied in Cincinnati before attending ASL and the Académie Julian, in Paris. Established as an artist in New York City by 1895, he discovered New Mexico in 1897 while on assignment for *McClure's* magazine. After another stay in Paris between 1902 and 1908, Blumenschein spent summers in New Mexico and helped form the Taos artist colony in 1912. In 1919 he settled permanently there. In 1926 he painted five murals for the Missouri State Capitol, Jefferson City. Unlike his near contemporary FREDERIC REMINGTON, Blumenschein (and the other Taos artists as well) was sympathetic to the native cultures of the

Southwest, imaginatively re-creating Indian and Mexican-American scenes based on local culture and folklore. Blumenschein painted portraits, landscapes, and narrative works. Until 1920 his academic, idealized figures were somewhat warmed by a mottled, brushy technique. Subsequently, he painted fewer such figures, preferring more realistic ones engaged in ordinary activities. His style also grew more expressionistic, as in *Dance at Taos* (1923, New Mexico Mus.). During the 1930s, socially conscious themes occasionally appeared in his work. *Lit.*: Pat Trenton, *Picturesque Images from Taos and Santa Fe*, exhib. cat., Denver Mus., 1974.

BLYTHE, DAVID GILMOUR (1815–1865), the leading satirical genre painter of the mid-19th century. Blythe came from East Liverpool, Ohio, and was apprenticed to a carpenter and woodcarver in Pittsburgh from 1832 to 1835. Though he is best known as a painter, some early decorative carvings done when he was a cabinetmaker still survive, and later he carved a large statue of the Marquis de Lafayette for the Fayette County Courthouse, in Uniontown, Pa., his one major wood sculpture.

In the late 1830s, Blythe visited the East while serving as a carpenter in the navy, and it is believed that the opportunity to view the works of professional painters there stimulated his ambitions. On his return to the region of Pittsburgh and the Ohio Valley, he commenced a career as an itinerant portraitist, and many of these works survive. At the same time, he painted a panorama of the Allegheny Mountains, which he took on tour through Maryland, Pennsylvania, and Ohio, one of the many similar topographical PANORAMAS that enjoyed great popularity during the 1840s. Blythe's most sophisticated work is in genre, pictures that show the seamier side of life in Pittsburgh as he knew it. Some, too, may have been inspired by boyhood experiences, and many reflect the poverty of his adult existence. Blythe painted a large group of pictures of young street urchins. These differ markedly from the usual idyllic 19th-century interpretations of childhood, not excepting the street children of JOHN GEORGE BROWN or even the newsboys of HENRY INMAN and THOMAS LE CLEAR. Blythe's subjects are dirty and ragged, almost deformed of body, and stupid, if sly, of expression. They are often shown stealing, playing hookey, lighting firecrackers—youthful criminal types. Blythe also portrayed adult criminals. His treatment of the legal and judicial system, the subject of many of his finer paintings, was no more favorable. Lawyers and judges appear boorish, corrupt, and venal, oppressing their clients, while members of juries are bored, moronic, or asleep. Even Blythe's less corrupt city scenes are mordant. In the horse markets, starving nags are mistreated; in post offices that loom up like forbidding prisons, overdressed upper-class women jostle pickpockets and tramps.

Blythe's figures are wildly distorted: either hugely bulbous and fat or overly bony and wiry. Colors are dull and muddy—unattractive, but in keeping with the nature of his themes. JOHN QUIDOR's expressive figural style bears some similarity to Blythe's, and one can sense a similar ideological disdain for hypocrisy and corruption in the lithographs of Blythe's contemporary Honoré Daumier, though Blythe usually fails to exhibit the great French master's underlying humanity.

Blythe was a rabid Unionist during the Civil War, and his art comes closest to Daumier's in a series of paintings glorifying Abraham Lincoln and bitterly condemning the political opponents who tried to obstruct his course of action (an example is in MFAB). And he painted a truly harrowing picture of the dreadful conditions in the Confederate concentration camps (*Libby Prison*, 1863, MFAB).

Blythe was recognized locally by Pittsburgh collectors and by the J. J. Gillespie Company, the oldest surviving art dealer in America, but a Bohemian life and idiosyncratic style of painting assured him only poverty in his own time. His works

today are for the most part still in Pittsburgh (Carnegie Inst.; Duquesne Club). *Lit.*: Dorothy Miller, *The Life and Work of David G. Blythe*, 1950.

BOCHNER, MEL (b. 1940), a post-Minimalist artist, born in Pittsburgh. After graduating from the Carnegie Inst. of Technology, Pittsburgh, in 1962, he travelled to San Francisco, before settling in New York City in 1964, where, with SOL LEWITT, EVA HESSE, and ROBERT SMITHSON, among others, he brought the art world to a post-Minimalist sensibility through both works of art and writings. In drawings made during the next few years, Bochner explored ways of visualizing set theory as well as the implications of following a system of notation to its logical conclusion regardless of the visual results. In such works, the focus shifts to the integrity of thought, perhaps even to the logic of strategy, from the means by which the artwork was produced, or even from the artwork itself. Thus, invention and accident, not to mention the criteria for visual interest, are secondary considerations. By the late 1960s, Bochner had presented drawings on gallery walls that followed specific systems based on circular forms, on the compass, and on the measurements of the exhibition space. He has also used sculptural pieces to explore basic properties of measurement, weight, and gravity (see CONCEPTUAL ART). *Lit.*: Brenda Richardson, *Mel Bochner: Number and Shape*, exhib. cat., Baltimore Mus., 1976.

BODMER, KARL (1809–1893) an early artist-visitor to the West. Born in Switzerland, Bodmer accompanied the German Prince Maximilian of Wied-Neuwied as a documentary artist on a scientific expedition up the Missouri River in 1832–34. Bodmer worked in watercolor, portraying the landscape and Indians of the Great Plains, thus becoming one of the earliest of the Indian painters. He was an artist of undeniably attractive talent, and his work has great significance in that it documents a way of life soon to disappear. His paintings were received with much appreciation when the narrative of the prince of Wied's journey was published in 1839–41, with Bodmer's watercolors in aquatint engravings. He was in America only until 1834, when he returned to Europe, living in Paris and then in Barbizon, France, where he was associated with Jean-François Millet. Bodmer was not truly an American artist, but his work figures importantly in the annals of early western art and has therefore been eagerly collected in this country. Since he had more academic training than GEORGE CATLIN, Bodmer's watercolor paintings are more surely drawn and more precise than the better-known work of Catlin and other American-born western artists of that early period. A collection of his work is in the Joslyn Art Mus., Omaha.

BOHROD, AARON (b. 1907), a painter. Born in Chicago, he lived principally in that city before joining the staff of the Univ. of Wisconsin, at Madison, in 1948. In the late 1920s, he studied at AIC and ASL before returning to Chicago in 1930. Influenced strongly by JOHN SLOAN, Bohrod painted Chicagoans at work, at play, at the theater, and on the beach. His style was varied, ranging from a tight, detailed manner to a more freely evocative, sketchlike one (*Dark Sunday*, 1942, PAFA). During World War II, he spent time in the South Pacific as a war artist and, in Europe, as a *Life* magazine artist. In the late 1940s, descriptions of place in his work began to grow fantastical, but Bohrod credits the infusion of a Surrealist type of subject matter to his work with ceramics in the 1950s. His style during that and subsequent decades grew stridently meticulous, and *trompe l'oeil* effects often appeared. Finally, he virtually ceased painting land- and cityscapes. Taking their place were oddly juxtaposed objects, usually presented against simulated wooden screens, as though a painting by WILLIAM MICHAEL HARNETT had been suddenly brought up to date (*Conrad A. Elvehiem*, 1963, Univ. of Wisconsin). Although occasionally chilling, Bohrod's

images usually have no overtones of Surrealist paranoia. *Lit.*: Aaron Bohrod, *A Decade of Still Life*, 1966.

**BOLOTOWSKY, ILYA** (b. 1907), an abstract painter. Born in St. Petersburg (now Leningrad), Russia, he came to this country in 1923. Between 1924 and 1930, he attended NAD. During the 1930s, he turned to geometrical abstraction and became a member of The Ten, a group of artists committed to modern art, as well as a cofounder of AMERICAN ABSTRACT ARTISTS, in 1936. His mural project for the Williamsburg Housing Project, New York City (1936), was one of the first abstract murals done for WPA-FAP. Bolotowsky's early abstractions reveal the common interwar mixture of Synthetic Cubism, Russian Suprematism, and the art of Joan Miró. Angular linear elements and unmodelled planes, usually geometrical in form, were arranged in carefully controlled spaces across a picture's surface. In the mid-1940s, responding increasingly to Piet Mondrian's art, Bolotowsky began to eliminate antic forms and diagonals for more rigid horizontal-vertical formats (*Large Vertical*, 1951–59, WMAA). He aimed for an order and clarity similar to that sought in Neoplasticism. In 1947 he began to use diamond-shaped canvases, (*Scarlet Diamond*, 1969, AK). These were followed by ovals and oddly shaped rectangles. Although concentrating on primary colors, plus black and white, he employed varying shades of a given hue in the same work, indicating his greater concern with formal and color relationships than with the more purely philosophical statements of Mondrian. In 1961 he began to make three-dimensional forms, usually vertical, straight-sided pieces, with paint applied in his usual manner (*Metal Column B 1966*, 1966, Walker Art Center). *Lit.*: *Ilya Bolotowsky*, exhib., cat., Guggenheim Mus., 1974.

**BORGLUM, (JOHN) GUTZON** (1867–1941), and **SOLON HANNIBAL** (1868–1922), brother sculptors. Gutzon was born in Idaho, Solon in Ogden, Utah. Both studied in Paris at the Académie Julian, but Gutzon was more pronouncedly influenced by the great French artist Auguste Rodin, and Solon, under the influence of Emmanuel Frémiet, turned to animal sculpture. Gutzon became the more famous of the two, also creating bronze animal sculptures and sculptures with a western theme, often with a tremendous sense of flow and movement. These qualities also infuse such other works as his outdoor civic memorial commission *The Wars of America* (1925–26, Newark, N.J.). A commission to carve a colossal head of Robert E. Lee for Stone Mountain outside of Atlanta was abortive, but it did lead to Gutzon's most famous assignment, one of the best known of all American sculptures, the colossal heads of presidents Washington, Jefferson, Lincoln, and Theodore Roosevelt for Mount Rushmore in South Dakota (1927–41). The project cost the U.S. Government over $1 million. Solon's specialty was the American Indian, equestrian or dismounted, in bronze: sculptures that reflect his early life as a cowboy in the West. *Lit.*: Robert Casey and Mary Borglum, *Give the Man Room: The Story of Gutzon Borglum*, 1952.

**BOURGEOIS, LOUISE** (b. 1911), a sculptor. Born in Paris, France, she turned to art after studying mathematics and philosophy. From 1936 to 1938, she studied at the Ecole du Louvre, EBA, and Académie de la Grande Chaumière, and with Fernand Léger. She came to New York City in 1938 and briefly attended ASL. Primarily a painter and printmaker at that time, she explored surrealistic images of containment, anxiety, and isolation that were more reflective of her conscious responses to life than of her unconscious states of feeling. She turned seriously to sculpture in the late 1940s. Although her work never became realistic, it has existed in "an atmosphere of figuration." Her first major works included painted, vertical, multipart wooden pieces, such as *The Blind Lead-*

*ing the Blind* (1949). During the 1960s, she began to carve in stone and cast in metal, but some of her most revealing works were done in plaster and latex. These include multiple forms, similar to the earlier pieces, as well as single-figured ones. Their imagery suggests sexual members and elements as well as sexual contests. The latter allude more to generalized sexual conditions than to specific events. Some emphasize, as in the Lair series, begun in 1964, the nurturing sense of interior spaces; others indicate the degree of vulnerability of a person's sexuality by the type, or texture, or hardness of the sculpted projections and openings. *Lit.*: Lucy Lippard, "Louise Bourgeois: From Inside Out," *Artforum*, Mar., 1975.

BRACKETT, EDWARD AUGUSTUS (1818–1908), a mid-19th-century neoclassical sculptor. Brackett grew up in Cincinnati, then the "Athens of the West," a city notable for its artistic activity, especially in sculpture. In 1839 Brackett moved to New York City but two years later settled in Boston, Mass., which remained the center of his artistic activity, for Brackett was one of the important mid-century sculptors to confine his activity to America. He specialized primarily in portraiture; his best-known bust is a very sensitive likeness of the leading Boston artist of the period, WASHINGTON ALLSTON (MMA), done after Allston's death, in 1844. The work was commissioned because an earlier bust of Allston sculpted by SHOBAL VAIL CLEVENGER a few years before the painter's death revealed the effects of age and illness in so harsh a manner that a more sympathetic, somewhat idealized likeness was wanted, and in creating it, Brackett was successful. His most ambitious work was *Shipwrecked Mother and Child* (1850–51, Worcester Mus.), an exceedingly melodramatic sculpture—yet effective because of its provocative nudity and sentimental morbidity. It was much praised in its own time by such artist-critics as HORATIO GREENOUGH. Brackett gave up sculpture in the 1860s.

BRADFORD, WILLIAM (1823–1892), the leading American painter of arctic scenes. Bradford was born and grew up in the fishing town of Fairhaven, Mass., which, in part, must account for his interest in marines, to which he turned in 1854. He began painting ship portraits and pictures of vessels at sea somewhat in the manner of FITZ HUGH LANE. However, a number of monumental and dramatic early renderings of shipwrecks and storms at sea have a dark romanticism quite in contrast to the general calm clarity of Lane's pictures and lack the key characteristics of the landscape painting of LUMINISM, of which Lane was a principal exponent. In the 1860s Bradford began taking frequent trips to Labrador and the Arctic, there making very large and precise drawings and taking photographs (of interest in their own right). From these he fashioned the dramatic polar scenes that were the basis for his considerable reputation in both America and England (Queen Victoria, in fact, collected his work). In 1873 he published a book, *The Arctic Regions*. Most of Bradford's paintings show small but precisely depicted sailing vessels, moored or even stranded in cold blue-and-white landscapes amid giant icebergs; often, minute figures on the ice serve to increase the romantic contrast between nature's grandeur and man's insignificance. Occasionally, polar bears add a sense of exotic menace to the scene. Perhaps Bradford's masterpiece is his late *Icebergs in the Arctic* (1882), a haunting, even hallucinatory vision of an uninhabited, alien land. Other well-known American painters of the period painted arctic scenes (the most successful were JAMES HAMILTON and FREDERIC EDWIN CHURCH), but Bradford became the only true specialist in this genre. *Lit.*: John Wilmerding, *A History of American Marine Painting*, 1968.

BRADY, MATHEW B. (1823–1896), a photographer, known for his pioneering work in daguerreotype portraiture, his collection of photograph portraits of celebrated Americans, and his contribu-

tion to the documentation of the Civil War (see PHOTOGRAPHY, CIVIL WAR). Born near Lake George in Warren County, N.Y., Brady left home at sixteen for Saratoga, N.Y., where he met the artist WILLIAM PAGE, a former student of SAMUEL F. B. MORSE. Brady and Page went to New York City in 1839–40, and Morse instructed Brady in photography. Brady opened his own daguerrean gallery in 1844, and it soon became one of the most successful there. His work consistently commanded top prizes at the annual fair of the American Inst., in New York City, which in 1849 awarded him a gold medal, the first given for daguerreotype. The excellence of Brady's daguerreotypes was also recognized abroad: He won a medal at the Great Exhibition of 1851 in the Crystal Palace in London. By 1854 Brady had turned to the new wet-plate technique (see PHOTOGRAPHY).

By 1845 he had begun to collect daguerreotype portraits of all the distinguished individuals he could persuade to sit for him. His camera recorded the features of every president but one (William Henry Harrison), from John Quincy Adams to William McKinley. Not limiting himself to political figures, he also photographed men and women in the military, theatrical, literary, and scientific fields. Although many of his portraits, especially the earlier ones, were taken by his own hand, many were not, since by 1847 he was also directing a large studio in Washington, D.C. Brady's real achievement was to conceive of himself as a photographic historian and to devote his life to it.

This ambition prompted him in his great endeavor to record the Civil War. He obtained permission through influential friends in Washington to be present on July 21, 1861, at the First Battle of Bull Run, where he retreated with the Union Army. The difficulties were extraordinary, but Brady continued personally to photograph in the field as well as to equip darkroom wagons and employ photographers (including Alexander Gardner and Timothy O'Sullivan) to cover a wide area, a project that cost him about $100,000.

Unable to recoup his losses after the war, Brady went bankrupt in the depression of 1873, and, though he continued to practice in Washington, other photographers and studios became more fashionable. Part of his invaluable collection of war views was auctioned off to the War Department, which allowed them to be destroyed through neglect and mishandling. L. C. Handy, Brady's nephew, preserved the largest part of the remaining pictures.

In his early daguerreotype portraits, Brady had a direct, uncompromising approach, never using elaborate props or touching up the pictures to flatter the sitter. He maintained this same approach in all his later collodion (or wet-plate) work, always anxious to record the features of the face, city street, or battlefield before him with all the undistorted exactitude possible in his medium. His great sensitivity to character, combined with an unfailing sense of the important subject, enabled him to create one of the finest large bodies of artistic work in the 19th century, also, of course, of enormous historical value. His book *The Gallery of Illustrious Americans* was published in 1850. Collections of his work are in the Library of Congress and the National Archives. *Lit.*: James D. Horan, *Mathew Brady: Historian with a Camera*, 1955.

BRICHER, ALFRED THOMPSON (1837–1908), a landscape painter. Bricher came from Portsmouth, N.H., and began painting in Boston, Mass., about 1851. He moved to New York City in 1870. Strangely, although he lived on an island in New York Harbor, almost all of Bricher's subject matter was drawn from summer sketching trips on the Massachusetts and Maine coasts and in Rhode Island (Grand Manan Island in the Bay of Fundy was also a favorite subject, as it was for many other artists of the period). Bricher's marine paintings are all coastal scenes, usually panoramic in their broad horizontality, and they carry the viewer

out to a sharp and clear horizon. His colors are cool and crisp, his atmospheres are clear and sunlit, and his compositions usually sweep around to large rocky promontories on one or the other side of the scene. (*Morning at Grand Manan*, 1878, Indianapolis Mus.). Boats are often found in his paintings, but figures are rare. Bricher's work reflects some of the aesthetic of LUMINISM, and he may fairly be considered one of the last of the Luminist artists. His works are invariably soundly crafted, but the fixed format of his artistic inspiration is somewhat monotonous. Bricher was also a very able watercolorist, and the sparkling luminosity of his works in this medium is the result of a sure linear touch and a greater freedom in the handling of color than is exhibited in his oils. He also explored a greater variety of subject matter in this medium, including attractive female figures, similar to those in the watercolors WINSLOW HOMER painted in the 1870s. *Lit.*: Jeffrey Brown, *Alfred Thompson Bricher*, exhib. cat., Indianapolis Mus., 1973.

BRIDGES, CHARLES (active in America 1735–1740), the earliest recorded professional artist in Virginia. Bridges was working in the studio of Sir Godfrey Kneller in London when Colonel William Byrd of Virginia first encountered him, and it may have been Byrd who encouraged Bridges to journey to Virginia. The majority of Bridges's known and generally accepted paintings are of the Byrd family of Westover plantation and of the members of other plantation families along the James River, though Bridges is also known to have been in Williamsburg, the capital of the colony. Bridges was an exceptionally sophisticated painter for his day, undoubtedly because of his training with Kneller, a leading portraitist of the age. Bridges's likeness of Maria Taylor Byrd (c. 1735, MMA), which is typical of his style, depicts a slim, elegant young woman, dressed in a simple gown that clings softly to her body. Bridges also often posed his subjects in romantic outdoor settings.

Because of the dearth of knowledge about Virginia artists of the colonial period, it has been the tradition until recently to attribute all the portraits of that period to Bridges, but recent scholarship has uncovered other painters, such as William Derring, active there; none of these artists seems to have been as well trained or as sophisticated as Bridges, however. Little is known of Bridges's life or work after he returned to London in 1740, though he is believed to have been alive in 1746.

BRIDGMAN, FREDERICK ARTHUR (1847–1928), the leading American painter of "Oriental" subjects. From Tuskegee, Ala., Bridgman was enrolled at NAD before travelling to Paris in 1866 to study with Jean-Léon Gérôme. In that same year, he became one of the leading Americans in the art colony in Pont-Aven, Brittany, and, like many French and American artists, he began exhibiting in the annual salons—in his case, Breton scenes. In 1873, however, he went to Egypt and afterward continued to paint pictures with North African themes, similar to the extremely accurate studies of North African daily life in which his teacher Gérôme specialized. Such material had been classified as Oriental from the time of Eugène Delacroix, though, in fact, it was Arabian and Islamic rather than East Asian, as the term might suggest. Bridgman so excelled in such paintings, bringing a greater freedom of touch and interest in light to the subject, that he was considered during the 1870s and 1880s not only superior to his teacher at times, but, unquestionably, the greatest of all the American expatriate artists. By 1890, however, interest in such subjects, and Bridgman's reputation, were on the wane. The artist continued to live in France, making only occasional visits to America.

BROOKES, SAMUEL MARSDEN (1816–1892), the most important West Coast still-life painter of the 19th century. Born in Middlesex, England, Brookes

grew up in the Middle West and began his career as a painter working primarily as a portraitist in Milwaukee and Chicago. He began to specialize in still life after settling in San Francisco in 1862, although he continued to paint portraits as well. His arrangements of lush fruit (unquestionably the finest are his studies of bunches of fruit hanging against a wall or in in a niche) must have appealed to the Californians newly wealthy after the discovery of gold and the development of the railroad, but he was best known in his own day for his paintings of fish. Sometimes the fish are shown still alive, as in *Trout in a Tank* (California Hist. Soc.), but usually they are shown either lying on the ground or hanging against a wall (*California Smelts*, Brooklyn Mus.; *String of Fish*, de Young Mus.). The finish of these works is infinitely detailed; this and the delicate colors of the fish and of their backgrounds give Brookes's work the quality of an optical illusion. He was also particularly adept at characterizing different kinds of fish of different degrees of scaliness. Although it was extremely rare for a still-life specialist, Brookes appears to have had as great financial security as any California artist of the time, enjoying the patronage of such collectors as E. B. Crocker and Mrs. Mark Hopkins; indeed, notices in the contemporary local press indicate that a minor mythology grew up regarding Brookes's extraordinary skill at creating the illusion of piscine reality. *Lit.*: Joseph A. Baird, Jr., *Samuel Marsden Brookes*, exhib. cat., California Hist. Soc., 1962.

**BROOKS, JAMES** (b. 1906), a painter associated with ABSTRACT EXPRESSIONISM. Born in St. Louis, Mo., he studied at Southern Methodist Univ., Dallas, and the Dallas Art Inst. between 1923 and 1926, before moving to New York City to continue his art studies at ASL. To support himself, he worked for many years as a commercial letterer. He created murals for WPA-FAP in the Queensborough Public Library, Woodside Branch, New York City (1938), the Little Falls, N.Y., Post Office (1940), and at La Guardia Airport, New York City (1942). (The first and last have been destroyed; the last was an especially important and impressive work, 12 feet by 235 feet, entitled *Flight*.) During the 1930s Brooks painted social-realist themes contained within carefully regulated spaces that pointed toward his future interest in abstract art. After serving as an artist-correspondent in World War II, he abandoned realism for a loosely woven type of Cubism. In 1948, impressed by the forms showing through the reverse side of a canvas, he began to allow allusive shapes, spontaneous gestures, and brushy accents to loosen the comparatively rigid Cubist framework of his earlier pieces. By 1951, the process completed, he reached artistic maturity. During the following decades, his forms have grown larger and fewer; and he has explored an increasingly greater chromatic range (*Rodado*, 1961, Brandeis Univ.). His art has remained lyrical rather than aggressive, closer to that of BRADLEY WALKER TOMLIN than to that of WILLEM DE KOONING. As a result, his shapes, despite their seeming randomness, reflect a sensibility carefully attuned to subtle color and spatial relationships. *Lit.*: Sam Hunter, *James Brooks*, 1963.

**BROWERE, ALBERTUS DE ORIENT** (1814–1887), a landscape painter of the HUDSON RIVER SCHOOL who also worked in genre and still life. Browere was the son of the sculptor JOHN HENRI ISAAC BROWERE, and much of his career was spent paying off debts incurred by his father in an ambitious sculpture project. Born in Tarrytown, N.Y., and largely self-taught, Browere attempted to establish himself in New York City in the 1830s as a historical and literary painter, exhibiting no less than eight subjects from the writing of Washington Irving. These have a certain naive charm but lack the satirical bite of the more original and able illustrator of Irving, JOHN QUIDOR. In 1840 Browere settled in Catskill, N.Y., the home of America's greatest landscape specialist, THOMAS COLE.

There Browere turned his attention to landscape painting. He remained in the area his entire life, with the exception of two trips to California, the first in 1852, via Cape Horn, to prospect for gold. He returned to Catskill in 1856 and then voyaged again to California in 1858, via the Isthmus of Panama, settling in San Francisco as an artist until 1861. Some of his most interesting paintings of this period (*Gold Mining in California*, 1858) are of gold mining, works of great regional significance. Browere's finest landscapes, however, are of the majestic California scenery and of the tropical landscape of Central America. These strive for some of the monumental qualities of the works of his contemporary FREDERIC EDWIN CHURCH, though Browere never had the scientific precision or the interest in atmospheric light that mark the landscapes of Church. Browere's Catskill scenes are naturally more placid but exude a definite, if slightly naive, charm. Browere was also an able still-life painter, and his best-known work today is a relatively rare excursion into genre, the humorous *Mrs. McCormick's General Store* (1844, New York State Hist. Assoc.).

**BROWERE, JOHN HENRI ISAAC** (1790–1834), one of the earliest professional sculptors. Born in New York City, where he studied painting, he went to Paris in 1816–17, the first American sculptor to study there and one of the few who did so before the late 19th century. On returning to America in 1817, he decided to create a sculptural portrait gallery of famous living Americans from the Revolution to his own day. The project was one of a number conceived in the 19th century, from CHARLES WILLSON PEALE's series of paintings to MATHEW BRADY's collection of photographs. Browere's procedure involved travelling about, making plaster life masks of his subjects and then working them into full busts of head and shoulders (the chest was usually covered by a classical toga). The head, of course, was vividly realistic. The casting of a life mask was exceedingly un-

comfortable and occasionally dangerous for the subject, since breathing was restricted while the plaster hardened. What Revolutionary figures were still alive at the time were naturally quite elderly and frail; indeed, Thomas Jefferson almost died when Browere made his life mask in 1826. Browere was regarded in his own time more as an artisan than as a sculptor, both because the heads of his sculptures were mechanically reproduced and because he did not work in marble (his sculptures remained in plaster until they were cast in bronze long after his death). Nevertheless, Browere has a significant place in the development of sculpture in America. *Lit.:* Charles Hart, *Browere's Life Masks of Great Americans*, 1899.

**BROWN, GEORGE LORING** (1814–1889), an expatriate landscape painter. Brown was born and grew up in Boston, Mass., making his first trip to Europe in 1832. There he was captivated by the landscapes of the 17th-century artist Claude Lorrain. Back in America in 1834, he painted *Leatherstocking Kills the Panther* (1834, MFAB), a rich, painterly, romantic conception of an event in James Fenimore Cooper's *The Pioneers* and very similar to JOHN QUIDOR's version of the same scene, dated 1832. However, literary illustration was not Brown's primary interest, and he returned to Europe in 1839 for twenty years, painting scenes in and around Rome and Florence that were extremely popular with Americans making the grand tour (*A View of Amalfi*, 1857, MMA). Brown filled his pictures with the most familiar monuments of classical and Renaissance Italy, with natural tourist attractions, and with picturesque peasants and their animals. He ranged as far south as Naples and was one of the first American artists to paint scenes of Venice. His landscapes are jewellike, with thick impastos and strong chiaroscuro contrasts, expressive of a romantic aesthetic akin to that of THOMAS COLE but already outmoded in mid-19th century America. He was often referred to as "Claude

Brown," in reference to his emulation of Claude Lorrain's treatment of light, composition, and passion for the Italian landscape. On Brown's return to America, he painted both native scenery and re-creations of Italian landscape. The former are less distinguished and less personal than his earlier European landscapes; the latter are weaker, nostalgic reflections of his previous work. Brown was also one of the earliest Americans to work in watercolor and with etchings.

**BROWN, HENRY KIRKE** (1814–1886), a leading postneoclassical sculptor. From Leyden, Mass., Brown began his career as a painter but turned to sculpture in 1839 and produced numerous busts of local worthies while living in Albany, N.Y., between 1839 and 1842. Brown spent the years 1842–46 in Florence and Rome working in the then-prevailing neoclassical style. He soon turned against its forms and symbolism, however. When he returned, to New York City, Brown became an outstanding spokesman for the growing number of Americans in favor of a national cultural expression in both subject matter and style. He executed a number of studies in bronze of the American Indian, still, however, in classical poses, and bronze monuments of such important leaders as De Witt Clinton (1850–52, now Greenwood Cemetery, Brooklyn, N.Y.). *De-Witt Clinton* is a realistic figure, but neoclassical features are still evident in the noble gesture and the enveloping cloak that resembles antique robes.

Brown is particularly remembered today for his equestrian statue of *George Washington* in New York City's Union Square (1853–56). Here, too, a naturalistic likeness and contemporary military costume are combined with a classically noble pose and gesture and a general reference to the most famous equestrian statue surviving from antiquity, *Marcus Aurelius*, in Rome.

JOHN QUINCY ADAMS WARD, Brown's assistant, eventually superseded his teacher as the leading American naturalist sculptor, and none of Brown's later

work, which included the *Abraham Lincoln* of 1868, also in Union Square, equalled *George Washington* in fame. Despite the ambivalence of his own sculpture, Brown's emphasis upon national ideals and his insistence that study in Europe was not necessary for artistic excellence profoundly influenced the younger artists who followed him. *Lit.*: Wayne Craven, "Henry Kirke Brown," *American Art Journal*, Spring, 1969, and Nov., 1972.

**BROWN, JOHN GEORGE** (1831–1913), one of the most popular genre specialists of the late 19th century. Brown was an artist born and trained in England, who settled in Brooklyn, N.Y., about 1855. In recent years, his early works have established him as one of the finest figure painters of his time, comparable to EASTMAN JOHNSON and the early WINSLOW HOMER. At the beginning of his career, he specialized in painting young children out-of-doors, in informal rural scenes of everyday life. A restrained sentimentality characterizes these pictures; they are a little slicker and more detailed than comparable works by his better-known contemporaries, but they are also fresh in observation and bathed in a strong clear light that was one of the artist's major interests and accomplishments. About 1880 Brown began to paint street urchins—newsboys, bootblacks, and youthful fruit vendors—poverty-stricken, but cheerful and well scrubbed. These pictures appealed to wealthy collectors, who appreciated the vast economic and social differences between the subjects and themselves. Many of these later works by Brown are frankly saccharine, and also suffer from repetitiveness. His depictions of the aged, too, are often overly sentimentalized (he seems only rarely to have dealt with people between youth and old age). Yet, occasional figures of old men are touched with a real pathos, a melancholy and reflectiveness that successfully suggest a long life nearing its end and myriad experiences to remember. Good examples of his work are *The Longshoreman's*

*Noon* (1879, Corcoran Gall.) and *Tuck-ered Out—The Shoeshine Boy* (c. 1890, MFAB).

BROWN, MATHER (1761–1831), an expa-triate portrait and history painter. From Boston, Mass., Brown studied with GIL-BERT STUART in 1773 during the brief period when Stuart was in America between his first and second vists to Great Britain. After working as an itin-erant portraitist, Brown went to Europe in 1780, reaching England the following year, at the close of the American Rev-olution. In London he studied with BEN-JAMIN WEST and soon had a lucrative business painting the portraits of distin-guished visiting Americans, including Abigail and John Adams, Thomas Jeffer-son, and the architect Charles Bulfinch. His portrait style was closely related to Stuart's, who had also studied with West: vivid, highly colored, and very painterly, though perhaps somewhat more sharply drawn. Both artists worked in the ideal-izing, aristocratic manner fashionable in England in the 18th century. Brown be-came historical painter to the Prince of Wales and sought the glory associated with that branch of painting of which the most respected English practitioner was his teacher West. His work as a his-torical painter, however, is curvilinear, soft, and colorful—more in the old-fash-ioned Rococo style than the more austere neoclassical manner of West. Brown never enjoyed great renown (he idolized West, to the detriment of his own repu-tation), and his later years were spent in English provincial centers as a portrait-ist. His *John Adams* is in the Boston Athenaeum.

BROWN, WILLIAM MASON (1828–1898), a popular still-life specialist. Brown came from Troy, N.Y., but painted in Newark, N.J., and then in Brooklyn, N.Y. His early works were painterly landscapes in the earlier romantic tradition of THOMAS COLE. In the 1860s, however, he turned almost exclusively to still life, motivated, in part, by his success in selling *A Basket of Peaches Upset* to the dealer William

Schaus for $2,000. The work was subse-quently reproduced as a chromolitho-graph, and Brown became one of a num-ber of painters to gain fame through the new printing process. (It is possible that the sharp preciseness and bright, clear tones of his still lifes were a response to the limitations of the medium). In any event, Brown completely renounced the fluid treatment of his earlier landscapes and painted the most photographic still lifes made in mid-19th-century America. In some of these, succulent fruit is contrasted with opulent Victorian back-grounds. Brown, however, was also a leading exponent of the "back-to-nature" still-life painting advocated by the English aesthetician John Ruskin (see PRE-RAPHAELITISM, AMERICAN). In these pictures, usually small fruit and/or flow-ers are shown in secluded natural set-tings, sometimes resting in or pouring out of a straw hat or wicker basket, and, though actually carefully contrived, the arrangements were meant to suggest the natural and the accidental. Among his most attractive paintings of this "unstud-ied" type is *Raspberries* (Speed Mus.); here, the fruit spills out, as though dropped by a careless hand, on the earth beneath an overhanging leafy branch.

BRUCE, PATRICK HENRY (1881–1936), an expatriate painter associated with SYNCHROMISM. Born in Long Island, Va., he came to New York City in 1901 to study with WILLIAM MERRITT CHASE. In 1903 he attended ROBERT HENRI's classes. He left for Europe that year, re-turning only briefly in 1905 and in 1936, a few months before committing suicide.

His work has been divided into four periods (what remains of it: Bruce de-stroyed many paintings). In the first, which lasted until about 1907, Bruce painted in Henri's manner and concen-trated on portraits. In the second, from about 1907 to about 1913, he showed the influences of Cézanne's composition as well as the bright colors of Pierre Au-guste Renoir and Henri Matisse. Still lifes from the second period are com-mon, and, although spaces are often

skewed, forms retain their wholeness and roundness. Matisse's influence grew strongest after 1907, when Bruce studied with him. The third phase lasted until about 1920. Works of this period are known as Compositions of which many examples are at Yale Univ. In them Bruce developed a hard-edged style primarily derived from the French Orphist painter Robert Delaunay. Forms are flat and unmodelled; colors are unmodulated; edges are angled or squared. An entire surface received nearly equal emphasis. These works were exhibited in New York City in 1917. In the last phase, geometrical forms were introduced on tablelike bases. By manipulating the colors and shapes of their tops and sides, Bruce provoked constant spatial ambiguities. (An example is *Formes sur la table*, c. 1925–26, Addison Gall.). *Lit.:* Tom Wolfe, "Patrick Henry Bruce," *marsyas*, 15, 1970–72.

BRUMIDI, CONSTANTINO (1805–1880), an Italian muralist working in America in the mid-19th century. Brumidi grew up in Rome, where he studied under the most famous neoclassical artists there, the Italian Vincenzo Camuccini and the Danish Bertel Thorwaldsen. Brumidi learned the art of fresco painting and worked in Rome in the Vatican and in the Torlonia Palace, but political events in Rome in 1848–49 led to his imprisonment; on his release, he came to America in 1852. Between 1855 and 1877, Captain Montgomery Meigs, supervisor of the decoration of the U.S. Capitol, contracted with Brumidi for mural paintings in several committee rooms, the President's Room, and the Senate Reception Room, and, in 1862, the dome of the Rotunda, which Brumidi completed in 1865. Much of Brumidi's work was ridiculed for the classical nature of the subject matter: cupids, gods, and goddesses. There were many calls for greater sobriety and more appropriate subject matter, and eventually EMANUEL GOTTLIEB LEUTZE was employed in his place. Brumidi's most important work in the Capitol is *The Apotheosis of Washington*, in the dome of the Rotunda. His major commissions outside of the Capitol were in churches in Washington, D.C., New York City, and Philadelphia, and in the cathedral in Mexico City. *Lit.:* Myrtle C. Murdock, *Constantino Brumidi*, 1950.

BRUSH, GEORGE DE FOREST (1855–1941), a painter, born in Shelbyville, Tenn. Brush was one of the host of Americans who studied with the great French master Jean-Léon Gérôme, and the precisely drawn, solidly constructed figures and space of his paintings reveal his indebtedness to the academic tradition. During the 1880s, Brush was one of the finest painters of American Indian themes, applying his academic technique to create extremely accurate interpretations of the aboriginal way of life. In the following decade, however, his subject matter, though not his style, underwent a radical change, and he turned to paintings of mothers and children, invariably modelled upon his own family (*Mother and Child*, 1895, MFAB). Although the figures were actually portraits, their features were generalized. As a result, the paintings were modern, secularized versions of the Madonna and Child. That these pictures are very much a part of the Renaissance revival of the late 19th century is attested by Brush's occasional choice of the tondo format favored by such artists as Botticelli and his use of actual or simulated Italian Renaissance frames. Brush's mothers and children cannot actually be mistaken for their counterparts of four hundred years earlier, but in his finest work Brush achieved a tender and affecting sentiment, a mood of reverie and gravity, and a timelessness that ran counter to the quickening pace of change in contemporary life and art.

BUNKER, DENNIS MILLER (1861–1890), a portrait and landscape painter significant for his role in the introduction of Impressionism to America (see IMPRESSIONISM, AMERICAN). Born in New York City, Bunker studied there under WILLIAM MERRITT CHASE from about 1878 to

1881 and later in Paris at the Académie Julian and EBA with Jean-Léon Gérôme from 1881 to 1884. Back in America in 1884, he settled in Boston, Mass., where he became a highly respected and important teacher during his relatively few remaining years, and where he enjoyed the patronage of Isabella Stewart Gardner. During this period, he painted a number of extremely sensitive portraits, such as the beautiful *Miss Anne Page* (1887). His landscapes of this period are allied to American Barbizon painting (see BARBIZON, AMERICAN). But in the summer of 1888, Bunker worked with JOHN SINGER SARGENT in Calcott, England, at a time when Sargent was involved with a modified Impressionism, under the influence of Claude Monet. Bunker's work of his last two years exhibits a new concern for colorful, impressionistic effects of light and atmosphere, particularly in a group of intimate landscapes painted at Medford, Mass. In these pictures, Bunker adopted Sargent's seemingly random, open-ended style of composition. New also was a partial dissolution of form with long, quill-like brushstrokes, and a palette of bright colors, still, however, limited in range. The dualism in Bunker's art is akin to that of the much longer lived JULIAN ALDEN WEIR, whose oeuvre included academic figure painting and more modern, impressionistic landscapes. *Lit.*: R. H. Ives Gammell, *Dennis Miller Bunker*, 1953.

BURCHFIELD, CHARLES (1893–1967), a painter of both the towns and countryside of middle-western America and enchanted woodland scenes. Born in Ashtabula Harbor, Ohio, he grew up in Salem, Ohio, and studied at the Cleveland School (now Inst.) of Art from 1912 to 1916. His mentor there was Henry Keller. In 1921 Burchfield moved to Buffalo, to design wallpaper (until 1929) for M. H. Birge and Sons; and he spent the remainder of his life there. His career can be divided into three distinct phases: During the first, which ended about 1918, he painted landscapes often based on childhood memories and fantasies; during the second, from about 1918 to 1943, he portrayed the grimy streets and rundown buildings of the eastern Ohio area; and during the third, from 1943 until his death, he returned to landscapes, investing them with a kind of ecstatic poetry. Burchfield often reworked old pictures, however, so that work from different phases may appear side by side. His preferred medium throughout his life was watercolor.

Intensely aware of woodland sounds and presences, Burchfield tried to capture bird and insect noises in his early landscapes by using small staccato accents and whiplash arabesques. Some knowledge of Oriental art helped him to simplify his forms. In 1917 he developed an abstract shorthand of systematically varying shapes to suggest specific moods (*Church Bells Ringing, Rainy Winter Night*, 1917, Cleveland Mus.). About this time, he also painted small houses with peculiarly haunted qualities. Escaping somewhat from his overheated imagination about 1920, he began to make studies of the architecture of middle-western streets. In part showing the influence of Sherwood Anderson's *Winesburg, Ohio*, Burchfield's paintings of the 1920s also reflected the general debunking of the American heartland by cultural critics. In such watercolors as *Sulphurous Evening* (1926, St. Louis Mus.), he captured the weary, depressed look of a house well past its prime. These works came to be considered forerunners of AMERICAN SCENE PAINTING of the 1930s. During that decade, Burchfield created major works that are highly descriptive of Depression America, including *The Parade* (1934) and *End of Day* (1938, PAFA).

In 1943, tired and bored with his work and fearful of arriving at an artistic dead end, Burchfield once more began to explore the landscape scenes of his youth. Adopting a less realistic style once again, he undertook, in an almost mystical fashion, to express the mystery of nature, even attempting to capture seasonal changes in a single picture (*The Four Seasons*, 1949–60, Illinois Univ.). He

reinvestigated ways of capturing forest sounds, so that entire paintings are a mass of quivering brushstrokes, and he often outlined forms with yellow to give them a halolike, transcendental appearance. Although the images of his last period are clearly recognizable and obey the laws of perspective, at their best they evoke an entire emotional as well as perceptual spectrum. His last paintings are filled with chimerical creatures—butterflies and dragonflies from another world. Few American artists have ever responded with such passion to the landscape or have made it such a compelling repository as well as mirror of their intimate feelings. Burchfield's papers and many paintings are in the Charles E. Burchfield Foundation, Buffalo. *Lit.*: Matthew Baigell, *Charles Burchfield*, 1976.

**BUTTERSWORTH, JAMES EDWARD** (1817–1894), a leading painter of ships and other marine scenes. Buttersworth was born on the Isle of Wight, in England, son of Thomas Buttersworth, also an able marine painter. A Nathaniel Currier lithograph of 1847 (see CURRIER & IVES) is the first indication of Buttersworth's presence and developing career in America. By the 1850s, he had an established reputation, and was settled in West Hoboken, N.J., where the ships in New York Harbor provided the subject for many of his paintings. Buttersworth was especially known for, and adept at, painting yachts—thus, creating "portraits" of famous vessels. He was also known for his depictions of warships, often shown in historic actions. In the English tradition, Buttersworth's ships are often placed before a low horizon, on a strong diagonal, with dramatic chiaroscuro treatment of both disturbed water and stormy sky. He also painted steam vessels, since he witnessed the gradual replacement of sail by steam in both commercial and military vessels. He was succeeded in his specialty (and even in his choice of residence, West Hoboken) by Antonio Nicolo Gasparo Jacobsen, a Danish artist who became the most popular portraitist of turn-of-the-century ships, naturally, by then, primarily steam vessels. *Lit.*: Rudolph J. Schaefer, *J. E. Buttersworth: 19th-Century Marine Painter*, 1975.

# C

**CADMUS, PAUL** (b. 1904), a painter. From New York City, he studied at NAD from 1919 to 1926 and at ASL in 1928 with JOSEPH PENNELL. He lived in Italy from 1931 to 1933. Perhaps because of his profound admiration for Italian Renaissance art—certainly because of the rigorous training he received—Cadmus has striven to perfect traditional ideals of craftsmanship in figural design and surface finish. He is a superb draftsman. Since 1940 his preferred medium has been egg tempera and his favored subjects have been the human body and modern society. His satirical views of the latter gained him early recognition and notoriety, especially his depictions of men on shore leave, such as *The Fleet's In!* (1934, Alibi Club, Washington, D.C.) and *Sailors and Floosies* (1938, WMAA). These vignettes of sailors and their women range from coy flirtations to frank displays of lasciviousness. Cadmus has also painted the typical antics of the "ugly American" tourist and the street-corner crowd eying the town beauty. In 1976 he produced what may be his *magnum opus:* a parade of disagreeable types, whose physical and spiritual ugliness is presented with gusto, called *Subway Symphony. Lit.:* Una E. Johnson, *Paul Cadmus: Prints and Drawings, 1922–1967,* 1968.

**CALDER, ALEXANDER** (1898–1976), one of America's most renowned sculptors. Born in Philadelphia, he was the son of the sculptor ALEXANDER STIRLING CALDER. After receiving a degree in mechanical engineering from the Stevens Inst. of Technology in 1919, he worked at various jobs before enrolling in ASL in 1923. His teachers there included JOHN SLOAN, GUY PÈNE DU BOIS, and BOARDMAN ROBINSON. During his student years, Calder also produced humorous drawings of sporting events for the *National Police Gazette.* Calder's brush-and-ink sketches of animals, among the finest works of his early years, prefigure his wire sculpture in their use of a single line to record both the contour and the disposition of a form in space. In 1925 Calder produced his first illustrated book, *Animal Sketching.* The years of study at ASL also resulted in a number of oil paintings, including many loosely brushed views of New York City executed in the manner of Sloan and GEORGE LUKS.

Calder produced his first wood carvings in 1926, shortly before his initial trip to Paris. Tropical woods carved directly into wittily conceived animals and primitivist figures comprise a significant portion of Calder's artistic production before 1930. Included among the best examples of works in this medium are *Double Cat* (1929, WMAA) and *Horse* (1929, MOMA).

Calder arrived in Paris in June, 1926, and during the next seven years spent most of his time in the French capital. There, he assembled a miniature hand-animated *Circus* (WMAA). At performances of the circus in his studio, Calder met many of the leading abstract artists of the period. He also made his first wire sculpture in Paris shortly after his arrival. By bending and twisting a single wire, he was able to describe a volume in space and produce humorous portraits, animals, and large figurative groups. *Romulus and Remus* (1928, Guggenheim Mus.) and *The Brass Family* (1928, WMAA) are among the most successful and ambitious works in this medium.

A visit to Piet Mondrian's studio in 1930 resulted in a new, abstract style. Early in 1931, Calder produced his first nonobjective constructions, which were later named "stabiles" by Jean Arp. His

first mobiles were produced in 1932 and were shown early that year in a Paris gallery exhibition organized by Marcel Duchamp, who also coined the term *mobile* for all of Calder's kinetic constructions. *The Bicycle* (1932, MOMA) was one of a group of motorized devices that had attracted Duchamp's interest. Shortly after, Calder began to produce wind-driven pieces like *Object with Red Discs* (1932), which is characteristic in that various elements of different sizes, shapes, and colors are connected yet free to describe an independent movement.

Calder's mobiles were first shown in the United States in May, 1932. In subsequent years, his constructions attracted considerable attention as the first works by an American to distill Constructivist and Surrealist elements in the creation of a personal sculptural idiom. In June, 1933, Calder returned to America and purchased a farmhouse in Roxbury, Conn., where he lived, for at least part of the year, for the rest of his life. (In the 1950s and after, he also lived in France for several months each year.) In 1938, the year it was made, Calder sold his motorized *Universe* to MOMA. The work included two planetary bodies that moved at different rates of speed and in different directions within an open sphere. Calder later declared that the organization of the universe was the underlying concept on which all of his abstract works were based. By the mid-1930s, Calder's sculptures had increased in scale and included several examples of standing mobiles intended for outdoor locations.

Martha Graham had several mobile elements enlarged in 1935 to serve as "plastic interludes" during the performances by her dance ensemble. In 1936, for a production of Erik Satie's *Socrate*, Calder designed a set that included several moving geometrical forms. In the later 1930s, however, organic imagery, suggesting a debt to Joan Miró, Jean Arp, and the Surrealists came to dominate his work. *Form Against Yellow*, (1936, Hirshhorn Mus.) is a painted panel with mobile elements suspended from the top edge, and it may be regarded as a three-dimensional equivalent of Miró's paintings of the 1930s.

When Calder fashioned *Gothic Construction from Scraps* (1936) the full sculptural vocabulary needed for decades of creative activity was established. This small construction was the prototype for Calder's monumental stabiles of the 1960s and 1970s. His first large-scale stabile, *Whale* (1937, MOMA), was succeeded by a limited number of examples in the 1930s. The same year, he designed the Mercury Fountain for the Spanish Pavilion at the Paris Universal Exposition. Due to the scarcity of metal during the war years, Calder devised some new abstract static works entitled Constellations that were made of small pieces of carved wood, painted in various colors and attached by wires. Calder produced a few small acrobats and animals in bronze in 1940 and in 1944 began a new series of more abstract examples, including *Snake on an Arch* and *Woman on Cord*. In the early 1950s, Calder began two new series of mobiles: Towers, wire constructions mounted on a wall, and Gongs, mobiles that incorporate sound. In 1954 Calder designed a fountain for the General Motors Technical Center in Warren, Mich. Other public commissions included *Spirale* for the UNESCO Building in Paris, *.125* for Kennedy International Airport, New York, and *Whirling Ear* (1958) for the Brussels World's Fair. In 1962 *Teodelapio*, a stabile sixty feet high was installed in a public intersection in Spoleto, Italy. In the following years, Calder completed a number of monumental stabiles: *El Sol Rojo* (1966) for the Aztec Stadium in Mexico City; *Man* for the Montreal World's Fair of 1967; and *La Grande Vitesse* in Grand Rapids, Mich., which was dedicated in 1969. Large-scale stabiles and some colossal mobiles were commissioned by federal and municipal agencies and private industry in the 1970s. These works constitute a major portion of Calder's artistic production in

his later years. His death coincided with a major retrospective of his works in a variety of mediums at WMAA. Calder's oeuvre includes sculpture in wire, sheet metal, wood, and bronze; oil paintings, watercolors, gouaches, etchings, and serigraphs; jewelry; tapestries; a number of innovative projects for the theater; and architectural interiors. *Lit.*: James Johnson Sweeney, *Alexander Calder*, exhib. cat., MOMA, 1943.

CALDER, ALEXANDER MILNE (1846–1923), a leading sculptor in Philadelphia. Born in Aberdeen, Scotland, Calder studied in Edinburgh, London, and Paris, before settling in Philadelphia in 1868. Most of his career was spent creating and carving the tremendous decorative sculptural program for Philadelphia's new City Hall, in connection with which he also supervised large numbers of artisans and workmen. Calder's best-known work is the gigantic statue of William Penn that surmounts the building. This naturalistic likeness, one of Philadelphia's most familiar landmarks, was based on BENJAMIN WEST'S depiction of the great political leader in the famous *William Penn's Treaty with the Indians* (1772). The sculpture is thirty-six feet tall and weighs twenty-six tons. It occupied Calder almost exclusively between 1886 and 1892; one of the problems it brought him was finding a foundry that could cast so colossal a statue. It was finally hoisted into position in 1894. Few other works by Calder are known; the finest and most impressive is his equestrian statue of General George Gordon Meade (1881) in Philadelphia's Fairmount Park. He was the father of the sculptor ALEXANDER STIRLING CALDER and grandfather of the best-known artist of this remarkable family of sculptors, ALEXANDER CALDER.

CALDER, ALEXANDER STIRLING (1870–1945), a sculptor working in the Beaux-Arts style. The son of ALEXANDER MILNE CALDER, and the father of ALEXANDER CALDER, he was born in Philadelphia. At the age of sixteen, he enrolled at PAFA,

where he studied drawing with THOMAS EAKINS. In 1890, when he left PAFA, he went to Paris and entered the class of Henri Chapu at the Académie Julian and of Alexandre Falguière at EBA. Calder returned to Philadelphia after two years in Paris and began to model allegorical figures and portraits, including *Man Cub* (1901), a likeness of his son Alexander. In 1903 Calder became an instructor at the Philadelphia Mus. School of Industrial Art. After moving to New York City in 1910, he taught at NAD and later at ASL. Calder gained national recognition and a silver medal at the St. Louis Exposition of 1904. By 1915 he was directing the entire sculptural program for the Panama-Pacific Exposition in San Francisco. His finest sculptural contribution to that exposition was the Fountain of Energy. In subsequent years, Calder received commissions for the Depew Fountain in Indianapolis (1915), a statue of George Washington for one pier of the Washington Square Arch in New York City (1918), the Swann Memorial Fountain in Philadelphia (1924), and the Leif Ericsson Memorial in Reykjavik, Iceland (1932). During the final decade of Calder's artistic career, he was overshadowed by his son. *Lit.*: Julian Bowes, "The Sculpture of Alexander Stirling Calder," *American Magazine of Art* 8 (1925).

CALLAHAN, HARRY (b. 1912), a photographer. Born in Detroit, Callahan began photographing in 1938 and was deeply impressed by a talk ANSEL ADAMS gave to Callahan's Detroit photography club in 1941. His early work, in the "straight" tradition (see STIEGLITZ, ALFRED; WESTON, EDWARD), was first shown at MOMA in the New Photographers exhibition of 1946. The same year, László Moholy-Nagy hired him to teach at the Chicago Inst. of Design, where he met architect Ludwig Mies van der Rohe and AARON SISKIND, who contributed notably to his subsequent interest in formal design. After 1948 EDWARD STEICHEN became his strong supporter and showed

his work in many MOMA exhibitions, including Photographs of Harry Callahan and Robert Frank, in 1962. In 1961 Callahan began teaching at RISD, where he established the photography program. An important retrospective was held at MOMA in 1976–77.

Callahan's work embraces the purist tradition of Weston and Adams and the abstract tradition of Moholy-Nagy and Siskind. Though he became interested in such techniques as double exposure and experimented with abstraction—sometimes allowing formal properties to dominate the image—for Callahan, subject matter was never unimportant. In fact, his formal concerns give unity to the intimate landscapes, the portraits of Eleanor, his wife, the studies of Chicago row houses in the 1940s and 1950s, and the famous series of people walking on Chicago's State Street in 1950. His more recent work includes a series of houses in Providence and pictures taken in Cuzco, Peru. A large collection of his work is in MOMA. Among other books, he has published *The Multiple Image* (1961). *Lit.*: Harry Callahan, *Harry Callahan*, ed. and intro. by J. Szarkowski, 1976.

CALLAHAN, KENNETH (b. 1905), a painter, and occasional sculptor, born in Spokane, Wash. A self-taught artist, he moved to San Francisco in 1925, went to sea in 1927, and settled in his native state in 1929. In 1930 he made the first of several trips to Mexico and travelled in Europe in 1954. He has completed a number of murals, including those for post offices in Centralia, Wash. (1935), and Anacortes, Wash. (1937), under federal sponsorships, as well as one for the Washington State Library, Olympia, (1960). In 1958 he began to make sculpture, moving from large metal pieces to slate carvings, terra-cottas, and bronzes by 1967.

Callahan's early paintings are expressively realistic, depicting local landscape as well as people at work. In 1946 his style changed, reflecting the influence of MARK TOBEY and MORRIS GRAVES. Figures grew distended and spectral, float-

ing freely or organized in large, whirling groups. Colors became arbitrary and vistas opened on strange moonscapes or cosmic voids (*Interwoven Thread*, 1948, MMA). Of these works, Callahan has said that he painted "the unending process of the evolving of forms and the dissolution of forms." Concerned with seeing with both the "inner and outer eye," he usually begins a work as a loose abstract pattern and allows it to evolve in the direction it wants to go. In the 1970s, he began to use more jagged forms and abrupt juxtapositions, tying them closely to the picture surface. Nevertheless, pockets of deep, amorphous space still vibrate mysteriously through his paintings. *Lit.*: Michael Johnson, ed., *Kenneth Callahan: Universal Voyage*, 1973.

CARLES, ARTHUR B. (1882–1952), an early modernist painter. Born in Philadelphia, he lived in that city until his death, except for trips abroad in 1905, 1907–10, 1912–13, and 1921–22. A student at PAFA between 1901 and 1907 (not continuously), he was initially influenced by the bravura technique of his teacher WILLIAM MERRITT CHASE as well as the early works of Edouard Manet; at the same time, he also painted in a precise, academic manner. Indeed, his facility in working with different styles may have kept him from achieving a coherent stylistic development. His work is that of a brilliant technician, lacking a cohesive psychological center. He became a modernist during his second ʼay abroad, presumably after meeting ALFRED MAURER and, through Maurer, other members of the Paris art world, including Gertrude and Leo Stein. (His Fauve *Interior with Woman at Piano*, of 1912, is in the Baltimore Mus.). Henri Matisse's paintings of the period 1893–1903 were especially influential upon Carles at this time, and he sustained an interest in Manet's comparatively untextured and colorless works. Perhaps responding to current taste in Philadelphia, he also continued to paint realistically.

During the 1920s, Fauve bursts of color and gestural freedom energized Car-

les's studies of nudes and still lifes (*Figure on Couch*, 1924–25, Philadelphia Mus.). During the 1930s, he maintained his Fauve manner, with less restraint than previously, but he also painted controlled hard-edged abstractions composed of small rectangular and triangular forms (*Composition No. 5*, 1935, Philadelphia Mus.). He stopped painting in 1941 because of an accident. The Philadelphia Mus. has about fifteen of his works. *Lit.*: H. G. Gardiner, *Arthur B. Carles*, exhib. cat., Philadelphia Mus., 1970.

CARLSEN, EMIL (1853–1932), a noted still-life specialist. A Dane, Carlsen came to America in 1872 and taught at AIC. In 1875 he returned to Europe, working in Paris and studying the paintings of the 18th-century French still-life specialist, Jean Baptiste Siméon Chardin. Carlsen's early success was based upon broadly painted, flashy, almost impressionistic depictions of flowers, particularly yellow roses. He later became the most important American exponent of the 19th-century Chardin revival in France. Some of his more dramatic early work displays Chardinesque subject matter—copper kettles, dead game, and gleaming bottles. His later still lifes go farther still, however, capturing the moods and spirit of the French master. In these Carlsen adopted open compositions and soft atmosphere in which forms gently merge into the backgrounds. His interest was in subtleties of form and light. Later, Carlsen turned his hand to large, often square, landscapes, tapestrylike and decorative, with light, bright colors suggesting a limited relationship with Impressionism, which he admired. To some of the landscapes, now emptier and more austere, Carlsen brought a sense of religious feeling. It is significant that the first American book published on the history of still-life painting, Arthur E. Bye's *Pots and Pans*, of 1921, was dedicated to Carlsen, for he endowed the genre with a seriousness and dignity at a time when the still-life

tradition was about to undergo a decline and metamorphosis.

CARVALHO, SOLOMON NUNES (1815–1894). See PHOTOGRAPHY, FRONTIER.

CASILEAR, JOHN WILLIAM (1811–1893), a significant landscape painter of the HUDSON RIVER SCHOOL, born in New York City. Like his more famous friend and mentor, ASHER B. DURAND, Casilear began his artistic career studying with the engraver PETER MAVERICK in 1826. He practiced both engraving and landscape painting for many years. As an engraver, he was one of the best of his time, producing large numbers of banknotes and commemorative graphics. His life was quiet and unassuming, as are his very pleasant and pastoral landscapes. They are beautifully drawn and painted, serene in feeling and usually filled with silvery atmosphere or golden light, reminiscent of Dutch 17th-century landscape painting. It must also be admitted, however, that they have the tight, meticulous realism of Durand's style without any of the drama or monumentality that infuses that greater artist's best work. The most significant event in Casilear's placid career was a trip to Europe with his friends Durand and JOHN F. KENSETT between 1840 and 1843. That these three ex-engravers turned to landscape painting suggests a relationship between the tight, meticulous, linear art of engraving and the detailed style of Hudson River School realism.

CASSATT, MARY (1844–1926), a painter and graphic artist. Born in Allegheny City, Pa., she spent her early years in Pennsylvania and travelling in Europe. By the 1860s, she had resolved to become an artist. In 1861 Cassatt enrolled at PAFA, where she studied until 1865. She then decided that Europe was the place for her artistic development and left for Paris in 1866. Although she had some formal training with a French painter, Charles Chaplin, Cassatt learned most by looking at the works of

other artists, living and dead. She copied the old masters in the Louvre Mus. but also appreciated such newer trends in French art as the naturalism of Gustave Courbet and the unconventional composition of Edouard Manet. At her family's insistence, Cassatt returned from Paris during the Franco-Prussian War. She brought with her the paintings made during her years of European study. Unfortunately, many of these works were destroyed in a fire, leaving little evidence of her early style. Shortly after the end of the war, in 1872, Cassatt returned to Europe. She travelled to Italy, stopping in Parma and Rome to study the work of Antonio Correggio and Francesco Parmigianino and graphics and painting with Carlo Raimondi. She also visited Spain, Belgium, and Holland, where she admired the paintings of Diego Velázquez and Peter Paul Rubens. Her work of this period shows that she was looking at these 17th-century artists with a knowledge of modern developments. *On the Balcony* (Philadelphia Mus.), which was exhibited at the Paris Salon of 1872, shows a debt to Manet, both in subject and in style.

These works of the early 1870s brought Cassatt to the attention of the French artist Edgar Degas. He sought her out, and they became close associates. Degas introduced Cassatt to the French Impressionists, whom she joined in 1877, exhibiting with them from 1879 until 1886. Cassatt quickly adopted Impressionist techniques: She applied paint in small touches, used a high-keyed palette, and drew subjects from everyday life. Here, however, she developed her own specialty. Unable to join male artists in cafes and responsible for her aging parents, Cassatt drew her subject matter from her home environment. Again and again, she painted her parents and her sister Lydia. Her nieces and nephews also became favorite subjects. She was especially drawn to the theme of children and mothers and painted it during the rest of her career. In 1878 she was asked by JULIAN ALDEN WEIR to show her

work with the new Soc. of American Artists (see NATIONAL ACADEMY OF DESIGN), and the two paintings she sent were among the earliest Impressionist pictures exhibited in America (see IMPRESSIONISM, AMERICAN); however, Cassatt was never appreciated as much in America as in France.

In the late 1880s, Cassatt changed her painting style to emphasize solid form and design. She abandoned Impressionist brushwork and color and filled her compositions with large, sharply silhouetted forms. After viewing an exhibition of Japanese prints with Degas in 1890 at EBA, she produced an extraordinary series of color prints, which were exhibited in Paris in 1891. To prepare herself for making them, she studied Japanese woodblocks and experimented with flattened forms and nontraditional points of view. Done in mixed media, including drypoint, aquatint, and etching, the series is also remarkable for a combination of techniques in individual prints. In *The Bath* (1892, AIC), flat pattern, silhouetting, and shallow space all attest to her successful absorption of the new influence into her own basic manner of painting, as well.

Although Cassatt remained active into the 20th century, it is generally accepted that the quality of her work declined with time. She progressively lost her eyesight and by 1914 was forced to give up painting. Her achievement is not limited to her oeuvre, however. She also deserves recognition for shaping American taste. She advised several important American collectors, among them, her friends the Havemeyers. This fine collection, which includes a large number of works by Degas, was bequeathed to MMA. Cassatt's work can be seen in many public collections, including MMA, NGW, and MFAB. *Lit.*: Adelyn Breeskin, *Mary Cassatt: A Catalogue Raisonné of the Oils, Pastels, Watercolors, and Drawings*, 1970.

CATLIN, GEORGE (1796–1872), the first major artist to devote his career to the

depiction of the American Indian. Born in Wilkes-Barre, Pa., Catlin received a classical education and practiced law before he turned to art. Self-taught, he painted portraits and miniatures in Philadelphia in 1823, and in Washington, D.C., from 1824 to 1829. While he was in Philadelphia, the sight of a delegation of Plains Indians on their way to Washington moved Catlin deeply, for he perceived in their bearing and deportment the classical ideals he had become acquainted with in his youth. He eventually determined to record the appearance and manners of these native Americans, whose way of life was so quickly disappearing. Beginning in 1832, he travelled for six years, from the Missouri to the Southwest, later visiting the Seminoles of the Southeast. Nearly five hundred paintings were the outcome of his investigations, both portraits of individual Indians and scenes of Indian life. The portraits are of two types—busts and full-length renditions. Some are thinly, even sketchily done; others are finished, very solid and dramatic three-dimensional images. These differences in technique must reflect, in part, the conditions under which Catlin worked: Some portraits undoubtedly had to be finished much more quickly than others because the subject was reluctant or unable to remain still for long. Despite the often difficult circumstances, Catlin was successful in almost every case in capturing the essential distinctions, physical and cultural, between the members of different tribes (of which he painted nearly fifty). He was often able to express character, particularly of very strong individuals. Much attention was given to clothing, headdresses, and other paraphernalia, and this, of course, has made these pictures an invaluable resource for anthropologists. Many are in the collection of the Smithsonian Institution, Washington, D.C.

Catlin's scenes of the Indian life are almost all painted in a sketchy, even shorthand, manner, done as they usually were when both the artist and the subject were in motion. Some of them show the Indians in camp; his famous depictions of the Mandan Indians, a tribe that soon passed out of existence, including the horrifying Mandan torture ritual, are among them. Others depict buffalo hunts, both in good weather and in bad. They are among the earliest examples of a subject that remained popular throughout the 19th century, developing inevitably into an alternative motif in which the buffalo and the Indian, indigenous both, were tragically equated as "The Last of the Tribe."

Catlin began publishing his work in 1841. Earlier still, in 1837, he began to exhibit his Indian Gall. of portraits and artifacts, first in North America and then in Holland, England, and France, where it was much praised by the romantics. Catlin travelled in Latin America in the 1850s, producing a series of landscapes and hunting scenes, less dramatic and powerful than his North American Indian pictures, but with a strong sense of rhythm, color, and design.

Catlin's Indian pictures are not as academically proficient as those of his near-contemporaries ALFRED JACOB MILLER, JOHN MIX STANLEY, SETH EASTMAN, and CHARLES WIMAR. They are, however, more spirited and less studied, often displaying the striking simplicity of genius; indeed, their ethnological significance has tended to obscure their greatness as pictures. A large number of Catlin's works are also in NCFA. Catlin wrote a number of accounts of his travels, including *Letters and Notes on the Manners, Customs, and Conditions of the North American Indians*, 1841. *Lit.*: Lloyd Haberly, *Pursuit of the Horizon: A Life of George Catlin*, 1948.

CAVALLON, GIORGIO (b. 1904), an abstract painter. From Sorio, Vicenza, Italy, he came to America in 1920 and attended NAD from 1925 to 1930. He then lived in Italy until 1933 and, on his return to America studied with HANS HOFMANN in 1935–36. He joined WPA-FAP in the mid-1930s and worked as an assistant to ARSHILE GORKY. He belonged

to the AMERICAN ABSTRACT ARTISTS from 1936 to 1957. Initially attracted to such cerebral abstractionists as Jean Hélion and Piet Mondrian, Cavallon brought a more random, gestural approach to his work after 1950; however, he invariably maintained a quasigeometrical control over frontal planes and bars of color that tended to hug the picture surface. Unlike other post-World War II expressionists, he insisted upon emphasizing the quality of surface: Even when his forms lack depth they still impart a sense of tactility. Because of their subtle atmospheric light, his paintings have been likened to abstract images of Mediterranean villages.

CENTENNIAL EXPOSITION, Philadelphia, 1876. Best remembered for its industrial exhibits (the Corliss engine became its symbol), the Centennial Exposition was also an important occasion in the history of American art. For the first time, people were able to see a full retrospective of American art and consider its internal development as well as measure it against European achievements. Of the 3646 exhibits from twenty countries, 760 were American paintings and 162 were American sculptures. In addition, the works of 144 photographers from sixteen countries were gathered in what was one of the earliest major photographic exhibitions. Engraver JOHN SARTAIN was chief of the Centennial's Bureau of Art and responsible for coordinating selections from Boston, New York City, and Philadelphia, then the major American art centers. English entries were appreciated for their storytelling properties and meticulous realism; Italian for their cleverness and sentimentality. The French entries were not well received because of their emphasis on technique rather than subject matter. American works, in general, were highly regarded, especially the landscapes, which were considered among the best executed anywhere. Although WILLIAM TROST RICHARDS's old-fashioned, meticulously detailed landscape *Wissahickon* (1872) was singled out for special praise, the works of such younger figures as JAMES A. M. WHISTLER, GEORGE INNESS, and THOMAS WILMER DEWING were also noted, an indication of growing American acceptance of the newer styles emanating from Munich and from Barbizon in France, in which suggestiveness replaced verisimilitude.

CERACCHI, GIUSEPPE (1751–1802), the earliest and most important Italian neoclassical sculptor to work in America. Ceracchi distinguished himself as a sculptor first in his native Italy, then, in the late 1770s, in London, and again at the Austrian court in Vienna. He returned to Rome in the 1780s and arrived in this country early in 1791, inspired with the desire to win a commission for a monument to Liberty. Toward that end, he produced a series of busts of the Great Men of America, modelled from life, some of which were cut in marble. The subjects included Thomas Jefferson, Alexander Hamilton, James Madison, and John Adams, as well as Washington. These busts, all characteristically heroic in expression, are based on classical prototypes for hair and drapery. An example, *George Clinton*, of c. 1792, is in NYHS. Ceracchi also created a colossal bust of Liberty to be placed behind the speaker's chair in Congress Hall, Philadelphia.

In 1792 he returned to Europe, but his increasingly liberal principles brought him into disfavor with the papal government. He returned to Philadelphia in the fall of 1794, seeking a commission for an elaborate Monument to American Liberty. The failure of this project led Ceracchi to return to Europe once again, this time to Paris, where he became a favorite of Napoleon, whose portrait he executed. Ceracchi rose high in politics under Napoleon but later became involved in a plot against the general's life and was put to death in Paris. Antonio Canova later used Ceracchi's bust of Washington as a likeness for the full-length, seated George Washington he designed for the North Carolina State Capitol, at Raleigh (completed in 1821). *Lit.:* Ulys-

ses Desportes, "Giuseppe Ceracchi in America and His Busts of George Washington," *Art Quarterly*, Summer, 1963.

CHAFETZ, SIDNEY (b. 1922), a printmaker. From Providence, R.I., he graduated from RISD in 1947 and studied in Paris in 1947–48, at the Académie Julian and with Fernand Léger. In 1950–51 he became an apprentice at Stanley William Hayter's Atelier 17 in Paris. Although he has worked in most print media, he is particularly partial to woodcut and intaglio. He is concerned with using graphic art as effective means of communication rather than for formal experimentation and has attacked politicians and, especially, befogged academics since the 1950s in his chosen media. He has also made probing portraits of poets and such major cultural figures as Sigmund Freud (1962). As much as any printmaker in the years after World War II, he has kept alive the tradition of using the print media as a platform for the opposition, whatever it may be at the moment. *Lit.*: *Sid Chafetz*, exhib. cat., Oberlin Coll., 1978.

CHALFANT, JEFFERSON DAVID (1856–1931), one of the finest still-life specialists in the *trompe l'oeil* manner. Born in Lancaster, Pa., Chalfant is associated artistically with Wilmington, Del., and his career there falls into three periods. During the 1880s he became perhaps the most sensitive imitator of the illusionistic style of WILLIAM MICHAEL HARNETT, depicting arrangements of musical instruments, books, and similar objects in a marvellously detailed and precisionistic manner; as with Harnett, his forms appear to move out into the real space surrounding the spectator. Chalfant's compositions are simpler than Harnett's, however, and the details are even more minute. Chalfant preferred cool, silvery tones to Harnett's dramatic color and bold contrasts of light and dark, and his works of this period express a lyric, poetic mood.

In 1890 Chalfant went to Paris to study under Adolphe William Bouguer-

eau. On his return, his style did not change but his subject matter did. He turned his hand to a series of paintings of Wilmington craftsmen and to studies of young boys, both black and Caucasian. These pictures are painted with the same precisionism as the still lifes and often incorporate still-life accessories, including his favorite musical instruments. The craftsmen series reflects the nostalgic respect felt by many American artists for America's artisan tradition then withering in competition with industrialization. Chalfant's studies of youth are examples of a popular artistic form best represented in the painting of JOHN GEORGE BROWN.

During the first decade of the 20th century, Chalfant once again changed his subject matter, this time turning to portraiture. His real genius, however, had been expressed in his still-life and genre paintings. *Lit.*: Alfred V. Frankenstein, *After the Hunt: William Michael Harnett and Other American Still Life Painters, 1870–1900*, 2d ed., 1969.

CHAMBERLAIN, JOHN (b. 1927), a sculptor, best known for his presentations of crushed automobiles. From Rochester, Ind., he studied at AIC between 1950 and 1952 and at Black Mountain Coll. in 1955–56, before moving to New York City in 1957. The use of welded tubular and sheet forms in open construction in his sculpture of the late 1950s reveals DAVID SMITH's influence. Unlike Smith's work of the 1940s, however, Chamberlain's had no symbolic meaning. In addition, he tended to work out from a dense core rather than to envelop space with extended forms. *Shortstop* (1957), his first work made from automobile-body parts, is related to the earlier mode of vision in that it is a work of compression rather than of expansion.

From 1959 to 1963, Chamberlain worked exclusively with crushed auto bodies, destroying forms rather than creating new ones. An example, *Sweet William*, of 1962, is at LACMA. As with other examples of ASSEMBLAGE art, the various elements Chamberlain used

maintain a sense of their own previous history, but also partake of the formal effects imposed upon them. The results may be considered less as those of preconceived planning than as those of happy accident. After 1963 Chamberlain created paintings with automobile lacquer, but in 1965, he returned to crushed forms, using, in succession, foam rubber, metals, coated paper, and Plexiglas. Like other artists who matured in the late 1950s, he remains fascinated by the properties of ordinary materials and uses them to create individual works, not environments. Since 1967 he has also produced videotapes. *Lit.:* Diane Waldman, *John Chamberlain,* exhib. cat., Guggenheim Mus., 1971.

CHAMBERS, THOMAS (1815–after 1866), a leading naive landscape painter. Born in England, Chambers worked in this country from the mid-1830s through the middle of the 19th century. He was in New York City for about a decade, then in Boston, Mass., and later in the Hudson River Valley. Chambers's work consists of views, usually of ships either on rivers or on the ocean. Although he was presumably untrained, Chambers's work is unlike that of most primitive artists. Instead of flat forms unmodulated by light and shade, he chose to paint large shapes, often silhouetted against bright skies or dark water. His colors are not subtle, but brilliant, and they contrast strongly with one another—vivid clouds against an intense blue sky, bright whitecaps atop greenish-black waves. The paint is laid on very boldly and with rich impasto, so that the vividness of the technique adds to the intensity and to the sense of movement. Although some of Chambers's work is undoubtedly based upon direct observation, much is derived from print sources, and in such cases the translation of the essentially linear black and white elements to the rich modulations of colored oils constitutes a formidable achievement. Among Chambers's finest and most dramatic accomplishments are paintings drawn from prints of the naval battles of the Revolutionary War and of the War of 1812. An example of c. 1845, *The "Constitution" and the "Guerrière,"* is in MMA. *Lit.:* John Wilmerding, *A History of American Marine Painting,* c. 1968.

CHAMPNEY, BENJAMIN (1817–1907), dean of the WHITE MOUNTAIN SCHOOL of landscape painting. Champney was born in New Ipswich, N.H., and was apprenticed to the Pendleton lithography firm in Boston, Mass., at the same time as FITZ HUGH LANE and DAVID CLAYPOOLE JOHNSTON, before beginning to practice as a portrait painter. Between 1841 and 1848, he was almost continuously in Europe, where he turned to landscape painting. He then became active in the Boston art world, but about 1850, when he travelled to New Hampshire with JOHN F. KENSETT, he established himself in summer headquarters on the Saco River at North Conway, to which he returned yearly. Champney's landscapes, mostly of this region that he knew and loved so well, are rather detailed, though often panoramic, views of White Mountain scenery, often centering about Mt. Washington and other peaks.

Champney's place in mid-century landscape painting is secure but modest; far more significant was his role in establishing North Conway as a landscape painters' haunt, more important, perhaps, for many years, than any other center, in the Catskills or at Lake George. His open hospitality attracted many other artists to the region, and many took instruction from Champney at his studio. Champney was also an ardent and able flower painter, drawing his subjects from the garden that his wife lovingly tended. His volume of memoirs constitutes one of the most beautiful and interesting autobiographical accounts by any American painter. *Lit.:* Benjamin Champney, *Sixty Years' Memories of Art and Artists,* 1900.

CHANDLER, WINTHROP (1747–1790), a provincial portrait painter of distinction from Connecticut. The facts of Chandler's artistic development are specula-

tive; he came from Woodstock, Conn., and may have studied with a house and/ or sign painter in Boston, Mass. His figures are large, intensely drawn, and emphatically individual, without any grace, flattery, or idealism in their presentation. Chandler endeavored to give his subjects full three-dimensional plasticity, and he thought in terms of monumental forms. His pictures, too, are often large, and many are paired portraits of husbands and wives. They are harsh in their interpretation of personality and dramatic in coloring. Chandler often included room furnishings in these portraits, and an occasional independent *trompe l'oeil* detail—for example, a shelf of books—anticipates the concern with such subjects in the late 19th century on the part of such artists as WILLIAM MICHAEL HARNETT and JOHN FREDERICK PETO. Chandler's work appears to have had some influence on other itinerant and naive painters of his period and area. It also bears a relationship to the somewhat more sophisticated and gentler art of his contemporary Connecticut colleague RALPH EARL. Portraits of Captain and Mrs. Samuel Chandler (c. 1780) are in NGW.

**CHAPMAN, CONRAD WISE** (1842–1910), best known as the principal painter of the Confederacy. Chapman was born in Washington, D.C., but grew up in Rome, where his Virginia-born father, JOHN GADSBY CHAPMAN, settled in 1848. Young Chapman, fired with devotion to Virginia, returned to America in 1861 and enlisted in the Confederate Army. In 1863 and 1864 he was detailed to depict the forts and batteries at Charleston, N.C. Intended to be merely descriptive, these sketches in many media (Valentine Mus.) are marvellously rich and painterly, with strong light-and-shade contrasts and deep perspective—some of the most brilliant paintings associated with the Civil War. Chapman went briefly to Rome in 1874 because of his mother's illness; when he returned, landing in Texas, he heard of Lee's surrender and decided to join Confederate General

Magruder in supporting the Emperor Maximilian in Mexico. This plan was aborted by the downfall of Maximilian but, while in Mexico, Chapman became enamored of the landscape and in 1866 painted an impressive, fourteen-feet-long *Valley of Mexico* (Valentine Mus.), a panoramic view of the entire valley. It is the finest painting of the Mexican landscape by a northern artist and bears comparison with similar works by Mexico's greatest 19th-century landscapist, José Maria Velasco. Later in 1866, Chapman returned to Rome. The rest of his career is of comparatively little artistic interest, though he executed a number of attractive Parisian skating scenes in 1869. Much of his later life was spent in Mexico as a "tourist artist" who painted on photographs. *Lit.: Conrad Wise Chapman: 1842–1910*, exhib. cat., Valentine Mus., 1962.

**CHAPMAN, JOHN GADSBY** (1808–1889), a leading expatriate artist of the mid–19th century. Chapman came from Alexandria, Va., studied with CHARLES BIRD KING in Washington, D.C., and then went to Italy. When he returned, in 1831, he established himself as a painter of portraits and history pieces, gaining for himself the extremely important and prestigious commission for a Rotunda painting at the Capitol in Washington, an award probably based more on geographical considerations than on faith in Chapman's unproven aptitude for major historical work. His *Baptism of Pocahontas*, however, though lacking in monumentality, is the most luminous and colorful of the Rotunda pictures. In 1848 Chapman returned to Italy, where he remained almost until his death. Though he continued to paint such historical and religious works as *Hagar* (1853, Gadsby's Tavern, Alexandria, Va.), he devoted himself primarily to views of the Roman Campagna. Filled with colorful, gaily painted peasants and contadinas, they were highly esteemed by the American tourists who visited his Roman studio. The radiant luminosity of these works calls to mind the much-ap-

preciated landscapes of the 17th-century painter Claude Lorrain, while their breadth and sweep suggest a relationship with the popular landscape PANORAMAS of the time.

Chapman was also author of the *American Drawing Book* (1847), probably the most popular of all the American how-to-do-it art books of the century. His two sons, CONRAD WISE CHAPMAN and John Linton Chapman, followed their father in landscape painting. *Lit.:* Georgia Stamm Chamberlain, *John Gadsby Chapman*, 1962.

CHASE, WILLIAM MERRITT (1849–1916), a painter and teacher, whose work mirrors many major styles of the late 19th century. Born in Williamsburg, Ind., he grew up in Indianapolis, where he studied art sporadically with Benjamin F. Hayes from 1867 to 1869. He then went to New York City, where he worked under Joseph O. Easton and studied at NAD with Lemuel E. Wilmarth. After working professionally in St. Louis, Mo., for a short time, Chase went abroad in 1872 to attend the Royal Acad. at Munich, where he remained until 1878. His teachers included Alexander Wagner, Wilhelm Leibl, and Karl von Piloty. Chase visited Venice in 1877 with his friends and fellow students at the academy FRANK DUVENECK and JOHN H. TWACHTMAN, and they all especially admired the works of Tintoretto. Before returning to America, Chase was offered a professorship at the academy, which he declined. On his return, he began his long teaching career—at ASL, from 1878 to 1894. He subsequently taught at the Brooklyn Art School, from 1890 to 1895; the Shinnecock Art School, Long Island, N.Y., from 1892 to 1902; his own Chase School, from 1896 to 1908; and PAFA, from 1898 to 1911, as well as in Chicago and Carmel, Calif., for brief periods of time. He also pioneered in the development of summer study classes abroad.

During the 1870s, he learned the flashy tonal style derived from such 17th-century artists as Frans Hals and Anthony Van Dyck and associated with Munich (see MUNICH SCHOOL). His *Turkish Page* (1876, Cincinnati Mus.) and *Tenth Street Studio* (1880, St. Louis Mus.) represent this aspect of his work. Chase travelled to Europe several times. Among the more important of his early trips was that taken in 1881, when he studied the work of Diego Velázquez in Spain and of Edouard Manet in France. He also met Alfred Stevens, the Belgian painter. Chase was especially struck by Stevens's modified Impressionism, and the results are seen to especially good effect in his *Portrait of Miss Dora Wheeler* (1883, Cleveland Mus.). The pose of Miss Wheeler is also reminiscent of that of the subject of JAMES A. M. WHISTLER's famous portrait of his mother (1872). Chase, however, did not meet Whistler until 1885; shortly thereafter, he began to imitate Whistler's flat patterning and minimal use of detail—particularly appropriately, in his full-length *James A. McNeill Whistler* (1885, MMA). In subsequent years, Chase occasionally painted in Whistler's manner, as in *The Mirror* (c. 1901, Cincinnati Mus.), a portrait of his daughter, notable for its thin colors and carefully studied tonal changes. By 1887 Chase had begun to experiment with Impressionist techniques, lightening his palette and, in extension of his earlier Munich manner, livening his surfaces with richly textured dabs of pigment. His *Park Bench* (1890, MFAB) exemplifies this development in his career. Like other Americans, he invariably maintained a firm realistic grasp on his subject matter, never allowing it to dissolve in a welter of independent color strokes (see IMPRESSIONISM, AMERICAN). Perhaps his finest pictures in this style date from the 1890s, when he summered at Shinnecock (*Shinnecock Hill*, c. 1895, Parrish Mus.). In these works, adults and children sit or play on the beaches or enjoy a pleasant afternoon in fields covered with low-growing plants and bushes. Chase's portraits from this period also reveal Impressionist influences, as in the *Portrait of Virginia Gerson* (c. 1894, Detroit Inst.). During the later years of

his life, Chase reworked his earlier styles in varying combinations, but all of his pictures were informed by a quality of liveliness rare in American art and a sense of surface finish that might be described as dashing. Since he never accepted modernist art, he lost his enormous influence over younger painters after 1905, yet he counted among his pupils GUY PÈNE DU BOIS, CHARLES DEMUTH, CHARLES SHEELER, GEORGIA O'KEEFFE, EDWARD HOPPER, and KENNETH HAYES MILLER. *Lit.:* Ala Story, *William Merritt Chase*, exhib. cat., Univ. of California, Santa Barbara, 1964.

CHRISTO (b. 1935), an environmental sculptor. Born Christo Javacheff in Gabrovo, Bulgaria, he studied at the Fine Arts Acad. in Sofia from 1952 to 1956, worked at the Burian Theatre in Prague in 1956, studied further in Vienna in 1957, and reached Paris the next year. He began to wrap and package objects in 1958. After settling in America in 1964, he created storefronts similar to stage sets. He is best known for covering enormous areas of land and buildings with plastic sheets. These projects have included wrapping the Berne Kunsthalle, in 1968, and a million square feet of Australian coastline, in 1972; and building a running fence in California, extending for 24.5 miles, in 1976. *Lit.:* Lawrence Alloway, *Christo*, 1970.

CHRYSSA (b. 1933), a sculptor. Born Chryssa Vardea, in Athens, Greece, she studied at the Académie de la Grande Chaumière, Paris, in 1953–54 and at CSFA the next year, before settling in New York City. Her first major works, perhaps done in reaction to ABSTRACT EXPRESSIONISM, were plaster, largely featureless reliefs called Cycladic Books (1955). During the next few years, she was among the first to explore the aesthetic of the banal in works that included engraved letters on metal tablets and large, single letters on metal tablets. These pieces were among the first in which words or letters are the entire content of a painting or a sculpture (see

JOHNS, JASPER). Chryssa also created works in the late 1950s based on impressions from newsprint. Her *Times Square Sky* (1962), a jumble of three-dimensional letters, was her first piece to contain neon tubing, a material that has continued to engage her attention. Within a year, she began to design works made entirely of tubing with the exception of their cases and electrical wires. Their subject matter includes multicolored letters and ampersands, often in repeated rows. Some are programmed to turn on and off, but because of their impressive size some works need not be lit to be appreciated. As a result, the effect of one of Chryssa's neon works originates in the viewer's perception of its basic configuration, its wires, the color of the tubes, and their illumination. Examples include *Clytemnestra* (1967, Corcoran Gall.) and five variations on *Ampersand* (1966, MOMA). *Lit.:* Pierre Restany, *Chryssa*, 1977.

CHURCH, FREDERIC EDWIN (1826–1900), a major landscape painter. Church was born in Hartford, Conn. He began his artistic career by obtaining instruction from Alexander H. Emmons and Benjamin H. Coe. In 1844, due to the good offices of the noted Hartford collector Daniel Wadsworth, he became the pupil of the *chef d'école* of American landscape painters, THOMAS COLE, with whom he studied until 1846. Not surprisingly, Church's early works show a clear debt to Cole. Quite soon, however, a divergence became apparent. Unlike Cole, who tended to look back to an imagined past, Church was interested in the landscape of the New World in contemporary times. He soon abandoned the historical and religious content of Cole's landscapes to concentrate on nature in a pure state, often without the presence of man. In this he reflected the transcendentalism of Thoreau and Emerson and their search for a higher moral plane through a oneness with nature. Turning from the sublime and operatic storms of his teacher, Church chose to depict nature in repose. The painterly technique

of his earlier works gave way to a crisp, forthright presentation with scarcely a brushstroke visible.

Established in New York by 1850 as a full member of NAD, Church was almost singular among American artists of his day in having no desire to travel to Europe. Instead, he systematically toured the United States in search of appropriate subjects. For his first destination abroad, in 1853, he did not choose Europe but, accompanied by Cyrus Field, travelled to South America. In his choice of locale he was influenced by the writings of the German naturalist and explorer Alexander von Humbolt, which he admired enormously. After his return, he used the many pencil and oil sketches he had made to produce *The Andes of Ecuador* (1855, Reynolda House, Winston-Salem, N.C.), the first work fully to announce the direction his art was to take. Church's first great success, and the work that placed him at the forefront of American landscape painters was *Niagara* (1857, Corcoran Gall.). The great falls had, of course, attracted many American artists before this time, but Church's view of the familiar site was a new and startling one. Whereas JOHN VANDERLYN in his painting of the same name had reduced the falls almost to insignificance by placing them in the midst of a much broader panorama, Church closed in on the violent cascade. His picture is sweepingly horizontal and abruptly cut off to suggest that this turbulent landscape continues out of our sight. The viewpoint places us precariously near the edge of the precipice but high enough above it so that the entire magnificent arc is visible. The texture of the paint varies as is appropriate to express water, spray, rock, and cloud. This was a vision of landscape at once objective and poetic. Church had recorded geological fact with an accuracy that would have pleased Emerson. At the same time, the rainbow, as in the later works of John Constable, was a positive and hopeful statement, an assertion of belief in the moral goodness of unsullied nature. Furthermore, the work invoked the enormous (though here unthreatening) power of natural forces. The work was a popular success in America and abroad, admired by such diverse notables as Millard Fillmore and John Ruskin.

Church continued to travel in New England, the Arctic, and South America. In a huge painting, *Heart of the Andes* (1859, MMA), the only man-made object is a crucifix that is, perhaps ironically, dwarfed by the majesty of God's creation. A trip to Labrador resulted, in 1861, in illustrations for a book by his travelling companion Louis Legrand Noble called *After Icebergs with a Painter*. Again, the writings of Humboldt seemed to draw Church to that forbidding place. It offered scope for the artist's interest in geology and botany as well as vistas on a heroic scale worthy of his ambitions. In his famous *Cotopaxi* (version of 1863, Reading Public Mus. and Gall., Reading, Pa.), the distant volcano is in eruption, spewing dark smoke across the horizon, but not so thickly as to obscure the brilliance of the newly risen sun. Volcanic eruptions had long been a staple of European romantic landscape painting, but here we contemplate the event at our ease across a vast landscape where gnarled trees grow out of rocky cliffs and water plunges into a steep chasm. Although Church was and is justly famous for his exotic arctic and tropical pictures, it is the Maine woods that are featured in what many consider his masterpiece, *Twilight in the Wilderness* (1860, Cleveland Mus.). This was the culmination of a series of powerfully emotional sunset views of the North American landscape, and it may reflect the anguished time through which the nation was passing.

Church produced his best work in the 1850s and 1860s, when his landscapes, with their compelling juxtapositions of explosion and calm, were, as they have often been described, "symphonic" and "Wagnerian." In 1867–69 Church travelled to Europe and the Middle East— including Jerusalem, which was the subject of a painting. His work, however,

was beginning to lose the energy of passionate description, becoming more rhetorical than resonant. In the 1870s, he collaborated with the architect Calvert Vaux to build "Olana," Church's striking villa overlooking the Hudson River. This monument to the artist's beliefs, his taste, and his success, housing his furnishings and collection, is still preserved.

Building in part upon the HUDSON RIVER SCHOOL and Luminist styles and in part upon the operatic, historical landscapes of Cole, Church developed a personal vision that was both realistic and heroic, closely tied to the aspirations and philosophy of 19th-century America. In his later years, he spent much of his time at his camp in Maine, where he continued to paint. His death was marked by a large exhibition at MMA. Collections of Church's superb oil sketches are in the Cooper-Hewitt Mus. and MFAB. *Lit.:* David C. Huntington, *The Landscapes of Frederic Edwin Church: Vision of an American Era,* 1966.

CLAGUE, RICHARD (1821–1873), the leading painter of the BAYOU SCHOOL of landscape painting. Clague was born in either Paris, France, or St. Louis, Mo. He was sent to school in Switzerland by his wealthy New Orleans family, but subsequent study with Leon Pomarede, a painter and muralist who worked in St. Louis and New Orleans, must have decided young Clague upon his future career. He was back in Paris in 1849, studying at EBA under the neoclassicist François Picot. After a trip down the Nile, Clague returned permanently to New Orleans in 1857.

Clague's portraits reflect the academic procedures of his French training; he was, and is, far better known for his landscapes, which are the first to capture successfully the character of the Delta. Clague expressed, in a romantic yet monumental style, the swampy landscape; the trees growing out of the bayous, the overhanging Spanish moss, and the hazy atmosphere of the region. Hunting camps, trappers' cabins, and boats on the sluggish streams are the frequent subjects of Clague's pictures. His landscapes are never mysterious, as they are usually civilized by the presence of human inhabitants; they seem, in fact, to suggest a relationship with Barbizon paintings he might have seen in Paris. By 1851 Clague had begun his career as a teacher; his students later included Marshall Smith, Jr. and William H. Buck, both of whom produced fine Louisiana landscapes. *Lit.: Richard Clague: 1821–1873,* exhib. cat., New Orleans Mus., 1974.

CLEVENGER, SHOBAL VAIL (1812–1843), one of the earliest professional American sculptors to work abroad. Clevenger came from Middletown, Ohio, and was inspired to become a sculptor by the example of HIRAM POWERS, who became the foremost American sculptor of the neoclassical movement. Clevenger first worked with David Guion in the early 1830s in Cincinnati, where a remarkable artistic tradition in painting and sculpture was developing, thanks especially to the patronage of the local connoisseur Nicholas Longworth. The latter had encouraged Powers and did the same for Clevenger, urging him to undertake portrait sculpture in the East. Clevenger worked in Washington, D.C., New York City, and Boston, Mass., in the late 1830s, producing busts of American political leaders and literary figures in a very forceful style. Never a subtle artist, Clevenger executed busts that are among the strongest and most direct by any of the earlier American sculptors; in fact, his bust of the ailing WASHINGTON ALLSTON was considered so truthful that EDWARD AUGUSTUS BRACKETT was commissioned after Allston's death to produce another, less insistent in its rendering of the subject's physical deterioration. Like almost all the sculptors of the period, Clevenger chose Italy as his goal, and, hoping to produce more significant and ideal works, he joined his friend and colleague Powers in Florence in 1840. There, he translated his American busts into marble and began to create imaginative works, but illness over-

came him and he died on his way back to America. He left his only full-length sculpture unfinished, one of the earliest representations of the American Indian. The piece has disappeared from the literature on American sculpture and is presumed to have been destroyed. Examples of Clevenger's work are in NYHS and the Maryland Hist. Soc. *Lit.:* Thomas B. Brumbaugh, "Shobal Clevenger: An Ohio Stonecutter in Search of Fame," *Art Quarterly*, Spring, 1966.

CLONNEY, JAMES GOODWYN (1812–1867), a genre painter. From Liverpool, England, he came to America as a young man and worked as a lithographic draftsman, possibly in Philadelphia as early as 1830. He attended NAD in New York City and by 1834 was an established miniaturist there. He can be said to have turned to genre about 1841, though *In the Woodshed* (MFAB) dates from as early as 1838. Preferring rural subjects, perhaps in emulation of WILLIAM SIDNEY MOUNT, Clonney also painted domestic interior scenes and, during the 1840s, scenes of men discussing politics or the latest news, as in *Mexican News* (1847, MWPI). Most of his works are spare and contain only two or three figures (*In the Cornfield*, 1844, MFAB; *Waking Up*, 1851, MFAB). His most ambitious painting, however, *Militia Training* (1841, PAFA), contains over thirty individuals. Preferring to model his figures simply and to keep interior and exterior scenes free of clutter, he invested his paintings with a clean and unpretentious quality. Usually, the scenes are mildly amusing and were presumably painted as a kind of visual entertainment.

CLOSE, CHUCK (b. 1940), a painter. Born in Monroe, Wash., he received the M.F.A. degree from Yale Univ. in 1964. He received critical attention in 1967 with his large realistic paintings in black and white of faces seen frontally (*Self-Portrait*, 1968, Walker Art Center). These works were made by subjecting a photograph to a grid system of varying light and dark areas and then transferring the grid to a canvas. When, soon after, he decided to paint in color he relied upon a handmade version of a commercial color-printing process using overlays of yellow, red, and blue. Initially, Close was associated with POP ART and PHOTO-REALISM because of his large, billboard-like images and use of photographs, but his work may just as easily be associated with MINIMAL ART and the process-oriented art of the 1960s and 1970s, given his use of repeated images (the face), his impersonal technique, and his desire to paint in a "nonstyle." In prints, watercolors, and pastels produced since 1972, he has further emphasized his interest in process by leaving the grid clearly visible in the finished work. He has also omitted one or two primary colors to reveal the build-up procedure he customarily uses when working in color and has enlarged each grid-square, which results in "low-resolution" images resembling a computer scan or printout.

COBURN, ALVIN LANGDON (1882–1966), a pioneer photographer who made the first nonobjective photographs, in 1917. Born in Boston, Mass., Coburn studied art with ARTHUR WESLEY DOW, among others, and was introduced to photography by his cousin F. Holland Day, a "pictorial" photographer (see PHOTO-SECESSION). Coburn later considered the trip he and Day made to London in 1899 and the art they saw to be of seminal influence on his life. After returning to Boston briefly in 1901, Coburn opened a studio in New York City the following year and in 1902 became a founding member of the Photo-Secession group. In 1912 he made a series of innovative bird's-eye views of New York, emphasizing the abstract patterns created by streets, parks, and buildings—for example, his famous "Octopus." The same year, he moved permanently to England, where he met the American poet Ezra Pound and the British painter and author Wyndham Lewis and joined the Vorticists. Feeling strongly that photography should be as modern as the other

arts, he began making Vortographs in 1917, photographing bits of crystal and wood through a triangle lined with mirrors. Having proved that photographs could achieve complete abstraction, he virtually ceased making them after this period.

Coburn, one of the finest and least sentimental pictorial photographers between 1902 and 1910, was the first member of Photo-Secession to keep up with modern developments in painting. He was a close friend of MAX WEBER and knew many of the artists of this period, including JOHN MARIN, whose involvement with the imagery of New York City was similar to his own. His Vortographs were revolutionary images, but they had little impact on subsequent photography. An important collection of Coburn's work is at GEH. He published, among other books, *London* (1909), *New York* (1910), and *Autobiography* (1966).

CODMAN, CHARLES (1800–1842), one of the earliest professional landscape painters in America. Codman came from Portland, Maine, and lived in his native state throughout his short life. He produced both literal landscapes and imaginary views, but both were painted in a very distinctive romantic vein. In fact, Codman's style is closer to that of the foremost landscapist of his time, THOMAS COLE, than was that of any other contemporary artist. His work does not have the range of Cole's, however, and he exhibits neither Cole's understanding of landscape traditions nor his sound sense of the underlying structure of natural forms. However, within a more provincial tradition, Codman was able to create very expresssive landscapes; for example, *Pirates' Cove*. Many of Codman's scenes are dark and mysterious, with irregular rock formations, calligraphic trees, deep caverns, and tangled underbrush. Nature is deliberately distorted, and a dark and restricted palette heightens the expressionistic effects. Even when painting topographically, Codman often emphasized the smallness and insignificance of man and his works, while manipulating light and clouds for dramatic purposes. America's first art critic, John Neal, who also came from Maine, supported Codman in his writing and was largely responsible for his success.

COLE, THOMAS (1801–1848), the premier landscape painter of the first half of the 19th century. Cole is considered the founder of the HUDSON RIVER SCHOOL and perhaps the first artist to attempt to portray the dramatic and expressive aspects of the American landscape. From Bolton-le-Moor, Lancashire, England, he worked as an engraver's assistant and as an engraver of designs for calico in Liverpool from about 1815 until his family left for America in 1818. Cole remained in Philadelphia, working as a wood engraver, before travelling briefly to the West Indies and then rejoining his family in Steubenville, Ohio, in 1819. Before 1823, when he returned to Philadelphia and studied at PAFA for two years, he learned the rudiments of art from an itinerant named Stein and tried his hand at a few landscapes. Soon after settling in New York City in 1825, he was discovered by JOHN TRUMBULL, WILLIAM DUNLAP, and ASHER B. DURAND. In that same year, he made the first of many sketching trips up the Hudson River Valley, finally settling in the village of Catskill in 1836. He journeyed abroad from 1829 to 1832 and again in 1841–42. Cole's many papers and journals are in the New York State Library, Albany, and most of his drawings and sketchbooks are in the Detroit Inst. His famous "Essay on American Scenery," which appeared in the *American Monthly Magazine* in 1836, is, like Durand's "Letters on Landscape Painting," a major statement about landscape painting of the period.

In the spectrum that extends from topographical views, at one extreme, to imaginative landscapes, at the other, Cole's paintings of the mid–1820s lay closer to the former. Works such as *Lake with Dead Trees* (1825, Oberlin Coll.) are filled with myriad details as if describing a specific site. At the same time,

from the blasted foreground tree stumps to the vast reaches of mountainous landscape, they reveal the sublime grandeur of the American wilderness. Cole, already not content with being, as he said, "a mere leaf painter," wanted to bring to landscape moral and religious meaning. In 1827–28 he completed a group of landscapes, including *Expulsion from the Garden of Eden* (MFAB) and *John the Baptist Preaching in the Wilderness* (WA), which conveyed messages more profound than those implied by blasted stumps. Basing his compositions on John Martin's illustrations for Milton's *Paradise Lost* (published in 1826 and 1827) and indirectly on Salvator Rosa's 17th-century Italian landscapes, Cole used grandiose natural features to intensify scenes of human and religious drama (like the novelist James Fenimore Cooper, Cole emphasized landscape features almost to the exclusion of the ostensible subject).

After completing these works, Cole visited England, France, and Italy, where, unlike artists of earlier and later generations, he was neither overly impressed nor markedly influenced by what he saw. He did, however, develop a keen interest in PANORAMAS, a type of popular entertainment in England in which paintings were displayed around the walls of a theater or on winding scrolls. Already interested in what might be done with pictures in a series, Cole may have been prompted by the temporal implications of the panoramas to undertake his great multipaneled works of the 1830s—*The Course of Empire* (1836, NYHS), *The Past and The Present* (1838, Amherst Coll.), and *The Voyage of Life* (1840, MWPI). The first depicts the rise and fall of an empire in five panels; the second shows a medieval castle and the subsequent decay of the structure in two panels; and the third illustrates man's journey through life, from childhood through old age, in four panels. In each series, each picture shows a change in time of day and season, underscoring the sense of the mutability of man's works, and of man himself, that

are vividly, even melodramatically evoked by the subject matter and execution. Indeed, time itself is as much the subject of these pictures as are the moral, philosophical, and religious principles Cole so strongly felt each work should express. These series were much admired. *The Voyage of Life* was circulated in numerous engravings, and in 1848 the pictures themselves were distributed in an AMERICAN ART-UNION lottery. At the same time, Cole also painted such vibrant and beautifully conceived landscapes as *Schroon Mountain, Adirondacks* (1838, Cleveland Mus.) and *The Oxbow* (1836, MMA), which simply celebrate American scenery. Compared to his landscapes of the previous decade, detail is subsumed by larger masses, focusing attention on the grandeur of landscape in broad terms and providing grand panoramic vistas—rather than concentrating on narrower points of interest and foreground underbrush. Cole alluded to his greater breadth of focus in a letter written to Durand in 1838: "Have you not found?—I have—that I never succeed in painting scenes, however beautiful, immediately on returning from them. I must wait for time to draw a veil over the common details, the unessential parts, which shall leave the great features, whether the beautiful or the sublime dominant in the mind." That these landscapes were also meant to elevate the soul is borne out by Cole's remarks in his "Essay on American Scenery." He felt, "the wilderness is yet a fitting place to speak of God." Although he delighted in finding American scenery wild and therefore a better locale in which to contemplate God and His undefiled works, Cole also anticipated "the time when the ample waters shall reflect temple, and tower, and dome, in every variety of picturesque magnificence." In wanting to preserve the present while welcoming the future, in combining a reverence for the beauty of the American wilderness with optimism for a future that would bring development of that land, Cole expressed an ambivalence common to contemporary and

even later artists, especially those who painted western scenes—GEORGE CATLIN, HENRY F. FARNY, and FREDERIC REMINGTON.

Through the 1840s, Cole executed both epic series and simple landscapes, the former expressing his increased interest in religion after a conversion to the Anglican church. More optimistic than the cycles of the 1830s, such epics of the 1840s as *The Cross and the World* (1846–47, studies in the Albany Inst.), his major project of this period, reveal Cole's abiding faith in God. Though natural scenery plays a secondary role in these works, Cole rose to new heights in his ability to transcend "mere views" in his expression of natural scenery. His *View Across Frenchman's Bay: From Mount Desert Island, Maine, After a Squall* (1845, Cincinnati Mus.) and *View of the Falls of Munda* (1847, RISD) are among his most "unposed" views, their assertive textures capturing the feel and substance of the materials of nature. Had Cole lived longer, he presumably would have brought together the dual paths on which he had embarked, perhaps changing the course of American landscape painting. As it turned out, subsequent artists avoided the heavy burden of Cole's epic subject matter for simpler expressions of nature's bounty, relying more on direct observation than intellectual conception, though retaining Cole's moral and religious conviction. *Lit.:* Louis Legrand Noble, *The Life and Works of Thomas Cole*, ed. Elliott S. Vesell, 1964.

COLEMAN, GLENN O. (1887–1932), an urban-realist painter. Born in Springfield, Ohio, he received some training in Indianapolis before travelling in 1905 to New York City, where he studied briefly with ROBERT HENRI and EVERETT SHINN. Except for brief visits to Cuba and Canada, and despite a developing interest in the landscape of rural Long Island, toward the end of his life, Coleman's chief occupation was observing and transcribing what he saw on the streets of New York. In his early work, he avoided the dynamic aspects of the modern metropolis, finding his subject matter in quiet alleyways, old neighborhoods, and secluded corners. For him, the individual anecdote—the person carrying a package or crossing a street—represented life in the city. Typical is *Minetta Lane, Night* (1910), in which a few people walk huddled against the cold, or *Coenties Slip* (1926, Newark Mus.), in which workers labor quietly and with no self-awareness. His was an essentially small-town view, in that for him each person was important. The general mood of these works is somber, their colors overcast with gray and applied in thin washes. About 1926 Coleman's preoccupation with human encounters shifted to an interest in urban architecture. Tall buildings replaced more intimate tenements. To frame this spatially broader view, Coleman developed a more rigid and abstract compositional structure. Occasionally, one scene is superimposed on another as if in recognition of Cubist practice, but even in these paintings anecdotal episodes occur. Throughout his career, Coleman's city was scaled to the size of human beings.

COLMAN, SAMUEL (1832–1920), a significant landscape specialist of the second-generation HUDSON RIVER SCHOOL. From Portland, Maine, he studied in New York City with ASHER B. DURAND. Colman is noted for landscape views, some of them quite large, of both European and American scenery. While not an exponent of LUMINISM, Colman often achieved effects by manipulating light, producing either a golden-yellow or a cool, silvery atmosphere. His compositions often center dramatically upon natural or man-made forms, as does, for example, his *Storm King on the Hudson* (1866, NCFA). Colman was one of several Hudson River School artists who painted beautiful and sensitive panoramic views of the West; unlike the contemporary work of ALBERT BIERSTADT, however, they do not emphasize

the grandiose nature of the scenery. One of Colman's finest and largest works of this period is *Ships of the Plains* (1872, Union League Club, New York City). Colman was also an important figure in the American Water Color Soc., founded in 1866, and served as its first president. Colman's work in this medium was rather tight and opaque, although his later oil paintings sometimes have a broader, more progressive style, suggestive of recent French Barbizon influences (see BARBIZON, AMERICAN).

COLOR-FIELD PAINTING. See MINIMAL ART.

COLUMBIANUM EXHIBITION. See PENNSYLVANIA ACADEMY OF THE FINE ARTS.

COMPUTER ART, "any aesthetic formation which has arisen on the basis of the logical or numerical transposition of given data with the aid of electronic mechanisms." Since the 1960s, computers have been used in graphic design, printmaking, sculpture, and films as well as in music, dance, and architecture. Computer graphics have had the longest artistic development, beginning in 1950, when the plotted diagrams of digital computers were first thought to have artistic possibilities. Initially, computer-generated design consisted of an idea stated as a program, which was then typed on punch cards and fed into a computer. The program could be ordered or random. Later, systems that can make images visible on screens for the purposes of correction, combining photography with computer printouts, were used, though the artistic ramifications were not systematically explored until the mid-1960s. The first show of computer graphics in this country took place in 1965 at the Howard Wise Gall., in New York City. A key work that helped popularize the medium was engineer A. Michael Noll's 1964 computer-generated approximation of Piet Mondrian's plus-minus *Composition with Lines* (1917). Charles Csuri, a pioneer in computer graphics, sculpture, and filmmaking since the mid-1960s, was among the first to make figural rather than abstract images. His subjects either aged, fell apart, and were reconstituted or were moved about in programmed sequences. Many computer artists must work with a trained programmer, but others, like Csuri, have mastered the mathematics necessary to write their own programs. *Lit.:* Jasia Reichardt, *Cybernetics, Art and Ideas*, 1971.

CONCEPTUAL ART, a catch-all term that includes artistic events, activities, and objects of a cerebral, purposely nonvisual kind. Permeating this art form, which developed in the late 1960s, is the notion that the idea, event, or activity and the execution or embodiment of the idea, event, or activity are more important than the finished product, which merely documents the idea, or event, or activity. Documentation may be in the form of printed statements, photographic or other mechanically reproduced records, or discrete objects. Such traditional aesthetic considerations as style, taste, permanence, and craft may be jettisoned in favor of the presentation of primary information. Conceptual Art expresses what the artist had in mind rather than the result of making. The Conceptual artist sees himself as part of an information system rather than as the creator of an object or as one who instructs. Some, like SOL LEWITT, may establish a module—perhaps lines drawn on a wall—and execute a piece based on previously conceived plans, or, as in *Box in the Hole* (1968), provide photographic documentation of such an event as the burial of a box. Joseph Kosuth has presented ideas or models that engage themselves in a dialogue with the concept of art object as object, as idea or as model for an art work. Others, like Robert Barry, use words or language as a medium, presenting letters both as objects and as conveyors of information. BRUCE NAUMAN uses his body as such a conveyor, the information referring to nothing but itself.

This type of self-concern, documenting one's very existence, substitutes physical awareness for ABSTRACT EXPRESSIONISM's psychological awareness. *Lit.:* Ursula Meyer, *Conceptual Art,* 1972.

COPE, GEORGE (1855–1929), an able exponent of the *trompe-l'oeil* still-life tradition. Cope spent almost all of his career in West Chester, Pa., where he was born, and during his lifetime his works seem to have been little known beyond that area. He began his career as a landscape painter but appears to have turned to still life about 1890, after the emergence, in the late 1880s, of WILLIAM MICHAEL HARNETT as the foremost painter of illusionistic still life. Indeed, Cope painted a version of Harnett's famous After the Hunt series (mid-1880s): his ambitious *Buffalo Bill's Trap* (1894). The subjects of his paintings of this nature include swords and uniforms, fishing gear, and game. Cope tended to a simple central placement of objects rather than to the grandly orchestrated compositions of Harnett; in his hanging still lifes, he also often emphasized wood panelling and its grain. Some of his finest works concentrate upon only one or two objects, a pipe or a single game bird, as in the superbly dramatic *The Day's Bag,* of 1910. Cope also painted tabletop still lifes, fascinating in their immensely hard drawing; these, however, are extremely photographic, displaying none of the dramatic handling of light that characterizes the best of Cope's hanging *trompe-l'oeil* pictures. *Lit.:* Alfred V. Frankenstein, *After the Hunt: William Michael Harnett and Other American Still Life Painters, 1870–1900,* 2d ed., 1969.

COPLEY, JOHN SINGLETON (1738–1815), a celebrated history painter and portraitist in England and colonial America. Born in Boston, Mass., Copley was instructed by his stepfather, the portrait painter and mezzotint engraver Peter Pelham. The young Copley studied the paintings of leading American artists, including JOSEPH BLACKBURN and ROBERT FEKE,

and copies and prints of works by the great European masters. He applied himself assiduously to the development of his own technique in painting and printmaking. Unlike most of his American contemporaries, Copley aspired to success as a history painter, since that was believed to be the highest expression of the painter's art. However, in Boston he was obliged to seek a livelihood as a portraitist. This he did very well and, at the age of nineteen, he was an established practitioner in the city, executing likenesses in oil and pastel and in miniature on ivory and copper.

Whether in large scale or small, Copley's Boston portraits show carefully posed sitters in informal settings, rendered with a hard outline and restrained modelling. What strikes the observer at once is Copley's ability to convey both the physical truths of appearance and the deeper truths about personality and social position. The clarity and forthrightness of presentation he achieved in the celebrated *Paul Revere* (1765–70, MFAB) are characteristic of his work of this period and appealed strongly to the taste for veracity among his American patrons.

In 1765 Copley sent a portrait (*Boy with Squirrel*) to London, where it was exhibited, to extraordinary praise, at the Soc. of Artists. Copley's compatriot BENJAMIN WEST (himself a successful London history and portrait painter) wrote to Copley encouragingly and urged him to settle in London. However much Copley may have been tempted by the prospect of a career in a major European center, he was more concerned with material prosperity. In Boston he earned "as much as if I were a Raphael or a Correggio," and he was loath to give up so lucrative a practice. But by 1774 impending hostilities between Britain and the colonies were imperiling his practice. He sailed, that year, for Europe.

Before settling in London, Copley travelled on the Continent, concentrating on Italy. He soon realized that in order to compete on the London market, he would have to alter his approach to

painting portraits drastically. He had to steep himself in the academic tradition, which he did by an intense study of the old masters as well as of the leading contemporary painters in England, including Joshua Reynolds and West. He was able to accomplish this so well that, perhaps lamentably, nearly every trace of his probing American style disappeared. His portrait group *The Three Princesses* (1785, Buckingham Palace, London), a study in posed elegance, demonstrates the completeness of the transformation.

In London, however, Copley was finally able to satisfy his penchant for history painting and, in this, he proved to be a major innovator. His *Brook Watson and the Shark* (1778, NGW; other versions in Boston and London) recounted a grisly episode in the life of a popular politician. Here a contemporary event was depicted as it might actually have looked to an observer on the spot. Unlike West's epoch-making *Death of General Wolfe* of 1770, this "modern history" piece had no moral message to offer. It was painted because it was sensational. It looks less posed than West's picture, and its intense realism indicated the line the artist would so successfully take. Copley also showed the requisite "learning" in the academic pyramidal composition of the men on the boat and in the figure of Watson, which is based on the Borghese Warrior.

Following up the success of *Watson and the Shark*, Copley continued to chronicle recent events in paintings that constitute the one major series of contemporary histories to emerge in 18th-century England. *The Death of the Earl of Chatham* (1779–80, Tate Gall., London) shows the collapse of the great statesman in the House of Lords, with nearly fifty of the peers represented. Ever the shrewd man of business, Copley devised a means of realizing a profit from his work in three different ways: He showed the work privately, charging admission; he sold engravings of it; he then sold the painting itself. This astute piece of business incurred the wrath of the Royal Acad. since, though a member, Copley was now a rival exhibitor. The lords too were chagrined at having their likenesses exhibited for private gain. But Copley prospered and continued to conduct his affairs in this manner. Perhaps his most impressive historical work is the *Death of Major Peirson* (1783, Tate Gall., London), a depiction of the last moments of a young officer mortally wounded while fighting the French in the Channel Islands. Unlike his predecessor West, Copley did not choose to show his hero expiring reposefully, removed somewhat from the battle; instead, the stricken soldier appears as he fell, with the battle still raging all around him. The woman at the right, fleeing with her children, adds a touch of sentiment to counterbalance the documentary interest and insured the wide appeal of the picture.

In his *Relief of Gibraltar* (1791, Guildhall, London) Copley returned to horrific subject matter. In his depiction of the suffering and deprivation of the garrison that had been defending the fortress, he anticipated such romantic works as Antoine Jean Gros's *Napoleon Visiting the Pesthouse at Jaffa* (1804), Théodore Géricault's *Raft of the "Medusa"* (1819), and Eugène Delacroix's *Massacre at Chios* (1824). Curiously, it was for the French romantics to bring this mode of history painting to fruition; Copley had no followers in England.

It has been said of Copley that he declined as a portrait painter when he left the colonies for Europe. This may be true. Certainly his English portraits are not remarkable compared with those of his contemporaries there, whereas his American ones, measured by the same yardstick, are outstanding. However, there is no question that he made, in England, a major contribution to the development of history painting that would not have been possible had he remained in Boston. Copley is a major figure in the history of both American and British painting and is rightly claimed by both countries. *Lit.:* Jules David Prown, *John Singleton Copley*, 1966.

**CORNELL, JOSEPH** (1903–1973), an object-
and assemblage-maker (see ASSEM-
BLAGE). Born in Nyack, N.Y., he attend-
ed Phillips Acad., Andover, Mass. He
settled with his family in New York City
in 1929. By 1932, inspired by Max
Ernst's collage album *La Femme Cent
Têtes*, he had begun to make collages,
which were exhibited that year at the Ju-
lien Levy, a major Surrealist gallery. Al-
though untaught, Cornell developed
within the Surrealist ambience, respond-
ing to its literature as well as to certain
influential 19th-century poets and writ-
ers who prefigured the movement; he
was also befriended by the Surrealists
who settled in New York City during
World War II.

In 1933, Cornell began to exhibit
small boxes filled with such objects as
thimbles, bells, sequins, and cut-up illus-
trations, and throughout the remainder
of his life he created tableaux, arranged
either vertically or horizontally, inside
relatively small boxes. Their meanings
invariably elusive, they usually evoke
moods of nostalgia, reverie, and dream.
Their imagery includes mementos of the
theater and the dance, the world of na-
ture and that of the heavens. Odd juxta-
positions elicit hitherto unsuspected re-
sonances; in isolation, objects create
spaces for daydreaming. Cornell's boxes
also often contain 19th-century memora-
bilia (especially those made during the
1940s, of ballerinas). At the end of the
1940s, Cornell's arrangements grew
more abstract, perhaps in response to the
work of Piet Mondrian, whom he ad-
mired, or, perhaps more likely, because
he used boxes with standardized rectan-
gular compartments. In his work of the
1950s, patterns instead of forms-in-depth
were often stressed.

Cornell painted his boxes—blue repre-
sented night, and yellow or white indi-
cated day. He worked in sets or series,
exploring themes in variation, but not by
serial progression: While reusing illustra-
tive material, he treated the same theme
in a slightly altered context in each box.
Some of these groups are: Soapbubble

Set (c. 1948–50), Multiple Cubes (1946–
48), and Observations, Night Skies, and
Hotels (1950–53). Of the first set, he
said, in partial explanation of all his
work: "Shadow boxes become poetic the-
aters or settings wherein are metamor-
phosed the elements of a childhood pas-
time." The Hirshhorn Mus. owns several
of his works. *Lit.:* Dore Ashton, *A Joseph
Cornell Album*, 1974.

**COVERT, JOHN R.** (1882–1960), a mod-
ernist painter. From Pittsburgh, he stud-
ied in that city before attending the Aka-
demie der Bildenden Künste in Munich
from 1908 to 1912. He continued to
paint in an academic style even while
living in Paris, from 1912 to 1914. Evi-
dently, he first effectively encountered
modern art in New York City, through
his cousin Walter Arensberg, whose cir-
cle included Marcel Duchamp, Francis
Picabia, and their American followers.
Between 1915 and 1918, Covert was es-
pecially close to Duchamp and helped
form the Soc. of Independent Artists in
1916. By that year, Covert's style had
begun to include Cubist elements, ma-
chine forms as well as lettering and col-
lage. Covert felt no attraction to the na-
ture-oriented artists associated with
ALFRED STIEGLITZ; he worked with word
games, puns, and other intellectual de-
vices based on the Cubist and Dada syn-
taxes. Due to lack of personal recogni-
tion, the breakup of the Arensberg
circle, and the absence of any vital mod-
ern movement after World War I, Co-
vert abandoned art in 1923. Several of
his works are owned by Yale Univ. *Lit.:*
Michael Klein, *John Covert*, 1976.

**COX, KENYON** (1856–1919), a leading
academician and mural painter at the
turn of the century. From Warren, Ohio,
Cox studied in Paris with C. E. A. Caro-
lus-Duran in 1877 and with Jean-Léon
Gérôme from about 1878 to 1882. It was
Gérôme's solid modeling and sharp, pre-
cise linearism that later dominated Cox's
art. His chief interest was in beautifully
rendered, academically correct figural

compositions centered on the female nude and inspired by the popularity of such subjects at the Paris salons. Good examples of such work are *An Eclogue* (1890, NCFA) and *A Blonde* (1891, NAD). The American public found the sensual qualities of such works disturbing, and Cox, receiving little appreciation, turned to magazine illustration for a living. As a result of the new impetus given to American mural painting by the WORLD'S COLUMBIAN EXPOSITION in Chicago in 1893, Cox was eventually able to apply his methods to the creation of monumental allegorical murals. Some examples are: *Venice* (1894), a lunette at Bowdoin Coll.; *The Reign of Law* (1898), in the Appellate Courthouse, New York City; and *The Judicial Virtues* (1908), in the Luzerne County Courthouse, Wilkes-Barre, Pa. For such works, Cox chose the relatively flat and decorative style of mural painting associated with the French artist Pierre Puvis de Chavannes and he, too, preferred simplified contours, light tonality, and the generalized rendering of classically derived figures. Cox was a constant defender of traditional values in painting. His views were expressed in many magazine articles and, especially, in his books: *Old Masters and New* (1905); *Painters and Sculptors* (1907); *The Classic Point of View* (1911); *Artist and Public* (1914); *Concerning Painting* (1917).

CRAWFORD, RALSTON (b. 1906), a painter, photographer, and lithographer. Born in St. Catharines, Ont., Canada, Crawford lived in Buffalo between 1910 and 1926. He studied at the Otis Art Inst., Los Angeles, and worked at the Walt Disney studio before attending PAFA from 1927 to 1930 and the Académie Colarossi and Académie Scandinave, in Paris, from 1932 to 1933. The photographs of New Orleans he took in 1937–38 were his first sustained work in that medium. During a trip abroad in 1951–52, he worked intensively in lithography, again in Paris. Associated with PRECISIONISM during the 1930s, Crawford painted the ascetic, depopulated industrial scenes that were characteristic of the group, and, toward the end of the decade, his work grew increasingly abstract. His forms were cropped, as if in a photograph, and his tilted perspectives could be read as flattened planes. Typical of his work of this period is the often-reproduced *Grain Elevators from the Bridge* (1942, WMAA). During the 1940s, abstraction dominated Crawford's vision, although odd, readable notations of weather occasionally appeared in his pictures, perhaps in conscious or unconscious reference to his wartime assignment preparing weather charts for pilots. *Lit.:* Richard Freeman, *Ralston Crawford*, exhib. cat., Univ. of Alabama, 1953.

CRAWFORD, THOMAS (1813–1857), one of the leading neoclassical sculptors. Born in New York City, Crawford began his career there working for JOHN FRAZEE and Robert E. Launitz. Although Crawford must have derived inspiration from Frazee, who was one of America's first artists to work successfully in the grand tradition, it was Launitz who gave Crawford an introduction to his own teacher, the famous Danish sculptor Bertel Thorwaldsen. Thorwaldsen was the foremost sculptor in Europe at the time, the most prominent exponent of the neoclassical aesthetic then working in Rome. Crawford was Thorwaldsen's only American pupil. In 1835 Crawford became the first American sculptor to settle in the Eternal City, and he remained there, except for visits to his native land, until his death. Initially, Crawford received commissions only for portrait busts, but he also attempted more challenging, ideal subject matter. His first major neoclassical conception, *Orpheus* (1839–43, Boston Athenaeum), was seen in plaster by young Charles Sumner, who persuaded a group of connoisseurs to raise funds to have it put into marble and then acquire it for the Boston Athenaeum. So successful was *Orpheus* in its combination of lofty theme and purity

of revived classical aesthetic, that Crawford was honored by a small sculpture exhibition at the Athenaeum upon its installation, the first one-man exhibition of the work of an American sculptor.

*Orpheus* brought Crawford fame equal to that of his famous contemporaries working in Florence HORATIO GREENOUGH and HIRAM POWERS. It also brought him many commissions, not only for the bread-and-butter work of portraiture but for ideal sculptures as well. Some of these are attractive "fancy pieces" depicting semi-idealized children and often involving musical themes, as, for example, *The Genius of Mirth* (1843, MMA). Others, such as *Adam and Eve* (c. 1853, Boston Athenaeum), are more noble in conception, and there are works with classical themes, too, such as *Flora* (1853, Newark Mus.). Some of his pieces (*Flora* is one), heralded the virtuoso carving, deep undercutting, and suggestion of baroque movement of the next generation of neoclassical sculptures, wherein the aesthetic belies the initial neoclassical inspiration.

Crawford's willingness to enter into competitions, coupled with an easy acquiescence to the dictates of his patrons, led him to become a prolific sculptor of public monuments. One such work was the bronze *Beethoven* (1853–55) for Boston's Acad. of Music, a work cast at the royal foundry in Munich; Crawford was the most Germanophile of all American sculptors and a close friend of the favorite sculptor of Ludwig of Bavaria, Ludwig von Schwanthaler. Crawford's governmental commissions began with an award in 1850 for an equestrian *Washington* for the State of Virginia, considered to be the earliest artistically successful commission for an equestrian sculpture by an American artist. (It, too, was cast in Munich, and now stands in Richmond.) His most elaborate work was *The Progress of American Civilization* (1853–63), the pediment sculpture for the Senate Wing of the U.S. Capitol, Washington, D.C., which contrasts the civilization of the white man with the dying way of life of the American Indian. Crawford also designed the bronze doors for the Senate (1855) and the colossal bronze statue of Armed Liberty (1855–62) atop the dome of the Capitol, probably inspired by Schwanthaler's great *Bavaria*, in Munich. Crawford died tragically at an early age, and much of his work had to be completed by his American colleagues in Rome, under the supervision of his widow. Subsequently, his studio casts were placed on exhibition in a New York Armory, a collection designed to become the nucleus for a museum in the city but most unfortunately destroyed in a fire. *Lit.*: Robert L. Gale, *Thomas Crawford, American Sculptor*, 1964.

CROPSEY, JASPER F. (1823–1900), called "America's painter of autumn." From Staten Island, N.Y., Cropsey showed an early interest in architecture and from 1837 to 1842 was apprenticed to the architectural firm of Joseph Trench, in New York City. He painted in his spare time and was encouraged by WILLIAM SIDNEY MOUNT, HENRY INMAN, and WILLIAM RANNEY. In 1843 he turned to painting full time, exhibiting his first work, *Italian Composition*, a landscape, at NAD. From 1847 to 1849, he made the grand tour of Europe, on occasion in the company of THOMAS HICKS (with whom he later shared a studio), WILLIAM WETMORE STORY, and the writer G. W. Curtis. From 1849 to 1855, he taught in New York City and took sketching trips to the White Mountains and areas around Greenwood Lake, N.J. He returned in 1856 to London, where his paintings were appreciated. Cropsey's services to Queen Victoria as an American commissioner for the London Exposition of 1862 earned him a medal. His friends at this time included the critic John Ruskin, Sir Charles Eastlake, and DANIEL HUNTINGTON. He returned to the United States in 1863 and painted a few Civil War studies of soldiers in action. His landscapes of this period reflect a growing concern with LUMINISM, and, in the mid-1860s, a resurgence of interest in architecture prompted him to design

a number of private houses, including "Aladdin," his grand residence in Warwick, N.Y. Among his executed architectural projects, some of the more interesting were his stations of the Sixth Avenue Elevated in New York City. In 1885 Cropsey moved to Hastings-on-Hudson, N.Y., where he lived and worked until his death.

Cropsey's early works were heavily influenced by THOMAS COLE. *Storm in the Wilderness* (1851, Cleveland Mus.) shows the wild, destructive aspects of nature in turmoil; the blasted treetrunk motif is strongly reminiscent of Cole, as is the painterly handling. From Cole, too, came Cropsey's interest in literary and allegorical landscape (*The Days of Elizabeth*, 1853, Corcoran Gall.; *The Millenial Age*, 1854) and, perhaps most important, an interest in serial painting. Cropsey transformed Cole's conception of a Voyage of Life into a kind of Voyage of Nature, emphasizing temporal change and flux through the cyclical movement of the seasons. Cropsey did many paintings of the seasons, in a number of which, typical national or regional geographies are identified with a specific season (*Winter in Switzerland, Spring in England, Summer in Italy,* and *Autumn in America*, 1859–61).

*Autumn on the Hudson* (1860, NGW), a tremendously optimistic landscape in which golden rays filling the scene seem to confer God's blessings on the land, is Cropsey's most ambitious and most famous painting. Exhibited in London a year after FREDERIC EDWIN CHURCH's *Heart of the Andes* (1859), it was enthusiastically received. Perhaps the painting's appeal for the British was due in part to certain similarities, noted by critics, to work by the Pre-Raphaelites; the English movement was then twelve years old but already familiar to American artists through articles in *The Crayon*, the first American art journal (see PRE-RAPHAELITISM, AMERICAN).

Though pictorial visions of America as a new and bountiful Eden tended to decline in number after the Civil War, Cropsey continued to paint landscape in that vein. *Starrucca Viaduct* (1865, Toledo Mus.), with its happy marriage of graceful railroad viaduct and lovely Susquehanna River, is a celebration of both American nature and the progress of American industry. *The Old Red Mill* (1876, Chrysler Mus.), exhibited at the CENTENNIAL EXPOSITION in Philadelphia and popularized through engravings and chromolithographs, is a nostalgic picture of an earlier and simpler way of life. In the 1880s, Cropsey's loosely painted scenes of nature in a more casually rustic mood betray a late interest in French Barbizon painting (see BARBIZON, AMERICAN). A founder of the American Water Color Society in 1866, Cropsey, in his later years, was an active worker in that medium. *Lit.:* William S. Talbot, *Jasper F. Cropsey: 1823–1900,* exhib. cat., NCFA, 1970.

CUMMINGS, THOMAS SEIR (1804–1894), a miniaturist. From Bath, England, he was brought to New York City as a child. In 1824, after receiving some preliminary instruction in New York City, he became a pupil of HENRY INMAN, with whom he established a partnership that lasted from 1824 to 1827. Afterward, Inman largely abandoned the field of miniature to Cummings. Cummings's years of activity lasted until 1851, when he stopped exhibiting. One of the artists locked out of the AMERICAN ACADEMY OF THE FINE ARTS in 1825, Cummings, helped found the NATIONAL ACADEMY OF DESIGN. Active in its affairs until 1865, he wrote the *Historic Annals of the National Academy of Design* (1865). Cummings's style never achieved the freedom of Inman's. His figures look boneless even when he captures the spark of personality in a sitter. Examples of his work are in the MMA and the Brooklyn Mus.

CUNNINGHAM, IMOGEN (1883–1976), a photographer and founding member of the F.64 GROUP. Born in Portland, Oreg., she grew up in Seattle. In 1901, inspired by reproductions of Gertrude Käsebier's work (see PHOTO-SECESSION), she bought a 4-by-5-inch view camera and began a

correspondence course in photography. After studying chemistry at the Univ. of Washington, working for two years in Edward S. Curtis's studio, and attending the Technische Hochschule in Dresden for a year, she opened a portrait studio in Seattle in 1910, which proved very popular. After moving to San Francisco in 1923, she met EDWARD WESTON, who convinced her of the importance of not interfering with the camera's intrinsic ability to record; she then abandoned the pictorial style of Käsebier and became a "straight" photographer. In the mid-1920s, Cunningham began her famous series of plants and flowers, first exhibited at the Film und Foto show in Stuttgart, Germany, in 1929. During her long career, she experimented with many genres of photography, including commercial work for *Vanity Fair* magazine in the 1930s. In the 1960s, she experimented with double-exposure and multiple-printing techniques.

Cunningham's most important work was done in the 1920s and 1930s in experimentation with PAUL STRAND's "pure photographic objectivity." She was involved in the discovery of beautiful forms in nature, as in her extreme close-ups of open flowers (which are comparable to GEORGIA O'KEEFFE's flowers of this period), and, at the same time, in the pictorial creation of pure abstraction, as in her studies of plant forms with shadows and pure white interstices. A brilliant portraitist, she later expanded her subject matter to include people and the environments they have made. Her last work, done as she approached ninety, constitutes an affecting meditation on old age. A collection of her work is in MOMA. *Lit.:* Imogen Cunningham, *Imogen Cunningham: Photographs*, 1970.

CURRIER, JOSEPH FRANK (1843–1909), one of the leading American painters working in the progressive aesthetic of late 19th-century Munich (see MUNICH SCHOOL). From Boston, Mass., Currier left there to study in Antwerp and Paris,

before settling in Munich after the outbreak of the Franco-Prussian War. A student there from 1870 to 1872, he became one of the most notable exponents of Munich realism as taught and practiced by the German artist Wilhelm Leibl, who himself had been tremendously influenced by Gustave Courbet, the great French realist. Leibl and his circle, which included such Americans as FRANK DUVENECK and WILLIAM MERRITT CHASE, idolized the 17th-century Dutch painter Frans Hals; the strong chiaroscuro and slashing brushwork characteristic of their painting come directly from both Hals and Courbet. Currier brought distinctly individual qualities to this new aesthetic with an explosive bravura and a psychological intensity in his portrait and figure pieces; his Barbizon-influenced landscapes and richly painted still lifes are often somewhat more conventional. In 1877 he moved to the Bavarian town of Polling, where he appears to have taken over the leadership of the American art colony in Germany after Duveneck went to Italy and Leibl took up a somewhat more restrained and academic style. Currier returned to Boston in 1898. *Lit.:* Nelson C. White, *The Life and Art of J. Frank Currier*, 1936.

CURRIER & IVES, a highly successful firm of printmakers, active from 1835 to 1907. Nathaniel Currier (1813–1888) was born in Roxbury, Mass. At fifteen he was apprenticed to the Boston, Mass., lithography firm of William S. and John Pendleton. He went from Boston to Philadelphia and then to New York City, where, in 1835, he founded his own company. It became "Currier & Ives" in 1857, when the bookkeeper, James Merritt Ives (1824–1895), himself a skilled lithographer, became a partner. Ives was born and trained in New York City, and his abilities, both artistic and managerial, seem to have been the catalyst for the firm's extraordinary success at mid-century. Sold at prices that ranged from twenty cents to three dollars, Currier &

Ives lithographs thereafter accounted for three-fourths of the American print market, and were also sold abroad.

Although early Currier & Ives prints look like chromolithographs (lithographs printed in colors), in fact, only black ink was used on the stone. After the initial printing process was completed, the scenes were colored by hand. The first true chromolithograph was not produced by the firm until 1889.

One kind of subject matter the firm adopted early and that remained ever popular was the spectacular event. *The Whale Fishery—The Sperm Whale in a Flurry* (published late 1850s), in which a whale is seen upsetting a boat full of sailors, was probably based on paintings by Garneray that had been lauded by no less an authority than Herman Melville. Also in this vein were *The Great Fire at Chicago* (1871) and a series of western and Indian scenes of the 1850s and 1860s based on the paintings of ARTHUR FITZWILLIAM TAIT, in which fur-clad hunters and trappers battle buffalo, bears, and Indians. Also popular were scenes of historical import, such as *The Surrender of General Burgoyne at Saratoga, N.Y., October 17, 1777* and *The Surrender of Lord Cornwallis at Yorktown, Va., October 19, 1781* (both 1852), based on the famous paintings by JOHN TRUMBULL (1824).

Increasingly, however, the popularity of Currier & Ives prints came to be based on homely genre scenes. *Husking* (published 1861), after a painting by EASTMAN JOHNSON, shows an idealized view of rural labor in the interior of a barn as it could only exist in the imagination of an urbanized middle class. Sporting scenes became a staple product of the workshop; a particularly engaging example is *Our National Game, Brooklyn Atlantics vs. New York Mutuals at Elysian Fields, Hoboken, August 26, 1865.* Among the most striking are views of sailing and steamboating, such as *Midnight Race on the Mississippi* (1860) where two majestic side-wheelers churn along the glistening, moonlit river.

Of the firm's staff artists, some, like Charles Parsons and FANNY PALMER, occasionally signed their work, whereas others labored in obscurity. Parsons drew the ambitious composition *Central Park, Winter—The Skating Pond,* (1862) a quintessential Currier & Ives work, full of anecdote and good cheer, in which a growing and prosperous America was shown an unclouded image of itself.

In 1907, its handicraft methods outmoded and its founders long gone, the firm closed, having made some seven thousand different prints. Although of varying quality, these prints often made available to a vast public the designs of the major artists of the day. More important, they provided, and still provide, a view of the pleasanter aspect of 19th-century life, which can be seen so comprehensively nowhere else. MCNY owns the largest collection of the firm's prints. *Lit.:* Harry T. Peters, *Currier & Ives: Printmakers to the American People,* 1931.

CURRY, JOHN STEUART (1897–1946), a major painter of the 1930s with THOMAS HART BENTON and GRANT WOOD. Born in Dunavant, Kans., he worked as an illustrator from 1919 until 1926, when he went abroad to study art for a year. After his return, Curry tried to find, in works such as *Baptism in Kansas* (1928, WMAA), American subjects for which no European models were available. His first solo show in New York City in 1930 helped popularize the growing trend toward AMERICAN SCENE PAINTING sparked by the Depression. Curry painted murals for the various FEDERAL ART PROJECTS in the Norwalk, Conn., high-school (1936–37), and in the Department of Justice Building (1936–37) and Department of the Interior Building (1939) in Washington, D.C. His most famous mural, *The Tragic Prelude* (1938–40), is in the Kansas State Capitol, at Topeka. Curry's subject matter was taken from American history, and deals, for the most part, with land settlement and racial justice. Although he celebrated the

land and its beauty, especially that of the Middle West, he was also attracted to such themes of violence as storms and animal fights. Contrary to modernist opinion, he believed that art should grow out of ordinary, daily experiences, that it should be comprehensible, and that it should be motivated by love and affection. He hoped people might understand their world better through art. His special interest, consequently, was the rural middle-western scene, the environment he knew best and visited annually. The Flemish Baroque artist Peter Paul Rubens was his chief stylistic influence. In 1936 he was appointed artist-in-residence at the Agricultural Coll. of the Univ. of Wisconsin, one of the first such appointments in the country. *Lit.:* Laurence Schmeckebier, *John Steuart Curry's Pageant of America*, 1943.

# D

**DADA.** See NEW YORK DADA.

**DALLIN, CYRUS EDWIN** (1861–1944), a specialist in the sculpture of the American Indian. Dallin came from Springville, Utah, and grew up in the West, where he found the subject matter that was to make his reputation. He studied first in Boston, Mass., in 1880, with sculptor Truman Bartlett, and then, in 1889, in Paris, where he began to produce a series of masterful equestrian Indian sculptures. Dallin was one of the most notable late 19th- and early 20th-century artists to devote his talent to producing bronze images of the American Indian, echoing the work of such earlier painters as GEORGE CATLIN, who saw the Indian of their day as a pitiful but appealing remnant of a once-proud and noble race. Dallin brought to his art careful study of physiognomy, anatomy, and costume, but his sense of the inherent dignity of the Indian, combined with a romantic nostalgia and melancholy, kept his sculptures from dry naturalism. His most important works are public monuments in Chicago (*Signal of Peace*, 1890, Lincoln Park), Philadelphia (*Medicine Man*, 1899, Fairmount Park), and Boston (*The Appeal of the Great Spirit*, 1908, MFAB). In 1940 he also created for Boston, where he made his home after returning from Europe, in 1900, a representation of Paul Revere.

**DARLEY, FELIX OCTAVIUS CARR** (1822–1888), the earliest American artist to specialize in illustration. Darley was born in Philadelphia, but most of his professional career after 1848 was spent in New York City. He produced designs for individual prints, for magazines, and for more than two hundred books. His works were reproduced by all the leading graphic techniques—lithography, wood engraving, and steel engraving. Darley's style was characterized by a sharp linearism with a minimal amount of shading. Although this was the result of his use of neoclassical draftsmanship, Darley drew in a free, spontaneous manner and a romantic spirit, invariably capturing the essential point or flavor of the scene to be portrayed. He worked primarily with the pen alone or combined flowing sepia washes with light pencil outlines. His earliest success came with his illustrations for John Frost's *Pictorial History of the United States* (1844), but his best-known illustrations were for Washington Irving's *Sketch Book* (1848) and *Knickerbocker History of New York* (1850). He also illustrated books by James Fenimore Cooper, Henry Wadsworth Longfellow, and Harriet Beecher Stowe, as well as such foreign authors as Charles Dickens. Darley influenced a whole generation of American illustrators. *Lit.:* Theodore Bolton, "The Book Illustrations of F. O. C. Darley," *Proceedings of the American Antiquarian Society* 61, (Apr., 1951).

**DASBURG, ANDREW** (b. 1887), a painter. Dasburg was brought to New York City in 1892 from Paris, where he was born. His development reflects the artistic life of both cities, as well as that of Woodstock, N.Y., where he lived and worked intermittently after 1902, and that of Taos, N. Mex., which he visited repeatedly after 1916 and settled in in 1930 (see TAOS COLONY). He studied with KENYON COX at ASL in 1902 and with ROBERT HENRI and Birge Harrison, before visiting France in 1909–10. Discovering modernism there, he was influenced strongly and permanently by Paul Cézanne. Between 1912 and 1916, Dasburg explored nonobjective modes and also experimented with SYNCHROMISM. His work was shown at the Forum Exhibition in 1916 (see INDEPENDENT EXHIBI-

TIONS). After 1916 his style was consistently Cézannesque, regardless of subject matter. Following a nearly fatal illness, which prevented him from painting between 1935 and 1946, Dasburg developed a brushy style reminiscent of JOHN MARIN's. Dasburg helped bring the native art of the Southwest to greater attention and, while a juror for the Carnegie International Exhibition of Painting in 1927, helped bring to public attention the paintings of JOHN KANE, the primitive artist.

DAVIDSON, JO (1883–1952), a figure sculptor working in bronze. Davidson was born in New York City and studied at ASL in 1899. He first intended to become a doctor and lived for a time with a sister in New Haven, Conn., preparing for medical examinations. However, a friend arranged for Davidson to take free art courses at Yale Univ., and he became interested in modelling. From 1901 to 1904, he was studio assistant to the sculptor Herman MacNeil; he executed his first independent commission the following year. In 1907 Davidson visited Paris and studied briefly at EBA. Thereafter, aside from periodic trips back to the United States, Davidson continued to live in France, where he died.

Davidson's first one-man show was held in New York in 1910, and it won him considerable fame as a portrait sculptor, both here and abroad. Davidson's prolific output included statues of many noted political, military, and cultural figures of the day, including President Wilson and General Pershing. One of his best-known works is a bronze portrait of Gertrude Stein (1920, WMAA), which depicts the author-patron seated Buddhalike in a compact, rounded pose that stresses the solid quality of her form. Lit.: Jo Davidson, Between Sittings, 1951.

DAVIES, ARTHUR B. (1862–1928), a painter and printmaker, and principal organizer of the ARMORY SHOW. Born in Utica, N.Y., he studied briefly with Dwight Williams about 1877, before attending the Chicago Acad. of Design, in 1878. Not yet committed to a career as an artist, he worked in Mexico as a civil-engineering draftsman from 1880 to 1882. After returning to Chicago, he studied briefly at AIC before moving, in 1886, to New York City where, for the next two years, he studied at ASL and the Gotham Art Students. He traveled abroad in 1893. In 1895 he took up lithography (the majority of his prints were made after 1913, however). He experimented with different techniques and media, including wax and fresco, and, interested in theories about Greek art, created a number of drawings with white chalk on black paper. An artist whose career was fraught with contradictions, he exhibited with The EIGHT in New York City in 1908, although he was not a realist and, as president of the Assoc. of American Painters and Sculptors from 1911 to 1913, he was instrumental in creating the Armory Show, even though he was not a modernist. In 1924 he painted murals for International House, New York City, and from 1925 until his death, he designed tapestries, which were woven at the Gobelin works, in France.

Despite his familiarity with contemporary realistic and modernist trends, Davies remained largely untouched by modern taste. His figures inhabit an Edenic world, free of contemporary worries. They often stroll or disport themselves in pastoral settings, clothed or unclothed, and occasionally act out mythical and allegorical fantasies. Davies included many children in his works, as if to draw parallels between childish innocence and the purity of the landscape. In a few of his earliest works, Davies emphasized linear contours, but he preferred to model his figures softly, giving them a boneless fragility. Landscapes are hazy and indistinct, in the manner of ALBERT PINKHAM RYDER or ALEXANDER WYANT, with whose poetic reveries Davies's works share spiritual resonances. Davies's work also reveals the influence of European artists as varied as Giorgione, Pierre Puvis de Chavannes, and Arnold Böcklin. Perhaps as a

result of a trip to the West in 1905, Davies substituted deeper spaces for his earlier claustrophobic surfaces, allowing his dreamy figures more space to pursue their vaporous pleasures. From this period date his best works, among them, *Unicorns* (1906, MMA) and *Crescendo* (1910, WMAA). After the Armory Show in 1913, Davies adopted a Cubist style. Although his figures were still brought to life within long, sinuous arabesques, their internal forms were re-created by faceted, overlapping planes. His subject matter remained the same, however: In *Day of Good Fortune* (1916, Detroit Inst.), for example, nude forms still dance across the picture's surface. By the early 1920s, Davies reverted to his earlier manner but retained a heightened awareness of two-dimensional pattern. Because of his interest in ancient art, the influence of Pompeian frescoes is also evident in his later work. Just before his death abroad, he painted a number of diaphanous landscapes of the French and Italian countryside.

DAVIS, GENE (b. 1920), a painter born in Washington, D.C., and associated with the Washington Color Painters (among them, MORRIS LOUIS and KENNETH NOLAND). Self-taught, Davis decided to become a painter in the 1950s. After experimenting with ABSTRACT EXPRESSIONISM, neo-Dada and proto-Pop styles and motifs, he made his first edge-to-edge painting of vertical stripes in 1958. The following year he may have been the first American painter to use hard-edged stripes in which no vestiges of painterliness remained. Since that time, he has painted only stripes in wide or narrow formats. Actually screens of color, they do not follow a preexisting chromatic scale. However, unlike FRANK STELLA's work of the early 1960s, Davis's stripes posit clear figure-ground configurations as certain stripes pull forward and others recede, depending upon their intensity of hue and width (*Red Screamer*, 1968, Des Moines Art Center). *Lit*: Gerald Nordlund, *Gene Davis*, exhib. cat., San Francisco Mus., 1968.

DAVIS, RONALD (b. 1937), a painter. Born in Santa Monica, Calif., Davis studied at the San Francisco Art Inst. from 1960 to 1964, and the influence of CLYFFORD STILL, who had taught there in the 1940s, can be seen in the jagged, thickly painted forms of his early work. However, by 1964 his paintings had assumed the geometrical qualities that have engaged the artist to the present day. Moving from brightly colored, complex configurations that resemble the products of Op Art (see MINIMAL ART), Davis simplified his images in 1964–65 and at the same time complicated the shape of the support, by choosing irregular and diagonally skewed canvases, sometimes in two parts. These works suggested shifting, interlocking planes and perspective illusions—which were to become explicit in his best-known series of paintings, made from 1966 to 1972 (an early example, *Two Ninths Grey*, of 1966 is in WMAA). Davis attained a compelling illusion of deep space by constructing these paintings out of multiple layers of polyester resin and fiberglass. On a waxed Formica table, polyester resin colored with strong toners was poured and brushed into taped-off areas. As each resin area hardened, the process was repeated until the desired image was achieved. The creation of *actual* color planes, with the layers first applied being closest to the viewer when the completed work was peeled from the Formica, allows a reading reaching far back in three dimensions. The irregular formats of Davis's resin paintings include fenced-in or divided rectangles, dodecahedrons, "folded" planes, cutaway, ashtray-like shapes, and other oddities of "solid" geometry. The careful perspective planning of internal divisions (for example, planar "spokes" of a wheel shape) are heightened in their illusory depth by the translucence of the thin layers of resin. In 1973 Davis returned to the medium of acrylic on canvas, for reasons of health as well as aesthetics. In the mid-1970s, his paintings were of large beams, blocks, planar arches, and fanned-out planes, which cast

shadows, float in an indeterminate space agitated by stains and vigorous splashes of pigment, and are transversed by multitudes of perspectival lines. In a more traditional medium, Davis maintains his interest in relating surface design to three-dimensional forms. *Lit.*: Charles Kessler, *Ronald Davis: Paintings, 1962–1976*, exhib. cat., Oakland, Mus., 1976.

DAVIS, STUART (1894–1964), one of the major painters of the first half of the 20th century, whose style developed with remarkable consistency yet reflected a variety of American and European attitudes and ideas. Born in Philadelphia, Davis was the child of artistic parents. His father, as art editor of the *Philadelphia Press*, knew ROBERT HENRI and other artist-reporters associated with Henri. Davis, maturing as a painter within this realist environment, studied with Henri in New York City from 1910 to 1913. He was also associated, from 1913 to 1916, with JOHN SLOAN on the left-wing journal *Masses* as a cartoonist and illustrator. However, the ARMORY SHOW, which Davis called the greatest single influence on his work, dissuaded him from pursuing a realist style. Impressed by the nonimitative colors and generalizations of form in the paintings he saw there, Davis resolved to become a modernist. For the remainder of the decade, he experimented variously with the kind of intensities of color found in the work of Vincent Van Gogh and with the flattened planes of Cubism. In 1918 he painted the still-realistic *Multiple Views*, in which different scenes, each equally emphasized, were placed in rows; shifting subjects, times, and moods were to be a feature of Davis's later work. Other harbingers of his mature style appear in this picture: signs, letters, and common objects found in the American environment.

About 1920, as many modernists began to explore the alternatives of realism, Davis's interest in modernist theories and styles intensified. In his writings, he said that subject matter was secondary to the internal logic of form and color relationships and paint must be his primary medium of expression, never subordinated to the demands of picture making. Although he painted recognizable images, he insisted that his pictures reveal a life of their own rather than mirror reality. To this end, Davis struck out in a number of directions. He painted imitation collages, as in *Lucky Strike* (1921, MOMA); he simplified and geometricized forms, as in *Odol* (1924), a portrait of a bottle of a popular mouthwash; and he reduced traditional landscape scenes to sequences of hard-edged, unmodulated forms. To emphasize pictorial two-dimensionality instead of realistic three-dimensionality, he preferred, as he said, "head-on" views rather than diagonal recessions in space. Consequently, his forms were characteristically frontal and flattened as well as pushed up against the picture plane.

In 1927, as the realistic movement was gaining momentum, Davis painted his first entirely abstract works, the Eggbeater series, based on the shapes of an eggbeater, a fan, and a pair of rubber gloves (examples in Phillips Coll. and WMAA). Composed of solid planes and wiry linear elements, these pictures recall the works Francis Picabia did in America in 1913, as well as contemporary paintings by Precisionists CHARLES DEMUTH and NILES SPENCER. They also reflect the use of unconventional materials as subject matter by Dada artists (see NEW YORK DADA). A trip to Paris in 1928 cooled Davis's interest in abstract art for a time. In the New York-Paris series (examples in Newark Mus. and WMAA), he painted uninhabited but charming city views of cafes and poster-flat buildings. After his return, he said that even though he liked Paris he preferred the "impersonal dynamics of New York City," and it was in the visual and kinetic rhythms of America that he reconciled his interest in abstract art and the American scene. Throughout the 1930s, he found subject matter in virtually every aspect of the American landscape, from the sea to the mountains, including gasoline stations, electric signs, and mo-

tion pictures. He felt that modern America had been deeply affected by radio, telephone, telegraph, and airplane, looking toward a mechanized future rather than to a cherished past, and he tried to create a pictorial language that would express the quickened pulse of life. Although Picassoesque images occasionally appeared in his work, he usually substituted American forms for the classic Cubist ones. Davis's art was less retrospective than THOMAS HART BENTON's, but he was as concerned with creating a representatively American style. Nevertheless, Davis always maintained that the social content of art was not the customs of a country at a particular time and place, but rather art itself. As he said, "The act of painting is not a duplication of experience, but the extension of experience on the plane of formal invention."

During the 1930s, Davis began to bring minor details to the same degree of amplification as major elements. In *Report from Rockport* (1940), all forms are recorded with equal energy and clarity—letters, lines, objects and abstract shapes—as if in pursuit of a country-and-western version of a Joan Miró painting. Davis's concern for "all-over" effects perhaps led him to experiment increasingly with nonobjective forms after 1940. In their compositional openness, such paintings as *Ultramarine* (1943, PAFA) are related to panoramic HUDSON RIVER SCHOOL works as well as to ABSTRACT EXPRESSIONISM. During these years, in which he emphasized, as he said, "color-space relationships," he half-mockingly referred to many of his paintings as examples of colonial Cubism (a painting of that name, dated 1954, is in the Walker Art Center). Synthetic Cubist in origin, these works are composed of taut, brightly colored shapes simulating paper cutouts.

Politically and artistically active in the cause of FEDERAL ART PROJECTS, Davis worked for WPA-FAP from 1935 to 1940, completing murals at, among other places, Indiana Univ. (1938) and radio station WNYC, New York City (1939).

He was active in the Artists Union and contributed to its journal, *Art Front*. He also served as national secretary and national chairman of the AMERICAN ARTISTS CONGRESS from 1936 to 1940. Yet he did not allow his political beliefs to dictate his aesthetic concerns, and he even criticized left-leaning artists for their propagandistic paintings.

Although his work contains pictorial elements like those of Europeans as diverse as Giorgio de Chirico, Pablo Picasso, Miró, and Fernand Léger, Davis's interpretations lack pictorial refinement and finish in the European sense. In response to a critic's comment about 1930 that his work was too European, he acknowledged such influences but insisted that he used them with a clear American accent. And though his reliance upon American imagery connects his work with AMERICAN SCENE PAINTING, he avoided its often parochial modes. Davis is, therefore, one of the very few artists whose works can be considered both consistently American and modern. Davis's papers, including some twenty thousand pages of articles, letters, and notes, are in the Fogg Mus. *Lit.*:John Lane, *Stuart Davis: Art and Art Theory*, exhib. cat., Brooklyn Mus., 1978.

**DAWSON, MANIERRE** (1887–1969), a painter. From Chicago, he trained as a civil engineer before joining the architectural firm of Holabird and Roche in 1909. Interested in painting, he wrote in his journal as early as 1908 that he understood the relationships between painting and music and that forms might be derived from feelings rather than from nature. He claimed to have been influenced by Cézanne by 1909 and may have made nonobjective works in 1910, remarkably early for an American. He travelled abroad that year and met Gertrude Stein, who purchased one of his pictures. After returning to Chicago, he devoted his energies to painting and, in 1913, to sculpture, abandoning architecture in 1914. His figural studies of this period oscillated between Cubist and Futurist styles. He exhibited a non-

objective work in the ARMORY SHOW when it opened in Chicago in 1913. Walter Pach, the artist-critic, met him there and included his work in an early all-American modernist show in New York City in 1914 called The Fourteen. Dawson's precocious development appears to have taken place relatively independently of activities in New York City. He abandoned art shortly after 1914 for financial reasons. *Lit.*: Mary Aedo, *Manierre Dawson*, exhib. cat., Mus. of Contemporary Art, Chicago, 1977.

**DEAS, CHARLES** (1818–1867), a painter of melodramatic western scenes. Deas studied in New York City in the mid-1830s, painting genre pictures at a time when scenes of everyday life were first beginning to command public attention and patronage. In 1840 he went west to visit his brother, and this led Deas to the subject matter upon which his subsequent reputation was based. He settled in St. Louis, Mo., soon after. Deas's western subjects were unique for their time. He was interested neither in the manners and appearance of the American Indian, as was GEORGE CATLIN, nor in the everyday life of the trapper and guide, as was WILLIAM RANNEY. Deas was an artist in the full romantic vein, revelling in scenes of prowess, danger, and death. His situations are exaggerated, and movement is emphasized in such typically rousing works as *The Prairie Fire* (1847, Brooklyn Mus.) and *The Voyageurs* (1846, MFAB). His masterpiece is *The Death Struggle* (1845, Shelburne Mus., Shelburne, Vt.), a horrific depiction of a trapper and an Indian, both on horseback, engaged in mortal combat as they plunge over the edge of a cliff to certain death. All the forms in the picture twist and writhe, as solid ground gives way to a sudden void at the left; the faces are wildly contorted. Such pictures were meant to titillate the growing curiosity of eastern audiences about this exotic, dangerous, and unknown America. At the same time, Deas suggests a knowledge of more traditional art; *The*

*Death Struggle* bears close resemblance, for instance, to European representations of the story of Marcus Curtius. The irrationality of Deas's art suggests a possible psychological imbalance; indeed, a few years after his return to New York in 1847, Deas was permanently confined in an asylum. *Lit.*: John McDermott, "Charles Deas: Painter of the Frontier," *Art Quarterly*, Aug., 1950.

**DE CAMP, JOSEPH RODEFER** (1858–1923), a painter and a member of the group called TEN AMERICAN PAINTERS. From Cincinnati, he studied at the Cincinnati School of Design and then in 1875 with FRANK DUVENECK in Munich, where he remained until 1880. He settled in Boston, Mass., after returning to America. Primarily a portraitist and figure painter, he developed a sober and muted palette as well as an interest in detail despite his Munich training with its emphasis on dynamic brushwork (see MUNICH SCHOOL). He received several commissions for society portraits. His figural studies include *The Guitar Player* (1908, MFAB). The landscapes, looser in style and closer to Impressionism in their lighter and brushier surfaces, are nevertheless informed by De Camp's fundamental conservatism (*The Little Hotel*, 1903, PAFA). *Lit.*: Patricia Jobe Pierce, *The Ten*, 1976.

**DECKER, JOSEPH** (1853–1924), a still-life specialist. Decker came to America from Würtemberg, Germany, in 1867, though like many Americans of his age, he studied in Munich, in the 1880s (see MUNICH SCHOOL). His professional life was spent primarily in Brooklyn, N.Y., where he enjoyed the patronage of one of the leading collectors of contemporary American art, Thomas B. Clarke. Decker painted a number of genre pictures of urchins in the 1880s and some landscapes in the following decade, but he is primarily known for his fruit still lifes. These fall into two very distinct groups. Those of the 1880s, relatively few in number, are extremely hard-edged. Some are tabletop compositions

and some are of fruit-laden tree branches, but they are all very sharply detailed and outlined, often heavily packed and cropped at the edges in a manner to suggest the influence of photography. Decker's technique was sometimes admired by the critics, but they universally complained of the hardness and unripeness of his subjects, and in the following decade his style changed abruptly, becoming a poetic, soft-focused treatment of fruit and nut subjects, the latter sometimes combined with equally soft and fuzzily painted squirrels. These softly modulated and illuminated compositions suggest not only Decker's reaction to the harsh criticism he had received but also a response in still life to the landscape art of his good friend and colleague GEORGE INNESS. They also suggest Decker's important place in the revival of interest in the work of the French still-life specialist of the 18th century Jean Baptiste Siméon Chardin.

DE CREEFT, JOSÉ (b. 1884), a sculptor, from Guadalajara, Spain. Interested in sculpture as a child, De Creeft made and sold works in the streets as a teenager. Before leaving for Paris in 1905 to study further, he was apprenticed, in 1895, to a maker of religious images; in 1898 to the firm of Masriera and Campin; and in 1900 to the government's official sculptor, Don Augustin Querol. De Creeft studied at the Académie Julian, in Paris, and in 1911 attended the Maison Greber to learn to reproduce in stone works initially made in clay and plaster. Feeling constrained by the techniques he had learned, he turned to direct carving in 1915 and had completed both wood and stone pieces within a year. Respected in academic circles, De Creeft was commissioned in 1918 to sculpt a granite war memorial in Saugues (Puy de Dôme) entitled Le Poilu. In 1925, and for a short time after, he experimented with assemblage techniques, but De Creeft remained a carver. In 1927–29 he created two hundred stone carvings for Roberto Romonje's Forteleza in Majorca. After emigrating to America in 1929, he

helped popularize both direct-carving methods and, beginning the following year, the use of ball-peen hammers to make three-dimensional forms from lead sheets (Les Deux Amis, 1941, Norton Gall., and School of Art, West Palm Beach, Fla.). In styles ranging from art moderne to expressionism, he projected an opulence of gesture. He once said "Sculpture is the creation of three-dimensional form in space. In my opinion, the most fundamental principle required to obtain that end is the use of massive volume and contour. I cannot believe that sculpture is a mechanical toy, a feat of engineering, or a series of spaces in material." In 1951 he sculpted the Poet for Philadelphia's Fairmount Park Assoc. Lit.: Jules Campos, The Sculpture of José De Creeft, 1972.

DE KOONING, WILLEM (b. 1904), a major Abstract Expressionist painter and, with JACKSON POLLOCK, principal exponent of a spontaneous, gestural mode of attack (see ABSTRACT EXPRESSIONISM). Born in Rotterdam, the Netherlands, he was apprenticed in 1916 in a commercial art firm. From that year until 1924, he attended evening classes at the Rotterdam Academie voor Beeldende Kunsten en Technische Wetenschappen. After emigrating to America in 1926, he worked for WPA-FAP in 1935 and, though his first solo exhibition was not held until 1948, he was an acknowledged major avant-garde figure by the mid-1940s. Perhaps the dominant American artist of the 1950s, whose style and approach were imitated across the country, he assumed a senior statesman's role toward the end of the decade, becoming an important but no longer significant artist. At least two conclusions may be drawn from this: First, his work suffered an absolute loss of quality (some have argued that his peak period lasted from c. 1946 to c. 1950); second, avant-garde taste is so changeable and superficial that an artist cannot cultivate, refine, or perfect an existing style for more than a few seasons before he must discard it or be himself discarded.

During the 1930s and early 1940s, de Kooning concentrated on three major themes—men, women, and abstractions (only the two latter were continued into subsequent decades). Few of these early works were completed. They seem to have been abandoned at a moment deemed appropriate by the artist, an early indication of his later open dialogue with the forms he was creating. Here, as in virtually all of his work, the revelation of process and of the history of making the piece are as important as the abandoned or final statement itself. De Kooning's abstractions of this period, which, on occasion, have suggested seaside reminiscences, tended to be composed of flattened biomorphic forms or, perhaps, cross sections of such forms that lay in indeterminate spaces on or behind the picture surface (*Elegy*, c. 1939, Norton Simon Mus.). Although these works are descended from images by Joan Miró and Jean Arp, their quality of finish remained rough and their edges often ragged. Unlike similar forms by ARSHILE GORKY, these convey no biological or mysterious messages. De Kooning's images of men are also located in nonenvironmental space. At times, parts of a body were left out and successive refinishings were allowed to remain visible. These factors contributed to their often-haunted presences.

His studies of women date from the very end of the 1930s. Initially, their heads were realistically done, but by the early 1940s their forms became intermingled with sections of background color. The intensity of pigment and the insistent shapes of the ground diffuse attention from the figures. Furthermore, definition of body parts, as in *Queen of Hearts* (1943–46, Hirshhorn Mus.) broke down, and often the colors defining a shape (an upper arm, for example) were blended into the immediately adjacent area. In these works, de Kooning was already rejecting the notion of the well-made picture. Through the mid-1940s, all of his paintings grew more violent, and accident increasingly played a role in determining composition. Superim-

posed sheets of paper served as models for works that reflected clearly their origins in collage. In a group of black-and-white paintings begun in 1946, it was as if all restraint had been abandoned in the quick markings, jagged and torn forms, splashes, and splatters. In some, the black acted as background color; in others, the white. Often effects were purposely left ambiguous so that space remained indeterminate but still within a loosened Cubist framework (*Painting*, 1948, MOMA). Throughout the series, velocity, occasionally around a central eye-catching form, remained the organizing constant. Evidently, de Kooning's European training did not allow him to forsake a compositional axis typically omitted from paintings of other Abstract Expressionists. Perhaps the masterpiece of this period is *Excavation* (1950, AIC), in which traces of other colors also appear.

Although recognizable subject matter fell into disfavor among his peers, de Kooning used the theme of woman after 1950 and has worked with it ever since (along with abstractions). Speaking of his choice of subject, he has said that it is absurd to paint a human image but just as absurd not to do so. At the same time, he has also remarked, "I am always in the picture somewhere." This statement may reflect the characteristic viewpoint of the existentialist generation for whom each confrontation with a new color or form called for a new response and a new act. It may also simply refer to different interpretations of the subject that crossed his mind (woman as mother, as destroyer, as pinup). In any event, de Kooning's images always lack fixity. The many sliding combinations of forms suggest a multiplicity of experiences and ever-new possibilities of choice—never fixed perimeters for activity. In the 1960s and 1970s, the colors and forms of de Kooning's women grew more rococo in feeling, but the same bold attack remained evident.

De Kooning also continued to paint abstractions through the 1950s. They are rich in color, heavy with texture, and

crammed with visual incident. About 1957 he allowed forms to grow larger and fewer, his color becoming sweetened and possibly evocative of landscape tones. In some works, the forms appear to be magnified details from earlier paintings, as in *Door to the River* (1960, WMAA). Although de Kooning clearly created these works by swift gestures of hand and decisions of mind, he did not establish patterns of velocity as did the Futurists, and as did Jackson Pollock in his drip paintings. Instead, he seemed to be rapidly isolating random areas of much larger, unseen works. Yet these paintings are invariably balanced—the drips, scratches, and smudges accidentally but felicitously placed—indicating his underlying intellectual control of what might have been a style given over to abandon. His many followers did not always understand the necessity of finding the balance between willfulness and recklessness, and, consequently, his style seemed easily imitated. In fact, it became debased in the hands of others and led, in the 1960s, to the general rejection of gesture painting. *Lit.:* Thomas B. Hess, *Willem de Kooning*, 1968.

DELANOY, ABRAHAM (1742–1795), a portrait painter. Delanoy was born in New York City and was the second American to go to London to study with BENJAMIN WEST. He may be one of the young men who figure in *The American School* (1765), a painting by MATTHEW PRATT of West and his pupils. In London under West's tutelage, Delanoy doubtless enjoyed superior advantages, and the prospects for a career in America were good. Certainly an early likeness of his teacher (in NYHS), though masklike in expression, reveals basic sophistications in its conscious, though not harsh, modelling and gracious turn of the head. Once back in the colonies, in 1767, however, Delanoy reverted to a more linear, primitive style, though he appears to have enjoyed some success at first, painting members of New York's Beekman family. He soon took the road of the itinerant artist, painting in Charleston, S.C.

and in the West Indies, where he may have gone for his health. He was back in New York by 1771, but he fell increasingly out of the mainstream, turning finally to sign painting. What little is known of his later art suggests a dependence upon traditions established by other, more talented artists: JOHN SINGLETON COPLEY, GILBERT STUART, and even RALPH EARL. He spent the last years of his life in New Haven, Conn.

DEMUTH, CHARLES (1883–1935), a major exponent of PRECISIONISM, who also painted in more poetic modes. From Lancaster, Pa., he never renounced his close association with his hometown despite his firsthand knowledge of the sophisticated art circles in New York City, Provincetown, and Paris. His art reflects his very varied interests. Though neither arcane nor complex, it suggests qualities sometimes more easily felt than described, perhaps because, unlike STUART DAVIS, who was able to combine European styles and American attitudes, Demuth appeared to be an American masquerading as a European or vice-versa.

Demuth first studied art at Philadelphia's Drexel Inst. in 1900. After a trip to Europe in 1904, he enrolled at PAFA, where he, like many of his notable contemporaries, studied under THOMAS ANSHUTZ. He remained there until 1911. In 1907–8 he briefly visited Europe again, spending most of his time in Paris, but it was not until a later visit in 1912–14, when he met Gertrude and Leo Stein and attended the Académie Colarossi and Académie Julian, that he seriously studied modern art. His first essays in modernism, chiefly watercolors, were simplified figure and flower studies, in which delicately toned areas of color often spilled over wiry outlines. Some had abrupt dark-light contrasts, with forms silhouetted against each other. His use of color at this time was usually characterized by constantly shifting, subtly changing tonalities. Even later, when he made his most determinedly Precisionist works, Demuth rarely painted large areas of flat, unmodulated color as did

Precisionists CHARLES SHEELER and NILES SPENCER. In fact, Demuth always maintained a pre-World War I attitude toward color, letting it pulsate and breathe across a picture's surface and, because of its thickened and thinned textures, suggest mysterious recessions. He was among those painters who intuitively know how to manipulate intensities of color to create subtle emotional effects, and this gift of provocative understatement adds to the impact of his watercolor illustrations for books and published plays, including twelve for Emile Zola's *Nana* and one for his *L'Assommoir* (1915–16); five for Henry James's "The Turn of the Screw," nine for Frank Wedekind's *Erdgeist* and *Pandora's Box*, and one for Edgar Allan Poe's "The Masque of the Red Death" (all 1918); and three for James's "The Beast in the Jungle" (1919). For all of these, Demuth seems to have followed James's admonition in the preface to the 1909 edition of *The Golden Bowl* that an illustrator should parallel the thought of the author rather than reproduce scenes already described.

Demuth became an intimate of the avant-garde Arensberg salon after returning to America in 1914 and had met Marcel Duchamp by 1916. He contributed a poem to the second number of Duchamp's *The Blind Man* magazine (May, 1917). Perhaps because of his continued exposure to Parisian styles, Demuth began, in 1916, to experiment with Cubist forms even as he continued to make his semi-expressionist illustrations. His effective commitment to modernism apparently took place during a stay in Bermuda with MARSDEN HARTLEY and, perhaps, Albert Gleizes, the French Cubist who lived in New York City during World War I. As in *The Monument, Bermuda* (1917, Phillips Coll.), the edges of his forms grew taut and rectilinear. Buildings, boats, trees, and even flags cut by Futurist rays are elements in the flattened compositions of this period. These forms were not rent asunder, as in traditional Cubist compositions, but merely became detached, like parts of jigsaw

puzzles, and, always retaining their object identity, were placed within arrangements including parts of other objects. These paintings, unlike Demuth's illustrations, never showed the human figure.

Demuth's first Precisionist paintings may be conveniently dated to 1919. An early example is *Backdrop of East Lynne* (1919, Univ. of Nebraska). In these works, usually considered compromises between European modernism and American realism, Demuth seems to have begun with realistic forms and then arranged them in an abstract format. Thus, he did not compose in the modernist way, keeping in mind the entire field of the painting and the interrelationships of forms, but visualized paintings in the traditional manner, seeing objects placed against a background. Thus, too, in his works one is always aware of spatial recessions. Skies, for instance, are never integral to the abstract composition but invariably remain as background elements. During the 1920s, Demuth's subject matter included the characteristically empty industrial and urban scenes of the Precisionists as well as views of his hometown. These works reflect the general cultural disillusionment of the immediate post-World War I years, when both artists and writers found in the growth of big business and the spread of the cities sources of alienation and isolation. Demuth, an ironist, mocked rather than railed against these forces. His *Incense of a New Church* (1921, Columbus Gall.) is a portrait of factory smokestacks, and *My Egypt* (1927, WMAA) suggests that anonymous grain elevators, not her cultural or historical monuments, are America's true heirlooms.

During the mid-1920s, debilitated by diabetes, Demuth painted many small-scale still lifes and flower studies. Unlike his architectural scenes, these tended toward realism, with only passing references to Cubist form. And, unlike his cool, detached views of buildings, the flowers and fruits in these smaller studies seem overripe and ready to burst. If the

industrial forms suggest the diffidence with which Demuth faced the world, if they represent his public person, then the more intimate studio pieces can be said to reveal the seething, but still disciplined, qualities of temperament that Demuth hid from view. These are private paintings. Between 1924 and 1929, he painted poster portraits of his friends, each one composed of objects that represented aspects of their lives. The best-known of these is *I Saw the Figure Five in Gold* (1928, MMA), based on a poem of the same name by William Carlos Williams, whom Demuth had known since his student days in Philadelphia. From 1930 to 1933, Demuth created another series of industrial paintings. More realistic than those of the previous decade, they exhibit a similar fastidiousness of tone and color.

Evidently aware of the limits of his talent and the reserve with which he held his emotions in check, he once said "John Marin and I drew our inspiration from the same source, French modernism. He brought his up in buckets and spilt much along the way. I dipped mine out with a teaspoon, but I never spilled a drop." Demuth, who worked in oils, tempera, and watercolor, made about 750 paintings and 330 drawings. *Lit.:* Emily Farnham, *Charles Demuth: Behind a Laughing Mask*, 1971.

DEWING, MARIA OAKEY (1845–1927), a flower painter. From New York City, Maria Oakey took up painting in 1862. She studied with JOHN LA FARGE in the 1860s, with WILLIAM RIMMER and Robert Swain Gifford at the Cooper Union School of Design for Women from 1866 to 1871, at the NAD Antique School, New York City, from 1871 to 1875, then briefly with WILLIAM MORRIS HUNT in Boston, Mass., and, in 1876, with Thomas Couture in Paris. Before her marriage to THOMAS WILMER DEWING in 1881, she painted more figure pieces and portraits than still lifes. Afterward, she concentrated on still lifes and flower pieces in indoor and outdoor settings, returning to figure studies after 1900. The primary

influences on her flower pieces were the works of La Farge and of such Japanese artists as Sotatsu, rather than the Impressionists. She often painted close-up views—isolated fragments, really—of gardens. Forms were cropped to suggest their continuation into the viewer's space, and depth was held to a minimum. Although characteristic features of individual flowers were clearly defined, Dewing used a brushy technique and softened edges. In this way, she invoked a gentle, generalized beauty rather than botanical specificity. She preferred using a horizontal format. In addition to painting, Dewing was adept at embroidery, pottery, and tapestry. She also wrote poems and books. Many articles by her appeared in the magazine *Art and Progress*. Examples of her work include *Garden in May* (1895, NCFA) and *Bed of Poppies* (1909, Addison Gall.). *Lit.:* Jennifer Martin, "Portraits of Flowers: The Out-of-Door Still-Life Paintings of Maria Oakey Dewing," *American Art Review*, Dec., 1977.

DEWING, THOMAS WILMER (1851–1938), one of the most sensitive figure painters of the turn of the century. Born in Boston, Mass., Dewing studied in the two major European art centers, Paris (1876 to 1878) and Munich (1878–79). On his return, he became associated with the new progressive art organization in New York City, the Soc. of American Artists (see NATIONAL ACADEMY OF DESIGN) but left it in 1897 to join the TEN AMERICAN PAINTERS. Dewing's earliest pictures are rather hard-edged and mannered—somewhat eccentric representations of women in poetic settings—but gradually his brushwork became softer and his atmospheres exceedingly hazy; he was thus one of the most clear-cut exponents of TONALISM. His range of subject was extremely limited. He painted only women in long, flowing gowns, elegant but exceedingly simple—not classical, but similar to the flowing robes of the ancient world. They appear in soft green fields, usually in groups, or, more often as single figures, in sparse but elegant in-

teriors. Dewing's women tend to be somewhat more mature than the young, virginal females painted by his friend ABBOTT THAYER. Thin and ethereal, and always passive, they bear the stamp of the upper classes. They often sit, engaged in nothing other than reading or playing a musical instrument, and, if the latter, a spinet rather than the more robust piano. Even these occupations really do not seem to absorb them; they are drawn inward and contemplative. Dewing's interiors are usually austere, but what objects and furniture there are are small, fragile, elegant and precious. His colors are restrained but extremely harmonious; indeed, for this if no other reason, Dewing's art seems to descend from the Aestheticism of the English painter Albert Moore. Dewing also painted elegant screens, a popular art and decorative form related to the current interest in things Japanese. Dewing was one of the finest draftsmen of his period, often working in the extremely sensitive medium of silverpoint, or in pastel, producing small, beautiful female heads or refined studies of the female nude. Several of his works are in the Freer Gall. of Art, Washington, D.C. *Lit.:* Patricia Jobe Pierce, *The Ten*, 1976.

**DICKINSON, EDWIN** (1891–1978), a painter. From Seneca Falls, N.Y., he studied at ASL under WILLIAM MERRITT CHASE and with CHARLES W. HAWTHORNE in Provincetown, Mass., between 1910 and 1914, and at the Académie de la Grande Chaumière, Paris, in 1919–20. A brilliant technician, he was able to combine precise realistic effects with Surrealist spaces and to juxtapose disparate objects with elegance by 1916. He might therefore be called a mannered traditionalist. During the 1920s, he created a singular series of imaginative works, some with abrupt foreshortening, in which seemingly random and cluttered objects were combined with body parts, solidly modelled and the flesh tones carefully rendered. *The Fossil Hunters* (1926–28, WMAA) is perhaps the most striking of these. Dickinson often played baroque

effects of light across his forms, creating a heightened sense of mystery and hallucination. Some of his sources are the tales of Edgar Allan Poe and the folklore of the Portuguese and American fishermen on Cape Cod, where he lived after 1913. His most complex work, *Ruin at Daphne* (1943–53, MMA) is filled with perspectival mysteries, strange overlays of form, and meticulous renderings of stones and cornices. Simultaneously, he painted naturalistic Cape Cod scenes, often with a soft-edged focus. His self-portraits are among the most psychologically probing likenesses made in the 20th century. *Lit.:* Lloyd Goodrich, *Edwin Dickinson*, exhib. cat., WMAA, 1966.

**DICKINSON, PRESTON** (1891–1930), a painter associated with PRECISIONISM. Born in New York City, he studied at ASL with ERNEST LAWSON before proceeding to Paris, where he lived from 1915 to 1919. There he developed a Cubist style, which, in the course of the next several years, was modified by the effects of an interest in Cézanne and in Oriental art. Such still lifes of the 1920s as *Still Life with Yellow-Green Chair* (1928, Columbus Gall.) show his return to a more realistic style—yet one still marked by the spatial dislocations and Oriental calligraphy he had earlier used. Dickinson's factory scenes tended to reflect more geometrical solutions, as in *Factory* (1924, Columbus Gall.), where architectural forms were reduced to planar elements. Unlike CHARLES SHEELER, Dickinson left visible his brushstrokes and modulated colors rather than hide either behind a smooth surface finish composed of unmodulated tones. In this regard, his work never became machine-like or industrial in feeling but retained antic elements of touch and personal idiosyncrasy, as did the works of CHARLES DEMUTH.

**DIEBENKORN, RICHARD** (b. 1922), a painter. From Portland, Oreg., he studied at Stanford Univ. and the Univ. of California, Berkeley, between 1940 and 1943, and at CSFA in 1946. Throughout

his professional career, he has been associated with California and, since the 1950s, more specifically with the San Francisco Bay area figurative style, whose other major exponents are DAVID PARK, Elmer Bischoff, and Paul Wonner. Diebenkorn's work has been among the most sensitively finished and psychologically acute of his generation. His earliest works recall the realism of such major figures as EDWARD HOPPER and CHARLES SHEELER. In the late 1940s, responding in part to the presence of CLYFFORD STILL and MARK ROTHKO in the Bay Area, Diebenkorn explored ABSTRACT EXPRESSIONISM in paintings that never quite lost their landscape implications, despite an intelligent grasp of what Still and Rothko were doing with placement and paint surface relationships (Berkeley series). Becoming distrustful of emotionalism and explosive techniques, he had returned to figuration by the mid-1950s. Such works as *Woman in a Window* (1957, AK) combine taut structural arrangements and a sense of pathos reminiscent of Hopper with the rich colors of Fauve painting and the accidental touches of Abstract Expressionism. The tension between depth and surface, between figures and the active paint application suggest an inner space rather than a specific locale occupied by the subjects. About 1967 Diebenkorn began Ocean Park, a continuing series of abstract paintings usually composed of large rectangles surrounded by horizontal and vertical stripes of varying widths. The colors are subtly modulated, and overpainted parts often show through. Depth is minimal, but there is room for breathing and slight tremors. Examples of this series rekindle, within the restricted vocabulary of recent abstractions, the sense of life and fluctuation that such artists as MAX WEBER and JOHN MARIN tried to capture in their younger days. *Lit.*: Linda Cathcart, *Richard Diebenkorn*, exhib. cat., WMAA, 1977.

**DILLER, BURGOYNE** (1906–1965), a painter and sculptor. Born in New York City, he studied at ASL from 1928 to 1932 and with HANS HOFMANN, whose theories of surface tension he applied to his own art. Diller made his first geometrical paintings in 1930 and, in 1933, was probably the first American to embrace fully the rigid formulas of Piet Mondrian's "pure plastic art," which included the use of horizontal and vertical lines as well as primary colors. An example is *Third Theme* (1946–48, WMAA). Diller's first sculptures date from 1934. These also adhere to Mondrian's strictures (*Project for Granite No. 5*, 1963, New Jersey State Mus., Trenton). Though he was a nonobjective painter, Diller became director of the Mural Division of the New York City WPA-FAP, and remained in government service until 1941. In his mature work, he pursued three "themes," which, as he described them in 1961, "had not been developed on a basis of regular progressions from one stage to the next," but were a "tangential development." They included noncontiguous geometrical elements arranged on a plane; elements generated by continuous lines that might touch or cross; and elements submerged in activity, reflecting the kind of busy surface seen in Mondrian's Boogie Woogie pictures. *Lit.*: Philip Larson, *Burgoyne Diller*, exhib. cat., Walker Art Center, 1972.

**DINE, JIM** (b. 1935), a painter and assemblage-maker. From Cincinnati, he studied at that city's art academy. Moving to New York City in 1959, Dine took part in the early development of HAPPENINGS. In the succeeding years, his canvases continued to include such participatory objects as lights that can be turned on and off (*Child's Blue Wall*, 1962, AK) and objects with participatory implications, such as hatchets and saws. Dine was associated with the rise of POP ART, but he has always remained closer to the ambience of Happenings and ASSEMBLAGE than to that movement of the 1960s: His subject matter, which includes personal as well as public images, seems an extension, and perhaps a partial record, of his private life, rather than

a cold reflection of commercial packaging and the communications media.

Like ROBERT RAUSCHENBERG's, Dine's roots as a painter lie in ABSTRACT EXPRESSIONISM, and his finish is brushy and gestural. Like JASPER JOHNS, by whom he was influenced early, Dine works with a Dadaist play of juxtaposed objects (for example, lawnmowers, clothing, fur, and toothbrushes), either attached or adjacent to his fully or partially painted canvases. He often emphasizes these real objects with painted shadows, or by repeating them as painted images, and then reinforces their existence as part of the picture by lettering—which also may describe the character of a work as a whole (*The Toaster*, 1962, WMAA).

Freestanding works have ranged from single objects, such as the aluminum pieces of about 1965, to complex wood, canvas, and metal assemblages (*Horse Piece*, 1968–69). Always a fine draftsman, he has since the mid-1970s increasingly concerned himself more with traditional pictorial problems than with free improvisation and multimedia effects. *Lit.*: John Gordon, *Jim Dine*, exhib. cat., WMAA, 1970.

DI SUVERO, MARK (b. 1933), a sculptor, whose works combine Abstract Expressionist impulses with ASSEMBLAGE techniques. Born in Shanghai, China, where his father, an officer in the Italian navy, was stationed, he came to San Francisco in 1941. After studying art between 1953 and 1957 at the Univ. of California, he moved to New York City and became an influential figure in establishing the Park Place, an early cooperative gallery. Until the mid-1960s, di Suvero combined large weathered timbers, rope, wire, and such found objects as tires in large-scaled, open compositions without bases (*Hank Champion*, 1960, WMAA). His forms are contained from pitching out of a piece by wires, which, in turn, help balance and displace weights and thrusts. Parts of some are movable. The effect is one of baroque flamboyance; these works have been called the three-dimensional equivalents of paintings by WILLEM DE KOONING and FRANZ KLINE.

Because of severe injuries sustained in 1960, di Suvero made smaller pieces composed of welded steel and wood in the years immediately following. In the mid-1960s, he began to use "clean" rather than used materials. Some are of monumental size. In the 1970s, di Suvero began to pare down the number of individual elements in his larger pieces so that they seem to be a strange and aggressive race of giants striding and cavorting on their slender steel supports across the land. He has also recently made small, sometimes intensely convoluted tabletop pieces of cut steel. As a sculptor whose works reflect an extravagant sense of invention, he has inherited DAVID SMITH's mantle as the country's most exuberant creator of three-dimensional form. Several outdoor pieces can be seen at the Storm King Art Center, Mountainville, N.Y. *Lit.*: James K. Monte, *Mark di Suvero*, exhib. cat., WMAA.

DIXON, LAFAYETTE MAYNARD (1875–1946), a painter of the American West. From Fresno, Calif., he studied briefly in 1893 at the San Francisco School of Design. Largely self-taught, he became a prolific illustrator whose works were published in western magazines beginning in 1893 with the *Overland Monthly* and, especially when he lived in New York City from 1907 to 1912, nationally distributed magazines such as *Scribner's* and *Harper's Monthly*. In 1900 he illustrated Jack London's *Son of the Wolf*. His mural commissions, eighteen in number, include those for the Southern Pacific Railroad Depot, Tucson, Ariz. (1907) and the U.S. Department of the Interior, Washington, D.C. (1939) as well as several in the San Francisco Bay area (Mark Hopkins Hotel [1926] and California State Library, Sacramento [1928]). His themes were invariably derived from the Southwest. Dixon painted his subject matter in its quieter moments, and his many Indian scenes are graced with sympathy, but he preferred unpeopled views of rolling hill and mountain country. During the 1930s, he turned to social themes of rural poverty

but afterward regained his interest in western material. Although his style varied according to the subject, he developed in the 1920s a Cubist-realist manner in which forms were made angular and color contrasts became abrupt. A large collection of Dixon's works is housed at Brigham Young Univ. *Lit.*: Wesley Burnside, *Maynard Dixon*, 1974.

DODSON, SARAH PAXTON BALL (1847–1906), a leading American expatriate painter. Sarah Dodson studied at PAFA before traveling to Paris to master the academic disciplines. There, she began exhibiting the large historical and biblical works so popular at the time. Her best-known picture, *The Baccidae* (1883, Indianapolis Mus.), is of this period. Dodson's work of the late 1870s and 1880s is strong and dramatic, emphasizing powerful movement, expressive gestures, and mastery of the human form. Later, she turned to more poetic subjects, personal in meaning, somewhat in the vein of current Symbolist painting. The later pictures often have religious overtones, which continued to characterize her art after she left France and settled in Brighton, England. She suffered a serious illness in 1893 from which she never fully recovered, but continued to paint in her later style. Dodson was one of the major women specialists in grand Salon figure painting and among the leading American expatriate women artists of the period. Lit.: John E. D. Trask, *The Work of Sarah Ball Dodson: An Appreciation*, 1911.

DOUGHTY, THOMAS (1793–1856), one of the first specialist landscape painters. Doughty came from Philadelphia and turned to painting about 1820. He lived chiefly in his native city and in Boston, Mass. in the 1820s and 1830s and later in New York City and elsewhere in New York State. His subject matter was drawn primarily from the Hudson River Valley region, and he is one of the earliest artists associated with the HUDSON RIVER SCHOOL, although many of his paintings have generalized, or even ideal, titles and his poetic vision often

makes it difficult to locate the topographical source of his views. Doughty's paintings have a lyrical fragility and they are almost completely without monumentality, certainly by comparison with the landscapes of his more notable contemporary THOMAS COLE. Usually set in the wilderness or remote countryside, they have no overtones of violence or danger. Often they include a single figure, fishing or in contemplation, which not only becomes a satisfying focal point but also serves as a reminder of the smallness of man in the vast expanses of nature. Doughty often relied upon a serene, golden light to soften foliage and produce a hazy atmosphere; *In Nature's Wonderland* (1835, Detroit Inst.) is a particularly lovely example. Occasionally, though rarely, a note of drama is sounded, as in *Mt. Desert Lighthouse* (1843, Newark Mus.), a seascape, also unusual in that the subject matter is drawn from as far afield as the Maine coast. Doughty was also a pioneer lithographer; his most notable productions in this art form are plates for the *Cabinet of Natural History and American Rural Sports* (1830–34). *Lit.*: Frank Goodyear, Jr., *Thomas Doughty*, exhib. cat. PAPA, 1973.

DOUGLAS, AARON (1898–1979), a painter and major figure in the florescence of black art and literature in New York City in the 1920s known as the Negro Renaissance. From Topeka, Kans., Douglas received a B.F.A. degree from the Univ. of Nebraska and studied in Paris, between 1925 and 1931, at the Académie Scandinave, and with Othon Frieze. He painted murals for Fisk Univ. (1930), where he taught for many years, and for the 135th Street branch of the YMCA (1933) and 135th Street branch of the Public Library (1934), both in New York City—all with federal sponsorship. Although Douglas painted portraits in a realistic manner, he developed a style that might be termed geometrical symbolism for his murals, combining African motifs and objects within angular Art Decolike formats. His figures, with stereotypical physiques, gesture theatri-

cally. His themes were drawn from the black heritage, made somewhat exotic.

DOVE, ARTHUR G. (1880–1946), a major first-generation modernist, whose forms, derived from nature, link him to both earlier and later artists. Yet Dove was one of the very few artists in a generation that prized individual attainment who developed an individual style independent of European and earlier American models. Born in Canandaigua, N.Y., he settled in New York City in 1903 and became a freelance illustrator for popular magazines, including *Harper's*, *Scribner's*, and *Century*. Deciding to become an artist, Dove went to Paris in 1907 and remained there until 1909. Through friendship with ALFRED MAURER, Dove became acquainted with modern art. *The Lobster*, exhibited at the Salon d'Automne of 1909, recalls Henri Matisse's bright Fauve palette as well as Paul Cézanne's pictorial structure. After returning to the United States, Dove exhibited in Younger American Painters, an early American modernist show mounted in 1910 by ALFRED STIEGLITZ. Soon after the exhibition, in the same year, Dove did six paintings called *Abstraction*. Although the imagery is derived from nature, they are among the first American works to avoid direct reference to the visual world. In a letter written to Arthur Jerome Eddy, an important early collector and supporter of modern art and author of *Cubists and Post-Impressionism* (1914), Dove explained his method of painting. First he chose from nature motifs in color. Second, he allowed his expression of the motifs to become subjective, dominating their actual appearance. Eventually, he "no longer observed in the old way" and began "to remember certain sensations purely through their form and color," producing works that stood independent of their original sources. Dove's method was different from that of Wassily Kandinsky, who tried to express moods and feelings, or from those of formalists who were concerned primarily with problems of composition and structure. Dove ac-

knowledged his ties to nature, his lack of interest in manipulating forms not derived from actual objects. Thus, in his early abstractions, vegetal shapes with minimal modelling established shallow spaces rather than airless, surface-bound patterns. Dove's unwillingness to create completely nonobjective works did not so much represent a lack of nerve as reflect a persistent American commitment, until that time, to paint from experience. In any event, he is considered the first American artist to have developed a consistent nonrepresentational style before the ARMORY SHOW.

Between 1911 and 1920, Dove consolidated his stylistic gains. Working largely in pastel, he created two closely related series, The Ten Commandments and Nature Symbolized (examples in major museums in New York City and Chicago). Sixteen of the latter were shown at the Forum Exhibition of Modern American Painters, in 1916 (see INDEPENDENT EXHIBITIONS). Using repetitive curving motifs and soft, breathing color, Dove created works that allude to nature but in the most abstract, symbolic sense. In these series, planes were often bounded by lines. Subsequently, Dove liberated line from defining the physical character of a shape, employing it instead to suggest the energies residing there. This use of line creates jazzy, quick-tempo rhythms in Dove's paintings with musical themes as, for example, *George Gershwin, Rhapsody in Blue, Part I* (1927). Other artists used such themes to express the quickened tempo of modern life, but Dove painted to capture "the reality of the sensation alone."

During the 1920s, Dove's style became increasingly airless. Even when he painted vistas, as in *Waterfall* (1925, Phillips Coll.), it was as though the scene had been viewed as a close-up. Perhaps Dove was influenced at this time by PAUL STRAND's photographs, which had similar qualities. This new approach may have sparked Dove's interest in collage during these years: Between 1924 and 1930, he created about twenty-five collages in which problems of pattern

coordination were of great concern. Yet Dove did not juxtapose the wide variety of objects he chose for these elegant, often witty, collages (flowers, leaves, paper, cloth, and objects such as magnifying glasses and wood and metal rods) solely for the purpose of exploring differences of texture and shape; the collages are also object portraits of people or places. *Portrait of Alfred Stieglitz* (1925, MOMA), for instance, includes a camera lens and a clock spring. Possibly, these works bear a distant relationship to Francis Picabia's object drawings done in this country in 1915.

In the 1930s, Dove painted large-scale forms on rather small canvases (usually no more than thirty-six inches wide), as if to suggest the forces and phenomena in nature that grow and move—from plants and animals to sounds. Often shapes built around a circular core undulate out to the canvas's periphery (*Life Goes On*, 1934, Phillips Coll.). Images with sexual connotations—vaginas, phalluses, spermatazoa, and egg shapes—abounded. Although many contain large and ungainly forms, these are among Dove's most magisterial paintings, technically proficient and thematically profound. Particularly fine examples include *Sunrise I* (William Lane Foundation, Leominster, Mass.), with its obvious phalluslike image, and *Cow I* (1935), with its vigorously brushed shapes suggesting a creation scene.

Toward the end of the decade, perhaps in response to the growing general interest in geometrical abstraction, Dove's work grew more angular and nonobjective. His colors, too, seemed less natural, as greens and blues grew harsh, less leafy and less atmospheric. Spaces closed up and surfaces became more hermetic as forms were less modelled. Titles also became less referential: *Formation I* (1943, Fine Arts Gall., San Diego), *Structure* (1942). Dove's use of wax emulsion after 1936 probably contributed to the new all-over evenness of touch that characterized his later works. Throughout his career, Dove seems to have wanted the viewer to share his de-

cisions of hand and mind. His work has a clearly handmade look, as if crafted from paint—neither, at one extreme, presenting a cold, impersonal appearance nor, at the other, demonstrating wild emotional exuberance. One can almost see him easing forms together as if to reveal a purposeful clumsiness. Some paintings of the 1940s seem almost to be the work of a primitive artist gone abstract. A heart attack in 1946 left him partially paralyzed, but he continued to paint, aided by his wife, Helen Torr Weed. *Lit.*: Barbara Haskell, *Arthur Dove*, 1975.

**Dow, ARTHUR WESLEY** (1857–1922), a painter, printmaker, and art educator. Born in Ipswich, Mass., he initially responded to the artistic influence of WILLIAM MORRIS HUNT and the work of the French Barbizon painters (see BARBIZON, AMERICAN). In his early years, Dow also admired the work of FRANK DUVENECK. In 1884 he left for Paris, where he enrolled at the Académie Julian. From then until 1889, Dow divided his time between art studies in Paris and landscape painting in Brittany, at Pont Aven, the artists' colony frequented by Paul Gauguin during the same years. Some have speculated that Dow was influenced by Gauguin and perhaps carried some of the French artist's radical ideas back with him to the United States. But recent research shows that Dow probably had little to do with Gauguin and his group. His paintings of this period, rather, reflect the influence of a conservative American artist who worked in Brittany, Thomas Alexander Harrison. Dow returned to Ipswich in 1889. He worked as a private teacher there and in Boston, Mass. In 1891 he met the curator of Japanese art at MFAB, Ernest Fenollosa, who was to have the decisive influence on Dow's art. Fenollosa introduced him to Oriental art and to its theory, which Dow applied to his own work. He did few oil paintings during the 1890s; instead, he explored the techniques of woodblock printing and brush drawing. He also attempted to develop a method

for explaining the basis of Oriental art to Western students. After teaching at MFAB, ASL, and the Pratt Inst., Brooklyn, N.Y., Dow recorded his methods for publication. In 1899 his book *Composition* appeared. It provided students with simple exercises to help them learn to manipulate line, color, and *notan* (a Japanese word that refers to tonal or value relationships within a composition). In 1903 Dow became head of the art education department at Columbia Teachers' Coll., one of the most prestigious teacher-training institutions in the United States. Because of his important position and his publications, Dow's ideas spread, and his influence was felt across the country.

Dow's mature paintings and prints are usually tame variations on Oriental motifs. Most often landscapes, they utilize subtle tonal contrast and simple forms. Although his own work was less than radical, Dow's ideas influenced the first generation of American modernists. His insistence that art need not imitate nature but grows from formal, abstract relationships allowed his students to experiment with modern modes of painting. Both MAX WEBER and GEORGIA O'KEEFFE have acknowledged his significance in the development of their mature styles. Examples of Dow's work are in MFAB and the Ipswich Hist. Soc. *Lit.:* Frederick C. Moffatt. *Arthur Wesley Dow*, exhib. cat., NCFA, 1977.

DUBREUIL, VICTOR (active late 19th century), a still-life specialist. Dubreuil is an artist about whom almost nothing is known, though painted letters in his illusionistic still lifes indicate that he lived for a time in New York City in the West Forties. He was a humorist, somewhat in the style of JOHN HABERLE, though his technique was relatively crude by comparison. Dubreuil made up for his lack of subtlety with an enthusiasm—intense and singleminded—for money. Money was the principal subject matter of his paintings—stacks of coins, barrels or safes full of bills, pictures of single bills, and paintings of bank-robbers in action.

Money, and everything else Dubreuil painted, was rendered in dark outline, and his compositions rely heavily on a kind of grid pattern. There are a few known works by him that do not depict money—pictures of photographs of George Washington and of Grover Cleveland, for example—but these, as one might expect, are much less interesting than those dealing with his favorite theme. *Lit.:* Alfred V. Frankenstein, *After the Hunt: William Michael Harnett and Other American Still Life Painters, 1870–1900*, 2d ed., 1969.

DUNCANSON, ROBERT S. (1821–1872), a black landscapist and portrait painter. Born in New York State, he grew up in Canada, moving to the Cincinnati area in 1841. Largely self-taught, he painted landscapes and stilted portraits there and in Detroit in the mid-1840s. Nicholas Longworth, an especially generous patron, commissioned him to paint murals in his Cincinnati home in 1848 (now in the Taft Mus.), and in these works Duncanson modified the realism of the HUDSON RIVER SCHOOL with a poetry ultimately derived from Nicolas Poussin and Claude Lorrain, with whose work he had become familiar through reproductions. He reached artistic maturity with *Blue Hole, Flood Waters, Little Miami River* (1851, Cincinnati Mus.), in which detail is modified by a lyrical grace original to Duncanson himself. In fact, throughout his career, Duncanson's work oscillated between a typically mid-century precision and a desire to soften forms and mood. He worked as a daguerreotypist in the early 1850s. After a trip to Italy in 1853–54, he incorporated classical motifs into his landscapes as well as scenes derived from literary sources, as, for example, in *Land of the Lotus Eaters* (1861, Royal Coll., Stockholm), based on Tennyson's poem. A second trip abroad to Canada, England, and Scotland, from 1863 to 1867 inspired him to choose themes from Sir Walter Scott's novels. Duncanson seldom painted racial themes. His *Uncle Tom and Little Eva* (1853, Detroit Inst.) is

one of his few excursions into the genre. *Lit.:* Guy McElroy, *Robert S. Duncanson,* exhib. cat., Cincinnati Mus., 1972.

**DUNLAP, WILLIAM** (1766–1839), a painter, and the first historian of American art. Dunlap came from Perth Amboy, N.J. In 1784 he went to London to study art with BENJAMIN WEST but was not diligent in this pursuit, spending rather more time at the theater, which became a fascination with him. Dunlap's entire career, in fact, alternated between playwriting and painting. As an artist, he was primarily involved with portraiture, but his talent for it was generally uninspired. He seems to have been slightly more proficient in the art of miniature painting. During the 1820s, he created his most ambitious pictures, a series of monumental paintings of the life of Christ drawn directly from the religious works executed during the previous decade in London by West. Dunlap took the series through eastern America in hopes of emulating the successful tour of *The Court of Death* (1820) by REMBRANDT PEALE. Only one of these, *Christ Rejected* (Princeton Univ.), is known today. Dunlap's most interesting pictures are those that combine his two major interests: the early *Artist Showing His Picture of a Scene from "Hamlet" to His Parents* (1788, NYHS) and *Scene from Cooper's "The Spy"* (1826, New York State Hist. Assoc.). More significant than either his paintings or his plays, however, are his pioneering histories of the two arts, *A History of the American Theatre* (1832) and *A History of the Rise and Progress of the Arts of Design in the United States* (1834).

**DUNNING, ROBERT SPEAR** (1829–1905), principal painter of the Fall River School of still life in the late 19th century. Born in Brunswick, Maine, Dunning painted portraits and also developed into a talented landscape painter in Fall River, Mass., in the 1850s. About 1865 he turned his attention to still life and, under his influence, professional artists in Fall River did so, too. At the time, Fall River was a wealthy mill town, though something of a cultural backwater. For that reason, the work of Dunning and his followers preserved a lushness, optimism, and opulence associated with mid-century painting in America and reflecting nothing of the contemporary *trompe l'oeil* style of WILLIAM MICHAEL HARNETT. Dunning's more ambitious works usually contain one or more large objects of crystal or silver and lusciously rendered fruit, all resting upon a well-polished table with elaborately carved edges. An unusual and exotic element that often figures in Dunning's works is the honeycomb, rendered with a fascinating textural complexity of which Dunning was a master. His earlier works are generally dark and rich, his later ones somewhat atmospheric and luminous.

Dunning was a founder, in 1870, of the Fall River Evening Drawing School, along with John E. Grouard, and many of the students at the school, some of whom later became teachers there, turned to still life: Bryant Chapin, Franklin H. Miller, Albert F. Munroe, Abbie Luella Zuill, and Herbert Cash. No other small community in the late 19th century seems to have maintained such a single-minded devotion to still-life painting as did Fall River, under Dunning's influence. *Lit.:* William H. Gerdts and Russell Burke, *American Still-Life Painting,* 1971.

**DURAND, ASHER BROWN** (1796–1886), an engraver and major landscape artist, and a principal painter of the HUDSON RIVER SCHOOL. From Jefferson Village (now Maplewood), N.J., he served as an apprentice to PETER MAVERICK, the Newark engraver, from 1812 to 1817. Durand then moved to New York City and was Maverick's partner until JOHN TRUMBULL commissioned him in 1820 to engrave his *Declaration of Independence* (1786–97), at which point Durand set up his own shop, having won the reputation of being the country's best engraver. Durand subsequently engraved banknotes, illustrations, and portraits after paintings

by major contemporary artists. In 1830 he became involved in a project for a magazine entitled *The American Landscape*, with text by poet William Cullen Bryant, for which Durand produced seven plates. Only one number was issued, however. Durand ended his active participation in engraving in 1831, though he engraved JOHN VANDERLYN'S *Ariadne* (1814) in 1835. By that time he had portraits, genre scenes, and landscapes in his repertoire, and, in 1837, began devoting most of his attention to painting. Many of Durand's genre scenes date from this period. Based on real and imagined historical events, they include *The Capture of Major André* (1834, Worcester Mus.) and *Dance on the Battery in the Presence of Peter Stuyvesant* (1838, MCNY). Some of Durand's early landscapes anticipate, in their directness of observation and freshness, his work after 1850; others emulate THOMAS COLE's moral allegories (*The Morning of Life* and *The Evening Of Life*, both 1840, NAD). In 1840–41 he went abroad with JOHN F. KENSETT, JOHN W. CASILEAR, and THOMAS P. ROSSITER.

After the death of Cole, Durand became the country's major landscape painter. In acknowledgment of his preeminence and of the importance of landscape painting in American art, he was made president of NAD in 1845 and served until 1861. His nine "Letters on Landscape Painting," famous in their day (and probably the best reflection of mid-19th century attitudes to the subject), were printed in *The Crayon* in 1855. Durand severely curtailed his artistic output in 1878 because of declining health.

Durand's early landscape style was derived from Claude Lorrain, the 17th-century French artist. On a flat ground plane, trees are often situated to either side of center. Between the trees, forms are so arranged that spatial recession seems logical and inevitable. Foliage tends to be rendered in large masses rather than as individual leaves. Buildings echo the verticality of the trees. Figures, appropriate to the scene, are located in the middle distance, or, if close to the picture plane, are made small in scale relative to the spaces around them. Durand evidently sought to express a balance between man and nature, holding that when "the human form exerts an influence in unison with the sentiment of inanimate nature, increasing its significance without supplanting it, the representative character of the landscape is not affected." This attitude grew out of his reverence for nature and for landscape painting as "the representation of the work of God in the visible creation, independent of man." A deeply religious person, Durand did not seek to impose his vision on nature but to allow nature, as a visible manifestation of the Deity, to represent itself. He found nature "fraught with lessons of high and holy meaning, only surpassed by the light of Revelation." Consequently, he exercised his imagination only to the extent of idealizing the real or of depicting those moments of perfection in which flora, fauna, and landscape show their most beautiful and typical qualities rather than momentary or eccentric ones. Because he felt that spiritual meaning was encapsulated in the forms of the actual world and that nature could provide man with models of ethical conduct, Durand's paintings are profoundly optimistic. Scene after scene (*Sunset*, 1838, NYHS; *View in the Catskills*, 1844, MFAB) is dressed in summer foliage, under a warm sun. Contentment reigns; man and nature exist in a state of exceptional harmony.

In the mid-1840s, Durand turned increasingly to particularization of effect, and the style of Claude became a less noticeable influence. *The Beeches* (1845, MMA) is Durand's earliest known work based on forms previously rendered directly from nature. Here, and in *Kindred Spirits* (1849, NYPL), an early masterpiece of his new style, Durand exercised a greater fidelity to nature. Trees were no longer automatically composed of masses of foliage; those in the foreground and middle distance have individualized leaves and branches. Textures

grew slightly richer and lines, acting both as outline and as directional movements, grew more apparent. As Durand confronted nature more directly, his scenes seemed less composed and less domesticated. These new traits perhaps reflect the influence of John Ruskin and the meticulous style associated with the School of Düsseldorf, examples of which he could have seen in New York City's DÜSSELDORF GALLERY, which remained open from 1849 to 1861. Wilderness scenes increasingly replaced rural ones, and, whereas the earlier views were often called beautiful, the later ones appeared more sublime, in that the viewer was invited to contemplate the grandeur of nature in addition to its beauty and harmony.

Durand's use of color, however, remained tonal rather than coloristic and was aimed at suggesting vast reaches of landscape space through carefully graduated atmospheric perspectives rather than glittering effects of surface tints. The viewer was not to be detained before the surface of a work but was expected to enter into its spaces, all the more to feel, in his communion with nature, a spiritual and moral elevation. As Durand said, "There is no tint, nor phase of light and dark, force or delicacy, gradation or contrast, or any charm that the most imaginative imagination ever employed . . . that is not seen in nature more beautiful and fitting than art has ever realized and ever can."

Durand helped develop an American landscape painting different from the dramatic and overtly allegorical style of Thomas Cole toward a quieter appreciation and interpretation. Selfless before the overwhelming majesty of nature, Durand willingly became the instrument through which its perfections could be communicated. But for him, as for Cole, landscape painting was a moral exercise. *Lit.:* David B. Lawall, *A. B. Durand, 1796–1886,* 1978.

**DURRIE, GEORGE HENRY** (1820–1863), a painter. Durrie studied portraiture in New Haven, Conn., with the leading lo-

cal portraitist there, Nathaniel Jocelyn. Although Durrie is known today almost exclusively for his landscapes, he began his professional career as an itinerant painter of portraits, some of which, especially those painted in and around Freehold, N.J., are beautifully restrained works in a very linear and decorative, semiprofessional (or semiprimitive) manner, such as those of the Conover family (Monmouth County Hist. Assn., Freehold). Durrie turned to landscape painting in the mid-1840s. He was by no means exclusively a painter of winter, but his winter scenes became and have remained his best-known works, a specialty somewhat parallel in kind to JASPER F. CROPSEY's. Durrie's winter pictures emphasize the cold whites of the snow and the bleak grays of the sky in the landscape around his native New Haven, and such local topographical features as East Rock and West Rock are often identifiable. Durrie's pictures almost invariably include man's activities in the rural winter landscape, and human figures and animals move through the scenes, which often also include homes, barns, and taverns of the area, almost to the point where the paintings begin to encroach upon genre (*Farmyard in Winter: Selling Corn,* 1852, Shelburne Mus., Shelburne, Vt.). At the end of his life, Durrie's art became well known through lithograph reproductions by CURRIER & IVES (some of these prints were posthumous). Though Durrie is America's most famous painter of winter, he was actually preceded by about a decade in this specialization by THOMAS BIRCH. *Lit.: George Henry Durrie, 1820–1863,* exhib. cat., WA, 1947.

**DÜSSELDORF GALLERY,** where paintings by artists associated with the short-lived but highly influential School of Fine Arts, in Düsseldorf, Germany, were exhibited from 1849 to 1861. Located at the Church of Divine Unity, 548 Broadway, New York City, it was established by the German-born wine merchant, John Godfrey Boker. Initially, the paintings shown were from Boker's private

collection and included works by the leading artists of the school, Karl Friedrich Lessing, Christian Köhler, Andreas Achenbach, and Hans Gude. Two of the most celebrated were Lessing's *The Martyrdom of Huss* (1850) and Köhler's *The Awakening of Germania in the Year 1848* (1849, NYHS).

Under Boker the gallery was enormously popular, its appearance coinciding with the arrival of a large and influential German population in New York and a growing interest among American artists in training at the Düsseldorf school. (From the 1840s through the 1850s, many of the most prominent artists studied there: EMANUEL GOTTLIEB LEUTZE, RICHARD CATON WOODVILLE, EASTMAN JOHNSON, T. WORTHINGTON WHITTREDGE, ALBERT BIERSTADT, and GEORGE CALEB BINGHAM, among others.)

Financial difficulties during the panic of 1857 forced Boker to sell his collection to the Cosmopolitan Art Assoc. of Sandusky, Ohio, which was modelled upon the AMERICAN ART-UNION. With the acquisition of Boker's collection, the Cosmopolitan Art Assoc. moved its headquarters to New York City and distributed to the public by lottery works by Düsseldorf artists and others. Three years later, the art dealer Henry W. Derby offered space and promotional help to the Cosmopolitan Art Assoc. The Düsseldorf Gallery, which had retained its name, was then transferred to Derby's Inst. of Fine Arts, at 625 Broadway. Its fortunes declined as enthusiasm for foreign art, and particularly the tightly drawn, academic naturalism of the Düsseldorf School waned. In 1862 the trustees gave up the gallery for financial reasons and sold the remaining 107 paintings at auction. *Lit.:* R. L. Stehle, "The Düsseldorf Gallery of New York," *New-York Historical Society Quarterly*, Oct., 1974.

**DUVENECK, FRANK** (1848–1919), a painter, etcher, sculptor, and teacher. He was born in Covington, Ky., and, though he had little formal education, he began to paint at an early age, working as an as-

sistant and also executing paintings in Catholic churches in Covington, Cincinnati, Latrobe, Pa., and Quebec, Canada. Duveneck went to Munich in 1870 and shared a studio with WILLIAM MERRITT CHASE. He studied painting with Wilhelm von Diez and was greatly influenced by the genre subjects of Wilhelm Leibl and the general enthusiasm there for Gustave Courbet's painterly realism (see MUNICH SCHOOL). Duveneck was one of an increasing number of American artists drawn to Munich by the expectation of a training that was both broader and freer than that offered either in Düsseldorf or in Paris. In a short time, Duveneck moved from the relative tightness of his American church decorations to his characteristic mature style of loose highlights brushed over ruggedly blocked-out forms emerging from a richly suggestive chiaroscuro. The immediacy and vitality of this technique is manifest in the frontal portrait *The Old Professor* (1871, MFAB). *Whistling Boy* (1872, Cincinnati Mus.) is an especially fine example of a mode in which Duveneck was particularly successful: the low-life genre subject. Ultimately, it was derived from paintings of peasant boys by Leibl. *Whistling Boy* and Duveneck's several later variations on the same theme were especially refreshing to an American audience accustomed to the drier manner of Düsseldorf painting. Duveneck's *Lady with a Fan* (1873, MMA) also reflects Leibl and the 17th-century Dutch tradition behind him. On occasion, Duveneck applied the same juicy paint handling and realistic approach to more exotic scenes, such as *The Turkish Page* (1876, PAFA), in which recession and textural contrasts are uncommonly emphatic.

In 1874, after a trip to Venice (one of many made over the years), Duveneck returned to America, exhibiting in Cincinnati and, the following year, in Boston, Mass., after which he returned to Munich. In 1878 he opened his own school in Munich and in the Upper Bavarian village of Polling. The attitude of the school and the exuberance of his

teaching are indicated by the term then applied to his students—"Duveneck Boys." One of his pupils was JOHN HENRY TWACHTMAN. Another pupil, Otto Bacher, introduced him to etching in 1880, and he learned much, too, from JAMES A. M. WHISTLER, who was in Venice in the early 1880s. Indeed, when three of Duveneck's etchings were exhibited in London in 1881, they were identified by some critics as the work of Whistler, who, his print output contracted to another firm, was thought to be showing them under a nom de plume. Over the years, Duveneck produced a body of prints in which the bravura of his painting style was successfully translated into the more delicate graphic medium.

About 1880 Duveneck's style changed, perhaps, it has been suggested, under the influence of Elizabeth Boott, his student, whom he married in 1886. The sketchiness of ambience remained, but the features of his subjects were more smoothly painted, with fewer hard contrasts of light and dark than before. At the same time, a greater psychological sensitivity appeared. The suggestion of wistfulness in his portrait *Amy Folsom* (1880, Montclair Mus.) anticipates the more fully developed sense of vulnerability in the much-admired, Spanish-influenced, full-length portrait of Elizabeth Boott Duveneck, in her wedding dress (1888, Cincinnati Mus.). After Duveneck's wife died, in 1888, he spent considerable time carving a beautiful *gisant* figure as a funeral monument to her.

From about 1890, Duveneck lived mostly in Cincinnati, with periodic travel in France and Italy. In 1900 he began teaching at the Cincinnati Art Acad. He spent his summers in Gloucester, Mass.,

producing a group of harbor subjects, landscapes, and marines high in key and with sumptuously controlled brushwork. Many of Duveneck's works may be seen in the Cincinnati Mus., a gift of the artist, who took an active interest in the institution. *Lit.*: Josephine W. Duveneck, *Frank Duveneck: Painter—Teacher*, 1970.

**DUYCKINCK FAMILY,** the earliest dynasty of artists and craftsmen in the colonies, active in New York for four generations. Evert I (1621–1702), from Westphalia (Holland) settled in 1638 in New Amsterdam (New York City), where he became a painter, glazier, and stained-glassmaker, among other occupations. The youngest child of Evert I, Gerrit (1660–1710), became a partner in his father's artistic enterprises. He probably painted his self-portrait and one of his wife about 1691 (both NYHS) as well as a portrait of Mrs. Augustus Jay. One of Gerrit's children, Gerardus I (1695–1746), also a painter, is thought to have been the author of one of the earliest known religious works made in the colonies, *The Birth of the Virgin* (1713). Gerardus II (1723–1797), the son of Gerardus I, was also a painter, especially on glass. Evert III (1677–1727), a grandson of Evert I, was also an artist. His father, Evert II (1650–1680), was a sea captain and returned to Holland, where Evert III was born. Evert III, however, settled in New York City in 1680 and is presumed to have been the author of at least nine portraits. Presumably, Evert III worked with his uncle Gerrit and his first cousin Gerardus I. *Lit.*: R. W. G. Vail, "Storied Windows Richly Dight," *New-York Historical Society Quarterly*, Apr., 1952.

# E

EAKINS, SUSAN HANNAH MACDOWELL (1851–1938), a painter, accomplished pianist, and amateur photographer. The daughter of an engraver, Susan Macdowell was born in Philadelphia. Her family encouraged her interest in art, which she studied at PAFA, as a prizewinning student, from 1876 to 1882, first with CHRISTIAN SCHUSSELE and later (1880–82) with THOMAS EAKINS, whom she married in 1884. Although she was considerably less active after her marriage, Susan Eakins never stopped painting; she maintained a separate studio and was encouraged by her husband in her work. After Thomas Eakins died, in 1916, Susan Eakins began painting more actively and continued to do so until her death.

Susan Eakins was primarily a portraitist, specializing in interior scenes showing one or two people seated and quietly reading or knitting. Typical of her work are *Kate Lewis* (1884, Art Mus., Allentown, Pa.) and *Portrait of Thomas Eakins* (c. 1889, Philadelphia Mus.), which feature loosely brushed, dark backgrounds, warm, rich colors, and sensitively painted faces and hands. Although her work undeniably reflects the influence of her husband, its quality was long ignored; her first one-woman show was held in 1973. *Lit.:* Susan P. Casteras, *Susan Macdowell Eakins*, exhib. cat., PAFA, 1973.

EAKINS, THOMAS (1844–1916), perhaps the country's finest painter and portraitist. Born in Philadelphia, he commenced his studies at PAFA in 1862 and supplemented them with anatomy classes at the Jefferson Medical Coll. In Paris, from 1866 to 1869, he attended EBA, working under Jean-Léon Gérôme and Augustin Dumont, and then with Léon Bonnat. Eakins traveled to Spain in 1869, returning to Philadelphia the fol-

lowing year. In Spain he was dazzled by Diego Velázquez's naturalism, objectivism, and brush technique and during the remainder of his career preferred to build up paintings in single layers of pigment rather than use the French method of laying down opaque pigment. Eakins continued his anatomy studies at the Jefferson Medical Coll. in 1873–74, and throughout his teaching career he encouraged his students to study anatomy firsthand and witness dissections as he had done. He began to teach at PAFA in 1876 but resigned in 1886 because of bitter criticism of his radical teaching methods, particularly his use of a nude male model in a mixed class. Loyal students left with him and established a rival Art Students League, at which Eakins taught, during the few years of its existence, without pay.

Eakins began to experiment with photography in 1880, and most of his surviving work dates from that decade. Some prints he used as studies for paintings. Although he was aware of the researches in motion photography carried on by EADWEARD MUYBRIDGE at the Univ. of Pennsylvania in 1884–85, Eakins himself seems not to have contributed greatly, if at all, to its development, contenting himself with using a Marey Wheel in which several exposures appeared on the same plate (however, his painting *The Fairman Rogers Four-in-Hand* [1879, Philadelphia Mus.] was among the first works of art that accurately show horses trotting). Eakins began to sculpt in Paris. Although he made clay figures and sketches during the 1870s, he made his first completed work, two reliefs, in 1882 (*Spinning* and *Knitting*, both Philadelphia Mus.). He completed ten sculptural works in all, including panels for the Trenton, N.J., Battle Monument (1893). (All of his finished sculptures were reliefs.)

Throughout his career, Eakins worked methodically, avoiding the bravura techniques of JOHN SINGER SARGENT, who was also impressed by the objective realism and dazzling brushwork of Velázquez. He was deeply interested in perspective and the structure of forms, and these concerns distinguish his paintings markedly from those of the contemporary Tonalists and Impressionists (see TONALISM; IMPRESSIONISM, AMERICAN). In the early 1870s, he painted several boating scenes, the best-known and most sophisticated of which is *Max Schmitt in a Single Scull* (1871, MMA). These are among the earliest urban vacation-recreation paintings done in the country, quite distinct from earlier works showing frontier scenes or views of people engaged in picturesque activity in a natural setting. Eakins also painted hunting scenes, and these are also less anecdotal than those of his contemporaries, including WINSLOW HOMER. An early masterpiece, *The Gross Clinic* (1875, Jefferson Medical Coll.), with its Rembrandtesque lighting and drama, is unusual in Eakins's oeuvre in its romanticism. The subject, Dr. Samuel D. Gross, is depicted as both a hero and a worker, a mediator between life and death as well as a surgeon. Eakins's later *Agnew Clinic* (1889, Univ. of Pennsylvania), also a portrait of a doctor at work, is much more typical in its straightforward manner of presentation. One of Eakins's few nudes dates from this early period, as well, *William Rush Carving His Allegorical Figure of the Schuylkill River* (1877, Philadelphia Mus.), a depiction of the Philadelphia sculptor at work in his studio with a nude model and her chaperone. Since Eakins believed that paintings of nudes required a logical context, he completed few of them. Examples include *The Swimming Hole* (1883, Fort Worth Mus.), and the paintings of boxers he made in the 1890s, such as *Between Rounds* (1899, Philadelphia Mus.).

About 1885, a year after his marriage to Susan Hannah Macdowell, who greatly encouraged him in his work (see EAKINS, SUSAN H. M.), Eakins gave up, for the most part, all categories of painting except portraits. His sitters were usually friends and relatives, or professionals like Agnew, and they are depicted with psychological insight rare in American art. Many of the female portraits, such as *Addie* (1900, Philadelphia Mus.) and *Mrs. Edith Mahon* (1904, Smith Coll.), show the numbing effect of psychological isolation and social uselessness, as do the pictures of women painted by such contemporary artists as THOMAS WILMER DEWING and EDMUND C. TARBELL. Unlike them, however, Eakins searched for character in a face rather than beauty. The Philadelphia Mus. has an extensive collection of his work. *Lit.:* Lloyd Goodrich, *Thomas Eakins: His Life and Work*, 1933.

EARL, RALPH (1751–1801), AND FAMILY. Ralph Earl was Connecticut's foremost portrait painter of the post-Revolutionary period. He was born in Worcester County, Mass. Little is known about his early training, and it seems probable that he was self-taught. By 1774 he had set up as a painter in New Haven, Conn., and in 1775 he travelled to Lexington and Concord, Mass., with his friend Amos Doolittle, the engraver, to make what WILLIAM DUNLAP called "the first historical pictures, perhaps, ever attempted in America": four paintings of the recent battles, which Doolittle engraved. Only one of the four is known: the rather naive *View of the Town of Concord*. The series reflects Earl's Loyalist sympathies, which soon caused him great difficulties. In 1778, fearing for his safety, he left for England. The only major work of Earl's first American period to survive, and one of his masterpieces, is the stark portrait of Roger Sherman, the Connecticut patriot and signer of the Declaration of Independence, the Articles of Confederation, and the Constitution. The stiffness of *Roger Sherman* (1775, Yale Univ.) reflects the limner tradition (see LIMNERS). There are several areas in the painting that are awkward by academic standards, for example, the lifeless drapery on the wall and the irra-

tional perspective of floor and wall. Yet, seen together, all elements, including the meticulously rendered cast shadows, function to thrust toward the viewer the image of a powerful, awkward, yet controlled personality.

In England, though not officially one of the pupils of BENJAMIN WEST, Earl seems to have been part of West's circle and probably travelled with him to Windsor. Like *Roger Sherman*, his early English paintings, such as *William Carpenter* (1779, Worcester Mus.), emphasize geometrical relationships; the presence of more furniture allows for more ambiguity in the construction of space. Earl's contact with the grand tradition of British portrait painting, however, soon gave his work a greater softness and sophistication. He also began to introduce landscape backgrounds in his portraits (*Sophia Isham*, 1783), a feature that became a characteristic of his later paintings. Earl's increasing mastery of spatial relationships is evident in *A Master in Chancery Entering the House of Lords* (1783, Smith Coll.), and his awareness of a lighter portrait mode can be seen in the painting of his second wife, *Ann Whiteside* (1784, Amherst Coll.).

In 1785 Earl returned to America. He worked at first in New York City, where he spent more than a year in jail for debt. During the 1790s, he was active in New York, Connecticut, Vermont, and Massachusetts. The portraits of Earl's second American period retain a good deal of British polish and compositional structure, perhaps in response to the tastes of his patrons. Many are notable for the personalized detail of the sitter's ambience, as in Earl's portrait of the merchant Elijah Boardman (1789), where one sees Boardman's New Milford dry-goods store in the background. But more often Earl used landscape backgrounds, frequently framed by a window, that were directly related to the life or home of the sitter. For example, in his portrait *Colonel William Taylor* (1790, AK), the subject is shown drawing the landscape that is visible through the window at his left. *Chief Justice and*

*Mrs. Oliver Ellsworth* (1792, WA) is both a double portrait and an estate portrait. The house seen through the window is the house in which they are sitting. A smaller number of independent landscapes (a rare genre in late 18th-century America) are also extant. James Earl (1761–1796), a younger brother, was also a portrait painter and had two children, Phoebe and Augustus, both of whom became artists. Ralph Earl's son, RALPH E. W. EARL (c. 1785–1838) was also a portraitist, known chiefly for his studies of Andrew Jackson. *Lit.:* Laurence B. Goodrich, *Ralph Earl, Recorder for an Era*, 1967.

EARTH ART, a type of activity supported by patrons and art-gallery owners but not connected with galleries, in which artists add to, take away, displace, or in some other way manipulate earth and what lies upon it or under it. Often the processes and procedures are documented by working drawings, slides, film, or photographs, and these are exhibited as records of the activities. The sources of Earth Art lie in HAPPENINGS and related events that take place outside of normal art-gallery contexts and in outdoor sculptural pieces in which the environment is assumed to be a part of the work. Major figures in the field are MICHAEL HEIZER, Dennis Oppenheim, ROBERT SMITHSON, and Walter de Maria. De Maria drew a plan for parallel walls a mile long as early as 1962, but the first important examples of Earth Art were Smithson's Non-Sites of 1966–67. By the late 1960s, large chunks of land were being moved around, generally in inaccessible areas of the American Southwest and in the Sahara—though CLAES OLDENBURG dug up and buried dirt in New York City's Central Park (*Placid City Monument*, 1967), and Heizer dug a pit in Munich in 1969. Even though their work is occasionally associated with ecological and environmental movements, Earth artists are not concerned with protecting nature in any way; they simply use it as the field of operation.

EASTMAN, SETH (1808–1875), a major painter of Indian life and western topographical scenes. Born in Brunswick, Maine, in 1824 he entered the U.S. Military Acad. at West Point, where he learned topographical drawing. After being stationed in Wisconsin, he returned to the academy from 1833 to 1840, and there he studied under ROBERT W. WEIR and wrote *Treatise on Topographical Drawing* (1837). On active duty again from 1841 to 1848, this time in Minnesota, he studied, primarily, the Dakota and Chippewa Indians, sketching their activities and making daguerreotypes. From 1850 to 1855, Eastman produced drawings for almost 300 plates used to illustrate Henry R. Schoolcraft's *Historical and Statistical Information Respecting the History, Condition, and Prospects of the Indian Tribes of the United States* (1851–57). Subsequently, Congress provided him with the means to paint Indian scenes once again. Eastman's work can be divided into two main categories: topographical and genre studies accurate in their portrayals of the West and of Indian life and more ambitious canvases intended for the eastern market. Into the latter, Eastman introduced sentimental and anecdotal elements or else stressed exotic or violent aspects of western life. An example of the former is *Sioux Indians Breaking Up Camp* (1848, MFAB). Collections of Eastman's work are in the Peabody Mus., and the Hill Reference Library, St. Paul, Minn. *Lit.:* John F. McDermott, *Seth Eastman: Pictorial Historian of the Indian,* 1961.

EBERLE, ABASTENIA ST. LEGER (1878–1942), a sculptor of urban genre scenes in bronze. The daughter of an army doctor, Eberle was born in Webster City, Iowa. Her childhood was spent in Canton, Ohio, where she studied modelling with Frank Vogan, and in Puerto Rico, where her father was later stationed. In 1899 Eberle moved to New York City and spent three years studying at ASL with C. Y. Harvey, KENYON COX, and GEORGE GREY BARNARD. During 1904 she

collaborated on many sculpture groups with her studio mate, Anna Vaughn Hyatt. Like most American artists of her day, Eberle travelled to Europe, visiting Italy in 1907–8 and France in 1913. The following year, she opened her own New York City studio. A serious illness contracted in 1919 ended Eberle's active sculptural career; however, she continued to receive numerous prizes and other honors.

Specializing in depicting the crowded tenement life of the Lower East Side area where she lived, Eberle has often been compared to sculptor MAHONRI YOUNG and the Ashcan School of painters (see The EIGHT). Her carefully observed studies of slum children playing in the streets (*Roller Skating*, before 1909, WMAA) and women cleaning house stress motion, through vigorous poses, lively gestures, and windblown drapery.

ECKSTEIN, JOHANN (c. 1736–1817), and FREDERICK (c. 1775–1852), sculptors. Johann, the father, probably born in Mecklenburg, Germany, worked as a history painter and sculptor for the Prussian court between about 1772 and 1794, and came to Philadelphia in the latter year. A founder of the Columbianum Society, (see PENNSYLVANIA ACADEMY OF THE FINE ARTS), he worked as an engraver as well as a painter and sculptor. In 1811–12 he designed an equestrian monument of George Washington dressed in Roman costume.

Frederick was probably born in Berlin, and he studied there before arriving in Philadelphia with his father. He moved to Cincinnati in 1823 and lived in the Middle West for the remainder of his life. He was a teacher of HIRAM POWERS and SHOBAL VAIL CLEVENGER. In 1825 he made busts of Andrew Jackson and the Marquis de Lafayette.

EDMONDS, FRANCIS WILLIAM (1806–1863), an early specialist in genre painting. A native of Hudson, N.Y., Edmonds became a banker in New York City; however, he was able to combine his principal career with a second in art, at

first exhibiting under the pseudonym of E. F. Williams. Although he painted literary subjects, portraits, and landscapes, his primary interest was in scenes of rural everyday life, often with humorous overtones. In this he was very much part of his time, for he became a professional artist when the American public was espousing the cause of a nationalistic, indigenous art and American painters were exploring themes that might be considered distinctly American. Thus, during the 1830s, genre painting became extremely popular, and the leading practitioner was WILLIAM SIDNEY MOUNT. Edmonds's work was similar to Mount's in subject matter and in its light and optimistic viewpoint (*The Image Peddler*, 1844, NYHS). Edmonds, however, was not as fluent an artist as Mount, and his figures often verge upon caricature. His forms are heavier and his compositions more awkward; he was really at his best in the painting of still-life accessories. American 19th-century genre was ultimately rooted in the popular tradition of the Scottish painter Sir David Wilkie, who introduced anecdotal, homespun themes into British art at the beginning of the century. Edmonds's style is perhaps closer to Wilkie's than is that of any other American. He may well have been familiar with the Scotsman's work, since engravings of Wilkie paintings were widely available at the time. *Lit.*: Maybelle Mann, "Francis William Edmonds: Mammon and Art," *American Art Journal*, Fall, 1970.

EHNINGER, JOHN WHETTEN (1827–1889), a genre painter and illustrator. After graduating in 1847 from Columbia Coll. in his native New York City, Ehninger travelled abroad and spent the next six years studying in France, Italy and Düsseldorf, Germany (with EMANUEL GOTTLIEB LEUTZE). In 1853 he returned to the United States and settled in New York City. After another sojourn in Europe several years later, he moved to Newport, R.I., and then to Saratoga, N.Y., where he lived until his death. The influence of Ehninger's European training

is readily apparent in many of his paintings. In *Yankee Peddler* (1853, Newark Mus.), for example, the background architecture is clearly European, though the subject is ostensibly American. Ehninger frequently chose to paint typical American scenes: *October* (1867, NCFA), a picture of a pumpkin harvest, and *The Turkey Shoot* (1879, MFAB) are typical examples of his themes and style. In *The Turkey Shoot*, his tendency to overload his paintings makes it difficult to appreciate the carefully painted details. Ehninger also illustrated an edition of Longfellow's poem *The Courtship of Miles Standish* that suffers from the same defect.

EICHHOLTZ, JACOB (1776–1842), a leading Pennsylvania portrait specialist. Eichholtz came from Lancaster, Pa., and was encouraged in the arts by the leading portrait painter in Philadelphia, THOMAS SULLY, and then by GILBERT STUART in Boston, Mass. Eichholtz developed a style that was attractive and competent. He was able to render form three-dimensionally, and his color was clear and bright—typical of his time. His style was primarily linear, with strong sharp outlines. His interpretations were straightforward, though never harsh. But he never achieved the aristocratic, idealized manner of Sully or of JOHN NEAGLE, which was ultimately rooted in British portraiture of the 18th century and introduced into America by Stuart. Nor was his brushwork as graceful and fluid as that of Sully and Neagle. Eichholtz also painted some landscapes and one well-known Revolutionary War subject. A typical example of his work, *Portrait of a Man of the Humes Family*, of about 1815, is in MMA. *Lit.*: Rebecca Beal, *Jacob Eichholtz, 1776–1842: Portrait Painter of Pennsylvania*, 1969.

EIGHT, THE, a group of artists who opposed the conservative American art establishment of the early 20th century: ROBERT HENRI, GEORGE LUKS, JOHN SLOAN, WILLIAM GLACKENS, EVERETT SHINN, MAURICE PRENDERGAST, ERNEST

LAWSON, and ARTHUR B. DAVIES. They exhibited together only once, at the Macbeth Gall., New York City, February 3–15, 1908, and the exhibition, which had considerable public success, was a milestone in American art. It served as a rebuttal to NAD, whose members had declined to show the work of Luks, Shinn, and Glackens in its annual exhibition the year before in spite of the efforts of Henri, at the time an NAD juror. The Eight also affirmed the principle of the "free" (nonjuried) exhibition, in which the participating artists chose both their colleagues and the work to be shown. The Exhibition of Independent Artists of 1910 was inspired by The Eight, and by Henri, who had helped organize exhibitions of young and new talent at the National Arts and MacDowell clubs (see INDEPENDENT EXHIBITIONS). The Eight's spirit of rebellion was also a strong force behind the 1913 ARMORY SHOW, for which Davies not only raised funds but helped assemble the modern European works.

Stylistically, the members of The Eight represent a spectrum of progressive tendencies in American art of the early 20th century. Luks, Sloan, Glackens, Shinn, and Henri (now considered the core members, though Davies was responsible for arranging the Macbeth exhibition) often chose to paint lively and sympathetic scenes of urban life new in American painting. Theirs was a humanist vision of democracy, expressed also in the poetry of Walt Whitman, whom Sloan and Henri read and admired. They also reflected some of the gusto of contemporary social reformers. These five artists of The Eight are sometimes called the New York Realists or, more often, the Ashcan School, in scornful reference to their chosen subject matter. Luks, Glackens, Sloan, and Shinn are also linked together by their background as newspaper artists whose on-the-spot drawings were featured in the *Philadelphia Press*, *Philadelphia Eagle*, and other dailies during the 1890s. A reporter's eye, as well as the techniques of Honoré Daumier, and the English illustrators

John Leach and Charles Keene are denoted by the vivid details and expressive vignettes of Sloan's rooftop and street scenes, Glackens's park scenes, and Shinn's theater subjects.

Henri was the leader of these urban realists. He met Sloan in 1892, shortly before the establishment of the Charcoal Club (in 1893), whose members met to draw from the model and organize pageants and other festivities; later, members of The Eight gathered at Henri's studio. In Sloan's opinion, it was Henri's "magical ability" as a teacher that led so many Philadelphians to pursue artistic careers; Henri's book *The Art Spirit* (1923) gives the flavor of his thought and attitude, which were to influence two generations of American painters including GEORGE BELLOWS and ROCKWELL KENT, EDWARD HOPPER and WILLIAM GROPPER.

The other members of The Eight differed from the realists in style and choice of subject matter. Prendergast, one of the first Americans to appreciate the importance of Paul Cézanne, developed a vigorous, colorful, pointillist style. Lawson, who took a more orthodox Impressionist approach, also studied Cézanne's color. Davies's romantic and symbolist art was eclectic, derived from an appreciation of Hellenistic art, Sandro Botticelli, Pierre Puvis de Chavannes, and Hans von Marées. After the Armory Show, he experimented with Cubism. *Lit.*: William Homer, *Robert Henri and His Circle*, 1969.

**EILSHEMIUS, LOUIS MICHEL** (1864–1941), an eccentric and singular visionary painter belonging to no school or tradition. Born near Newark, N.J., he lived in Europe from 1873 to 1881. After attending Cornell Univ., he studied at ASL from 1884 to 1886 and at the Académie Julian, in Paris, from 1886 to 1887. He settled permanently in New York City in 1888, but travelled to Europe and North Africa in 1892 and to Europe again in 1902–3. At first, his paintings were reasonably advanced for an American, reflecting, until about 1895, Impressionist

influences in landscapes and Edgar De-
gas's manner in figure studies. Before
the century's turn, however, his works
began to ignore the logic of time, place,
and even gravity. In *Afternoon Wind*
(1899, MOMA), women, still painted re-
alistically, float over an arcadian land-
scape. Subsequently, his treatment of the
figure grew more personal, often sketch-
like, and simplified. Landscape elements
were summarily indicated—bushes by
quick strokes, branches by rapid linear
notes. His themes grew increasingly pri-
vate, even when founded in ordinary ac-
tivities. Although treated poetically, his
subjects were not derived from poetry,
resembling, rather, the quick visualiza-
tions of a dream. Eilshemius sometimes
draped his figures in flowing garments,
as if to give them historical connotations
despite the apparent absence of signifi-
cant action.

Neglected by the public, Eilshemius
grew increasingly eccentric, declaring
himself to be a supreme genius and the
world's mightiest intellect. His paintings,
however, reveal a truer picture of his
mind. No later than 1912, such themes
of horror and tragedy as shipwrecks and
jealous confrontations began to appear.
His colors grew ever more somber and
dark. As he began to express his moods
more quickly, perhaps, his forms as-
sumed an artless quality, as if he were
gradually shedding the influence of his
training. His style grew sketchlike and
textures were emphasized. During
World War I, Eilshemius painted battles
of the imagination, ranging from rela-
tively realistic scenes to ones including
Christ and mythical creatures (*Christ
Intervening the Dragon of War*, 1917).
Although championed by Marcel Du-
champ, who saw his painting *Supplica-
tion* in the Soc. of Independent Artists
exhibition in 1917, Eilshemius did not
gain the popularity he felt he deserved.
In 1921 he stopped painting, but, ironic-
ally, when his work was recognized by
critics in the 1930s he was no longer able
to gain from it either artistically or fi-
nancially. Although he had no followers,
elements of his style have surfaced in the

works of such painters as Louis Bouche,
who employed a feathery touch and
sketchlike finish. *Lit.*: Paul J. Karlstrom,
*Louis Michel Eilshemius*, 1978.

ELLIOTT, CHARLES LORING (1812–1868),
one of the finest American portrait
painters of the mid-century. Elliott came
from upper New York State. In 1829 he
studied with JOHN QUIDOR in New York
City, and Quidor's example inspired El-
liott about 1830 to paint a number of
somewhat awkward but dynamic and
exciting illustrations from Washington
Irving's *Knickerbocker History*. For
about ten years, Elliott was a primarily
itinerant portraitist in New York State.
From 1839 until almost the year of his
death, he was active in New York City.
In the mid-1840s, he formed a friend-
ship with HENRY INMAN, shortly before
the latter's death, and was inspired to
paint Inman's posthumous likeness
(1847, NAD). He was to become, in the
following decades Inman's successor as
New York City's premier portraitist. But
Elliott's style was startlingly dissimilar
from that of Inman and also from that of
THOMAS SULLY, Philadelphia's chief por-
traitist. Elliott's portraiture was strong,
dramatic, and individual. Except for
some of his earliest work, he avoided the
fluid paint handling and aristocratic flat-
tery of the previous generation. Instead
of the bright colors of Inman and Sully,
he emphasized the neutral tones. Nor
were his figures idealized; he did not
work from a formula for beauty or no-
bility. At his least inspired moments, El-
liott rivalled the new arts of daguerreo-
type and photography with his precise,
detailed realism; at his finest, as in *Mrs.
Thomas Goulding* (1858, NAD), his
work recalls the great character portrai-
ture of JOHN SINGLETON COPLEY, almost a
hundred years earlier. *Lit.*: Theodore
Bolton, "Charles Loring Elliott: An Ac-
count of His Life and Work," *Art Quar-
terly* 5 (1942).

ENNEKING, JOHN JOSEPH (1841–1916), a
painter. Born in Minster, Ohio, he began
his professional life in Boston, Mass., as a

landscape painter in the manner of the HUDSON RIVER SCHOOL. Enneking went to Europe in 1872, working in Munich and later in Paris, where he fell under the influence of the Barbizon School and possibly became acquainted with the work of the French Impressionists. He returned to New England in 1876, settling in Hyde Park, Mass., with a summer home in North Newry, Maine, beginning in the early 1880s. Many of his landscapes depict the White Mountains. Animals appear occasionally in his paintings, figures seldom. His works may be divided into two types of landscape interpretation. The more "advanced" pictures are brightly colored, with an all-over effect of dappled sunlight, which critics described as combining Impressionism, LUMINISM, and TONALISM, giving an impression of unity as a preeminent characteristic. Probably Enneking's finest landscapes are his more muted pictures. He was especially noted for his intimate November twilights, serene but grave works of wooded areas somewhat in the manner of GEORGE INNESS or of his good friend in Boston, GEORGE FULLER. Enneking's later pictures include his best known, which is also extremely atypical: *The Mother Church of Christ Scientist*, painted in 1907 for Mary Baker Eddy and now in the Eddy home in Brookline, Mass. *Lit.*: Patricia Jobe Pierce, *John Joseph Enneking: American Impressionist Painter*, exhib. cat., Pierce gall., north Abbington. Mass. 1972.

ESTES, RICHARD (b. 1936), a major painter in the style of PHOTO-REALISM. From Kewanee, Ill., he studied at AIC from 1952 to 1956 and then moved to New York City in 1959. He lived in Spain in 1962. Always a realist, he preferred painting the urban scene from the outset of his career. His works of the mid-1960s focused primarily on people. Buildings were generalized, colors were earthy in tone and forms were brought to a medium sharpness of focus. By 1967 his paintings had become hard-edged. Colors brightened and more closely approximated actuality, and architectural forms began to replace people as objects of interest. An example of this phase of Estes's work is *Candy Store* (1968–69, WMAA). Estes photographs a scene before creating a painting. Working with several views of what he has chosen to depict, he combines forms and colors, often making a number of alterations, until the "finished" version is locked on the canvas. He tends to bring his work to a point of near-completion with acrylics and then, for depth and clarity of focus, to switch to oils. In several works, including *Central Savings* (1975, Nelson Gall.), reflections from glass surfaces, such as large picture windows, create incredibly complex readings of depth. Occasionally, the viewer finds he is really studying the reflected shape of a building that must be behind him. Some works (*Ansonia*, 1977, WMAA) that are ostensibly views up one side of a street are actually full views because of window reflections of the other side. Here again, the viewer sees forms presumably outside of the picture space. For artists such as Estes, the city is a visual spectacle rather than the psychological vortex described by the earlier realist EDWARD HOPPER. Indeed, Estes's city is usually a bright, sunny place where even the garbage may look attractive. *Lit.: Richard Estes: The Urban Landscape*, exhib. cat., MFAB, 1978.

EVANS, DE SCOTT (1847–1898), a newly rediscovered, late 19th-century still-life painter. Evans was a middle-western artist, who studied in Paris with Adolphe William Bouguereau and taught at the Cleveland Acad. of Fine Arts before moving to New York City in 1887. He was primarily a painter of portraits and genre pictures, including many small scenes of attractive young women in interiors, somewhat in the manner of the Belgian artist Alfred Stevens; he was also a decorator of note and actually lost his life in the sinking of the S.S. *Bourgogne*, on his way to Paris to execute a ceiling. Although he painted occasional tabletop fruit still lifes, Evans's best-known pictures, which appear to have been paint-

ed in his New York years, are vertical still lifes of fruit—apples or pears—hanging on a string against a simulated wooden background with illusionistically painted graining, chips, cracks, and knotholes. The humor in such deceptions appears to have been carried still further by Evans in a series of pictures, almost identical to those described above but signed with the pseudonym Scott David (actually, the artist was born David Scott Evans; only after his French years did he Gallicize his name). There is yet another group of paintings, signed "S. S. David," depicting a glass-fronted case filled with peanuts, or, in one case, with almonds (*Peanuts*, Portland [Oreg.] Mus.). These are equally illusionistic, the glass covering seemingly cracked and broken with a nut or two appearing to "escape" out of the case toward the spectator. The reason why Evans adopted these pseudonyms is unknown; perhaps his still-life jokes seemed too private and too trivial for acknowledgement by a high-style figure painter.

EVANS, WALKER (1903–1975), a photographer. Born in St. Louis, Mo., he spent his childhood in Chicago and moved to New York City with his mother when his parents separated. Hoping to become a writer, he attended Williams Coll. but returned to New York after one year. He spent 1926–27 in Paris, auditing classes at the Sorbonne and studying contemporary painting. In 1928 he began to teach himself photography, looking with disdain on what he saw as ALFRED STIEGLITZ's "artiness" and EDWARD STEICHEN's "commercialism." About 1931 Lincoln Kirstein, then editor of *Hound and Horn*, where Evans's first photographs were published, encouraged him to photograph the indigenous architecture of New England. He also photographed the ordinary trappings of American daily life in a straightforward, unemphatic style. Spurning all commercial work, he illustrated Hart Crane's *The Bridge* (1930) and Carlton Beal's *The Crime of Cuba* (1933). His first one-man show was held at the Julien Levy Gall., New York City, in 1932.

Evans's most important and best-known work was done for the FSA (see FARM SECURITY ADMINISTRATION PHOTOGRAPHS) from 1935 to 1937, when he travelled through the South and documented the rural poor and the small towns, with their stores and schools. Evans was brilliant at evoking the people, their poverty and their way of life, by recording the interiors of their cabins and shacks. The objects of a dignified squalor make their owners' lives more present than actual portraits. A perfect tonal and textural clarity characterizes all of Evans's photographs, but none are so moving as those done in that year and a half. In 1938 an exhibition of Evans's FSA photographs at MOMA resulted in his book *American Photographs* and in 1941 a selection accompanied James Agee's *Let Us Now Praise Famous Men*.

In 1938 and 1941, Evans made a series of photographs of subway riders with a camera hidden under his topcoat, sacrificing control of composition and lighting for immediacy of mood. During the mid-1940s, he did a similar series on the streets of Chicago and New York. Returning to writing, he joined the staff of *Time* magazine from 1943 to 1945 and in 1945 transferred to *Fortune* magazine as a writer and photographer. In 1965 he became professor emeritus of graphic arts at Yale Univ., where he remained until his death.

Throughout his career as a photographer, Evans maintained qualities of reticence, objectivity, and the greatest clarity. His subjects were invariably people or their environments, structures, and artifacts of daily life. More than social statements, his pictures often display an irony of juxtaposition, and always a stark beauty. The uncompromising directness with which he looked at the life of America initiated an important tradition, the "social landscape," continued in the work of ROBERT FRANK. A collection of Evans's work is at MOMA. *Lit.*: Walker Evans, *Walker Evans*, 1971.

EVERGOOD, PHILIP (1901–1975), a painter, social realist, and fantasist. Born Philip Blashki, in New York City, Evergood

grew up in England where he lived from 1909 to 1923. From 1921 to 1923, he studied at the Slade Art School, in London, and, after moving to America, at ASL in 1923–24. From 1924 to 1926, he lived abroad, primarily in Paris, where he attended the Académie Julian and classes given by André Lhote. He lived abroad again from 1929 to 1931, staying in France and Spain, where the paintings of El Greco especially impressed him. Despite his years in Europe, he chose to return to live in America, the country he considered his own. From 1934 to 1938, he worked for the Public Works of Art Project and the WPA–FAP (see FEDERAL ART PROJECTS). His murals include *The Story of Richmond Hill*, 1936–37, for the district library in that part of New York City, and *Cotton from Field to Mill*, in 1938, for the Jackson, Ga., Post Office. Politically active, Evergood took a constructive role in the art movements of the 1930s, including picketing when necessary and serving as president of the Artists Union.

During the 1920s and early 1930s, Evergood painted many imaginative and biblical themes. His style reflected Paul Cézanne and El Greco but had a deliberate awkwardness of form and figural arrangement. His spaces tended to be shallow, and colors clashed rather than coordinated. In these as well as subsequent paintings, the figures hover in a world that is neither realistic nor fantastic, but a mixture of logical and imagined space. In such works as *M. T. Florinsky and D. S. Mirsky and the Pidget* (1928, and c. 1945), Evergood's virtuoso linearism asserted itself in face of his then more typical Cézannesque sense of modelling. In fact, through the 1930s, modelling and contour seemed to vie for dominance within his figures—the contest, in the main, resolving itself in favor of the latter during the 1940s.

By 1935 Evergood had turned to social realism (see AMERICAN SCENE PAINTING), his work reflecting the agonies of the Depression without preaching or pointing to specific courses of political action. A major exception is *American Tragedy* (1937), painted in response to a pitched battle between pickets and police at a steel mill in Gary, Ind. On the other hand, *The Story of Richmond Hill* is a painted hymn to that aspect of the American dream in which enlightened social planning creates idyllic living and working conditions. Like other artists who found topical and political themes less appealing after 1940, Evergood allowed a poetic, fantastic vein to emerge in his work. *Moon Maiden* (1944), an early example, is less a reproach against superficial aspects of American life than a romantic dream about an excursion of a young woman through an unreal space inhabited by businessmen, hornets, and buildings. Conscious of his effects, Evergood said that he sought to combine the daring of JACKSON POLLOCK with the discipline of Giotto. His fantasy was free, but never allowed to run uncontrolled. In the 1950s, satire appeared in such works as *Satisfaction in New Jersey* (1951). Other works suggested social themes but lacked plausibility, as if studio nudes rather than workers had been asked to pose. In the late 1950s and later, Evergood occasionally attempted richly textured, thickly brushed expressionist works but did not significantly lose his great linear virtuosity. In a few pieces, such as *The New Lazarus* (1927, 1940, 1954; WMAA) Evergood reworked earlier paintings. *The New Lazarus* is a good example of Evergood's occasional forays into an art of complex but not arcane meaning. *Lit.*: John I. H. Baur, *Philip Evergood*, 1975.

EZEKIEL, MOSES JACOB (1844–1917), a second-generation expatriate sculptor. From Richmond, Va., he studied anatomy at Virginia Medical Coll. before turning to sculpture in 1868. In that year, he moved to Cincinnati, where he studied with John Insco Williams and worked under Thomas D. Jones. The following year, he went to Berlin to study at the Royal Art Acad. and in 1874 travelled to Rome, where he spent the remainder of his life with the exception of occasional trips to America. Very popular in his day, he carved the figural group *Religious Liberty* in 1874 (now in

Philadelphia's Fairmount Park) as well as other imaginative works, some based on such ancient themes as Homer and Guide (Univ. of Virginia). A major portraitist as well, he was commissioned in the 1870s to carve busts of the world's twelve greatest artists (all now in the Botanical Gardens, Norfolk, Va., with the exception of *Thomas Crawford*, in the Virginia Mus.). Ezekiel's work is among the last by the American neoclassical school in Rome. After 1875 sculptors began increasingly to turn to Paris for inspiration and to emulate the more realistic and meticulously detailed styles developed there.

# F

FARM SECURITY ADMINISTRATION PHOTO-
GRAPHS (1935–43). Originally called the
Resettlement Administration, the FSA
was a branch of the U.S. Department of
Agriculture headed by Roy Stryker, es-
tablished primarily for the purpose of
making a photographic record of the
devastation of the Depression as well as
to convince the public of the need for
federal aid to those farmers suffering
from the effects of foreclosure and dust
storms. Although the best-known pic-
tures are of the South, the program ulti-
mately undertook the social documenta-
tion of all areas of the country. The FSA
hoped to reunite the nation by showing
to the urban poor (and to the rich) the
plight of the rural poor. It marked the
beginning of the important photograph-
ic tradition of the "social landscape" (see
EVANS, WALKER; FRANK, ROBERT).

Stryker, who had earlier worked with
LEWIS WICKES HINE, hired Walker Ev-
ans, DOROTHEA LANGE, Carl Mydans, Ar-
thur Rothstein, and BEN SHAHN; he later
recruited John Collier, Jr., Jack Delano,
Russell Lee, Gordon Parks, Marion Post-
Wolcott, John Vachon, Theodor Jung,
Paul Carter, and Arthur Siegel. All of
these photographers, with the exception
of Evans, used the Leica, a small hand-
held camera that greatly facilitated the
photographers' mobility and enabled
them to record fleeting moments and ex-
pressions that could not be captured with
the old 8-by-10-inch view camera.
Stryker asked them to "look for the sig-
nificant detail. The kinds of things that a
scholar a hundred years from now is go-
ing to wonder about." The photogra-
phers concentrated on small-town life,
the poor farm families, and the dispos-
sessed, frequently posing the people in
front of or inside their homes in a
straightforward manner, recording their
shabby clothing and meager possessions
and the stark surroundings.

The FSA pictures document the tragic
lives of those worst hit by the Depres-
sion, but they also preserve a glimpse of
an American small-town life now van-
ished. Seventy thousand FSA photo-
graphs were deposited in the Library of
Congress, Washington, D.C. *Lit.*: *The
Bitter Years 1935–1941*, exhib. cat.,
MOMA, 1962.

FARNY, HENRY F. (1847–1916), an illus-
trator and painter of western scenes.
From Ribeauville, Alsace, his family set-
tled near Warren, Pa., in 1853 and
moved to Cincinnati in 1859. Farny
worked in that city for engravers and
lithographers as well as for *Harper's*
magazine before moving to New York
City in 1867. In that year, he journeyed
to Düsseldorf, Germany, where he brief-
ly studied. After returning to the United
States for a few years, he commenced his
studies again in Munich in 1875–76.
During the 1880s, he made several trips
to the West. His sketches were dissemi-
nated in magazines and newspapers un-
til 1890, when he turned almost exclu-
sively to painting. He tended to record
the quieter aspects of Indian life—camp
scenes (*Indian Camp*, 1890, Cincinnati
Mus.) and views of Indians on the trail.
Despite his acquaintance with FRANK
DUVENECK and the Munich style, Farny's
images usually are sharply delineated
and distant vistas are clearly focused.
The Cincinnati Mus. owns many of his
paintings. *Lit.*: Pinkney L. Near, *Henry
F. Farny: 1847–1916*, exhib. cat., Cin-
cinnati Mus., 1965.

FEDERAL ART PROJECTS, a range of pro-
grams to assist artists, sponsored by the
government between 1933 and 1943.
Part of the broader history of govern-
mental relief during the depression of
the 1930s, the Federal Art Projects have
a vital history of their own. Born from

the desperate need that ensued in the wake of the stock market crash of 1929, the Projects offered artists a livelihood as well as a kind of official recognition and community backing they never received in earlier or later decades. From 1930 to 1933, various schemes were put forth to help needy artists, the most important of which was that sponsored in 1932, by the Gibson Committee, a relief organization in New York City, and the College Art Assoc. It was apparent, however, that federal support on a nationwide basis was necessary. In May, 1933, GEORGE BIDDLE tried to interest his friend President Roosevelt in a mural painting program that would emulate the Mexican mural movement of the 1920s. Roosevelt responded favorably, perhaps also influenced by the Emergency Work Bureau Artists Group (later, the Artists Union), which petitioned Harry Hopkins, director of the Federal Emergency Relief Administration, in December, 1933. A half-year program was instituted in the same month, called the Public Works of Art Project (PWAP), financed by the Civil Works Administration. Organized into sixteen regional divisions, each manned by museum administrators and volunteers, PWAP was guided from Washington, D.C., by Edward Bruce, the director, and by Forbes Watson, the technical director, and his assistant, Edward Rowan. Its primary aim was to employ artists to decorate nonfederal public buildings and parks. The program's dominant theme was the American Scene (see AMERICAN SCENE PAINTING). By June 30, 1934, when PWAP ceased to exist, it had aided 3,749 artists, who had produced an estimated 15,633 works in a variety of media.

As this experiment in governmental support was a success, other programs were developed to take into account qualitative differences among indigent artists. In October, 1934, the Section of Painting and Sculpture was established in the Treasury Department to secure art of the highest quality for public buildings through open competitions. An elitist program led by Bruce, Watson,

and Rowan, it was funded by a small percentage (1 percent) of the money allocated for the construction of public buildings. The first major projects undertaken by the section included the decoration of the Justice and Post Office Department buildings in Washington, D.C., by such artists as Biddle, JOHN STEUART CURRY, ROCKWELL KENT, and LEON KROLL. At its demise in July, 1943, the Section had commissioned 1,116 murals and 301 sculptures for new federal buildings. Its name was changed in 1938 to Treasury Section of Fine Arts, and in 1939 it became the Section of Fine Arts of the Public Buildings Administration of the Federal Works Agency, an organization outside of the Treasury Department. In keeping with a government program of this type, the Section favored conservative and platitudinous art and safe rather than adventurous subject matter.

The Treasury Relief Art Project was a smaller sibling of the Section. Sponsored by the Works Progress Administration, but administered by the Treasury Department, TRAP existed from July, 1935, to June, 1939. Directed by Olin Dows, it was more of a relief program than was the Section, although, it, too, sponsored the decoration of public buildings. Most of its artists were hired from relief rolls, and commissions were granted for murals and sculptures for small post offices and already erected federal buildings. A master artist usually ran each project. Under its aegis, 446 artists completed 10,000 easel paintings, 43 sculptures, and 89 murals.

The largest federal program, and the one many people confuse with all of the others, was the Works Progress (later Works Projects) Administration's Federal Art Project (WPA-FAP), which included units for art, music, theater, and literature. A work relief project, it was established in October, 1935, and existed until July, 1943, under the direction of Holger Cahill. Major subdivisions of the art unit included easel painting, graphics, motion pictures, murals, photographs, posters, and sculpture, as well as

the Index of American Design, the Design Laboratory, and the Art Teaching Division. Under WPA-FAP, 108,000 paintings, 200,000 prints of 1,000 designs, 2,500 murals, 2,000,000 silk screen posters of 35,000 designs, and 23,000 plates for the Index were produced. Except for those employed by Index, which was devoted to copying examples of pre-20th-century crafts and decorative objects, artists in WPA-FAP were allowed greater freedom of experimentation than those employed by the Section. Their works ranged from realistic to surrealistic, to abstract, and the themes they chose included both chauvinistic and critical appraisals of the American past and present. The name of WPA-FAP was changed in 1939 to Art Program of the Works Projects Administration of the Federal Works Agency and, in 1942, to Graphic Section of the War Services Division.

A smaller painting and photographic project sponsored by the Resettlement Administration was initiated in 1935. The photographic program was enlarged and taken over by the Historical Section of the Farm Security Administration. Under Roy Stryker's direction, 270,000 photographs were made, of which 70,000 are in the Library of Congress. (see FARM SECURITY ADMINISTRATION PHOTOGRAPHS). *Lit.*: Francis V. O'Connor, *Federal Support for the Visual Arts: The New Deal and Now*, 1969.

FEININGER, LYONEL (1871–1956), a Cubist painter and printmaker. Although Feininger was born in New York City, his development as an artist and a great part of his career took place abroad. In 1887 he went to Germany to study music but instead decided to study art. He enrolled first at the Kunstgewerbeschule in Hamburg and later at the Berlin Acad. Feininger drew political cartoons for German newspapers to earn a living in the late 1890s. A contract for cartoons from the *Chicago Sun Tribune* gave him the means to move to Paris for two years. There, from 1906 to 1908, Feininger saw the work of the Post-Impres-

sionist painters Vincent Van Gogh and Paul Cézanne. He gave up cartooning to become a full-time painter and returned to Germany. In 1911 he exhibited several of his paintings at the Salon des Artistes Indépendants in Paris. While in Paris to see the exhibition, he became aware of Cubism. He met the artist Robert Delaunay, whose Orphic Cubism was a major influence on his painting. He shared Delaunay's interest in the emotional effects of color as well as in the architecture of the city as subject matter for painting. Feininger painted the Gothic architecture of Germany, fracturing his medieval cityscapes into facets of color (*Gaberndorf II*, 1924, Nelson Gall). Aspects of modern life also interested Feininger: Factories, bridges, ships, and harbors were presented in the same quiet, pristine fashion as the cathedrals. Feininger was associated with many of Germany's avant-garde artists. In 1913 he exhibited with the Blaue Reiter group (which included Franz Marc, Wassily Kandinsky, and Paul Klee). In 1919 Walter Gropius, founder of the Bauhaus, invited him to join the faculty of the school in Weimar. Feininger's woodcuts were also used to illustrate Bauhaus publications. Feininger stayed with the Bauhaus through its moves to Dessau and Berlin. After the Nazis closed the school in 1933, Feininger was left in Berlin without employment. He taught in 1935 at Mills Coll. in Oakland, California. He returned to Germany for only one year and then came to the United States again, in 1937. In 1937 some of Feininger's paintings were confiscated by the German government and exhibited in the infamous Nazi show of "degenerate art." In 1938 Feininger executed murals for two buildings at the 1939 New York World's Fair. His work can be seen in public collections throughout the world, including the MMA, MOMA and WMAA. *Lit.*: June L. Ness (ed.), *Lyonel Feininger*, 1974.

FEITELSON, LORSER (1898–1978), an abstract painter. Feitelson was born in Savannah, Ga., and was raised in New

York City. His father, a businessman with an interest in art, encouraged him to pursue a career as an artist. As a young man, he studied both the library and painting collections at MMA, and especially works by the Renaissance masters Michelangelo and Tintoretto. Feitelson was also exposed to European modernism, first through art journals, then at the ARMORY SHOW of 1913. At the age of eighteen, Feitelson had a studio in Greenwich Village and was an active member of the New York City art world. In 1919 he made the first of several trips to Paris. In 1927 he travelled to Los Angeles, where he settled permanently. There, as one of few artists with a direct experience of modern art, Feitelson was a strong influence on the local avant-garde.

His early work in the modern idiom attempts to merge the rhythmic composition of the late Renaissance with stylistic elements of Cubism and Futurism. His pictures in this manner are in this respect similar to the early figural work of THOMAS HART BENTON. In Los Angeles during the late 1920s, Feitelson's work changed. Interested in Surrealism, he developed, with the painter Helen Lundeberg, an American variant, called subjective classicism. In the late 1930s, Feitelson was an administrator of the southern California WPA-FAP and produced five murals under its auspices. Feitelson found his mature style in the mid 1940s. His work after this date was entirely abstract. He evolved his forms from nature, but made few specific natural references. The spatial ambiguity caused by color and tone contrast and perceptual confusion between figure and field are the major concerns in his mature work (*Hard-Edge Line Painting*, 1964, Univ. of Virginia). Although Feitelson worked in southern California, his hard-edged style has affinities with the work of other hard-edged painters, especially ELLSWORTH KELLY, Myron Stout, and Leon Polk Smith. His work can be seen in the WMAA, LACMA, and the Long Beach Mus. of Art, Long Beach, Calif. *Lit.*: Diane Moran, "On Lorser Feitelson," *Art International*, Oct.-Nov., 1977.

**FEKE, ROBERT** (c. 1705–1751), a portrait painter, generally considered to be the most important artist in America before JOHN SINGLETON COPLEY, as well as a significant figure in the development of a native style of painting. Few facts are known about his life. According to family tradition, he was born in Oyster Bay, Long Island, N.Y., the son of a preacher. It is said that before beginning his career as an artist Feke was a mariner. As such, he presumably made trips to England and the Continent, where he no doubt assimilated some knowledge of European painting. In 1742 Feke was married and settled in Newport, R.I., having given up his career at sea.

About sixty surviving portraits can be attributed to him, ranging in date from 1741 to 1750. Like most colonial artists, Feke was an itinerant, and he worked between Boston, Mass., Newport, R.I., and Philadelphia. The most important painting of his early career is *Isaac Royall and His Family* (1741, Harvard Univ. Law School). It is clearly based on JOHN SMIBERT's *The Bermuda Group* (1728–29), which Feke probably knew firsthand. The composition is simplified, and there is less emphasis in Feke's group portrait on sculptural form and more upon surface pattern and the accurate depiction of textures and details. Feke's work after this time shows an increasing individuality, as can be seen in *Mr. Tench Francis* (1746, MMA), which was painted in Philadelphia. Feke included a landscape in the background of his portrait, a conventional way of indicating that the subject was a person of importance. He enhanced the tradition, however, by making the landscape a topographical view of Francis's farm in Willingboro, N.J. The trip in 1746 to Philadelphia seems to have been important in Feke's career since the number of works he produced each year thereafter greatly increased.

Often considered one of his most accomplished portraits is *Isaac Winslow*

(1748, MFAB), done in Boston. This late work shows Feke's mastery of technique in the careful definition of forms and depiction of details. The subject is more successfully integrated with the landscape, yet, at the same time, an attractive ornamental pattern was created on the picture surface by a pronounced contouring of shapes and by an emphasis on the textures of the costume.

We have no information about Feke after 1751, when he left Newport, until 1767, when his name entered a record that states that he was deceased. According to family tradition, Feke left Newport about 1750 on a long voyage from which he never returned. He may have died in Bermuda, but some believe that his destination was Barbados, a prosperous colony at the time, where Feke may have gone to find commissions. There is record of a burial of a Richard Feak on the island in 1752, and it has been suggested that this may actually have been Robert Feke, the painter. *Lit.:* R. Peter Mooz, "Colonial Art," in *The Genius of American Painting*, ed. John Wilmerding, 1973.

FERBER, HERBERT (b. 1906), a sculptor. From New York City, he became a dentist in 1930, but had already begun to study art seriously by 1926. From 1927 to 1930, he attended the Beaux-Arts Inst. of Design in New York City, and during those years also travelled in Europe, where he was introduced to the sculpture of Ernst Barlach and to German Expressionism. Shortly thereafter, he made his first wood and stone carvings, combining interests in solid volumes with frank contours, as in *To Fight Again* (1936–37, MMA). At the time, his subject matter was symbolic yet realistic. In 1940, however, he began to make open wood pieces by gluing and dowelling, and through the mid-1940s, under the influence of the European sculptors Ossip Zadkine and Henry Moore, his forms grew more slender and open. Images of reclining women, for instance, became curved and bent arabesques in space. After experimenting with soldered metal

(by 1945) and the blowtorch (in 1949), Ferber modified his style to include spiky forms that broke the once-continuous outlines of his earlier pieces. The new works, created in the ambience of Surrealism, were among the earliest Abstract Expressionist sculptural pieces then being made (see ABSTRACT EXPRESSIONISM). Examples are *Labors of Hercules* (1948, New York Univ.) and *Portrait of Jackson Pollock* (1949, MOMA). The new pieces, abstracted from nature, appeared menacing and aggressive, filled as they were with hooks, spikes, knobs, and projections. They either sprawled around an implied center or lifted up vertically from their bases.

After receiving a commission for the facade sculpture of the B'nai Israel Synagogue, Millburn, N.J., in 1950–52—one of several religious commissions he has been granted—Ferber began to eliminate the base. Exploring this idea in both freestanding and hanging works, in 1954 he came upon the idea of "roofed sculpture," in which parts were raised from a flat base and hung from an attached ceiling, as in *Sundial* (1956, WMAA). By 1958 these pieces had been enlarged to architectural scale. They did not create voids and spaces within themselves as much as help define the space of the entire environment. One such piece is installed in the Rutgers Univ. Art Gall. Through the 1960s, he explored related ideas using relatively thin rods of sculpture to envelop spaces. Some of these were made from Corten steel. In the 1970s, Ferber began to devote considerable time to painting. *Lit.:* Wayne Anderson, *The Sculpture of Herbert Ferber*, exhib. cat., Walker Art Center, 1962.

FIELD, ERASTUS SALISBURY (1805–1900), an itinerant portrait painter born in Leverett, Mass. Although he may have served a short apprenticeship in SAMUEL F. B. MORSE's New York City studio in 1824, Field never became a trained artist. He returned to his home state in 1825 and began his career combing central Massachusetts for commissions and

painting portraits that are clearly not the work of an artist skilled in academic methods. The modelling is flat and the figures ill-proportioned by traditional standards. Yet they have appeal. The play of pattern, color, and line reveals an artist of inherent ability. In the 1840s, Field returned to New York City. Little is known of his activities during this period, although he was listed as an artist in city directories. Apparently, he learned to operate a daguerreotype camera at that time. In 1848 he returned once more to Massachusetts, where he again worked as a portraitist, often relying on daguerreotypes as models for his paintings. About 1850 he began to paint historical and biblical subjects. The best-known of these is *Historical Monument to the American Republic* (Springfield Mus.), which he executed in 1876 to commemorate the centennial of the American Revolution. Highly detailed and completely literal, it has the exuberant charm of a child's drawing and looks forward in style to the work of HORACE PIPPIN and ANNA (GRANDMA) MOSES. The Shelburne Mus., Shelburne, Vt., and MFAB have examples of Field's work. *Lit.:* Mary Black, "Rediscovery: Erastus Salisbury Field," *Art in America*, Jan., 1966.

FISHER, ALVAN (1792–1863), the earliest native American landscape specialist. Fisher spent his life in the Boston, Mass., area, studying early with the painter of decorative and ornamental scenes John Ritto Penniman. He was doing rural landscapes as early as 1811, in harsh, dramatic tones, but by the end of that decade his style had become softer and more refined. After a trip to Europe in 1825, Fisher returned to Boston. In his later landscapes, the figures are small and delicate, though seldom fully integrated into the scene (looking rather like decals), and the colors are poetically lyrical. Among his finest are a number of depictions of Niagara Falls (two in NCFA and one, dated 1831, in WA) in which the grandeur of the natural phenomenon is successfully represented and contrasted with insignificant human figures along the shore. In these, Fisher was actually more convincing than were his more famous contemporaries JOHN TRUMBULL, JOHN VANDERLYN, and THOMAS COLE, though his interpretation does not approach in monumentality or vastness the later definitive treatment of the subject by FREDERIC EDWIN CHURCH. Though Fisher is today remembered primarily as a landscape painter, he produced a large number of competent if rather unmemorable portraits, some very early paintings of animals—famous racehorses—and early examples of rural genre in barn scenes and stable interiors, the latter in the tradition established in England in the 18th century by the well-known George Morland.

FLANNAGAN, JOHN B. (1895–1942), a sculptor. From Fargo, N. Dak., he studied art at the Minneapolis Inst. of Arts from 1914 to 1917. Encouraged by ARTHUR B. DAVIES (for whom he worked as a farmhand in 1922–23) to carve directly in wood, Flannagan reexplored this kind of direct attack on the material, as did ROBERT LAURENT and WILLIAM ZORACH at the same time. His early themes, revealing primitive influences, and invoking religious qualities, were derived from female and animal forms, brought to life through rounded volumes and sharp planes. Flannagan began to carve directly in stone in 1926, preferring natural to quarried material. Especially in his sandstone, limestone, and granite pieces, one senses his utter respect for natural form and texture, as if the living presence of each stone contributed to the life of the subjects chiselled into and released from it. He seemed to be searching in each mass for an archetypal form, particularly in such mother-and-child and birth-and-rebirth pieces as *Monkey and Young* (1932–33, Addison Gall.) and *Jonah and the Whale* (1937). In his mature style, especially after trips to Ireland in 1930–31 and 1932–33, his pantheism is quite evident. He eliminated accidental details, giving each statue a compact, earthbound density, as if each

piece were caught in an early moment of its evolution. A similar concern for the basic, the timeless, and the changeless was manifested by other artists in the late 1930s and 1940s, for example, JACKSON POLLOCK and ADOLPH GOTTLIEB. Because of physical disabilities, Flannagan committed suicide. *Lit.: The Sculpture of John B. Flannagan*, 1942.

FLAVIN, DAN (b. 1933), a multimedia artist. From New York City, he had little formal training. His early paintings and mixed-media reliefs reflect his knowledge of the contemporary art scene in their references to ABSTRACT EXPRESSIONISM and to the work of JASPER JOHNS. In 1961 Flavin made his first "electric-light icons," square panels topped or ringed by incandescent or fluorescent lights. In these he attempted to invoke magical presences, which, as he said, celebrated barren rooms. In 1963 he produced his most seminal work, a fluorescent tube hung diagonally on a wall. Since then, he has used standard-length light tubes of different colors placed on walls, in corners, and as freestanding units. Usually, they are arranged to suit the space in which they are exhibited rather than as objects complete in themselves, as in traditional sculpture. Each piece has three major aspects: the light of the tubes, the diffusion of light from the tubes, and the tubes' arrangement. Despite the fact that Flavin has dedicated his works, each presentation has only phenomenal meaning. Flavin has preferred the term "image-object" to describe his use of the medium and has called his pieces "proposals" rather than sculpture. Like FRANK STELLA in the 1960s, Flavin wanted his pieces to be quickly comprehensible and to be viewed as "keenly realized decoration." Examples are *The Nominal Three (to William of Ockham)* (1968, National Gall. of Canada, Ottawa) and *Pink and Gold* (1968, Mus. of Contemporary Art, Chicago). *Lit.:* Brydon Smith, *Fluorescent Light, etc., from Dan Flavin*, exhib. cat., National Gall. of Canada, Ottawa, 1969.

FOLEY, MARGARET (c. 1820–1877), a New England cameo portraitist and sculptor. The exact year and place of her birth are uncertain. Largely self-taught, Foley established a reputation for fine cameo-cutting in Boston, Mass., before traveling to Rome in 1855 to study the art of sculpting marble, as were so many of her female colleagues (see WHITE MARMOREAN FLOCK). In Rome, the charm and precision of Foley's cameo work, exemplified by her portrait of William Cullen Bryant (NYHS), became part of a delicate portrait style in other media. Her work was renowned for its appeal and its fidelity to the subject, and, despite the fact that the artist visited America only once, in 1865, after settling in Rome, she received numerous commissions from American patrons. Among her best-known full-scale sculptures are a bust of Henry Farnam (1868, Yale Univ.) and a bronze statue of General Stonewall Jackson, cast in London and erected in Richmond, Va., in 1873. Foley was represented at the Philadelphia CENTENNIAL EXPOSITION, where her gracefully designed fountain of overlapping leaves supported by figures of small children was placed in the Horticulture Building. *Lit.:* William H. Gerdts, Jr., *The White Marmorean Flock*, exhib. cat., Vassar Coll., 1972.

FOLK ART a term used (almost interchangeably with "naive art" and "primitive art") to describe art not associated directly with cosmopolitan centers or institutions of artistic training. Folk Art has been called by Holger Cahill, one of the first modern scholars in the field, "the expression of the common people, made by them and intended for their use and enjoyment." Folk artists have worked in the traditional fine-arts media of painting and sculpture in addition to designing and making objects for practical use. But even though fine-arts sources lie behind Folk Art, many categories of production, such as weathervanes, are clearly derived from the craft traditions of wood- and metal-working. In America, Folk Art traditions have

usually reflected ethnic background. Thus, we find African-influenced work in the Southeast, Spanish and Pre-Columbian styles in the Southwest, and northwest European traditions throughout the American Northeast, Middle West, and Far West. Some Folk traditions, such as the Pennsylvania German, developed from already established Folk sources, whereas others were derived, at both a geographical and a stylistic distance, from cosmopolitan ones. Although it has existed almost from the time of the first European settlements, Folk Art—at least that inspired by the traditions of northwestern Europe—flourished particularly from about 1770 to about 1875, when photography and machine-made objects assumed many of the untrained artists' functions.

In the field of Folk painting, both itinerant artists and those who lived in one community for most of their lives made portraits, biblical and imaginary scenes, landscapes, genre pictures, still lifes, and memorials, as well as wall decorations, signs, fireboards, and cornice and overmantel decorations. Some artists, like WINTHROP CHANDLER, built up extensive practices and developed distinctive styles. Most received minimal training and often used models, such as engravings, derived from cosmopolitan originals. (For example, a Folk portrait by AMMI PHILLIPS may be similar in pose and composition to a sophisticated portrait made by the English artist Sir Godfrey Kneller a century or so earlier.) Some of the more than six hundred identified Folk painters specialized in wall decorations as did RUFUS PORTER; in ship portraits as did JAMES and JOHN BARD; or in biblical scenes as did EDWARD HICKS. Common stylistic traits include frontality, minimal modeling, taut contouring, emphasized outlines, flattened forms with no atmospheric envelope around them, simplified compositions, unmodulated and often bright colors, and careful attention to detail. Instead of providing forms with dominant and subordinate elements or clear and less clear parts, in an approximation of normal vision, Folk artists tend to paint memory images of separate units, bringing to each a clarity of focus not optically verifiable. In addition, folds in clothing and hanging draperies are usually systematized rather than painted in natural falls. Although facial features may vary from work to work, eyes tend to stare and lips appear to be pasted on.

One special and interesting category of Folk painting is the work done in female seminaries, particularly during the first four decades of the 19th century. Subjects included flower and fruit arrangements, but portraits and imaginative works were also attempted.

Perhaps most interesting of all are memorial paintings, which usually include figures arranged around a tomb or gravestone with a weeping willow nearby. These were sometimes stenciled or copied from prints and in their fine detailing recall embroidery designs. The names Harriet Moore and Harriet Sewall are often associated with these works.

Another important category is the fractur painting of the German settlers of southeastern Pennsylvania. Originally a style of writing based on a 16th-century German typeface itself derived from medieval manuscripts, fractur soon came to encompass painting when it was introduced in America at the Ephrata Cloister in Lancaster County in the late 1720s. A fractur painting recorded births, baptisms, weddings, and other memorable events and included views of buildings and farms as well as portraits and fanciful subjects. The techniques of fractur painting were taught in local schools until the Civil War. Its patterns were also applied to ironwork, furniture, pottery, glassware, and architectural ornament.

Folk sculpture included all sorts of carving: weathervanes, signs, gravestones, lawn figures, ship figureheads, cigar-store Indians, and scrimshaw (incised designs on whale bones and teeth). Works were often brightly colored. The earliest extant carved gravestones date from about 1650, and the ornamentation includes symbols of the passage of time

and of death and resurrection. Portraits of the deceased were added in the early 18th century. Ship figureheads, usually but not always female, have been identified with such craftsmen as Samuel McIntire and Isaac Fowle. Julius Theodore Melchers was one of the ablest carvers of Indian figures. In both categories, pine wood was the preferred medium.

The first important studies and exhibitions of Folk Art occurred in the 1920s, and major collections were first assembled at that time. Important collections are now housed in MMA; MFAB; the Shelburne Mus., Shelburne, Vt.; Williamsburg, Va. (the Abby Aldrich Rockefeller Folk Art Collection); Old Sturbridge Village, Mass.; the Henry Ford Museum, Dearborn, Mich.; and the Smithsonian Institution, Washington, D.C. *Lit.:* Jean Lipman and Alice Winchester, *The Flowering of American Folk Art: 1776–1876,* 1974.

FRANCIS, JOHN F. (1808–1886), one of the finest mid-19th century still-life specialists. Francis was born in Philadelphia and, though he spent much of his life in rural Pennsylvania, he helped maintain the strong still-life tradition of 19th-century Philadelphia after the Peale family (see PEALE, CHARLES WILLSON) and before WILLIAM MICHAEL HARNETT. His career reflects the thematic development of American painting in the last century. He began as an able portraitist in the romantic tradition, idealizing his subjects and depicting them in bright, glowing colors with expressions of dreamy good humor, in the manner of his better-known Philadelphia contemporary THOMAS SULLY. About 1850, however, Francis turned to still life almost exclusively. His bright colorism persisted, however, and one can easily imagine animated, cheerful family gatherings about his well-laden tabletops. Francis was one of the country's leading specialists in the "luncheon" or "dessert" still life, featuring a whole meal consisting of fruits, cakes, cheeses, nuts, and other sweet repasts, complimented by a variety of wine bottles, patterned silver, ceramics, and glassware. Francis's preference for pastel tones of pink and blue and his painterliness in a period of extreme precision make his pictures easy to identify. He also replicated many of his compositions with only minor variations over a long period of time, substituting a metal sugar bowl for a ceramic one, or a blue pitcher for a pink one. Francis's fame as an outstanding still-life specialist is recent. During his lifetime he was little known and lightly regarded. The paintings of GEORGE HALL, GEORGE COCHRAN LAMBDIN, and even MARTIN JOHNSON HEADE were far more popular. Much of Francis's work is in private collections, but a fine example of his more elaborate painting (*Luncheon Piece*) is in the Newark Mus. *Lit.:* George L. Hersey, *Catalogue of Paintings by John F. Francis,* exhib. cat., Bucknell Univ., 1958.

FRANCIS, SAM (b. 1923), a painter. From San Mateo, Calif., he turned to art while recuperating from an injury in the San Francisco Bay area. Aware of the work of the Abstract Expressionists, but without having had any serious training, he developed an abstract mode of painting before studying art at the Univ. of California, Berkeley, between 1948 and 1950. By 1949 two important components of his mature style were in evidence: the irregular-cell or blotlike color-shape and a preference for thinned oil and acrylic pigments. While in France in 1950, he began to make monochrome paintings suggesting fog or silvery mists. When the "fog" took shape, it crystallized into small units of Francis's characteristic blot or patch, often with runnels of paint trickling down. Soon after, he reintroduced brilliant color in overlapping and dripping pad shapes so that a rich underpainted surface peeked out between the last-applied color areas, as in *Big Red* (1953, MOMA). In the mid-1950s, the color areas started to disperse, leaving large sections of canvas exposed. Works from this period, such as *The Whiteness of the Whale* (1957, AK), are

among his most brilliant coloristic forays, perhaps prompted by a study of Japanese art during a round-the-world trip of that year. In the Blue Balls series of the early 1960s, Francis became one of the first American artists to explore the formal problems inherent in "empty-center" paintings. Experimentation with this format led, in the late 1960s, to an extreme variation in which huge canvases had thin pipings of pigment staining their peripheries, as in *Untitled* (1969, LACMA). After 1970 Francis moved his imagery back to center. In *Berkeley* (1970, Univ. of California, Berkeley), for instance, color is puddled outward from the painting's core. The impression is that of exploding corpuscles of paint moving through huge arterial systems. Since he has lived in France for much of his adult life, Francis is considered as much a French artist as an American. *Lit.*: Peter Selz, *Sam Francis*, 1975.

FRANK, ROBERT (b. 1924), a "social landscape" photographer. Born and raised in Zurich, Switzerland, Frank began doing industrial photography at twenty-two, "to avoid school and father's business." In 1947 he came to the United States and was soon a successful fashion photographer for *Harper's Bazaar*, whose art director, Alexey Brodovitch, encouraged him to broaden his work. Adopting the thirty-five-millimeter Leica, a hand-held camera, whose ease of handling and inconspicuousness contributed much to his mature style, Frank made a trip to Peru in 1948, where he photographed the Andean Indians in a flat, journalistic manner. During two trips to Europe, in 1950 and 1953, he devloped his personal style, wherein his subjects, usually unaware of his camera, become archetypal. He frequently photographed at odd angles—giving the viewer a sense of the secret nature of his picture taking—and on overcast days, which created mood and gave a subtle tonal range. His London series of that period seems to capture all the implications of Empire and arid seediness that coexist in Britain.

With a Guggenheim grant in 1955, renewed in 1956, Frank turned his critical eye on America, and travelled all over the country for two years. The results, which firmly established his reputation, were published first in Paris, in 1958, as *Les Américains* and then in New York, in 1959, as *The Americans*, with an introduction by Jack Kerouac, who called him "a great tragic poet." Less luxurious in surface, these pictures are without idealism, a desolate but true vision of life as it is really lived on the back roads of our culture. Never documentary, they seem to interpret acts rather than simply present people or places. Frank himself has said, "Black-and-white is the vision of hope and despair." His work has inspired such younger photographers as Lee Friedlander, Garry Winogrand, and DIANE ARBUS.

After *The Americans*, Frank put away his camera and began making films, while continuing to do magazine and advertising work. His first film, *Pull My Daisy* (1959), was based on a Kerouac play and showed his friends Allen Ginsberg, Gregory Corso, Peter Orlovsky, and LARRY RIVERS acting "spontaneously." It earned Frank the label "graphic spokesman for the Beat Generation." Included in four group exhibitions at MOMA, he finally had his first one-man show at AIC in 1961 and was in a major exhibition with HARRY CALLAHAN at MOMA in 1962. Recently, he has been living in Nova Scotia and taking "snapshots" with a Polaroid camera. His work is collected in MOMA and GEH. *Lit.*: Robert Frank, *Robert Frank*, 1976.

FRANKENSTEIN FAMILY, a gifted group of siblings in a family of German immigrants: John Peter (c. 1816–1881), Godfrey N. (1820–1873), George, Gustavus (d. 1902), Marie, and Eliza. The family arrived in Cincinnati in 1831 and moved to Springfield, Ohio, in 1849. John Peter painted portraits in Cincinnati from 1831 on. He moved to Philadelphia in 1839 but four years later returned to Ohio, where, in addition to portraits, he painted religious works. Although he

modelled in clay as a young adult, he turned seriously to sculpture only in the 1840s, favoring a naturalistic style (*Judge McLean*, Cincinnati Mus.). Godfrey was apprenticed to a sign painter in 1832, opened his own business the next year, and undertook portraiture in 1841. He painted many views of Niagara Falls between 1844 and 1846 (example in Cincinnati Mus.) and, with the help of George and Gustavus, created a panorama of that natural wonder in the early 1850s. From 1867 to 1869, he travelled abroad with Gustavus. George was a portrait and landscape painter who lived from 1875 to 1900 in New York City, where he also worked as a journalist. Gustavus was a landscape and marine painter. Marie and Eliza were amateur artists. *Lit.:* Edna Maria Clark, *Ohio Art and Artists*, 1932.

FORUM EXHIBITION OF MODERN AMERICAN PAINTERS (1916). See INDEPENDENT EXHIBITIONS.

FRANKENTHALER, HELEN (b. 1928), a painter of uncommon sensitivity, who is, unfortunately, best known for only one work, *Mountains and Sea* (1952). Born in New York City, she studied with the Mexican artist Rufino Tamayo while in high school; with Paul Feeley at Bennington Coll., from which she graduated in 1949; with Wallace Harrison that same year; and briefly with HANS HOFMANN in 1950. By 1950, she had already met leading avant-garde figures and was as capable as any of them of painting intelligently in a post-Abstract Expressionist climate and of pushing the medium beyond the limits it had reached at that time. She did so with *Mountains and Sea*. Realizing that JACKSON POLLOCK's method of painting with his canvases placed on the floor and his willingness to allow pigment to soak into unprimed canvas (in his black paintings of about 1950) marked a radical departure in technique, she further explored their implications. By allowing thinner pigments to soak directly into the canvas, she achieved a close identification between

pictorial image and physical surface since the weave of the cloth remained visible through the image, which now appeared to be part of the surface rather than layered upon it. No longer the simple support for an image, the canvas had now become a painted object. The emotional aura Frankenthaler was able to create also rested in her ability to suggest atmospheric effects. Forms could be read as veils of color floating both on the surface and at an indeterminate plane behind it, since she varied the intensities of her pigment. These sensations of depth were reinforced by the organic allusiveness of her forms. It remained for other artists, like MORRIS LOUIS and KENNETH NOLAND, who saw *Mountains and Sea* in 1953, to try to create depthless pictorial fields (see MINIMAL ART). About 1957 Frankenthaler reduced her forms to small sun shapes and linear skeins. These gave way in the early 1960s to Rorschach-like dabs and blots. In 1963 she allowed forms to grow expansive once again and to fill the surface of the canvas. Her colors grew richer, too, when she turned to acrylics. Through the late 1960s and 1970s, she has explored the varying relations of large, gracious forms to each other and to the framing edge (*Mauve District*, 1966, MOMA) and has experimented with emptying and filling the canvas's center (*Stride*, 1969, MMA). Throughout, frank improvisational play has been regulated by a carefully honed color sense. In the mid-1970s, the artist began to exhibit sculpture. *Lit.:* Barbara Rose, *Helen Frankenthaler*, 1970.

FRASER, CHARLES (1782–1860), a painter of miniature portraits. From Charleston, S.C., where he spent his life (with the exception of many trips to northern cities), Fraser began to make miniatures about 1800 or earlier. He did not pursue a full-time artistic career until 1817, however, studying or working in the law until that time. He knew THOMAS SULLY as a youth and about 1800 met EDWARD GREENE MALBONE, who influenced his early style. Until about 1830, Fraser preferred

the crosshatching technique, as did Malbone. Afterward, he used the stipple method to bring his figures to life. In his later works, a mid-century realism replaced his earlier and softer romantic focus on feminine sweetness and masculine dash. Fraser brought frank characterization to the more than five hundred miniatures he painted during his career. He favored gray backgrounds, shading them toward blue, yellow, green, or pink. Occasionally, clouds appear, or the suggestion of a column or a window emerges behind a sitter. Landscapes are rare, the first one appearing in the portrait of James R. Pringle (1820). Fraser's miniature of the Marquis de Lafayette, painted on the occasion of the hero's visit to Charleston during his triumphal tour of America in 1825, is in that city's Municipal Building. *Lit.:* Alcie R. Huger Smith and D. C. Huger Smith, *Charles Fraser*, 1924.

FRAZEE, JOHN (1790–1852), a sculptor. Born in Rahway, N.J., he was apprenticed to a bricklayer in 1804. His first works date from about 1808, and his first attempt at idealized figure carving was made in 1815, an image of Grief placed at his son's graveside. In 1818 he opened a marble shop in New York City and specialized in funeral sculpture. His portrait bust *John Wells* (1824, St. Paul's Chapel, New York City) is considered to be the first carved bust made by an American. Although influenced by the neoclassical styles of GIUSEPPE CERACCHI (in America between 1791 and 1795) and Enrico Causici (in America from 1822 into the 1830s), Frazee nevertheless sculpted figures with realistic, not idealized, features. His bust *John Jay* (1831, U.S. Capitol, Washington, D.C.), the first government commission of its type given to a native-born sculptor, and his *Chief Justice John Marshall* (1834, Boston Athenaeum) combine a naturalistic head with a toga-covered upper torso. During the 1830s, Frazee was in partnership with Robert E. Launitz, who, in addition to portraits, did ideal pieces. Frazee directed the building of the Cus-

toms House in New York from 1834 to 1840 and, it is assumed, was responsible for much of the sculptural embellishment there. *Lit.:* "The Autobiography of John Frazee," *American Collector*, Sept.–Nov., 1946.

FRENCH, DANIEL CHESTER (1850–1931), one of the leading sculptors of the late 19th century, who maintained his popularity and fame well into the 20th. French was born in Exeter, N.H. As a youth, he lived in Concord, Mass., and there came under the influence of the intellectual circle that included Ralph Waldo Emerson and Louisa May Alcott. He chose to become a sculptor early in life and had the benefit of instruction from WILLIAM MORRIS HUNT, WILLIAM RIMMER, and JOHN QUINCY ADAMS WARD, a particularly auspicious group of instructors with a diverse approach and a sympathetic professionalism.

With the assistance of Emerson, French received a commission for *The Minuteman* from the town of Concord in 1874, a statue that immediately catapulted him to fame. Though based upon the classical *Apollo Belvedere*, the figure was not shown in classical garb but in historically accurate dress—in keeping with the then advanced style for historical bronze monuments that was superseding the earlier neoclassical mode. In 1876 French went to Italy and studied with THOMAS BALL, another instructor of prominence, whose work combined neoclassicism with the new naturalism. Some of the first works French executed on his return were not unlike the popular plaster groups of JOHN ROGERS; however, his fame came principally from the large public monuments he created for the Customs House in St. Louis, Mo. (1878), the U.S. Court House in Philadelphia (1879), the Boston Post Office (1882), and, above all, the gigantic statue of the Republic that dominated the WORLD'S COLUMBIAN EXPOSITION of 1893.

French's trademark became a type of allegorical figure widely emulated by other sculptors: a statuesque, somewhat sexless, woman in a long, flowing gown,

representing an abstraction such as *Alma Mater* (1903, Columbia Univ.) or *The Spirit of Life* (1913–15, Spencer Trask Memorial, Saratoga Springs, N.Y.). The heavy, voluminous drapery often covered the heads of these figures as well, as can be seen in French's most eloquent and personal work, *The Angel of Death and the Sculptor* (1891–92, bronze version in Forest Hills Cemetery, Roxbury, Mass.). It is a memorial to the talented Martin Milmore, a friend and fellow sculptor who died in his prime. The moving figure of Death confronts an idealized artist at work on a relief of a sphinx—a reference to Milmore's most famous work, the Civil War Memorial *Sphinx* in Mount Auburn Cemetery, Cambridge, Mass.

French's best-known works are his two statues of Abraham Lincoln. The first, a standing figure, in Lincoln, Neb. (1912) is similar to one in Chicago by AUGUSTUS SAINT-GAUDENS, with whom French shared the most important commissions of the late 19th century. The second, of 1922, is French's most famous sculpture, the seated figure in the Lincoln Memorial, Washington, D.C., done in collaboration with the architect Henry Bacon, with whom French worked on a number of commissions.

French's home and studio, "Chesterwood," near Stockbridge, Mass., are preserved intact and have recently been donated to the National Trust for Historic Preservation. *Lit.:* Margaret French Cresson, *Journey Into Fame: The Life of Daniel Chester French*, 1947.

FRIESEKE, FREDERICK CARL (1874–1939), a major second-generation American Impressionist (see IMPRESSIONISM, AMERICAN). He was born in Owosso, Mich. About 1898 Frieseke went to Paris to study with several of the French academic painters, and there he was also influenced by JAMES A. M. WHISTLER, as can be seen in his dark early work. He was also influenced by the contemporary Art Nouveau movement, whose strong linear emphasis and decorativeness continued to characterize Frieseke's painting. However, about 1907 Frieseke began to summer in Giverny, the home of Claude Monet, and his subsequent work took on strong Impressionist overtones. Frieseke adopted the full, prismatic color spectrum of Impressionism, applying it to both outdoor garden scenes and sunlit interiors. Unlike Monet, and more like Pierre Auguste Renoir, Frieseke's principal subject was the human figure: large and voluptuous in form, often partially or completely nude, dappled with colored sunlight but never fully dissolved by it. In his outdoor scenes particularly, Frieseke's figures are enveloped in patterns made by colored flowers, garden furniture, and light, an all-over decorative display that moves toward Post-Impressionism, for Frieseke avoided the small brushstrokes of Impressionism in favor of areas of alternating color, as did his French contemporary Pierre Bonnard. With Richard Miller, whose work in subject and style strongly resembles that of Frieseke (though it is more academic and more acid in color), Frieseke was the leading expatriate American Impressionist of his time. Examples of his work include *Lady Trying on a Hat* (1909) and *On the Bank* (c. 1915), both in AIC. *Lit.:* Morissa Domit, *Frederick Frieseke*, exhib. cat., Telfair Acad. of Arts and Sciences, Savannah, Ga., 1974.

FROST, ARTHUR BURDETT, JR. (1887–1917), a painter, son of a well-known Philadelphia illustrator. Frost was considered a talented adherent of SYNCHROMISM, though he was never formally allied with MORGAN RUSSELL and STANTON MACDONALD-WRIGHT. He was one of the first Americans, along with Russell, Macdonald-Wright, and PATRICK HENRY BRUCE, to study color theory in relation to abstract art. After learning to sketch from his father, Frost enrolled in PAFA. In 1905 he went to New York City and entered the studio of WILLIAM MERRITT CHASE, but it was ROBERT HENRI who first significantly influenced him. In order that Frost might profit from the older tradition of artistic training, his family moved to Europe in 1906, living

first in London and then in Paris, where Frost entered the Académie Julian. In Paris Frost met Patrick Henry Bruce and as a result began a systematic study of Impressionism, Post-Impressionism, and the work of Paul Cézanne. Bruce also introduced Frost to Henri Matisse, whose class Frost entered, and, later, to Robert Delaunay in the spring of 1912. By the end of 1912 Frost and Bruce were working closely together in Delaunay's studio. Frost returned to the United States in 1914, but Bruce's compositions continued to influence his development of color abstraction. Thus, Frost's *Unfinished Abstraction* incorporates Bruce's method of working from a photograph as well as his use of black and white. Frost introduced the new color theories to other American artists, including James Daugherty and Jay Van Everen before his early death.

FROTHINGHAM, JAMES (1786–1864), a portraitist. From Charlestown, Mass., he painted coaches built by his father before teaching himself the rudiments of portraiture. By 1806 he had become a professional painter, after receiving minimal instruction from an obscure student of GILBERT STUART named Whiting. Subsequently, Stuart helped Frothingham, who later incorporated elements of Stuart's style into his own work, especially the transparent flesh tones. Frothingham also tended to avoid the slick finish of mid-century portraiture, keeping alive the more painterly English manner domesticated in America by Stuart. A prolific artist, he rarely indicated background elements in his portraits but concentrated instead on capturing an alert gaze and a general sense of liveliness in his sitters. Before moving to New York City in 1826, he painted in Salem, Mass. Many of his portraits are owned by the City of New York; several others, including that of the poet William Cullen Bryant (1833) are in MFAB.

F. 64 GROUP, an association of California photographers, formed around EDWARD WESTON, with the purpose of exhibiting and promoting the concept of "straight" or "purist" photography. The charter members of 1932—ANSEL ADAMS, IMOGEN CUNNINGHAM, John Paul Edwards, Sonia Noskowiak, Henry Swift, Willard Van Dyke, DOROTHEA LANGE, and Weston—were reacting against the prevailing mode of pictorial photography (see PHOTO-SECESSION), which they considered to be the mere imitation of painting. Both Weston and Cunningham had earlier been pictorialists, but when they became convinced of the superiority of PAUL STRAND's "objectivity," their work was no longer acceptable in the salons of the day. Their first group exhibition was held at the de Young Mus. in 1932, though many of them had deeply impressed critics at the famous 1929 Film und Foto exhibition in Stuttgart, Germany. A coherent group for only a few years, their style was predominant until the 1960s and has remained extremely influential in both theory and practice.

"F. 64" denotes the smallest lens opening, or aperture, on the large 8-by-10-inch view cameras the group used (the smaller the aperture, the longer the exposure, and the greater the detail of the image). The phrase symbolized their belief in strict noninterference with the camera's ability to record. The view camera has a large glass viewer on which the photographer can see the image he wishes to record at the same scale as the resulting picture. It seemed logical and, according to their credo, important to "previsualize" the final print before exposure so that later alterations would be unnecessary. The view camera also produces an 8-by-10-inch negative, which may be "contact printed": Rather than having to enlarge a small negative, as with small cameras, the 8-by-10-inch negative is placed directly on light-sensitive paper and exposed. By this method, the "grain" in the negative—produced by chemical crystals—is not blown up and visible in the print, and the highest detail is retained. Demanding perfect clarity of form as well as calm, classical compositions, the group usually made close-up views of natural forms: flowers,

nudes, landscapes. They hoped to present images of such intensity that the forms would be as if seen for the first time, producing a heightened, even transcendent, vision.

**FULLER, GEORGE** (1822–1884), a painter. From Deerfield, Mass., he began to paint in 1841, studying art at the Boston Artists' Assoc. and NAD and sculpture, briefly, with HENRY KIRKE BROWN in Albany, N.Y. From 1842 to 1847, he lived in Boston, Mass., where early in his stay he shared a studio with sculptor THOMAS BALL. After attending NAD in 1847, Fuller worked primarily as a portraitist. He travelled to Europe in 1860 and, on his return, settled in Deerfield as a farmer. Painting now only to please himself, he turned to landscapes and figural works. Rediscovered in 1875, he became very popular, appealing to the new taste for melancholy subjects and painterly stylistic effects, since by that time he had developed a style of scumbled pigments, scrapings, and layered glazes keyed to a predominantly brown tonal scheme, which gave his work a sad, nostalgic quality. Though related to the contemporary taste for Barbizon themes, (see BARBIZON, AMERICAN) Fuller's studies of figures in the landscape are closer in mood to the dreamy later works of WASHINGTON ALLSTON and the more mystical landscapes of GEORGE INNESS, and in paint handling to the rich style of ROBERT LOFTIN NEWMAN. Fuller did not emphasize rural labor or bucolic pleasures. In *The Dandelion Girl* (1877, MFAB), eerie lighting techniques illuminate a young girl (a favorite subject of Fuller) and separate her from the landscape background. But other typical works like *The Afterglow* (c. 1880, Phillips Coll.), show figures better integrated into the landscape. *Lit.:* Josiah B. Millet (ed.), *George Fuller: His Life and Works*, 1886.

**FUNK,** the term for a tendency in art evident in works in a wide range of media produced in the San Francisco Bay area during the 1950s and 1960s. The environment created by the Beat poetry that was performed there in the 1950s provided the stimulus for a similar kind of personal expression and nonconformist interpretation in the visual arts. The highly individual nature of Funk art resists definition. It is akin to Dada in its denial of tradition and owes something to the work of JASPER JOHNS and ROBERT RAUSCHENBERG in that ordinary objects appear in an art context. One general trait of Funk art is an unsettling, deviant quality: Previously unexplored or taboo subjects are frequently portrayed or alluded to. The Funk artists never subscribed to a particular set of symbols or formulas, but each created a vocabulary that identified his or her work as earthy, erotic, paradoxical, anecdotal, and/or ambiguous. The materials of Funk art were not predetermined either. Although the original Funk artists were painters, they soon turned to sculptural techniques, especially assemblage, as the form for their new art. Despite the fact that at first they downplayed the intrinsic worth of materials in favor of personal statement, a trend towards permanence developed resulting in greater care in execution. Plastic polychromed metal and fiberglass became very popular materials, as can be seen in the work of Robert Hudson, Harold Paris, and Arlo Acton. Other Funk artists include Roy DeForest, Sue Bitney, and Robert Arneson. *Lit.:* Peter Selz, *Funk,* exhib. cat., Univ. of California, Berkeley, 1967.

# G

**GALLO, FRANK** (b. 1933), a sculptor. Born in Toledo, Ohio, he studied art from 1951 to 1959 at the Univ. of Toledo, Cranbrook Acad. of Art, Bloomfield, Mich., and the State Univ. of Iowa. In the late 1950s, he began to use the material—polyester resin reinforced with fiberglass—that gives his sculptures a viscous finish. Although he is noted for his studies of women, some of whom are fancifully and colorfully clad, Gallo has also made sculptures of men, including Abraham Lincoln. His work is often mildly erotic. His figures are often elongated and may sit or recline in postures suggesting extremes of boredom or self-involvement. He has also made lithographs, using the same thematic material. Examples of his work are in the Hirshhorn Mus. and LACMA.

**GALT, ALEXANDER** (1827–1863), a southern portrait sculptor. From Norfolk, Va., he was largely self-taught. Before studying in Florence from 1848 to 1854, he worked in crayon and pencil. Introduced to the neoclassical style while abroad, he made many ideal pieces, including a bust entitled *Bacchante* (c. 1852, Corcoran Gall.) notable for its smooth, softly modelled forms, and an *Aurora* (1859–60, Chrysler Mus.). In Virginia between 1854 and 1856, Galt carved many portrait busts. These have a realistic turn, perhaps reflecting the wishes of his subjects, who included such leading Confederates as Jefferson Davis. Galt returned to Italy, where he remained until 1860, and there he completed a statue of Thomas Jefferson (Univ. of Virginia). Much of his work was destroyed in a warehouse fire in 1863. *Lit.:* William B. O'Neal, "Alexander Galt," *Arts in Virginia*, Fall, 1966.

**GARDNER, ALEXANDER** (1821–1882). See PHOTOGRAPHY, CIVIL WAR; PHOTOGRAPHY, FRONTIER.

**GATCH, LEE** (1902–1968), a painter. Born near Baltimore, he studied with LEON KROLL, at the Maryland Inst. of Art in 1920 and then in Paris with André Lhote and Moise Kisling until 1924. During the 1930s and 1940s, when he lived in Lambertville, N.J., Gatch painted scenes of the Delaware Valley that are Cubistic, yet modified by a familiarity with Paul Klee's color sense, wiry linearity, and peculiar expressionistic touch. An example is *Pennsylvania Barn* (1936, Delaware Art Mus.). During the 1940s, large areas of color dominated many pictures, leading, during the 1950s, to an increasingly nonobjective approach in which color dominated subject (*The Flame*, 1951, Addison Gall.). Gatch's paintings of the 1950s and 1960s are much more antic and fanciful than the earlier ones. Gatch also used the device of placing a painted rectangle within the rectangle of the canvas, which both blocked and distorted spatial recession. In 1960 Gatch began to make collages of oil paint and thinly cut stone, the edges of which were so finely cut that their relief was barely noticeable (*Winter Stone*, 1966, AK). *Lit.:* Adelyn D. Breeskin, *Lee Gatch 1902-1968*, exhib. cat., NCFA, 1968.

**GAY, WALTER** (1856–1937), an expatriate painter from Hingham, Mass. Gay's artistic career is one of the most curious in his time, for he specialized in four distinct subjects painted in very different manners, though he is known today only for the last of these. Between 1873 and 1876, he established a reputation in Boston, Mass., as a flower specialist, but in the latter year he left for Paris to become a favorite pupil of Léon Bonnat. After a visit to Spain, he began to paint delicate, colorful, crisp figures in 18th-century costumes, in the manner of the popular French artist Jean Louis Ernest Meissonnier. He was also influenced by

the Spanish-Roman artist Mariano Fortuny, much patronized by American collectors. In 1884 Gay turned from these brilliant but somewhat trivial pictures to harshly realistic scenes of peasant life in Brittany—monumental figures austerely presented in a dark, monochrome palette that emphasized their bleak life, their poverty, and piety. Successful with these for about a decade, Gay once more turned to a new specialty, the depiction of glittering and elegant rococo interiors—empty rooms filled with fine furniture and decorations, much of which was drawn from his own collection. These found buyers on both sides of the Atlantic; in America they mirrored the surroundings of the rich patrons who collected them. *Lit.*: Walter Gay, *Memoirs of Walter Gay*, 1930.

GIFFORD, SANFORD ROBINSON (1823–1880), a landscape painter and portraitist. Born in Greenfield, N.Y., Gifford spent his childhood in Hudson, N.Y. He attended Brown Univ. for two years but left in order to devote his full attention to art and in 1845 moved to New York City to study under John Rubens Smith. A great admirer of THOMAS COLE, Gifford made a sketching tour of the Catskill and Berkshire mountains in 1846, and, though he continued to do some portraits, from then on spent most of his artistic energies on landscape painting. Though he did not share Cole's interest in religious and allegorical subjects, Gifford's early landscapes—such as *Summer Afternoon* (1853, Newark Mus.), with its mountain pool—clearly reflect Cole's influence.

Gifford travelled to Europe in 1855 and was impressed by both the Barbizon School and Joseph M. W. Turner's use of color. Indeed, Gifford's later works were often praised and criticized for their daring chromaticism. In *Twilight in the Adirondacks* (1864, Adirondack Mus.), for example, Gifford invested the landscape with an almost luminous quality, and he purposely picked that time of day when the play of light is at its most interesting. Gifford is now considered a major Luminist (see LUMINISM). *Lit.*: Nicolai Cikovsky, Jr., *Sanford Robinson Gifford*, exhib. cat., Univ. of Texas, 1970.

GIFT BOOKS, small, elegant, leatherbound volumes published annually during the first half of the 19th century for gift giving at Christmas and New Year's. Intended to be both uplifting and entertaining, they contained sentimental stories and poems illustrated with high-quality original engravings of contemporary paintings. They were, thus, one of the first real popular markets artists and engravers found for their work. Two of the best-known gift books were *The Atlantic Souvenir*, which began publication in Philadelphia in 1826, and *The Token*, first published in Boston, Mass., in 1828. They continued as a joint publication, *The Token and Atlantic Souvenir*, between 1833 and 1843. A substantial number of the paintings reproduced were by Americans, most often the landscape and genre painters, including: ALVAN FISHER, JOHN GADSBY CHAPMAN, THOMAS DOUGHTY, HENRY INMAN, THOMAS COLE, ROBERT W. WEIR, WASHINGTON ALLSTON, THOMAS BIRCH, ASHER B. DURAND, and SAMUEL F. B. MORSE. Usually, the painter was commissioned first, and then an author was asked to invent a story or poem to fit the illustration. Among the most famous paintings reproduced were Allston's *Moonlight Landscape*, of 1819 (*The Atlantic Souvenir*, 1828, George B. Ellis, engr.), which accompanied a verse of the same name by H. Pickering, and JOHN NEAGLE's *Patrick Lyon at His Forge*, of 1829 (*The Atlantic Souvenir*, 1832, Thomas Kelly, engr.). *The Talisman*, the finest gift book published in New York City, was issued between 1828 and 1830. *Lit.*: David S. Lovejoy, "American Painting in Early Nineteenth Century Gift Books," *American Quarterly*, Winter, 1955.

GIGNOUX, RÉGIS FRANÇOIS (1816–1882), a French landscape painter who came to America about 1840. From Lyons, he studied with Paul Delaroche. He settled in Brooklyn, N.Y., about 1840, and GEORGE INNESS became one of his pupils

for a brief period in 1843. Gignoux's landscapes were noted for their crisp detail, but unlike the works of the contemporary HUDSON RIVER SCHOOL painters, his pictures today seem to have a saccharine and sentimental gloss. An example is *Winter Scene in New Jersey* (1847, MFAB). Gignoux returned to France in 1870.

GILLESPIE, GREGORY (b. 1936), a painter. From Roselle Park, N.J., he studied at Cooper Union, New York City, from 1954 to 1960 and at the San Francisco Art Inst. from 1960 to 1962, then leaving for Italy, where he remained until 1970. A technically superb realist whose work in its subject matter invokes intimations of the master of fantasy painting, Hieronymus Bosch, and in style the Italian Renaissance painter Carlo Crivelli, Gillespie has explored a Dostoevskian vision of modern life that often borders on nightmare. In *Two Men Seated* (1961–62, Hirshhorn Mus.), for instance, there is no logical explanation for the disquiet both men communicate, nor does one understand why the subject of *Doll Child* (1968, Univ. of Georgia) sits alone in a doorway. In his early work, Gillespie used photographs, which he overpainted, and altered the images. Odd juxtapositions, suggested by his source material, became loaded with sexual references after 1967, either in the form of explicit nudity or in objects invested with sexual properties. About the same time, he also began to make "shrine paintings" in which a section of a room appears converted into a vaguely defined reliquary. Gillespie has also painted still lifes, incredibly precise in detail and unnerving in content. In the 1970s, he has made several self-portraits. Like the realist PHILIP PEARLSTEIN, he comments on the isolation and desperation of modern life. Regardless of subject matter, Gillespie prefers to use gesso-covered wood panels upon which he builds up thin layers of pigment. *Lit.:* Abram Lerner, *Gregory Gillespie,* exhib. cat., Hirshhorn Mus., 1977.

GILLIAM, SAM (b. 1933), a painter. Born in Tupelo, Miss., he received the M.A. degree from the Univ. of Louisville in 1961 and moved to Washington, D.C., the following year, becoming a member of the second-generation Washington Color Painters (MORRIS LOUIS, KENNETH NOLAND, and GENE DAVIS are of the first generation). Gilliam began to pour acrylic paint over canvas in 1966, two years after he turned to abstraction. He exhibited his first folded canvases in 1968, the same year in which he first made stretcherless paintings. Depending upon the ways these are hung, they can become environmental as well as wall pieces. One of the best-known examples of these brightly colored, draped works is *Carousel Form II* (1969). Since 1974 he has experimented with collage techniques.

GLACKENS, WILLIAM (1870–1938), a painter and member of The EIGHT. Born in Philadelphia, he became an artist-reporter for that city's *Record* and *Press* in 1891. The following year, he began attending evening classes at PAFA. By the time he went to Paris in 1895, he had become friendly with ROBERT HENRI and the other realist painters who became the nucleus of The Eight. On his return, he settled in New York City, where he did illustrations for magazines and newspapers, including the *New York Herald* and the *New York World,* until 1914, when he devoted all his time to painting. He went to Cuba in 1898 to cover the Spanish-American War for *McClure's* magazine. Despite many trips abroad— in 1906, and often after 1925—Glackens chose not to be influenced by 20th-century movements. In 1912 he began to purchase works for Dr. Albert C. Barnes, who developed one of the great private collections of the time (now in Merion Station, Pa.).

Of all the realists around Henri, Glackens was perhaps least attracted to the life of the streets, preferring scenes of middle-class activities in parks, in the theater, at shopping, or on vacation. Until about 1905, he painted in a rich, dark

tonal style derived from such artists as Frans Hals and the early Edouard Manet. An example is *The Drive—Central Park* (1904, Cleveland Mus.). In later years, he increasingly fell under the influence of Pierre Auguste Renoir's colorism; at the same time, he discarded urban themes in favor of studio scenes (posed models and still lifes) as well as landscape and seaside subjects *(At the Beach*, 1914, PAFA). Unlike Renoir, Glackens never lost the habit of separating figures quite distinctly from their background so that, despite his reliance upon Impressionist colors, traditional spatial recession was maintained and his forms never lost their definition as objects. *Lit.:* Ira Glackens, *William Glackens and the Ashcan Group*, 1957.

GLARNER, FRITZ (1899–1972), an abstract painter. Born in Zurich, Switzerland, he grew up in Italy and studied at the Royal Inst. of Fine Arts in Naples from 1914 to 1920. He arrived in Paris in 1923, and there he met many abstract artists, including the Robert Delaunays and Theo van Doesburg. His pictures during those years were composed of flat planes of color that suggested screens arranged around a viewer creating a shallow space. Glarner came to New York City in 1936 and fell in with figures associated with the AMERICAN ABSTRACT ARTISTS group. Nineteen forty-five saw the beginning of his mature phase, in which he produced a large number of works all called *Relational Painting*. Influenced by Piet Mondrian, Glarner began to balance and contrast colored rectangles to create an abstract two-dimensional rhythm. Although he, too, used the primary colors in addition to black and white, Glarner admitted tonal differences and also, on occasion, worked with circular compositions. The dynamism of these pictures resulted from the use of diagonal lines that break up the rectangles, so that at any moment a specific form may seem to become part of the surrounding space. As a result, intricate relationships were established between the different units of a work. Glarner

also created murals for the Time-Life Building, New York City (1959–60), and the Justice Building, Albany, N.Y. (1967–68). Examples of his mature work are in the Philadelphia Mus., Baltimore Mus., Cleveland Mus., and MOMA. *Lit.:* Margit Staber, *Fritz Glarner*, 1976.

GOLUB, LEON (b. 1922), a figurative painter. Born in Chicago, he studied at the Univ. of Chicago and AIC, from which he received a graduate degree in 1950. In one form or another, his subject has always been man, the would-be controller of events, or man, victim of circumstance. Until about 1953, Golub painted single, hieratic, usually frontal figures of shamans, seers, and kings. About 1954 they assumed more musculature and ampler proportions in emulation of classical statuary, but lacking in grace and aplomb. Golub's figures of this period were often limbless, or brutalized in other ways. Executed in a lacquer medium, the surfaces seemed as gutted and pitted as the figures. The theme of the Burnt Man, the victim who, despite the strength and self-importance of his bearing is nevertheless helpless, originated at this time. For paintings like *Colossal Man* (1961, AIC), Golub used figures from the Hellenistic Altar of Pergamon as models. These works address directly the question whether man can ever fulfill the promise of his physical power and moral passion in other than destructive ways. If the broken but monumental figures with their charred-looking and corroded surfaces indicate a negative answer to the question, Golub nevertheless insists that they must still strive for success. After 1960 he switched to acrylics, which allowed looser treatments of body parts and surface textures. In the Gigantomachies of 1965–68, Golub dealt with struggles between heroically scaled nude warriors, actually modern versions of traditional battle pictures. With the Assassin series of 1972–73, the locale of the conflict became specific—Southeast Asia—as the protagonists assumed the guise of white soldier or yellow civilian. As if to underline the failed excellence

and the brutality of no longer godlike contemporary warriors, Golub cut away parts of each canvas, thus using shaped canvases (see MINIMAL ART) for symbolic purposes. In 1974–75 he began to paint portraits of contemporary figures. *Lit.:* Lawrence Alloway, *Leon Golub*, exhib. cat., Mus. of Contemporary Art, Chicago, 1974.

GOODNOUGH, ROBERT (b. 1917), a painter. From Cortland, N.Y., he studied art at Syracuse Univ. and, in 1946–47, at the Ozenfant and Hofmann schools of art in New York City. In 1953 he began to make collages in addition to paintings and in 1954 turned to sculpture, making constructions of dinosaurs, birds, and human beings. After an essay at ABSTRACT EXPRESSIONISM in the early 1950s, he curbed his impulsive painterly gestures with a tautly lined Cubist framework, as in the aptly named *The Struggle* (1957, AK). Concerned with the problems of representing shapes on the picture surface rather than with content during this period (and afterward), he said "I try to uncube the 'cube,' to create a space which is neither recessive nor advancing, but just special relationships on a single plane." In the late 1950s, he worked with large forms with firm edges, like cutouts (*Anghiari II*, 1968, Houston Mus.) and in the 1960s began to float small birdlike clusters of shapes on enormous, open fields of light, often creamy colors (*Slate Grey Statement*, 1972, MFAB). An artist with an acute color sense, Goodnough has made some of the most elegant works of the 1970s. *Lit.:* Martin H. Bush and Kenworth Moffett, *Goodnough*, exhib. cat., Wichita State Univ., 1973.

GOODRIDGE, SARAH (1788–1853), a painter of miniatures. From Templeton, Mass., she was largely self-taught. She began to paint professionally in 1812 in crayons and watercolors. After settling in Boston, Mass., she turned to oils and began to paint in miniature. About 1820 GILBERT STUART gave her some informal instruction, which improved Goodridge's skill at characterization and enabled her to control subtle spatial adjustments of facial features. Her miniatures are largely devoid of background since she concentrated on heads and torsos. Her subjects were usually posed in three-quarter profile. In 1828–29 and 1841–42, she travelled to Washington, D.C. Examples of her work are in MFAB and Bowdoin Coll. Her portrait of Stuart (1825) is in the MMA.

GOODWIN, RICHARD LA BARRE (1840–1910), a leading practitioner of *trompe l'oeil* still-life painting. Goodwin was born in Albany, N.Y., and began his career as a portraitist in western New York State but turned to still life in the mid-1880s while travelling around the country (he was, indeed, the most peripatetic artist of the school of WILLIAM MICHAEL HARNETT). Goodwin was a fine painter of fruit, but he is best known as a painter of game hanging on a door. These pictures were all based upon Harnett's *After the Hunt*, which had been an enormous success at the Stewart Saloon in New York City in 1886. Goodwin's earliest known attempt at the subject is dated 1889, and he had mastered it by 1890, when he went to Washington, D.C., to live. The game portrayed may be plentiful or few; other objects, too (horseshoes, powderhorns, guns, hats, and feathers) vary considerably. Elements only occasionally used by Harnett occur in Goodwin's work repeatedly— the floating feather and the signature "carved" into the wooden door. The most famous example is a relatively late one, *Theodore Roosevelt's Cabin Door*, painted in several versions in Portland, Oreg., in 1905, at the time of the Lewis and Clark centennial, and based upon the door exhibited there from a hunting cabin in the Dakotas where Roosevelt had stayed fifteen years earlier. Goodwin also painted kitchen pictures. There is a handsome one of 1890 (Stanford Univ.) depicting hanging onions and a shelf with a candlestick and dish, but it also features the day's bag—a bird and a large rabbit (Goodwin was one of the

most single-minded of the talented followers of Harnett). *Lit.:* Alfred V. Frankenstein, *After the Hunt: William Michael Harnett and Other American Still Life Painters, 1870–1900,* 2d ed., 1969.

GORKY, ARSHILE (1905–1948), a painter, whose art of the 1940s was a germinating force for ABSTRACT EXPRESSIONISM. Gorky was born Vosdanig Manoog Adoian, in Khorkom, Van Province, Armenia. His early childhood was a rich education in Armenian folk culture and in ancient Armenian art, which he first saw at his family's ancestral home, a monastery in Vosdan. Gorky began painting at the age of six. Between 1910 and 1915, he attended the American Mission School in Aikesdan, a suburb of Van City. In November, 1916, the Turkish army invaded Van, and Gorky and his family fled. For the next three years, the Adoians were impoverished refugees; Gorky's mother, who had become seriously ill, died of starvation in 1919. The following year, Gorky and his youngest sister, Vartoosh, were able to rejoin their sisters in Watertown, Mass., and later were reunited with their father in Providence, R.I.

Despite the wanderings and upheavals of his childhood, Gorky drew constantly. Once in America, after a year of a technical high school in Providence and a short stint at a shoe factory, from which he was fired for drawing on the shoe boxes, Gorky began to teach art at the New School of Design in Boston, Mass. Moving to New York City in 1925, he settled in Greenwich Village and for the next five years both studied and taught at the Grand Central Art School. During the 1920s and 1930s, he became a familiar figure in the Fifty-Seventh-Street galleries and was known in the art world as a painter's painter, champion of Cubism, and an outstanding talker on the art of all periods. STUART DAVIS and later WILLEM DE KOONING became his close friends, and de Kooning was greatly influenced by Gorky. Gorky's friendship with Davis broke off in the early 1930s, when Davis became president of the politically oriented Artists Union. Gorky, who felt that art-making alone was of value, had little patience with the leftist political stance of many 1930s artists for whom formal considerations often came second to a work of art's revolutionary content. Employed by WPA-FAP from 1935 to 1939, Gorky's response to requirements for an "art for the people" was his abstract mural for the Newark, N.J., airport, whose Cubist forms, images culled from aerial photographs, and Surrealist organic shapes at first aroused controversy but later were praised by officialdom (the mural, presumed lost, was rediscovered at Newark in 1977).

Gorky began to exhibit in 1930, when three still-life paintings were included in the MOMA show Forty-six Painters Under Thirty-five. In 1932 he was among the very few Americans invited to join the Paris-based Abstraction-Création group, which also included ALEXANDER CALDER among its American members. After 1944 he exhibited annually at the prestigious Julien Levy Gall. His work in the 1945 exhibition, which was praised in a catalogue statement by André Breton, the Surrealist leader, brought Gorky a widened public. From about 1940, advanced European artists including Roberto Matta Echaurren, Max Ernst, and Yves Tanguy became Gorky's friends. Ill health and personal tragedy marked Gorky's life after 1947. He died by suicide.

The critic Harold Rosenberg has referred to Gorky as an artist 'in exile' for whom art became a homeland. Major paintings, for example, the three versions of *The Artist and His Mother* (1926–29, WMAA) are an expression of loss, memory, and nostalgia. As an exile, Gorky sought artistic roots and undertook a rigorous, self-designed apprenticeship in the style of Paul Cézanne (1926–27); about 1936 he became an ardent disciple of Pablo Picasso (*Enigmatic Combat,* c. 1936, San Francisco Mus.). Other artists Gorky studied closely during the 1930s were Uccello and Ingres. He shared the latter interests with JOHN GRAHAM, another exiled artist who

viewed modernism as the radical synthesis of the art of the past. Graham made an important contribution to Gorky's concept of a dialectic evolution in art.

About this time, Gorky (who is sometimes called an "abstract Surrealist,") became acquainted with Surrealism. The Surrealist shapes that counterbalance the more geometrical, Cubist-derived constructions in his paintings date back at least to 1927. Joan Miró's fluid, biomorphic shapes were an influence on the approximately twenty large ink drawings of the Nighttime, Enigma, and Nostalgia series (1931–34, example in the Univ. of Arizona) and on the Newark mural. In the early 1940s, the Surrealist emphasis upon dreams and the subconscious as sources of imagery was an exemplary and liberating force upon Gorky's art. In the Garden in Sochi paintings (c. 1941–43; example in MOMA) and the *Plow and the Song* series (1944– 47; examples in AIC and Oberlin Coll.), Gorky relived memories and emotions of his Armenian childhood and combined them with sensuous images of what he called the "life of the grass," a reference to his vivid experience of landscape at his parents-in-law's farm in Virginia. In the three versions of Garden in Sochi, the softening of forms, the improvisational gestures, and the new freedom of his brushwork are especially apparent.

Gorky's art, in an extraordinary flowering after 1941, was entirely new for him, in its washes, plumes of color, and slashed and dotted elements as well as in its imagery. Encoded in the abstract forms were motifs or "ideograms," which Gorky, who thought of art as a language, constantly reworked to extract meaning; they were illusive but often charged with biological, metamorphic, and erotic content. His autobiographical "liver/palette" motif is such an ideogram. (One of the best examples of a painting in which this motif is developed is *The Liver Is the Cock's Comb*, 1944, AK) Since the ideograms are packed with personal associations, images from nature and the unconscious, and syntheses of his art and that of others, their meanings are both private and universal. Gorky's work of the 1940s has the look of complete freedom, even though it is built on detailed preparatory drawings carefully transcribed on canvas. His art's exuberance and emotional charge formed a groundwork for the development of Abstract Expressionism. *Lit.:* Harold Rosenberg, *Arshile Gorky: The Man, The Time, The Idea*, 1962. James Jordan and Robert Goldwater, *The Paintings of Arshile Gorky*, in Press.

GOTTLIEB, ADOLPH (1903–1974), a major exponent of ABSTRACT EXPRESSIONISM, whose works are linked with those of MARK ROTHKO, CLYFFORD STILL, and BARNETT NEWMAN in their emphasis on color relationships. One of the country's few important artists actually born in New York City, Gottlieb studied at ASL in 1920 with JOHN SLOAN and ROBERT HENRI before abruptly departing in 1921 for Paris, where he worked at the Académie de la Grand Chaumière. After returning in 1923, he studied at various art schools. In 1935 he became a founding member of The Ten, a group devoted to expressionist and abstract art but less austere than the AMERICAN ABSTRACT ARTISTS. Gottlieb, who exhibited with the group for five years, worked in an expressionist-realist vein. About this time, he also began to collect primitive sculpture, which undoubtedly was the source of images in his work during the 1940s. He joined WPA-FAP in 1936, and for the Treasury Department he painted a mural in the Yerington, Nev., Post Office in 1939. In 1941 he began the first of the four major series of works that occupied him for the remainder of his life: Pictographs, 1941–51; Grids and Imaginary Landscapes, 1951–57 (Imaginary Landscapes once again, mid-1960s); and Bursts, 1957–74. With Rothko and Newman, he helped compose a response to a review by a critic of the *New York Times*, which helped focus the new art of the 1940s. In his compartmented Pictographs, Gottlieb turned to primitive

iconography to evoke mythological responses; with a primitive aesthetic, he created a post-Cubist flattened space (*Vigil*, 1948, WMAA). In the Imaginary Landscapes, he counterposed circular forms above broad horizontal bands of color. The Bursts are usually single circular forms above large ragged ones—suggesting sky and land, or closed and exploded shapes (*Expanding*, 1962, AIC). From the early, near-monochromatic Pictographs, Gottlieb developed a progressively more subtle color sense, which, in the late Bursts, culminated in extremely refined value and hue relationships. Within the narrow range of shapes he permitted himself, Gottlieb allowed a measure of improvisation. "You arrive at the image through the act of painting," he once said.

In 1952 he designed a stained-glass facade (1,350 square-feet) for the Milton Steinberg Memorial Center, New York City, and, like others of his generation (SEYMOUR LIPTON, HERBERT FERBER), he created works for synagogues that are religious in mood without reference to a specific liturgy or dogma. *Lit.*: Robert Doty and Diane Waldman, *Adolph Gottlieb*, 1968.

GOULD, THOMAS RIDGEWAY (1818–1881), a sculptor. From Boston, Mass., Gould was a businessman before he turned to sculpture as a hobby about 1851. He was taught briefly by Seth Cheney. During the Civil War, he began to model portraits for a living and completed a bust of Ralph Waldo Emerson (c. 1860s, Harvard Univ.). His head of Satan, made in plaster in 1864 and turned into marble in 1878, now in the Boston Athenaeum, is based on a Roman imperial bust. In 1868 Gould moved to Florence, where he remained for the rest of his life, except for brief trips to America in 1878 and 1881. While there, he made many ideal works, including *The West Wind* (Mercantile Library of St. Louis, St. Louis, Mo.), which was replicated seven times. This work reveals Gould's strengths and weaknesses—an adroit ability to suggest flesh under skin-tight, transparent drapery; an inability to give a figure appropriately heroic proportions.

GRAHAM, JOHN (1881–1961), a painter, writer, and collector who was influential in the formation of ABSTRACT EXPRESSIONISM. Born Ivan Dambrowsky, in Kiev, Russia, he studied law and served on the czar's staff before the Revolution. Although little is known about his early years, he seems to have become familiar with the works and ideas of Kasimir Malevich, Mikhail Larionov, and Wassily Kandinsky, which he absorbed either in Russia or in western Europe. He came to this country in the early 1920s and studied with JOHN SLOAN at ASL. His paintings alternated between abstraction, realism, Fauvism, and Surrealism. Younger artists, such as DAVID SMITH and ARSHILE GORKY, were introduced to the importance of the unconscious as a source of artistic inspiration through his African sculpture collection, the European magazines he received, such as *Cahiers d'art*, his book *System and Dialectics of Art* (1937), and magazine articles he wrote. He painted many portrait busts of strange, cross-eyed women. In the 1940s, he repudiated modernism and retreated into the occult. The last years of his life were spent in London.

GRAVES, MORRIS (b. 1910), a painter associated with the Pacific Northwest. Born in Fox Valley, Oreg., Graves grew up in the Puget Sound area, where he lived off and on until 1964, when he settled in northern California. He has travelled to Mexico and visited Ireland for some time in the mid-1950s, but it is the Orient and Asian systems of thought that have most profoundly influenced him. Between 1928 and 1930, he made three trips to the Far East, which he has also visited in later years. The effect on his paintings appears less a matter of specific artistic influence than a permeation by Eastern philosophies directly and through the work of such Eastern-influ-

enced artists as MARK TOBEY, whom he met soon after 1935. In 1936 and for the next few years, Graves was supported by WPA-FAP. From the start, his favorite subject matter was birds, animals, and trees; his preferred medium has been tempera, although he has worked in oils. In that delicate area between description and evocation of a subject, Graves was originally more descriptive, though his forms were always incorporated within sinuous outlines and flattened spaces. In his Message series paintings of 1937 (examples in MOMA), a new development in subtlety removed his creatures from physical landscape and placed them instead within the landscape of the mind. Increasingly, the birds he painted represented both a mood and the matter of spirit or sense of continuity between the artist and the universe around him. Of his *Little-Known Bird of the Inner Eye* (1941, MOMA), he said: "The images seen within the space of the inner eye are as clear as seeing stars before your eyes if you get up suddenly. It is certain that they are subjective, yet there is the absolute feeling that they are outside around your head." For Graves, birds also symbolize solitude, the shore, the environment of childhood. About 1940 he most profoundly explored Tobey's "white-writing" technique (calligraphic webs of white pigment), using it both as a structural device, filling large areas of a painting, and as a thematic element. Graves likened the scrawls around the legs of the birds in the Blind Bird series of 1940 (example in MOMA) to "the blind darkness written in our mind and heart [which] can be so dark that the very ground is luminous in comparison."

Through the following decades, he made many paintings in series, including Joyous Young Pine (1943), Hibernating Animal (1954), and Ant War and Insect (1958). The period of Graves's most allusive and illusory paint handling was probably the 1940s. Afterward, textures thickened, giving his images a physical reality they did not earlier possess. At that time, his images, too, were most precariously located between the real and the imaginary. Afterward, they tended to appear either as physical presence (perhaps in physical movement) or as wraithlike hallucination, a projection of a vision in a spaceless void. Many of his works are in the Seattle Art Mus., Phillips Gall., and MOMA. *Lit.:* Frederick S. Wight, *Morris Graves,* 1956.

GRAY, HENRY PETERS (1819–1877), a leading New York portrait and history painter of the mid-19th century. From New York City, Gray went to Italy in 1839, after studying for a year with his near-contemporary DANIEL HUNTINGTON, whose development, career, and reputation were amazingly similar to Gray's own. He returned in 1841. Both artists were respected as leaders in the attempt to advance historical painting in pre-Civil War America, and Gray's series of somewhat allegorical pictures, tending toward the classical, including *Greek Lovers* (1846, MMA), *Wages of War* (1848), *Judgment of Paris* (1861, Corcoran Gall.), and *Birth of Our Flag* (1874), were widely praised. Like another contemporary, WILLIAM PAGE, Gray was inspired by the palette and figural monumentality of Titian, though he did not investigate the old master's glazing technique as did Page. He, too, dared Victorian conventions in painting the nude, but his rather passionless manner spared him the charges of indecency hurled against his colleague. Gray also produced a series of idealized heads and figures of attractive young women, in the somewhat anemic figure-painting tradition that was uprooted by French-trained artists in the 1870s. Also like Huntington and Page, Gray was an able portraitist, though seldom an inspired one.

GREENE, BALCOMB (b. 1904), a painter. From Niagara Falls, he taught English at Dartmouth Coll. for three years, before taking up painting in 1931–32. He then attended the Académie de la Grand Chaumière, in Paris, but did not receive formal instruction there. By 1935 his work had become totally abstract, a

combination of hard-edged Cubism and Constructivism, with forms composed of flattened, tilted planes, quasi-geometrical patterns and linear sequences. In this style, he created works for the Federal Hall of Medicine at the New York World's Fair and the Williamsburg Housing Project, New York City, both in 1939. A few years earlier, in 1936–37, he became the first chairman of the AMERICAN ABSTRACT ARTISTS. Between 1943 and 1947, the human figure reappeared in his work, but within a fragmented universe, as if observed through a kaleidoscope. Subsequently, transitions between parts of the body grew more logical, but they were still tangled within planar forms that provided them with a distinct emotional charge. In the 1950s, Greene occasionally painted the human form in outdoor settings and with a sense of drama. In later years, Greene's figures grew increasingly monumental and were studied from odd perspectival angles. *Lit.:* Robert Beverly Hale and Niké Hale, *The Art of Balcomb Greene*, 1976.

GREENE, STEPHEN (b. 1918), a painter. From New York City, he studied at ASL in 1937. Until a stay in Rome in 1953–54, he explored psychological states of being in a precise, macabre, realistic vein. To emphasize their anguish, his figures, often with emaciated bodies or missing limbs, were isolated in nonspecific environments, as in *The Burial* (1947, WMAA). After 1954 Greene's work grew increasingly abstract. Linear outlines and carefully articulated detail gave way to freer invention, suggesting presences rather than specific forms. By the 1960s, a biomorphic abstraction emerged, impregnated with veiled and somber allusions to despair and alienation, as in *White Light* (1961, Guggenheim Mus.). *Lit.:* Dore Ashton, *Stephen Greene*, exhib. cat., Corcoran Gall., 1963.

GREENOUGH, HORATIO (1805–1852), the first of the neoclassical sculptors. Greenough grew up in Boston, Mass., and studied at Harvard Univ. He was one of the few American sculptors to come from a well-to-do family and to have a sound classical education, which undoubtedly fostered his inclination to neoclassicism, as did his friendship with WASHINGTON ALLSTON, the most significant American painter of historical and classical works of the time. Greenough was early attracted to sculpture by a statue of Phocion in the garden of his family's home, and he studied woodcarving, modelling, and stonecutting. A bust of Bacchus he made as a boy was one of the earliest classical sculptures by an American artist. On graduating from Harvard in 1825, Greenough went to Rome to pursue his classical studies with an introduction to Bertel Thorwaldsen, the leading European neoclassicist among the sculptors in Italy. Greenough fell ill not long after his arrival in Rome and in 1827 had to return to America, where he executed busts in plaster of such notables as Mayor Josiah Quincy of Boston and John Adams and John Quincy Adams, in Washington, D.C. In 1828 he returned to Italy.

Shortly after his establishment in Florence, Greenough received his first major commission, an order by James Fenimore Cooper to execute a two-figure group entitled *The Chanting Cherubs* (1828–30), the theme derived from a painting by Raphael in the Pitti Palace. The work was later exhibited in America, where it received some adverse criticism both because the cherubic figures were nude and because they did not actually sing. Among other works of this period was a bust of the Marquis de Lafayette (1831–34, MFAB), sculpted in Paris, and a full-length figure of the dead Medora (1831–32), derived from Byron's poem "The Corsair."

In 1832 Greenough received a commission from Congress to execute a colossal *George Washington* for the Rotunda of the U.S. Capitol, the first major sculptural commission given to an American. The head of this famous work is based upon the representation of Washington made from life by the French sculptor Jean-Antoine Houdon; the body

and pose of the figure are derived from reconstructions of the *Olympian Zeus* by Phidias. Although many connoisseurs appreciated the sculpture when it arrived, it was generally criticized for its seminudity and for its characterization of Washington as a classical deity. Moreover, the ineffective lighting in the Rotunda detracted from the work, which was finally put out-of-doors before being transferred to a succession of buildings of the Smithsonian Institution Greenough's second major governmental commission, given in 1837, was for a group known as *The Rescue*, a companion to the *Discovery* group by the Italian artist Luigi Persico. (It was recently removed from the Capitol's east entranceway.) Greenough's monumental statues represented a frontiersman restraining an Indian from attacking a cowering woman with a baby, and he took great pains to achieve an accurate representation of the Indian physiognomy and costume. The work, begun in 1839, was not assembled until after the sculptor's death. Among Greenough's other sculptures were a full-length female nude entitled *Venus Victrix* (1837–41, Boston Athenaeum) and a bas-relief *Castor and Pollux* (c. 1847–51, MFAB). In addition, he sculpted a number of religious subjects, including *Angel Abdiel* (1838, Yale Univ.), a relief of *Saint John and the Angel* (1833, Yale Univ.), and busts of Christ and Lucifer (1841 and 1845, both Boston Public Library). Greenough returned to America in 1851, to pursue the possibility of executing an equestrian sculpture of George Washington. He also was hoping to create a monument to his friend Cooper, when he died.

Greenough was the first of a line of American sculptors to settle in Italy and emulate the neoclassical standards set by Antonio Canova and Thorwaldsen (see NEOCLASSICAL SCULPTURE). Although he worked in Florence, the majority of his patrons were Americans and the greatest single repository of his work is in MFAB. RICHARD SALTONSTALL GREENOUGH, his brother, was also a sculptor of note. In addition to his sculpture, Greenough was

a prolific essayist, and he is well-known today for his theory of functionalism, best stated in his Stonecutter's Creed:

By beauty I mean the promise of function.
By action I mean the presence of function.
By character I mean the record of function.

*Lit.*: Nathalia Wright, *Horatio Greenough, The First American Sculptor,* 1963.

**GREENOUGH, RICHARD SALTONSTALL** (1819–1904), a noted sculptor of the Victorian era. Born in Boston, Mass., and educated there at the Latin School, Greenough decided, at seventeen, to follow his brother in a career in sculpture. In 1837 he left for Italy, where HORATIO GREENOUGH had already established a reputation. In Florence, like so many young artists before him, he drew from the antique and learned his craft. Ill health forced him home, however, and he established himself in Boston in 1839. It was not until 1844, with a plaster bust of William H. Prescott, that Greenough began to attract critical notice for his portrait busts and "fancy pieces." In 1848 he went again to Europe and joined the American expatriate communities of Paris and Rome. His portrait bust of Cornelia Van Rensselaer (1849, NYHS) is typical of his style, with its softly modelled face and intricately detailed ruffles and laces. In addition to portraits, Greenough, like many of his American contemporaries, produced statues that combined neoclassicism with genre subject matter, as does his *Shepherd Boy and Eagle* (1853, Boston Athenaeum), which was cast in bronze in America by the Ames Foundry. This led to a commission, the first granted by the City of Boston to an American sculptor, for a bronze full-length statue of Benjamin Franklin (1855, City Hall). This made Greenough's reputation as a leading sculptor, and he continued to execute public monuments of this kind to the end of his career. Equally striking are his large-scale neoclassical statues,

such as *The Carthaginian Girl* (1863, Boston Athenaeum) and *Circe* (1882, MMA), in which picturesque detail and a certain coquettishness take precedence over sculptural form. *Lit.:* Thomas Brumbaugh, "The Art of Richard Greenough," *Old-Time New England,* Jan.–Mar., 1963.

GREENWOOD, JOHN (1727–1792), a portrait painter and engraver. From Boston, Mass., he served an apprenticeship with Thomas Johnston, a sign painter, decorator, and engraver, from about 1742 to about 1745. Greenwood's earliest portraits date from 1747 and, during the next few years, which marked the tag end of JOHN SMIBERT's career and preceded the rise of JOHN SINGLETON COPLEY, he was the leading artist in Boston. He painted about fifty portraits there. His style hovered between the airless, flat-patterned works of untutored provincials and the more volumetric and softly focused paintings of cosmopolitans like Smibert. What Greenwood's figures lack in charm and grace they make up in assertiveness of character, as does his *Greenwood-Lee Family* (c. 1747), one of the few multifigured paintings executed during the colonial period. In 1752 he went to Surinam, where, during the next five years, he painted about 115 portraits as well as the Hogarthian genre piece *Sea Captains Carousing in Surinam* (c. 1758, St. Louis Mus.). He then proceeded to Holland in 1758 to study mezzotint engraving further and finally settled, in 1762, in England, where he became an art dealer. His late style is European, in that his forms acquired grace, his colors grew subtle, and he mastered the ability to suggest depth. *Lit.:* Alan Burroughs, *John Greenwood in America, 1745–1752,* exhib. cat., Phillips Acad., Andover, Mass., 1943.

GROOMS, RED (b. 1937), a sculptor. Born Charles Rogers Grooms, in Nashville, Tenn., he studied at AIC; Peabody Coll. for Teachers, Nashville; the New School for Social Research; and the Hans Hofmann School in New York City. In the late 1950s and early 1960s, Grooms, like JIM DINE, Allan Kaprow, and CLAES OLDENBURG, was active as a creator of HAPPENINGS in New York City. In this vein, he presented *Burning Building* (1959), a modern melodrama with scenery and performances by the artist and his friends. The event was an outgrowth of Grooms's lifelong fascination with the pageantry of the circus. The patched-together quality of his Happenings made them seem an enlargement and continuation of a child's "backyard extravaganza"; it also related them to ASSEMBLAGE. Grooms also constructs permanent objects, which he often presents in groups, thereby making whole environments. He works in a variety of materials—cardboard, wood, plaster, paper—and sometimes incorporates real objects into his pieces as well. *Loft on 26th Street* (1965–66, Hirschhorn Mus.) is an example of his mixed-media technique, although it is mainly constructed of layers of painted cardboard. It represents the artist's studio, crowded with his possessions, family, and friends—a 20th-century version of Gustave Courbet's huge *Interior of My Studio* of 1855. Unlike the French painter, for Grooms the studio is not the place for serious introspective philosophical work on the part of the artist. Rather, it is filled with a dancing, eating, celebrating crowd. Grooms's work almost always reflects this attitude of simple fun. Whether he produces a reconstruction of a discount store (1970) or a model of Manhattan Island (1976), Grooms seems little concerned with making political or sociological comments about his subjects. He and his collaborators, the Ruckus Construction Co., produce colorful, hectic figures, clearly meant for the amusement of both the artist and the viewer. His work can be seen at Rutgers Univ. and AIC. *Lit.:* Judd Tully, *Red Grooms and Ruckus Manhattan,* 1977.

GROPPER, WILLIAM (1897–1977), a major cartoonist and a painter of social concerns. Born in New York City, he studied there with ROBERT HENRI and

GEORGE BELLOWS at the Ferrer School from 1912 to 1915. He took their nonpolitical, realistic art and turned it into a pungent critique of the ills of modern society and of the hypocrisy of its leaders, most notably members of the U.S. Senate (*The Senate*, 1935, MOMA). At the same time, his sympathy for the laborer, the displaced person, and the underdog gave his art a humanitarian warmth that muffled any propagandistic shrillness. Hired by the *New York Tribune* in 1919 as a cartoonist, Gropper subsequently drew illustrations and cartoons for a wide range of magazines, including the sophisticated *Vanity Fair* and the leftwing *New Masses*. He began to paint in earnest in 1921 but did not have his first solo exhibition until 1936. In 1938 he painted a mural in the Department of the Interior, Washington, D.C., one of three government-sponsored murals he completed. In 1948, after touring eastern Europe, he decided to make one painting a year in memory of the victims of the Warsaw Ghetto.

Gropper's supple line easily exaggerates gestures and postures and his style often borders on caricature; his colors often appear to be smeared and coarse. But he responds, as he said, to life, not to art styles. Through the 1950s and 1960s, he often emphasized line at the expense of form and he occasionally thinned his pigments, but his paintings never became pallid. They retain their biting incisiveness, and his themes remain cogent. *Lit.*: August Freundlich, *William Gropper: Retrospective*, exhib. cat., Univ. of Miami, 1968.

GROSS, CHAIM (b. 1904), a sculptor. From Wolowa, Austria, he studied at the National Acad. of Fine Arts in Budapest, in 1919, and the Kunstgewerbeschule in Vienna, in 1920, before arriving in New York City in 1921. He attended the Educational Alliance and the Beaux-Arts Inst. of Design, in New York City, from 1921 to 1926, before enrolling briefly at ASL in 1927 to learn direct-carving techniques from ROBERT LAURENT. By 1930

Gross, one of the pioneer carvers of his generation, had created works in thirty different types of wood. Supported by federal programs in 1934–35, he was also awarded commissions for the main U.S. Post Office, Washington, D.C., in 1936, the Federal Trade Commission Building, Washington, D.C., in 1938, and the Irwin, Pa., Post Office. After World War II, he received a number of commissions from synagogues as well as from the Hadassah-Hebrew University Medical Center, Jerusalem, in 1964. Throughout his career, happiness and optimism have suffused his work. The human figure, his central image, is often shown as a circus performer or dancer and also as a devoted family member. His forms are usually squat and amply volumed; wood grains often emphasize swelled thighs and buttocks (*Handlebar Riders*, 1935, MOMA). In the late 1950s, Gross turned increasingly to bronze, which allowed him considerable opportunity to open up his previously solid-core compositions. *Lit.: Chaim Gross: Sculpture and Drawings*, exhib. cat., NCFA, 1974.

GROSVENOR, ROBERT S. (b. 1937), a sculptor. From New York City, he studied painting at the Ecole des Beaux-Arts in Dijon, France, in 1956. Four years later, he settled in Philadelphia, where he began to sculpt cantilevered forms in plywood and metal. By the mid-1960s, he had become an important Minimalist (see MINIMAL ART), notable for his arrangements of simple forms in close interaction with the environment of the enclosing space (gallery, loft). Unlike the works of other Minimalists, Grosvenor's seemed to defy gravity, bringing into question the physical balance of forms. After 1965 his interest in architectural space extended to the outdoors, where he even worked with the ocean as a foil for pieces anchored offshore. After 1972 he began to use weathered timbers, often single pieces, placed on the floor. Unlike his earlier works, these pieces do not relate to enclosed spaces, nor do they question gravity as an essential factor in

sculpture. Rather, they are alien objects, brought in to confront a space psychologically rather than primarily visually.

GROSZ, GEORGE (1893–1959), a painter and caricaturist. Born in Berlin, Germany, and trained in Dresden (1909–11), Berlin (1911), and Paris (1913), he came to this country in 1932 and settled here the following year. Grosz's caricatures began to be printed as early as 1910. In 1918 he joined the Berlin Dada group and during the next decade illustrated magazines and designed sets for the theater. His mordant comments on German society, as in the Ecce Homo series (1922), created problems with the government and ultimately caused him to leave the country. After his arrival, Grosz tried to adapt to the American scene by painting many views of New York City. His satirical works were replaced by nightmare visions and scenes of the brutality of warfare. He adopted a Baroque oil-painting technique as well as a quasi-surrealistic interest in strangely juxtaposed objects (*Peace II*, 1946, WMAA). In 1947–48, he introduced the "Stickman" theme, in which lumpy figures on sticklike legs engage in nightmarish activity. His autobiography, *A Little Yes and a Big No*, appeared in 1946. *Lit.:* Hans Hess, *George Grosz*, 1974.

GUGLIELMI, O. LOUIS (1906–1956), a painter. Born in Cairo, Egypt, he came with his parents to New York City in 1914 and attended NAD from 1920 to 1925. Until about 1933, his paintings, displaying simplified architectural and urban motifs, were linked with PRECISIONISM. After that date, a new moodiness and use of muted colors, and an evident knowledge of the strange world of empty spaces and isolated objects in Giorgio de Chirico's metaphysical art, brought the artist closer to MAGIC REALISM and Surrealism. On the other hand, his subject matter remained prosaic. He compassionately portrayed the lives of ordinary people, especially the disadvan-

taged, showing them sitting in front of tenements, bored by the tedium of unemployment or forced onto welfare rolls, their dignity barely intact (*Relief Blues*, 1939–40, NCFA). The use of modified Surrealist idioms in a socially conscious art was termed "social Surrealism" at the time, and Guglielmi was its leading practitioner. His *Mental Geography* (1938), which shows a twisted and blasted Brooklyn Bridge, was intended to warn humanity against the spread of destructive forces unleashed by the Spanish Civil War. After 1945 Guglielmi turned toward more formal concerns, developing a stylized quasi realism of fragmented vistas, objects, and color planes akin to the manner of STUART DAVIS. In his last years, he painted completely abstract works. *Lit.:* John Baker, "O. Louis Guglielmi: A Reconsideration," *Archives of American Art Journal* 15 (1975).

GUSTON, PHILIP (b. 1913), a painter best known for his association with ABSTRACT EXPRESSIONISM during the 1950s and 1960s. From Montreal, Canada, he grew up in Los Angeles, where his family moved in 1919. He began to draw and paint in 1927 and later briefly studied at the Otis Art Inst., but he probably profited more from his friendship with LORSER FEITELSON and his close examination of the art of Giorgio de Chirico and the Italian Renaissance. During a trip to Mexico with painter Reuben Kadish in 1934, he painted a mural in Emperor Maximilian's former summer palace in Morelia. Reaching New York City in 1935–36, he joined WPA-FAP. Committed to mural painting at the time, he also completed large works for the New York World's Fair of 1939, the Queensbridge Housing Project, New York City, in 1940, and the Social Security Building, Washington, D.C., in 1942. These works express social messages in a style combining elements of Mexican art with influences from Pablo Picasso and de Chirico. In 1940 Guston began to concentrate on easel paintings, turning increasingly to symbolism and flattened modern

forms. Despite their pulsating tonal variations, his figures had a Piero della Francesca-like aloofness, as in *Martial Memory* (1940–41, St. Louis Mus.). While teaching at the Univ. of Iowa and at Washington Univ., from 1941 to 1947, Guston explored this style further, adding mythological and personal references to his imagery. After 1947 he increasingly reconciled his narrative gifts with modernist demands for the integration of content and shape. Gradually, his images grew disembodied until, by 1952, they had become lost in a shimmer of small strokes that coalesced around richly textured and colored centralized areas of interest (*Dial*, 1956, WMAA). Through the 1950s and 1960s, Guston's wispy forms grew denser. Shapes replaced calligraphy. Colors grew darker and, in the mid-1960s, were often reduced to shades of gray. The sense of pleasure in manipulating pigment was replaced by suggestions of tragedy, loneliness, and personal quest (*Close-up III*, 1961, MMA). After making a number of drawings in 1966–67, Guston began to paint common objects with acrylics. In this new departure, he inventoried things found in a house or an artist's studio, but with a surrealistic interest in juxtaposing unrelated elements, disembodied parts of bodies, and hooded (self-portrait) forms. His style, still painterly, has grown consciously and consistently more awkward. *Lit.*: Dore Ashton, *Yes, But: A Critical Study of Philip Guston*, 1976.

GUY, FRANCIS (c. 1760–1820), an early landscapist. From either Lorton or Burton-in-Kendall, in England's Lake District, Guy worked as a silk-dyer in London before coming to this country in 1795. Settling first in Brooklyn, N.Y., and then in Baltimore, where he lived from about 1798 to 1817, he continued in the silk-dyer's trade as well as others, including dentistry. He is supposed to have turned to art about 1800, though his *Tontine Coffee House* (NYHS), a detailed urban view of New York City

streets, can be dated about 1797. While in Baltimore, he painted "estate portraits," such as *View of Baltimore from Beech Hill—1804* (Maryland Hist. Soc.), a study of the estate of Robert Gilmor, Sr. During the War of 1812, he painted marine views. In 1817 he returned to Brooklyn where he painted *A Winter Scene in Brooklyn* (c. 1817–20, Brooklyn Mus.), a lively view of a street filled with people engaged in a variety of activities. Self-taught, he was able to create realistic detail and logical perspectival recession with a tent-like apparatus he constructed consisting of a viewing hole next to a windowlike arrangement covered with stretched cloth on which he marked carefully the objects to be painted. As a result, his forms are precise and usually small in scale, typical of topographical works rather than academic ones. Guy often included promenading paired figures in his paintings. About 350 pictures have been associated with his name, but only about 25 have been definitely established as his. *Lit.*: J. Hall Pleasants, *Four Late Eighteenth-Century Anglo-American Landscape Painters*, 1942.

GWATHMEY, ROBERT (b. 1903), a painter. From Richmond, Va., he studied at the Maryland Inst. of Art, Baltimore, in 1925–26 and PAFA from 1926 to 1930. Attracted to social themes, he painted murals for the Eutaw, Ala., Post Office during the 1930s and was a winner in the Forty-Eight States Mural Competition sponsored by the federal government in 1939. His favorite subjects are southern rural blacks at work, at rest, and, simply presented, in indoor settings. Gwathmey does not deal with economic or social questions; his quite distinctive semiabstract style seems to be the raison d'être of his pictures. Figures are presented in simplified surroundings, their forms incorporated into strong linear patterns and their volumes reduced to flattened planar networks, as in *Singing and Mending* (1944, Hirshhorn. Mus.).

# H

HABERLE, JOHN (1853–1933), a master of humorous, illusionistic still-life painting. Haberle spent his life in New Haven, Conn. Of all the followers of the *trompe l'oeil* still-life artist WILLIAM MICHAEL HARNETT, Haberle was the most original and independent. Yet Haberle's involvement with *trompe l'oeil* appears to have been of short duration—during the years just before 1890 and until about 1898, when deteriorating eyesight forced him to paint broader, more traditional still lifes. Haberle undertook all subjects compatible with deceptive realism—pictures of paper money, of blackboard slates with messily erased chalk marks, and of amazingly complicated and diverse conglomerations of playing cards, tickets, stubs, scissors, and other paraphernalia (*The Bachelor's Drawer*, 1890–94). He also painted several of the largest *trompe l'oeil* still lifes known, *Grandma's Hearthstone* (1890–94, Detroit Inst.) and a later return to such deceptive illusion, *Night*, either a *trompe l'oeil* of an unfinished painting or an uncompleted *trompe l'oeil* (1909, New Britain Mus.). Among his most fascinating subjects, however, are the several versions of *Torn in Transit*, in which landscape paintings are depicted wrapped in brown paper with labels and string, with some of the paper "torn in transit," exposing much of the canvas. The papers, labels, string, and their shadows are all painted in *trompe l'oeil* manner, but the landscapes themselves are very broadly painted, not at all meticulously. These are not landscape paintings but paintings of landscape paintings, and the very effectiveness of the humor is achieved because most of the painting is not *trompe l'oeil* at all. *Lit.: Haberle Retrospective Exhibition*, exhib. cat., New Britain Mus., 1962.

HAIDT, JOHN VALENTINE (1700–1780), a Moravian painter. Born in Gdansk (Danzig), Poland, he studied at the Royal Art Acad. in Berlin from 1710 to 1714 and with his father, a goldsmith at the Prussian court. After travelling through central Europe and Italy, he settled in London where, attracted to the Moravian sect, he became both a preacher and a painter. He subsequently painted on the Continent before settling, in 1754, in Bethlehem, Pa., the center of the sect's American activities. During his years there, he painted many religious works as well as portraits, of which about thirty of the former and about forty of the latter survive, primarily in the Moravian Archives, Bethlehem, and the Moravian Historical Museum, Nazareth, Pa. In the portraits, he relied on stock formulas for the poses and cast of the facial features, most noticeably the longish noses, and he favored red-brown color schemes. Despite the family resemblances of his sitters, he managed to give them a lively sense of character, in part because their eyes invariably stare at the viewer and their mouths are turned up in slight smiles. *Lit.:* Garth A. Howland, "John Valentine Haidt," *Pennsylvania History* 8 (Oct., 1941).

HALE, PHILIP LESLIE (1865–1931), a painter, known primarily for his decorative and artful paintings of the female figure. Born in Boston, Mass., the artist studied at ASL under JULIAN ALDEN WEIR and in Paris at the Académie Julian and at EBA. After his return, he taught at the Boston and Philadelphia museum schools, where he was most influential. During the 1890s, Hale undertook many sporting scenes. From 1900 to 1910, he painted women in infinite variation: in the nude, in landscapes, and indoors. Characteristically impressionistic

in technique, they suggest the influence of Edgar Degas, as, for example, does *The Visit*, where forms are abruptly cut off at the edges of the canvas and diagonal elements predominate. In the 1920s, Hale turned to depictions of man pitted against the overpowering force of nature in such large allegorical canvases as *Riders to the Sea*. He executed a few portraits, for example, the silverpoint *Portrait of a Woman* (1900, Cooper-Hewitt Mus.), though he once admitted he was far more interested in human situations than in the character of individuals.

HALL, ANNE (1792–1863), a miniaturist and portrait painter, and the first woman member of NAD. Born in Pomfret, Conn., Hall received preliminary instruction in miniature painting from Samuel King in Newport, R.I. Although she later studied oil painting with Alexander Robertson in New York City, where she settled, Hall eventually decided to devote herself entirely to miniature painting. Her style was delicate, in the manner of EDWARD GREENE MALBONE, and her compositions well balanced, as can be seen in the painting of the artist with her sister and nephew (1828, NYHS). Characteristic of Hall's work is the extensive use of flowers in her portraits of children. As WILLIAM DUNLAP remarked in his history of art in the United States, "The flowers and children combine in an elegant and well-arranged bouquet." The delicacy and charm of Hall's work and the vitality of her color are particularly evident in her group portraits, in which the artist excelled.

HALL, GEORGE HENRY (1825–1913), one of the most admired still-life specialists of the mid-19th century. From Manchester, N.H., Hall went to study in Düsseldorf, Germany, in 1849 with his good friend EASTMAN JOHNSON, and later settled in New York City, though he travelled extensively, often choosing his subject matter from Spain, Italy, and Egypt. His genre pictures, often exotic and

Mediterranean, were well received, but he is known today primarily for his fruit and flower subjects. Hall was one of the foremost exponents of the lush, optimistic fruit and flower pictures of the mid-century, often emphasizing the abundance of nature, and a variety of different species and reflecting a scientific understanding of his subjects that was admired in his time. His still lifes are often placed upon a highly polished tabletop—almost a hallmark of his art—but he also participated in the return of the still-life subject to a natural setting, placing small, tender fruit subjects—raspberries seem to have been a special favorite of Hall's—in a casual, out-of-doors ambience, a form of still life advocated by the influential English aesthetician John Ruskin and practiced by many American artists after 1860 (see PRE-RAPHAELITISM, AMERICAN). *Lit.*: William H. Gerdts and Russell Burke, *American Still-Life Painting*, 1971.

HALPERT, SAMUEL (1884–1930), a painter of New York City scenes, the French landscape, and still life. Born in Russia, Halpert came to the United States at the age of five. He studied at NAD and in 1902 travelled to Paris, where he remained, off and on, for ten years. In Paris he studied under Léon Bonnat, but Paul Cézanne and then Henri Matisse also influenced him. After shaking off the influence of Bonnat, Halpert developed an honest, personal style. He established himself in New York and, with his firsthand knowledge of the French avant-garde, he became one of the pioneers of the artistic revolution in America. His work is spontaneous and unlabored with a good sense of composition and color. Halpert exhibited at the ARMORY SHOW in 1913 and he is represented at the Detroit Inst. (*The Checkered Cloth*) and the Newark Mus. (*Summer*).

HAMILTON, JAMES (1819–1878), a marine and landscape painter known as the "American Turner." Fifteen years after his birth in northern Ireland, Hamilton and his family emigrated to Philadel-

phia, where he lived and worked almost all of his life. A wealthy patron sponsored his studies at a drawing school, and later Hamilton spent some time in the loosely organized classes at PAFA. He became acquainted with English art through engravings and drawing manuals, particularly admiring the work of Joseph M. W. Turner and Samuel Prout, and furthered his knowledge during a trip to England in 1854. From the 1840s Hamilton's pictures, the majority of which are turbulent seascapes, often with spectacular lighting effects, were shown in the important annual exhibitions in eastern cities. In 1854 and 1856 the artist collaborated with Elisha Kent Kane, a ship's physician with the Grinnell expeditions to the Arctic, producing illustrations for Kane's writings on Arctic exploration. Hamilton's works are characterized by a preference for a broad and sketchy treatment that is in contrast with the minute realism of many of his contemporaries. He often selected romantic themes—storms, shipwrecks, naval encounters, explosions, and fires at sea. Although he borrowed directly from Turner only occasionally, reinterpretations of the English artist's compositions are obvious in Hamilton's paintings, many of which may be seen in Philadelphia at PAFA, the Atwater Kent Mus., the Free Library of Philadelphia, the Philadelphia Maritime Mus., and the Pennsylvania Hist. Soc. *Lit.:* Arlene Jacobowitz, *James Hamilton,* exhib. cat., Brooklyn Mus., 1966.

HANSON, DUANE (b. 1925), a sculptor associated with PHOTO-REALISM. From Alexandria, Minn., he studied art at various colleges before completing graduate work at the Cranbrook Acad. of Art, Bloomfield, Mich., in 1951. He lived in Germany from 1953 to 1961, where he taught in the U.S. Army Dependents School System. While in Bremerhaven, he met the German artist George Grygo, who was then working with polyester resin and fiberglass, materials Hanson would begin to use in the 1960s. In 1972 and 1974, Hanson returned to Germany

(where his work is very popular). His mature style dates from 1966, when, in emulation of GEORGE SEGAL's plaster figures, Hanson created *Abortion,* a plaster sculpture of a dead woman. This was followed the next year by *War* (Lehmbruck Mus., Duisburg), his first major multifigured piece. Each figure was made from negative body molds of dental plaster bandages into which polyester resin stiffened with fiberglass had been poured. After each figure was assembled, Hanson painted it, adding such realistic details as hair, clothing, and objects from the environment. He frequently chose themes of violence until 1970, when satirical pieces, such as *Tourists* (1970) and *Sunbather* (1971, WA) appeared. In 1971 he briefly attempted to portray figures in movement, but they proved less successful than static figures like *Businessman* (1971, Virginia Mus.). Usually Hanson creates an environment made of store-bought items, into which he places figures. Despite their physical individuality, these figures neatly reflect the prosaic and predictable in their actions, achieving a kind of poky universality. Hanson is particularly sensitive to the feelings of loneliness and isolation of old people. *Lit.:* Martin H. Bush, *Duane Hanson,* exhib. cat., WMAA, 1976.

HAPPENINGS, a kind of nonverbal often spontaneous theatrical presentation developed primarily by artists, including RED GROOMS, Robert Whitman, JIM DINE, CLAES OLDENBURG, and, most important, Allan Kaprow, the only one of the original group who has continued to stage them. According to Kaprow, a Happening "is an assemblage of events performed or perceived in more than one time and place. Its material environments may be constructed, taken over directly from what is available, or altered slightly, just as its activities may be invented or commonplace." It may occur anywhere and at any time; it may or may not be planned; and it may or may not require an audience. The first organized Happening, Kaprow's *18 Happen-*

*ings in 6 Parts,* which took place in 1958, was born in the milieu of the As-SEMBLAGE movement of the late 1950s. However, the genre developed out of a long tradition of staged events within the history of modern art (most notably, Dada art) as well as from the theatrical ideas of Antonin Artaud. More immediately, they grew from the uses of chance by composer John Cage, with whom Kaprow studied from 1957 to 1959, and the drip painting of JACKSON POLLOCK. Like a combine by ROBERT RAUSCHENBERG, a Happening does not necessarily have a center of focus or a hierarchy of images or ideas. Early Happenings tended to contain Surrealist elements, but soon their themes and subjects grew mundane. The first Happenings were given in lofts and studios; later, they took place in larger spaces, including auditoriums and college campuses. Often lacking a specific plot or developmental sequence, a Happening communicates meaning by the association and accumulation of information. Materials are often perishable. Since rehearsals are not essential, each Happening is a unique event. *Lit.:* Allan Kaprow, *Assemblage, Environments and Happenings,* 1966.

**HARD-EDGE PAINTING.** See MINIMAL ART.

**HARDING, CHESTER** (1792–1866), a painter, whose success in eastern cities as well as in England is in part attributable to the attractiveness of his frontier bearing and manners slightly glossed over with an acquired sophistication. Born in Conway, N.H., he grew up largely uneducated in the wilderness of western New York. A house painter and sign painter in Pittsburgh in 1817, Harding began his artistic career in earnest soon after in Paris, Ky., where his brother, a chairmaker and portraitist, had settled. In *My Egotistigraphy,* his autobiography published in 1866, Harding mentions that he made more than one hundred portraits in six months there. About 1820 he studied briefly at PAFA before returning to Kentucky, where he painted a likeness of Daniel Boone. He then travelled as an itinerant artist through Ohio, Missouri, Kentucky, and Massachusetts, where he became extremely popular, before journeying to England. There, he established himself successfully from 1823 to 1826 and absorbed some of the mannerisms of Sir Thomas Lawrence, a major portraitist of the period. Upon his return, Harding settled in Massachusetts and founded Harding's Hall. in Boston, among the first associations of artists to promote group exhibitions of contemporary work. Most of his more than one thousand portraits are busts, for anatomical accuracy eluded his grasp. His studies of women, though usually done with great sympathy, tend to be more controlled and less penetrating than those of men. A collection of his works in MFAB includes some of his rare full-length portraits. Other works are in the MMA.

**HARDY, JEREMIAH PEARSON** (1800–1888), a portrait painter, born in Pelham, N.H., Hardy first worked as an engraver in Maine. In 1821 he went to Boston, Mass., to study painting with David Brown. He received further training from SAMUEL F. B. MORSE in New York City. In 1827 he returned to Maine, where he lived and worked for the rest of his life. Although his career has not been fully studied, Hardy seems to have rejected the painterly portrait style of his teacher Morse. His double portrait from the 1840s, *Catherine Wheeler Hardy and Her Daughter* (c. 1842, MFAB) is characterized by crisply delineated forms, sharp silhouettes, tight, controlled handling of paint, and a smooth surface. It has been cited as an example of the permeation of the aesthetic of LUMINISM to genres of painting other than landscape. MFAB owns several other portraits by Hardy. *Lit.:* Fannie Hardy Eckstorm, "Jeremiah Pearson Hardy: A Maine Portrait Painter," *Old-Time New England,* Oct. 1939.

**HARE, DAVID** (b. 1917), a sculptor and photographer. Born in New York City, Hare graduated from the Univ. of Colorado in 1936 with a degree in chemistry.

He has had no formal training in art, always approaching it as a field of experiment. He took up photography in the 1930s, and by the end of the decade was working in color. In 1940 he was commissioned by New York's American Mus. of Natural History to document the Pueblo Indians of New Mexico and Arizona. This assignment resulted in twenty images produced through the complicated color-dye-transfer process, published in portfolio form in 1941. By this time, Hare had developed an automatist process of photographic image-making, which was dubbed "heatage" by the gallery owner Sidney Janis: An unfixed negative from an 8-by-10-inch plate was heated from below, causing the emulsion, and thus the image, to melt and flow. During the early 1940s, a time when he was closely involved with the emigré Surrealists in New York, Hare made his first sculpture, using wire and feathers. Experimenting with plaster, wax, cast bronze, and stone, Hare developed forms that were visual analogues to portmanteau words. Taking two or three objects, one of which was usually a human form, Hare combined them into a hybrid entity that revealed characteristics of all its component parts (*Suicide,* 1946, Chicago National Bank). After visiting France in 1948, Hare intensified the experimental approach, inventively devising multi-media combinations such as steel with alabaster. There, he also began his figure and landscape series, in which many materials interpenetrate to create connected images of rocks, plants, sky, and celestial bodies. Upon his return to the United States, Hare began to use steel rods melted and poured into plaster molds and to make sculptures incorporating metal sprayed with a gun, as in *Sunrise* (1955, AK). A mythological series begun in the late 1950s developed into the Chronos series, which Hare has been elaborating upon since 1967 in both painting and sculpture, using in the latter medium a combination of metal, Plexiglas, sand, and polyurethane. *Lit.:* Robert Goldwater, "David Hare," *Art in America,* Winter, 1956–57.

HARNETT, WILLIAM MICHAEL (1848–1892), a still-life painter. Harnett was born in Clonakilty, County Cork, Ireland, but was raised in Philadelphia. From a family of artisans, he was first trained as an engraver of silverware, a skill that undoubtedly contributed to his precise, linear style as a painter. During the late 1860s, Harnett studied at PAFA. In 1871 Harnett moved to New York City, and attended night classes in art at Cooper Union while working on silver during the daytime. Three years later, he began to devote himself to painting full time, and, in 1875, after a year's study at NAD, began producing the carefully executed, minutely detailed pictures for which he is known today. In 1876 he returned to Philadelphia and at some time during the next four years he became friends with JOHN FREDERICK PETO, later, with Harnett, one of America's finest practitioners of the exacting art of still life.

Harnett's early works, painted before 1880, are mostly small still lifes of tabletops cluttered with casually arranged pipes, mugs, newspapers, letters, and pens—in the still-life tradition of the Philadelphia painter RAPHAELLE PEALE.

A particularly interesting picture of this period is Harnett's *The Artist's Card Rack* (1879, MMA). This tour de force of illusionism shows a popular early form of bulletin board: strips of tape or ribbon tacked onto a wall, forming a crisscrossed network into which various flat objects—calling cards, stamps, theater tickets, and the like—are tacked and suspended for easy reference. Because of the remarkable verisimilitude, the viewer becomes convinced that the letters and faded photographs can be plucked out of the card rack by their curling, dog-eared edges; ragged newspaper clippings tantalize one with their carefully painted copy that is never quite legible. Peto also painted many card-rack pictures; indeed, the rack painting, popular at the beginning of the 19th century with Raphaelle Peale and others, has been traced back to the 17th-century Dutch and Flemish still-life tradition.

But Harnett took the genre to its greatest possible lengths, painting the graffiti and nail holes on the surface of the wall, a piece of old string hanging from the top of the card rack, and the place where a photograph had once been affixed and then torn away, exposing the lighter wood tones underneath.

In January, 1880, Harnett went to Europe, spending much of his time in Munich. Most of the works he produced in Europe are smaller, richer tabletop still lifes, such as A Study Table (1882; MWPI), which stresses the textures and details of relatively valuable objects—pieces of armor and ornately worked tankards—arranged in a pyramid along with the more usual books, lamps, and writing materials. However, Munich critics—who preferred a vigorous, brushy painting style—dismissed Harnett's illusionistic, miniaturist's approach as old-fashioned. So he went to Paris, where his art was more warmly appreciated, and where he painted his famous series of four very similar pictures of weapons and game, all produced during the mid-1880s, all entitled After the Hunt. The fourth and largest version of this painting (CPLH) was executed in Paris in 1885 and exhibited in that year's spring Salon. It shows a scratched wooden door with elaborately curved metal hinges, upon which hang a horseshoe, several weapons and a powder horn, a battered hat, a hunting horn, a knapsack, a small earthenware jug, a pair of antlers, a dead rabbit, and three dead birds. As is usual with mature works by Harnett, each object is minutely and accurately described. It has been suggested that Harnett based his After the Hunt quartet on a series of large photographs taken about 1860 by Adolphe Braun, a noted Alsatian photographer whose work was then known throughout Europe. When he returned to the United States in 1886, Harnett sold this fourth After the Hunt to Theodore Stewart, who hung it in his well-known New York saloon. The picture proved so popular with Stewart's customers that further versions, painted by other artists, proliferated in American bars and hotels for several decades thereafter.

Soon, Harnett's declining health severely limited his artistic production. Together with his usual still-life subjects, Harnett's late works include a number of studies of individual objects—a single horseshoe, a bird, a pistol—silhouetted against a monochrome wall. Even his more complex pictures of this period, such as The Old Violin (1886) are characterized by a monumental, almost classic simplicity of form, light, and color. The Old Violin was reproduced as a chromolithograph and frequently copied by other artists. Painting became increasingly difficult for Harnett during his last years, due to the effects of crippling rheumatism, and he died in 1892 in New York, where he had spent the previous six years.

Because his work was considered so old-fashioned by influential critics, Harnett enjoyed virtually no artistic reputation until his last years, and very little is known about his life. Although he is estimated to have produced about five hundred paintings, more than two-thirds of these have been lost. Assessment of Harnett's oeuvre is further complicated by the many forgeries of his work that appeared in later years. Once his name became better known than Peto's, for example, many of the latter's pictures were re-signed with Harnett's name. This fact was discovered fairly recently, after Harnett's reputation was revived by an exhibition of his work at the Downtown Gall. in New York City in 1929. His exacting realism was understandably attractive to the 20th-century Surrealist artists, and today Harnett is recognized as the most influential late 19th-century American painter of still life. Lit.: Alfred V. Frankenstein, After the Hunt: William Michael Harnett and Other American Still Life Painters, 1870–1900, 2d ed., 1969.

HART, GEORGE OVERBURY (1869–1933), known as "Pop" Hart, a painter cut from the archetypal mold of the wandering bohemian and anti-intellectual (FRE-

DERIC REMINGTON, THOMAS HART BENTON, and JACKSON POLLOCK have all had aspects of the latter quality in their characters). From Cairo, Ill., Hart travelled constantly and visited many parts of the world. He studied briefly at AIC. From 1907 to 1912, he painted signs for amusement parks in the New York City area and, until 1920, did stage sets for motion-picture studios at Fort Lee, N.J. Preferring watercolor to oils, he first began to make prints in 1921, drypoints initially and then lithographs, etchings, and other types of graphics. In his drypoints especially he made provocative use of dark-light contrasts. Most of Hart's work—impromptu observations of scenes observed during his travels—is illustrative. He generally concentrated on both the telling gesture and local color to give his work visual and folkloric interest (*Courtyard, New Orleans*, 1917, MMA). *Lit.: George O. "Pop" Hart*, exhib. cat., Newark Mus., 1935.

**HART, JAMES MACDOUGAL** (1828–1901), **AND FAMILY.** James Hart, a leading figure among the second-generation painters of the HUDSON RIVER SCHOOL, was born in Paisley, Scotland, but his family emigrated to America in 1831, settling in Albany, N.Y. He was apprenticed to a sign maker but turned to painting and was a member of a small coterie of talented artists in Albany. In 1850 he went to Düsseldorf, Germany, where so many American artists studied during the 1840s and 1850s. He returned to Albany in 1853, but settled permanently in New York City in 1857, where he later became vice-president of NAD. Hart painted a number of large panoramic landscapes during the 1840s and 1850s in meticulous detail and peopled with idyllic scenes of school-children and farmers, luminously glowing evocations of the conception of America as a rural Eden. James's later landscapes are more broadly painted and more bucolic, often depicting cattle in a mode that recalls the French Barbizon artist Constant Troyon. Hart also occasionally executed animal paintings. His sister Julie Hart

Beers Kempson (1835–1913) was one of the few professional women landscape painters of her time, and James's wife, Marie Theresa Gorsuch (1829–1921) was a still-life painter. WILLIAM HART, James's older brother, became an important landscapist.

**HART, JOEL TANNER** (1810–1877), a sculptor of portrait busts. Hart was born in Winchester, Ky., then at the American frontier, and, with no formal education, was apprenticed to a stonecutter in Lexington, Ky. There, he saw the work of SHOBAL VAIL CLEVENGER, who was making a likeness of Henry Clay. In the 1830s, Hart made busts of Clay and of another local hero, Andrew Jackson. A plaster bust of Clay with Hart's name inscribed is now in NYHS, and it may be one of his earliest works.

In 1845 Hart travelled to the major eastern cities, where his busts drew considerable attention. In Richmond, Va., the Ladies' Clay Assoc. was so taken by his bust of the statesman that they commissioned a full-length statue (1859, State House, Richmond, Va.). Hart was a methodical worker and not until three years later did he travel to Florence to execute the statue. After ten years' labor, the awkwardly posed, overly detailed, distinctly unheroic statue was unveiled in Richmond to wide acclaim. Replicas were ordered, which would make Hart financially comfortable the rest of his days.

After a triumphal visit to Kentucky, the sculptor returned in 1849 to Florence, where he became a prominent member of the American community there. He produced portrait busts and an occasional ideal piece at his slow, deliberate pace, until his death. His strength was in forthright presentation of accurate likeness, but his more ambitious work is marred by faulty anatomy and too much detail in the ill-fitting clothing. His total output was not large. *Lit.:* J. Winston Coleman, Jr., "Joel T. Hart: Kentucky Sculptor," *Antiques*, Nov. 1947.

HART, WILLIAM (1823-1894), a leading
landscape painter of the second genera-
tion of HUDSON RIVER SCHOOL artists.
William, and his youngest brother, JAMES
HART, were born in Paisley, Scotland,
but the family emigrated to America in
1831, settling in Albany, N.Y. William
was apprenticed to a carriage-maker but
turned to portraiture in 1849. In 1854 he
settled in New York City, where he was
joined three years later by his brother.
Hart's work was painted in the manner
of the leading landscape artist of the pe-
riod, ASHER B. DURAND, though it lacks
Durand's monumentality. His scenes are
peaceful and serene views of native
scenery, his earlier works painted in a
detailed and meticulous manner, his lat-
er works more broadly conceived, and,
like those of James, more bucolic. Hart
painted a number of dramatic small sea-
scapes set off the coast of Maine, at
Grand Manan Island, with waves vio-
lently breaking upon the towering cliffs,
and these suggest the influence of the
popular German artist of the period An-
dreas Achenbach, of Düsseldorf. Wil-
liam Hart was also one of the founders
and later president of the American Wa-
ter Color Soc.

HARTIGAN, GRACE (b. 1922), a painter.
Born in Newark, N.J., she worked as a
draftsperson in a factory in 1943 and
studied with Isaac Lane Muse in New
York City. Soon after a year spent in San
Miguel de Allende, Mexico (1949), she
became part of the so-called second gen-
eration of ABSTRACT EXPRESSIONISM. By
1952 her imagery, still recognizable, had
come to reflect that of WILLEM DEKOON-
ING (The Persian Jacket, 1952, MOMA).
Such works, charged with energy, are
built up in rich, thick brushstrokes. At
the end of the decade, she abandoned
figuration for an art of complete gestural
abstraction, as in New England, October
(1957, AK). She contained the explosive
forms in these heavily textured works
within thickened lines. In the 1960s, her
work turned lyrical. It became charged
with mythological content in the early
1970s and then grew tapestrylike at mid-

decade. Despite their stridency, Harti-
gan has always derived her colors from
nature.

HARTLEY, MARSDEN (1877-1943), a
painter, poet, and author and a pioneer
of modern art. Born in Lewiston, Maine,
he showed early talent when, at the age
of thirteen, he executed a series of pre-
cise drawings of moths, butterflies, and
flowers for a professional naturalist. In
1892 he moved to Cleveland, Ohio, and
took weekly art lessons from John Ser-
mon. That same year, he won a scholar-
ship to attend the Cleveland School (now
Inst.) of Art. Hartley went to New York
City in 1898 and entered the Chase
School, working under Frank F. Du-
Mond and WILLIAM MERRITT CHASE, but
after becoming disillusioned with the
Chase system, he left the school in 1900
to study at NAD under Edgar Ward and
F. J. Dillman, among others.

Hartley spent his summers painting in
Maine, and about 1908 he broke with
the tradition of American naturalism
and began executing mountain land-
scapes in the Impressionist "stitch" style
of Giovanni Segantini (The Mountains,
1908, Columbus Gall.). These were ex-
hibited in his first one-man show, held at
ALFRED STIEGLITZ'S LITTLE GALLERIES OF
THE PHOTO-SECESSION in 1909. A year
later, however, his "black" landscapes
(Storm Clouds, Maine, Walker Art Cen-
ter) demonstrated the influence of AL-
BERT PINKHAM RYDER—an artist to whom
Hartley responded later in his career as
well. Stieglitz not only exhibited Hart-
ley's early works, he also introduced him
to the European modernism of Henri
Matisse, Pablo Picasso, and Paul Cé-
zanne, whose influences could be seen in
Hartley's still lifes by 1912. With the
help of Stieglitz and ARTHUR B. DAVIES,
Hartley went abroad in 1912. In France
he experimented with Cubism and Fau-
vism before moving on to Germany,
where he remained from 1913 to 1915,
except for a brief trip to America in
1913. Influenced by the Blaue Reiter
artists Wassily Kandinsky and Franz
Marc, Hartley produced large, semiim-

provisational abstract compositions. This work contained mystical references to numbers and shapes; several paintings were based on German military emblems and included, in addition to Iron Crosses and flags, checkerboard and zigzag patterns, as in *Portrait of a German Officer* (1914–15, MMA). Hartley also exhibited with the Blaue Reiter group as well as in the First German Autumn Salon in Berlin.

After returning to America, weary, as he said, of emotionalism in art, he abandoned mysticism for a more straightforward abstract art composed of flat, angular planes and related to Cubism, but probably more directly derived from sailboat forms (*Abstraction, Provincetown*, 1916, AIC). In Maine in 1917, he executed a number of paintings on glass, perhaps remembering both American and Bavarian folk art. After two trips to New Mexico, where he executed pastels and developed an expressionist manner, he returned to Europe in 1921 and remained there for ten years. During that period, he often painted recollections of the New Mexican landscape with Ryderesque overtones. He also experimented in lithography from 1923 to about 1934. In the mid-1920s, he renounced expressionism, claiming that the theoretical aspects of painting were more important than the imaginative ones. As part of his renunciation of emotionalism, he moved to Aix-en-Provence to paint Mont Sainte-Victoire in a Cézannesque mode, but his concern solely for the theoretical was short-lived.

Hartley's mature style emerged in his Dogtown series, done in Gloucester, Mass., in 1931. Forms grew heavy and blocky and were presented frontally, often with heavy outlines. Colors grew both strong and somber. Ever restless, Hartley continued to wander: to Mexico in 1932 (Popocatepetl series); to Germany in 1933 (Garmisch-Partenkirchen series: an example of 1933 is in the Univ. of Minnesota); to Bermuda; and to Maine in 1934. He lived in Maine for the remainder of his life, except for a trip to Nova Scotia in 1936. His later works, of northern scenes, make up in gravity and grandeur what was sacrificed in imaginative play. Ryder's influence also reasserted itself (*Northern Seascape*, 1936–37, Milwaukee Art Center). Perhaps responding to the rigors of northern life, Hartley also completed some works, such as *Fishermen's Last Supper* (1940–41) in a direct, almost primitive manner.

Hartley was a lonely and reclusive person. Although he seldom admitted it, he was highly susceptible to influences, and it was not until he had worked from realism through the various styles and philosophies of modern European art that he came into his own, producing powerful, expressionistic paintings of profound aesthetic and emotional content. Color, always one of his primary concerns, grew particularly exquisite in his late works. His diversity of style and orginality of design are most strikingly evident in his later landscapes, especially those containing mountains, a motif that occupied him all his life. These landscapes in particular reveal his intense feelings for nature and have a sensuous and spiritual beauty uniquely their own. Hartley's creativity also manifested itself in literature, for he was a poet and the author of four books and numerous articles. *Lit.*: Elizabeth McCausland, *Marsden Hartley*, 1952.

**HARVEY, GEORGE** (c. 1800–1878), a painter of miniatures, landscape, and genre. From Tottenham, England, he came to America in 1820 and lived for the next several years in the Middle West. He returned before 1828 to New York City, where he became well known. Probably in 1829, he moved to Boston, Mass., where he completed about four hundred miniatures. He traveled to England for further study in the early 1830s, returning to America in 1834, when he purchased land along the Hudson River, built a house, and helped Washington Irving with the construction of his house, "Sunnyside." He began a series of "atmospherical landscapes" to illustrate the changes in climate in the Hudson River Valley. These delicate,

crisp watercolor studies, such as *View on the Hudson* (c. 1837, MFAB) reveal expanses of landscape with each form, usually small in scale, precisely delineated. They presage the rise of LUMINISM during the mid-century period. Harvey intended to publish a set of engravings of his landscapes, but only four, entitled *The Seasons*, were completed, in 1841. Many of the watercolor studies are in NYHS. Harvey also painted genre scenes, such as *The Apostle Oak* (1844, NYHS). He travelled between England and America after 1847, but made his home abroad after that date. *Harvey's Illustrations of Our Country* was published in 1850. *Lit.*: Donald A. Shelley, "George Harvey and His Atmospheric Landscapes in North America," *New-York Historical Society Quarterly* 22 (Apr., 1948).

HASELTINE, WILLIAM STANLEY (1835–1900), an important American landscape specialist. Haseltine studied with the German emigré artist Paul Weber in his native Philadelphia, and followed his teacher back to Germany in 1854. Haseltine then became an important figure in the American group in Düsseldorf, associating there with EMANUEL GOTTLIEB LEUTZE and with the landscapists T. WORTHINGTON WHITTREDGE and ALBERT BIERSTADT, with whom he went on sketching trips and a visit to Rome in 1856, and whom he joined in New York's Tenth Street Studio Building, in 1858. It was about this time that he painted his finest pictures, coastal scenes in New England, characterized by a extraordinary clarity of light and form, emphasizing severe geometry and displaying extraordinary geological precision. In 1866 he left for Paris, briefly associating with the Barbizon School landscape painters, but in the following year he settled in Rome for the rest of his life and there became a prominent figure in the Anglo-American art colony. In his later landscapes, Haseltine replaced the cool austerity of his New England skies with the brilliant yellow sunlight of Italy, and adopted a fuller

chromaticism in accord with the landscape expression of the international art colony in Rome. *Lit.*: Helen Haseltine Plowden, *William Stanley Haseltine*, 1947.

HASSAM (FREDERICK) CHILDE (1859–1935), a leading exponent of Impressionist painting in America (see IMPRESSIONISM, AMERICAN). Hassam was born in Dorchester, Mass., of old Puritan stock; the original family name was Horsham. Early in his career, Hassam was persuaded to drop his first name the better to exploit the exotic suggestion of his middle and family names. Raised in a cultivated household, Hassam decided early to become an artist. He left high school to work for the Boston, Mass., publisher Little, Brown & Co. and also began training as a wood-engraver. He turned to illustration and received commissions to illustrate Celia Thaxter's *An Island Garden* in 1894. He also took lessons at the Boston Art Club and the Lowell Inst.

Hassam made his first trip to Europe in 1883, but it was not until 1886 that he embarked on a three-year stint of art study in Paris. He was enrolled for a short time at the Académie Julian, known for its noisy, crowded studios and absence of discipline of any kind. There, Hassam saw a wide range of styles, as the school attracted many foreign artists as well as young French ones, including the Nabis. It was, however, the work of the Impressionists that attracted Hassam. Although light had previously played a major role in Hassam's work, as *The Beach at Dunkirk* (1883, MMA) shows, color remained subdued. His *Grand Prix Day* (1887, MFAB) demonstrates, after only a short time in Paris, a much more heightened sense of color. It is almost an Impressionist street scene in both its composition and broken brushstroke. Only a lingering solidity of form identifies it as American. Works such as *The Flower Garden* (1888, Worcester Mus.), with brilliant light playing over flowers and women's dresses, come very close to the early Claude Monet, but the formality of arrangement and careful defini-

tion of forms are, again, typically American.

Hassam was an anglophile who interpreted his own approach in terms of the British landscape tradition, but there is no question that he returned to the United States with the technique and sensibilities of the French Impressionists, tempered with American realism. Impressionism came to Boston and flourished in the 1880s without the furious protest it had aroused in France. It is not surprising, then, that in 1898 Hassam joined with the former academic painter JULIAN ALDEN WEIR and JOHN HENRY TWACHTMAN in founding the TEN AMERICAN PAINTERS, which was to include, among others, FRANK WESTON BENSON, ROBERT REID, and EDMUND C. TARBELL. This group of Impressionists mounted a series of exhibitions that were by far the most coherent of any held in America in that era.

For Hassam everything came easily; his career and his life passed as smoothly as one could wish. He entered most of the important American exhibitions and seldom failed to win a prize. His style developed after 1900 toward greater simplification and flatness; his *French Tea Garden* of 1910 may even suggest Pierre Bonnard, though Hassam retained the illustrator's eye for descriptive detail. He was represented in the ARMORY SHOW of 1913 but later repudiated its more extreme aspects. A series of street scenes, vibrant and patriotic with bright banners, including *Flag Day* (1919, LACMA) are considered the peak of Hassam's achievement and are somewhat reminiscent, in distortions of space and proportions, of his fellow Bostonian MAURICE PRENDERGAST. Late in his career, Hassam produced numerous lithographs of harbor scenes in the manner of JAMES A. M. WHISTLER and charming views of rainy city streets, which remain among his most popular works. *Lit.:* William Steadman, *Childe Hassam*, exhib. cat., Univ. Arizona, 1972.

HAWTHORNE, CHARLES W. (1872–1930), a traditional portraitist and genre painter closely associated with the Cape Cod School of Art, Provincetown, Mass., which he founded and directed from 1899 until his death. Born in Lodi, Ill., he grew up in Maine. He studied at ASL in 1894–95 and then with WILLIAM MERRITT CHASE in 1896–97. During a visit to Holland the following year, Hawthorne was greatly impressed by Frans Hals and developed a strongly tonal style. In 1899 he began to make genre pictures of Provincetown fishermen. Regardless of pose or activity, their faces invariably reflect an inexplicable inner sadness. Around 1904 he began to paint portraits with the figures usually part of an interior domestic scene. Facial features were solidly modelled, linking Hawthorne with conservative artists rather than with ROBERT HENRI and other modern realists. A trip to Italy in 1906–07 diverted his attention from realistic scenes to more idealized settings for his figures and also temporarily mellowed his bravura attack. Although Impressionist influences appeared in his work about 1910, he generally preferred solid volumes to surface effects (*The Mother*, c. 1910, MFAB). *Lit.:* Elizabeth McCausland, *Charles W. Hawthorne: An American Figure Painter*, 1947.

HEADE, MARTIN JOHNSON (1819–1904), a painter of landscapes, flowers, and birds. From Lumberville, Pa., he worked with EDWARD and THOMAS HICKS about 1838–39 and became a professional portrait painter, before travelling in France, England, and Italy between 1840 and 1843. On his return, he painted landscape and genre scenes, such as *The Roman Newsboys* (c. 1848, Toledo Mus.). An inveterate traveller, Heade went again to Europe in the late 1840s, lived briefly in several American cities, visited South America on at least three occasions (Brazil in 1863 and Colombia in 1866 and 1870), and finally settled in Florida in 1883, although, he frequently left that state for varying periods of time.

Heade's mature landscapes, more in the style of LUMINISM than in the HUDSON RIVER SCHOOL tradition, date from

the late 1850s and include *Rhode Island Landscape* (1858, MFAB). Detail is precisely rendered and sharply focused, distant forms are painted with clarity, and compositional formats tend to be horizontal. His seacoast scenes often show farmers, small in scale, toiling in the middle distance. Though he executed at least thirty seascapes in the 1860s, Heade's marsh scenes, first painted in that decade, are his most popular works of the time. They are horizontal in format and meticulous in detail, and the subject matter often includes stacks of salt hay under changeable skies. The Newburyport, Mass., marshes were a favorite haunt of the artist. During these years, he also painted storm scenes, a rarity in American art at the time, which demonstrate Heade's keen eye for weather changes and their effects on the aspect of objects (*Thunderstorm over Narragansett Bay*, 1868; *Approaching Storm: Beach near Newport*, 1865–70, MFAB). He continued to paint marsh scenes in the 1870s, the locale removed to New Jersey, but the later ones are more high-keyed in color and textured in finish. Altogether, Heade painted about one hundred such scenes.

A devoted student of hummingbirds, the artist began to paint them in 1863 and planned a book on the subject, *Gems of Brazil*, unfortunately never completed. Unlike earlier bird painters, he often placed his brilliantly colored subjects in detailed studies of their habitats, as, for example, in *Two Hummingbirds: Copper-Tailed Amazili* (c. 1863–65, Brooklyn Mus.). Beginning in 1871, he showed the birds with orchids arranged in a tropical setting. A fine example is *Jungle Orchids and Hummingbirds* (1872, Yale Univ.). In this way, he combined his great interests, still life (he made many studies of flowers beginning in 1860) and landscapes, a union of themes he maintained in his work into the 20th century. His paintings of the Florida landscape, appropriately lush and revealing the warm, sultry colors of its lowlands and marshes, are also in the Luminist manner, but Heade sometimes allowed a brushy quality to soften the forms in his late landscapes, as in *Sunset: A Florida Marsh* (c. 1895–1900, Parrish Mus.). *Lit.:* Theodore E. Stebbins, Jr., *The Life and Works of Martin Johnson Heade*, 1975.

HEALY, GEORGE PETER ALEXANDER (1813–1894), a prolific artist who was America's first international portraitist. From Boston, Mass., he opened a studio there in 1830, even though he was as yet largely untrained. An easy facility for portrait painting, as well as the sponsorship of the socially prominent Mrs. Harrison Gray Otis, made it possible for Healy to go abroad, for the first time, in 1834 (he subsequently made thirty-four Atlantic crossings) to study briefly with Antoine Jean Gros in Paris. Almost at once, the primitive qualities of his portraits were replaced by a suave, hard-edged manner sometimes approximating the effect of a photograph. He returned to this country in 1842 with commissions from King Louis Philippe of France and painted portraits of leading figures here, including John Tyler, Daniel Webster (versions in the Virginia Mus. and MFAB), and John Calhoun. During the succeeding years, Healy painted the great and the famous in both Europe and America, producing flattering likenesses notable for an alert glance and often assertive gestures. His rare historical works include *Webster Replying to Hayne* (1851, Faneuil Hall, Boston). After a visit to Spain in 1871, Healy's technique grew freer, particularly in landscapes. A resident of Chicago from 1855 to 1866, he returned to that city from Paris in 1892, having lived there during the intervening years. Although many of his works were destroyed in the Chicago fire of 1871, representative examples abound in MFAB, NCFA, and the Newberry Library, Chicago. Healy wrote *Reminiscences of a Portrait Painter* (1894). *Lit.:* Marie de Mare, *G. P. A. Healy: American Artist*, 1954.

HEIZER, MICHAEL (b. 1944), a painter and creator of EARTH ART. From Berke-

ley, Calif., he probably absorbed his feeling for land and space from his archaeologist father. From 1963 to 1964, Heizer attended the San Francisco Art Inst. where he studied painting. His work, then reflecting Minimalist tendencies (see MINIMAL ART), included square and rectangular canvases with broad bands of gray and white. By 1966 he had begun to create earthworks on a monumental scale. He has preferred to work in the open desert areas of the Southwest. His *Double Negative*, of 1969–70, a huge trench at Virgin River Mesa, Nev., displaced 40,000 tons of earth. Although primarily an earth mover, he has also raised forms above ground. Beginning to paint once again in 1972, and therefore accepting the tradition of creating an art object rather than an art event or a series of activities in an art context, Heizer returned to his earlier style. However, for the rigid geometrical units, he substituted circles and ovals. Like the earlier pieces, too, these are occasionally shaped by cuts into the framing edges.

**HELD, AL** (b. 1928), a painter. Born in New York City, he attended ASL from 1948 to 1949, before leaving for Paris, where he studied at the Académie de la Grande Chaumière and remained until 1952. From 1950, when he abandoned a politically oriented social-realist mode, until 1959, he painted in an Abstract Expressionist manner. He hoped, he said, to combine the subjectivity of JACKSON POLLOCK with the objectivity of Piet Mondrian. Between 1960 and 1967, he abandoned the thick, encrusted textures and random gestures of ABSTRACT EXPRESSIONISM for a more severely controlled, bright-colored, and flat-planed geometrical formalism (*House of Lords*, 1960, San Francisco Mus.). In works in this manner, often large in size with overscaled, aggressive forms, shapes do not hug the picture plane nor do they engage in an exacting dialogue with the framing edges as do paintings by FRANK STELLA or KENNETH NOLAND. Rather, Held's forms assumed an architectural

cadence suggestive of planes in space. In 1967 he began to make black-and-white paintings; using black lines against a white ground, or white against black, he created geometrical forms that seem to advance into the viewer's space or recede into pictorial space (*South Southwest*, 1973, WMAA). These, in effect, explore the spatial terrain of Analytic Cubism, but with the large-scaled forms of the 1960s and 1970s. These concerns are notably presented in Held's 90-foot-wide *Albany Mural* in the Empire State Plaza, Albany, N.Y., of 1971. *Lit.:* Marcia Tucker, *Al Held*, exhib. cat., WMAA, 1974.

**HELIKER, JOHN** (b. 1909), a painter. Born in Yonkers, N.Y., he studied at ASL from 1927 to 1929. An emphatic draftsman, he treated farm and urban scenes in a realistic style tempered by his keen interest in formal organization during the next decade. In the mid-1940s, Heliker began to stress formal relationships, exploring mythic forms, perhaps under the influence of the Surrealists then in New York City (see ABSTRACT EXPRESSIONISM). The majority of these paintings were characterized by closely knit planes with complex, flattened geometrical patterns of varying texture (*Still Life*, 1956, WA). These grew in complexity during repeated visits to Italy between 1948 and 1958 as well as during summers often spent along the Maine coast. An example is *Rocks and Trees, Maine* (1961, WMAA). Through the 1960s, Heliker softened and simplified the Cubist faceting of forms in his portraits and landscapes. *Lit.:* Lloyd Goodrich and Patricia Fitzgerald Mandel, *John Heliker*, exhib. cat., WMAA, 1968.

**HENRI, ROBERT** (1865–1929), leader of the early 20th-century realists known as The EIGHT and also as the Ashcan School, and a teacher who ranks with BENJAMIN WEST and HANS HOFMANN as a major source of inspiration for at least two generations of artists. Born Robert Henry Cozad in Cincinnati, Henri changed his name in 1883 after his fa-

ther killed a man. He spent his youth in the West, then settled with his family in New Jersey. In 1886 he entered PAFA and studied with THOMAS ANSCHUTZ and THOMAS HOVENDEN. He left in 1888 for Paris, attending the Académie Julian until 1891, when he returned to Philadelphia and, for the next few years, painted in an Impressionist manner. By 1895, before returning to Europe, where he remained, for the most part, until 1900, he had met the newspaper artist-reporters who would become the nucleus of The Eight—WILLIAM GLACKENS, JOHN SLOAN, GEORGE LUKS, and EVERETT SHINN. Had Henri not dropped Impressionism for the style of the Baroque painter Frans Hals and the early dark manner of Edouard Manet during these years, the styles of these realist painters might have developed differently. Henri encouraged them to have self-confidence in their feelings and reactions and to respond directly to their subject matter. Ignoring conventional academic styles, art-for-art's-sake aestheticism, and Impressionism, Henri guided them, and himself, to an understanding and an appreciation of Hals, Rembrandt, Manet, and THOMAS EAKINS, artists with tonal rather than coloristic styles and whose brush techniques prompted Henri and his friends to adopt a slashing, quick attack in order to record the vitality and immediacy of their feelings. But, though he drew his subjects from the urban milieu, Henri avoided the political messages and social commentary that pervaded contemporary muckraking literature and realistic American novels.

His return to New York City in 1900 symbolically represents the beginning of modern art in America; in 1902 he stated "the big fight is on"—against the traditional forces in the art world. In that year, he began teaching at the New York School of Art and would remain there until 1908, establishing his own school in 1909. Elected to NAD in 1906, he had already begun to undermine its authority. In 1904 he had organized a show at the National Arts Club in New York City that included works by six of The

Eight—Henri, Luks, Sloan, Glackens, MAURICE PRENDERGAST, and ARTHUR B. DAVIES. Angered because NAD slighted two of his paintings selected for their spring show, rejected submissions by Luks, Shinn, Glackens, ROCKWELL KENT, and Carl Sprinchorn, refused to elect certain modernists as members, and did not reelect him to jury succeeding exhibitions, Henri helped organize an exhibition of The Eight in 1908 at New York's Macbeth Gall., which included the realists and also Prendergast, Davies, and the Impressionist ERNEST T. LAWSON. Henri also helped organize the 1910 Exhibition of Independent Artists. These all helped break the conservative stranglehold on American art (see INDEPENDENT EXHIBITIONS).

As a teacher, Henri stressed self-reliance and self-respect. He believed that art grew from life, not from theories. Unlike later painters of the American Scene, such as THOMAS HART BENTON, he felt it less important to convey a sense of the locale than to understand and sympathize with the subject. By sympathetic interaction with others, Henri believed that artists could see beyond the specific to the universal, discovering what is basic in human nature. Thus, he felt the commonest activities were invested with dignity. He sought support from such writers as Tolstoy and Emerson for his intense interest in human beings. He traveled widely in America and in Europe in search of, as he said, "his people." He wanted to make his paintings "as clear and as simple and sincere as is humanly possible." To avoid the pitfalls of theory, he urged his students to paint with intensity. Each individual brushstroke, he said, should convey the state of their feelings as pigment was applied. Portraits, he thought, should be painted rapidly so that the living presence of the sitter might be captured.

Henri did not always follow his own best advice. In his early views of New York, such as *West 57th Street, New York* (1902, Yale Univ.), he seems to have found poetry rather than dynamism, becoming a proletarian Tonalist

rather than the leader of a group of urban realists. His landscapes and portraits, however, did grow increasingly vigorous over the years. His work assumed an aura of greater immediacy and improvisation. Brushstrokes became more ragged and colors more bouncy, as in the portrait of Eva Green (1907, Wichita Art Mus.). After 1910 he concentrated increasingly on likenesses and figure studies. In these works, he emphasized vibrancy of personality rather than social position and condition, as can be seen in the portraits *Himself* and *Herself* (1913, AIC). Actors and dancers lent an extra measure of liveliness to his subject matter. After 1913 Henri modified his tonal style by admitting a wider range of colors to his palette. Although the influence of the ARMORY SHOW upon his work should not be discounted, Henri's adoption of the Maratta system accounts, in the main, for his new interest in color. (In 1909 he had met and been impressed by Hardesty Maratta, a painter and color theorist who had developed a color system analogous to musical scales and chords to determine harmonies of color.) Of lesser importance, though significant for Henri's later development, was Jay Hambidge's theory of dynamic symmetry, according to which certain geometrical ratios said to underly Egyptian and Greek art were proposed as compositional formulas for modern artists. Perhaps like JOHN MARIN, who imposed order on his painted images by laying black lines across the surface, Henri felt a need for coloristic and structural discipline to contain his emotional explosiveness. *The Art Spirit* (1923), a collection of Henri's letters, aphorisms, and lectures, summarizes his attitudes toward art. *Lit.:* William Innes Homer, *Robert Henri and His Circle,* 1969.

**HENRY, EDWARD LAMSON** (1841–1919), a genre painter of the late 19th century. From Charleston, S.C., Henry studied in Paris with Gustave Courbet between 1860 and 1862, but nothing of Courbet's vigorous, dramatic style or artistic beliefs is reflected in Henry's painting. His small genre scenes were peculiarly old-fashioned for the period in their minute detail and brilliant coloration, his style totally without monumentality but full of anecdote. Many dwell upon things of the past—antique furniture, old china, old-time occupations such as spinning, and elderly people. His paint handling and color may owe something to the English Pre-Raphaelites; his nostalgic rendering of scenes and objects of the past are part of the vogue for antiques collecting that began with the Philadelphia CENTENNIAL EXPOSITION in 1876. His masterworks are a series of early railroad scenes in which a multitude of closely observed details are presented together with, surprisingly, a real sense of open space (*The 9:45 Accommodation, Stratford, Connecticut,* 1867, MMA). Though Henry's artistic approach remained consistent during his lifetime, his later painting is less sharply defined, and his palette changed from deep bright tones to lighter, almost pastel colors. A large collection of his work is owned by the New York State Department of Education, Albany. *Lit.:* Elizabeth McCausland, *The Life and Work of Edward Lamson Henry,* 1945.

**HESSE, EVA** (1936–1970), a sculptor. Brought to New York City from her native Hamburg, Germany, in 1939, she attended Cooper Union from 1954 to 1957 and received the B.F.A. degree from Yale Univ. in 1959. She began to sculpt seriously in Germany in 1964. After her return to America, Hesse became a major figure in the post-Minimalist movement (see CONCEPTUAL ART). Hesse worked with many materials, preferring fiberglass and latex after 1967, and used them in both expressionist and eccentric ways, influenced here by both ABSTRACT EXPRESSIONISM and the work of JASPER JOHNS. She employed serial and modular systems, often in antic ways, stressing noncompositional formats and seemingly casual arrangements of units (see MINIMAL ART). In place of the sculptor's traditional anthropomorphic core, she experimented with effects of

gravity, hanging works from ceilings or leaning them against walls. She also used floors as an integral part of many pieces. In works such as *Contingent,* a hanging piece in eight parts, she said that she sought an effect of nonart that was non-connotative, nonanthropomorphic, and nongeometrical. In effect, she searched for a point of reference other than those traditionally associated with art. Recognizing the sense of absurdity in her work, she once remarked, "Its ridiculous quality is contradicted by its definite concern about its presentation." Her work does have a disquieting presence, and, in its departure from earlier conventions of form and composition, it has been compared to the art of JACKSON POLLOCK and BARNETT NEWMAN. *Lit.:* Lucy Lippard, *Eva Hesse,* 1976.

HESSELIUS, GUSTAVUS (1682–1755), one of the earliest professional artists to work in Philadelphia and the Middle Atlantic colonies. Hesselius was a Swedish painter whose brother was a minister in Christina, now Wilmington, Del. Gustavus followed him to the Swedish colony there but soon moved on to Philadelphia. He settled in Maryland in 1719, a few years after the death of JUSTUS ENGLEHARDT KÜHN, who had worked in Annapolis, but he returned to Philadelphia in 1734.

Most of Hesselius's known paintings are portraits, and the majority of these are rather weakly painted, noninterpretive likenesses. His finest are those of the two Indian chiefs Tishcohan and Lapowinsa (1735, Pennsylvania Hist. Soc.), among the earliest known likenesses of the American aboriginals. They are strong, sensitive interpretations of character, painted for John Penn to commemorate the signing of a treaty. While in Maryland, Hesselius may have painted a number of religious pictures for churches there. There also exist two classical scenes, perhaps based upon print sources (*Bacchus and Ariadne,* c. 1725, Detroit Inst.; *Bacchanalian Revel,* c. 1720, PAFA), which are usually attributed to Gustavus though some give them to his artist-son, JOHN HESSELIUS. Thus,

Hesselius is of particular interest as one of the few colonial painters who is known to have undertaken themes other than formal portraiture. *Lit.: Gustavus Hesselius,* exhib. cat., Philadelphia Mus., 1938.

HESSELIUS, JOHN (1728–1778), a leading portraitist of the Middle Atlantic colonies. John Hesselius was the son of a Swedish artist working in America, GUSTAVUS HESSELIUS, but his father seems to have influenced him very little. On the other hand, the volumetric emphasis and poetic interpretations of ROBERT FEKE, who was active in Philadelphia in 1746, are evident in the younger Hesselius's early portrait style. By the mid-1750s, however, Feke's influence had been replaced by that of JOHN WOLLASTON, an English painter then working in the colonies, as Hesselius took up the facial mannerisms, the complacent expressions, and even the strange diagonal tilt to the head that often characterize Wollaston's work. Hesselius's best-known portrait is *Charles Calvert* (1761, Baltimore Mus.); in this picture, the warm tones, the metallic drapery, and the general facial treatment bespeak Wollaston's influence, but the solidity of form and frank presentation are individual—and most appealing. In a few of Hesselius's later paintings, the mannerisms become still less pronounced, replaced by a strong, forthright realism, comparable in vigor to the work of JOHN SINGLETON COPLEY and CHARLES WILLSON PEALE. Hesselius, in fact, was Peale's earliest master, though his influence upon the younger painter was short-lived. Like his father, Hesselius is believed to have painted classical and religious subjects, as well as landscapes and still lifes, but the only undoubted works by him are portraits.

HICKS, EDWARD (1780–1849), the best-known primitive painter of the 19th century. Born in Bucks County, Pa., Hicks spent most of his life in Langhorne, Pa. He was a cousin and early teacher of THOMAS HICKS. He began as a coachmaker in Milford, Pa., in 1801. The busi-

ness was successful, enabling him to start a branch in Newtown in 1811, where he concentrated on coach, sign, and ornamental painting. With that as his trade, he took up landscape, history, and religious painting as an avocation. He also became an active Quaker preacher. The Quaker Separatist movement, led by a relative, the Reverend Elias Hicks, was a source of deep distress to Hicks, and it may have prompted him to take up the theme of the Peaceable Kingdom, of which he painted over one hundred versions as gifts for his friends from 1820 to 1849. In these charming pictures, animals of many species, including the biblical lion and lamb, are seen amicably sharing a grassy bank with distant view of trees and water, and often of William Penn, founder of the Quaker movement in America, confirming a treaty with the Indians. A gilt paraphrase of biblical text executed in the best sign-painter's manner often accompanies the picture. Hicks borrowed motifs from popular prints and other sources for his paintings. But his stock animal types have an individual, naive charm and project a delightful quality of Edenic innocence. Flat color, stylized form, and decorative patterning, appropriate to the products of his daily occupation, were transformed into personal expressions of faith. Versions of *The Peaceable Kingdom* are in the Brooklyn Mus., Newark Mus., Denver Mus., and MMA. *Lit.*: Alice Ford, *Edward Hicks: Painter of the Peaceable Kingdom*, 1952.

HICKS, THOMAS (1823–1890), a portrait painter and landscape artist. From Newtown, Penn., he received training from his cousin EDWARD HICKS, possibly as early as 1836. After subsequent study at PAFA and NAD, he went abroad in 1845, visiting London, Florence, and Rome and finally settling in Paris, where he studied further under Thomas Couture. He returned in 1849. *Calculating Man* (1844, MFAB), typical of his early style, is a portrait of a man in an interior engaged in his occupation and surrounded by the objects of his work. Hicks's

subsequent paintings, at first in a more softly brushed European manner and then in a realistic, photographic style, concentrated on the person of the sitter. Examples include *Luther Bradish* (1856) and *John W. Chambers* (c. 1870), both in NYHS. A popular portraitist, he painted likenesses of Harriet Beecher Stowe, Henry Ward Beecher and William Cullen Bryant. Several of his portraits are also in NYHS. His genre paintings (*The Musical: Barber Shop, Trenton Falls, N.Y.*, 1866, North Carolina Mus.), present scenes of pleasant domesticity which, on the one hand, avoid the saccharine sweetness prevalent in much genre painting at the time, but, on the other, lack the forcefulness of works by Hicks's contemporary EASTMAN JOHNSON.

HIGGINS, EUGENE (1874–1958), a painter and printmaker. Born in Kansas City, Mo., he studied art in St. Louis before receiving further training in Paris in the 1890s at EBA and the Académie Julian. Sympathetic with the underprivileged, he published illustrations of the poor in the magazine *Assiette au beurre* (Jan. 9, 1904) when abroad. Soon after his return, in the same year, he settled in New York City, where he depicted the underside of urban life. His subjects included tramps, poverty-stricken workers, the sad, and the hungry, as well as peasants. His style was based on that of Honoré Daumier, though tinged by a greater degree of sentimentality; moreover, Higgins painted symbols rather than individuals, generalizing situation and locale and masking activities behind hazy outlines and blurred forms (*Meager Shelter*, 1945, MMA). The Library of Congress owns 200 of his etchings.

HILL, JOHN (1770–1850) AND FAMILY. John Hill was an important early 19th-century printmaker. Born in London, he had an active career in that city before emigrating to America. He made topographical plates for many English books, including Pugin and Rowlandson's *Microcosm of London* (1808–11). He arrived in New York City in 1816 but set-

tled initially in Philadelphia, where he collaborated with JOSHUA SHAW, whose paintings he etched and aquatinted for inclusion in the pioneering *Picturesque Views of American Scenery* (1819–21). Initially issued in three numbers, it was one of the first projects devoted to recording American scenery. The book included views of the kind of wild, uninhabited landscape that was to become the favorite subject of the HUDSON RIVER SCHOOL. Hill moved to New York City in 1822 to engrave in aquatint watercolor views of the Hudson River area by a London-trained contemporary, William Guy Wall, for the subsequently very popular *Hudson River Portfolio* (1821–25). He also made views of Niagara Falls and West Point, and worked for a number of publishers until his retirement in 1836.

His son, John William Hill (1812–1879) was a landscape and topographical painter and aquatint engraver, who worked for the New York State Geological Survey and also made commercial views of American cities. He fell under the influence of John Ruskin and became an important American Pre-Raphaelite (see PRE-RAPHAELITISM, AMERICAN). A grandson, John Henry Hill (1839–1922) was also a landscape painter and printmaker. *Lit.:* Richard J. Koke, "John Hill (1770–1850), Master of Aquatint," *New-York Historical Society Quarterly* 48 (1959).

HILL, THOMAS (1829–1908), best known for his paintings of California's Yosemite Valley region. From Birmingham, England, he was brought to America about 1841 and lived in Taunton, Mass. He became an apprentice coach-painter in Boston in 1844, and also a decorator. In 1853 he attended PAFA and made a living by painting portraits and flower pieces. Hill traveled to San Francisco in 1861, where, in addition to painting portraits, he explored western themes. He studied in Paris in 1866–67, lived in Boston again until 1871, and then settled permanently in San Francisco, devoting

himself to western subject matter. Although his work always contained carefully rendered detail, he enriched textures and added passages of scumbled pigment to it later in his career. In his paintings of western scenery, Hill often included anecdotal elements to modify the awesome impact as well as suggest the scale of the setting. Although many of Hill's pictures convey the immensity of western spaces, he also focused on smaller vistas, as in *Paper Mill Creek, Marin County* (CPLH). *Lit.:* "Thomas Hill," *California Art Research*, Dec., 1936.

HINCKLEY, THOMAS HEWES (1813–1896), an animal and landscape painter. From Milton, Mass., he began to study art in 1829 while living in Philadelphia. He became a professional artist in 1833 after returning to Milton, working as a sign painter, a portraitist, and, after 1843, an animal painter. He visited Europe in 1851 to study the works of Edward Landseer, the English animal painter. In 1870 Hinckley also visited California, where he painted landscapes with animals.

HINE, LEWIS WICKES (1874–1940), a documentary photographer. Born in Oshkosh, Wisc., he studied sociology at Columbia and New York universities. In 1905 Hine took up photography to illustrate his research, first documenting the arrival of immigrants, their domestic lives, and their struggle for survival. He made a sociological photographic study of miners, published as *The Pittsburgh Survey* about 1908. The National Child Labor Committee appointed him staff photographer in 1908, and his photographs of the outrageous conditions endured by children in the work pool, and their exhaustion, helped bring about the passage of child labor laws in America. During World War I, Hine accompanied the American Red Cross to the Balkans, returning to New York in 1920. In the 1920s, he photographed *Men At Work* (1932), which included documentation

of the construction of the Empire State Building. A little-known aspect of his work at this time is the photographs he made of inmates at mental institutions.

Despite Hine's social-scientific orientation, his pictures are filled with a warm sympathy for the human experience. Showing people engaged in their usual occupations and activities, his work combines naturalness with compositional subtlety. Although his pictures look objective, they are clearly critical of an exploitative social system and, in that sense, make no pretense at complete objectivity. Many examples of Hine's work are at GEH. *Lit.:* Walter and Naomi Rosenblum, *America and Lewis Hine: Photographs, 1904-1940,* 1977.

HIRSCH, JOSEPH (b. 1910), a painter and printmaker. Born in Philadelphia, he studied there at the School of Industrial Art between 1928 and 1931, before going to New York City to work briefly with GEORGE LUKS in 1932. He travelled abroad in 1935. In 1938 he completed the mural *Football* for WPA-FAP in Benjamin Franklin High School, Philadelphia. Two additional murals he made in that city were *Integration and Beginnings of Early Unionism* for the Amalgamated Clothing Workers Building (1939) and *Adoption* for the Municipal Court Building (1940). As a pictorial war correspondent in World War II, Hirsch made about seventy-five paintings and drawings between 1943 and 1944 in the South Pacific, Africa, and Italy. A social realist during the 1930s (see AMERICAN SCENE PAINTING), who once said that he wanted his work to reveal his beliefs, Hirsch never turned to propaganda but has continued to present a humanistically positive, often heroic image of people, despite his use of caricature and exaggeration, especially in early canvases like *Two Men* (1937, MOMA). With classic techniques, he explores prosaic subject matter ranging in theme from washing windows to leading invocations (*Invocation,* 1966, Butler Inst.), sometimes with mocking overtones. He has also repre-

sented various generalized kinds of human action—questing, plundering—through the use of monumental human forms.

HIRST, CLAUDE RAGUET (1855-1942), the only significant woman artist in the late 19th-century *trompe l'oeil* school of still-life painting. From Cincinnati, Hirst appears to have been a typical and probably not an unusually distinguished fruit and flower painter. She began exhibiting pictures of this sort in New York in 1884, but in a few years her subject matter abruptly changed to the very unfeminine themes of pipes, tobacco, spectacles, and books. Her new approach seems almost certainly to have been prompted by the return to New York City of WILLIAM MICHAEL HARNETT, as he settled in a Fourteenth Street studio only two doors away from Hirst. Her paintings are skillful adaptations of Harnett's with some special qualities and special emphasis. First of all, she worked primarily, though not entirely, in watercolor, the only important member of Harnett's circle to do so. Second, most of her paintings, as is common with watercolor specialists, are small. She also emphasized choice objects— bowls, canisters, candlesticks—the bric-a-brac elements in Harnett's work, rather than the more specifically *trompe l'oeil.* Success eluded Hirst, and she died in abject poverty. *Lit.:* Alfred V. Frankenstein, *After the Hunt: William Michael Harnett and Other American Still Life Painters, 1879-1900,* 2d ed., 1969.

HITCHCOCK, GEORGE (1850-1913), a leading expatriate figure painter. Hitchcock began his career practicing law, turning to art relatively late, in 1879. He studied in Europe—Paris, Düsseldorf, and The Hague—finally moving to Egmond-aan-Zee, Holland, where JULIUS GARI MELCHERS was also soon to settle. Hitchcock began to paint large-scale religious scenes in 1886, following the German painter Fritz von Uhde, who, in 1884, had begun to work with a new kind of religious imagery: traditional

Christian subjects in contemporary guise, with the protagonists as peasantry in contemporary settings, surrounded by figures in contemporary dress. Hitchcock's peasant women are often hieratically posed, and halos are suggested in headdresses, baskets, and even the handling of outdoor light. Toward the end of the century, Hitchcock became more concerned with formal innovations and turned from the silvery gray light and dull atmosphere of his earlier pictures to a rich colorism that earned him the appellation of "painter of sunlight." His subject matter became increasingly secular, figures in Dutch tulip fields and even simply the fields themselves, with which theme he became particularly identified.

HOFFMAN, MALVINA (1887–1966), a sculptor. From New York City, she studied painting at the Woman's School of Applied Design and with JOHN WHITE ALEXANDER at ASL, before deciding to become a sculptor. She then worked under Auguste Rodin in Paris from 1910 to 1914. While there, she made several studies of dancers, including the vigorous *Bacchanale Russe* (1912, MMA). From 1930 to 1935, she executed more than one hundred studies of racial types for the Field Mus. of Natural History, Chicago. These included heads and full-length works. Although she sculpted in a naturalistic way, her work ranged in style from the roughly finished portrait of Ignace Paderewski, the Polish pianist (1923, MMA), to the smooth-surfaced study of Anna Pavlova (1924, MMA). The variations resulted from her desire to capture the spirit of each individual who sat for her. *Lit.:* Malvina Hoffman, *Yesterday Is Tomorrow*, 1965.

HOFMANN, HANS (1880–1966), a major abstract painter, also considered among the greatest teachers of the 20th century. Born in Bavaria, Germany, he initially acquired a technical knowledge of mechanics and, while working for the Director of Public Works of Bavaria between 1896 and 1898, he invented the electromagnetic comptometer. He was introduced to Impressionism when he began studying art in Munich in 1898 and during a prolonged stay in Paris, from 1903 to 1914, he met such major modernists as Henri Matisse, Pablo Picasso, Georges Braque, and Robert Delaunay. He established his own school in Munich in 1915, closing it only in 1932, when he left permanently for America. (During the summers of 1930 and 1931 he taught at Univ. of California, Berkeley.) After teaching for a short time at ASL, Hofmann opened his own school in New York City in 1933 and a summer school in Provincetown, Mass., in 1935. Both were closed in 1958 so that he could devote all of his energies to painting. His book *Search for the Real and Other Essays* first appeared in 1948.

During the 1930s, Hofmann maintained the traditions of the School of Paris in face of the strong trend to AMERICAN SCENE PAINTING. When Americans turned once again to European models in the 1940s, Hofmann stood as symbol of the cosmopolitan origins of American modernism, a key figure who in the period between world wars had sustained the ideals of modern art. Despite his acknowledged importance as a teacher, however, no major Abstract Expressionist studied with him.

For Hofmann the essence of a picture was the picture plane. On that surface, all intellectual, emotional, and sensory experiences had to be welded together by purely pictorial means. Form and color were to be unified through their intrinsic qualities rather than through the objects they might represent. To assert the importance of the animated picture surface as an area with an intense life of its own, apart from any representational function, Hofmann developed his celebrated dictum: "Depth in a pictorial plastic sense is not created by the arrangement of objects one after another toward a vanishing point, in the sense of Renaissance perspective, but on the contrary by the creation of forces in the sense of push and pull." This is essentially a statement of the method of Paul Cé-

zanne, from whose art Hofmann's ultimately descends, in the sense that different forms and colors may be read at different times as lying on the picture plane and receding or advancing in space. For Hofmann, such an art was wrought by the continuing interaction of eye and hand with the forms and colors as they evolved on a canvas and were ultimately brought into equilibrium. His interest in color developed most keenly after 1936 in works using a syntax of small fragmented forms composed of primary-color contrasts. In these pictures, semi-Cubist in form and somewhat Fauve in color, recognizable objects can be seen. Hofmann's interest in nonobjective forms began about 1940. *Spring* (1940, MOMA) was one of the first paintings in which random drips and spatters appear, a technique JACKSON POLLOCK was to use with great success later in the decade. Hofmann's titles of the 1940s evoke mythical and metamorphic associations similar to those of the young Abstract Expressionists, but the works lack their sense of anxiety and alienation (see ABSTRACT EXPRESSIONISM). In his pictures of the 1950s, line was subordinated to color as surfaces were created by the prodding and pushing around of pigment, sometimes in great buttery gobs. Hofmann worked in different modes simultaneously, but what all his pictures share is a manic energy of attack. In the absence of this, they might almost seem to come from several different hands. His last magisterial works of the 1960s include large rectangular units echoing the perimeter of the canvas frame and, in complete antithesis, explosive bursts of color defying containment by their frames. Hofmann gave a large collection of his paintings to Univ. of California, Berkeley. *Lit.:* Sam Hunter, *Hans Hofmann*, 1963.

**HOLTY, CARL ROBERT** (1900–1973), a painter. Born in Freiburg, Germany, he moved with his family to Milwaukee in the year of his birth. In 1919 he studied at AIC and attended NAD in 1920–21. From 1926 to 1935 he travelled extensively in Europe and North Africa, enrolling in the Hans Hofmann school in Munich in 1926 and, sponsored by Robert Delaunay, joining the Abstraction-Création group in Paris in 1932. His dedication to abstract art was thus determined early in his career. On his return to the United States in 1936, he became a charter member of the AMERICAN ABSTRACT ARTISTS, maintaining his association with the group until 1944. Much of Holty's early work contains residual hints of naturalistic imagery, and his titles sometimes frankly refer to the subjects he originally worked from. In the 1930s freeform biomorphic shapes that were related to the organic surrealism of Jean Arp and Joan Miró as well as to the floating geometrical shapes of Wassily Kandinsky were dispersed over Holty's canvases. The forms intersected in larger patterns and had become somewhat more disciplined in their contours by the early 1940s. After a brief exploration of a pointillist type of landscape (in 1950), for a few years Holty painted small squares of color that quilted the surface, dashing in abbreviated suggestions of subject matter with a fluid line. By 1958 he had acquired a technique that he maintained, with refinements, until his death. Color was laid down in thin washes, with remnants of geometrical form mixed among looser areas. Always praised for his masterly control of color, Holty added blotted and dripped areas here and there into his basic scheme to accentuate the lush chromatics of his stained surfaces. Holty wrote *The Painter's Mind* (1969) with ROMARE BEARDEN. *Lit.:* Patricia Kaplan, *Carl Holty/Fifty Years*, exhib. cat., City Univ. of New York, 1973.

**HOMER, WINSLOW** (1836–1910), a major figure in American painting, also an illustrator and printmaker. Born in Boston, Mass., and raised in Cambridge, Homer had no artistic training until, at the age of nineteen, he was apprenticed to the lithographer J. H. Bufford, who had taught EASTMAN JOHNSON. Unhappy with this work, he became, in 1857, an

illustrator for *Ballou's Pictorial* in Boston. By 1859 he was also employed by *Harper's Weekly* in New York, which, at the outbreak of the Civil War, sent him to the front. His illustrations were singularly straightforward and uncompromising and rank with the photographs of MATHEW B. BRADY as the finest wartime reportage.

Homer came to painting relatively late, though he had studied drawing at NAD and painting, briefly in 1861, with a little-known artist, Frédéric Rondel. One of his first major canvases, *Prisoners from the Front* (1866, MMA), is a curiously detached, "camera's eye" view of an arbitrarily chosen and unimportant incident, which nevertheless, in its deft presentation of character, captures one aspect of the conflict between South and North. Like Mathew Brady and the poet Walt Whitman, Homer was not interested in the romance and drama of war but, in the true spirit of the genre painter, was attracted to its more mundane realities.

Late in 1866, Homer travelled to Paris to see the Universal Exposition. While in Paris, he may have seen paintings by Edouard Manet, whose flat figures and bold tonal contrasts may have had some influence on Homer. The Japanese prints shown at the exposition may also have affected him, but he could have seen several examples in Boston during the 1860s. However, such prints may have had the effect of lightening Homer's palette and strengthening his sense of decorative form and asymmetrical design.

Upon his return to the United States, Homer took a studio in the New York University Building, where his neighbor was the genre painter Eastman Johnson. His earliest works from this period clearly reflect the experience of the French trip. As did the Impressionists, Homer began to depict people taking their leisure out-of-doors. His famous picture of boys at play in a country landscape, *Snap the Whip* (1872, Butler Inst.) though it owes much to French pleinairism, is equally indebted both in subject

and in its breezy, sunlit clarity to the great American painter of rustic genre WILLIAM SIDNEY MOUNT. Homer's *Breezing Up* (1876, NGA) shows boys sailing on a choppy sea. The mast tilting diagonally out of the picture and the animated treatment of sky and water create a marvellous impression of lively motion. *Boys Wading* (1873, Colby Coll.), though it also uses children as its subject—here, gathering clams in shallow water near Gloucester wharves—introduces a quality that became increasingly important in Homer's work, an intense quietude, which later was to evolve into an almost desolate isolation.

This change of mood is most apparent in Homer's work after his sojourn in 1881–82 in England, near Tynemouth on the rugged North Sea coast. Working as effectively in watercolor as in oils, he produced such striking works as *Inside the Bar, Tynemouth* (1883, MMA), in which his earlier fair weather has given way to the harsher aspects of nature. We are made aware of the heroic struggle for survival of the hardy fisher folk posed statuesquely against the turbulent sea and sky. These are often women, bent under heavy loads and anxiously watching for the return of the fishermen. Frequently in London, the artist may have been moved by the watercolors of Joseph M.W. Turner and John Constable as well as certain Pre-Raphaelite works; in any case, there is in his English pictures an emotional content that carries his art from the detachment of his earlier style into another, more poetic realm.

Back in America, Homer soon turned to another rough sea coast, at Prout's Neck, Maine, and settled there permanently and alone. His subject became the sea and the outdoor life of the people who lived near it. Such paintings as *Northeaster* (1895, MMA) are among the most impressive paeans to the force and majesty of the sea after Turner's. *The Life Line* (1884, Philadelphia Mus.) and *The Look-Out: "All's Well"* (1896, MFAB) are some of the pictures that established Homer's reputation as the fore-

most American artist of the day and captured for succeeding generations an image of the hard seafaring life of 19th-century New England.

Although Homer often braved the trying Maine winter alone in his house by the sea, he did, sometimes, travel in order to paint different aspects of nature, such as the north woods in the Adirondacks (beginning in 1889) and eastern Canada (frequently after 1892). In the Caribbean, which he visited several times after 1884, he returned to his favorite theme, the sea and the struggle for survival, as in *The Gulf Stream* (1899, MMA), in which a lone sailor steers a broken-masted boat through shark-filled waters with an ominous storm on the horizon. Many land- and seascapes he executed in watercolor, a medium Homer began to use in 1873. Perhaps more than any other American artist, he raised the medium to the same artistic level as oil painting. Most impressive are his late pictures in both oil and watercolor of the drama of nature seen from his house on the Maine shore. *The Fox Hunt* (1893, PAFA), showing a fox pursued by crows on a barren snowy coast, demonstrates that, toward the end of his life, the artist was still growing in power of expression and design. In *Right and Left* (1909, NGW), the title of which refers to the barrels of a shotgun, a hunter in the distance fires almost directly at the viewer, while in the foreground of this aerial view, two ducks in flight are being struck down. Their bodies and spread wings are flattened against the banded forms of the landscape, shoreline, and horizon in what may be the most powerfully abstracted of all the artist's many interpretations of the struggle for existence.

Always taciturn, Homer became very nearly reclusive in his last years. He remained indifferent to his great fame and to the honors and awards heaped on him. He seems, from his letters, to have been perfectly content with his solitary life. *Lit.:* John Wilmerding, *Winslow Homer*, 1972.

HOPPER, EDWARD (1882–1967), perhaps the premier 20th-century realist. Born in Nyack, N.Y., he studied commercial art in 1899–1900, then switched to fine art, becoming a pupil of ROBERT HENRI and KENNETH HAYES MILLER at the New York School of Art from 1900 to 1906. Between 1906 and 1910, he made three trips abroad but remained essentially unaffected by European movements. He was, however, attracted to printmaker Charles Meryon and possibly to Albert Marquet, the "conservative" Fauvist. In any event, he subsequently showed an ability, unusual for a realist painter, to organize compositions abstractly. (He once said, perhaps in reaction to Henri's slapdash organizational methods, that it took him about ten years to get over Henri.) Between about 1915 and 1923, he completed some fifty etchings that helped clarify his artistic personality. In these prints, he articulated themes to which he would continually return throughout his career—the solitary individual looking out a window, the individual isolated in an urban environment, the solitary building (usually a dwelling), and landscape. By 1923, especially in watercolors of houses, streets, and village life, his mature style was formed. About this time, Hopper also began to work in oils to a greater extent than in the previous ten-year period. Like many other artists of his generation, he summered in New England, especially along the coast, and many of his works originated there. During the 1940s and 1950s, he visited the West and Mexico. He stopped painting in 1965.

By the late 1920s, Hopper was recognized, with CHARLES BURCHFIELD, as the most successful interpreter of what was to be called the American Scene (see AMERICAN SCENE PAINTING). Although he avoided entangling himself with the more nationalistic aspects of that movement, he objected to strong European influences on American art. He believed that a nation's art was greatest when it reflected the character of the people. What he found in that character was not very optimistic. Unlike the exuberant at-

titudes toward urban themes taken by THE EIGHT, Hopper did not paint pleasant, anecdotal, intimate scenes. As early as 1908, in *Railroad Train* (Addison Gall.), which shows the last two cars of the vehicle hurtling out of the picture space, he was attracted to scenes suggesting isolation, alienation, absence of self-awareness, and loss of communication between people. His point of view paralleled those of such literary figures as Waldo Frank and Lewis Mumford, whose writings after about 1920 commented upon the destructive aspects of urban living on the personality. In Hopper's paintings, the Roaring Twenties never existed, nor in later decades did they ever seem to shed their malaise. One of his most poignant recurring images, full of unfulfilled longing, was that of a nude woman sitting or standing before an open window. Separated from the rest of the world yet wanting access to it, she remains perpetually locked within the confines of her solitary mental as well as environmental spaces (*Eleven A.M.*, 1926, Hirshhorn Mus.). In other works, such as *Night Windows* (1928, MOMA), Hopper looked into windows but often failed to show the entire scene, as if he did not want to know too intimately the lives of his subjects. A taciturn person, he once said of *Cape Cod Morning* (1950, Sara Roby Coll., New York City), "It perhaps comes nearer to my thought about such things than many others." The picture shows a woman through the side of a bay window as she stares out the central pane. The viewer looks past her out of the glass on the far side. It is a work that stresses missed psychological connections.

Hopper's figures are bounded by architectural enframements. They stand or sit in doorways and lobbies, against walls, on porches. They are rarely free of protective shells, which often seem to overwhelm them. It is as if they must know exactly where they are, leaving nothing to chance or the imagination. Their sense of isolation is intensified by Hopper's uncanny ability to tie their forms into the abstract rhythms of a painting, so that, as essential compositional elements, they cannot move or suggest the possibility of movement. Although they have bulk, they are locked into two-dimensional compositional schemes, which further emphasizes their sense of helplessness. In addition, Hopper's colors, though bright, tend to be cold. He once said, "Maybe I'm not very human. What I wanted to do was to paint sunlight on the side of a house." (In *House by the Railroad* [1935, MOMA] and other paintings of buildings, Hopper used sunlight and shadow to impose interesting arrangements of light and dark patterns across a facade.)

Over the years, Hopper's style remained consistent. However, he did tend to eliminate details, allowing the underlying formal structure, often architectural in nature, to dominate, as in *Sun in an Empty Room* (1963). Spaces, even interiors, seemed less claustrophobic, and his palette moved toward blonder tones. In his later career, he worked less directly from nature. "I find I get more of myself by working in the studio," he said. Virtually all of his late watercolors were made during trips to the West and to Mexico. After his death and that of his wife, Jo, an artist, the following year, a cache of paintings, which he had never mentioned, was left to WMAA. *Lit.:* Lloyd Goodrich, *Edward Hopper*, n.d.

HOSMER, HARRIET (1830–1908), a neoclassical sculptor in marble. Born in Watertown, Mass., she studied sculpture with Paul Stevenson in Boston. Male artists of the time typically studied anatomy along with medical students—who were also men. Since women were barred from this avenue of learning, Hosmer arranged for private study with a doctor in St. Louis. Two years later, she produced her first statue, an ideal bust entitled *Hesper*. That same year, 1852, Hosmer went to Rome, where she studied with the English neoclassical sculptor John Gibson and became the leader of the WHITE MARMOREAN FLOCK, Henry James's epithet for the group of expatriate American women sculptors that in-

cluded EDMONIA LEWIS. Disdaining the popular portrait bust, Hosmer made her reputation with full-length statues of mythological and historical personages. She specialized in romantic scenes of shepherdesses mourning their departed lovers and such playful figures as *Puck*, a saucy, dimpled child seated on a toad-stool (roughly fifty replicas were made; one, dated 1856, is in NCFA). One of her most popular works, *Zenobia* (1858, MMA), the portrait of a remote and dignified captive queen, exemplifies Hosmer's usual combination of smooth planes and idealized facial features with masses of precise ornamental details on clothing and accessories.

After a brief visit to America in 1860, Hosmer returned to Europe and became an extremely popular artist and a colorful member of the international set in Rome. She produced little sculpture after 1875, concentrating instead on her lifelong interest in mechanical inventions. Hosmer returned to the city of her birth in 1900 and lived there until her death. *Lit.*: Cornelia Carr, ed., *Harriet Hosmer: Letters and Memories*, 1912.

HOVENDEN, THOMAS (1840–1895), a painter. Born in Dunmanway (County Cork), Ireland, he was apprenticed to a carver and gilder and also studied at the Cork School of Design before coming to New York City in 1863, where he attended NAD. In France from 1874 to 1880, he studied with Alexandre Cabanel at EBA and lived, during the late 1870s, in the American colony at Pont-Aven. After returning to America in 1880, he concentrated on genre scenes, developing a preference for interiors with two figures *(Sunday Morning*, 1881, CPLH). His most famous work, *Breaking Home Ties* (1890, Philadelphia Mus.), was voted the most popular painting at Chicago's WORLD'S COLUMBIAN EXPOSITION in 1893. Despite the sentimentality of the subject, the picture remains worthy of notice today. This is due in part to the careful structuring, which reveals Hovenden's mastery of French academic techniques, and the

artist's integrity of feeling—qualities perhaps even more clearly apparent in his earlier treatment of a black family, *Their Pride* (1888, Union League Club, New York City). Though in his genre studies, which he continued to paint until his death, Hovenden worked to achieve a naturalism of detail and a clear readability of parts, he also painted lesser-known works as early as the 1870s in which he recorded the often-blurring effects of light falling on objects. In 1893 he added to his repertoire a landscape that may be called quasi-Impressionist: Brushy techniques softened forms, and his palette turned brighter and lighter. Hovenden is also remembered today as a teacher of note at PAFA.

HOXIE, VINNIE REAM (1847–1914). See REAM, VINNIE.

HUBARD, WILLIAM JAMES (1807–1862), an important southern portraitist. From Whitechurch, Shropshire, England, he showed an early and remarkable talent for cutting silhouettes. After touring the British Isles, Hubard came to America in 1824 and travelled for at least two years before turning to portraiture. He may have left the country in 1826, perhaps for Canada, but in 1827 is supposed to have received some instruction and advice from GILBERT STUART and THOMAS SULLY. His career as a portraitist commenced in 1829, when he began to tour eastern Pennsylvania, Maryland (he made at least twenty-eight paintings in Baltimore in 1831), and Virginia, before settling in Gloucester, Va. He usually made small, cabinet-sized works on wood panel, 6 by 5 inches for busts and 20 by 14 inches for full-length figures placed in landscape or interior settings. His subjects included such important figures as Chief Justice John Marshall and Henry Clay (1830–32, 1831–32; both Univ. of Virginia). Through the 1830s, Hubard's modelling ability improved, and his earlier awkwardness in indicating proportions and three-dimensionality disappeared. In Italy and France, from 1838 to 1851, Hubard turned his

hand to larger portrait busts as well as to genre and historical themes. He also took some subjects from Sir Walter Scott's Waverly novels. He settled in Richmond, Va., upon his return and pursued a career in painting until 1853, when he turned to sculpture, eventually making six bronze casts of Jean-Antoine Houdon's marble statue of George Washington in the Virginia State Capitol. A large collection of Hubard's work is in the Valentine Mus. *Lit.:* Helen G. McCormack, *William James Hubard*, exhib. cat., Valentine Mus., 1948.

HUDSON RIVER SCHOOL, a large, loosely knit group of artists who painted landscapes in New York State, New England, and even the far West between about 1825 and about 1875. Their favorite haunts included rivers and streams and mountains and forests either untouched by European settlement or where wild nature was just passing into a rural phase. Individual works may offer intimate impressions of a bend in a stream, with or without cattle; grand, panoramic orchestrations of several miles of mountains and river valleys; or vistas of intermediate scope. Although most Hudson River School scenes were based on careful, direct perusal of the American landscape, the compositions often followed European formulas derived from the peaceful, balanced landscapes of Claude Lorrain or more dramatic ones by Salvator Rosa.

Although landscape painting became increasingly popular in the early 1820s through the publication of such picture books as W. G. Wall's *Hudson River Portfolio* (1821) and because of the ever-increasing spirit of American nationalism, no artist, not even THOMAS DOUGHTY, was thought to have captured the peculiar qualities of the American landscape until the advent of THOMAS COLE. An instance of the right person appearing at the right time, he gave stylistic direction to the growing interest in landscape painting, and he is usually considered the founder of the Hudson River School, whose inception is dated to 1825, the year in which JOHN TRUMBULL, WILLIAM DUNLAP, and ASHER B. DURAND discovered three of his landscapes in a shop window. The school reached its zenith between about 1840 and 1860, and, even though several of its adherents lived into the 20th century, it was replaced as the premier landscape school after the Civil War by new styles emanating from France and Germany see BARBIZON, AMERICAN; MUNICH SCHOOL).

Although considered the founder, Cole was not the quintessential Hudson River School painter. Instead of transcribing nature faithfully for herself alone, he would also occasionally turn landscape into overt religious and moral allegories. In addition, he applied pigment more thickly than other Hudson River artists, and, as in *Schroon Mountain, Adirondacks* (1838, Cleveland Mus.), altered colors for emotional or spiritual effect. Durand's work is more central to the school, and his "Letters on Landscape Painting" (published in *The Crayon* in 1855) are its credo. His landscapes, painted with thinner pigment and with more scrupulous attention to detail, were also conceived as expressions of religious sentiment, but in more generalized terms than Cole's. Durand believed nature to be a manifestation of God; thus, the study of nature or paintings of nature brought man more profoundly to appreciate the Divinity and to lead a more noble life. His pictures tend to be more accurate images of actual scenery than Cole's, though never camera's-eye transcriptions. As Durand once said of himself, and by extension of the whole school, "The artist as a poet will have seen more than the mere matter of fact, but no more than is there and that another may see if it is pointed out to him."

FREDERIC EDWIN CHURCH, who sought subjects on several continents, painted grandiose visions of nature. His use of the horizontal format, as in *Niagara* (1857, Corcoran Gall.), probably influenced the Luminist artists (see LUMINISM). JOHN FREDERICK KENSETT, who with Church was part of the second Hudson

River School generation, can also, because of his great interest in subtle atmospheric effects, be considered a Luminist. Other figures include JASPER F. CROPSEY, known for his autumnal scenes (*Autumn on the Hudson River*, 1860, NGW) and SANFORD ROBINSON GIFFORD. Although the later painters did not bring to their work the same religious intensity as did Cole and Durand, they, too, responded to the rising sense of American nationhood and patriotism by painting America's wilderness as if it were a new Eden from which a glorious civilization would arise. *Lit.:* John K. Howat, *The Hudson River and Its Painters*, 1972.

HUGHES, ROBERT BALL (1806–1868), a sculptor. From London, England, he began his studies there at the Royal Acad. in 1818 and won many awards. Although in England he followed the popular neoclassical currents in style and subject matter, he worked in a more realistic manner in America, even when his figures are clad in a toga. He arrived in New York City in 1829, and there he soon received commissions for many portrait busts, the best of which is the forceful *John Trumbull* (1834, Yale Univ.). Hughes also attempted larger works, notably the full-length *Alexander Hamilton* of 1834–35, the first marble portrait statue executed in this country, and, unfortunately, lost in a fire in 1835. When in Philadelphia about 1838, Hughes entered the competition for an equestrian statue of George Washington sponsored by the Order of Cincinnati. His model, in the Society for the Preservation of New England Antiquities, Boston, Mass., and the earliest surviving example of an equestrian monument in the country, is remarkably animated and graceful. It shows Washington in military uniform rather than in classical garb. Hughes also had a talent for handling contemporary clothing in a dignified way, as his full-length bronze statue of Nathaniel Bowditch (1846, Mt. Auburn Cemetery, Cambridge, Mass.) shows. After the late 1830s, as his commissions fell off, Hughes turned to cameo likenesses and wax medallions. By the middle 1850s, he had largely abandoned sculpture. *Lit.:* Georgia Chamberlain, *Studies on American Painters and Sculptors of the Nineteenth Century*, 1965.

HUNT, RICHARD (b. 1935), a sculptor. From Chicago, he attended AIC from 1953 to 1957. Although he concentrated on sculpture there, especially welding, he also studied lithography. He travelled abroad in 1957. Initially influenced by Julio Gonzales, Hunt had become a major open-form, direct-metal sculptor by 1960. His material included found objects and auto parts that he transformed into plantlike and insectlike forms. With their spiky linear extensions, they are perhaps images culled from his experience working in a zoological experimental laboratory at the Univ. of Chicago. Some pieces rise from a single base; others appear to grope across the floor. In the late 1960s, Hunt began to combine closed with open forms, calling them "hybrid figures." In them, the influence of Futurist sculpture can be felt. In addition to welding, Hunt also began to cast pieces in aluminum. In the 1970s, he added inventive baroque flourishes to his forms so that solids seemed both to penetrate voids and to be penetrated by them. His public commissions include a candelabra for St. Matthew's Methodist Church, Chicago, 1970. *Lit.: The Sculpture of Richard Hunt*, exhib. cat., MOMA, 1971.

HUNT, WILLIAM MORRIS (1824–1879), an influential painter and teacher in Boston, Mass. Hunt was born in Brattleboro, Vt., and later moved to New Haven, Conn. His brother Richard Morris Hunt was the famous architect of the Vanderbilt houses, "Biltmore" and "The Breakers." William attended Harvard Coll., where he studied sculpture for a time with HENRY KIRKE BROWN. After three years, he left in strained health and went abroad in 1843. In 1845 Hunt enrolled in Düsseldorf at the school there so important for so many American artists. He

soon tired of academic training, however, and went to Paris to study with the sculptor of animals Antoine-Louis Barye and the academic painter Thomas Couture from 1846 to 1852. Losing patience with the rigorous methods of Couture, Hunt gravitated to the group of French landscape painters working at Barbizon, becoming especially close to Jean-François Millet.

Hunt returned to the United States in 1855, settling first in Newport, R.I. Such works as *The Little Gleaner* (1854, Toledo Mus.) and *The Belated Kid* (1857, MFAB) reflect the strong influence of Millet. To the already idealized rusticity of the French master, Hunt added an even greater sentimentality; cows and children bear the same sweetness of expression. Occasionally, as in *The Bathers* (1877, MMA), nudes, softly modelled in Millet's style, appear in his genre pieces. Hunt's practice and teaching of Barbizon style and theory was to have a profound effect on taste and patronage in Boston, where he moved in 1862 (see BARBIZON, AMERICAN). His own style tended to revert to a drier realism that is particularly noticeable in his many portraits.

In 1876, while working with his students in the area around Cape Ann, Mass., Hunt painted his well-known *Gloucester Harbor* (1877, MFAB), of which he exclaimed that at last he had painted a picture with "light in it!" The stillness and hazy atmosphere of the harbor scene would suggest JAMES A. M. WHISTLER, were it not for the over-careful composition and solidity of the forms. The rapid execution, if not spontaneous in the Impressionist sense, showed an extraordinary freedom—for Hunt and, indeed, for an American artist at that time. Hunt received a commission in 1878 to paint two major murals for the New York State Capitol, at Albany. His themes were "The Flight of Night" and "Christopher Columbus: The Discoverer." A photograph of the artist's studio at this time shows the walls filled with large studies for the project. The grandeur of conception and the po-

etry and freedom of execution reflected in the preparatory sketches (both 1878; MFAB, PAFA) make it probable that the works should be considered the finest examples of American mural painting; however, they have both fallen into ruin. Hunt's health, always fragile, was broken by his exertions. The artist was drowned, perhaps a suicide, several months later.

Hunt was not a major talent but he enjoyed a major reputation as artist and was undoubtedly a most influential teacher (one of his pupils was JOHN LA FARGE) and tastemaker; his *Talks on Art*, published in 1875, was widely read. Through his engaging personality, he persuaded Bostonians to patronize the Barbizon painters, who were not yet accepted even in France, and was one of the first artists to try to incorporate modern French trends into the American visual tradition. He seems to have been aware of Japanese art also, as is shown by the delicate drawings of birds and butterflies he made casually for his children. *Lit.:* Helen M. Knowlton, *Art Life of William Morris Hunt,* 1900.

HUNTINGTON, DANIEL (1816–1906), a leading New York painter. Huntington's acquaintance with CHARLES LORING ELLIOTT while a student at Hamilton Coll. turned him in the direction of portraiture. In 1835–36 he studied in New York City with SAMUEL F. B. MORSE and HENRY INMAN, and soon became one of the city's leading portrait painters. His ascendance was confirmed by election to the presidency of NAD, which he held between 1862 and 1870 and again from 1877 to 1890. Many of Huntington's portraits are rather dry and naturalistic; here, he was at his best when able to combine a lingering romanticism with a personal affection for members of the New York City-based Knickerbocker cultural community, as in his likenesses of the poet William Cullen Bryant and his fellow-artist THOMAS COLE (1841, NYHS). But Huntington turned almost exclusively to portraiture only after about 1850; during the preceding dec-

ade, after a trip to Italy in 1839, when he painted and was heavily influenced by the old masters, especially Titian, Huntington was among the artists who aspired to bring historical, allegorical, and biblical art to America. He also painted subjects from John Bunyan's *Pilgrim's Progress*, a book that was enjoying a great revival of popularity at the time. The first version of *Mercy's Dream* (1841, PAFA), whose pious sentiment and studied stylistic references to old master Annunciation themes and to Guido Reni's popular *Saint Michael* made it one of the most popular American works of the decade, was engraved extensively, and prints and copies hung in thousands of American households. The artist replicated it himself in 1850 and again in 1858. It established Huntington, at least briefly, in the forefront of America's artistic avant-garde. Equally successful as a print was the artist's *Lady Washington's Reception* (1861, Brooklyn Mus.). Many of his portraits are in NYHS. *Lit.: Drawn from Nature/ Drawn from Life,* exhib. cat., Ithaca Coll., 1971.

HURD, PETER (b. 1904), a painter of the Southwest. From Roswell, N. Mex., Hurd turned seriously to art in the early 1920s. He studied at PAFA from 1924 to 1926 and simultaneously with illustrator N. C. Wyeth. About 1929 he began to experiment with oil washes and tempera on gesso-prepared panels, the latter becoming his preferred medium. During the mid-1930s, he settled permanently near his place of birth and, in addition to painting federally sponsored murals in post offices in Big Spring, Tex., Alamogordo, N. Mex., and Dallas, developed a style that captured the vast spaces of that area and suggested the dry quality of the desert air. Not an antiquarian reinventing or perpetuating 19th-century western Americana, Hurd paints ranch and landscape scenes of the modern rural Southwest. In 1950 he completed a fresco cycle for Texas Technical Univ. in Lubbock. He has made many lithographs and watercolors. His works are well represented in the Roswell Mus. and Art Center. *Lit.:* Paul Horgan, *Peter Hurd: A Portrait Sketch from Life,* 1964.

# I

**IMMACULATES.** See PRECISIONISM.

**IMPRESSIONISM, AMERICAN,** a style of the late 19th and early 20th centuries that followed, at a distance, the stylistic and coloristic achievements of the French Impressionists in the 1860s and 1870s. MARY CASSATT, the first American successfully to adopt the Impressionist palette, exhibited with the French artists from 1877 until 1886. She was in. fluenced primarily by Edgar Degas, but other key figures responded more emphatically to the brushstroke and informal subject matter of Pierre Auguste Renoir, Alfred Sisley, and especially Claude Monet. Although few Americans became pupils of the French painters, they were able to see Impressionist works in Paris, where many studied during the 1880s. Several, including THEODORE ROBINSON, Lila Cabot Perry, and Theodore E. Butler, spent summers with Monet at Giverny in the 1880s. A good example of the kind of influence Monet exerted on these artists is Robinson's *The Vale of Arconville* (c. 1888, AIC), a light-suffused study of a woman on a flower-filled hillside. Robinson's Impressionist works were among the earliest showing Monet's influence exhibited in America—at the Soc. of American Artists in New York City in 1888. They complimented the major exhibition of European Impressionist works organized in New York by the Parisian art dealer Paul Durand-Ruel in 1886. The short-lived DENNIS MILLER BUNKER was also an early, influential exponent of the style in this country. In the early 1890s, WILLIAM MERRITT CHASE turned to Impressionism, adding luster to the American branch of the style. By 1893, the year of the WORLD'S COLUMBIAN EXPOSITION in Chicago, French Impressionism had been relatively quietly accepted, and the American Impressionist exhibitors there were highly acclaimed.

CHILDE HASSAM, JOHN HENRY TWACHTMAN, and JULIAN ALDEN WEIR were also major American Impressionists. They helped form, in 1898, the loose association known as the TEN AMERICAN PAINTERS, which at the century's turn encouraged the spread of Impressionism.

Unlike their European counterparts, the Americans usually did not dissolve forms in a maze of brushstrokes but allowed them to retain their solidity and object definition. Even out-of-doors they did not paint the film of light lying between themselves and the objects illuminated by bright sunlight. Their techniques varied and the name American Impressionism elastically includes the firmly modelled figural forms of EDMUND C. TARBELL, the vigorous brushwork of EDWARD REDFIELD, and the diaphanous mists of Twachtman, who, of all the Impressionists, best understood the abstract structure of Impressionist art. Their subject matter tended to be restricted and conservative, perhaps because the American palette also remained subdued as a result of the influence of JAMES A. M. WHISTLER. They preferred rural themes but also painted urban landscapes, celebrating the beauty of the countryside at all seasons as well as that of sunlit streets. Some, like Tarbell and FRANK W. BENSON, often painted women in interiors or in garden settings. ERNEST LAWSON, WILLIAM GLACKENS, and other later artists carried the Impressionist style well into the 20th century. *Lit.:* Richard Boyle, *American Impressionism,* 1974.

**INDEPENDENT EXHIBITIONS.** A variety of group shows held in New York City during the first two decades of the 20th century provided both a focus and an impetus for the development of modern realist and abstract art outside of traditional academic circles. Together with some more traditionally conceived exhi-

bitions in art galleries, they challenged the authority of the NATIONAL ACADEMY OF DESIGN to dictate stylistic preferences.

The first important show of art of progressive tendency (both realist and modernist) was organized by ROBERT HENRI for the Allan Gall. in 1902. It included works by, among others, the realist WILLIAM GLACKENS and ALFRED MAURER, then a follower of JAMES A. M. WHISTLER. In 1904 Henri organized another show, this one held in January at the National Arts Club, of works by six of the realist group called The EIGHT (not represented were EVERETT SHINN and ERNEST LAWSON). The first exhibition of work by all of The Eight took place at the Macbeth Gall. in February, 1908, and it drew much critical attention and public interest.

Desiring to keep the idea of independent exhibitions alive, Henri organized, with WALT KUHN and JOHN SLOAN, the Exhibition of Independent Artists, which took place in April, 1910. It was a non-juried show to which were invited 103 artists who worked in various styles, many of whom were Henri's students. In 1911 ROCKWELL KENT organized one of the first independent modernist exhibitions, a small show that included works by Maurer, ARTHUR B. DAVIES, MAURICE PRENDERGAST, MARSDEN HARTLEY, JOHN MARIN, and GEORGE LUKS.

The famous ARMORY SHOW took place in 1913. The following year, Walter Pach, who had been involved with that international exhibition, organized a show of modernist artists called Exhibition '14. Joseph Weichsel's People's Art Guild sponsored a modern Americans' show from November, 1915, to January, 1916. In the latter year, the Soc. of Independent Artists was formed by Marcel Duchamp, H. P. Roche, Arthur Craven, Jean Crotti, Katherine Dreier, Walter Pach, William Glackens, MAN RAY, JOHN COVERT, and GEORGE BELLOWS. It held annual exhibitions in New York City from 1917 to 1944.

The most important modernist exhibition after the Armory Show was the Forum Exhibition of Modern American Painters held at the Anderson Galleries from March 13 to March 25, 1916. Organized by Willard Huntington Wright, brother of STANTON MACDONALD-WRIGHT, the show included the works of seventeen American modernists, including artists of ALFRED STIEGLITZ's circle, among them John Marin and ARTHUR DOVE, as well as ANDREW DASBURG and Synchromists Macdonald-Wright and MORGAN RUSSELL. It helped promote, if briefly, the abstract wing of early modernism in America. Following World War I, fewer independent exhibitions were held as galleries increasingly exhibited the works of advanced realists and modernists. Lit.: William Innes Homer, Robert Henri and His Circle, 1969. Avant-Garde: Painting and Sculpture in America, 1910–1925, exhib. cat., Delaware Art Mus., Wilmington, 1975.

INDIANA, ROBERT (b. 1928), a self-styled "American painter of signs" associated with POP ART. Born Robert Clark in New Castle, Ind., he took his native state's name as his own. He studied art in Indianapolis in 1945–46, at MWPI in 1947–48, at AIC from 1949 to 1953, at the Edinburgh Coll. of Art, Edinburgh, Scotland, in 1953, and London Univ., in 1954, before settling in New York City in 1956. His first hard-edged paintings date from 1957 and his first constructions from 1959. Although not closely associated with the theater or with dance groups as were others of his generation (ROBERT MORRIS, ROBERT RAUSCHENBERG), Indiana designed costumes for a small dance company in 1963. His most famous image, the letters spelling out LOVE, first appeared in 1966 in paintings and sculptures. His constructions are usually composed of vertical wooden panels with symmetrical attachments and are stenciled (Star, 1962, AK). Not quite part of the ASSEMBLAGE movement of the late 1950s, Indiana's pieces remained spare and severe rather than playful. They are thematically suggestive of the waterfront where he lived rather than an expression of neo-Dada high jinks. His paintings, too, often reflect specific themes—some, as in the Southern State series of 1965–66, reveal-

ing social and cultural concerns. His paintings usually consist of concentric bands of words as well as objects placed in circular configurations. His awareness of earlier American art is exemplified, for instance, by his *The Demuth American Dream No. 5* (1963, Art Gall. of Ontario, Toronto), which discloses, in its association with CHARLES DEMUTH's work, a modern Precisionist strain: clean-lined, taut-edged, solid-colored, and critical in its appraisal of objects and aspects of the American environment. *Lit.:* John W. McCoubrey, *Robert Indiana*, exhib. cat., Univ. of Pennsylvania, 1968.

INGHAM, CHARLES CROMWELL (1796–1863), a leading New York City portraitist. Ingham was born in Dublin, Ireland, and was trained there, arriving in this country only in 1816. He quickly rose to prominence, at a time when HENRY INMAN was probably New York's foremost portrait specialist. Critics, praising Inman for his male portraits, Ingham for his depictions of women, cautioned against confusing the two, which—given the similarity of their surnames—has, in fact, predictably occurred. Yet, the styles of the two painters were markedly different. Inman painted in a broad, romantic, painterly manner, echoing that of the English Sir Thomas Lawrence. Ingham's pictures assumed a porcelain-like smoothness, with flesh rendered as hard as polished ivory, a style achieved through laborious glazing rather than direct painting. The masterpiece of his early years is *Amelia Palmer* (c. 1829, MMA), wherein Ingham revealed a true romantic sensibility; Miss Palmer emerges dramatically from a lovely wooded setting. *Flower Girl*, a likeness of Marie Perkins of New Orleans (1846, MMA), is a fuller figure revealed in full, even light, more straightforward and sentimental. Both paintings include beautiful, lush, flower still lifes, echoing the appeal of the young women who are the subjects of the portraits.

INMAN, HENRY (1801–1846), the leading New York City portrait painter of his time. Inman was born in Utica, N.Y.,

and lived there until his family moved to New York in 1812. Two years later, he entered into an apprenticeship with JOHN WESLEY JARVIS, who was fast becoming the most fashionable portraitist in the city; JOHN QUIDOR was a fellow apprentice. Inman's relationship with his teacher was a cordial one, and they travelled together to New Orleans in the winter of 1820–21. At the conclusion of Inman's seven years with Jarvis, the two artists were together in Boston, Mass., in 1822, and there Inman painted miniatures while his former teacher painted life-size oil portraits. Back in New York, Inman soon began to eclipse Jarvis, gaining the patronage of such distinguished families as the Eckfords, the Drakes, and the De Kays, and also became part of Knickerbocker society there. When the NATIONAL ACADEMY OF DESIGN was formed, Inman became its first vice-president. The artists of the young academy were among the leading figures of the Sketch Club, and this group also included the artists responsible for illustrating *The Talisman*, the most prestigious of all the GIFT BOOKS or annuals of the time.

Inman remained in New York for most of his short life. In 1831 he moved to Philadelphia, soon thereafter taking a country residence across the river in Mount Holly, N.J., where he remained until the end of 1834. He had a severe financial setback in the economic crisis of 1837, and about the same time his health, never good, began to deteriorate. In the early 1840s, he hoped to go abroad but was only able to do so in 1844, remaining in England about a year, during which time he painted portraits of Wordsworth and other notables as well as landscapes in the countryside around the poet's home. Upon his return, Inman's health failed precipitously and he died at the beginning of 1846. During his last days, the members of NAD began to organize an exhibition that took place in February, one of the earliest one-man memorial exhibitions in the United States, the proceeds of which went to the support of Inman's family.

Inman was particularly noted in his

own time for his versatility. He was one of the country's finest miniature painters during the early 1820s, though thereafter he seems to have left the field to THOMAS SEIRS CUMMINGS, who was his partner for several years. He painted a number of sweet, idyllic landscapes and some very popular genre paintings during the early 1840s, a number of which, among them *Newsboy* and *Mumble the Peg*, were engraved in gift books. He occasionally painted literary subjects, the best known of which was *Bride of Lammermoor* (1835), taken from Sir Walter Scott. After three years of negotiation, in 1837 Congress awarded him the commission for one of the large historical paintings in the Rotunda of the U.S. Capitol, in Washington, D.C. Inman's subject was *The Emigration of Daniel Boone to Kentucky*, but the artist does not appear to have gone beyond preparatory sketches for this before his death. During his years in Philadelphia and Mount Holly, Inman was one of the pioneers in the development of the new art of lithography, forming, with his close friend Cephas G. Childs, the Philadelphia firm of Childs and Inman, which existed between 1830 and 1833.

Nevertheless, Inman was primarily a painter of life-size oil portraits, notable for their suggestion of humor, self-confidence, and vivacity. His portraits of ladies emphasized their beauty; those of gentlemen were dashing yet dignified; and his many portraits of children, often in groups, suggested carefree innocence. His ability as a landscapist stood him in good stead, as many of his subject were handsomely set off by romantic, outdoor settings. It is his own *Self-Portrait* (1834, PAFA), however, dashed off in the course of an afternoon's instruction that captures the modern eye—with its cheerful insouciance of mood, its rich painterliness, and feeling for light and textures. Inman's fame won him six commissions for the mayoral and gubernatorial portraits for New York City Hall. He also painted a number of well-known actresses and dancers and a whole series of leading Episcopal clergymen of the period. Inman and THOMAS

SULLY were both called the "American Lawrence," in allusion to Sir Thomas Lawrence, the great English portraitist, whose dashing, colorful, and painterly style Inman emulated. His works are plentifully represented in New York (NYHS), and copies by him of CHARLES BIRD KING's Indian portraits commissioned by the Bureau of Indian Affairs and destroyed in a fire at the Smithsonian Institution, Washington, D.C., in 1865 are in the Peabody Mus. *Lit.:* Theodore Bolton, *Art Quarterly* 3 (Autumn, 1940).

INNESS, GEORGE (1825–1894), the leading American Barbizon painter (see BARBIZON, AMERICAN), whose late work, in part because of his interest in the religious philosophy of Emanuel Swedenborg, has Symbolist overtones. Born in Newburgh, N.Y., Inness grew up near New York City and Newark, N.J. He studied briefly with the itinerant artist John Jesse Barker about 1841 in Newark, became an apprentice engraver in New York City about 1841–43, and studied about 1843 with RÉGIS FRANÇOIS GIGNOUX. Inness travelled abroad in 1850/51–52 in Italy and France, in 1853 or 1854 until 1855 in France, and from 1870 to 1875 in Italy and France. During the second trip, the most significant one, he profoundly responded to the works of Barbizon artists, especially to those of Théodore Rousseau. Inness met WILLIAM PAGE in 1863, when he lived near Perth Amboy, N.J., for about a year, and it was through Page that Inness became interested in Swedenborg. Inness subsequently lived in New York City, Boston, Mass., and Montclair, N.J.

Although Inness's works of the 1840s and 1850s, such as *Landscape* (1848, CPLH), have been associated with the romantic realism of the HUDSON RIVER SCHOOL, their twisting tree trunks, visible brushstrokes, and compositional formats ally them more closely with 17th-century paintings by various Dutch landscapists and by the Frenchman Claude Lorrain. Following Inness's return from France in 1855, his handling of pigment grew freer, color became

brighter, and horizon lines flattened out, bringing to his works an increased recti-linearity. Some paintings seem to accom-modate the thickened pigments and slightly claustrophobic atmosphere of Barbizon surface to the spacious vistas of the Hudson River School, as in *Delaware Water Gap* (1861, MMA), a painting that helped formulate the new approach to landscape painting in this country after the Civil War. In other works, such as *Hackensack Meadows, Sunset* (1859, NYHS), trees appearing in the middle distance rather than in the foreground, create an odd abstract quality that was to be considerably developed later in the century. Inness held that a painting should have three planes, the first and second being the foreground and the third indicating the background. The principal subject, not necessarily con-fined to the first plane, did, however, have to reach above the horizon line, thus compressing pictorial space into comparatively flattened bands and masses of color. These qualities were es-pecially developed during the 1860s in such works as *Golden Sunset* (1862, Cin-cinnati Mus.), in which the sun and its enveloping glow seem to be the subject of the painting. Such works also seem to have spiritual qualities, perhaps less of a religious nature (see ASHER B. DURAND) than of personal mood and feeling.

During the 1870s, Inness suppressed rather than omitted details. Object-de-fining contours grew fuzzy, foreground elements appeared as strokes of color clotted on the canvas surface, and tex-tures became more palpable. His colors and tonal changes also grew more ad-venturous. Skies included sections of blue, red, and yellow hue, and in works like *The Monk* (1873, Addison Gall.) dramatic contrasts of tone add consider-ably to the painting's poetic qualities. As Inness commented, "A work of art does not appeal to the intellect. It does not ap-peal to the moral sense. Its aim is not to instruct, not to edify, but to awaken an emotion. . . . Details . . . must be elabo-rated only enough fully to reproduce the impression which the artist wishes to re-produce." Unlike Hudson River School artists, Inness did not paint portraits of real scenes, nor did he explore the char-acter of a locale and its varying flora. In-ness also rejected Impressionism because its great concern for reality over-whelmed the kind of spiritualization that moved him.

Inness's interest in Swedenborg's writ-ings unquestionably influenced his ma-nipulation of form and his attitude toward content. To Swedenborg, and presumably to Inness, correspondences existed between the whole of the natural world and that of the spiritual world. It was these correspondences that provided the medium of conjunction between the two spheres, or between Heaven and mankind. But since the spiritual world, which touched and, in a sense, coextend-ed with the natural world was not mate-rial, objects in it did not occupy space. Rather, they had to be considered as ap-pearances. Very likely as a result of the influence of this concept, Inness painted landscape scenes in which the objects were cast in forms halfway between the firm definition of objects of the natural world and the vague definition of those of the heavenly world—tentative of out-line, lacking in substance and depth. In-ness's forms perhaps provide hints of the forms resident in the spiritual world, which were closer than those of the nat-ural world to the divine sphere where God existed. Thus, from religious neces-sity and from his response to a theologi-cal vision, Inness painted indistinct forms. Yet, when he once said, "There is such a thing as the indefinable which hides itself that we may feel after it," he would also have been understood by contemporary French Symbolists.

Inness's late style may conveniently be dated from 1884, when his mystical be-liefs began to have their greatest impact on his work. Moods grew quiet, less dra-matic. Atmosphere appeared almost as apparent as objects. Compositions, al-though subtle, became simplified. Hori-zontal bands of field and sky predomi-nated, interrupted by the verticals of trees and occasional figures. Foreground detail appeared as a blur or color. Tex-tures grew scratchy. Skies seemed to lie

on the picture surface rather than at an infinite distance. Fine examples of his late period include *Brush Burning* (1884, Nelson Gall.) and *Autumn Landscape* (c. 1894, Univ. of Notre Dame). Although these works are thematically and stylistically (see TONALISM) tied to the 19th century, they also look forward to the art of the early 20th century because of their mysticism, their idiosyncratic manipulation of space, and their obviously arbitrary compositions, which force awareness of design as much as of subject matter. *Lit.:* Nicolai Cikovsky, Jr., *George Inness*, 1971.

IRWIN, ROBERT (b. 1928), a painter, sculptor, and theorist influential among southern California artists concerned with dematerialization of materials. He studied at the Otis, Jepson, and Chouinard art institutes in Los Angeles between 1948 and 1953. An Abstract Expressionist during the 1950s, he turned Minimalist at the end of the decade, renouncing personal expression (see ABSTRACT EXPRESSIONISM; MINIMAL ART). In a series of two-color line and dot paintings and another of spray-painted discs, he increasingly questioned the notion of the object as a discrete entity. By 1968 he had spotlighted the discs, which were projected from walls, in order to incorporate a sense of interior and exterior spaces into a continuum of related shapes, shadows, and illuminated forms. For Irwin, as for LARRY BELL, all elements of an interior space became part of the viewer's visual experience. During the 1970s, he has explored various arrangements of interior light and space. *Lit.: Robert Irwin*, exhib. cat., WMAA, 1977.

IVES, CHAUNCEY BRADLEY (1810–1894), a popular sculptor of idealized figures in marble. Born in Hampden, Conn., he learned to work in wood and clay from R. F. Northrop in New Haven, Conn., and possibly also from HEZEKIAH AUGUR. Ives then practiced for a time in Boston, Mass., and New York. Such portrait busts as *Noah Webster* (1841, Yale Univ.) demonstrate the artist's skill and sensitivity to his sitters. Due to ill health, Ives moved to Italy and in 1844 settled in Florence, joining the community of American sculptors, which included HORATIO GREENOUGH and HIRAM POWERS. Powers's *The Greek Slave* (1843) was just gaining international repute, and it and other such works by his countrymen inspired Ives to pursue a more idealized mode. Although he continued to produce portrait busts in the prevailing naturalistic style of the day, these, with their togalike drapery, became increasingly smooth and neoclassical. It was not until Ives moved to Rome, after seven years in Florence, that this idealizing tendency reached full development, however. His *Pandora* (1854, Virginia Mus.) was a great success, but perhaps his most impressive work is *Undine Receiving Her Soul* (1855, Yale Univ.). Subject of a poem by Karl de la Motte-Fouqué, the water nymph is shown rising from a fountain with arms upraised and thin, wet drapery falling like water over her form with a fine, virtuoso effect. Ives's talent was for carving soft flesh in marble. His full-length portraits of Roger Sherman and Jonathan Trumbull, commissioned by the state of Connecticut in 1872 (both U.S. Capitol, Washington, D.C.) show his weakness at rendering male anatomy. He retired in Rome in 1875, but his studio continued to make replicas of his popular works. *Lit.:* William H. Gerdts, "Chauncey Bradley Ives, American Sculptor," *Antiques*, Nov. 1968.

# J

**JACKSON, WILLIAM HENRY** (1843–1942). See PHOTOGRAPHY, FRONTIER.

**JARVIS, JOHN WESLEY** (1780–1840), a leading New York City portraitist. Jarvis was born in England but grew up in Philadelphia and was apprenticed to ED-WARD SAVAGE, with whom he moved to New York City in 1801. The following year, he went into partnership with the specialist in small, cabinet-size portraits Joseph Wood. Jarvis rose to prominence in New York about 1808, when JOHN TRUMBULL returned to Europe and other potential rivals, including REMBRANDT PEALE, JOHN VANDERLYN, CHARLES BIRD KING, and THOMAS SULLY were already abroad or soon to go. Jarvis became one of the leading Knickerbocker painters, establishing a close relationship with Washington Irving, whose graceful, elegant portrait he painted in 1809. When in 1815 Gilbert Stuart quarrelled with Commodore William Bainbridge, whose portrait he had been commissioned to execute for New York's City Hall, and Sully was wary, in turn, of offending Stuart, Jarvis received the commission for this and five full-length depictions of the military heroes of the War of 1812. These historical portraits are among Jarvis's most commanding, especially *Commodore Oliver Hazard Perry at the Battle of Lake Erie* (1816), though even here Jarvis's limited grasp of form and stiff manner of posing are evident. Typical of his likenesses, too, are the serious expressions, devoid of humor, and the somewhat hesitant look of the eyes. Of his later portraits, the bravura likeness of Andrew Jackson of 1819–20 is especially dashing, though it was Vanderlyn who was awarded the official City Hall commission. During these years, Jarvis achieved sufficient fame to attract the young artists JOHN QUIDOR and HENRY INMAN as apprentices; with the latter, he

journeyed to New Orleans in 1820 and in 1822 to Boston, Mass., where the younger artist, striking out on his own, achieved greater success than his former teacher. High living, and Bohemian habits followed by illness, ended Jarvis's supremacy in New York portrait painting, and by the late 1820s Inman had supplanted him. *Lit.:* Harold E. Dickson, *John Wesley Jarvis*, 1949.

**JENKINS, PAUL** (b. 1923), a painter, Born in Kansas City, Mo., he studied at the city's Art Inst. from 1937 to 1942. Interested in the theater and in writing plays, he decided to become an artist and studied further at ASL from 1948 to 1952. He was influenced there by YASUO KUNIYOSHI. In 1953 he went abroad and has lived there for long periods of time ever since. In 1964–66 a film, *The Ivory Knife: Paul Jenkins at Work*, was made of his working procedures. He began to make lithographs in 1967. Before reaching his mature style, Jenkins, like many other modernists, turned to mysticism, delving into alchemy, Zen Buddhism, the writings of Carl Jung, and other sources of mystical insight and guidance. He came, ultimately, to see his work as marvels, rather than as descriptions of particular subjects, and also as religious in meaning. "I paint what God is to me," he said in 1962. His earliest pictures, almost entirely destroyed, included figural references. After *Sea Escape* (1951), manipulation of paint became the outstanding feature of his work. In 1963, influenced by Wolfgang Wols and MARK TOBEY, Jenkins began to pour pigment in veils of varying thickness and overlay. These were laced with thin, often white, linear spills. Surfaces grew richly textured in the next few years. In both a literal and a metaphysical sense, fluidity and flow of pigment, time and mood characterize these works. About 1960

Jenkins's intense, overcharged forms grew expansive as underlying white areas became exposed. Since each canvas was primed, forms remained veils rather than soak-stains. In contrast to the Abstract Expressionists, Jenkins projects a spiritual rather than a kinetic abstraction as he tries to capture an evanescent illumination akin to that in MARK ROTHKO's paintings. His work suggests that the firmament is in a state of undefined flux. *Lit.*: Albert Elsen, *Paul Jenkins*, n.d.

**JENNYS, RICHARD** (active 1766–c. 1800), and **WILLIAM** (active c. 1790–1805), itinerant New England portraitists, who may have been related to each other. Richard first appears as the author of a mezzotint of the Reverend Jonathan Mayhew of Boston, Mass., in 1766. A mature work, slightly inferior to prints by Peter Pelham, it suggests that Richard may have been trained as an engraver; however, no other prints by him have been found. In 1783 he was in Charleston, S.C., after a trip to the West Indies, for he advertised himself there as a painter of portraits and a miniaturist. He remained in Charleston about a year before moving to Savannah, Ga., where he lived until about 1790. He next appeared in New Haven, Conn., in 1792, and, later in the decade, painted at least eleven portraits in the New Milford, Conn., area. These portraits, oval for the most part, are in the itinerant tradition. Likenesses are keen, personalities are carefully studied, but forms are rigid, edges are crisp, details are exaggerated, and no atmospheric envelope surrounds the subjects. Jennys's surfaces are especially thin. Examples include *Elizabeth Canfield* (1794, Litchfield Hist. Soc., Litchfield, Conn.) and *Elisha Bostwick* (1799, New Milford Hist. Soc.).

William Jennys was also active in the New Milford area in the 1790s. He was in New York City in 1797–98 and in central and northern New England after 1800. He, too, painted figures in oval formats. His early work is similar to Richard's, though after 1795 his portraits grew more realistic, but, a less careful draftsman, he often produced arms that look tubelike and overly sloping shoulders. There is still much confusion between the two artists. An example of William's work is *John Bancroft* (1801, Westfield Atheneum, Westfield, Mass.). *Lit.*: William Lamson Warren, "A Checklist of Jennys Portraits," *Connecticut Historical Society Bulletin* (Apr., 1956).

**JEWETT, WILLIAM (1789/90–1874).** See WALDO & JEWETT.

**JOHNS, JASPER** (b. 1930), a major post-Abstract Expressionist painter, sculptor, and printmaker. From Augusta, Ga., he grew up in South Carolina and moved to New York City in 1949. His mature work dates from the mid-1950s. In 1954 Johns began to create the pictorial images with which he has been most closely associated in the public mind and which were an important source for POP ART—flags, targets, and numbers. Examples include *Flag* (1955, MOMA) and *Numbers in Color* (1959, AK). He first began to attach objects to paintings in 1956–57 (*Device*, 1961–62, Dallas Mus.). His first alphabets appeared in 1956, his first sculpture in 1958 (*Painted Bronze*, 1960, Kunstmuseum, Basel, Switzerland), and his first lithographs in 1960. Johns has described all of these images as "preformed,. conventional, depersonalized, factual, exterior elements," which remain impersonal no matter how they are analyzed. In contrast to the Abstract Expressionists' concern with the artist's emotions and manner of execution, these works offered open-ended trains of thought and stimulated interest in the relationship between subject matter and painted surface. Furthermore, though realistic, the images lack depth, a notable commingling of traditional belief in the priority of subject matter and the modern interest in the flatness of the picture surface. Johns's Flag paintings were especially important for the development of MINIMAL ART, inasmuch as the viewer must perceive the image as a whole rather than as a series of parts. In

the case of the Number paintings, figures may act as shapes alone or signify numerical quantities, and they suggested to younger artists ways to manipulate linguistic elements (letters, numbers, words, phrases) visually. Because of their subsequent influence, these images, taken altogether, are among the most important ever produced by an American artist.

In 1959 Johns began to complicate the surfaces of his paintings with bold splashes of color and vivid combinations of lettering and color areas at the time when Pop artists and Minimalists were still pursuing a commercial and impersonal manner of painting. He applied his new manner to a series of Map paintings (an example is in MOMA, dated 1961) as well as to a long sequence of nonobjective works. Many of these had objects attached to them. They ranged from complicated but decipherable statements concerning both the art and the act of painting, as, for example, *According to What* (1964), which makes reference to the work of Marcel Duchamp, whom Johns met in the late 1950s, and *Studio* (1964, WMAA), to entirely personal statements. The finished product, which may look as if it were painted in spontaneous fashion, is, more often than not, part of a system of thought that may lead in several directions at once.

Since 1972 Johns has used a cross-hatching motif as his principal image. As in his earlier works, the forms appear to be improvised but are, in fact, carefully arranged. Throughout his career, Johns has used the encaustic medium, which, in its textured surfaces and rich colors, affirms an interest in pigment manipulation despite the seeming impersonality of the images it brings to life. Because of this sensuous quality in his work, Johns's famous deadpan comment about his method and purpose, "Take an object, do something to it, do something else to it," tells only half the story. *Lit.*: Michael Crichton, *Jasper Johns*, exhib. cat. WMAA, 1977.

JOHNSON, EASTMAN (1824–1906), a painter of portraits and genre subjects. John-son was born in Lovell, Maine, and raised in Augusta, where his father held political office. In 1840 he was in Boston, Mass., employed by the lithographer John H. Bufford. Travelling about the East Coast, Johnson gradually earned a reputation for his charcoal portraits, particularly in Washington, D.C. In 1849 he went to Düsseldorf, Germany, an important training ground for American painters, where he was associated with EMANUEL GOTTLIEB LEUTZE. Finding German painting colorless, however, Johnson moved to The Hague, Holland, where he was strongly impressed by the work of Rembrandt and Frans Hals. After a sojourn in Paris and a brief period of study with Thomas Couture in 1855, Johnson returned to the United States in that year and, after practicing in various cities, settled in New York in 1859.

The artist's reputation was made by *Old Kentucky Home: Life in the South* (1859, NYHS), a work in the sentimental, realistic mode of his British contemporary Sir David Wilkie. The black banjo player and other elements suggest the work of WILLIAM SIDNEY MOUNT. Curiously, with the Civil War on the horizon, the American public, even in the North, still preferred this dreamlike gloss of the slavery question to any attempt to deal with reality. In the 1870s, Johnson maintained a studio on Nantucket Island. Such outdoor genre scenes as *The Old Stagecoach* (1871, Milwaukee Art Center) have a crisp draftsmanship and attention to detail reminiscent of Mount and a lightened palette that suggests a renewed acquaintance with the work of Leutze as well as familiarity with that of GEORGE CALEB BINGHAM. Among Johnson's most impressive works is a series of mostly large pictures of cranberry harvesting on Nantucket, a subject he treated more than twenty times. *The Cranberry Harvest* (1880, Timken Gall.) shows an increasing tendency toward large, open, plein-air composition with meticulously observed detail sharply drawn.

As a portraitist, Johnson found ample patronage among the wealthy families of New York, even when interest in his

genre paintings waned. *The Hatch Family* (1871, MMA) is an old-fashioned conversation piece showing a family among its possessions. Here, despite the restrictions of the Victorian portrait genre, Johnson managed to achieve a telling psychological interpretation of personalities and relationships as well as a marvellously truthful reflection of upper-class urban family life. Johnson had even more success with *The Funding Bill* (1881, MMA), in which two well-to-do middle-aged men of affairs are shown seated in the large leather chairs of a well-appointed office or club to settle some great matter between them. The intense light and somber shadows give the figures a monumental gravity, a quality THOMAS EAKINS used to great effect, and in its painterly richness and insightful characterization *The Funding Bill* is not far from Eakins. In the 1880s, Johnson's reputation declined and he settled into a comfortable portrait practice in New York. *Lit.:* Patricia Hills, *The Genre Painting of Eastman Johnson*, 1977.

JOHNSON, WILLIAM H. (1901–1970), a painter. From Florence, S.C., he studied at NAD from 1921 to 1926, largely with CHARLES W. HAWTHORNE, his mentor. Abroad for the most part from 1926 to 1938, he lived in Paris until 1929 and in Denmark and Norway until his return to this country. In Paris his style turned radically away from Hawthorne's conservative academicism and began markedly to reflect the influence of Chaim Soutine's pulsating, convoluted, expressionist style. During the 1930s, however, such landscape elements as trees and boats, though strongly outlined and spatially askew, appeared as discrete planes rather than as forms caught up in flame-like swirls of pigment. After returning to this country, both Johnson's style and his subject matter changed radically once again. His forms grew simple and primitive, though still remaining extremely distorted, and figures assumed a calculated awkwardness. Themes revolved increasingly around his experiences as a black person. Religious, prison, war, and farm scenes were all populated by blacks. Like MAX WEBER, who at this time found subject matter in his religious background, Johnson explored his own heritage. He worked for WPA-FAP from 1939 to 1943. Many of his works are in NCFA. *Lit.:* Adelyn Breeskin, *William H. Johnson*, exhib. cat., NCFA, 1971.

JOHNSTON, DAVID CLAYPOOLE (1798–1865), the first American satirical artist of note. Born in Philadelphia, he was apprenticed to Francis Kearney, a local engraver, from 1815 to 1819. Johnston may have lived in London from 1822 to 1824. Although his first caricatures date from about 1819, his career may be said to have begun when he settled in Boston, Mass., in 1825. He made the first commercially successful American lithographs, beginning with an illustration for the *Boston Monthly Magazine* in December, 1835. (Bass Otis is thought to have created the first American lithograph in 1819 in Philadelphia.) Between 1828 and 1849, he published nine volumes of *Scraps*, based on the journal *Scraps and Sketches*, first published by the British caricaturist George Cruikshank in 1827. Johnston included between nine and twelve vignettes in his volumes, each satirizing different aspects of American life. Altogether, he illustrated more than forty books and made more than one hundred paintings, mostly watercolors, many of which are in the American Antiquarian Soc., Worcester, Mass. About 250 of his drawings are in the Houghton Library, Harvard Univ. Johnston's subject matter was often drawn from the theater, with which he was familiar both as an observer and as a performer. His style was that of an illustrator—clean and easy to read. His caricatures exaggerated the foibles of his subjects rather than their physical characteristics or oddities of personality, indicating that he was more interested in humor then in harming or hurting people. *Lit.:* Malcolm Johnson, *David Claypoole Johnston*, exhib. cat., American Antiquarian Soc., Worcester, Mass., 1970.

JOHNSTON, HENRIETTA DEERING (d. 1728/29), one of the earliest professional artists working in the colonies. Henrietta Deering married the Reverend Gideon Johnston in Dublin, Ireland, in 1705 and accompanied him to Charleston, S.C., where she assisted in the support of the family by painting pastel portraits of local residents, and, in 1725, of several subjects in New York City during a visit there. The pastel medium had only recently emerged as a viable aesthetic alternative to oil portraiture and had achieved great success in the hands of the internationally famous Rosalba Carriera. Perhaps the identification of the medium with a woman artist enabled Johnston to find a market for her talents. Johnston's pictures, which are imitative of the style of Carriera, betray a lack of anatomical knowledge and a lack of intensity; they are, however, sweet and sensitive, most successful when the subjects are women and children. She has a historical position of importance as America's earliest woman artist and as the earliest recorder of the wealthy members of a number of the illustrious Charleston families, both English and French Huguenot. The majority of Johnston's works have remained at Gibbes Gall. *Lit.:* Margaret S. Middleton, *Henrietta Johnston of Charles Town, South Carolina*, 1966.

JOHNSTON, JOSHUA (active 1796–1824), the earliest professional black artist in America. Johnston may have been a mulatto and was for a time, perhaps, a slave in Baltimore, though he is listed in the directories as a freeman of that city. His training is obscure, though it is believed that he may have studied with members of the Peale family (see PEALE, CHARLES WILLSON), most probably with Charles Peale Polk, who was active in Baltimore at the end of the 18th century. Johnston's figures are invariably posed upon a settee, stiff and doll-like, with little suggestion of anatomy but displaying a great deal of prim charm. Especially attractive are his rather naive likenesses of children and of women garbed in Em-

pire gowns. His figures are thinly painted and generally appear rather flat, though Johnston made attempts at three-dimensional modelling. The faces of his subjects are tight and expressionless, with equal attention given to the bright gold buttons of costumes and brass nailheads of furniture. Prominent Baltimore residents sat for him, though his talents were far more primitive than those of REMBRANDT PEALE, Philip Tilyard, or even the young SARAH MIRIAM PEALE. *Lit.:* J. Hall Pleasants, *Joshua Johnston: The First American Negro Portrait Painter*, 1942.

JOUETT, MATTHEW HARRIS (1787–1827), the leading portrait painter of Kentucky in the early 19th century. Abandoning the law for art, Jouett was mostly self-taught except for a few months spent with GILBERT STUART in 1816. Despite the brevity of this study, Jouett gained a great deal from Stuart, and the notebook he kept at the time is the most complete extant record of that great portrait artist's theories, methodology, and practice. On returning to Kentucky, Jouett worked throughout the state, though he spent winters in New Orleans. His most ambitious picture is a portrait of the Marquis de Lafayette (1824, State Capitol, Frankfort, Ky.), but the majority of his paintings, like those of Stuart himself, are bust portraits, usually with plain backgrounds, that are somewhat naive but engaging reflections of Stuart's art. Jouett was at his best in facial likenesses; he was not especially knowledgeable in anatomy, and his treatment of hands was often quite poor. Nor was he a master of the full-length portrait. An early artist to emerge from what was then the West, he was, and still is, much honored locally. *Lit.:* Edward Jonas, *Matthew Harris Jouett: Kentucky Portrait Painter*, 1938.

JUDD, DONALD (b. 1928), a sculptor, whose works and writings are central to MINIMAL ART. From Excelsior Springs, Mo., he studied at ASL from 1947 to 1948 and from 1950 to 1953. From the

latter date until the early 1960s, he worked as a painter. He turned to free-standing sculpture in 1963, the year in which his first Minimalist pieces were made. Using wood and metal at first, Judd composed simple, baseless forms—a horizontal pipe holding vertical boards placed at right angles; a stepladder-like arrangement connecting side boards. Easy to comprehend at a glance, these works generated a sense of order based on perception of the totality of the piece rather than on the observation of relational sequences or thematic continuities. Opposed to the effects of composition because these, as he said, "tend to carry with them all the structures, values, feelings of the whole European tradition," Judd preferred a work to appear as a unified whole that conveyed no meaning other than its own existence. By 1963 in floor and wall pieces he employed repetitive forms and symmetrical arrangements (repetition as an aesthetic device had been explored by the Paris-based Nouvelle Tendence group in the late 1950s). Judd's manipulation of box forms revealed the subtle differences of spatial interpenetration simple forms might assume in the hands of a careful student of the medium's essentials: namely, mass, volume, and gravity. Through the 1960s and 1970s, Judd has used a variety of metals fabricated to his specifications, often colored in rich, metallic monochrome hues. *Lit.:* Donald Judd, *Don Judd: Complete Writings 1959–1975*, 1976.

# K

**KAINEN, JACOB** (b. 1909), a printmaker, who, between 1942 and 1970, was associated with the Division of Graphic Arts of the Smithsonian Institution, Washington, D.C. Born in Waterbury, Conn., he moved with his family to New York City about 1919. By 1925 he was studying painting at ASL. From 1926 to 1929, he attended the New York Evening School of Industrial Art, New York City, and graduated from Pratt Inst. there the following year. Although primarily a painter at the time, he gravitated toward printmaking, and in 1935 joined the Graphics Art Project of WPA-FAP in New York. At first attracted to lithography, he explored, with Russell Limbach, new techniques in color lithography. Kainen has also worked in drypoint, etching, woodcut, silk screen, serigraph, and aquatint as well as in combinations of these media. His output in the 1930s reflected social-realist themes (see AMERICAN SCENE PAINTING). About 1940 he began to emphasize shape to a greater extent and to limit three-dimensional space. By the end of the decade, he worked with nonobjective forms, though not exclusively. Throughout his later career, he balanced his ability to manipulate linear elements against his evident interest in broad planar effects. In his woodcuts of the 1950s and 1960s, Kainen effectively used abrupt tonal contrasts to create subtle, psychologically charged portraits. However, in most of his later work he has emphasized technical mastery at the expense of insightful readings of character. *Lit.:* Janet Flint, *Jacob Kainen Prints: A Retrospective*, exhib. cat., NCFA, 1976.

**KANE, JOHN** (1860–1934), a self-taught painter. Born in West Calder, Scotland, he came to Braddock, Pa., in 1879. During the remainder of his life, he moved around Pennsylvania and Ohio, holding mill, carpentry, and house-painting jobs. By 1889 he had secured employment painting railroad cars and would sketch on their sides before applying uniform coats of paint. About 1890 Kane began to undertake industrial themes. He worked briefly at enlarging color photographs in 1907. His important work began in 1910, when he was living in Akron, Ohio, but it is almost impossible to date specific works before 1928, the year after he received public recognition at the Carnegie International Exhibition of Painting. Altogether, about 140 paintings by Kane have been recorded. Like other primitive artists, he rendered detail in a meticulous manner and made each form easy to read, clearly distinguishing one from the next, but, at the same time, he conveyed an underlying sense of abstract relationships. He painted many landscapes, industrial scenes, and a few portraits. A typical example is *Juniata River* (1932, AK). *Lit.:* Leon Anthony Arkus, *John Kane: Painter*, 1971.

**KANTOR, MORRIS** (b. 1896), a painter. From Minsk, Russia, he settled in New York City in 1906. Ten years later, he studied briefly at the Independent School of Art. His paintings of the following few years were visionary, semi-abstract scenes that might well be described as romantic Futurism. During the early 1920s, he explored Cubist techniques, reverting in 1924 to realism. After returning from a year in Paris in 1928, his naturalism became colored by fantasy: Urban views of New York City's Union Square were host to large floating flowers, for example. An interest in early Americana prompted him to paint a number of pictures whose spooky mystery evokes comparison with some of the tales of Nathaniel Hawthorne. *Haunted House* (1930, AIC) shows a New England interior invaded by ghostly pres-

ences that must make their way across spaces in varying perspective. In the mid–1930s, Kantor began to paint figure studies, which, by 1940, had become enmeshed in the linear and planar tangles of a modified-Cubist realism. He also began to use tempera in addition to oil paint at that time.

**KAPROW, ALLAN** (b. 1927). See HAPPENINGS.

**KARFIOL, BERNARD** (1886–1952), a painter. From Budapest, Hungary, he grew up in New York City, where he studied at NAD in 1900. He went abroad in 1901 and worked in Paris at the Académie Julian and EBA before returning to America in 1906. A painter of studio scenes and subjects, he concentrated on nudes and still lifes. He also painted occasional landscapes. His style reflected the influence of Pierre Auguste Renoir, Paul Cézanne, and Pablo Picasso's Blue Period. *Lit.:* Jean Paul Slusser, *Bernard Karfiol*, exhib. cat., WMAA, 1931.

**KÄSEBIER, GERTRUDE** (1852–1934). See PHOTO-SECESSION.

**KATZ, ALEX** (b. 1927), a painter. From New York City, he attended Cooper Union there from 1945 to 1949. By the late 1950s, he was painting figures, most often frontally, either in completely unspecified locales or with the setting barely indicated. The stylistic sources of these pictures seem to have been the work of MILTON AVERY and of Henri Matisse. At the same time, Katz also began to make cutouts—paintings of people cut out and pasted to plywood grounds—which created, when first seen, likenesses and presences as startling as those of GEORGE SEGAL's plaster-cast figures. By the early 1960s, he increasingly concentrated on head-and-shoulder views of his sitters, isolating them from their environments. From the beginning of that decade, too, he painted flower pieces as well as groups of people who resembled his cutouts. These works, with their smooth outlines and underdrawing, are simplified but not stylized. Although Katz can indicate deep space, he rarely models his forms. Since his figures are gigantic in scale relative to the size of the canvas, they tend to leap out at the viewer and impose themselves on his psychological and physical space. *Lit.:* Alex Katz, *Alex Katz*, exhib. cat., Univ. of Utah, 1971.

**KEITH, WILLIAM** (1839–1911), a painter in the Barbizon style (see BARBIZON, AMERICAN). Born in Old Meldrum, Aberdeenshire, Scotland, Keith emigrated to New York City in 1850 and during the mid-1850s worked as an engraver, before turning seriously to painting. Keith settled in California after travelling to San Francisco in 1859 as an engraver for Harper & Brothers. He studied briefly in Düsseldorf, Germany, in 1869 and in Munich during a trip abroad from 1883 to 1885. The naturalist John Muir, with whom he had become friendly, joined him in his travels through the West during the 1870s and 1880s. Keith went abroad again in 1893 and 1899. In 1891, he was visited by the artist GEORGE INNESS, also a follower of the Spiritualist Emanuel Swedenborg. During the earlier part of his career, Keith had painted western landscape scenes, but after meeting Inness he began to create intimate studies of meadows, groves of trees, and, as in *Landscape* (MMA), paintings of cattle amiably foraging near a secluded stream. Using a technique of applying pigment and glazes that also reflected Inness's influence, Keith suggested details as much by touches of color as by careful delineation, and generally all forms were softened by the light of dusky, twilight skies. Unfortunately, hundreds of Keith's paintings were destroyed during the earthquake and fire of 1906. *Lit.:* Eugen Neuhaus, *William Keith: The Man and the Artist*, 1938.

**KELLY, ELLSWORTH** (b. 1923), a painter and sculptor, whose hard-edged works prefigured and were part of the MINIMAL ART of the 1960s. From Newburgh, N.Y., he studied at Pratt Inst., New York

City, in 1941–42, before serving in the army as a camouflage specialist. He attended the school of MFAB from 1946 to 1948, and there he developed an expressive realistic style. He then went to France, where he remained until 1954. Within a year of his arrival in Europe, Kelly began to experiment with automatic drawing techniques and then with abstract designs based on the simplified shapes of road markers, windows, and shadows. These were usually dispersed evenly across the surface of a painting, collage, or relief, establishing a system of equal elements rather than one based on, say, a central dominant element and subordinate units. By 1951 Kelly had begun to make grid paintings. In *Spectrum Colors Arranged by Chance* (1952–53), the colors of the several small squares that constitute the picture were selected more or less randomly. *Colors for a Large Wall* (1951, MOMA) is like a large, multicolored checkerboard. Soon after, Kelly started making works that looked like large color charts, with broad areas of unmodelled, solid color placed side by side or stacked in repeated vertical rows. Beginning about 1952, he also painted monochrome canvases, in which color and form were, in effect, the same. Through the mid-1950s, he experimented with shaped canvases (see MINIMAL ART). But, for all his interest in modular units and nonobjective shapes, Kelly still painted works derived remotely from such observed forms as shadows and reflections—as in *Atlantic* (1956, WMAA), with its great looping arcs. In subsequent years, Kelly created pictures that explored precise relationships between colors, especially in the Spectrum series of the mid-1960s (*Spectrum III*, 1967, MOMA), and color-shape relationships in large canvases with bold, nongeometrical shapes. Most of these paintings contained only two colors, which denied traditional figure-ground relationships and asserted the flatness of the picture surface because of their intensity and placement (*Chatham XI: Blue Yellow*, 1971 AK).

Kelly's sculpture of the late 1950s and later is like his paintings in that it is often brightly painted and frontally presented. Those works that occupy three dimensions (*White Angle*, 1966, Guggenheim Mus.) look like the shapes of a typical Kelly painting bent out into space. Kelly has also made drawings of plants, precisely outlined and unmodelled, in which he presents realistic forms with the same emotional coolness that characterizes his abstract works. Because his color schemes and shapes seem to spring from no preestablished formulas, Kelly's art can be said to be perhaps the most intuitive of that of all the artists associated with Minimalism. *Lit.:* E. C. Goossen, *Ellsworth Kelly*, exhib. cat., MOMA, 1973.

KEMEYS, EDWARD (1843–1907), America's first specialist in animal sculpture. From Savannah, Ga., he grew up in the New York City area and began to sculpt only in 1871, after seeing someone modelling an animal in a New York City zoo. His talent manifested itself immediately, and his *Hudson Bay Wolves* of the same year was purchased for Philadelphia's Fairmount Park soon after. During the 1870s, he travelled through the West, studying animals in nature at first hand. Like FREDERIC REMINGTON, he assumed an obligation to record aspects of the American West that were rapidly disappearing. He went abroad from 1877 to 1879 and exhibited to great acclaim his *Bison and Wolves* at the Paris Salon of 1878. Subsequently, he made major large works including *Still Hunt* (1883, Central Park, New York City), the colossal bison head for the Union Pacific Railroad bridge in Omaha, Nebr. (c. 1885–90), and the bronze lions at AIC (1895). Kemeys's strength lay in conveying the character of each species as well as a sense of natural movement. His naturalism belies any desire to prettify the actions and the forms of his animal subjects with academic artifice.

KENSETT, JOHN FREDERICK (1816–1872), an engraver and landscape painter and an influential member of the second-

generation HUDSON RIVER SCHOOL. Kensett began his career as an engraver of banknotes and maps, after learning the trade from his father, Thomas Kensett, an engraver who had emigrated from England to America with his family at the beginning of the century. The younger Kensett, who was born in Cheshire, Conn., worked in New Haven, Conn., Albany, N.Y., and New York City, where he made the acquaintance of JOHN W. CASILEAR, who encouraged him to study art and consider a career in painting. In 1838 Kensett showed his first landscape painting at NAD. Two years later, he embarked upon a European tour in the company of his fellow artists ASHER B. DURAND, THOMAS P. ROSSITER, and Casilear.

While abroad, Kensett helped to support himself by doing commercial engravings for American firms. He copied paintings by Claude Lorrain, studied at one of the academies that prepared students for EBA, and sketched at Fontainebleau. Kensett frequently met socially the other American artists studying or working in Paris, a group that included Rossiter, Durand, DANIEL HUNTINGTON, GEORGE P. A. HEALY, and BENJAMIN CHAMPNEY. Kensett met THOMAS COLE at this time, and benefited from the advice of JOHN VANDERLYN.

A trip in 1843 to England to receive a family legacy gave the artist the opportunity to sketch in the English countryside and accumulate studies of picturesque natural objects to be used later in larger compositions painted in the studio—a then standard working method for landscape painters. In his sketches and finished paintings of the period, Kensett showed some awareness of contemporary English artists, notably John Constable and H. J. Boddington. Kensett was now finally able to abandon engraving to devote himself fully to painting. In 1845 he returned to the Continent to travel in France, Germany, Switzerland, and Italy with Champney. He counted his subsequent Italian experience—two years of living in Rome and travelling around the country, often in the company of THOMAS HICKS—as some of the most important of his years abroad.

By 1847, the year of his return to America, Kensett had abandoned the technique he favored in his English works, one characterized by lively brushwork, broken lights and darks, and a relatively heavy application of paint. He subsequently adopted a more reserved and less painterly style, preferring to depict the quiet effect of natural light and atmosphere on landscape. There exists a remarkable degree of stylistic coherence in Kensett's work from the late 1840s on, the major movement in it being the continuing simplification of compositional elements. In his mature pictures, Kensett often employed one of a small number of favorite compositional arrangements that juxtaposed serene landscape forms with bodies of water and expanses of sky, as in *Rocky Coast at Newport* (1869, AIC).

By 1850 Kensett's career was prospering. He had achieved critical and popular success with his paintings and had been made a full member of NAD. His works were widely exhibited and quite a few had been purchased by the AMERICAN ART-UNION as well as by private collectors. Kensett settled into a routine of summers spent travelling and sketching, frequently in the company of his old friends from student years abroad, and winters spent producing finished canvases. Although he sometimes went farther afield, Kensett travelled primarily in the northeastern states, and his works reflect his particular fondness for the mountainous and coastal regions of New York, Massachusetts, Rhode Island, and New Hampshire (see WHITE MOUNTAIN SCHOOL).

In contrast to the drama of views of exotic places favored by FREDERIC EDWIN CHURCH and ALBERT BIERSTADT, Kensett concentrated on the careful depiction of light and atmosphere as they affected the color and texture of selected natural forms (see LUMINISM). The delicate rendering of fleeting atmospheric effects in such works as *View Near West Point on the Hudson* (1863, NYHS) pro-

vides a link between his work and the Luminist ones of FITZ HUGH LANE and MARTIN JOHNSON HEADE.

Kensett remained an important figure in the American art scene until his death. In 1859 he was appointed to serve on a presidential commission on the decoration of the U.S. Capitol, in Washington, D.C. He was one of the original founders (in 1870) and later trustee of MMA, which owns a number of his works, including a group of thirty-eight sketches done on Long Island, N.Y., during the artist's last summer. *Lit.*: John K. Howat, *John Frederick Kensett 1816–1872*, exhib. cat., American Federation of Arts, New York, N.Y., 1968.

KENT, ROCKWELL (1882–1971), a painter, printmaker, and writer. Born in Tarrytown Heights, N.Y., he studied with WILLIAM MERRITT CHASE from 1897 to 1900 and then with ROBERT HENRI, KENNETH HAYES MILLER, and ABBOTT THAYER. Early works, such as his many studies of Monhegan Island, Maine, and of workers (*Road Roller, New Hampshire*, 1909, Phillips Gall.), reveal an exuberant approach similar to that of GEORGE BELLOWS. But Kent soon developed a preference for smooth, broadly massed forms notable for their stark contrasts of tone. This style was well suited to his preference for winter and arctic scenes, such as *The Trapper* (WMAA). (Kent made several trips to Greenland as well as to Alaska and Tierra del Fuego.) Kent also used symbolic figures, especially in his prints (*Over the Ultimate*, 1926). An organizer of the Exhibition of Independent Artists in 1910 (see INDEPENDENT EXHIBITIONS), he was also politically active and received the Lenin Peace Prize in 1967. His numerous writings include his autobiography, *It's Me O Lord* (1955). A large collection of his prints is at the Philadelphia Mus.

KIENHOLZ, EDWARD (b.1927), an assemblage-maker (see ASSEMBLAGE). Born in Fairfield, Wash., he is a self-taught artist. After moving to Los Angeles in 1953, he opened the Now Gall. in 1956 and in 1957, co-founded the Ferus Gall. considered the city's first vanguard art galleries. Soon after his arrival, he began to paint and make wooden reliefs, using leftover pieces of wood nailed and glued together and painted with a broom. Of these works, he said that he wanted to make something ugly so that he could better understand beauty. By the late 1950s, his assemblages grew increasingly figurative as well as three-dimensional and incorporated such elements as toys and mannequin parts. Between 1960 and 1961, Kienholz fitted his pieces into wooden boxes but, as their references became more topical and less abstract, they required larger, room-sized formats. He created his first large tableau in 1961, *Roxy's*, which referred to a Las Vegas bordello, circa 1943. The figures, composed of incomplete body parts, were arranged in rooms decorated with real furniture—a jukebox, rugs, etc.—a fusion of the actual with the created and the immediacy of the moment with the remembered dream or nightmare. Other works, such as *The Wait* (1964, WMAA), a study of an old woman with bones for legs, combine aspects of Americana with universal observations on human behavior. Usually Kienholz seasons his work with references to brutality, death, and the passage of time. During the 1960s, he also made "single-image" works such as fiberglass television sets showing the face of Mickey Mouse. In 1965 he developed the concept-tableau, which a buyer can purchase—own the idea, so to speak—and, if he desires, have the tableau built. *Lit.*: Maurice Tuchman, *Edward Kienholz*, exhib. cat., LACMA, 1966.

KINETIC ART, art that moves or appears to move. Art objects that incorporate motion have been made for centuries, but recognition of the genre as a major art form, and the term itself, are relatively new. Marcel Duchamp's *Bicycle Wheel* mounted on a kitchen stool (1913) was the first 20th-century kinetic sculpture. The Futurists, who early proposed using mechanical motion in sculp-

ture, constructed examples in 1914. The Constructivists Naum Gabo and Antoine Pevsner issued their "Realistic Manifesto" in 1920, calling, among other things, for the use of kinetic elements in art to express the true nature of time. MAN RAY's self-moving sculptures of the early 1920s were part of the early history of modern Kinetic Art, as were Naum Gabo's electrically-driven, oscillating wire construction (1920) and László Moholy-Nagy's *Light Space Modulator* (1921–30) and Thomas Wilfred's Clavilux performances (1920s), both based on light effects. ALEXANDER CALDER's first mobiles date from 1932. As a distinct movement, however, Kinetic Art did not emerge until the 1950s, and its coming of age was marked by a historically important exhibition, Le Movement, in Paris in 1955.

Kinetic Art embodies two types of movement: virtual or illusory movement created by moving the spectator (not the object) or by overloading the visual system; and actual movement, created artificially by mechanical, magnetic, electromechanical, electronic, or chemical means or by harnessing the forces of nature. Movement in Kinetic Art, whether real or apparent, occurs in time; therefore, the fourth dimension is always a factor. Kinetic Art is wide-ranging, encompassing many art forms.

Optical Art (see MINIMAL ART) is dependent upon visual illusions of movement, such as the apparent vibration caused by certain color juxtapositions. Victor Vasarely is its prime exponent, though JOSEF ALBERS, through his work and influence on a younger generation, contributed more significantly to the development of Op Art in America. Robot art, developed by the Israeli artist P. K. Hoenich, who uses the sun, wind, and earth's rotation to activate mobiles and to structure light and shadow, has attracted a multitude of young sculptors who use modern electronic and computer technology to create intricately automated pieces. JAMES SEAWRIGHT is perhaps the best-known artist in this group. The HAPPENINGS created in late 1950s

and early 1960s—a cross between art exhibition and theatrical performance—were a form of Kinetic Art. There are also nonvisual kinetic sculptures called "feelies"—the moving objects are felt, but not seen.

A more recent development in the genre followed the introduction of the laser, which produces a narrow, intense beam of coherent light. A variety of effects have been created with the laser combined with other media. Michael J. Campbell's and James Rockwell's *Laser Beam: Synthesizer* (1969) throws a changing oscillating pattern on a projection screen to the electronic sounds of a twelve-harmonic electronic wave synthesizer. A number of laser effects coordinated with music are on exhibition at the permanent laser show Laserium at the Hayden Planetarium in New York City. Moving holographs (three-dimensional images) are a direct development of laser technology.

The leading American creators of kinetic sculpture are GEORGE RICKEY and Alexander Calder, who have vastly expanded the boundaries of the field; Robert Breer, whose "crawling" objects—motorized, geometrical forms of styrofoam plastic—move randomly about a room; and Len Lye, whose programmed machines, which consist of vibrating clusters of steel rods, reproduce the myriad dazzling effects of movement in nature. *Lit.*: Frank Popper, *The Origins and Development of Kinetic Art*, 1968.

KING, CHARLES BIRD (1785–1862), a portraitist and painter of Indians and still lifes. From Newport, R.I., he studied there with Samuel King and with EDWARD SAVAGE in New York City in 1800, before becoming a pupil of BENJAMIN WEST in London in 1805. There he shared a studio with THOMAS SULLY. He returned to America in 1812, settling first in Philadelphia and then permanently in Washington, D.C., in 1816. Although he completed portraits of leading figures of his era, King is best known for his series depicting members of the Indian delegation that visited the capital city

in 1821. It was the first group of oils ever made of prominent Indians of the West (earlier portraits by JACQUES LE MOYNE DE MORGUES and GUSTAVUS HESSELIUS are of eastern Indians), and it formed the nucleus of the National Indian Portrait Gall., which was burned in the Smithsonian Institution fire of 1865. Numerous copies exist; some by Henry Inman (complete set in the Peabody Mus.). King is also considered the most important early 19th-century still-life painter outside the Peale family (see PEALE, CHARLES WILLSON), even though only a few such works are known to exist. They include the moralistic *Poor Artist's Cupboard* (c.1815, Corcoran Gall.) and *Vanity of an Artist's Dream* (1830, Fogg Mus.), which comment upon the difficult life of an artist in America. In style they approach the *trompe l'oeil* pictures of WILLIAM MICHAEL HARNETT and his circle at the end of the century. *Lit.*: Andrew Cosentino, *The Paintings of Charles Bird King* (1785–1862), exhib. cat. NCFA, 1977.

**KLINE, FRANZ** (1910–1962), the last major contributor to the pictorial range of ABSTRACT EXPRESSIONISM. From Wilkes-Barre, Pa., he studied art at Boston Univ. from 1931 to 1935 and in London from 1937 to 1938, before settling in New York City. He taught at Black Mountain Coll. in 1952. His work of the 1930s and 1940s was expressively realistic, and rural scenes were occasionally flavored by Regionalist sentiment (see AMERICAN SCENE PAINTING). As late as 1948, his imagery was quite recognizable, though after 1945 concern for pigment and for spatial and shape relationships superseded his interest in identifiable subject matter. His friendship with WILLEM DE KOONING, especially, turned his attention to abstract art (influences may have been mutual between them). From 1946 to 1950, he experimented with tumultuously fashioned nonobjective forms, in the creation of which accident and chance seem to have been guiding principles. Using a Bell-Opticon enlarger to project forms on a wall as a means to abandon representation, Kline increas-

ingly tended to emphasize thickened lines and large slablike forms. These began to dominate his art by 1950. Limiting himself to black and white paint, he created large nonobjective works that seemed improvised, but which in reality were carefully meditated and grew slowly under his brushes only after many adjustments (some brushes were as wide as eight inches). The black lines and broad white slabs seemed to hurtle across his canvases, pushing toward the edges rather than collecting around a central focus of interest, suggesting a continuation of movement beyond the perimeters. These works have, as a result, been compared with 19th-century panoramic landscapes as well as with JACKSON POLLOCK's unbounded drip paintings. In most pictures, Kline chose not to distinguish between figure and ground or to allow black or white to act as a background, so that his forms seemed to move laterally rather than in depth. Although Kline's subject matter was allusive, his use of black and white paint recalls to a remarkable degree the winter landscape of Pennsylvania, with its snowy hills outlined against the horizon by silhouetted, leafless trees. In the late 1950s, he reintroduced color once again, first for accents, then in large slabs. Although Kline's formal structure remained unaltered, his use of color had the effect of slowing down the velocities of his great bars and color sections. *Mahoning* (1956, WMAA) is a major example of his first abstract style. *Lit.*: Henry Gaugh, *Franz Kline: The Color Abstractions*, exhib. cat., Phillips Coll., 1979.

**KNATHS, KARL** (1891–1971), a painter. From Eau Claire, Wis., he studied at AIC from 1912 to 1916. Paintings by Cézanne in the Chicago version of the ARMORY SHOW affected him deeply. He settled in Provincetown, Mass., in 1919 and remained there the rest of his life. In 1934 he participated in the PWAP program (see FEDERAL ART PROJECTS) and was one of the original exhibitors with AMERICAN ABSTRACT ARTISTS in 1937. By the late 1920s, Knaths had developed an intimate, domesticated Cubist style,

varying complexity and textures for interior, still-life, seaside, and landscape views. People rarely appear in his work. An extraordinarily subtle colorist, he evolved systems of color notations and intervals to determine spatial harmonies and measurements, yet his work never seems studied. Through his ability to combine arbitrary shapes with recognizable imagery and a personal use of color, he created one of the few authentically independent Cubist styles. *Indian Blanket* (1948, Univ. of Nebraska) is a fine example of Knaths's achievement. *Lit.*: Charles Easton, *Karl Knaths*, exhib. cat., International Exhibitions Foundation, 1973.

KOHN, GABRIEL (1910–1978), a sculptor. From Philadelphia, he studied at New York City's Cooper Union and Beaux-Arts Inst. of Design from 1929 to 1934 while working for academic sculptors. From 1935 to 1942, he was a motion-picture set designer in Hollywood. After World War II, in 1946, he studied with Ossip Zadkine in Paris and lived abroad until 1951. While there, he began to develop his own style, a combination of Cubist and Surrealist elements. His favorite materials were terra-cotta and plaster. In 1954 he began to work in wood and soon developed an exquisite sense of craft. Rather than carve into a solid block, he laminated and dowelled together thin sheets in asymmetrical, abstract groupings. Some pieces, in their odd balances and extended forms, suggest the Baroque manipulation of space. Yet his work has a traditional massiveness and solidity even when forms are open. In the 1950s, he made vaguely birdlike forms, distant relatives of the more spiky, aggressive shapes of SEYMOUR LIPTON and HERBERT FERBER. Examples of Kohn's work are *Acrotere* (1960, MOMA) and *Azimuth* (1960, Norton Simon Mus.). *Lit.*: Thomas H. Garver, *Wood: The Sculpture of Gabriel Kohn*, exhib. cat., Newport Harbor Art Mus., Newport Beach, Calif., 1971.

KRASNER, LEE (b. 1908), a painter associated with ABSTRACT EXPRESSIONISM.

From New York City, Krasner grew up and matured in the changing New York art world of the 1930s, 1940s, and 1950s. Between 1926 and 1932, she studied in New York, first at Cooper Union and then at NAD. From 1937 to 1940, she was a pupil of HANS HOFMANN. She participated in WPA-FAP from 1934 to 1943. During the 1930s, her work was realistic, but by 1940 she was exhibiting with AMERICAN ABSTRACT ARTISTS. By about 1945, she had assimilated Surrealist techniques of improvisation and adapted them to her basically Cubist style, which placed her in the center of the avant-garde. Between 1946 and 1950, she created the Hieroglyph series, composed of heavily painted, mostly black-and-white works broken up into small rectangular units containing forms evocative of hieroglyphs. After 1950 Krasner began to float large, primarily vertical forms on fields of color, sometimes broad, at other times dense and cluttered. The gestural impact in most remained visible, even in those evocative of Henri Matisse's cutouts. Toward the late 1950s, her use of line, thick and sinuous, grew independent of precise shape definition and often floated free of background elements or suggested large biomorphic shapes. In 1959 she designed a large mosaic for 2 Broadway, New York City, in a style reminiscent of Matisse's cutouts. Through the 1960s, dynamic thickened lines coiled and curved through her work as if responding to intensive bursts of energy. Linear elements in the 1970s, perhaps showing the influence of MINIMAL ART, grew crisp and once again seemed able to contain forms that appeared or wanted to spill over and off their surfaces. *Lit.*: Marcia Tucker, *Lee Krasner: Large Paintings*, exhib. cat., WMAA, 1973.

KRIMMEL, JOHN LEWIS (1787–1821), the first significant genre painter in America. From Ebingen, Württemberg, he studied with Johann Baptist Seele in Germany, before settling in Philadelphia in 1810. Although he began to make genre paintings almost at once, he earned a living as a portraitist. His favor-

ite subjects were activities and events observed on the spot in Philadelphia. These included celebrations (*Fourth of July in Centre Square, Philadelphia*, 1810–12, PAFA), elections, and fires. He developed a formula for his outdoor scenes, probably derived from the work of the emigrant English painter William Birch (see BIRCH, THOMAS) which included crowds of small well-dressed figures, an identifiable event, and a recognizable locale. Though in composition they are stilted, Krimmel's indoor scenes caught the flavor of American interiors and activities. Such works as *Interior of an American Inn* (1813, Toledo Mus.) were based on paintings by William Hogarth and Sir David Wilkie, which Krimmel knew through print sources. Figures, usually arranged in bas-relief fashion, gesture vigorously and engage in various activities, diffusing their energies across the picture's surface. Krimmel travelled in Germany, Austria, and Switzerland from 1817 to 1819. His sketchbooks are in the Winterthur Mus., Winterthur, Del. *Lit.*: Joseph Jackson, "Krimmel, 'The American Hogarth,'" *International Studio*, June, 1929.

KROLL, LEON (b. 1884), a painter, important teacher, and significant representative of the continuing realistic tradition in 20th-century art. From New York City, he studied there at NAD and at ASL (under JOHN HENRY TWACHTMAN), and, in Paris, at the Académie Julian— all before 1911. In 1936–37 he completed a mural for the U.S. Department of Justice under the U.S. Department of the Treasury's Section of Painting and Sculpture and, in 1938–41, another, for the Worcester, Mass., Memorial Hall. A realistic artist, whose work occasionally includes allegorical overtones, Kroll has retained an abiding interest in the human form, draped and undraped (*Morning on the Cape*, 1935, Carnegie Inst.). Over the many decades of his career, his expressive romanticism became modified by a more objective point of view. His landscapes invariably reflected the richness and fecundity of the earth. For him, "abstract art . . . is merely the be-

ginning of a picture. . . . I like motifs that are warm with human understanding; the natural gesture; the touch of people, landscapes where people live and work and play. The living, breathing light over forms. I sense the beyondness and the wonder of simple living people and the things they do. I try to express this feeling without being too obvious about it."

KÜHN, JUSTUS ENGLEHARDT (active c. 1708 –1717), the earliest professional artist to work in the Middle Atlantic colonies. Kühn was a German who settled in Annapolis toward the end of 1708. Nothing is known of his previous training, but he was patronized by the powerful Roman Catholic families of the Maryland colony, the Carrolls, Diggeses, and Darnalls. His adult bust portraits are undistinguished, but his full-length children's portraits, such as those of Eleanor Darnall and Henry Darnall, III (c. 1710, Maryland Hist. Soc.) introduce an element of romantic fantasy into early American portraiture. The children are presented in fantastic architectural and garden settings, dressed in sparkling, elaborate costumes and accompanied by attributes of their social position, the toys and pets of childhood, and, in the case of Henry Darnall, the bow and arrows of the young hunter and a black slave acknowledging his young master. Very few of Kühn's paintings are known today, and all are portraits, although the inventory of his estate suggests that he may have painted other subjects as well. *Lit.*: J. Hall Pleasants, *Justus Englehardt Kühn*, 1937.

KUHN, WALT (1877–1949), a painter and major organizer of the ARMORY SHOW. Born William Kuhn, in New York City, he began to use the name Walt about 1900, while illustrating magazines in San Francisco. He subsequently studied at the Académie Colarossi in Paris and in Munich's Acad. of Fine Arts, between 1901 and 1903. From 1905 to 1914, he worked in New York City as an illustrator and cartoonist for many publications, including *Life* and *Puck*. As executive

secretary of the Assoc. of American Painters and Sculptors, he travelled abroad collecting material for the Armory Show. Between 1912 and 1920, he acted as art advisor to John Quinn, who assembled one of the early major modern collections in this country. He also advised Averell and Marie Harriman and Lillie P. Bliss, whose collection became the nucleus of MOMA. Like WILLIAM GLACKENS, who worked with Dr. Albert C. Barnes, Kuhn was instrumental in domesticating modern art in America in his role as advisor to private persons whose collections subsequently became available to the public.

Although Kuhn destroyed much of his work, the basic outlines of his stylistic evolution can be traced. Through the first decade of the century, he worked in a hard-edged Fauve manner in which unmodelled forms were often outlined in black and arranged in horizontal bands. Family and vacation themes were favorites during this period. In the 1920s, Kuhn turned to large, single-figure compositions, infusing aspects of pathos into postures and glances. At the same time, he painted the Imaginary History of the West, twenty oils completed between 1918 and 1923, which have elements of German Expressionism and Fauvism. Thematically, the series evokes the West of cowboys and Indians. In 1929 Kuhn painted *The White Clown*, a sad-eyed, seated figure that announces virtually all of his subsequent figural compositions (*The Blue Clown* of 1931 is in WMAA). Kuhn used bright, even garish, colors in these works. Forms were outlined in black and details were hidden behind large planes of color. This type of Cézannesque realism also informed his still lifes, a theme he also undertook during the remainder of his career. *Lit.*: Philip Rhys Adams, *Walt Kuhn*, exhib. cat., Cincinnati Mus., 1960.

KUNIYOSHI, YASUO (1893–1953), a painter. From Okayama, Japan, he came to America in 1906. He studied at the Los Angeles School of Art and Design from 1907 to 1910, and then in New York City at NAD with ROBERT HENRI in 1910, at the Independent School of Art from 1914 to 1916, and at ASL from 1916 to 1920 with KENNETH HAYES MILLER. He also worked as a photographer of art. He travelled in Italy and France in 1925 and in France again in 1928. During the latter trip, he studied lithography. After a brief voyage to Japan in 1931, he worked for the Graphics Division of WPA-FAP during the mid-1930s. His art was a successful blend of East Asian and West European styles. The Eastern element was most evident between 1921 and 1927, when he painted scenes of fantasy in a purposefully primitive manner, as in *Fisherman* (1924, MOMA). His favored palette at this time, browns, ochers, dark reds, grays, and black, was applied to imaginative landscapes often containing bigheaded, large-eyed, and emphatically contoured figures. Cows and children were among his favorite themes (*Child*, 1923, WMAA). After 1927, Kuniyoshi turned away from fantasy and concentrated instead on manipulating paint. In this, he was influenced by Jules Pascin and André Derain. His subjects included still lifes, landscapes, and, especially, women, who sit or recline and seem to be bored. Probably in response to world events, Kuniyoshi's art of the 1940s grew more complicated. Behind still lifes and studies of women, desolate landscapes appeared containing rocks and rubble, indicative of destruction. Some works, such as *Headless Horse Who Wants to Jump* (1945, Cranbrook Acad. of Art, Bloomfield, Mich.), draw on a private iconography. These works tend to be lighter in color, and the application of pigment is drier. After 1947 Kuniyoshi explored new techniques and themes. His color grew bright, almost raucous with shining purples, reds, and golds. Surfaces were scuffed and glinting, appropriate in style to the carnival themes peopled by masked figures, whose disguised forms provoke uneasy thoughts, (*Amazing Juggler*, 1952, Des Moines Art Center). *Lit.*: Lloyd Goodrich, *Yasuo Kuniyoshi*, exhib. cat., WMAA, 1948.

# L

**LACHAISE, GASTON** (1882–1935), a sculptor, best known for his images of women. Born in Paris, he received his initial training from his father, a woodcarver and cabinetmaker. In 1895 he entered the Ecole Bernard Palissy, in Paris, to study sculpture. He continued his training, in 1898, at the Académie Nationale des Beaux-Arts and in 1904 worked for René Lalique. Between 1900 and 1903, he met Isabel Dutaud Nagle, who became his chief model and for him the embodiment of feminine form and beauty. He followed her to America in 1906 and settled in Boston, Mass. They were married in 1917. Lachaise worked for the academic sculptor Henry Hudson Kitson in Boston before moving to New York City in 1912, where he assisted PAUL MANSHIP for a few years. Among Lachaise's major public commissions were reliefs for the American Telephone and Telegraph Building (1921) and Rockefeller Center's International Building (1934), both in New York City, and for A Century of Progress Exposition, Chicago, 1932. Primarily a sculptor of the female body, he also made occasional male nudes as well as portrait busts. His major themes included standing women (perhaps his major achievement), reclining women, acrobatic and floating figures, male and female lovers, and body fragments, some greatly distorted. His first nudes were created in Boston and, despite his conservative training, were surprisingly unacademic. They are sketchlike and reveal the marks of the sculptor's hand. In 1917, with *La Force Eternelle* (Smith Coll.), Lachaise began to stylize drapery, allowing it to cling to the body and reveal its rounded volumes. *Woman* (1918, Lachaise Foundation, New York, N.Y.) was probably his first cult figure, with pendulous breasts and rounded stomach. These figures culminated in *Standing Woman (Elevation)* (1912–27, AK), a stylized, monumental female nude. His first reclining woman may date from as early as 1903, and the last are the versions of the *The Mountain* made between 1921 and 1934 (examples at Arizona State Univ., Worcester Mus., MMA). These are powerful female images in which Lachaise accented the curvilinear volumes of thighs, stomachs, and torsos. His first fragmented figures date from the mid-1920s. In some, the genitalia are distended and of enormous size, especially in those of the early 1930s and after. Yet many of these pieces, because of their smooth surfaces, volumetric simplification, and isolated parts, can be understood as much for their formal qualities as for their obvious sexual content. Lachaise's last works revealed a growing interest in more expressive manipulations of reflected lights and shadows. Throughout his career, he looked over his shoulder at preclassical, classical, and Indian art, the last being more clearly reflected in his small, nonmonumental pieces than in his larger works. The Lachaise Foundation, in New York City, controls the number of castings made from his plaster models. *Lit.*: Gerald Nordland, *Gaston Lachaise*, 1974.

**LA FARGE, JOHN** (1835–1910), a painter and author, who enjoyed the highest reputation in his time. John La Farge was born in New York City to a French emigré family. His earliest training in art came from his grandfather, who was a painter of miniatures.

After studying law for a time, La Farge went to Paris in 1856 and studied painting with Thomas Couture. He also stopped in London, where he saw the work of the Pre-Raphaelites. Returning to America, he studied with WILLIAM MORRIS HUNT in Newport, R.I., where his professional career began. Although he attempted a wide range of subjects, La Farge was, at this early stage, most

given to landscapes in the manner of the Barbizon School (see BARBIZON, AMERICAN), in which, however, he undertook an exacting investigation of the properties of light and color. But his most impressive pictures are delicate, loosely painted flower studies, such as *Flowers on a Window Ledge* (1862, Corcoran Gall.), in which he achieved a freedom from the intellectual constraint that often marred his other works. He was also capable of works in the eerie, Gothic mode of his colleagues WILLIAM RIMMER and ELIHU VEDDER. *The Wolf Charmer*, a watercolor of 1866–67, is a good example.

In the 1870s, La Farge turned, as did many American artists, to an interest in other media: watercolor, woodcut book illustration, mural painting, and stained glass. In 1876 he received a commission to decorate H. H. Richardson's Trinity Church in Boston, Mass. His designs for murals (churches of the Incarnation and the Ascension; 1885, 1888; both New York City) and stained glass placed him in the forefront of the American Arts and Crafts movement. La Farge joined with such architects as Richardson and McKim, Mead and White and the sculptor AUGUSTUS SAINT-GAUDENS in a revival of medieval and Renaissance techniques and ideals in an attempt to make public monuments again works of art.

La Farge was also one of the first Americans to admire Japanese art and, with the writer Henry Adams, made a trip to Japan in 1886. In 1890, accompanied by Adams, La Farge travelled to Tahiti, searching, like Paul Gauguin and Robert Louis Stevenson, for exotic escape from the banal realities of life in the industrialized West. Such paintings as *Maua, Our Boatman* (1891, Addison Gall.) show La Farge's skill at landscape, still life, and portraiture heightened by the exotic forms and colors of the tropics. Yet La Farge saw Tahiti in terms of European art, invoking J. B. Camille Corot and even Rembrandt in his writings. Never did he abandon himself to the primitivism of Gauguin's Tahitian pictures.

La Farge's books, including *Consider-ations on Painting* (1895) and *An Artist's Letters from Japan* (1897) show a sensitivity and aestheticism similar to JAMES A. M. WHISTLER's. La Farge travelled in the most cosmopolitan circles, and a certain eclecticism of mind may have kept him from developing the originality that his talent warranted. *Lit.*: Royal Cortissoz, *John La Farge*, 1911.

**LAMBDIN, GEORGE COCHRAN** (1830–1896), now known primarily for his still-life paintings of roses, was recognized in his own time for his genre paintings as well. From Pittsburgh, he was the son of the portrait painter James Reed Lambdin, from whom he received his earliest instruction. As a young man, he lived briefly in New York City, then studied in Munich and Paris in 1855 and in Rome in 1870. Frankly sentimental in his approach to genre painting, Lambdin received his greatest acclaim for *The Dead Wife* (1860). In this composition, the body of a young woman lies on a bed, beside which her bereaved husband kneels, clasping her hand. This painting made so great an impression that it was selected for exhibition at the Paris Universal Exposition of 1867. Lambdin also painted portraits, especially of young Philadelphia women, in which roses are often displayed (*Girl Reading*, 1872, St. Johnsbury Athenaeum, St. Johnsbury, Vt.). Lambdin made a careful study of the flower, explaining rather elaborately that every tint and tone in a rose may be matched to the tint and tone in a young girl's complexion. But it is his study of the roses themselves that have the highest artistic merit. Lambdin's flower pictures are of two kinds: bouquet paintings, in which light-colored flowers are arranged in vases and displayed simply, as in *Still Life: Vase of Flowers* (1873, MFAB), and paintings of his own rose garden, showing the flowers growing in situ. *Lit.*: Anne H. Wharton, "Some Philadelphia Studios," *The Decorator and Furnisher*, Dec., 1885.

**LANE, FITZ HUGH** (1804–1865), a lithographer and painter, whose seascapes,

particularly, have brought him recent recognition as one of the quintessential painters in the Luminist mode (see LU-MINISM). Born Nathaniel Rogers Lane in Gloucester, Mass., Lane was obliged to use crutches as the result of a crippling childhood disease. It is not known why he chose to change his name to Fitz Hugh. He did not receive any formal artistic training until he went to Boston, Mass., in the early 1830s to work in the lithography firm of William S. and John Pendleton. As an apprentice draftsman, along with BENJAMIN CHAMPNEY and DA-VID CLAYPOOLE JOHNSTON, Lane drew commercial topographic views of Boston. Although he was considered to have a good grasp of perspective and naval architecture, his approach to such matters was actually more intuitive than scientific. While working for Pendleton, he made the acquaintance of the English marine painter ROBERT SALMON, who had settled in Boston and who clearly influenced the younger artist. In 1835 Lane decided to embark upon some lithography projects of his own. The first, finished the following year and sold by subscription, was a panoramic view of Gloucester, which accurately depicted local landmarks and included many narrative elements, in the tradition of Dutch 17th-century painting. This print met with sufficient success for Lane to follow it with slightly different views in 1846 and 1855. Lane produced a number of lithographs on his own and with another artist, John W. A. Scott, until the 1850s, when he allowed production to lag. (Lane sometimes based his prints on sketches of events or places inaccessible to him drawn by other artists; the fairly limited geographical range of all of his work seems to have been partially due to his physical handicap.)

From the 1840s, the artist's attention turned increasingly to oil painting. Occasionally, he produced oils and lithographs of the same subjects, which were chiefly landscape and harbor views, and occasionally he found time to paint the ship portraits (*Ship "Starlight" in the Fog*, c.1860, Butler Inst.) so popular in the 19th century. *View of Gloucester from Dolliver's Neck* (1844) exhibits, for the first time in Lane's work, the specific tendency later identified as part of a Luminist sensibility: a strong interest in light and atmosphere as almost independent expressive elements within a composition. From the late 1840s, Lane produced and exhibited more spacious and poetic works, gradually abandoning the insistent narrative content and topographical detail of earlier lithographs and paintings. Contemplation of the serene beauty of nature rather than minute description of it became the central purpose of his work. His subject matter during these years included sailing ships and steamships, harbor and wharf scenes, landscapes, and a few portraits. The majority of the works were of Gloucester and its environs, where the artist returned to live in 1847, after firmly establishing himself as a painter in Boston. The descriptive titles of many pictures identify local landmarks, for example, Stage Rocks, the Old Fort, Fresh Water Cove, and Ten Pound Island (*Ships in Ice off Ten Pound Island, Gloucester*, 1850s, MFAB).

In his mature works, those of the 1850s and 1860s, Lane subordinated individual natural and man-made forms within controlled compositions that emphasized the tranquil nature of his subjects. Lane's working methods, which put some distance between the original drawings and the final conception, seem to have furthered the quality of timelessness in his work. It has become known in recent years that Lane did not hesitate to employ various artistic aids, including photographs and perspective devices, in the preparation of his finished pictures.

As the years went on, Lane exhibited frequently in Gloucester, Boston, Albany, N.Y., and New York City. A number of his works became well known through purchase and distribution by the AMERI-CAN ART-UNION. Lane became more and more absorbed by the rendering of transitional effects of light and atmosphere, frequently painting sunrise and sunset scenes, while utilizing familiar nautical

subject matter. Warm colors, contrasting with the somber palette of his early years, appeared in his paintings of the 1850s, many of which were done from drawings executed while cruising along the Maine coast. Such other artists as ALVAN FISHER, JOHN F. KENSETT, FREDERIC EDWIN CHURCH, and BENJAMIN CHAMPNEY, were frequenting the same areas in Maine, and occasionally their paths crossed Lane's. Church may have been influenced by Lane at this time. It is also apparent that Lane was aware of his contemporaries: By 1860 his work shows an awareness of that of MARTIN JOHNSON HEADE, another major Luminist.

Lane remained an extremely popular artist until his death. Although contemporary appraisals emphasize the supposed absolute fidelity to nature of Lane's work, in truth he continually moved away from realism to present his own conception of nature's inner order and harmony. The majority of his paintings, drawings, and lithographs are in two Massachusetts collections: the Cape Ann Hist. Assoc., in Gloucester, and the M. and M. Karolik Coll. at MFAB. *Lit.*: John Wilmerding, *Fitz Hugh Lane*, 1971.

**LANGE, DOROTHEA** (1895–1965), a documentary photographer. Born in Hoboken, N.J., Lange was educated in New York City. In 1915, having decided to become a photographer, she visited Arnold Genthe, an early journalistic photographer, who encouraged her and even gave her a camera. During 1917–18 she took Clarence H. White's photography course at Columbia Univ. (see PHOTO-SECESSION). She then decided to work her way around the world as a photographer but got only as far as San Francisco, where, in 1919, she opened her first portrait studio. By the early 1930s, she had developed a direct style and was confirmed in her interest in social issues and the poor as subjects. In 1935 she worked for the State of California, documenting migratory farm laborers, and then moved to the Farm Security Administration, for which she made her most important body of work (see FARM SECURITY ADMINISTRATION PHOTOGRAPHS). Her work was first exhibited at MOMA in 1940–41, and she received a major showing in MOMA's The Bitter Years: 1935–1941, in 1962. Her first one-woman show was at the Siembab Gall., Boston, Mass. in 1961. She continued to do documentary photography until her death.

Lange was a photographer at once capable of presenting visual facts with uncompromising directness, communicating an intense human situation, and revealing her deep compassion. Unlike other FSA photographers, she concentrated completely on people rather than on their environments as well. Her famous "Migrant Mother, Nipomo, California" (1936), a closeup of a woman with her three dirty children pressing closely to her in speechless fear, beautifully expresses the delicate balance between the mother's strength and her anxiety. Lange's work played a large part in making the country aware of the plight of the rural poor. The FSA photographs are in the Library of Congress, Washington, D.C., and good collections of Lange's work are also in MOMA and GEH. *Lit.*: *Dorothea Lange*, exhib. cat., MOMA, 1966.

**LASANSKY, MAURICIO** (b. 1914), a printmaker. From Buenos Aires, Argentina, he studied there at the Superior School of Fine Arts in 1933 and then taught in his own country before coming to New York City in 1943. There, he worked in Stanley William Hayter's Atelier 17, before joining the staff of the Univ. of Iowa in 1945. Lasansky's primary image has been the human being. Early works, in the hamfisted Mexican style, include social themes as well as odd surrealistic juxtapositions. When in New York City, he explored intaglio procedures, which he came to prefer above all others. In the late 1940s, brutality and enigmatic confrontations became recurring images, as in the series For an Eye an Eye (1946–48). These themes culminated in The Nazi Drawings (1961–66). Lasansky's

many portraits and self-portraits, large in size and scale, suggest haunted (rather than hallucinated) states of mind, reflecting his Spanish heritage as much as the contemporary human condition. A superb technician, and an artist concerned with enlarging the possibilities of printmaking techniques, he has combined as many as fifty-four separate plates in a single work, most notably in *Quetzalcoatl* (1972). Its bright colors are very different from the somber hues he favored in the 1940s. Together with figures like GABOR PETERDI and RUDY POZZATTI, Lasansky has helped create a brilliant period in the history of American printmaking. *Lit.: Lasansky: Printmaker*, 1975.

LASSAW, IBRAM (b. 1913), a sculptor. From Alexandria, Egypt, he came to America in 1921. From 1926 to 1931, he studied art at the Brooklyn Mus. and at the Clay Club (Sculpture Center) and the Beaux-Arts Inst. of Design in New York City. He was employed in various governmental projects from 1933 to 1942. In 1936 he became a founding member of the AMERICAN ABSTRACT ARTISTS. An abstractionist virtually from the start of his career, he created biomorphic works in the 1930s under the influence of Hans Arp, Pablo Picasso, and the Surrealists (see BIOMORPHISM). Most of his early works were done in plaster. In 1937 he began to use sheet metal assembled and brazed with solder, and he turned to welding techniques the following year. In 1940, responding to the influence of Piet Mondrian, he straightened out his curving forms and organized them in more rigidly architectonic fashion. By 1944 he had started to combine biomorphic forms with carefully controlled rectangular formats, integrating his earlier style with his current one. Lassaw's mature style appeared in 1950, when, influenced by the drip paintings of JACKSON POLLOCK, he began to create three-dimensional mazes that retained both the flexibility of his earlier curving forms and the regularity of his Mondrian-influenced work. Lassaw referred to the spaces trapped within the mazes as polymorphous voids in which there was "the idea of a process going on, a continuum of forces in space." An example is *Galactic Cluster #1* (1958, Newark Mus.). Lassaw has also designed architectural sculpture for several synagogues, including Temple Beth El, Springfield, Mass., in 1953. *Lit.*: E. C. Goossen, et al., *Three American Sculptors: Ferber, Hare, Lassaw*, 1959.

LAUGHLIN, CLARENCE JOHN (b.1905), a photographer. Born in Lake Charles, La., he lived on a plantation as a child but moved in 1910 to New Orleans, where he has lived most of his life. About 1925 he discovered Baudelaire and the French Symbolists and began to write poetry. He learned to photograph in 1934, admiring ALFRED STIEGLITZ, MAN RAY, and Eugène Atget. From 1936 to 1969, he made his living primarily as an architectural photographer; his book *Ghosts Along the Mississippi* (1948) is an evocative study of decaying plantation architecture.

Laughlin has described himself as an "extreme romantic," using a diversity of photographic techniques to create his richly imaginative pictures. Appropriately, his work was shown in November, 1940, at the Julien Levy Gall. in New York City with that of Atget, a French photographer discovered and admired by the Surrealists. Both concentrated on sensitive studies of architecture that evoked a bygone era and on weird juxtapositions of objects and reflections. Laughlin, however, goes much further than Atget, fabricating strange and ghostly images through staging, combination printing, and double exposure. In this, he almost single-handedly carried on the tradition of "manipulated" photography from the 1940s to the 1960s, when younger photographers broke free of EDWARD WESTON's rigid purist aesthetic (see UELSMANN, JERRY N.). A complete archive of Laughlin's work is at the Univ. of Louisville. He has also published *New Orleans and Its Living Past* (1941). *Lit.: Clarence John Laughlin*, 1973.

LAURENT, ROBERT (1890–1970), one of
the earliest sculptors influenced by mod-
ernism. He left his home in Concarneau,
France, for America when he was twelve
years old, accompanied by Hamilton
Easter Field, who helped develop his tal-
ent. Sent to Paris in 1905 as an appren-
tice art dealer, he became acquainted
with modernist art, especially Cubism,
and with primitive art. In Rome in 1908,
he was apprenticed to a framemaker,
from whom he learned the fine art of
carving wood. Beginning with his solo
exhibition in New York City in 1915, his
method of direct carving and stylization
of natural forms propelled him to the
forefront of important sculptors in the
country. He first worked directly in
stone in 1921. In 1925 he began to teach
at ASL and influenced a younger gen-
eration of sculptors to carve their materi-
als directly. By 1920, Laurent and WIL-
LIAM ZORACH, another pioneer, had
developed effective forms of sculptural
expression through abstraction, simplifi-
cation, and respect for the nature of
their materials. Laurent subsequently
worked in wood, bronze, alabaster, and
marble. An example of his mature work
is the alabaster *Kneeling Figure* (c.
1935, WMAA). *Lit.*: *Robert Laurent
Memorial Exhibition*, exhib. cat., Univ.
of New Hampshire, 1972.

LAWRENCE, JACOB (b. 1917), among the
first of the black artists to be accepted in
the white art world. His paintings are
thought to represent most consistently
the black experience in America. From
Atlantic City, N.J., he studied art in New
York City from 1932 to 1937, first with
Charles Alston and then with Henry
Bannarn at the Coll. Art Assoc. and at
WPA-FAP classes in Harlem. From 1937
to 1939, he studied with Anton Refre-
gier, among others, at the American Art-
ists School in New York City. He joined
WPA-FAP in 1938 or 1939 and re-
mained with it until 1941. Influenced by
the social realism of the Mexican mural-
ists and perhaps of such American artists
as BEN SHAHN, as well, Lawrence ex-
plored from the start of his career
themes that dealt with life as a black. He

expressed these in series devoted to such
individuals as Toussaint L'Ouverture
(1937), Frederick Douglass (1938–39),
and Harriet Tubman (1939–40); to such
places as Harlem (1942); and to such
themes as War (1947). Some works, like
*Tombstones* (1942, WMAA), describe
ghetto experiences. Tempera is Law-
rence's preferred medium. His style, ob-
viously sophisticated, nevertheless em-
ploys primitive elements of sim-
plification, stylization, bright coloration,
and minimal tonal changes. Despite an-
gular distortions, his forms are easily
readable and remain within a story-
telling context. Some of the series are ac-
companied by written texts. During the
1960s, Lawrence's work reflected the
civil-rights struggle, but since that time,
he has tended to cultivate a more per-
sonal, decorative mode of painting, al-
beit within a social context consistent
with his earlier efforts. *Lit.*: Milton
Brown, *Jacob Lawrence*, 1974.

LAWRIE, LEE (1877–1963), a sculptor.
Born in Rixdorf, Germany, he was
brought to America as an infant. In 1891
Lawrie began to work for the sculptor
Richard Henry Park in Chicago and
made some pieces for the WORLD'S CO-
LUMBIAN EXPOSITION in 1893. The follow-
ing year, he went to New York City,
where he gained experience under AU-
GUSTUS SAINT-GAUDENS. Lawrie created
many public sculptures, beginning in
1900 with marble reliefs on the theme of
ancient and modern civilization for the
Pawtucket, R.I., Library and including
works for the Nebraska State Capitol,
at Lincoln, in the 1920s; Rockefeller
Center, New York City, about 1931; a
Century of Progress Exposition, Chica-
go, in 1932; and the New York World's
Fair, in 1939. Lawrie's aim was both to
decorate a building and to characterize
the purpose for which it was built. Since
his work was often to be viewed at a dis-
tance, it was created in a broad style of
simplified and cubic volumes, unclut-
tered outlines, and minimal detail. Many
pieces are in the Art Deco manner, espe-
cially those done in the 1920s and 1930s.

LAWSON, ERNEST (1873–1939), a painter. From Halifax, Nova Scotia, he first studied art in Kansas City, Mo., in 1888, before enrolling at ASL in 1891. He also studied with JOHN HENRY TWACHTMAN and JULIAN ALDEN WEIR, absorbing their approaches to Impressionism, before departing in 1893, for Paris, where he attended the Académie Julian. Returning to North America in 1895, Lawson lived briefly in Toronto, Canada, and in Columbus, Ga., before settling in New York City in 1898. In 1908 he exhibited with The EIGHT, despite the fact that he was an Impressionist, a style he never abandoned. He did, however, use that style to depict urban scenes like theirs, as well as typically Impressionist rural ones. Initially, he alternated between the assertiveness of Alfred Sisley and the lyricism of Twachtman. After meeting JOHN SLOAN and other realists, his use of color grew crisper and his forms clearer. Paint was usually applied thickly and was likened to "a palette of crushed jewels." Unlike his realist friends, Lawson usually painted vistas rather than intimate views. Visits to Spain in 1916 and Nova Scotia in 1924 and teaching engagements in Missouri and Colorado in 1926 and 1927, respectively, did not appreciably alter his style. Characteristic examples of his work include *Winter on the River* (1907, WMAA) and *Spring Night, Harlem River* (1913, Phillips Coll.). *Lit.*: Henry and Sidney Berry-Hill, *Ernest Lawson*, 1968.

LEBRUN, RICO (1900–1964), a painter. Born in Naples, Italy, he studied at the Naples Acad. of Fine Arts and assisted fresco painters between 1918 and 1922. After designing stained glass for a factory in that city from 1922 to 1924, LeBrun was sent to a branch in Springfield, Ill., and settled in New York City the following year, becoming a successful commercial artist. On return trips to Italy, he studied fresco painting. A mural he began in 1936 for the Pennsylvania Station Post Office Annex, New York City, was never completed. In 1938 he moved to California. Nine years later, he began the Crucifixion series, which culminated, in 1950, in *Crucifixion Triptych* (Syracuse Univ.). His Buchenwald series (1954–58) was one of the few major sustained artistic attempts to respond to the mass murders of World War II. A brilliant draftsman and deft tonalist, who could essay styles as diverse as the Dutch Baroque masters' and the Cubists', LeBrun explored themes ranging from the maudlin to the tragic. He concentrated on man's inhumanity to man and filled his works with "creatures of darkness," which nevertheless expressed an incandescent hope for a resurrected humanity. His large forms and theatrically abrupt lighting schemes as well as his high sense of spiritual drama gave his art a Baroque gloss rarely seen in modern times. In 1962 he turned seriously to sculpture. *Lit.*: Henry J. Seldis, *Rico LeBrun*, exhib. cat., LACMA, 1967.

LECLEAR, THOMAS (1818–1882), a portraitist and genre painter, born in Oswego, N.Y. LeClear first worked as an untrained portraitist in northern New York State. In 1839 he moved to New York City, where he opened a studio and continued to practice as a portrait painter. There, he received some training from HENRY INMAN, the leading portraitist in New York at that time. LeClear remained a student of the older artist until Inman's death in 1846. That year he sold a genre painting, *The Reprimand*, to the AMERICAN ART-UNION. After this success, he continued to paint genre subjects as well as portraits. In 1847 he moved to Buffalo, where he lived until 1863. Upon his election as a portrait painter to NAD in 1863, he seems to have abandoned genre subjects. He left Buffalo and moved nearer to New York City, presumably to be closer to his portrait clientele. A fine example of LeClear's uncluttered and direct genre work is *Buffalo Newsboy* (1853, AK). The loosely applied paint on a reddish primer indicates LeClear's debt to Inman. In portraiture, LeClear is at his most characteristic in his portrait of William Page (1876, Corcoran Gall.).

**LEE, DORIS** (b. 1905), a painter. From Aledo, Ill., she studied in 1928 at the Kansas City, Mo., Art Inst. with ERNEST LAWSON and at CSFA. She painted a mural for the U.S. Post Office Building, Washington, D.C. under the Department of the Treasury, Section of Fine Arts. In France in 1927 and 1929, she studied with André Lhote. Her work has hovered between realism and a studied primitivism and sometimes has been based on popular prints. Her *Thanksgiving Day*, which won a prize at AIC in 1936, charmingly presents frantic family banquet preparations in an old-fashioned kitchen (such works as these were part of AMERICAN SCENE PAINTING of the 1930s). Lee's subjects are taken from everyday life and often interpreted in a folksy way. In her later work, she isolated objects to a much greater extent, indicating an acceptance of PRECISIONISM.

**LEE, RUSSELL** (b. 1903). See FARM SECURITY ADMINISTRATION PHOTOGRAPHS.

**LE MOYNE DE MORGUES, JACQUES** (d. 1588), a watercolorist and draftsman, born in Dieppe, France. In 1564 he accompanied the French explorer René de Laudonnière on an expedition to Florida. There, he made studies in watercolor to document the events of the trip and the appearance of the area. He is remembered mainly for his studies illustrating the daily lives of the Indians of Florida, which are known today chiefly through engravings after his work by the Flemish artist Théodore de Bry, who published them in London in 1591. In these versions of Le Moyne's work, the figures often conform to the European artistic tradition. A single example of Le Moyne's original Indian paintings survives and thus is the only evidence of the character of the originals. This composition, which represents the meeting of Laudonnière and Chief Athore, is rich in color. It depicts a friendly encounter between the French explorers and the native Americans. To fulfill his responsibilty as a visual documentator, Le Moyne detailed the variety and richness of local vegetation and the Indians' exotic costumes. This rare watercolor is in NYPL. A portfolio of botanical illustrations by Le Moyne is in the Victoria and Albert Mus. in London, and a book containing both Le Moyne's illustrations and his account of the expedition was published in 1875.

**LESLIE, ALFRED** (b. 1927), a painter, born in New York City, Leslie studied under TONY SMITH, WILLIAM BAZIOTES, HALE WOODRUFF, and John McPherson at New York Univ. in 1956–57. He was already regarded as one of the leading painters of the second wave of ABSTRACT EXPRESSIONISM, naturally assuming extreme freedom in handling paint. By the late 1950s, he had become one of the most aggressive of those who espoused "hard-core" Action Painting, his very large canvases marked by explosive paint application. Yet Leslie was careful to work out systems to structure the sweeping gestures. Using a restricted number of colors, he composed shapes in large rectangular areas, the horizontal bands checked by an occasional double vertical stripe. He would sometimes use multiple canvases, joined to impose a physical grid on the work. In 1962 the artist's structural tendencies led him to introduce big geometrical elements that dominated the shrinking areas of gesture. After a short transitional phase of abutting abstract forms with realistic collage elements, Leslie turned to realistic painting in 1964. He never abandoned his massive scale. Even when not full-length, self-portraits from 1964 to 1966 (example in WMAA) present the artist as a looming, frontal, centered image eight feet or more high. He continued to employ such dramatic devices as low lighting and a hard, precise manner that made all materials, including skin, look like metal or vinyl. In the mid-1970s, invoking Caravaggio, Leslie proclaimed his intention of returning to art the function of moral edification. In this regard, he has purposely borrowed compositions from the Baroque master to portray contemporary events and has

also embarked on reviving such venerable biblical themes as The Raising of Lazarus.

LESLIE, CHARLES ROBERT (1794–1859), a successful painter in England, remembered chiefly as the friend and biographer of John Constable. Born in London of American parents and taken home as a child, to Philadelphia, he returned to London in 1811 to study art at the Royal Acad. school, where he was a pupil of BENJAMIN WEST and WASHINGTON ALLSTON. Like his teachers, Leslie aspired initially to history painting. He was soon converted to the academic realism then gaining ascendancy in England—a style, practiced most notably by Sir David Wilkie, a popular contemporary artist in England, that often combined a latter-day version of 17th-century Dutch genre painting with historical or literary anecdote. Although Leslie admired the narrative skill of William Hogarth and imitated him, he tidied up the brushwork and avoided the bluntness of that master's art. His career flourished as he painted scenes from Tristram Shandy, Le Malade Imaginaire, The Merchant of Venice, and Don Quixote. He departed occasionally from literary themes for such official portraits as Queen Victoria in Coronation Robes. Perhaps his most famous work is The Two Princes in the Tower, in which the innocents are shown kneeling at prayer in a gloomy interior with heavy furniture and a single glowing lamp. Of the grisly murder that is about to take place there is not a hint. The scene is imbued with the sentimental condescension with which the Victorians often viewed children. The style reflects the looser, later manner of Wilkie. Leslie was also a noted collector and author. His Memoirs of the Life of John Constable, published in 1843 and several times revised, remains a valuable, first-hand account, but, as in his art, Leslie sweetened his subject, never even mentioning Constable's bitter sarcasm. Lit.: Charles Leslie, Autobiographical Recollections, 1860.

LEUTZE, EMANUEL GOTTLIEB (1816–1868), the most prominent historical painter in America in the mid-19th century. Leutze was born in Schwäbisch-Gmünd, Germany, but grew up in Philadelphia, where he studied with John Rubens Smith. He began his professional career as a portraitist working in Fredericksburg, Va., but in 1840 he travelled to Düsseldorf, Germany. One of the first Americans to study there, Leutze was to become famous and respected on both sides of the Atlantic. Düsseldorf at the time was an important center of training for young artists from many nations throughout the Western world. The emphasis in the schools there was upon historical painting, although landscape and genre were also beginning to gain attention. Leutze was allied in Düsseldorf with the German historical painter Karl Lessing, and as Lessing achieved prominence through a series of vast canvases glorifying the early religious reformer and martyr Jan Hus, so Leutze gained fame through a group of paintings illustrating the story of Columbus. Leutze and Lessing were among the most liberal-minded artists in Düsseldorf, where factionalism was rife between the traditionalist Roman Catholic aristocrats supporting the Prussian rulers in Berlin and the more nationalistic Rhinelanders, who were middle-class and Protestant. Leutze conceived of Columbus as a visionary who defied tradition and authority in the discovery of the New World. Leutze was subsequently to become a leader in Düsseldorf's revolutionary attempts to throw off the yoke of Prussian bondage. While active in Düsseldorf, Leutze remained very much the American, acting as host and friend to the scores of American art students who came to Germany in the 1850s and sending many of his most notable historical pictures back to America. His subject matter was drawn primarily from English and American history, rather than German. His most famous work was Washington Crossing the Delaware (1851, MMA), the first version of which was destroyed in Bremen in World War

II. This, the best-known of all American historical paintings, was not only a glorification of America's revolutionary history but a rallying call to the defeated German revolutionaries, who identified their own cause in 1848 with America's in 1776. Leutze returned with the picture to the United States in the hopes of persuading Congress to acquire it for the Capitol; though he failed, the work was enormously popular and the engraving after it circulated widely.

Leutze returned to Düsseldorf, but the revolutionary spirit there had been irrevocably dampened and he took the opportunity to return again to the United States in 1859 to paint the first of what was hoped would be a vast mural program in the Capitol. *Westward the Course of Empire Takes Its Way* (1861–62), created in the new stereochromy technique, combining pigments, minerals, and waterglass, developed by Wilhelm Kaulbach in Berlin, may be seen as the apogee of the American dream. A party of hardy, indomitable pioneers surmounts all obstacles in the settling and conquest of the continent. The sentiments that such works express may seem obvious and melodramatic, but they suited the optimistic spirit of mid-19th century America. Leutze's art was the inspirational key to the development of nationalistic history painting in America in the 1840s and 1850s. Indeed, the government's encouragement of Leutze's mural project during the Civil War may be interpreted in part as an attempt to instill confidence in the populace in the face of crisis. *Lit.:* Barbara Groseclose, *Emanuel Leutze, 1816–1868*, exhib. cat., NCFA, 1975.

LEVINE, JACK (b. 1915), a painter. From Boston, Mass., he enrolled in art classes at the MFAB school while very young. One of his instructors, Harold Zimmerman, introduced Levine, and Levine's fellow student HYMAN BLOOM, to a close study of the art of the past. Dr. Denman Ross of Harvard Univ. noticed both promising students and gave them free instruction. Levine spent much time studying the Old Masters at MFAB and the Fogg Mus. He joined the WPA-FAP in 1935. Levine's upbringing in a lower-class neighborhood and his experience of the Depression influenced his choice of subject matter, for he deals in social protest and social comment. He has depicted underworld figures, police, and politicians engaged in actions calculated to reveal their basic insincerity or triviality: gangsters attending a funeral for a fellow criminal and high-ranking military officials smugly reaping the rewards of their underlings' victories at postwar banquets. Examples include *The Feast of Pure Reason* (1937, MOMA) and *The Turnkey* (1956, Hirshhorn Mus.). This social commentary is made with a virtuoso technique that strongly indicates Levine's interest in the old masters, especially the Venetian School, and his debt to Chaim Soutine and the Expressionists. Using thin layers of oil and glazes, Levine's surfaces sparkle with slashing strokes of bright color. His canvases have an overall light-dappled look, the figures sometimes almost dissolving into the atmosphere in extreme cases. This sumptuous style curiously complements Levine's images that lampoon the rich, for their skin, which seems to dissolve and corrode in the light, reflects and expresses the glittering world that surrounds them. Levine has in recent years seen fit to comment upon the American middle class as well, gently exposing their pretentious behavior at Miami resorts and the like. In addition, he has continuously produced pictures on various biblical themes, which are serious and often contemplative. *Lit.:* Frank Getlein, *Jack Levine*, 1966.

LEWIS, EDMONIA (1845–?), a neoclassical sculptor in marble. The child of a black father and a Chippewa Indian mother, she was born near Albany, N.Y. After studying at Oberlin Coll., Lewis went to Boston, Mass., in 1865, where she worked with the sculptor EDWARD AUGUSTUS BRACKETT. In Boston she made a portrait bust of Colonel Robert Shaw, the leader of a black Civil War regi-

ment. The sale of reproductions of this popular bust enabled Lewis to go to Rome about 1867, and there she became an important member of the WHITE MARMOREAN FLOCK, Henry James's mordant epithet for the expatriate American women sculptors in Rome, a group that included HARRIET HOSMER. Lewis is best known for the works she did that relate to her own ancestry—studies of slaves and various Indian subjects, including scenes from *Hiawatha* (1868). She also produced numerous busts of such prominent personalities as Charles Sumner, Henry Wadsworth Longfellow, and Abraham Lincoln. Lewis's sculpture has been praised for its smooth surfaces and accurate details. Imbued with neoclassical dignity, her work also stresses the humanity of her subjects (she depicted President Lincoln in contemporary dress and emphasized the emotions of newly freed slaves by pose and facial expression). Exhibited at the CENTENNIAL EXPOSITION, Philadelphia, Lewis's last major work, *The Death of Cleopatra* (c. 1876), attracted critical attention, since it shows the queen a moment after the asp's bite and clearly demonstrates the physical effects of approaching death. Although she was active in Rome as late as 1887, the place and year of Lewis's death are not known. *Lit.*: William H. Gerdts, Jr., *The White Marmorean Flock*, exhib. cat., Vassar Coll., 1972.

LEWIS, MARTIN (1881–1962), a printmaker and painter. From Castlemain, Australia, he studied at the Julian Ashton Art School in Sydney before emigrating to San Francisco in 1900 and settling in New York City soon after. He traveled to England in 1910. Best known as a printmaker, Lewis made his first etching in 1915. His preferred media became etching and drypoint. He excelled at city themes and may be considered a latter-day follower of The EIGHT. Many of his urban scenes (he made about 145 prints in editions of up to one hundred) are night views, which show his ability to throw forms into silhouette and also probably satisfied his desire to use odd

compositional effects despite a resolute realism. His paintings are realistic, too, but in the years just after the ARMORY SHOW, he experimented with bright and bold slashes of color. *Lit.*: *Martin Lewis*, exhib. cat., Kennedy Galleries, New York, N.Y., 1973.

LEWITT, SOL (b. 1928), a sculptor, draftsman, author, and major exponent of CONCEPTUAL ART. From Hartford, Conn., he received the B.F.A. degree from Syracuse Univ. in 1949 and worked for architect I.M. Pei in 1955–56. His first reliefs date from 1962 (*Double Wall Piece*, 1962, WA); his first three-dimensional pieces from 1963 (*Standing Open Structure, Black*, 1964, WA); his first modular pieces of open cubical form from 1964; his first modular pieces in serial form (*Cube Structure Based on Nine Modules*, 1976–77, Smith Coll.) (see MINIMAL ART) and his first wall drawings from 1967. Lewitt's art seems to be the result of a search for universal and impersonal formulas for creating objects, or structures (the term he prefers). His points of departure lie in the abstract thought processes of philosophy, linguistics, and mathematics rather than in religion, emotion, or the human figure. Quite often his sculptures are painted white in order to emphasize the idea lying behind the piece rather than the piece itself, with all of its real or implied sensuous qualities. In key articles written for *Artforum* magazine (June, 1967) and *Arts Magazine* (Apr., 1970), he described his approach to art, stating that the concept is the most important part of a work. For him, planning has been more significant than execution. Lewitt's best-known structures include the open-form modules. These are made from wood or metal and are composed of open squares in various combinations and permutations. Most important to these works is not a traditional center of focus or a hierarchy of forms but the logical working-out of the basic premise, usually stated in the title. Meaning is derived by observing how the piece reflects the implications of the title. Lewitt's

wall drawings are perhaps his most controversial works, since they are painted over after the completion of the exhibition for which they were made and thus exude an aura of mortality. The wall drawings have been done by assistants, who follow the directional system established by the artist. Lewitt's first book of drawings was published in 1966. Since then, more than thirty have appeared. MEL BOCHNER summed up Lewitt's work very well when he wrote, "New art is attempting to make nonvisual (mathematics) visible (concrete)." *Lit.*: *Sol Lewitt*, exhib. cat., MOMA, 1978.

LICHTENSTEIN, ROY (b. 1923), an artist central to POP ART. From New York City, he studied briefly at ASL in 1939 before attending Ohio State Univ. between 1940 and 1943 and then again from 1946 to 1949. There, he was influenced by Hoyt Sherman. The latter's rigorous theories concerning figure-ground relationships underlie Lichtenstein's transformations of cliché subjects as well as his preference for making Pop versions of paintings by such artists as Pablo Picasso and Piet Mondrian, whose works lend themselves to precise figure-ground analyses. In this regard, Lichtenstein's images are basically Cubist even though they have the hard-edged, brightly painted look associated with 1960s MINIMAL ART and despite the artist's occasional choice of a JASPER JOHNS-like holistic image, as in *Compositions I* (1964), a notebook cover. Through the late 1950s, Lichtenstein employed the techniques of ABSTRACT EXPRESSIONISM, but his subject matter often included references to common American themes and objects, ranging from cowboys and Indians to paper money. By 1961, while teaching at Rutgers Univ., he was influenced by colleague Allan Kaprow's HAPPENINGS and began to use comic-book and cartoon figures. An important example is *Flatten ... sandfleas* (1962, MOMA).

Almost at once, his mature style crystalized: a preference for red, yellow, and blue, and occasionally green; colors of uniform intensity; intermediate shades made not by the addition of white but by use of the Benday system, in which dots are placed in a white field (fewer dots read as a lighter color); the use of heavy black outlines; and frontality of figures. Although his choice of subject matter is personal, his sensibility encourages impersonality—or, as Lichtenstein said in 1964, "I think the meaning of my work is that it's industrial." Later, he added, "I want my painting to look as if it has been programmed." This is another way of saying, as CHARLES SHEELER did earlier in the century, that he wants to hide the record of his hand. Lichtenstein's choice of subject matter, based on images of mass communication, reflects a tolerance of the environment without recording his opinion of it, especially since his subjects always look well scrubbed and nonlocalized. They have been groomed for middle-class consumption. His most famous subjects, the comic-strip and comic-frame paintings, were done between 1961 and 1965. Since 1962 Lichtenstein has used the works of other artists as source material, indicating the interchangeability of high- and mass-culture. Between 1964 and 1966, he painted sunset and landscape views in which linear elements were minimalized. In 1966 he began to emulate 1930s Art Deco/*art moderne* streamlining effects. In the early 1970s, he re-created the look of mirrors or, one might say, made Pop versions of Op Art (see MINIMAL ART). Primarily a painter, he has worked in ceramics and enamelled steel since 1965 and, since 1967, in metals and glass; however, the pieces he designs are fabricated by technicians. *Lit.*: Diane Waldman, *Roy Lichtenstein*, 1971.

LIE, JONAS (1880–1940), a landscape and seascape painter, and president of NAD from 1934 to 1939. Lie grew up in Oslo, Norway, and studied drawing under Christian Skredsvig as a child. In 1892, he moved to Paris to live with his uncle, whose house guests included such famous Norwegians as Edvard Grieg and

Henrik Ibsen. A year later, Lie came to New York City, and in 1897 he graduated from the Ethical Culture School, where he had concentrated on art. For nine years, beginning in 1898, Lie designed fabric patterns for a textile business. In the evenings, he attended Cooper Union and NAD. Later, he studied at ASL. Public recognition came after WILLIAM MERRITT CHASE bought one of his paintings in 1903. Lie returned to Norway in 1906 and then went to Paris, where he was struck by the work of Claude Monet. In 1910 he visited Panama. Lie's paintings are colorfully impressionistic, exhibiting a broad and facile handling of pigment and a harmonious blending of light and air. His picturesque scenes of New York City, New England coastlines, and the Panama Canal in the last days of its construction won him numerous awards. An example is *The Conquerors, Panama Canal* (1913, MMA).

**LIMNER:** The term *limner* comes from the verb *to limn*, derived from an old French word meaning to illuminate books with ornamental letters and borders. In American art, the term denotes the anonymous, colonial artisan-painters who created our earliest portraits, landscapes, and still lifes. Their naive style is characterized by the rendering of objects as two-dimensional pattern. It is also an appellation given to early artists who are known to us only through the people whose portraits they painted. Among the best-known are the Mason Limner, the Pollard Limner, and the Stuyvesant Limner. These artists were active in both New England and New York between 1660 and 1730. One of the finest and most affecting examples of their work is a portrait of the child Alice Mason (1670, Adams National Historic Site, Quincy, Mass.). The absence of modelling in the face and figure, the undifferentiated light and undeveloped spatial sense are more than compensated for by the charming manner in which costume and ornament are carefully detailed.

Several authorities link this flat, decorative style of portraiture to earlier 17th-century English Tudor painting. *Lit.:* Thomas Flexner, *First Flowers of Our Wilderness*, 1947.

**LINDNER, RICHARD** (1901-1978), a painter. Born in Hamburg, Germany, he was raised in Nuremberg. He studied at Nuremberg's School of Fine and Applied Arts in 1922 and at the Acad. of Fine Arts in Munich in 1924. After fleeing the Nazi regime in 1933, Lindner settled in Paris. In 1941, he came to the United States and illustrated such magazines as *Vogue* until 1950, when he began painting full time. From 1951 to 1965, he taught at Pratt Inst., New York City. Elements of his personal history as well as literary associations are important in his work. Although Lindner's themes have remained the same throughout his life, their flavor has become increasingly American (*The Meeting*, 1953, MOMA; *Rock—Rock*, 1966, Dallas Mus.). Continental circus women became New York streetwalkers and authority figures traded European military uniforms for those of New York's police force. Lindner uses flat areas of rich, sometimes garish colors separated by hard edges, with passages of ambiguous perspective. Modelling is generally limited to clothing, faces, and body parts whose sexual qualities are emphasized by constricting them in corsets and straps or by isolating them with abstract shapes of color. Lindner's cast of characters—mainly women, precocious children, and men who are "strangers," voyeurs, or fantasizing bourgeois—are often posed while engaged in such daily activities as receiving a visitor. But the intensity of hard-edged color areas, exaggerated body parts with fierce sexual implications, and ambiguous space all transform normal situations into personal, obsessive inner visions. It is this personal, inner quality that distinguishes Lindner's work from POP ART, despite his increasing use of images from the American mass media. *Lit.:* Dore Ashton, *Richard Lindner*, n.d.

**LIPPOLD, RICHARD** (b. 1915), a sculptor. From Milwaukee, he studied at AIC and the Univ. of Chicago from 1933 to 1937. He then worked as an industrial designer until 1941, when he began to make sculpture from different thicknesses of wire. These, which have been called "semi-automatic scribblings in cubic space," evoked organic imagery. Derived ultimately from Constructivism, Lippold's works force attention more on the spaces trapped within the wire than on the patterns made by it. In 1947 he substituted rigid shapes for the earlier curvilinear ones (*Primordial Figure*, 1947–48, WMAA). These formed intricate sequences of triangles, hexagons, circles, and rectangles. In the following year—1948—he further limited personal caprice by experimenting with modular units. He also made variations on geometrical forms, as in *Variation #7: Full Moon* (1949, MOMA), based on the double cone. Lippold has made large pieces, which, when set against dark backgrounds, evoke a romantic aura, or, when suspended from ceilings, as in Avery Fisher Hall, New York City (c. 1960), become elegant architectural embellishments. *Lit.*: Lawrence Campbell, "Lippold Makes A Construction," *Art News*, Oct., 1956.

**LIPTON, SEYMOUR** (b. 1903), a self-taught sculptor, who, like DAVID SMITH, is a major figure of his generation. From New York City, Lipton became a dentist in 1927. The following year, he began to concentrate his energies on sculpture, modelling in clay and carving in stone and wood. He exhibited for the first time in 1933–34 and taught at the New School for Social Research from 1940 to 1965. In 1944–46 he started using sheet-lead construction techniques; in 1947, lead-soldered sheet steel; in 1949, brass rods brazed onto sheet steel; and, in 1955, brass rods brazed onto sheet Monel metal. His public commissions include works for synagogues (Temple Beth El, Gary, Ind., 1955), cultural centers (Milwaukee Performing Arts Center, 1967),

and corporations (IBM, Yorktown Heights, N.Y., 1961–62).

Until about 1941, Lipton's work was semirealistic and, on occasion, socially oriented. His pieces of this period, such as *Straphanger* (1933) were usually carved. Mood and ambience were generalized, for Lipton included only parts of bodies, and he simplified anatomy considerably. He did not catalogue social ills but emphasized feeling, often by exaggerated gestures and postures. These works, he said, "reflected an atmosphere of social discontent" rather than an explicit desire for social change. Each of these early pieces was uniformly textured in either continuous small facets or smooth surfaces.

About 1941 Lipton became increasingly concerned with myth—initially, American myths that "would retain the flavor of the folk," as well as broaden "into natural and universal human significance." In works exploring these themes (*Folk Song*, 1944), abstract elements began to dominate representational forms. By 1945 general biological images had replaced obvious anatomical ones, and themes of social discontent were replaced by compelling private ones, notably of savage bestiality. Menacing bony and thornlike forms with hooks and screws, seemingly capable of cannibalistic acts, dominated Lipton's art for the next few years. Semisurrealistic, these pieces suggested struggle and disorder, mystery rather than myth. Interested in "evoking images and moods of the primordial insides of men," Lipton found there "the sense of the dark inside, the evil of things, the hidden areas of struggle." Powerful and brutal images, they reflect the influence of the Surrealists in New York City (See ABSTRACT EXPRESSIONISM) as well as Lipton's own reactions to World War II. At the same time, they invoke in an ahistorical, timeless way images of passion Lipton had sculpted more realistically in his socially conscious work of the 1930s. The new pieces were created in series: Moloch, Moby Dick, and a group devoted to

bird forms (THEODORE ROSZAK and David Smith also chose bird forms in the late 1940s to suggest predation as well as escape). Despite suggestions of violence and a concern with hidden destructive forces, Lipton's works are tightly organized, their broken contours contained within implied perimeters. Jaw shapes and tooth forms tend to point inward rather than reach out; they look menacing, but not dangerous.

In 1948 Lipton explored images related to the cage and containment, the latter being the more important for his later work. In *Sentinel* (1948), a small independent shape is enclosed within larger elements. Soon after, the contained shape became part of a continuous movement linking inner and outer. Although some forms remained spiky, they began to suggest budlike or generative shapes rather than destructive ones, living organisms in which outer shells enfolded inner developing parts. Such pieces as *Sanctuary* (1953, MOMA) both formally and psychologically convey enormous tension because of the hard-pressed truce achieved between compressive and expansive elements. As Lipton explained, there is a "concept of centrifugal movements, of ever-opening vistas, ever-widening experience, but always controlled through centripetal movements of containment." Most of these works are organized with horizontal emphases. The vertical ones, however, are more suggestive of man's inner turmoil and his relationship to the universe. Emphasizing their archetypal qualities, Lipton has given these works such names as *Knight* (1957), *Pioneer* (1957), *Sorcerer* (1958), *Prophet* (1959), and *Laureate* (1968). (Examples are in MMA and WMAA.) These propulsive images stride affirmatively, their destinies lying somewhere in the future. Pervading all of these works is a profound concern for the biological element, linking abstract forms with the evolving shapes of nature. In this regard, Lipton's work invokes the organic metaphors central to the paintings of JOHN MARIN and ARTHUR G. DOVE as well as to Abstract Expressionism. *Lit.*: Albert E. Elsen, *Seymour Lipton*, n.d.

LITTLE GALLERIES OF THE PHOTO-SECESSION, the gallery run by ALFRED STIEGLITZ from 1905 to 1917 at 291-93 Fifth Avenue, New York City (later called simply "291"), considered to be at the very heart of early American modernism and consequently described by MARSDEN HARTLEY as "the largest small room of its kind in the world." It was founded after Stieglitz and EDWARD STEICHEN discussed the need to show photographic prints to the American public on a regular basis. The name was probably derived most immediately from the photographic exhibition Stieglitz organized at the National Arts Club in 1902 called An Exhibition of Photographs Arranged by the Photo-Secession. The initial exhibition at the Little Galleries included one hundred prints by PHOTO-SECESSION members. Soon after, Stieglitz showed prints by British and Continental photographers as well as by Americans. The first nonphotographic exhibition, of drawings by Pamela Coleman-Smith, took place in 1907. Subsequently, Stieglitz devoted much more energy to the display of modernist painting and sculpture, introducing to a bemused and often hostile public works by Auguste Rodin and Henri Matisse in 1908, by Paul Cézanne in 1910 and 1911, and by Pablo Picasso in 1911. After 1909 Stieglitz also showed there works by radical Americans, including ALFRED MAURER, JOHN MARIN, and Marsden Hartley. He also exhibited children's art in 1912 and 1913 as well as African sculpture in 1914. The gallery closed in 1917. Although the Little Galleries was not the only gallery supporting modernist artists, it was the most determined and outspoken, reflecting in great measure Stieglitz's personality, and publicized by his magazine *Camera Work*. *Lit.*: Dorothy Norman, *Alfred Stieglitz: An American Seer*, 1960.

LOCKWOOD, WARD (1894–1963), a painter. Born in Atchison, Kans., Lockwood first studied art in his native state, before

entering PAFA in 1914. He studied there until 1917. Influenced primarily by the work of Paul Cézanne during a visit to France in 1921–22, he turned back to his American heritage after his return. In 1926 he moved to Taos, N. Mex., the community with which he is most closely associated and whose environs he painted repeatedly in oils and watercolors. (See TAOS COLONY). Lockwood responded to the influences of temporary and regular visitors, including ANDREW DASBURG and JOHN MARIN and, in the 1930s, BOARDMAN ROBINSON, whom he met in Colorado. For the federal art programs of the 1930s, Lockwood painted murals for the Taos County Courthouse (1933), the Wichita Post Office (1935), and the U.S. Post Office Building, Washington, D.C. (1937), among others. After moving to San Francisco in 1940, he experimented with abstract forms and with totemic themes associated with such artists as WILLIAM BAZIOTES. In the early 1960s, seeking new combinations of images and of materials, he created junk assemblages. Never innovative, Lockwood's work nevertheless reflects closely the progression of art styles during the four decades between 1923 and 1963. *Lit.:* Charles C. Eldredge, *Ward Lockwood*, 1974.

**LOUIS, MORRIS** (1912–1962), a post-Abstract Expressionist painter, a subtle colorist, whose works after 1954 challenged traditional assumptions about drawing and three-dimensionality in painting. Born Morris Bernstein in Baltimore, he studied there at the Maryland Inst. of Fine and Applied Arts from 1929 to 1933. Except for the years between 1936 and 1940, when he lived in New York City, he resided in Baltimore until moving to Washington, D.C., in 1952. Louis was influenced by Action Painters like JACKSON POLLOCK and ROBERT MOTHERWELL until 1954. Only after that time did he become an important figure in the history of American art—when he extended certain stylistic implications in the works of Pollock and HELEN FRANKENTHALER. Louis's significance is usually explained in the following way: Between 1947 and 1950, Pollock created drip paintings, some of which were very dense. As a result, lines did not define contours of objects, which might have suggested depth. Instead, these works created an optical rather than a tactile space, one to look at but not into. In 1951 and 1952, Pollock painted a series of black-and-white works in which the black color soaked into the white canvas and appeared to be part of it rather than color lying on the surface. Tactile qualities were also minimized in these paintings. Frankenthaler, following Pollock's lead, stained unprimed canvas so that different colors became part of its fabric, creating allusive, intangible spaces. Louis saw one of these pictures, *Mountains and Sea* (1952), in 1953. Impressed, he is reported to have said: "She was the bridge between Pollock and what was possible." Frankenthaler evidently liberated Louis's gift for color, allowing him to find means to deal with color and space beyond what Pollock had achieved. For the remainder of his life, Louis explored ways of creating shapes without suggesting depth, a difficult task, since any shape in a painting seems to lie on the canvas and implies that a background exists around it. Or, to say it differently: Can one make shapes and also deny their tactility? In four major series, Louis dealt with these problems: Veils, 1954, 1957–59 (he destroyed most of his work of 1955, 1956, and early 1957); Florals, 1959–60; Unfurleds, 1960; and Stripes, 1961–62. Leaving Abstract Expressionist brushwork behind, Louis spilled, puddled, and poured thinned acrylic paint across unprimed canvases. He may also have folded or pleated some canvases and used a stick to guide the flow of pigments. Although he left blank areas around waves of pigment, the colored areas do not invariably appear as positive shapes on negative grounds. Rather, the color is seen as part of the canvas fabric, forcing awareness of surfaces. Edges of individual color stains do not always appear drawn, but seem to be part of a continuum with oth-

er stains. As a result, figuration appears without benefit of drawn edges or sharply defined superimpositions of shapes. Furthermore, without individual brushmarks charting the progress of the work's creation, it is virtually impossible to follow the chronological deployment of shapes across a surface. Often, shapes seem to have appeared all at the same time. Such a paralysis of time induces a similar paralysis of depth perception. Nevertheless, not all of Louis's works appear depthless. The Veils, with their continuous shimmers of close-valued colors, appear to be flatter than the Unfurleds. The Unfurleds, with their diagonal rivulets of color flanking empty centers, seem flatter than the Stripes. The Florals, with their obvious overlays of colored bursts, evince the greatest amount of depth and are, therefore, the least purely optical, even though their colors are ravishing. Except for the very last works, the Stripes, the relationships between colored areas and the shapes of each canvas were not as critical as was true of the works of such related figures as KENNETH NOLAND and FRANK STELLA. Compared to such other great colorists of the century as MILTON AVERY and MARK ROTHKO, Louis evoked little emotion or psychological presence in his work. The various color combinations appear to be for one's eyes alone. With GENE DAVIS and Kenneth Noland, he was one of the first-generation Washington D.C. Color Painters. Examples of Louis's work include *Tet*, a Veil (1958, WMAA), *Beth*, a Floral (1960, Philadelphia Mus.), *Alpha Gamma*, an Unfurled (1960, Detroit Inst.), and *Orange Column*, a Stripe (1960, Fogg Mus.). *Lit.*: Michael Fried, *Morris Louis*, 1970.

LOZOWICK, LOUIS (1892–1973), a painter and illustrator. Born in Ludvinovka, Ukraine, Russia, he studied at the Kiev Art School in 1904–5, before emigrating to America in 1906. He continued his studies at NAD with LEON KROLL from 1912 to 1915. Between 1919 and 1924, he travelled in Europe, joining the radical Novembergruppe in Berlin in 1920.

In 1922 he visited Russia after meeting such Russian artists as El Lissitzky. Lozowick later wrote *Modern Russian Art* (1925) and co-authored *Voices of October* (1930). He made illustrations for the *New Masses* after his return from Europe. In 1934 he worked for the graphics division of the Public Works of Art Project and in 1937 was engaged in a mural project (see FEDERAL ART PROJECTS). As early as 1922, Lozowick, who was attracted to the aesthetic of Constructivism, began to make drawings of machine ornaments. He was also interested in urban themes, which he interpreted with modernistic streamlined forms overlayed with Futurist ray lines. In his work, uninhabited cityscapes and buildings rise dramatically, often in odd and exaggerated perspectival schemes. In this regard, his work is linked with PRECISIONISM. *Lit.*: Barbara W. Kaufman, *Louis Lozowick*, exhib. cat., 1973.

LUKS, GEORGE B. (1866–1933), a painter known for his gusto as much as for his art. From Williamsport, Pa., he studied at PAFA as well as in Düsseldorf, Germany, Paris, and London, from 1885 to 1895. He worked in 1896 as an artist-reporter for the *Evening Bulletin* in Philadelphia, where he met the nucleus of The EIGHT, before moving to New York City in 1896. An exhibitor in the Macbeth Gall. show of The Eight in 1908, Luks initially favored themes drawn from the urban ghetto and slum life. (*Allen Street*, 1905, Chattanooga Art Assoc.). These he painted in a brushy, tonal style. Of all the realists associated with ROBERT HENRI, Luks painted poor people with greatest understanding but was, nevertheless, less penetrating than contemporary novelists who worked with urban themes. He delighted in catching the rapid-fire activities of busy market days, as in *Hester Street* (1905, Brooklyn Mus.) and quieter moments in the movement of individuals through the streets, as in *The Old Duchess* (1905, MMA). After 1915 Luks chose rural themes more frequently although in the 1920s he did paint scenes showing the

harsh life of Pennsylvania coal miners. For Luks, the 20th century remained a personal adventure untouched by abstract artistic or political theories. A large collection of his work is in MWPI. *Lit.: George Luks*, exhib. cat., MWPI, 1973.

LUMINISM, not a school or movement but a sensibility shared by a number of 19th-century painters that is expressed in clearly ordered compositions—often marine and harbor views—meticulously rendered in an ultra-clear light. By the middle of the century, landscape had been treated as a symbol of an untamed land, as an uplifting expression of God's presence in nature, and as a tranquil retreat from contemporary Victorian life. For painters of the 1850s, there was no break in this tradition; however, several of them chose to affirm the importance of light as landscape's binding ingredient. Recent art historians have called these painters Luminists. The artists whose work is most often assigned to this category are FITZ HUGH LANE, MARTIN JOHNSON HEADE, and JOHN F. KENSETT, but a number of prominent and minor artists of the period occasionally produced a Luminist or near-Luminist picture, and Luminist qualities also infuse, to a greater or lesser extent, works done earlier in the century by WILLIAM SIDNEY

MOUNT, GEORGE CALEB BINGHAM, and certain naive painters.

In Lane's *Off Mount Desert Island* (1856, Brooklyn Mus.), a low horizon line, the shimmering atmospheric effects of light on water and sky, and the carefully detailed shoreline create a hushed, tranquil mood, characteristic of the best Luminist work. These same qualities, and also an interest in the effects of the changing time of day on the aspect of nature, are found in a series of haystacks painted by Heade in the salt marshes near Newport, R.I. (*Sunset Over the Marshes*, c. 1863, MFAB). Kensett, a leader of the HUDSON RIVER SCHOOL, was noted for the topographical accuracy of his landscapes. The detailed realism of such emphatically horizontal marine and river paintings as *Shrewsbury River* (1859, NYHS), is both emphasized and transformed by the clear Luminist light and atmosphere of utter quiet.

Since John I. H. Baur first wrote on Luminism in 1954, several contemporary art historians have linked its insistent observation of nature and palpable light to the writings of the transcendentalist Ralph Waldo Emerson. *Lit.*: John I. H. Baur, "American Luminism," *Perspectives—U.S.A.*, Autumn, 1954. Barbara Novak, *American Painting of the Nineteenth Century*, 1969.

# M

MACDONALD-WRIGHT, STANTON (1890–1973), a painter and co-founder, with MORGAN RUSSELL, of SYNCHROMISM in 1913. A major figure in the purely abstract stream of early American modernism (as JOHN MARIN is a major figure in the nature-based school of modernist abstraction), Macdonald-Wright was most influential between 1914 and 1918. Born in Charlottesville, Va., he studied at the Art Students League of Los Angeles before sailing in 1907 for France, where he briefly attended the Académie Colarossi and Académie Julian as well as EBA. He had begun studying color theory by 1910 and met Russell soon after. By 1912 both had assimilated Impressionism and the styles of Paul Cézanne and Henri Matisse. Together, they developed Synchromism, a style in which color generated form. Major exhibitions of their work were held in Munich and Paris in 1913 and in New York City in 1914. Between 1914 and 1916, Macdonald-Wright helped his brother Willard Huntington Wright compose major early texts of the modernist movement, including *Modern Art: Its Tendencies and Meaning* (1914). Stanton returned to the United States in 1916 and in 1919 settled in California, where he experimented with color processes for motion pictures. He produced the first full-length stop-motion film ever made in full color. Abandoning Synchromism in 1920, he explored aspects of Oriental art and philosophy but returned to color painting, in modified form, in the mid-1950s. Throughout his career, he alternated between including figural representation in his works and painting pure abstractions. *Lit.: The Art of Stanton MacDonald-Wright*, exhib. cat., NCFA, 1967.

MCENTEE, JERVIS (1828–1891), a landscape painter associated with the HUDSON RIVER SCHOOL. From Rondout, N.Y.,

he studied with FREDERIC EDWIN CHURCH in New York City in 1850–51, became a professional artist in 1855, and toured Europe in 1859. McEntee, who described J. B. Camille Corot as an "incomplete and slovenly" painter, worked in a tight, precise style, recording detail with great accuracy. He spent much time in the Catskill Mountains and preferred to paint simple rather than grandiose views. Opposed to the idea of art for art's sake, he strove to arouse emotion in the viewer as well as to instruct him. Never a sentimental painter, he nevertheless attempted to convey the sentiment of a scene in order to stimulate an edifying thought. His works often have melancholy overtones associated with autumn and winter. When they were exhibited, the content was underlined by the inclusion of a few lines of poetry: To *Melancholy Day* (1861, NAD), for example, a passage of William Cullen Bryant's "The Death of the Flowers" was appended. Not surprisingly, McEntee remained one of the more conservative landscape painters as the century progressed and resisted the new influences emanating from Munich and Barbizon.

MCILWORTH, THOMAS (active c. 1757–1770), a New York portraitist. Almost nothing is known of the artist's life, training, or career. He is mentioned as working in New York City for about five years, beginning in 1757. Later, he appears to have been active in the Hudson River Valley and the Albany-Schenectady area, painting the wealthy landowners. He may have died, about 1770, in Montreal, Canada. In New York City, he was one of the very few painters active after the departure of JOHN WOLLASTON. His portrait style is similar to that of the young JOHN SINGLETON COPLEY, though somewhat more simplified and

stylized, and for these qualities he may have been indebted to Wollaston. His portraits are characterized by sharp studio lighting, an emphasis upon solid three-dimensional form, and a general sobriety of expression. McIlworth emphasized simple geometry—the features of a face with sharp, planar edges set into a long rectangle. He was active too early to have been influenced by Copley, and the source of their mutual involvement with a classical realism quite distinct from the prevailing style of the Rococo remains a mystery. Several of his portraits are in NYHS.

McIVER, LOREN (b. 1909), a painter of fantasy. Born and raised in New York City, where she still lives and works, McIver has painted since early childhood, although her only formal art-school training was about a year of children's classes at ASL in 1919. Between 1929 and about 1935, McIver developed the major themes of her art, often choosing small natural objects, "transformed"—as she calls it—by rain or mist. Portraits of poets and clowns have been her only human subjects. McIver often paints maplike landscapes and cityscapes evocative of children's art. McIver's work came to public attention during the 1930s concurrent with early New York exhibitions of European Surrealists. *Shack*, done for the WPA-FAP Easel Project, was acquired by MOMA in 1934. In 1936, McIver was included in MOMA's influential Fantastic Art, Dada and Surrealism exhibition in the category reserved for such artists as ALEXANDER CALDER and GEORGIA O'KEEFFE, whose personal imagery developed independently of formal Surrealism. McIver's most important artistic kinship is with the imagist poets, especially e.e. cummings and Lloyd Frankenberg, her husband. During the 1950s and 1960s, when McIver travelled and lived in Europe, her imagery was drawn from the Provençal landscape and the streets and lights of Paris and Venice. More recently, she has been concerned with geological subjects. Museum collections of her

work include MMA, the Hirshhorn Mus., and LACMA. *Lit.*: John I. H. Baur, *Loren MacIver—Rice Pereira*, exhib. cat., WMAA, 1953.

MACMONNIES, FREDERICK WILLIAM (1863–1937), one of the most successful sculptors of his time. Born in Brooklyn, N.Y., the son of a Scottish immigrant, MacMonnies was a prodigy at carving stone. At eighteen he was doing menial tasks in the studio of AUGUSTUS SAINT-GAUDENS when the master discovered his talents and made him an assistant. After four years that included evening study at ASL and NAD, he left for Paris and enrolled in the classes of Jean-Alexandre-Joseph Falguière and Marius-Jean-Antonin Mercié. MacMonnies made his name with a *Diana*, which won an honorable mention at the Salon of 1889. Although the subject is classical, the figure had the slender proportions and soft vivid modelling of Falguière's style. Success brought numerous commissions, including *Nathan Hale* for City Hall Park, New York City, which Theodore Dreiser called "one of the few notable public ornaments of New York." Its lively texture, a feature of Falguière's neo-Rococo style, elicited disapproval from uninitiated New York critics, however. In 1893 MacMonnies's bronze *Bacchante and Infant Faun* became a *cause célèbre*. The female nude shown dancing in joyous, tipsy abandon (much in the spirit of 16th-century Mannerist bronzes by Giovanni da Bologna) was commissioned by the architect Charles F. McKim for his Boston Public Library building. The citizenry, led by Charles Eliot Norton and the Women's Christian Temperance Union, protested, and the statue was removed to MMA, where it became a great attraction. The brouhaha of this affair helped MacMonnies gain the large public commissions that chiefly occupied him after the mid-1890s. After completing the massive allegory *Triumph of Columbia* for the WORLD'S COLUMBIAN EXHIBITION in Chicago in 1893, MacMonnies produced a *Shakespeare* for the Library of Congress about 1895

and, soon after, three large groups for the Brooklyn Memorial Arch in the operatic manner of François Rude's *La Marseillaise* on the Arc de Triomphe. MacMonnies continued to work in and teach his eclectic Beaux-Arts style through the first decades of the 20th century. He returned to the United States during World War I and took up painting, at which he was competent but unoriginal. Before his death, he designed a 130-foot-high monument, *The Battle of the Marne* (Meaux, France). The bright young sculptor of the 1890s became the quintessential academic, and the modern movements of the early 20th century took place without his notice.

**MAGIC REALISM,** a term that gained currency following a MOMA exhibition in 1943 entitled American Realists and Magic Realists. Pointing out a trend then widespread, the exhibition concentrated on "pictures of *sharp focus and precise representation,* whether the subject has been observed in the outer world—*realism*—or contrived by the imagination—*magic realism.*" MOMA director Alfred Barr, Jr., described the term as "sometimes applied to the work of painters who by means of an exact realistic technique try to make plausible and convincing their improbable, dreamlike or fantastic visions." Sources of Magic Realism lay in the work of such earlier Americans as RAPHAELLE PEALE and WILLIAM MICHAEL HARNETT as well as in the contemporary German Neue Sachlichkeit (New Objectivity). Cutting across various groupings of American artists, Magic Realism attracted, among others, CHARLES SHEELER, a key figure, who by 1925 had developed the archetypal style, IVAN LE LORRAINE ALBRIGHT, LOUIS GUGLIELMI, and Jared French. *Lit.: American Realists and Magic Realists,* exhib. cat., MOMA, 1943.

**MALBONE, EDWARD GREENE** (1777–1807), a leading miniaturist of his time. From Newport, R.I., he painted landscape scenery for the theater and perhaps received instruction from Samuel King, before becoming a miniaturist in 1794. In the pictures done earlier in his career, faces are more noticeably stippled and curtains frame the subjects. Details are finely wrought yet firmly modelled. By 1797 the curtains had largely disappeared, and Malbone's colors brightened and grew more lively. Occasionally, trees and landscape features appeared, but these were secondary to the figures. During these years and until 1801, when he travelled to England with his good friend WASHINGTON ALLSTON, Malbone painted in Boston, Mass., New York City, and Philadelphia. He studied with BENJAMIN WEST when abroad and painted some larger pieces, including *The Hours* (Providence Athenaeum, Providence, R.I.). On his return to America, he worked in Charleston, S.C., as well as in the northern cities. Although he occasionally turned his hand to oils, watercolors, and pastels, he most often restricted himself to the miniaturist's medium of watercolor on ivory. Most of his works are oval in shape, the sitters turned slightly to the side. His self-portrait (c. 1798) is at the Corcoran Gall. *Lit.:* Ruel Pardee Tolman, *The Life and Work of Edward Greene Malbone,* 1958.

**MANSHIP, PAUL** (1885–1966), a sculptor. From St. Paul, Minn., he attended that city's Inst. of Art from 1892 to 1903. He enrolled in ASL in 1905 and assisted SOLON BORGLUM before transferring to PAFA for two years. From 1909 to 1912, he worked at the American Acad. in Rome. He began to make garden and architectural sculpture after returning to this country, eventually becoming one of the artists most sought after for public commissions. These included the *Prometheus* in Rockefeller Center, New York City (1934) and the Woodrow Wilson Memorial for the League of Nations complex in Geneva, Switzerland (1939). He lived in Paris from 1922 to 1926. A student of earlier styles, Manship was influenced by Greek, Roman, and, about 1916, Indian art, but he was not an abject copier. He rejected the naturalistic

and freely modelled modes stylish early in his career, preferring to emphasize a decorative line and crisp modelling rather than frank realism or dramatic intensity. In 1912 he said of ancient art: "We feel the power of design, the feeling for structure in line, the harmony in the dimensions of spaces and masses. . . . It is the decorative value of the line that is considered first. Nature is formalized to conform with the artist's idea of Beauty. . . . The entire statue can be considered as a decorative form upon which all the detail is drawn rather than modelled." These words might be chosen to caption his *Dancer and Gazelles* (1916, NCFA), an exercise in emphatic silhouetting. Through the 1920s, Manship emphasized mass to a greater extent than line, providing his figures with rounded volumes. His portrait busts also grew increasingly realistic. Throughout his career, he worked primarily in stone and bronze. *Lit.*: Edwin Murtha, *Paul Manship*, 1957.

MARCA-RELLI, CONRAD (b. 1913), a virtuoso collage-maker. Born in Boston, Mass., he spent his childhood abroad. After settling permanently in New York City in 1926, he studied at various schools, most notably Cooper Union in 1930. From 1935 to 1938, he was employed by WPA-FAP. He turned to circus themes and architectural motifs while studying abroad in 1948–49, dealing with them in a style reminiscent of Giorgio de Chirico. After his return, he developed a controlled, rather sharp-edged, abstract biomorphic manner in which discrete forms hovered in indeterminate spaces. Rectilinear elements containing urban themes appeared in his work about 1952. By chance, he turned to collage in 1953. Working only with canvas and pigment, he developed the following technique: First, he quickly sketched forms on bare canvas; then, he cut them out and pinned them to a supporting canvas, changing their positions when necessary. By this unwieldy process, he allowed accident and chance to interact with his initial conceptions.

About the same time, he added paint to some strips. Images either were abstract or suggested seated and reclining figures. Some, like *The Surge* (1958, Cleveland Mus.), seem to be filled with a multitude of people. By 1960 his forms had grown mostly nonobjective. In the years immediately following, he experimented with metal and vinyl sheets, which gave his work a vaguely industrial appearance. He applied the same formal considerations, greatly simplified, to sculptural forms during that decade. These, in turn, affected the collages, which grew simpler over the years, but no less studied. *Lit.*: William C. Agee, *Marca-Relli*, exhib. cat., WMAA, 1967.

MARDEN, BRICE (b. 1938), an abstract painter. From Bronxville, N.Y., he received the M.F.A. degree from Yale Univ. in 1963. Since that time, he has created a narrow range of images comprised of monochromatic panels. Until 1968 he painted one-panel works in which a small margin at the lower edge was kept bare of paint except for drips and spatters. When he began, in 1968, to make two- and three-panel works (initially, with vertical joining; horizontal joining appeared in 1970), the entire surface was covered with pigment. All panels are usually equal in size and juxtaposed without spaces between. Colors are subdued, but variations occur since Marden's preferred medium, a mixture of beeswax and oil, dries unevenly. The multipanelled works are composed of different hues of equal value, but because of strong hue differences (i.e., orange and blue), the lighter colors are read as having a higher value. Series, such as Red, Yellow, Blue (1974, example in AK) follow the tenets of serial imagery (see MINIMAL ART). *Lit.*: Linda Shearer, *Brice Marden*, exhib. cat., Guggenheim Mus., 1975.

MARE, JOHN (c. 1739–c. 1795), a portrait painter active in New York City. Mare was, with THOMAS MCILWORTH, one of the few portrait painters practicing in New York after the departure of JOHN

WOLLASTON. He remained in that city until 1772, when he went to Albany, N.Y., but was back two years later. It is difficult to trace Mare's activities during the 1780s and 1790s. Although records indicate that a John Mare owned property in New York during those decades, there is no evidence of artistic output. Then, too, we have records of the appearance of a John Mare in Philadelphia in the late 1780s. Mare was the brother-in-law of WILLIAM WILLIAMS and may also have known Williams's pupil BENJA-MIN WEST when the latter was in New York in 1759, but little influence from either artist is evident in his painting. He seems instead to have shared with McIlworth and the far greater JOHN SINGLE-TON COPLEY a tendency toward solid realism, sharpness of line, and strong characterization. His work, less stylized than that of McIlworth and the earlier Wollaston, is more gentle and natural. Copley may have influenced him, but Mare seems actually to have developed his own brand of realism at the same time as Copley, and long before the latter's sojourn in New York in 1770–71. Official recognition of Mare's talent is proven by his commission from the Board of the Common Council of New York for a now-lost portrait of William Pitt, which he painted from an engraving. Two portraits by Mare stand out today. One is that of John Ketaltas (1767, NYHS), in which a painted fly on the sitter's lace cuff stands as an extremely early American example of *trompe l'oeil* illusionism, further emphasizing Mare's concern with the reality of appearances. His masterpiece is the large *Jeremiah Platt* of the same year (MMA), which is characterized by a sympathetic realism almost worthy of Copley.

**MARIN, JOHN** (1870–1953), a major early modernist, best known for his watercolors but who also worked in oils and made many etchings. Born in Rutherford, N.J., he had begun sketching with some seriousness by 1888. His earliest watercolors combined elements of Impressionism (see IMPRESSIONISM, AMERI-CAN) and TONALISM. They show the influence of Tonalists such as DWIGHT TRYON and also reveal some aberrations of form Marin would develop later. In the early 1890s, he worked for four architects and by 1893 had designed six houses in Union Hill, N.J. Deciding to become an artist, he studied at PAFA from 1899 to 1901 under THOMAS AN-SHUTZ and at ASL from 1901 to 1903. Marin went abroad in 1905 and remained there until 1910 with the exception of a brief return visit in 1909. Unlike others who travelled to Europe in those years, he did not immediately become immersed in the most modern styles, preferring instead the art of JAMES A. M. WHISTLER, Pierre Bonnard, and the Nabis as well as Neoimpressionism. Nevertheless, he met EDWARD STEICHEN and, through him, ALFRED STIEGLITZ, who exhibited his work with ALFRED MAURER's in 1909 and then gave him a solo exhibition in 1910. While abroad, Marin concentrated on printmaking (at least two-thirds of his roughly 180 etched plates were done between 1905 and 1913), a fact that may help account for his neglect of Paul Cézanne and the Cubists, whose graphic works were not yet well known. Thus, preferring to paint objects that responded to the logical pull of gravity and infusing luminous atmospheric effects into his works, Marin remained a late 19th-century artist while in Europe. His subjects were most often urban ones, except for the watercolors painted during a trip to the Austrian Alps in 1910. After returning to America, Marin substituted New York City for Paris and Venice as an important subject. His earlier integration of painting and drawing, which often produced a Whistlerian haze, was now interrupted by a quickened sense of line under broad areas of color, coiled through them, or thickened into independent segments of widened brushstrokes. Although Marin began consciously to use "ray lines" around 1914, their presence was apparent from 1910 on.

In 1912 Marin's style changed. His use of color grew arbitrary and he initiated a

more intimate relationship with his subject matter instead of simply trying to capture transient moods of nature and atmospheric variations. Formal relations gained ascendency over realistic description. But, above all, Marin no longer sought a generalized, fin de siècle spiritualization of mood but an energized equivalent of the great forces he now began to feel coursing through all matter. He attempted to represent the flux of life that moved through and carried along the objects of the world. Although his interpretations were his own, he was probably influenced by Cézanne and Pablo Picasso, whose works were shown at Stieglitz's gallery in 1911, and by the works of American modernists and the Orphists. He may have known about the Futurists, whose works he was probably introduced to at second hand, through the catalogue of their great Paris exhibition of 1912. In any event, Marin's newly styled works, such as *Movement, Fifth Avenue* (1912, AIC), established him as a premier modernist. Within the next few years, he refined his style, making shorthand notations to indicate buildings or, in his landscapes, leaving large areas of paper bare so that these areas might become vital forms interacting with landscape features. The Cubist works at the ARMORY SHOW as well as the presence in New York of Francis Picabia and Albert Gleizes during World War I most probably contributed to Marin's movement in the direction of abstraction, which reached its apogee about 1917, just after the Forum Exhibition of Modern American Painters in 1916 (see INDEPENDENT EXHIBITIONS).

Marin first went to Maine in 1914, and the many seascapes he painted there until the very end of his life reflect an intimacy with the northern ocean as profound as that of WINSLOW HOMER, though Marin's convey excitement rather than antagonism in the meeting of rocks, waves, and sand. He began spending all his summers there after 1920, with the exception of visits to Taos, N. Mex., in 1929 and 1930. Consequently, his oeuvre consists of urban and rural scenes in roughly equal numbers. Many of the rural pictures he painted about 1920 have been characterized by one historian as "color orgasms," for, in painting pure color sensations, it seemed as though Marin were trying to convey the living, dynamic energies of nature. His urban scenes, sometimes worm's-eye views (*Lower Manhattan*, 1920, MOMA) and bird's-eye views (*Lower Manhattan [Composing Derived from Top of Woolworth]*, 1922, MOMA) capture, in unregimented, freeflowing brushwork, the excitement of the modern city. Like his near-contemporary GEORGE BELLOWS, Marin responded emotionally to the forces of life, but in abstract rather than anecdotal ways. Like ARTHUR G. DOVE, another near-contemporary and fellow abstractionist, Marin brought to his pictures a vital energy that evoked, but did not replicate the movements and powers he felt residing in his subjects. Perhaps to temper his exuberance, Marin began, in the early 1920s, to use the "frame within the frame" technique, by which thickened lines tied disparate images together (*Sun, Sea, Land, Maine*, 1921, Philadelphia Mus.). This type of compositional arrangement also accented both the flatness of the picture surface and the sense of depth suggested by the subject matter within the frames. Through the 1920s, Marin's work was, by turns, controlled and expressionistic. Objects might be presented frontally or be dissolved in a welter of brushmarks. Occasionally, human subjects appeared, but as parts of design schemes rather than as principal subjects. Late in the decade, Marin began to devote more time to oil painting, developing turbulent effects similar to those he achieved in watercolor. Pursuing his own vision, he was not influenced by the realistic tide of AMERICAN SCENE PAINTING and the geometrical formalism of the interwar years (see AMERICAN ABSTRACT ARTISTS). Instead, he maintained the buoyant optimism associated with the pre-World War I period.

Through the 1940s, Marin reexplored earlier styles he had developed. How-

ever, about 1947 he began to emphasize line once again, this time as a virtually independent force, curving and wiry, dominating objects caught in its web. Although in this he may have been influenced by JACKSON POLLOCK's drip paintings, the development was consistent with Marin's earlier work and may be considered as analogous to the expressionistic styles developed in their old age by artists as different as Donatello and CHARLES BURCHFIELD. Then too, Marin's sources always lay in nature rather than myth or the unconscious. His last paintings reflected a tempestuous response to nature as did the works of the 1912–13 period.

Marin wrote about himself and his art in a Whitmanesque manner, celebrating both nature and his responses to it in a grand way. The major collection of his etchings is in the Philadelphia Mus. Many watercolors and oils are in MMA. *Lit.*: Sheldon Reich, *John Marin*, 1970.

MARSH, REGINALD (1898–1954), a second-generation Ash Can School painter and printmaker, best known as an urban regionalist of the 1930s (see The EIGHT, AMERICAN SCENE PAINTING). Born in Paris, the child of artist parents, Marsh was brought to this country in 1900. He began to study art at Yale Univ. and ASL in 1919. Although he attended ASL through the early 1920s, he worked primarily as an illustrator in New York City until 1930. A staff artist for the *New York Daily News* between 1922 and 1925, he turned out thousands of drawings for that newspaper as well as for *Esquire, Harper's Bazaar*, and the *New York Herald*, among others. After studying in Paris in 1925–26 and then with KENNETH HAYES MILLER afterward at ASL, he turned seriously to painting. In 1929 he was introduced to the egg-tempera medium, which he used extensively for the rest of his life. He also experimented, between 1940 and 1946, with a medium invented by Jacques Maroger of the Louvre Mus., Paris, which Maroger thought had been used in the 15th century by the Van Eyck brothers. In 1935

Marsh painted a set of murals for the U.S. Post Office Building, Washington, D.C., and in 1937 completed a set for the Customs House, New York City, both for the Department of the Treasury's Section of Painting and Sculpture. An admirer of Peter Paul Rubens and Eugène Delacroix, he disliked modernist art; indeed, his lifelong preoccupation was with people—enjoying themselves at beaches, at amusement parks, or on crowded urban streets. He also painted derelicts of New York's tenderloin districts. Figures often crowd his paintings to the point of evoking, uncomfortably or exhilaratingly, the frenzies of urban living. He did not like the changes time brought to his favorite haunts, and, at the end of his life felt as if he were living in another century. Characteristic examples of his work include *Second Avenue El* (1929, Brandeis Univ.), *Negroes on Rockaway Beach* (1934, WMAA), and *Ten Shots, Ten Cents* (1939, St. Louis Mus.). *Lit.*: Lloyd Goodrich, *Reginald Marsh*, 1972.

MARTIN, AGNES (b. 1912), a painter. From Maklin, Saskatchewan, Canada, she became an artist during the 1940s while attending Columbia Univ. During the 1950s, both before and after living in Taos, N. Mex., in 1956–57, her work approximated the biomorphic abstractions popular during the previous decade (see BIOMORPHISM). However, she became increasingly interested in systems and in a more systematic approach to figuration. By 1958 her work had grown hard-edged, forms assuming a rigid frontality and compositions reduced to fewer and repetitive forms. In 1959 she painted her first grids, on plain brown canvas, and this subject she has explored ever since. Her colors had grown richer by 1963 but never reached the degree of brightness and saturation typical of contemporary Minimal paintings (see MINIMAL ART). The grids were often applied with pencil strokes and, over the years, grew more regularized. Until about 1964, the grids stopped short of the framing edge; subsequently, they reached the edge. The

earlier grids seem to be applied to the canvas; the later ones suggest that the canvas was incorporated into a modular system of continuous small rectangles composing the grid. Or, to say it differently, the canvas became absorbed by the grids. Martin's personal handling of color, the veillike allusiveness of her surfaces, which never become opaque and impenetrable, link her, ultimately, to the Abstract Expressionist ethos. *Lit.*: *Agnes Martin*, exhib. cat., Inst. of Contemporary Art, Univ. of Pennsylvania, 1973.

**MARTIN, HOMER DODGE** (1836–1897), a painter open to many influences but chiefly associated with the Barbizon style (see BARBIZON, AMERICAN). From Albany, N.Y., he studied briefly with the landscapist JAMES MACDOUGAL HART in that city, before opening his own studio there. In 1862–63 he moved to New York City, where he became especially friendly with JOHN LA FARGE, who may have encouraged Martin to soften and to poeticize his panoramic style, which was similar to that of the HUDSON RIVER SCHOOL (*Lake Sanford in the Adirondacks, Spring*, 1870, Century Assoc., New York, N.Y.). In any event, during the 1860s Martin displayed a highly personal feeling for nature in undertaking to create a forest interior scene based on Beethoven's Fifth Symphony. After travelling abroad in 1876, Martin grew responsive to the art of JAMES A. M. WHISTLER and began to use increasingly softer, muted colors and scumbled forms, losing detail in blurred edges as well as in evocative passages of pigment. From 1881 to 1886, he lived in France, where his work was influenced by the work of French Barbizon artists, among them, J. B. Camille Corot. Martin visited England and France again in 1892. Because of failing eyesight, he moved to St. Paul, Minn., in 1893, hoping that the clear air would help him. Late in his career, his interest in color grew stronger as did his concern for abstract form. Influences upon his work, invariably present, now ranged from that of La Farge (*Wild Coast, Newport*, 1889, Cleveland

Mus.) to that of Impressionism or, at least, an awareness of Impressionism, as is evident in his well-known *Harp of the Winds* (1895, MMA). Nevertheless, Martin usually painted in his studio, relying on the memory of a scene rather than its immediate visual impact. Even *Harp of the Winds* is a remembered view of the Seine River. *Lit.*: Frank J. Mather, *Homer Martin, Poet in Landscape*, 1912.

**MATHEWS, ARTHUR F.** (1860–1945), a painter and designer. Born in Markesan, Wisc., he moved to Oakland, Calif., in 1867. First trained as an architectural draftsman in his father's office, he went abroad to study painting in Paris from 1885 to 1889 at the Académie Julian under Gustave Boulanger and Jules Lefebvre. While in Europe, he also studied independently in Holland. After his return to the Bay Area, Mathews became an instructor at the California School of Design, in San Francisco. In 1900 he became director of that school. Following the San Francisco earthquake and fire, Mathews and his wife, Lucia Kleinhans Mathews, encouraged the rebuilding of the city by starting a magazine, *Philopolis*, and opening the Furniture Shop in 1906. Through the journal and the store, the Mathews popularized a style known today as the California Decorative Style. Related to the European Arts and Crafts Movement, the California Decorative Style was based on motifs selected from western environment: Flowers and plants native to California, especially the poppy, were the chief decorative elements on the carved and painted furniture sold at the shop. The landscape of the state also became an important subject of Mathews's painting after his return from France, where he had practiced a conservative version of Barbizon School painting. His landscapes reflect the contemporary style of TONALISM, characterized by softly defined areas of color closely related in intensity or tone. Their effect is poetic, a view of nature harmonious and sometimes mysterious. Examples of Mathews's California land-

scapes are in the collection of the Oakland Mus., which also owns furniture designed by the Mathewses. Arthur Mathews's mural cycle on the history of California decorates the State Capitol rotunda, in Sacramento. *Lit.*: Harvey L. Jones, *Mathews: Masterpieces of the California Decorative Style*, exhib. cat., Oakland Mus., 1972.

MAURER, ALFRED HENRY (1868–1932), a major early modernist, whose art was more expressionistic than that of STANTON MACDONALD-WRIGHT and less firmly based in nature than that of JOHN MARIN and ARTHUR G. DOVE. Born in New York City, the son of Louis Maurer, a commercial artist for CURRIER & IVES, Alfred Maurer worked in the family lithographic business as a young man. He attended NAD in 1884. In 1897 he left for France, where he remained until 1914, with the exception of a brief return trip to America in 1901. He studied in Paris at the Académie Julian for a brief period in 1897. Before World War I, Maurer's artistic development bridged the gap between traditional and radical styles. Initially attracted to the works of Frans Hals and Diego Velázquez as well as to those of WILLIAM MERRITT CHASE, JOHN SINGER SARGENT, and JAMES A. M. WHISTLER, he developed a rich, brushy, tonal style. His Whistlerian study of a woman crouching on a rug placed in front of a Japanese screen, *An Arrangement* (1901, WMAA), won first prize at the Carnegie International Exhibition of Painting in 1901.

Between 1905 and 1907, Maurer abandoned his tonal style (and a promising career as a traditionalist) and developed instead a brilliant Fauvist approach to color and form. With this change, he probably became the first modernist American painter. His conversion may have been prompted by friendship with Gertrude and Leo Stein and his response to the newly evolving Fauve style on display at the famous Salon d'Automne in 1905, as well as to an important retrospective of Paul Cézanne's paintings in 1907. In any event, by 1907 (dating is

imprecise since much of Maurer's European work has been lost), he was using high-keyed colors in place of muted tonalities, strong contrasts of color rather than of tone, and more simplified, angular schemes of figural representation. Because Maurer also applied color in equal intensity throughout a painting, subtle shifts in spatial recession, already minimal in his Whistlerian works, almost entirely disappeared. As in Henri Matisse's work of this period, all parts of a painting were emphatically colored and vigorously brushed, so that the picture plane vividly asserted itself. But even though the new forms exploded across the picture surface, they were forced to coalesce within taut compositional schemes, as Maurer's traditional training asserted itself. As a result, virtually all of Maurer's early modernist works reveal a firm organizational core despite the intuitive, improvisatory Fauvist manner (*French Landscape*, c. 1907, Blanden Art Gall., Fort Dodge, Iowa).

What makes Maurer's change of style so interesting is, first, its abruptness; second, the speed with which he gained assurance; and, third, and perhaps most-intriguing of all, his receptiveness to a range of radical modes of painting. American art had always lagged behind European developments by as much as a generation. After Maurer, and until reaction set in in the 1930s, the majority of important American artists began to explore radical contemporary styles soon after their invention, as if to announce their cultural coming-of-age.

Although ALFRED STIEGLITZ did not support Maurer, exhibiting his work only once, in 1909, in his LITTLE GALLERIES OF THE PHOTO-SECESSION, Maurer became friendly with most of the young modernists in New York City after his return in 1914. Since almost all American artists had left Europe after the outbreak of World War I, the period between 1914 and 1919 was most important for the development of modern art in America. At home, Maurer, like others, initially explored a more abstract idiom than usual, perhaps in response to the presence in

New York of the Europeans Marcel Du-
champ, Francis Picabia, and Alfred
Gleizes, perhaps also in response to the
new movement SYNCHROMISM. During
these years, Maurer's work showed simi-
larities to that of MARSDEN HARTLEY and
Dove, although Maurer's invariably has
an emotional charge absent from theirs
(*Abstract Still Life*, c. 1919, Hirshhorn
Mus.). In addition to painting studio in-
teriors, he also continued to paint land-
scapes, some with the seemingly effort-
less freedom of his earlier Fauve
manner, others reflecting the more air-
less, planar, and controlled syntax of
Cubism. In these years of experimenta-
tion, Maurer exhibited in the ARMORY
SHOW (1913), the Forum Exhibition of
Modern American Painters in 1916 and
with the Soc. of Independent Artists
from 1917 until his death.

During the 1920s, Maurer concentrat-
ed on still lifes and figural pieces, par-
ticularly heads and half-length studies of
women. (*Two Heads With White Hair*,
c. 1930, Univ. of Minn.). In many, forms
were bound by broken, wiry lines. The
still lifes were variations on the Cubist
vocabulary of flattened forms, tilted ta-
bletops, and simplified contours. The
heads, at first realistic, grew abstract late
in the decade. Some, in which two heads
were merged, suggest a spiritual content
beyond their decorative Cubist forms. It
has been suggested that these works re-
flect Maurer's physically close but psy-
chologically distant relationship with his
father, who died at the age of one hun-
dred, shortly before Maurer committed
suicide. At the same time, these works
may bear upon Maurer's situation as a
not very popular artist who perhaps felt
himself adrift in the culture of his coun-
try. They are certainly his most personal
and enigmatic statements. Many exam-
ples of works in Maurer's various styles
can be found in the Hirshhorn Mus. and
at the Univ. of Minnesota. *Lit.*: Sheldon
Reich, *Alfred Maurer, 1868–1932*, ex-
hib. cat., NCFA, 1973.

**MAVERICK, PETER** (1780–1871), a print-
maker. Born in New York City, he
learned his trade in his father's print
shop. He established his own shop in
1802, and in 1809 moved to Newark,
N.J., where he remained until 1820 and
then returned to New York City. ASHER
B. DURAND was his partner from 1817 to
1820. In the course of his career, Maver-
ick engraved or lithographed about 1500
bookplates, maps, bank notes, and book
and magazine illustrations. He was
among our first lithographers, using the
process as early as 1824 for the plates for
the *Annals of the Lyceum of Natural
History of New York*. (Bass Otis is sup-
posed to have made the first lithograph,
in 1819.) Maverick engraved portraits of
Henry Clay (1822, copy in PAFA) and
DeWitt Clinton (c. 1831, NYPL). Sever-
al of his children also became print-
makers. *Lit.*: Stephen Stephens, *The
Mavericks: American Engravers*, 1950.

**MEAD, LARKIN GOLDSMITH** (1835–1910),
a sculptor, born in Brattleboro, Vt. The
son of a prominent attorney, Mead trav-
elled to New York City in 1853 to work
in the studio of HENRY KIRKE BROWN
alongside JOHN QUINCY ADAMS WARD.
Though little is known of his early work,
Mead first gained attention in Vermont
in 1856 by making a large angel out of
snow. He soon received a commission to
represent the state of Vermont in a colos-
sal statue of Ceres (1857, State House,
Montpelier). At the outbreak of the Civil
War, Mead made illustrations for
*Harper's Weekly* but in 1862 departed
for Italy. In Florence he made the
aquaintance of HIRAM POWERS, THOMAS
BALL, and JOEL TANNER HART, with
whom he shared a studio. His major
work of this period was a statue of Echo
(1863, Corcoran Gall.) based on an an-
tique nude female torso.

After a brief return to the United
States, Mead was again in Florence, at
work on a bronze monument to Abra-
ham Lincoln (begun 1865, Oak Ridge
Cemetery, Springfield, Ill.). This lacklus-
ter work was not a success. Mead fared
better with a statue of the Vermont hero
Ethan Allen (1876, U.S. Capitol, Wash-
ington, D.C.). The eclectic figure in

18th-century military uniform was based on Michelangelo's *David*. Another success was a marble version of Mead's youthful snow sculpture, *The Recording Angel* (c. 1885, All Souls' Church, Brattleboro).

As his fame grew, Mead occupied himself with large public works such as his pedimental decorations for the Agricultural Building at the WORLD'S COLUMBIAN EXPOSITION at Chicago in 1893, of which his brother, of the firm of McKim, Mead and White, was one of the architects. This was executed only in plaster and is now lost. The sculptor died in Florence, among the last of the American expatriate artists there. *Lit.*: Wayne Craven, *Sculpture in America*, 1968.

MELCHERS, JULIUS GARI (1860–1932), a leading expatriate artist and portrait painter. Melchers was born in Detroit, of German ancestry, which in part determined his decision to study at the academy in Düsseldorf in 1877, at a time when that city had lost its leading role in the arts to Munich—and, for Americans, even more to Paris. But the strong drawing and firm modelling that characterize Melchers's early work can be attributed to the training he received there. In 1881 he was in Paris studying at the Académie Julian. In 1884 he established himself in the Dutch town of Egmond-aan-Zee, a member of the small American colony working in Holland that included GEORGE HITCHCOCK and Walter Mac-Ewen. Here, he began to portray the villagers in scenes of everyday peasant life, often emphasizing religious observance, as in the well-known *The Sermon* (1886, NCFA). He bathed his strong, volumetric shapes in the clear, bright natural lighting that characterizes the contemporary peasant pictures of the German artists of the period Max Liebermann and, especially, Fritz von Uhde. Later, Melchers's art became flatter and more decorative and he adopted some of the religious symbolism of the contemporary School of Brion in Switzerland. At the turn of the century, his art became modified toward brighter colors and looser brushwork under the influence of Impressionism. In 1909 he settled in Weimar, Germany, presiding over the art academy there, but at the beginning of World War I he returned to America, settling in Fredericksburg, Va. He had already painted murals in America, first for the WORLD'S COLUMBIAN EXPOSITION in Chicago in 1893, and in 1900 for the Library of Congress and the Missouri State Capitol, at Jefferson City.

METCALF, WILLARD LEROY (1858–1925), an Impressionist landscape painter. Metcalf came from Boston, Mass., where he studied with GEORGE LORING BROWN before going to Paris and enrolling at the Académie Julian. He was one of the first Americans to visit Giverny, where Claude Monet had gone to live, a year before THEODORE ROBINSON settled there in 1887. Yet, Metcalf was only tentatively affected by Impressionism until a trip to Maine in 1903 brought about a decisive change in his art: more vibrant brushwork and a higher, more colorful palette. Metcalf devoted himself to the New England landscape, a cheerful and uncomplicated celebration, somewhat akin stylistically to the painting of CHILDE HASSAM, though with a greater emphasis on draftsmanship. His landscapes display a great seasonal interest, and some of his finest pictures are winter landscapes; the important art critic and writer Royal Cortissoz wrote that Metcalf caught the beauty of snow only slightly less successfully than JOHN HENRY TWACHTMAN. He was also one of the American landscape painters who most often chose the nontraditional square format, though he did not explore the protomodern spatial potential of that form as did Twachtman and ALBERT PINKHAM RYDER. Critics tended to stress the American qualities of Metcalf's art despite its basically French style, calling him "the finest American painter of New England countryside." As such, he was one of the most important members of the art colony in Old Lyme, Conn. Metcalf was a member of the Impressionist group the TEN AMERICAN PAINT-

ERS. *Lit.*: Patricia Jobe Pierce, *The Ten*, 1976.

MILLER, ALFRED JACOB (1810–1874), a portraitist and early painter of western scenes. From Baltimore, he received some instruction there before studying in Philadelphia with THOMAS SULLY in 1831–32. He then studied further at EBA, in Paris, as well as in Rome in 1833–34. After returning to Baltimore, he relocated, in 1837, in New Orleans, where he met William Stewart, a Scot who had made and was to make a number of trips to the West. Accompanying him on an expedition to the Rockies in the same year, Miller recorded aspects of Indian life, including food gathering, hunting, and social customs, in some 200 watercolor sketches. As important as his visualizations of Indian life are his studies of the mountain men, whose era of greatest renown lasted from about 1820 to about 1840. Miller then returned to New Orleans, where he painted oils based on his sketches. In 1840, he visited Stewart in Scotland, where he made additional copies. Returning again to Baltimore in 1842, he painted portraits and hundreds of copies in oil and watercolor of his western sketches (between 1846 and 1870, he painted at least 100 oil replicas). A collection of 200 watercolors, made in 1859–60, is housed at the Walters Gall. *Lit.*: Marvin C. Ross, *The West of Alfred J. Miller*, 1951.

MILLER, KENNETH HAYES (1876–1952), a painter. Born in Oneida, N.Y., he studied in New York City at ASL under KENYON COX and at the New York School of Art under WILLIAM MERRITT CHASE. He travelled abroad in 1899. Uninfluenced by the modern styles, Miller initially painted nude and seminude figures in undefined landscape settings in a hazy, romantic manner. About 1919 Pierre Auguste Renoir's work of the late 1880s momentarily appealed to him, but Miller soon developed a preference for Renaissance nudes as well as techniques, using glazes and underpainting to build up his surfaces. His figures grew more

sculptural and their contours more precise. He turned to urban themes in the mid-1920s, his preferred subjects becoming women shopping or working in their homes. Many of these reflect Renaissance compositions (*The Fitting Room* [1931, MMA], for example, recalls Raphael's tapestry designs) and have a gentle, rather wooden charm. Although primarily a figure painter, he also created landscapes, which tend to be more freely brushed than his other work. A member of ASL from 1911 to 1951, he was an important teacher of many urban realists who came of age in the 1920s and 1930s, including REGINALD MARSH and ISABEL BISHOP. *Lit.*: Lloyd Goodrich, *Kenneth Hayes Miller*, 1930.

MILLS, CLARK (1815–1883), an important sculptor and bronze-caster of the mid-century. From Onondaga County, N.Y., Mills began his artistic career in Charleston, S.C., creating plaster busts based upon life masks. His principal fame as a sculptor, however, rests upon an equestrian statue of Andrew Jackson, unveiled in 1853, the result of his successful entry into the competition for a Jackson memorial five years earlier. The work, which stands in Lafayette Square in Washington, D.C., was the first equestrian statue made in America. The likeness of Jackson is crude and the pose of the figure is extremely stiff and out of scale with the rocking-horse animal beneath. Yet the work brought the artist national plaudits, since it involved an ambitious and complex compositional design, with the animal in dynamic movement, necessitating the heavy weighting of the hindquarters of the horse and its tail. Equally innovative was Mills's creation of his own foundry outside of Washington, the first erected in America for the casting of monumental bronze statuary. The Jackson monument brought the artist the commission from Congress for a second outdoor equestrian bronze statue, this one of George Washington, erected in Washington Circle in 1860. Two years later Mills completed his greatest feat in bronze casting, the colossal *Armed Lib-*

*erty* designed by THOMAS CRAWFORD for the dome of the U.S. Capital, Washington, D.C., installed, despite the progress of the Civil War, in 1863.

MILMORE, MARTIN (1844–1883), a sculptor. From Sligo, Ireland, he was brought to Boston, Mass., in 1851. First taught by his brother, Joseph, a stonecutter, who later became his assistant, Milmore was apprenticed to THOMAS BALL from 1858 to 1862, working mainly on the latter's equestrian *George Washington* (1858–61, Boston Public Gardens). On Ball's departure for Italy, Milmore became Boston's leading sculptor. Although he attempted ideal themes, he was basically a realist whose style lacked poetic overtones. He made busts of leading Bostonians, including Wendell Phillips (c. 1870, Old State House), in a straightforward manner. Best known for his Civil War monuments, Milmore contributed to the development of new—and later often imitated—memorials that featured, in the smaller examples, the common soldier rather than officers and, in the more complex ones, a shaft surrounded by plaques and sculptural figures. A monument in Claremont, N.H. (1869) represents the former type, a large one on the Boston Common (1874), the latter. He completed the Boston piece while in Rome in the early 1870s. In his subsequent portrait commissions, he continued to practice pedestrian realism that became increasingly dated by comparison with the more spirited naturalism emanating from Parisian ateliers.

MINIMAL ART, an all-embracing term that describes major aspects of painting and sculpture of the 1960s. These include, but are not necessarily limited to, Primary Structures, Color-Field Painting, Optical (Op) Art, serial imagery, the shaped canvas, as well as Hard-Edge Painting. Although they all developed out of earlier modern art, most, especially Optical Art, have specific histories of their own.

A series of important exhibitions during the 1960s played a significant role in adumbrating the aims, general contours, and limits of Minimal Art. These included, in New York City: Toward a New Abstraction (Jewish Mus., 1963), The Responsive Eye (MOMA, 1965), Art in Process (Finch Coll., 1965), and Systemic Painting (Guggenheim Mus., 1966); and, in Los Angeles, Post-Painterly Abstraction (LACMA, 1964) and American Sculpture of the Sixties (LACMA, 1967). The exhibition organizers, alert to new movements as never before, pointed out new tendencies and at the same time cast them in retrospective dress. Minimal Art thus assumed an instant middle age almost as soon as it was identified.

Its ideological origins lay ultimately in the reductive tendencies of figures as diverse as Marcel Duchamp, Kasimir Malevich, and Piet Mondrian. More immediately, Minimal Art was both a reaction against the expressive and autobiographical aspects of ABSTRACT EXPRESSIONISM and a development out of the nongestural art of such artists as MARK ROTHKO, BARNETT NEWMAN, and AD REINHARDT. Minimal Art surfaced in the 1950s in the work of such young artists as Leon Polk Smith and ELLSWORTH KELLY, who painted panels containing hard-edged (clearly contoured) shapes in a minimum of colors, and in the color Veils of MORRIS LOUIS. FRANK STELLA's paintings of the early 1960s, in which the stretcher itself became a critical factor in determining pictorial content, mark an extreme statement of the Minimalist sensibility. Its basic features include the following: A painting or sculpture is considered an object. Surface pattern and the relationship between pattern and framing edge often take precedence over traditional content and, in painting, indications of three-dimensionality. In fact, the relationships between pattern and edge are often the only content. Because of the artist's concern with the shape of the work rather than with its details, it must be viewed holistically rather than as a surface upon which elements are placed and then related to each other. As a result, most Minimal works contain few forms but do offer repetitive sequences

of the same form. In painting there is little or no sense of movement, either across a surface or into depth. Sculptural forms are unitary, their surfaces neutral and textureless. Colors are usually unmixed, and since they are often made from plastic compounds, they tend to be bright and imposing. With large works, size, scale and color are the content, and their effects can be startling. Such an art is essentially an empirical one, in that meaning is derived from and invariably limited to perception alone. Spiritual, religious, personal, and thematic suggestions and allusions are avoided.

*Color-Field Painting* evolved from and includes the works of Rothko, Reinhardt, Newman, and CLYFFORD STILL because of their use of: (1) colors close in value or tone (Reinhardt); (2) different colors of nearly equal value and intensity (Rothko and Still); (3) large areas of single-color images (Newman). The rubric includes the work of such improvisational stain painters as HELEN FRANKENTHALER as well as of systematic Hard-Edge artists like KENNETH NOLAND and Stella. Characteristics include reduction of depth cues, minimal use of overlapping forms, suppression of hierarchical elements and of dominant and subordinate units (no centrally placed Renaissance triangles), severe control over relational units, and a preference for a few large forms and repetitive patterns and symmetrical layouts. As a result, a Color-Field work tends to be read as a single unit rather than as a series of parts. Color is often considered as being congruent with a surface rather than as lying on it. Although forms and colors may express mood or feeling, this aspect of the art-making enterprise is of minimal importance.

*Optical Art (Op Art)* was a version of Hard-Edge Painting, popular in the mid-1960s, concerned with the suggestion of movement of forms that do not, in fact, move, and of the presence of colors that are not, in fact, present. Although this work can be improvised, or carefully tested, examples are usually based on researches in optics made at least as long ago as Michel Eugène Chevreul's *De la loi du contraste simultané des couleurs* (*The Principles of Harmony and Contrast of Colors*) of 1839. European artists such as Victor Vasarely and groups such as the Nouvelle Tendence form a more immediate background. The interest in Optical Art may have sprung in part from the widespread availability of plastic paints and materials that lend themselves to intense juxtapositions of color. RICHARD ANUSZKIEWICZ used small units of bright complementary colors to heighten auras and to create afterimages and subliminal effects. Others employed moiré patterns, which are overlapping sequences of two or more sets of slightly askew parallel lines or circles, to achieve the sophisticated optical illusions that characterize this style.

*Primary Structures* is a term used to describe Minimal sculpture, an aesthetic that rejects the linear, welded, richly textured and content-laden sculpture of the Abstract Expressionist generation, as well as the randomly selected, oddly juxtaposed, seemingly spontaneous forms of ASSEMBLAGE. Instead, forms are clearly articulated, hard-edged, smoothly surfaced, either neutral in color or painted with bright plastic colors. Volumes tend to be simple, and, since surface richness is deemphasized, mass is stressed, except, of course, in transparent works. The stylistic range includes the unitary objects and repetitive forms of DONALD JUDD and the extended, additive forms of George Sugarman. Works usually lack bases and reach across spaces shared with the viewer. As a result, some pieces are environmental in effect, especially the very large ones that restrict human space; others maintain a separateness from such space. Modern materials—Plexiglas, aluminum, fluorescent-light tubes, and plastics—are all used. Works conceived by the artist are not necessarily executed by him, fabrication taking place in a factory. An artist's style may thus appear in the configuration of a piece, but not in the touch or finish.

*Serial imagery* is a phrase that gained

currency in the 1960s describing "a type of repeated form or structure shared equally by each work in a group of related works" (John Coplans, *Serial Imagery*, Pasadena Mus., 1968). The group might be a set of paintings or sculptures. Serial imagery is not to be confused with works in a series, for in the latter great variation may occur that may not have been planned or anticipated at the start of the particular cycle. In serial imagery there is initially a clear concept of the macrostructure and its parts. The variations of units are predictable and determined systematically, as in the early paintings of Frank Stella. Each unit remains distinct within the aggregate. When the various predetermined permutations and combinations are exhausted—by whatever process, mathematical or otherwise—the cycle is completed. Once the cycle is started, it cannot or should not be altered in any way. Sequence is not especially relevant. This factor effectively counters the traditional notion of a beginning and an end of a series, or of a first and last work. Once the serial imagery is established, units can be read in any order.

*Shaped canvases* were an important aspect of Minimal Art, though not invented in the 1960s. A canvas is considered shaped if it is not in the traditional rectangular, square, or circular formats. It may be two- or three-dimensional (examples of the latter have been called "pictorial reliefs"). The immediate history of the shaped canvas may be said to have begun in 1950 with Barnett Newman's very narrow vertical paintings. Ellsworth Kelly made shaped canvases in the 1950s as well. Frank Stella's notched works, initiated about 1960, in which parts of the canvas perimeter were cut away, helped call attention to this development. Kenneth Noland's lozenge-shaped works of the mid-1960s also made significant contributions. Two other important exploratory figures, both of whom turned to shaped canvases in 1965, are Paul Feeley and Charles Hinman. Perhaps the principal purpose behind the use of the shaped canvas was to call attention to the ground as an object rather than as a repository for paint. *Lit.*: Gregory Battcock, ed., *Minimal Art*, 1968.

**MITCHELL, JOAN** (b. 1926), a painter associated with second-generation ABSTRACT EXPRESSIONISM. From Chicago, she received the B.F.A. and M.F.A. degrees from AIC in 1947 and 1950, respectively. She travelled to Europe in 1948 and settled in France, semipermanently, in 1955. Her earliest work was figurative. After moving to New York City in 1950, she responded to the paintings of such figures as ARSHILE GORKY and WILLEM DE KOONING. Her own style emerged a few years later, predicated on capturing the feelings and light effects engendered by landscape forms encased within a vocabulary of vigorously brushed shapes (*Mont St. Hilaire*, 1957, Lannan Foundation, Palm Beach, Fla.). "I would like," she once said, "to paint what [the landscape] leaves me with," a statement that indicates her ties to the modern American landscape tradition that commences with such painters as JOHN MARIN. Mitchell has painted many multipanelled works that may allude to the passage of time. *Lit.*: Marcia Tucker, *Joan Mitchell*, exhib. cat., WMAA, 1974.

**MOELLER, LOUIS** (1855–1930), well known at the end of the 19th century as a genre painter. A New Yorker, he studied drawing at NAD with the genre painter Lemuel Wilmarth and, from 1873 to 1882, in Munich with Wilhelm Von Diez and FRANK DUVENECK. Upon his return to New York City the following year, he exhibited genre paintings at NAD, winning the academy's Hallgarten Prize for a small painting entitled *Puzzled*, bought by the important patron of American artists Thomas B. Clarke. The genre paintings for which Moeller became known are small in format. Small animated figures vie for the viewer's attention with objects treated almost as independent still-life elements. The objects are often *objets de vertu*—collectors'

prizes, which gave cachet to their proud possessors, those wealthy Americans who bought art so avidly at the end of the 19th century. Thomas B. Clarke was such a collector, and the interior of another Moeller painting, *Another Investment* (1884), is a representation of Clarke's parlor. Paradoxically, Moeller's two most moving and eloquent works, *The Old Armchair* (Oberlin Coll.) and the *Sculptor's Studio* (1880s, MMA) have no people in them. In these paintings, which may have been conceived as memorials, the objects comprising the total content of the compositions are left as clues to the identity of the absent person. Not only are Moeller's compositions interesting from the standpoint of subject matter, they also are painted with a high degree of technical proficiency. The sculptor Frederick Wellington Ruckstull, who wrote an article on Moeller in 1894, predicted that he would become the "American Meissonier." This sobriquet is a gauge of the way his contemporaries regarded him and explains why he fell from favor. (Jean-Louis-Ernest Meissonier, a 19th-century painter of genre subjects, specialized in tiny canvases and an absolute historical correctness.) *Lit.*: William H. Gerdts, "The Empty Room," ALLEN MEMORIAL ART MUSEUM, *Bulletin* (Oberlin, Ohio), 1975–76.

**MOORE, CHARLES HERBERT** (1840–1930), a landscape painter and historian. From New York City, he studied with Benjamin H. Coe in 1853, before precociously beginning his career shortly afterward. He lived in Catskill, N.Y., from 1865 to 1871, when he moved to Cambridge, Mass. He joined the faculty of Harvard Coll. in 1874, and there he taught art and wrote several books of architectural history, including *The Development and Character of Gothic Architecture* (1890). He was a Pre-Raphaelite artist (see PRE-RAPHAELITISM, AMERICAN) as well as a contributor to the *New Path*, the journal of that movement. His works of the late 1850s through the mid-1870s, when he largely abandoned painting,

were noted for their extreme detail and observance of textural differences, as can be seen in his several landscapes and studies of the Hudson River region. Many of these are at Princeton Univ. and the Fogg Mus. Moore also made several incredibly detailed drawings and etchings of trees and bushes, as precise as any made in the country at the time. *Lit.*: Frank Jewett Mather, Jr., *Charles Herbert Moore: Landscape Painter*, 1957.

**MORAN, MARY NIMMO** (1842–1899), an etcher and landscape painter. Born in Stathaven, Scotland, Mary Nimmo came to America as a child, and married the landscape painter THOMAS MORAN, with whom she is said to have studied. After their marriage in 1863, she accompanied her husband on a trip to Europe. About 1879 Moran took up etching, which, as a rule, she executed in a bold and energetic manner. During the 1870s, the Morans lived in Newark, N.J., where the artist painted the landscape *Newark from the Meadow* (c. 1879, Newark Mus.). This landscape is unusual in that it is one of the earliest depictions of the industrial scene in America. The Morans later moved to New York, where the artist may have executed *View, East Hampton* (1887).

**MORAN, THOMAS** (1837–1926), a painter, best known for his depictions of the Far West. From Bolton (Lancashire), England, he grew up in Philadelphia. In 1853 he was apprenticed to a wood-engraving firm; by the decade's end, he had already begun to work in oils and watercolors and had made etchings and lithographs. Although his principal works were in oils, his watercolors are also important, since it was in that medium that Moran usually made small, vivid sketches for his larger works. He declared himself a professional artist about 1855, when he was studying with his brother, Edward, a marine and historical painter. An early work of Moran's, *Ruins on the Nile* (1858, Philadelphia Mus.), based on Shelley's poem "Alastor," al-

ready revealed the influence of Joseph M. W. Turner, the English landscape artist, whose presence is felt throughout Moran's oeuvre. Although he did not go to England until 1861 (he made many subsequent trips), Moran was introduced to Turner's work by the Philadelphia-based JAMES HAMILTON and owned two sets of engravings by the English artist. Moran first travelled to the West in 1871, accompanying Dr. F. V. Hayden's expedition to the Yellowstone area, and then again in 1873, with Major John Wesley Powell's surveying party to the Grand Canyon region. He later travelled many times to the West, finally settling in Santa Barbara, Calif., in 1916. Perhaps the artist who more than any other made the West familiar to easterners, Moran painted in the Yellowstone, Yosemite, Zion, Grand Canyon, and Teton Mountains regions and recorded views of the Mount of the Holy Cross, the Devil's Tower, and the Petrified Forest. His first major successes were *The Grand Canyon of the Yellowstone* and *The Chasm of the Colorado* (1872, 1873; both U.S. Dept. of the Interior, Washington, D.C.). Similar scenes (examples in Milwaukee Art Center and NCFA) were painted throughout his career. An exponent of the panoramic view, Moran employed it as early as the mid-1850s. He recorded the great sweep of landscape vistas and the overwhelming vastness of American spaces, tending to minimize details, as did the HUDSON RIVER SCHOOL painters of the eastern wilderness before him. On the other hand, Moran's forms, though suffused by a Turnerian color and mist, did not vaporize in the manner of late 19th-century Barbizon works (see BARBIZON, AMERICAN). Figures rarely appear in Moran's paintings; narrative incident is limited to the effects of erosion, the play of waterfalls, and the spectacular movement of sunlight and haze across multicolored rock formations. Occasionally, as in *Spirit of the Indian* (1869, Philbrook Art Center, Tulsa), a nostalgic feeling for the lost past is evoked. A related quality informs Moran's burnished views of Venice (examples in the New-

ark Mus., LACMA; both 1902). Moran stated in 1879 that he placed no value on literal transcriptions of nature, believing that a given locale had no importance in itself. He preferred to idealize a landscape scene, providing it with a film of color to soften forms and blur edges so that the soul could take flight over the vast empty spaces of a canyon or gorge, or across a great expanse of water. He is sometimes linked with ALBERT BIERSTADT and THOMAS HILL, who also painted far western scenes. *Lit.*: Thurman Wilkins, *Thomas Moran*, 1966.

**MORRIS, GEORGE L. K.** (1905–1975), an abstract painter and critic. Born in New York City, he studied at ASL in 1929 and immediately afterward in Paris with Fernand Léger and Amédée Ozenfant. Following these studies, Morris's career as an abstract artist was established. In 1936 he helped found the association that advanced the cause of modernism during the 1930s and 1940s (see AMERICAN ABSTRACT ARTISTS) and became its leading spokesman. He also helped publish *The Miscellany* (c. 1929) and *Plastique* (1937–39), and was an editor of *Partisan Review* from 1937 to 1943. Morris's style, which matured about 1934, was derived from the international abstract modes that flourished between the two world wars. His shapes were hard-edged, but not necessarily geometrical; colors were bright and largely unmodulated; depth was severely limited. Morris once said that he wanted to "strip art inward to those very bones from which all cultures take their life." His few sculptural pieces reflect this purpose, too. In the 1950s, probably inspired by ABSTRACT EXPRESSIONISM, he responded to the more eloquent aspects of stroke and pigment, but in the 1960s, he reverted to his earlier, cool style. Although his work is not noted for the American quality of its imagery, some pictures, such as *Nautical Composition* (1937–42, WMAA), *I.R.T.* (1936–53, PAFA), and his late studies based on Navajo themes, exist in an American context, at least. *Lit.*: Donelson Hoopes,

*George L. K. Morris: A Retrospective,*
exhib. cat., Corcoran Gall., 1964.

**MORRIS, ROBERT** (b. 1931), a major
sculptor of the 1960s and 1970s. His
writings that appeared in *Artforum*
magazine between 1966 and 1970
helped explain various developments in
those decades. Basic texts of MINIMAL
ART, they are equivalent as a manifesto
and explication of a major movement to
ASHER B. DURAND's "Letters on Land-
scape Painting," which appeared in *The
Crayon* in the 1850s. Morris was born in
Kansas City, Mo., studied at that city's
Art Inst. from 1948 to 1950 and then at
CSFA in 1951. While living on the West
Coast, he was involved with improvisa-
tory theater, film, and painting. He
moved to New York City in 1961. Like a
number of artists of his age, he did grad-
uate work in art history, earning a mas-
ter's degree at Hunter Coll. in 1963.

His first sculptures, a plywood taper-
ing tunnel and a box entitled *Box with
the Sound of Its Own Making* date from
1961. Such individual pieces, according
to Morris, were not to be made accord-
ing to criteria of taste—an outmoded
concept—but in response to various
complex perceptual, intellectual, spatial,
and historical factors. One might even
describe pieces in terms of strategies and
positions rather than aesthetic criteria.
Such an art points to a turning inward
within the field, for Morris's work, like
that of some other contemporaries, is
best understood, if not always appreciat-
ed, in the light of earlier developments.
For instance, *Box with the Sound,* a
nine-inch cube containing a tape that re-
corded the sounds of the object being
made, comments upon ABSTRACT EXPRES-
SIONISM's stress on the act of creation; yet
*hearing* Morris's box under construction,
the viewer nevertheless makes no prog-
ress toward *comprehending* the motiva-
tion behind the act. Furthermore,
though the work is completed, the pro-
cess of its making goes on and on. Mor-
ris's *Four Mirrored Cubes* (1965), four
cubes to whose sides mirrors are fas-
tened, is related both to Piet Mondrian's

classicism and Marcel Duchamp's Dada.
The mirrors, by reflecting everything,
destroy the stability of the cubes. Al-
though their simple forms suggest time-
lessness, their mirrors reflect the passage
of time. As *Box with the Sound* records
its own prehistory, *Four Mirrored Cubes*
records its post-history.

As early as 1961, and until about 1967,
Morris made unitary Minimal pieces.
These were monochrome, usually gray,
and made of plywood. Anybody could
fabricate them, given their measure-
ments. Like DONALD JUDD, during this
period Morris emphasized the essential
aspects of a piece, creating simple shapes
in which the relations between detail
and whole, color and texture, and sur-
face and weight were denied in favor of
the unified complete perception. In ad-
dition to stating basic properties of a
three-dimensional piece—surface, bulk,
and weight in relation to gravity—Mor-
ris was also concerned with scale and the
interaction of a piece with its environ-
ment. Its size and position were to be
viewed in relation to surrounding spaces,
the amount of light available, and the
changing field of vision. Morris wanted
the viewer to be aware of the piece itself
and its position in its environment. The
simply shaped piece acted as a constant
in a space, which, as the viewer moved,
provided a gamut of experiences. Al-
though Morris used basic geometrical
shapes, he avoided modular formats, be-
lieving that such works concentrated at-
tention on shape rather than dispersing it
through the entire environment. One
might view Morris's Minimalist pieces,
in CARL ANDRE's phrase, as rather large
"cuts in space."

Between 1963 and 1965, Morris was
involved in five dance and theater pieces
with artist Walter de Maria, composer
La Monte Young, and dancer Yvonne
Ranier. These activities probably rein-
forced his interest in whole spatial fields,
evident in the arrangements of his Mini-
malist pieces, and affected to a greater
extent Morris's art after 1966, when he
intensified his investigation of both the
field and the process or activity of mak-

ing art. The former aspect may best be seen in his earth and sod pieces dating from 1966 (see EARTH ART). The latter aspect permeates all of his work after this time. In the earth pieces, which are infiltrated with stray objects, no single element acts to organize the whole. Order is casual and imprecise as multiple units and random patterns approximate normal fields of vision, which usually consist of a blur of objects located in an indeterminate space. It is the entire visual field (rather than the object) that provides the structural basis, however loosely conceived, for the art experience. Just as important for comprehending an earth piece is the fact that Morris stressed the making activity as a systematic mode of behavior rather than the resultant object as a systematic and consistent visual experience. In 1967 he began to make works of felt (an example is in MOMA), a material that yields to gravity. Having always had an interest in the properties of materials, he now also became intensely concerned with the effects upon them of chance arrangements, especially when a piece was moved and set up elsewhere. Works of this type follow a principle of indeterminacy and certainly raise questions about changeability of form in an art object as well as about preconceived notions regarding what its form should be. By 1968 Morris had begun to make so-called antiform pieces, constructed or performed indoors and/or outdoors, and made up of piles of debris, bodies in movement, and even steam. The processes of their making and records of the various activities involved might include photographic documentation, participation, or passive observation, by an audience. Some pieces, such as the installation of beams and concrete in WMAA in 1971, existed only for a limited period of time. Other pieces, such as the activity of galloping a horse over a marked space, last as long as the action takes place and until all traces of its history have vanished—in this case, until the grass grew back over the path created by the horse's hooves. The significant question raised by these pieces is this: Is one mode of behavior (galloping a horse), organized and separated from other modes, distinct enough to be considered an art product when done by an artist?

During the 1970s, Morris has further explored the relationships between objects, environments, and sounds as well as between attractive and (potentially) destructive or forbidding aspects of objects. In one of these recent pieces, the threat of electric shock was realized when it was touched. In another, a labyrinth challenged one's visual, tactile, and spatial senses. As in his earlier work, the questions raised by perception of the object rather than by the object itself remained paramount. *Lit.*: Annette Michelson, *Robert Morris*, exhib. cat., Corcoran Gall., 1969.

MORSE, SAMUEL FINLEY BREESE (1791–1872), a leading historical and portrait painter. He was born in Charlestown, Mass. After graduating from Yale Coll. in 1810, Morse gained the commendation of GILBERT STUART and WASHINGTON ALLSTON for his amateur efforts in art, and the following year he accompanied the latter to England, where he studied with Allston and with Allston's own former master BENJAMIN WEST. West was then stimulating a revival of historical painting, which turned both Allston and Morse in that direction, and Morse won great success at the Royal Acad. with the oil painting *Dying Hercules* (1813, Yale Univ.). A small preparatory sculpture of the subject won him a medal at the Soc. of Artists, also in 1813. Both works feature a strongly articulated, anatomically powerful figure, ultimately derived from the Hellenistic-period sculpture *Laocoön*. Morse followed up this success with another classical work, *Judgment of Jupiter* (1814), a tamer, narrative picture, somewhat in the manner of the English artists Robert Smirke and Thomas Stothard.

Financial considerations forced Morse to return in 1815 to America, where his essays into historical art were unappreciated. So he turned to portraiture,

which he despised, though some of the likenesses he painted in New England and Charleson, S.C., between 1815 and 1821 are very fine. His most ambitious efforts were reserved for historical portraiture, first, *The Old House of Representatives* (1822, MMA), in which he combined a series of eighty-six cabinet-sized portraits of congressmen and a vast perspective view of the newly opened assembly chamber. It is a study of space and light with no drama or narrative. Inspired by the success of the *Interior of a Capuchin Chapel* (1815) by the Frenchman François Granet, Morse attempted to take the picture on tour around the country, but it aroused little interest. He was successful, however, in a competition against JOHN WESLEY JARVIS, HENRY INMAN, CHARLES CROMWELL INGHAM, REMBRANDT PEALE, and Samuel Waldo (see WALDO & JEWETT) for the most prestigious portrait commission of his generation, the New York City Hall likeness of the venerable hero the Marquis de Lafayette, during his triumphal return visit to America in 1824–25. Morse proved himself equal to the challenge, creating a portrait at once historical and symbolic. The old man is portrayed in subtle elongation, a commanding, striding figure, towering above both the spectator before him and the panoramic landscape behind, silhouetted by an evening glow. He turns toward the busts of his fellow revolutionaries Washington and Jefferson, and a third, empty, pedestal awaits his own likeness—a graceful conceit.

In 1825 Morse was at the height of his fame, momentarily financially successful, too, after receiving the lucrative commission and half the profits from the engraving of Lafayette's portrait. At the same time, he led a group of young dissidents away from the moribund AMERICAN ACADEMY OF THE FINE ARTS to found the Soc. for the Improvement of Drawing, soon to become the NATIONAL ACADEMY OF DESIGN. Yet, his dissatisfaction with the art life in America continued, and in 1829 Morse returned to Europe for further experience, financing his

voyage to the Continent with commissions for copies, genre scenes, and landscapes of picturesque Europe. In Paris, Morse began *The Exhibition Gallery of the Louvre* (Syracuse Univ.), which he completed back in New York in 1833. A tribute to the old masters whom he desired to emulate, Morse conceived this as an armchair introduction to the masterpieces in the great French repository of art, but again he was unsuccessful in his attempts to take it on a national tour.

Morse's subsequent few years as a painter were even more frustrating. Though he became the first professor of drawing at New York Univ., the job came without salary and with few pupils. His term as president of NAD was beset by wrangling among the members. Finally, his failure, through the enmity of John Quincy Adams, to secure one of the commissions for a historical work for the U.S. Capitol Rotunda caused him to abandon painting. He subsequently pursued the art of the daguerreotype and electrical studies (which led him to invent telegraphy), with both of which he had become acquainted on his second European stay. Morse's artistic swansong was the brilliant, monumental painting of his daughter Susan, *The Muse* (1836, MMA), in which beautifully restrained sentiment is combined with large, majestic forms and a chromatic brilliance and daring unique in American art at the time. Morse's work is well represented at Yale Univ. *Lit.*: Oliver Larkin, *Samuel F. B. Morse and American Democratic Art*, 1954.

MOSES, ANNA MARY ROBERTSON ("GRANDMA MOSES") (1860–1961), the most popular primitive painter of the 20th century. Born Anna Mary Robertson in Greenwich, N.Y., the largely self-taught painter did not turn seriously to art until the 1930s. Earlier, however, she decorated objects for home use, including a fireboard and a table. Altogether, she created about 1600 paintings, about 50 pictures made from yarn (between about 1931 and about 1952) and 85 tiles

designed in 1951–52. Her basic themes were chosen from rural life in the 19th century. She also painted Revolutionary War scenes associated with New England and northern New York State, where she spent a large part of her life. She painted peaceful, often idyllic farm landscapes, genre, and interior scenes based on memory and old photographs and illustrations. In her paintings of the 1930s Grandma Moses tended to concentrate on content and restrict the number of figures. By the 1940s, her use of space had grown more expansive, encompassing ranges of hills. Figures grew proportionately smaller and in some works, such as *The Village Clock* (1951), as many as thirty-five might appear. Throughout her career, she was able to combine a concern for meticulously realized detail with an ability to establish large, abstract shapes encompassing large stands of trees or fence-bounded plots of land. Her figures were invariably flattened and unmodelled, but, unlike other primitives, she did not always present them frontally or in profile. Her last works were among her most exuberant and even approached an Impressionist thickness of texture and facture. There is a collection of her work in the Bennington Mus., Bennington, Vt. *Lit.:* Otto Kallir, *Grandma Moses*, 1973.

MOTHERWELL, ROBERT (b. 1915), a painter, collage-maker, printmaker, and author, a leading figure of the Abstract Expressionist generation (see ABSTRACT EXPRESSIONISM). From Aberdeen, Wash., he studied at the Otis Art Inst., Los Angeles, in 1926 and briefly at CSFA in 1932. Trips to Europe in 1935 and 1938–40 were interspersed with graduate work in philosophy at Harvard Univ. and in art history at Columbia Univ. In 1941 he briefly studied engraving with Kurt Seligmann and, in 1945, at Stanley William Hayter's Atelier 17. Motherwell's first collages date from 1943. In the following year, he began to edit the Documents of Modern Art series of books, to which he has contributed several introductions. *The Dada Painters and Poets:*

*An Anthology* (1951) is perhaps the most significant in the group. He has also designed murals, including one for the Kennedy Building in Boston, Mass., in 1966.

By 1941 Motherwell had been introduced to Surrealist theories of automatism. Favoring abstract art over "hand-painted dream photographs," however, he experimented with certain shapes and configurations that he has used, in various combinations, ever since. These include linear elements and ovoid forms presented frontally, in which spaces fluctuate between the relatively shallow and the guardedly deep. Throughout all of his work, Motherwell has shown a fine regard for the calligraphic stroke, subtle and probing rather than dynamic or explosive. His subject matter, as in the collage *Pancho Villa Dead and Alive* (1943, MOMA), tends to be speculative and inferential rather than didactic and straightforward. His most famous series Elegy for the Spanish Republic, was begun in 1949 and grew from an abstract illustration of a poem written by critic Harold Rosenberg (examples are in MMA, MOMA, Cleveland Mus., and Brandeis Univ.) These large, predominantly black-and-white works contrast with Motherwell's more colorful collages, some of which, in the 1970s, reached a height of six feet. Other important series include the Je t'aime's of the mid–1950s, in which he experimented with high-keyed colors and heavily impastoed surfaces structured around the centrally painted words *Je t'aime*. After a strongly expressionist and gestural phase in the early 1960s (of which the Boston mural is an example), Motherwell began the Open series in 1967. These pictures consist, usually, of a field of color that fills the canvas with a centrally drawn rectangle, combining images of the wall and the window, suggesting expansiveness and constriction simultaneously. (Examples are in the San Francisco Mus., the Menil Foundation, Houston, Tex., and MOMA.) Since the 1960s, he has made enormous collages and the A la pintura series a variant of

the Open series. *Lit.*: H. H. Arnason, *Robert Motherwell*, 1977.

MOULTHROP, REUBEN (1763–1814), a self-taught New England painter. Born in East Haven, Conn., he is not known to have painted portraits outside of his native state. About forty-five works have been associated with his hand. His first pictures are dated at about 1788, the portraits of Mr. and Mrs. Samuel Hathaway (New Haven Colony Hist. Soc., New Haven, Conn.), which, in their flat, heavy outlines, rigid forms, and shallow backgrounds, indicate the influence of WINTHROP CHANDLER. Although Moulthrop never loosened the atmospheric envelope around his subjects nor succeeded in eliminating taut outlines in favor of rounded volumes, a new amplitude of vision appeared in his work about 1790, perhaps due to the influence of John Durand, who painted portraits in Connecticut and New York in a more sophisticated, Rococo-influenced manner. In portraits such as that of Amos Morris (c. 1791, New Haven Colony Hist. Soc.), Moulthrop gave more careful attention to detail and to simulating textures and fabrics. Moulthrop's portraits after 1800, perhaps reflecting the influence of RICHARD and WILLIAM JENNYS, are thinner in texture with flatter forms. His late work, dating from about 1811, exhibits coarser drawing and has lost the dignity of his earlier work. Altogether, Moulthrop's portraits are among the most spirited and insightful by the self-trained artists who flourished in New England after the Revolutionary War. *Lit.*: Ralph W. Thomas, "Reuben Moulthrop: 1763–1814," *Connecticut Historical Bulletin*, Oct., 1956.

MOUNT, WILLIAM SIDNEY (1807–1868), the foremost American genre painter. Born on Long Island, N.Y., Mount lived much of his life there in the villages of Setauket (his birthplace), Stony Brook, and Port Jefferson. He made long visits to New York City, first to live with his uncle, a composer, then, in 1824, to serve an apprenticeship in his brother's sign-painting shop. The seventeen-year-old Mount spent a great deal of time in the galleries of AAFA and studied with the portrait painter HENRY INMAN. He was chiefly occupied at this time with making drawings of scenes from such plays as *Hamlet* and *Pericles*. In 1826 he became one of the first students at NAD (then called National Acad. of the Arts of Design).

In 1828, having returned to Stony Brook, Mount began to paint portraits and historico-religious pictures. *Christ Raising the Daughter of Jairus* (Stony Brook Mus.) and *Saul and the Witch of Endor* (NCFA) are pompous and stiffly posed essays in the grand, romantic-classical manner of BENJAMIN WEST and WASHINGTON ALLSTON. A portrait of his mother (1830, Stony Brook Mus.), however, is uncompromising in its straightforward realism.

Mount produced his first genre piece, *Rustic Dance After a Sleighride* (MFAB) in 1830. Though the figures are still a bit stiff, the work is full of lively movement and anecdote. The black fiddler is the first of many to appear in Mount's paintings. (Like his French contemporary Jean Auguste Dominique Ingres, Mount was a passionate violin player and even invented "improvements" on the instrument). The picture was shown at the annual exhibition of NAD and at a trade fair held by the American Inst. of the City of New York. As Mount had only been working as an artist for four years, the success of this picture startled him as much as it did anyone else. In 1831 he became an associate of NAD and in the following year a full member. Its president, SAMUEL F. B. MORSE, said that Mount would be "regarded as one of the pioneers of American art."

Although he continued to paint portraits and landscapes, scenes of life in rural Long Island became the mainstay of his art. *Bargaining for a Horse* (1835, NYHS), and a reprise of the same subject, *Coming to the Point* (1854, NYPL) show two men discussing the sale of a horse while whittling. When they "come

to the point" of their sticks, each will make his final offer and the sale will be transacted. The sense of homely ritual, of the deliberate pace at which rural life proceeds, together with a deftly humorous touch, gave Mount's art its tremendous appeal, for the 19th century as well as our own. However, contemporary critics, whether for or against, tended to dwell more than we would today on the narrative element. Such pictures as *Cider Making* (1841, MMA) were deciphered in anecdotal detail far beyond the artist's probable intent. What was not much appreciated then was Mount's Ingresque clarity and precision of draftsmanship and the overall technical skill, which was still a rare commodity in American art. The Populist aspect of Mount's work has also been overstressed. It is interesting that in his copious diaries, which reveal a more complex personality than his paintings would lead us to expect, Mount never expresses any particular attitude toward rural life but writes only of technique.

Through the efforts of William Schaus, an agent for a European dealer, Mount's paintings came to be lithographed and circulated in Europe, and he became the first painter in America to be widely known there. Mount was persuaded to produce such works as *The Banjo Player* (1856, Stony Brook Mus.) and other paintings of black musicians specifically for the European market. Although Mount was the first artist to depict black people as having any individual character, these works were directed to the European taste for American exotica.

After 1850 Mount's productivity declined sharply and he seemed to suffer a kind of exhaustion. His personal life may have been uncomfortable. He was unmarried and lived as a perpetual guest at the homes of his relatives, without the kind of familial authority his age should have warranted. Although he worked to the end, travelling the Long Island countryside in a portable studio he built for the purpose, he had misgivings about his work which he expressed in his dia-

ries. After his death, his estate, which included six violins and a violoncello, was valued at $6,572.27, not a great deal to show for a long, successful career in art.

Ultimately, the great appeal of the art of William Sidney Mount lies in its Americanness. He wrote to himself, "Paint pictures in private houses—also, by the way side—in Porter saloons, Black smith shops—shoe shops where ever character can be found—and not be confined to your studio." This is, of course, sound advice for any genre painter, and Mount was, in his time, compared to the English genre artists George Morland and Sir David Wilkie and to the 17th-century Netherlandish masters. But Mount also had, like his countryman Mark Twain, a sure instinct for the kind of subject that Americans would respond to as somehow distinctly their own. Mount rejected all high ideals for art and wrote, quite frankly, "Paint pictures that will take with the public— never paint for the few, but the many." Like Twain, Mount was a highly sophisticated artist who chose to express himself in the vernacular. It may be said with some justification that his work lacks the emotional depth of the great genre painters. Certainly, he never probed deeply into the characters of his subjects. But if his work lacks a certain resonance it also avoids the hollowness of so much mid-century genre painting. For the most part, Mount was able to avoid being either pretentious or condescending. His art had a rightness for its time and place. Lacking emotion, it had credibility. And this, in the eyes of the American public was, more than anything, the test of a true artist. A nearly complete collection of Mount's pencil sketchbooks and many of his paintings are to be found at the Stony Brook Mus. *Lit.*: Alfred Frankenstein, *William Sidney Mount*, 1975.

**MOZIER, JOSEPH** (1812–1870), a sculptor. Born in Burlington, Vt., he was best known for such ideal works as *The Wept of Wish-ton-Wish* (1869, Arnot Art Mus., Elmira, N.Y.), a statue depicting

the title figure of James Fenimore Cooper's novel (1829) about a white woman and her Indian husband. Originally a businessman, Mozier turned to art in 1845, when he went to Italy to live, first in Florence and then in Rome, where he spent most of his life. In 1858 Nathaniel Hawthorne visited his studio and wrote of it in the *Italian Notebooks* (1871). In 1866 Mozier returned to America briefly and exhibited seven of his sculptures in New York City. Successful as a creator of works based on biblical, classical, and literary themes, he also made many portrait busts. His *Undine*, which won a grand prize in Rome in 1867 (now at Dayton Univ.), is a good example of the controlled eroticism seen in many mid-century pieces. The nymph's drapery, which clings to her body, reveals as much as it conceals. Often Mozier's work suggested a moral, for example, *Pocahontas* (1877) who is shown discovering Christianity in the wilderness.

MUNICH SCHOOL, the name of a group of artists who either studied in Munich or adopted the style of painting current there during the 1870s. Although Americans had begun to study in the German city by 1861 (David Neal is considered to have been the first), Munich became a mecca in the 1870s, rivaling Paris in significance. Wilhelm Leibl was perhaps the most gifted and charismatic of the German artists in Munich at the time, but Karl von Piloty and Wilhelm von Diez were popular teachers of the American students there. Major figures in the school included FRANK DUVENECK, who lived there from 1870 to 1873 and from 1875 to 1879 and opened a school there in 1878; and WILLIAM MERRITT CHASE and WALTER SHIRLAW, who studied there from 1871 to 1878 and 1870 to 1877, respectively. Duveneck and Chase, both energetic and gifted teachers, transmitted the Munich manner widely at home through their teaching. Paintings in the Munich style were realistic rather than idealized. Frans Hals, Diego Velázquez, and Gustave Courbet were major influences in the development of a richly brushed, darkly colored, directly modelled technique. The style became popular in America after Duveneck's works were first seen in Boston, Mass., in 1875. Its quick vogue caused a schism in the NATIONAL ACADEMY of DESIGN that led to the formation of the Soc. of American Artists. By the late 1880s, the manner had largely been replaced by the new interest in Barbizon and Impressionist paintings (see BARBIZON, AMERICAN; IMPRESSIONISM, AMERICAN). However, the Munich manner was revived in the early 20th century in the work of ROBERT HENRI and his circle. *Lit.: Munich and American Realism in the 19th Century*, exhib. cat. Crocker Gall., 1978.

MURAL PAINTING MOVEMENT; the result of a new enthusiasm after the Civil War for large-scale painted decoration in public buildings. During the 18th and early 19th centuries, wall paintings were made for the hallways and dining rooms of luxurious private houses. However, public commissions were relatively rare, the best known of which are those for the U.S. Capitol, in Washington, D. C., especially JOHN TRUMBULL's four large historical paintings of 1817–24, *The Declaration of Independence, The Surrender of General Burgoyne at Saratoga, The Surrender of Lord Cornwallis at Yorktown* and *The Resignation of General Washington at Annapolis*, and EMANUEL GOTTLIEB LEUTZE's *Westward the Course of Empire Takes Its Way*, completed in 1862.

At the end of the 19th century, a large number of public buildings, both secular and religious, were erected, stimulating a demand for monumental decorations. JOHN LA FARGE and WILLIAM MORRIS HUNT were the first artists to create murals for the new architectural spaces. In 1878 Hunt painted two large murals directly on the limestone walls of the new State Capitol at Albany, N.Y. These lunettes, entitled *Anahita (The Flight of Night)* and *Columbus (The Discoverer)*, soon damaged by water seepage, were covered by a new ceiling in 1888. Two years earlier, in 1876, La Farge had col-

---

laborated with the architect Henry H. Richardson in the decoration of Trinity Church in Boston, Mass. Their assistants were the architects Charles F. McKim and Stanford White and the sculptor AUGUSTUS SAINT-GAUDENS.

After the Civil War, many American artists went to Paris, attracted by the training offered at EBA and in the ateliers of various French masters. The American students particularly admired the decorative work of Pierre Puvis de Chavannes of the 1860s and Paul Baudry's decorations for Charles Garnier's Paris Opéra, completed in 1874. Their experience proved useful when Chicago's WORLD's COLUMBIAN EXPOSITION of 1893 brought mural painting to the attention of the American public. The grand Beaux-Arts scheme for the buildings at the fair demanded the collaboration of architects, sculptors, and painters. The Director of Decorations was Francis D. Millet; among the artists whose paintings adorned the exposition architecture were J. Carroll Beckwith, EDWIN H. BLASHFIELD, MARY CASSATT, KENYON COX, JULIUS GARI MELCHERS, Mary MacMonnies, ROBERT REID, WALTER SHIRLAW, and Edward Simmons.

Partly as a result of the Chicago exposition, the American mural movement reached a crest of activity between 1895 and 1910. Some noteworthy examples created during this approximate period, and some of the artists involved, include: murals at the State Capitol, Des Moines, Iowa; by Edwin H. Blashfield and Kenyon Cox; murals at the State Capitol, St. Paul, Minn. by Edwin H. Blashfield, Kenyon Cox, John La Farge, Francis D. Millet, Howard Pyle, Edward Simmons, and Henry O. Walker; murals at the State Capitol, Harrisburg, Pa., by EDWIN AUSTIN ABBEY, JOHN WHITE ALEXANDER, and Violet Oakley; murals at the State Capitol, Madison, Wis. by John White Alexander, Hugo Ballin, Edwin H. Blashfield, Kenyon Cox, and Francis D. Millet.

These secular mural programs, usually executed by several artists working in separate spaces, often combined allegori-

cal representations of patriotic virtue with historical scenes of local importance. The aim was to instruct and edify American citizens. Although most decorators attempted to adapt their individual styles to the requirements of mural painting, the general tendency was to choose a flat, linear manner, imitative of the Renaissance tradition. They were also frequently inspired by the numerous mural cycles executed by Puvis de Chavannes in France and, in America, in 1893–95, for the Boston Public Library.

After 1910 commissions for mural painting declined as a result of a slowdown in building and of a loss of idealism brought about by World War I but also because of a shift in architectural taste. The mural movement was revived during the 1930s through the efforts of WPA-FAP (see FEDERAL ART PROJECTS). *Lit.:* Edwin H. Blashfield, *Mural Painting in America*, 1913. "Mural Painting in Public Buildings in the United States," *American Art Annual* 19, 1922.

MURCH, WALTER TANDY (1907–1967), a realist painter with romantic tendencies. From Toronto, Canada, he attended the Ontario Coll. of Art from 1925 to 1927, before entering ASL, where he remained for a brief time. He then studied with ARSHILE GORKY until about 1929. After a period of illustrating fashion magazines, he painted murals during the 1930s and 1940s in apartment houses and hotels, including restaurant and supper-club rooms (St. Regis Hotel, New York City), as well as in department stores. JOSEPH CORNELL became a friend in the late 1930s and gave Murch old photographs, and it was at this point that Murch developed his mature style of painting still-life arrangements in muted lights with a daguerreotypical patina. His subject matter ranged from motors, metronomes, and machine parts to more traditional fruits and flowers. These were set against neutral backgrounds that looked pitted by the passage of time. The objects, too, seemed to have been put to sleep years before they were painted.

The close-up views favored by Murch provided his forms with an abstract quality paradoxically emphasized by their old-master-like finish. In his works after 1960, a subtle dematerialization took hold of some objects. *Lit.*: Daniel Robbins, *Walter Murch*, exhib. cat., RISD, 1968.

MURPHY, GERALD (1888–1964), for a brief period in his life, a painter. From Boston, Mass., he turned to art only after following a career in business. His interests developed abroad, where he lived with his family from 1921 to 1930 and became friendly with artists and writers, especially Fernand Léger (the Murphys were, in part, F. Scott Fitzgerald's models for the Divers in *Tender Is the Night*). While taking lessons from Natalia Goncharova in 1921, he helped repaint sets for Sergei Diaghilev's Ballet Russe after a fire damaged them. Subsequently, he painted ten works of his own. These were rediscovered when five were exhibited at the Dallas Mus. in 1960. Murphy depicted everyday objects in flat, largely unmodulated colors. Realism and abstraction were combined in the precise but schematized details of razors, interiors of watches, and the smokestacks of ocean liners. Altogether, the paintings may be described as approximating the style of STUART DAVIS and the ethos of POP ART. *Lit.*: William Rubin, *The Paintings of Gerald Murphy*, exhib. cat., MOMA, 1974.

MURPHY, J(OHN) FRANCIS (1853–1921), a leading landscape specialist in the style of TONALISM. Murphy, from upstate New York, was a self-taught artist who emerged as an able practitioner of poetic landscape derived from the manner of the French Barbizon painters and allied to the popular art of America's foremost landscapist of the period, GEORGE IN-NESS. By the end of the 19th century, Murphy was working in the manner of Inness's late pictures and following the general tenets of Tonalism. The artists of this movement radically simplified their compositions in form, space, and color,

emphasizing a single harmonious atmospheric tone that eliminated details. Topographical references were completely abandoned in favor of suggestions of times of day, seasons of the year, conditions of weather, and, above all, poetic mood. Murphy's palette ranged within the grayish-greens or golden browns, the paint applied in thick impastos that created an irregular, pulsating surface. A typical work by Murphy appears extremely empty, often featuring wet, marshy terrain with a simple, wispy clump of trees at one side in the foreground, and a smaller, even more vague group of trees on the opposite side in the middle distance. Variations of this formula brought the artist great critical praise and remuneration during his lifetime. Primarily a painter in oils, Murphy was equally adept at watercolor. *Lit.*: Eliot Clark, *J. Francis Murphy*, 1926.

MURRAY, SAMUEL A. (1869/70–1941), a sculptor. Born into the family of a Philadelphia stonemason, he commenced his art studies at the Philadelphia Art Students League under THOMAS EAKINS. It is as Eakins's student and later close friend that Murray is chiefly remembered. Murray arrived at the league in the fall of 1886, after it had been in existence for less than a year as a rival institution to PAFA. The league had been set up by students who had resigned protesting Eakins's forced resignation from the academy in February, 1886. Murray eventually became Eakins's assistant at the student-run league and later taught anatomy and life-modelling for fifty-one years (1890–1941) at the Philadelphia School of Design for Women (later the Moore Coll. of Art).

By 1892 Murray, whose attention had been directed away from painting to sculpture by Eakins, was often using the same models and portraying the same subjects as his mentor. There is some evidence to suggest that the two artists may have assisted each other with certain projects. Murray appears in a number of paintings by Eakins and was the sculptor of several statues of the older artist and

members of the Eakins family. Murray introduced Eakins to the world of professional fighting, the theater, and the Roman Catholic clergy, providing him with subjects for many of his later works. His own fairly successful career has been largely overlooked. He received many commissions for portrait busts and statues of prominent individuals. Many of these works remain in and around Philadelphia. Murray collaborated with other former students of Eakins on such Philadelphia projects as sculpture for the Smith Memorial in Fairmount Park and the Witherspoon Building. Murray received the commission for the freestanding sculpture and historical reliefs for the Pennsylvania State Monument on the Gettysburg battlefield. His early works were closer to Eakins's sort of realism; the later pieces often exhibited stiff and awkward qualities. In general, his full-length figures were more successful than his busts or reliefs.

**Muybridge, Eadweard** (1830–1904), a photographer and pioneer in motion photography. Born Edward Muggeridge in Kingston-on-Thames, England, he came to America in 1852 and settled in San Francisco in 1855. He studied photography in England during a visit there from about 1860 to 1866 and also with Carleton E. Watkins in San Francisco. Working under the name of Helios the Flying Camera, he became one of the earliest photographers of the Yosemite Valley. His early work there, dating from 1868, included panoramic studies, but subsequent visits resulted in more intimate views. In style his work tended toward the picturesque and included varieties of tonal gradation. He became Director of Photographic Surveys for the U.S. Government in 1867 and visited Alaska that year. In 1872 he made the acquaintance of the landscape painter Albert Bierstadt, whose influence may be detected in Muybridge's subsequent increased interest in space and atmospheric effects. In 1875 he went to Central America, where he produced a fine body of landscape and journalistic photographs.

Although Muybridge made a series of photographs of a horse in motion as early as 1873 (the pictures were commissioned by Governor Leland Stanford), he explored the applications of motion to photography only in later years. In 1878, for example, he made a brilliant photographic panorama of San Francisco, and, in that same year, using a number of cameras placed in a row, recorded the movement of a horse through space. This lead to his development of the zoopraxiscope, in which motion was recorded on a rotating disk. Perhaps Muybridge's most interesting work was done in 1884–85, when, at the Univ. of Pennsylvania, he photographed animal and human movement using banks of cameras rather than a single camera with a continuous strip of film. These studies resulted in major publications of his work, including *Animal Locomotion* (1887) and *The Human Figure in Motion* (1901). Many of Muybridge's slides are in the Science Mus. in London. *Lit.:* Robert Bartlett Haas, *Muybridge: Man in Motion,* 1976.

**Myers, Jerome** (1867–1940), a painter. From Petersburg, Va., he worked as a sign painter in Baltimore before going to New York City in 1886. He painted theater sets in the immediately succeeding years. In the late 1880s, he studied in New York at Cooper Union and ASL under George de Forest Brush. He travelled to Paris in 1896 and again in 1914. Though a realist, he helped organize the Armory Show. His preferred subjects were immigrants in ghetto settings. He recorded market scenes, children at play, and people enjoying outdoor summer concerts. Attracted to urban life, he filtered it through a screen of sentimentality and light-heartedness, emphasizing picturesque rather than oppressive aspects of ghetto conditions. His figures, usually small in scale, were brought to life through sketchlike brushstrokes, and they rarely establish psychological con-

tact with the viewer. Some works, because of touches of light color, seem as though bejewelled. His autobiography, *Artist in Manhattan*, appeared in 1940. The Phillips Coll. possesses a small collection of his work. *Lit.:* Grant Holcomb, "The Forgotten Legacy of Jerome Myers," *American Art Journal*, May, 1977.

# N

NADELMAN, ELIE (1882–1946), an early modernist European sculptor, who settled in America in 1914. Born in Warsaw, Poland, he studied briefly at the Warsaw Art Acad. about 1899 and again in 1901, before leaving for Munich in 1904. Shortly thereafter, he proceeded to Paris. A person of catholic interests, he became familiar with styles from prehistoric times to the present while forging his own distinctive artistic personality. He worked in a variety of materials, including bronze, marble, wood, terracotta, galvano-plastique (plaster covered by electroplated metal), papier-mâché, and ceramic. On occasion, he would reproduce a design in more than one medium. Beginning in 1920, he also turned out editions of bronze and wood figures. Well-known when he arrived in America, Nadelman was given an exhibition at the LITTLE GALLERIES OF THE PHOTO-SECESSION in 1915, and, within a few years, seven museums had acquired examples of his work. An avid collector himself, he assembled a large group of folk sculptures during the 1920s, which was dispersed during the Depression.

Nadelman asserted that he helped invent Cubism. Drawings dating from 1905 and sculpture done as early as 1908 suggest Cubist qualities, and a head of about 1908 may well have influenced Pablo Picasso in his sculpture. But Nadelman did not pursue that particular stylistic development. Rather, regardless of the style of the moment they represented, his works were usually elegant, mannered and rounded whether they were the crisply contoured Greek-inspired figures to which he often returned, or the smooth, tubular, and slightly ballooned forms he also essayed. A few pieces, especially those based on animal themes, such as *Buck Deer* (c. 1915, San Francisco Mus.), approached abstraction. Between 1916 and 1919, he

explored themes of contemporary life, including *Woman at the Piano* (c. 1917, MOMA), which were based on American FOLK ART sources. His galvano-plastique pieces, first made around 1924, emphasized volumes rather than the cleaner lines of the earlier works. In subsequent years, his style alternated between these two extremes. Although trained and artistically formed in Europe, he became the country's most sophisticated sculptor in the years before the maturation of ALEXANDER CALDER and DAVID SMITH. He brought to American sculpture a concern for form rather than material, as well as a sense of cool detachment from theme, which may have played a distant role in the formulation of PRECISIONISM. *Lit.:* Lincoln Kirstein, *Elie Nadelman*, 1973.

NAHL, CHARLES CHRISTIAN (1818–1878), California's first significant artist, and HUGO WILHELM (1820–1889), his half-brother, also an artist. Born in Kassel, Germany, to a family of artists, Charles Christian Nahl attended the art academy in his native city before going to Paris with Hugo Wilhelm to study with Horace Vernet and Paul Delaroche. They left for America as a consequence of the Revolution of 1848 and, after first settling in New York City, departed for California in search of gold. Charles's early studies of mining-camp life were lost in a fire in Sacramento in 1852, but, after the brothers moved to San Francisco in that year, they turned out a seemingly endless stream of book, magazine, and newspaper illustrations. Two books Charles illustrated for the writer Alonzo Delano (*Pen Knife Sketches*, 1853, and *Old Block's Sketch Book*, 1856), show a variety of scenes reflecting the robust, bawdy, and difficult life of the miners and early settlers. Charles also worked as a photographer. His few surviving oil

paintings, including *Saturday Evening in the Mines* (1856, Stanford Univ.) and *Sunday Morning in the Mines* (1872, Crocker Gall.), also describe the man's world of the camps. Nahl painted humorous and violent episodes with a precise technique and a searching eye for detail. He designed the bear on the California state flag and Hugo designed the state seal. *Lit.:* Moreland Stevens, *Charles Christian Nahl: Artist of the Gold Rush*, exhib. cat., Crocker Gall., 1976.

NAKIAN, REUBEN (b.1897), best known as a creator of often erotically charged Abstract Expressionist sculpture. From College Point, N.Y., he had briefly studied art by 1911. He then worked for an advertising agency before, in 1915, attending the Independent School of Art, New York City, perhaps the only studio at the time to bring modernist art into its curriculum. From 1916 to 1920, Nakian apprenticed himself to PAUL MANSHIP in whose studio he met GASTON LACHAISE, then Manship's chief assistant. Nakian's work of the 1920s recalls their influence in his use of stylized forms, smoothly contoured volumes, and undulating arabesque-like profiles (*Seal*, 1930, WMAA). In 1932 he began a series of portrait busts that culminated the following year in portraits of leading federal bureaucrats and politicians, including cabinet members. His famous eight-foot-high plaster statue of Babe Ruth was done in 1934. Nakian joined WPA-FAP in 1936. Through the 1930s, however, he began to reevaluate his art and grew increasingly responsive to School of Paris modernism, in part because of his friendship with ARSHILE GORKY and STUART DAVIS, whom he had met by 1933. By the late 1940s, his style had completely changed, approximating the loose, freeform pictorial approach of WILLEM DE KOONING's interpretation of ABSTRACT EXPRESSIONISM. Works in plaster and terra-cotta appeared to be improvised. Rough textures and deep gouges replaced smooth surfaces. Baroque opulence fleshed out Art Deco styliza-

tion. Mythological themes replaced animal subjects and portrait busts. The bronze *La Chambre à Coucher de l'Empereur* (1954) was the first large-scale work in his new style. Reflections of light ripple and flutter over its surfaces, clearly revealing on the plaster matrix the artist's touches, and even caresses. In the 1950s, Nakian also used steel rods to hold aloft variously sized steel sheets, giving a baroque touch to a Constructivist combination of solid and empty volumes (*The Duchess of Alba*, 1959, LACMA). Monumental in scale, his work lends itself to placement in open spaces, as is the case with *Voyage to Crete* (1960–62), currently installed at Lincoln Center, New York City. *Lit.:* Frank O'Hara, *Nakian*, exhib. cat., MOMA, 1966.

NATIONAL ACADEMY OF DESIGN, an institution founded in 1825 in New York City as the Soc. for the Improvement of Drawing, when, after years of deteriorating relations between artists and the AMERICAN ACADEMY OF THE FINE ARTS, two artists were prevented one morning from entering the building and using its facilities. Renamed the National Acad. of the Arts of Design in 1826 and then the National Acad. of Design in 1828, NAD avoided problems encountered in other artistic organizations run by businessmen by including only artists as members (see PENNSYLVANIA ACADEMY OF THE FINE ARTS). SAMUEL F. B. MORSE was its first president. The Antique School opened in 1826; there, students drew from casts of antique sculpture. Women were admitted in 1831. A Life School was established in 1837. The first permanent instructor was hired in 1840 to replace supervising academicians. A Life School for women and a Painting School were started in 1871 and 1872, respectively. The older Life School closed in 1874, and its demise stimulated the organization of the ART STUDENTS LEAGUE, which became one of the leading art schools of the 20th century. Even though few sculptors were NAD members, exhibitions were major events

throughout the art world, primarily be-
cause academicians were demoted in
rank if they did not submit works at reg-
ular intervals. Initially more progressive
than other artistic organizations in that it
only exhibited works of living artists,
NAD grew conservative over the dec-
ades. In 1875 an unresponsive jury re-
jected for exhibition the works of youn-
ger painters who had brought newer
styles back from Europe. Two years lat-
er, when their works were finally hung,
the hostility of the academicians precipi-
tated the formation of the American Art
Assoc., renamed the following year The
Soc. of American Artists. The new group
included such avant-garde figures as
JOHN LA FARGE, GEORGE INNESS, and
WALTER SHIRLAW, who advocated the
painterly techniques of the Barbizon and
Munich schools (see BARBIZON, AMERI-
CAN; MUNICH SCHOOL). The new group
in turn grew conservative about 1890
and merged with NAD in 1906. *Lit.:* El-
iot Clark, *History of the National Acad-
emy of Design, 1825-1953,* 1954.

NAUMAN, BRUCE (b. 1941), a multimedia
artist. From Fort Wayne, Ind., he stud-
ied art at the Univ. of Wisconsin, Madi-
son, and at the Univ. of California, Da-
vis, from 1962 to 1966. By 1968 he had
established himself as an artist who
worked with films, photographs, video-
tapes, sound systems, neon tubing, rub-
ber, fiberglass, and holograms. His rub-
ber and fiberglass pieces of 1965-66
helped establish a post-Minimalist inter-
est in the properties of objects rather
than in the objects themselves. These
pieces hang, lean, bend, fold, and ripple.
Their forms are dictated by what is done
to them. Nauman later used his own
body in both actual and taped perfor-
mances and as a model for castings in fi-
berglass, clay, and neon templates. The
notion of process was here transferred
from one of art making to one of record-
ing the activities of the self. Both the
products and the records of personal ac-
tivities became the artistic statement,
suggesting an interesting parallel with
the self-awareness fads of the 1960s and

1970s. Manipulation of self also ex-
tended to manipulation of audiences, es-
pecially in closed-circuit video perfor-
mances and such arrangements as
narrow walkways to control their prog-
ress. This type of art is one of experience
and engagement rather than of product.
Therefore, thought, language, experi-
ence, behavior, and time are essential as-
pects of Nauman's work, both for the
artist and for the viewer. But unlike, say,
Wassily Kandinsky or MAX WEBER, who
wanted to re-create their feelings in the
viewer's mind, Nauman has been more
concerned with recording or manipulat-
ing activities and responses. *Lit.:* Jane
Livingston and Marcia Tucker, *Bruce
Nauman,* exhib. cat., WMAA, 1972.

NEAGLE, JOHN (1796–1865), a leading
Philadelphia portrait painter. Neagle
was the stepson-in-law of THOMAS SULLY,
Philadelphia's foremost portraitist. He
modelled his style on that of Sully, tem-
pering it to a degree after a visit in 1825
to Boston, Mass., where he sought the
advice of the aging GILBERT STUART. His
painting of Stuart (Pennsylvania Hist.
Soc.), done at the time, combined the
brilliant tones and command of Sully's
work with a scintillating and sparkling
brushwork reminiscent of Stuart. Some
of Neagle's finest portraits are likenesses
of fellow artists and of architects, includ-
ing PETER MAVERICK (1826, Newark
Mus.), John Haviland (1827), and Wil-
liam Strickland (1828). In these portraits,
Neagle adopted Sully's mannerisms and
even exaggerated them—producing gen-
erally idealized likenesses, with broad
foreheads to signify intellectuality, pro-
nounced facial features to suggest aristo-
cratic lineage, and a keen, commanding
air. Also reminiscent of Sully are Nea-
gle's female portraits, richly colored and
broadly painted in a manner consciously
recalling the art of the greatest English
portraitist of the period, Sir Thomas
Lawrence. Neagle's masterpiece is *Pat
Lyon at the Forge* (1826, MFAB; repli-
ca, 1829, PAFA), a significant, and
unique, departure from conventional
formal likenesses. The rugged Irishman

is depicted at full-length working amid the tools of his trade and illuminated by the glow of the forge. Lyon requested this unusual treatment in defiant protest against the authorities who had been responsible for his unjust incarceration for bank robbery. He appears sturdy and forthright in open shirt and work apron, though the cleanliness of his white shirt and the elegant buckled shoes are somewhat at odds with the air of simple workman. Among Neagle's best-known later paintings are the several versions of *Henry Clay* (1843, Union League, Philadelphia), in which the famous statesman is shown surrounded by the attributes of his role as national political figure and as farmer of the land.

NEEL, ALICE (b. 1900), best known as a portraitist. From Merion Square, Pa., she studied at the Philadelphia School of Design for Women (now Moore Coll. of Art) from 1921 to 1925. After living briefly in Havana, Cuba, she settled in New York City in 1927. She participated in various FEDERAL ART PROJECTS during the 1930s. In the 1920s, her work reflected German Expressionist influences. By 1930, however, she had developed a portrait style that has served her ever since: exaggerated facial features, simplified contours often thickly outlined, abrupt tonal changes in modelling, and a frontal pose. During the 1930s and 1940s, she also painted scenes of urban poverty. In her portraits, she often evokes the spiritual fallibility and physical gracelessness of her subjects, but in ways that make them appealing as human beings. They seem to have witnessed and bear the evidence of life's humiliations (*Andy Warhol*, 1970, WMAA). *Lit.: Alice Neel*, exhib. cat., Georgia Mus. of Art, Athens, 1975.

NEOCLASSICAL SCULPTURE was first executed in the early 19th century by a group of European-born artists trained in the styles of Antonio Canova and Bertel Thorwaldsen. They included GIUSEPPE CERACCHI, Giuseppe Franzoni, and Giovanni Andrei, whose work was stylis-tically in keeping with the new public architecture then rising in our major cities and in the nation's capital. Through the 1820s and 1830s, a number of native American artists, such as John S. Cogdell (memorial to his mother in St. Philip's Church, Charleston, S.C., 1833), were also independently influenced by the style. The first important American neoclassicist was HORATIO GREENOUGH, the country's first professional sculptor to go (in 1825) to study in Rome, then the major center of the neoclassical style. He is best known for his seminude, seated statue of George Washington (1833–41) portrayed as the god Zeus. HIRAM POWERS was perhaps the most famous American neoclassicist. In 1837 he moved to Florence, where he remained for most of his life, creating classically inspired, smooth-surfaced, idealized marble figures, including the internationally renowned *Greek Slave* (1869, Brooklyn Mus.). Other significant sculptors in the antique manner were THOMAS CRAWFORD, RANDOLPH ROGERS, and WILLIAM WETMORE STORY. Crawford, who worked in bronze as well as in marble, followed the neoclassical canon more strictly than Greenough or Powers. His best-known work was done for the U.S. Capitol, Washington, D.C., and includes the marble group for the pediment of the Senate Wing (1855) and the monumental bronze *Armed Liberty* (1855–62) for the dome. Rogers produced popular sentimental works such as *Nydia, the Blind Girl of Pompeii* (1855–56, MMA), of which more than a hundred versions were created. Story was a sculptor of literary themes and often represented famous biblical and classical heroines such as Cleopatra (1869, MMA) and Salome (1871, MMA). Also part of the neoclassical repertoire were ideal works (CHAUNCEY BRADLEY IVES, *Undine Receiving Her Soul*, 1855, Yale Univ.), full-length historical figures (VINNIE REAM, *Abraham Lincoln*, 1869–71, U.S. Capitol Rotunda), and allegorical subjects (Powers, *California*, 1858, MMA). Sculptors also turned, perhaps most successfully, to the neoclassical style for portrait busts

(Crawford, *Charles Sumner*, 1839, MFAB; Powers, *Andrew Jackson*, c. 1835, MMA). In all these pieces, the artists were attempting to create an ideal of beauty based primarily on antique and Renaissance models—often at the expense of expressiveness and emotion. Surfaces were smoothly carved, with gradual transitions in modelling from one plane to another. Although many works were carved in the round, they often were best seen from the front. By 1875 the taste for neoclassical sculpture had been replaced by one for greater realism and naturalism. *Lit.:* William Gerdts, *American Neo-Classic Sculpture*, 1973.

NESBITT, LOWELL (b. 1933), a realist painter. From Baltimore, he graduated from the Tyler School of Fine Arts, Philadelphia, in 1955 and the following year attended the Royal Coll. of Art, London, where he studied stained-glass-making and etching. Initially an abstractionist, he turned to PHOTO-REALISM in 1963. His first works in this style were based on X rays. These were followed by studies of over-scaled flowers that looked real but, because of their size, could also be read abstractly. Since then, he has tended to paint in series. His favorite themes are urban views, including building facades (1964), studio windows and interiors (1964; 1966), and bridges (1971). Like other Photo-Realists, he concentrates on objects rather than people. In his work, the city is a deathly quiet place in which objects have not been transformed through compositional necessity but are instead preserved as silent monuments. Unlike other Photo-Realists, Nesbitt simplifies forms so that, in spite of his sharp-focus realism, one is aware of paint handling and the conscious decisions of his mind.

NEVELSON, LOUISE (b. 1899), a sculptor. Born Louise Berliowsky in Kiev, Russia, she was brought to Portland, Maine, where her family settled in 1905. Arriving in New York City in 1920, she studied art with Theresa Bernstein and Wil-

liam Meyerowitz. Between 1929 and 1933, she continued her studies at ASL with KENNETH HAYES MILLER and Kimon Nicolaides. She also studied briefly with HANS HOFMANN in Munich in 1931 and at ASL in 1932. In the latter year, she assisted Mexican muralist Diego Rivera, who aroused her interest in primitive art. (She travelled to Mexico in 1950.) From 1953 to 1955, Nevelson worked at Stanley William Hayter's Atelier 17 in New York City and, in 1963, at the Tamarind Workshop in Los Angeles, where she completed twenty-six editions of lithographs.

Although she has allowed many early works to perish, surviving pieces from the 1930s reflect Nevelson's interest in carving angular forms, blocklike in effect, with hollows cut into the solid areas. As early as 1942, she had begun experimenting with techniques related to ASSEMBLAGE, especially in the Circus series (now destroyed), the pieces of which were exhibited together, the first of her environmental sculptures, for which she would subsequently become famous. In the mid-1940s her work began to grow increasingly abstract. Odd, castoff objects, usually altered so that their previous histories were hidden, were juxtaposed on platforms or on tripodlike bases. Open in form, these were among her most purely sculptural pieces. Their often amusing and strange combinations of elements (for example, a small ceremonial lion with a baluster) also suggested Surrealist influences. Between 1946 and 1955, she rarely exhibited. During the mid-1950s, she began to color found objects in a single hue, which, particularly in the black pieces, invested them with an aura of mystery. When she did exhibit again, she preferred arranging the monochrome forms according to theme in order to maintain a continuity of mood from piece to piece. The first such environment was called *Royal Voyage* (1956). During these years, she began to mount assembled forms in boxes, and by 1958 she had started to stack the boxes into wall-like pieces meant to be seen frontally. Her

first major wall, *Sky Cathedral* (1958, AK), is a relieflike pile of stacked boxes filled with found and altered forms made of wood and painted black. The proliferation of detail within the rectangular boxes suggests a kind of improvisational geometry. Of works like these, Nevelson once said that she had dealt "with shadow and space. I think those are the two important things in my work and for me because I identify with the shadow." Like Abstract Expressionist paintings, her walls lack central points of focus, deny deep spatial penetration, and project a sense of weightlessness. In 1959 she painted her wall constructions white. Immediately thereafter, and until 1963, Nevelson used gold paint and stacked the boxes in more regular, gridlike patterns, filling them with more rounded forms. In 1966 she began to make Plexiglas and aluminum pieces, using the former as models for the latter, before creating distinctive walls in aluminum (*Atmosphere and Environment I*, 1966, MOMA; *Transparent Sculpture II*, 1967–68, WMAA). Because of the nature of their substance, and perhaps in response to the hard-edged taste of the 1960s, these walls are more austere than those of the previous decade. The transparency of Plexiglas brings into question solid-void relationships within those sculptural pieces; the open-screened aluminum works—and, in the late 1960s, the Cor-ten steel constructions—trap and release space simultaneously. These are major, if late, Constructivist sculptures modified by the influence of American Color-Field Painting (see MINIMAL ART). Through the 1950s and after, Nevelson also made totemic figures, first in wood and then in metal, the later ones more three-dimensional than the former (*Dawn's Wedding Column*, 1959, MOMA). Like the walls, they, too, are made of found elements. The walls of the 1950s, especially, mediate between the private autographic works of ABSTRACT EXPRESSIONISM and the less personal and often random agglomerations of Assemblage. *Lit.*: Arnold B. Glimcher, *Louise Nevelson*, 1972.

NEWMAN, BARNETT (1905–1970), a major exponent of ABSTRACT EXPRESSIONISM who helped give visual and verbal definition to the biomorphic style of the 1940s (see BIOMORPHISM), and whose stripe paintings after 1948, bypassing the popular gestural modes of the 1950s, prefigured MINIMAL ART of the 1960s. Newman held, like others of his generation, that art was neither merely decorative nor an enterprise to be learned from European models but rather a product of an intensely meditated act of personal creation. This point of view, which for Newman and some others necessitated an investigation of primitive art, nevertheless demanded independence from it—as well as a high seriousness of purpose. Both the act of painting and what was painted became inseparable from the life of the artist. Especially in its rejection of European precedents, conventions of style, and subject matter, this attitude may be said to indicate a coming-of-age in American art. It would be elaborated during the 1960s in the work of such figures as FRANK STELLA and DONALD JUDD.

Born in New York City, Newman studied at ASL in the early 1920s and again in 1929–30. He destroyed most of his early work and, in part because of the crisis in art engendered by World War II, stopped painting about 1940. He took it up again about four years later and until 1948 explored biomorphic shapes. These resembled ova and spermatozoa (*Pagan Void*, 1948) or budding seeds (*The Song of Orpheus*, 1945). Titles evoked ancient civilizations and the commencement of life itself, as well as life after death. It was in his writings of these years, which help clarify the artistic character of the 1940s, that Newman indicated his break with the European tradition. He was no longer concerned with sensual appeal but with the expression of his mind. Such expression had no necessary connection with the Surrealists' interest in the human psyche; rather, in it he attempted to penetrate the sense of mystery and the sense of tragedy he saw as basic truths of life. In

Nietzschean terms, these truths were Dionysian in aspect because they directly confronted the chaos of existence. From that chaos, Newman wanted to extract or discover new pictorial forms. He invoked what he thought was the attitude of primitive peoples toward art and life to help him. In his essay for the important exhibition The Ideographic Picture, which he helped organize in 1947, he wrote, "To [the Kwakiutl artist] a shape was a living thing, a vehicle for an abstract thought-complex, a carrier of the awesome feelings he felt before the terror of the unknowable." Such art, Newman believed, "was directed by a ritualistic will toward metaphysical understanding." Like his friends MARK ROTHKO and ADOLPH GOTTLIEB, Newman recognized the relevance of primitive art to the needs of contemporary artists but unlike Gottlieb he did not use primitive motifs. Newman, Rothko, and Gottlieb, however, were all more attracted to Carl Jung's primordial experiences and archetypes than to Freud's individual psyche.

In 1948 Newman was working on a painting that contained two equal dark red units bisected by a central vertical piece of tape. He painted the tape bright orange and, after studying the painting, realized that it was complete. He called it Onement I (it is in a private collection; Onement II, of 1948, is in WA). Newman later said of Onement I, his first stripe painting, that, though previously he had been emptying paintings of space, now he had found a means to fill them. The forms appeared to lie flat on the picture surface and the units had to be seen together, as a whole, rather than as elements in relation to each other. In addition, the forms were dependent on the framing edge for complete definition, thus forcing awareness of the entire work not simply as a painting but as an object. It appeared that Onement I was about nothing but itself. For these reasons, this and subsequent stripe paintings, such as Vir Heroicus Sublimis (1950–51, MOMA), had an influence on Minimal Art. However, Newman did not intend his works merely to describe a state of objectness. His titles are often meaningful, for example, invoking comparison between the artist and the Deity who created form from chaos. Thus, in Vir Heroicus, the verticals may symbolize mankind. Newman's Stations of the Cross, fourteen black-and-white paintings completed between 1958 and 1966, are also meant to convey meaning, most notably the notion of life after death. Unlike the paintings of many Minimalists, Newman never abandoned sensousness of surface despite his use of smooth, opaque finishes in either oil or acrylic. Despite their forward-looking qualities, his paintings also recall the past, despite the artist's disclaimers. In fact, they are connected with Wassily Kandinsky's earliest abstractions in their implications of meaning. In this regard, they may also be compared with later CONCEPTUAL ART pieces because, as Newman said, "the artist's intention is what gives a specific thing form," an idea with which Conceptualists would agree.

After completing Onement I, Newman worked for the remainder of his career within the same format: vertical bands, either hard-edged or roughly trimmed, placed within broader fields of color. The bands might be quite thin or virtually equal in size to the fields. In 1950 Newman created his first narrow pictures—as narrow as 1⅝ inches wide—which have been called the first shaped canvases (The Wild, 1950, MOMA). He also designed his first sculptural pieces in that year, also narrow vertical ribbons. His most notable sculpture, Broken Obelisk (1963–67), is composed of a pyramid supporting an inverted obelisk (versions in MOMA and Inst. of Religion and Human Development, Houston, Tex.). Newman also experimented with lithographic techniques in 1961 and 1963, making a series entitled Cantos. Lit.: Thomas B. Hess, Barnett Newman, exhib. cat., MOMA, 1971.

NEWMAN, ROBERT LOFTIN (1827–1912), a painter of mood, sometimes associated with ALBERT PINKHAM RYDER, with whose work he shared thematic and stylistic affinities, especially during the

1880s. Born in Richmond, Va., he grew up in Clarkesville, Tenn. Although he read voraciously on art, he received no instruction, with the exception of five months spent with Thomas Couture in Paris in 1850. At that time, his predilection for color manifested itself in his great admiration for Titian. Newman made a second trip to Paris in 1854, resumed an acquaintance with WILLIAM MORRIS HUNT, and was introduced to the Barbizon painters. After serving with the Confederate forces during the Civil War, he probably lived in New York City until 1867, before moving, in 1872, to Nashville, Tenn., where he tried to establish an academy of fine arts. Once again in New York City in 1873 (where he stayed for the remainder of his life with the exception of trips abroad in 1882, 1908, and 1909), Newman designed stained glass for five years for Francis Lathrop. This brought him into contact with leading artists and cultural figures who helped support him, even though he rarely exhibited his work. His subject matter was usually limited to children, mothers and children, and Old and New Testament themes (*Hagar*, MMA; *Christ Saving Peter*, Brooklyn Mus.). Usually dominating their murky landscape settings, his monumental, often vaguely sketched, figures were brought to life by accents of color rather than by their contours. Eugène Delacroix was an important source of subjects for Newman. *Lit.:* Marchal E. Landgren, *Robert Loftin Newman*, 1974.

NEW YORK DADA, a short-lived movement centered on the activities of two French artists and an American: Marcel Duchamp, Francis Picabia, and MAN RAY. It began with the arrival in New York City of Picabia, in March, and Duchamp, in June, 1915. Shortly thereafter, Ray met Duchamp. These three, and other Europeans peripheral to the movement, such as painter Jean Crotti and musician Edgard Varèse, met at the home of scholar and collector Walter Arensberg, who, in effect, held the American equivalent of an avant-garde salon. Picabia left New York City in the summer of 1916; Duchamp returned to Paris in 1918 but made annual trips between the two cities for the next few years; Arensberg moved to California in 1920; and Ray left the country for Europe in 1921. Of those American artists affected by the creations, if not the nihilistic spirit, of the Europeans, MORTON LIVINGSTON SCHAMBERG died in 1918 and JOHN R. COVERT stopped painting in 1923.

The chief publications to emerge from Dada activities were Ray's *The Ridgefield [N.J.] Gazook* (March 31, 1915) and *T.N.T.* (March, 1919). The magazine *291*, given its Dada character by Picabia's influence, lasted for twelve issues (between March, 1915, and February, 1916). Other publications included *The Blind Man*, put out by Henri-Pierre Roché with Duchamp (April and May, 1917), Duchamp's *Rongwrong* (July, 1917), Picabia's *391* (June, July, and August, 1917), and *New York Dada* (April, 1921).

During these years, Duchamp created Readymades, including *In Advance of the Broken Arm* (1915) and *Fountain* (1917). Picabia worked in a machinist style, and Man Ray, in 1916, made probably the first Dada assemblage in America, *Self-Portrait*, consisting of two electric bells and a pushbutton on a background of black and aluminum paint. In 1916 Schamberg—uncharacteristically—made an assemblage consisting of plumbing pipes mounted on a miter box and called it *God* (Philadelphia Mus.). Interest in machine forms undoubtedly influenced the Precisionists in their use of industrial themes during the 1920s, although such themes had been explored throughout the 1910s (see PRECISIONISM). It was not, however, until the 1950s, with the art of JASPER JOHNS and ASSEMBLAGE that Dadaism became an integral part of American art. *Lit.:* Arturo Schwarz, *New York Dada*, 1973.

NEW YORK SCHOOL, originally another name for the Abstract Expressionists (see ABSTRACT EXPRESSIONISM), it has come to embrace virtually all major developments in modern art in America since

[ 254 ]

the 1940s. It has replaced the phrase "School of Paris" as a means of signifying all that is new and vital in modern art as well as of locating modern art's cultural and economic center. The term now includes the following: the original Abstract Expressionist generation; the second-generation Abstract Expressionists who matured after 1950, for example, HELEN FRANKENTHALER; the artists who, during the 1950s, explored realistic and abstract alternatives, among them, JASPER JOHNS and LARRY RIVERS; the contributors to such movements of the late 1950s as HAPPENINGS and ASSEMBLAGE, including Allan Kaprow and ROBERT RAUSCHENBERG, and to the movements that followed in the 1960s and 1970s, POP ART, MINIMAL ART, and CONCEPTUAL ART. *Lit.:* Irving Sandler, *The New York School,* 1978.

NEY, ELIZABET (1833–1907), a sculptor of portraits, who established her reputation in Texas during the latter part of the 19th century. She was born in Westphalia, Germany, and lived there until, at the age of eighteen, she went to Munich to study sculpture. In 1854 Ney travelled to Berlin to further pursue her career as an artist. She remained there until December, 1870, when she sailed from Bremen to New York City. After extended travel to various American cities, Ney and her husband settled outside of Austin, Texas.

That Ney's work was held in high esteem in Germany can be deduced from the list of notable clients who sat for her, including Arthur Schopenhauer, Ludwig II of Bavaria, Otto von Bismarck, Justus von Liebig, and Giuseppe Garibaldi. Her style was a compromise between neoclassicism and naturalism, characterized by strongly individualized facial features and a masterful control over her medium, as can be seen in her memorial to General Albert Sidney Johnson at the State Cemetery, Austin (1901–3).

For over twenty years after her arrival in the United States, Ney neglected her art, but in 1893 she produced a portrait of Sam Houston for the State Building of the WORLD'S COLUMBIAN EXPOSITION in Chicago, and it distinguished her, at last, as a talented American artist. A marble copy of the Houston statue, as well as one of Stephen Austin, were unveiled in 1903 in the State Capitol: These works and the memorial to General Johnson established Ney's reputation in Texas. She never achieved national fame. Many of her works can be seen in the Elizabet Ney Mus., which the Texas Fine Arts Assoc. maintains at Austin. *Lit.:* B. N. Taylor, *Elizabet Ney, Sculptor,* 1938.

NIEHAUS, CHARLES HENRY (1855–1935), a sculptor. Born in Cincinnati, he learned stonecutting and marble carving before attending the McMicken School of Design in Cincinnati. Niehaus subsequently studied for four years (1877–81) at the Royal Acad. in Munich, where he acquired a taste for the heavy, realistic style of the German academy. This tendency in his work was later modified by the neoclassicism he adopted while working in Rome in the 1880s. From the late 1880s until his death, Niehaus maintained a studio in New York City. His work consists largely of portrait statues and busts, large monuments, and architectural sculpture, executed in a variety of materials and styles. Among his better-known commissions are those for bronze doors for New York's Trinity Church and for the Library of Congress. Niehaus also sculpted a series of statues for the Library of Congress as well as some for the Capitol and other sites in Washington, D.C. His work was exhibited at the Pan-American Exposition in Buffalo (1901) and the Louisiana Purchase Exposition in St. Louis, Mo. (1904), when his portrait statues were in demand. It has been noted that Niehaus's sketches and models were often more appealing than the finished works, which demonstrated a rather stolid eclecticism. *Lit.:* Regina Armstrong, *The Sculpture of Charles Henry Niehaus,* 1901.

NOGUCHI, ISAMU (b. 1904), a Los Angeles-born sculptor, who has also designed

furniture, lamps, gardens, and play-grounds as well as stage sets. Taken to Japan in 1906, he returned to this country in 1918. Four years later, he was briefly apprenticed to GUTZON BORGLUM. He then studied at the Leonardo da Vinci School in New York City, before leaving for Paris in 1927. There, he studied privately with Constantin Brancusi and at the Académie de la Grande Chaumière and Académie Colarossi. He returned to New York City in 1929 but departed the following year for Europe and the Far East, where for two years he studied brush drawing with Chi Phi Shi in Peking and pottery in Japan. In 1935 he began to design sets for dancer Martha Graham, creating at least twenty altogether. In 1935 he travelled to Mexico City, where he completed a high-relief mural in polychromed cement. Its subject was the history of Mexico. He designed the stainless-steel bas relief in the Associated Press Building, Rockefeller Center, New York City, in 1938. As early as 1933, he designed (but never had built) large-scale environments, including a *Monument to a Plow*, covering 12,000 feet of landscape, and an expandable playground. His gardens include those for the UNESCO Building, Paris (1956–58), and for the Beinecke Rare Book and Manuscripts Library, Yale Univ. (1960–64). He has also designed gardens in Japan and two bridges in Hiroshima (1951–52).

A product of two cultures—American and Japanese—Noguchi combined artistic aspects of his dual heritage with those of European modernism. In the late 1920s, his work revealed a Brancusi-like reductionism of forms to simple smooth surfaces, but it skirted abstraction in favor of suggestions of organic movement. "I created a certain morphologic quality," he said. He wanted the materials stone and metal to express themselves to a greater degree than Brancusi allowed. He also created some hanging sculptures of brass rods at this time. After a brief flirtation with social realism in the mid-1930s, he returned to his "undulating" abstract mode. Although he considered

carving to be "the bedrock" of sculpture, he experimented with many materials. In 1942 he placed a lightbulb inside of a burlap-reinforced piece of magnesite, creating one of the first illuminated sculptures. The following year, he started adding lights as integral elements to his pieces. Tension and gravity became essential components of his Gunas, a name applied to a series of works begun in 1945 and composed of flat, amoeba-like marble slabs standing on tripod supports (*Humpty Dumpty*, 1945, WMAA). These works evoke ancestral or mythic images and are related to the rise of BIO-MORPHISM in the middle of the decade.

In small stone and ceramic pieces, especially those made during the 1950s, Noguchi explored problems relating to bases. He either omitted them entirely or integrated the support with the sculpture, searching, as he said, for "bases that bite into the sculpture [or] sculpture that rises from the earth." In the 1960s and later, he increasingly emphasized textural roughness so that, however subtle a composition might be, its surfaces were often left unpolished, (*Sesshu*, 1958, WA; *Stone of Spiritual Understanding*, 1962, MOMA). He also began to use aluminum extensively about 1959 and a few years later created very simple bronze forms that prefigure Minimalist sculpture. However, rather than use reductive systems typical of the MINIMAL ART of the 1960s, Noguchi preferred to explore the mysterious resonances of roughened surfaces as well as the relationships between objects and their environments in his sculpture as well as in his gardens, which range from the completely marble-covered to the virtually natural. In his gardens especially, Noguchi shows how well he has absorbed the Japanese manner of placing objects so that they seem to emerge inevitably from the ground rather than to be located arbitrarily in space. *Lit.:* Sam Hunter, *Isamu Noguchi,* 1978.

NOLAND, KENNETH (b. 1924), a painter closely associated with MINIMAL ART. From Asheville, N.C., he studied at

Black Mountain Coll., primarily with ILYA BOLOTOWSKY but also, to a lesser extent, with JOSEF ALBERS from 1946 to 1948. He received further instruction from Ossip Zadkine in Paris in 1948–49. Until his artistic maturity, which began in 1957, Noland absorbed the abstractionist influences of his teachers and responded to the antic forms and heightened color sense of Paul Klee, to Henry Matisse's concern for structuring through color, and to the gesturalism of ABSTRACT EXPRESSIONISM. As ROBERT MOTHERWELL said in another context, Noland carried the history of modern art around in his head. In 1953, after seeing HELEN FRANKENTHALER's stained paintings, he was able to define his own aims more clearly and, as he said, "to think about and use color." He, too, began to experiment with staining pigment into raw canvas with plastic rather than oil-based paints. His friendship with DAVID SMITH and with critic Clement Greenberg also helped Noland clarify his thoughts and encouraged him to reject autobiographical statement for an emphasis on form, to use color structurally rather than decoratively, and to relate pictorial shapes both to the shape of the canvas and to its surface. In working through these various concerns, Noland explored a relatively narrow range of imagery after 1957. Initially, he chose circular forms whose outermost edges remained jagged. Then in 1961 he eliminated painterly gestures from his handling of pigment. The following year, he developed the oval cat's-eye motif, a circle within an oval. In 1963 he started using chevron motifs in rectangular and diamond-shaped canvases. Some chevrons were assymetrically placed, as in *Bend Sinister* (1964, Hirshhorn Mus.), whereas others filled the canvas surface completely. These motifs were replaced about 1966 by horizontal stripes, which were initially made up of color bands of nearly equal size and later (*April Tune*, 1969, Guggenheim Mus.) of small peripheral and large central bands. Until this time, Noland had manipulated colored shapes in such a way that they did not allow a canvas to be read as a colored object upon which forms echoed its rectilinear shape nor as a field suggesting three-dimensionality. Rather, he attempted to neutralize all depth cues and to bring all shapes on a canvas—including those made by interior forms and the framing edges—into active interaction with each other. As is true also of the stark black-and-white paintings of FRANZ KLINE, there are no backgrounds in a successful painting by Noland—that is, until Noland interrupted these subtle investigations of shape, structure, and surface in 1971, when he began to make "plaid" paintings. In these pictures, overlapping forms and colors are clearly visible. In 1975 he returned to his original line of inquiry by beginning a still-continuing series of irregularly shaped canvases composed of flat, juxtaposed wide bands of color. With GENE DAVIS and MORRIS LOUIS, Noland is one of the first-generation Washington [D.C.] Color Painters. *Lit.:* Diane Waldman, *Kenneth Noland: A Retrospective*, exhib. cat., Guggenheim Mus., 1977.

# O

O'KEEFFE, GEORGIA (b. 1887), a painter of the first generation of American modernists. Born near Sun Prairie, Wis., and raised in that state and in Virginia, she studied at AIC with John Vanderpoel in 1905–6. She then attended ASL, studying with the artists WILLIAM MERRITT CHASE, KENYON COX, and F. Luis Mora. It was during this time in New York City (from 1907 to 1908) that O'Keeffe had her first brief contact with modern trends in the art world. She visited an exhibition of drawings by Auguste Rodin at ALFRED STIEGLITZ's gallery at 291 Fifth Avenue (see LITTLE GALLERIES OF THE PHOTO-SECESSION).

Although O'Keeffe was a successful student at ASL, awarded a scholarship for still-life painting by Chase, she abandoned painting from 1908 to 1912. During that time, she worked as a commercial artist. Her interest in painting was rekindled when she attended summer classes in 1912 at the Univ. of Virginia. There, she encountered the ideas of ARTHUR WESLEY DOW, an influential art educator of the time. After spending two years as the supervisor of art for public schools in Amarillo, Tex., she returned to New York City in 1914. Enrolling at Teachers Coll., Columbia Univ., O'Keeffe studied with Dow himself. Although Dow's paintings seem traditional by comparison with his pupil's work, Dow nonetheless was a major influence on her. His belief that the artist should be concerned only with "filling a space in a beautiful way" seems to have fired O'Keeffe's imagination. In 1915 she began a series of remarkable drawings and watercolors in an individual, abstract style. Most of these works are spare and restricted in color, texture, and form. One, *Blue Lines* (1916, MMA), shows two narrow bands rising above an area of blue pigment at the bottom of the sheet. Such watercolors, which have lit-

tle to do with the kinds of painting that O'Keeffe had been trained to do, illustrate her stylistic independence and her desire at that time to "satisfy no one but myself."

O'Keeffe sent a group of these drawings and watercolors to a friend in New York, who showed them to Alfred Stieglitz. O'Keeffe objected to Stieglitz's hanging them without asking her, and told him so, thus beginning their long association. Stieglitz encouraged her to continue her work, exhibited it in his various galleries, and used her as a model for a large series of his photographs. They were married in 1924.

After her first show with Stieglitz, in 1916, O'Keeffe returned to Texas as head of the art department at West Texas State Normal School, at Canyon. There, her work flourished. The landscape—the plains and canyons—inspired her to paint brightly colored, minimally stated, yet evocative renditions of the natural surroundings. *Evening Star III* (1917, MOMA) captures her fascination with a star appearing at sunset. With four circular and three horizontal strokes, she rendered the star and the flat land merging where the watercolor bleeds together.

From 1918 until 1928, O'Keeffe worked mainly in New York City and at Lake George, a resort area in New York State. Her paintings from this decade established her characteristic themes and style. In 1924 she began to paint flowers—singly, enlarged to fill the entire canvas, closely seen, and often painted in strong, saturated colors. To many critics, these works (*Black Iris*, 1926, MOMA) seemed the visual expression of O'Keeffe's feminine nature.

Also in the 1920s, O'Keeffe did a group of paintings of New York City scenes. These paintings (*Radiator Building—Night, New York*, 1927, Fisk

Univ.) contrast the effects of natural and artificial light on the sharp edges of urban architecture. O'Keeffe also painted rural landscape in the 1920s. The country around Lake George provided her with images to contrast with the city. It was in this decade (in 1929) that O'Keeffe made her first extended trip to New Mexico, a state she visited each summer until 1949. In that year, after settling Stieglitz's estate, she moved to Abiquiu, N. Mex. She continues to live and work in the same area today.

It is, perhaps, for her paintings of New Mexico that O'Keeffe is best known. She has painted both the landscape and the architecture of the Southwest. Sometimes the scale is vast—huge cliffs or large expanse of space (*The White Place in Shadow*, 1942 Phillips Coll.). In others the vision is more intimate, at a closer range, many of her paintings of the dried animal bones she found in the desert. Often in the paintings, the bones are suspended in space before a blue sky. In these works, the space between the bone is as solid and palpable as the bone itself. As in all O'Keeffe's work, the intervals between objects are as important and intensely seen as the objects themselves.

O'Keeffe renders forms in an austere manner. Details are omitted, and her subjects are reduced to their essential components. Color, too, is usually limited in range. She often explores tonal relationships. Although her work still bears comparison with PRECISIONISM, of which she was an exponent during the 1920s and 1930s, it has always been very different in one respect. O'Keeffe's surface finish is never completely smooth and impersonal. Although her canvases are not highly textured, the brushwork is quite visible. Similarly, the edges of her forms are not ruler-straight. Her lines waver slightly; the touch of the artist is clearly present.

O'Keeffe has exhibited extensively in the United States and abroad. Until 1950 her work was shown in Stieglitz's galleries: 291, the Intimate Gall., and An American Place. For a major exhibition of her work in 1966, O'Keeffe painted *Sky Above Clouds IV* (AIC), her first work of mural scale (8 by 24 feet). In 1976 a large collection of reproductions of O'Keeffe's paintings, accompanied by selections of her writings was published by Viking, and it affords a complete survey of her career. Her work can also be seen in numerous public collections, including MMA, WMAA, and NGW. *Lit.: Georgia O'Keeffe*, 1976.

**OLDENBURG, CLAES** (b. 1929), the most important sculptor associated with POP ART. Born in Stockholm, Sweden, he came to America in 1936 and settled with his family in Chicago. After graduating from Yale Univ. in 1950, he returned to Chicago, where he worked as a newspaper reporter. Deciding to concentrate on art, he studied at AIC from 1952 to 1954. In 1956 he moved to New York City, where he soon became part of the artistic milieu in which HAPPENINGS and Pop Art developed. His earliest pieces, influenced by the writings of the French author Louis-Ferdinand Céline and the French artist Jean Dubuffet, revealed a rich combination of fantasy and reality in the use of materials and images evoking the tawdry and junk-filled streets of New York's older business districts. For Oldenburg, to survive in the slums meant to consider and treat that environment as nature and to form an art derived from it. This he did, in an organized way, in *The Street* (1961) and *The Store* (1962). *The Street*, one of the first total-environment exhibitions, included images of cars, people, and objects made from charred cardboard and wood painted brown or black. The effect was one of impoverishment and dejection. Simultaneously, the artist experimented with Happenings as a way to manipulate and to extend pictorial space. A major result was *The Store*, which Oldenburg exhibited in a rented Lower East Side building. It included painted papiermâché and plaster objects of daily life—clothing, flags, shoes, and food (examples are in the Chrysler Mus. and MOMA). Open and friendly (if clut-

tered) compared to *The Street*, with its implications of violence, *The Store*, as Oldenburg remarked of shows in general, "is the gesture of being alive . . . a look into one's continuing daily activity." This attitude undoubtedly also lay behind the genesis of *The Bedroom* (1963), a re-creation of a room that marks Oldenburg's response to Southern California and its motel culture. A modern variant of the realism of The EIGHT, these pieces implied human acts without showing humans in action. Committed to an art of content rather than of purely formal concerns, Oldenburg recomposed into environmental situations those objects that had initially gained his attention and which commanded the attention of their viewers.

The seemingly slapdash techniques used to make all of these environmental pieces allied Oldenburg with the ASSEM-BLAGE movement. The giant objects he began to make in 1962—hamburgers seven feet in diameter, for instance— were closer to Pop Art, in that they were isolated objects meant to be contemplated one at a time. Some were made of painted plaster, others of stuffed and sewn canvas. Linking these objects to advertising, Oldenburg compared them to automobiles displayed in shop windows. Like his earlier sculptures of ray guns (an example of 1959 is in MOMA), these giant works, such as *Floor Burger* (1962, Art Gall. of Ontario, Toronto), have sexual overtones.

Within a year, Oldenburg began to make soft sculpture. *Soft Pay-Telephone* was the first; it was made of vinyl stuffed with kapok. Another was *Soft Dormeyer Mixer* (1965, WMAA). Usually shiny, they mock modern concern for newness and utility. From a formal point of view, they were considered a major innovation in sculpture because their surfaces yielded to pressure and could collapse under the weight of gravity. Furthermore, chance played a part in their appearance since they could be rearranged to fall in several different ways. By the mid-decade, Oldenburg had begun to make three versions of

these common objects—a "hard" one, perhaps of painted cardboard; a "ghost" version, of canvas; and a "soft" one, of vinyl. (An example is *The Ghost Version of a Giant Soft Fan*, 1967, Houston Mus., and *The Soft Version of a Giant Soft Fan*, 1967, MOMA.) In these triplicated pieces, Oldenburg explored various technical problems in creating the same object in different media as well as the different relationships between each version and the real-life subject. Each single piece generated an interest intrinsic to itself, but each set generated interest in its relationships to modern culture and the nature of reality.

In 1965, once again emphasizing environmental concerns, Oldenburg began to draw proposals for colossal monuments, which included a half-peeled banana for Times Square. Some of these have been realized, including a lipstick mounted on a movable tractor (1969, Yale Univ.) and a gigantic clothespin (1975, Philadelphia). Ever alert to new possibilities, Oldenburg created one of the first Earthworks (see EARTH ART) when, in 1967, he dug a hole in New York City's Central Park and then reburied the soil taken from it. During the 1970s, he has reexplored, in different media, forms and themes developed during the previous decade, such as the geometrical mouse (which connotes death), three-way plugs, cigarette butts (fagends), and typewriter erasers. These may vary in size from a few inches to several yards. *Lit.:* Barbara Rose, *Claes Oldenburg*, exhib. cat., MOMA, 1969.

**OLITSKI, JULES** (b. 1922), a painter and, secondarily, a sculptor. Born Jules Demikovsky in Gomel, Russia, Olitski was brought to this country in 1924 and grew up in the New York City area. His serious study of art began in 1939, when he attended the ASL until 1942. From 1940 to 1942, he also studied sculpture at the Beaux-Arts Inst. of Design, New York City. Abroad from 1949 to 1951, he briefly attended the Ossip Zadkine School and the Académie de la Grande Chaumière, in Paris. Always interested

in effects of color, texture, and surface, Olitski as a young student was attracted to artists like Rembrandt. By the mid-1940s, Fauvism had become an absorbing interest, but, while abroad, the artist made "blindfold" paintings in order to free himself from influences. These experiments led to the creation of semiabstract works finished with bright colors. On his return to America, Olitski eschewed aggressive coloration and painted in monochrome on used drawing boards. These richly impastoed works contained dense and nonfigurative passages at their centers, but retained elements of figuration around the perimeters. Because of Olitski's concern for surface qualities, these works have been associated with a French sense of finish; certainly, they contrast with the raw surfaces then current in American painting (see ABSTRACT EXPRESSIONISM). In 1960 Olitski changed his style by experimenting with stain techniques and prismatic colors. Textural effects vanished and biomorphic shapes filled once-empty centers. Contours, figural placement, and hue became dominant concerns. But at the same time, Olitski strove to retain a sense of the density of pigment. In effect, he wanted to emphasize both structure and surface, allowing the pigment rather than the composition the greater responsibility for determining pictorial qualities. Through the early 1960s, his forms grew hard-edged and his compositions nonrelational or holistic: That is, each painting was to be viewed as a single, integrated unit rather than as a series of related elements. Olitski increasingly emphasized color rather than

drawing by establishing subtle and indistinct changes in both hue and value within shapes. By 1964 the flow of color had begun to dominate other concerns. In that year, but more seriously in 1965, Olitski first used the spray gun as a way to eliminate internal divisions of shape. Around the perimeters of his pictures, however, he used bars of color to suggest frames within the actual frame of the canvas (*High A Yellow*, 1967, WMAA). These served to set off the large fluid areas of subtle hue and value modulation that moved across a painting's center. His use of spray and staining techniques, and the thick buildup of pigments in certain sections, provided surfaces with a solidity that appealed more to eyesight than to touch and provided compositional integrity without emphasizing the relationship of forms. As a result, the all-over quality of Olitski's work derives from properties of color rather than properties of structure, unlike the paintings of most major 1960s artists, for example, FRANK STELLA. In the 1970s, again taking a divergent course, Olitski has explored monochromatic problems by providing paint with a solidity that allows one to concentrate on pigment rather than on structure—and further, on pigment as part of a painting rather than as the covering of a painted object (the canvas). *Lit.:* Kenworth Moffett, *Jules Olitski*, exhib. cat., MFAB, 1973.

OPTICAL ART (OP ART). See MINIMAL ART.

O'SULLIVAN, TIMOTHY H. (c. 1840–1882). See PHOTOGRAPHY, CIVIL WAR; PHOTOGRAPHY, FRONTIER.

# P

**PAGE, WILLIAM** (1811–1885), a leading painter of portraits and of classical and religious works. Page was regarded in his own time as the heir to WASHINGTON ALLSTON because of his attraction to traditional historical subjects and to the luminous glazing techniques of the old Venetian masters; both artists, in fact, were called the "American Titian." Page was a colorist of genius, with a detached, experimental interest in the building blocks of his craft—form, color, light, and surface—and a poetic sensibility, a combination of qualities that distinguishes his works markedly from those of his contemporaries. It is not, in fact, until the end of the century, in the more romantic milieu that produced ALBERT PINKHAM RYDER and the later works of GEORGE INNESS that one again finds artists spiritually akin to Page.

Born in Albany, N.Y., Page was initially educated in the law, but about 1825 he began the formal study of art with the portrait painter James Herring. In 1826 he entered NAD, where he worked with SAMUEL F. B. MORSE. During the 1830s and 1840s, Page was active in New York State and Massachusetts. *John Quincy Adams* (1838, MFAB), a rich, grave, and carefully considered study of an old statesman, is a fine example of Page's original and psychologically insightful approach to portraiture.

A number of his thematic pictures, such as the early *Cupid and Psyche* (1843, MMA), brought him afoul of the Puritan prejudices of Victorian America. Though they are, in fact, idealized and lyrical visions, they treat the human body and, in the case of *Cupid and Psyche*, human sexuality in an unconventional (nonliterary, imaginative) way that made many of Page's contemporaries uncomfortable. His reputation was most assured during the decade of the 1850s, when he was the leading painter of the American and British expatriate colony in Rome, making portraits of such notables as Robert Browning and copies after his beloved Titian. Many of Page's pictures, once brilliantly luminous, have darkened and turned to ghostly apparitions as a result of his technical experimentations. He was, however, almost alone in his time in grasping the substance of the expressive and lyrical possibilities of the human form as realized by the old masters, instead of merely copying poses and reviving earlier themes. A collection of his paintings is in MFAB. *Lit.:* Joshua Taylor, *William Page: The American Titian*, 1957.

**PALMER, ERASTUS DOW** (1817–1904), the most important American neoclassical sculptor to pursue his professional career at home rather than abroad in Italy. Palmer was born at Pompey, near Syracuse, N.Y. He was first a carpenter, but, while working in Utica, he began to undertake cameo cutting, at which he was extremely talented. The detailed work was detrimental to his eyesight, however, and he turned to modelling in clay portrait busts later to be put into marble. He moved to Albany, N.Y., in 1846 and remained there the rest of his life, and it is with that city that he is particularly associated.

Palmer began to exhibit in New York City at NAD in 1849. In 1856 he had a one-man show at the Church of the Divine Unity in New York City of marble relief medallions (called the Palmer Marbles), the most important exhibition of a single American sculptor's work held up to that date. Palmer's reputation was made by the exhibition. He also achieved success with high-quality photographs of his sculpture, which sold extremely well in America and even in Europe and, at the same time, popularized his work and brought him orders for rep-

licas. He himself did not visit Europe until late in his career, and then for only a few months. Although Palmer's career was thus almost completely confined to America, he was very much a part of the neoclassical movement. Indeed, his best-known sculpture, *The White Captive* (1859, MMA), is obviously Palmer's answer to HIRAM POWERS's *Greek Slave* (1843), the most famous neoclassical sculpture ever made by an American. Though Palmer's *White Captive* is American in subject, a young woman held against her will by the Indians, the smooth forms and the nudity of the figure are typical features of American neoclassicism. Palmer's second famous full-length piece was *Indian Girl; or, The Dawn of Christianity* (1853–56, MMA), again distinctly American in theme but with religious overtones, as the half-nude woman is shown contemplating a Christian crucifix she has discovered in the woods. Indeed, of all the neoclassical sculptors, Palmer imbued his work most often with religious meaning. Palmer was also particularly proficient in relief sculpture, perhaps more than any other American artist of his day. His early *Morning* and *Evening* (1850, 1851; Albany Inst.), which show the head of an angel, respectively, asleep and awake, reflect the contemporary interest in the passage of time. *Peace in Bondage* (1863, Albany Inst.), an allegory of the Civil War, is a lovely, lyrical relief of great refinement and delicacy. Critics of Palmer's era attributed to his work special nationalistic qualities, since he did not work in Italy, and, despite the notable similarity between Palmer's sculptures and those of his expatriate colleagues, it is true that the New York artist's are marked by a greater suggestion of softness and fleshiness. Indeed, some specialists have found his facial types to be distinctly American. *Lit.*: J. Carson Webster, "Erastus D. Palmer: Problems and Possibilities," *American Art Journal*, Nov., 1972.

**PALMER, FANNY** (c. 1812–1876), an illustrator of prints for CURRIER & IVES. Born Frances Flora Bond, in England, she came to New York City in the early 1840s and joined the staff of the popular printmaking firm well before 1852. She probably made more illustrations than anybody else associated with the company, both alone and with members of her family. She produced scenes of railroads crossing the continent, steamboat races, hunters stalking game, and birds and animals, as well as domestic and rural subjects, most of which show the more positive aspects of life in the 19th century. Among her most famous works are *American Farm Scenes—No. 4* (1853), *A Midnight Race on the Mississippi* (1860), and *The Lightning Express Trains* (1863). *Lit.*: Harry T. Peters, *Currier & Ives: Printmakers to the American People*, 1931.

**PANORAMAS,** a type of theatrical entertainment based on painted scenery, most popular in the United States during the 1840s and 1850s. Invented by Robert Barker in Edinburgh, Scotland, in 1787, the panorama consisted of a circular painting viewed from a central platform. Barker used a *camera obscura* (see PHOTOGRAPHY) to make his original notations, which were then transferred to the canvas itself. This technique ensured great accuracy and, when enhanced by appropriate lighting effects, created a compelling illusion of reality. The first completely circular panorama was erected by Barker in London in 1792 and the entertainment soon became very popular. WILLIAM WINSTANLEY introduced it to America, demonstrating a panorama in New York City in 1795. His subject, painted like the others in the precise topographical tradition, included views of Westminster and of London. In 1807 JOHN TRUMBULL made drawings of Niagara Falls, from which he made two 2½-by-14½-foot panoramas, with the intent of enlarging them to full size in London. Nothing came of his project, however. It was not until 1818 that the first building was erected in America for panoramic viewing—JOHN VANDERLYN's rotunda in City Hall Park, New York City. The first

paintings shown there were made by Henry Barker and Robert Burford, two English artists. Vanderlyn's own *Palace and Gardens of Versailles* (MMA) was presented in 1819. He exhibited other panoramas in the rotunda with intermittent success until 1829. By that time, the moving panorama, in which painted scenery was pulled from one giant roller to another, had been perfected. An early example that served as the backdrop for a play in 1828 was WILLIAM DUNLAP's *A Trip to Niagara*. The stage was designed to look like the deck of a boat and, to the rear, scenery was moved across as the boat "travelled" upstream.

The panoramas had their influence on contemporary painters, notably THOMAS COLE. In the early 1830s, he painted *Italian Scenery at Four Times of Day*, which showed a progression in time from dawn to dusk and, by the addition of architectural embellishments, from ancient to medieval days. He later undertook a number of serial works (*The Voyage of Life*, 1840) as well as wide-focus landscapes (*The Oxbow*, 1836), for all of which he owned a conceptual or technical debt to the panoramas. Later, during the 1840s and 1850s, FREDERIC EDWIN CHURCH and ALBERT BIERSTADT, similarly inspired, were also to paint large, horizontal works.

Panoramas also helped fill the public's insatiable desire for information about the remote areas of the continent. As many as seven were made describing life on the Mississippi. JOHN BANVARD's, begun in 1840, was the most popular, but only one is extant today—a collection of vignettes of river life painted about 1850 by John J. Egan after sketches by Dr. Montroville Dickeson (Univ. Mus., Philadelphia). Even religious panoramas were produced, such as that shown in New York City in 1850 by scene painters May and Kyle illustrating John Bunyan's *Pilgrim's Progress*. After the Civil War, the public grew less interested in panoramas, in part because of the rise of photography. *Lit.*: Lee Parry, "Landscape Theater in America," *Art in America*, Nov.-Dec., 1971.

**PARK, DAVID** (1911–1960), a leader of the San Francisco Bay area figurative school, a group of artists who, in the 1950s, used Abstract Expressionist techniques to paint the human form. From Boston, Mass., he studied briefly at the Otis Art Inst., Los Angeles, in 1928 and then settled in San Francisco, where he remained throughout his life. He taught at CSFA from 1943 to 1952, during the years when the school emerged as a major center of ABSTRACT EXPRESSIONISM under the influence of CLYFFORD STILL and MARK ROTHKO, and at the Univ. of California, Berkeley, from 1955 to 1960. Until 1950 Park was an Abstract Expressionist. Then, realizing, as he said, that "your job is not to force yourself into a style but to do what you want," he reintroduced the figure into his work but evoked it through the rich, textural assertiveness of Abstract Expressionism and the bright colors of Fauvism. His subjects, nude or clothed, were often posed frontally and seem either to stare into space or to be preoccupied with their own thoughts. Park also painted simple still-life arrangements, including sinks, brushes, combs, and table settings, that prefigured West Coast POP ART. With Elmer Bischoff and RICHARD DIEBENKORN, he initiated figure-drawing sessions in 1955, which led to the development and recognition of the Bay Area figurative school. *Lit.: David Park*, exhib. cat., Staempfli Gall., New York City, 1961.

**PATROON PAINTERS,** a recognizable school of largely anonymous painters who flourished in the Hudson River Valley from about 1700 to about 1750. Influenced by both Dutch and English traditions, these artists made portraits of the patricians and wealthy middle class in cities and towns between Albany, N.Y., and New York City. (About 185 works were done by them in the Albany area alone between 1713 and 1744.) Although scholars differ on questions of identificaton, most agree with the following: At least two generations of artists comprise the Patroon Painters. The "Aetatis Sue"

artist (so called because of the inscription giving the subject's age on most of his pictures) was perhaps the major early figure in Albany. He painted in a manner that combined Dutch realism with Flemish courtly elegance (*Portrait of Anthony Van Schaick*, 1720, Albany Inst.). Working at the same time were a group more oriented to England (*Johannes De Peyster III*, 1718, NYHS) and a more modest, homegrown group associated with the DUYCKINCK FAMILY. The second generation, whose works date from the 1730s, included Pieter Vanderlyn, who may be the Gansvoort Limner (c. 1687–1778) (though it has also been claimed he may have been responsible for some of the "Aetatis Sue" pictures) and the painter of charming young children (*The De Peyster Boy*, 1738, NYHS).

English mezzotints often served as models for these artists. As a general rule, their forms tended to be flattened and simplified. Some gave their sitters assertive countenances, others dreamy ones. By 1750 better-trained English artists had begun to arrive in the colonies, relegating the Patroon Painters to the status of folk artists. *Lit.*: Robert Wheeler and Janet MacFarlane, *Hudson Valley Paintings, 1700–1750*, exhib. cat., Albany Inst., 1959.

PAXTON, WILLIAM M. (1869–1941), a prominent painter. Paxton painted genre subjects, portraits, and murals and experimented widely in other media, including etching and lithography. Born in Baltimore, he was brought to Newton, Mass., as a child. A pupil of DENNIS MILLER BUNKER at the Cowles Art School, in Boston, he studied also with Jean-Léon Gérôme at EBA. After returning to America in the early 1890s, Paxton taught at the MFAB school from 1906 to 1913. This artist is best known for his depictions of the leisure class and its servants, as in *Tea Leaves* (1909, MMA), *The New Necklace* (1910, MFAB), and *The Housemaid* (1910, Corcoran Gall.). Recalling Jan Vermeer in their soft and translucent washes and extraordinary attention to details of flesh and textile, these paintings depict the female figure in an idealized and artful fashion. Characterized by highly finished surfaces in the Beaux-Arts manner, they emphasize the material surroundings of their figures and the reflection of light, as is true also of the works of many of Paxton's contemporaries in Boston, including EDMUND C. TARBELL, FRANK WESTON BENSON and PHILIP LESLIE HALE. Paxton was also quite well known as a portrait painter and, after having painted portraits of many fashionable Philadelphians, he earned the sobriquet "court painter of Philadelphia." He also executed murals for the Army and Navy Club, New York City.

PEALE, ANNA CLAYPOOLE (1791–1878), one of several women artists in the Peale family of Philadelphia. Born in that city, Anna Peale was primarily a painter of miniatures, though, like her sisters MARGARETTA ANGELICA and SARAH MIRIAM PEALE, she also painted still lifes. Miniature and still-life painting, in fact, were the two areas of art practiced by early American women painters, both because that was the custom in Europe and because academic training was not available to women at the time. Her few known still lifes are somewhat primitive, but as a miniaturist she enjoyed a professional status equal to that of ANNE HALL in New York City and SARAH GOODRIDGE in Boston, Mass. As with many women artists in both Europe and America, such artistic experience as she received undoubtedly came during her childhood in a household of professional artists; her father, JAMES PEALE, her uncle CHARLES WILLSON PEALE, and her cousin RAPHAELLE PEALE were all extremely able miniaturists. She shared with them a directness of vision and a wiry linearism. Anna Peale's likenesses tend toward a romantic sensitivity and a gentle fragility appropriate to the age in which she painted. She appears to have retired from professional life in the 1840s. *Lit.*: *The Peale Family*, exhib. cat., Detroit Inst., 1967.

PEALE, CHARLES WILLSON (1741–1827), a painter, naturalist, soldier, and entrepreneur. From Queen Annes County, Md., the son of a schoolmaster, Peale was obliged to work as a saddler's apprentice to support his widowed mother. Blessed with boundless energy, he was able to learn something of painting from JOHN HESSELIUS in Philadelphia so that by 1763 he could advertise as a sign painter as well as pursue the trades of saddler, silversmith, and clockmaker. Fiscal embarrassments forced him to leave Annapolis, where he had settled, and on a trip to Boston, Mass., he saw the work of JOHN SMIBERT and met JOHN SINGLETON COPLEY, who encouraged his efforts at portraiture. Returning to Maryland, Peale was the beneficiary, in 1766, of a subscription taken up in order to send him to London to study art. Once there, and by pure chance, he happened upon the studio of BENJAMIN WEST, himself only recently established in London. From West Peale learned all he was to know of the Italian masters. He acquired Italian drawings, which, as he later told John Adams, he always used as his models. He also kept a copy he made of West's copy of a *Venus* by Titian. Though he was often to invoke Venetian coloring in his writings, he could only have known it from such indirect sources as these.

Equally important for Peale were theoretical writers, including Giovanni Paolo Lomazzo, the 16th-century Italian who called the imitation of nature the imitation of God. This fitted nicely with Peale's own deist philosophy. He was also strongly influenced by Charles Du Fresnoy's Latin poem *De Arte Graphica* and by William Hogarth's *Analysis of Beauty*, in both of which the balanced, serpentine curve is described as the essence of formal beauty.

Peale returned to Maryland in 1769 to establish a successful portrait practice. His patrons included George Washington, for whom he also made a set of false teeth. In the War of Independence, Peale served as a captain of the Pennsylvania militia and became a leader of the radical Whigs. He celebrated American victories in large allegorical paintings, which led to important public commissions. The artist's brother JAMES PEALE was given charge of miniature portraits so that Charles could concentrate on large-scale works.

Peale's numerous portraits of Washington (1772, Washington and Lee Univ.; 1776, Brooklyn Mus.; 1779, PAFA; 1784, State House, Annapolis) brought him fame and financial advantage, though the pictures themselves failed to achieve the heroic image he sought. (It remained for GILBERT STUART to create the authoritative icon of the first president, in 1795.) Peale was more successful with his less ambitious portraits. *Mrs. Thomas Harwood* (c. 1771, MMA) is an assured, polished likeness in the realistic manner of Copley. The late, intimate *Lamplight Portrait* of his brother James (1822, Detroit Inst.) is a virtuoso study of the effects of cast light and shadow on different surfaces and textures, and, at the same time, a sensitive interpretation of personality.

Convinced that skill in art was entirely the result of conscientious application and not at all dependent on native talent, Peale deliberately set himself knotty technical problems, as in the *trompe l'oeil* portrait *The Staircase Group* (1795, Philadelphia Mus.), showing his sons Raphaelle and Titian standing on a staircase. The picture was originally set in a door frame, with a real step at the bottom continuing the illusionistic space into the real space of the viewer, and legend has it that George Washington himself was momentarily fooled by it, as were many others. More than a clever trick, the work is indicative of the artist's interest in the veristic rendering of appearance with dramatic light, curvilinear forms, and unusual subjects and compositions.

From 1786 to the end of his life, Peale's preoccupation was his natural history museum. He conceived of it, in its entirety, as a work of art, a "great school of Nature," as he called it. The new republic needed such things if its

lofty ideals were to survive. The artist helped to support the museum by painting 250 portraits of famous Americans to be exhibited in its gallery. Though not an important figure in the history of science, Peale made certain innovations in the exhibition of his specimens, such as showing birds against painted backdrops of the natural habitat. Hearing that large bones were being unearthed on a farm in New York State, Peale travelled there and virtually took control of the operation, expending a great deal of energy and funds to secure the resulting finds for his own use. He painted *The Exhumation of the First American Mastodon* (1806, Peale Mus., Baltimore) to commemorate the event. Surrounding the elaborately detailed apparatus for the excavation are shown seventy-five figures in all, including the artist's relatives and friends and many of the famous scientists of the day. Peale himself stands proudly with his family holding up a drawing of a great thigh bone and pointing to the real one, thus emphasizing his dual role as artist and scientist. If the event was a boon to American science, it was also a triumph for the enterprising Peale. The painting was exhibited beside the skeleton in the museum. In addition to his museum, Peale also established in Philadelphia an art school and the country's first society of artists, the short-lived Columbianum; in 1805 he helped found the PENNSYLVANIA ACADEMY OF THE FINE ARTS.

In the portraits he made of members of his family, Peale emphasized their artistic and scholarly accomplishments by surrounding them with the implements of their work. This tendency culminated in his famous self-portrait, *The Artist in His Museum* (1822, PAFA), in which Peale shows himself with his palette, surrounded by the bones and stuffed animals he had painstakingly collected and preserved. As a portrait type, it may derive from Daniel Mytens's 17th-century painting of the Earl of Arundel showing to the viewer his collection of antiquities. More important, the Peale work is the autobiographical statement of a man

without complex philosophy who is proud of his accomplishments and who wishes, near the end of a long life, to record these for posterity. To posterity Peale also left seventeen children. Raised in an atmosphere of culture and learning, and bearing such weighty names as RAPHAELLE PEALE, REMBRANDT PEALE, RUBENS PEALE, Titian Ramsay Peale, and Angelica Kauffmann Peale, they fulfilled their father's intent and became noted artists and naturalists. Charles Willson's portrait of the Peales (*Family Group*, NYHS, 1773) is a charming study of his remarkable family.

Peale was a quintessentially American product of the Enlightenment. His virtues were also his shortcomings: His enthusiasm led to ill-conceived business ventures but also to the founding of a great museum; moderately accomplished as a painter, his tendency to experiment with pigments led to some Leonardesque disasters but also produced works of startling originality. Highly idealistic but with a homespun pragmatism, Peale was a worthy citizen of the age of Franklin and Jefferson. *Lit.*: Charles Coleman Sellers, *Charles Willson Peale*, rev. ed., 1969.

PEALE, JAMES (1749–1831), a painter and soldier, and the youngest brother of CHARLES WILLSON PEALE. James Peale was born in Chestertown, Md., where he received his early training as a cabinetmaker and learned painting from his brother while making frames for him. During the War of Independence, he served as an officer in the Continental Army. Peale began the professional practice of art in 1782. He and his brother, with typical pragmatism, divided the portrait market between them, with Charles executing oils and James doing mostly miniatures. James's work from this period is virtually indistinguishable from that of Charles, particularly since the brothers frequently touched up and copied each other's work. Some of James's best miniatures are of members of the family. *Mrs. C. W. Peale, Rachel Brewer* (1790, AIC) is a forthright and

attractive portrait. On its verso, framed in braided brown hair, is a scene of a woman mourning at a tomb. James's large-scale portraits tend to be stiffly posed, though they often have romantic landscapes in the background. Gradually, the artist turned to landscape painting and produced some large, impressive works. *On the Schuylkill* (1830, Cincinnati Mus.) has a suggestion of the wind-blown, cloud-laden skies of Constable. It was only in advanced age and with failing eyesight that James took up still-life painting, which brought him his greatest success. Such fruit pieces as *Still Life with Fruit* (1820, Corcoran Gall.) were quite popular. Despite the interest in paint handling, however, they lack the keen observation that distinguishes the still lifes of James's nephew RAPHAELLE PEALE. *Lit.:* The Peale Family, exhib. cat., Detroit Inst., 1967.

PEALE, MARGARETTA ANGELICA (1795–1882), one of the finest women artists of Philadelphia's Peale family. She was born in Philadelphia. Like her sisters SARAH MIRIAM and ANNA CLAYPOOLE PEALE, Margaretta grew up in an artist's household, which accounts for her predilection for painting, and for her early training. Although all of the artistic daughters of JAMES PEALE painted still lifes, Margaretta alone seems to have specialized in this genre, inspired by the work of her father and her cousin RAPHAELLE PEALE, both of whose pictures she occasionally copied. Her original fruit pieces are also similar to theirs in subject matter and in their simple austerity of composition. Margaretta, however, brought a psychological quietness and a dramatic starkness to her work, which makes it the most interesting of that of the Peale women. Her known still lifes are few, but they span a period of over fifty years (there is a good example, of 1828, at Smith Coll.). The continuing activity of Margaretta and her sisters may well help to account both for the attraction of women artists to still life and the large number of women still-life specialists in the Philadelphia area. *Lit.:*

*The Peale Family,* exhib. cat., Detroit Inst., 1967.

PEALE, RAPHAELLE (1774–1825), an impressive painter of still life. Born in Annapolis, he was the first son of CHARLES WILLSON PEALE, the famous painter, soldier, and naturalist, and he grew up in an atmosphere carefully contrived to nurture artistic talent and wide learning. In 1796–97 Raphaelle and his brother, the history painter REMBRANDT PEALE, were painting portraits—life-size and miniature—in Baltimore and, after their father's example, operating a museum and picture gallery. Excelling in miniatures, Raphaelle became an itinerant portraitist, extolling the virtues of his work in humorous newspaper advertisements that offered low prices and a guarantee of satisfaction. In the first decade of the 19th century, Peale began to tour the country with a copying device with which he could produce silhouette portraits in vast numbers very quickly. Using his father's inventions and many more of his own, he attempted to turn a profit with devices for the desalination of sea water and the protection of the bottoms of ships and a method for explaining the workings of the solar system.

Though he was an able portraitist, Peale found his métier as a painter of still life. The first of these was not exhibited until 1812, but, once embarked on this path, Raphaelle followed it to the point of developing a rare mastery. Contrary to the prevailing style in still-life painting, represented by the work of his uncle, JAMES PEALE, who presented a fulsome display of objects and foliage, Raphaelle favored a sparse and carefully selected assortment of fruit, dishes, and other implements on a table, each studied with a keen regard for its own identity, and particularly its unique geometrical form (examples in Brooklyn Mus., Newark Mus., WA). He occasionally substituted vegetables, meat, and fish for fruit, setting off qualities of crispness and dampness against qualities of elasticity and oiliness (*Still Life with Steak,*

1817, MWPI). His was a sensibility, though he never travelled abroad, more closely akin to that of the 17th-century Dutch artists than to that of his contemporaries. Unable to resist a visual pun, he often used as a signature a curling apple peel protruding over the edge of the table.

Perhaps Raphaelle's most famous painting, certainly his most startling, is a *trompe l'oeil* piece called *After the Bath* (1823, Nelson Gall.). It shows a white cloth that seems to hang on a string over the canvas. Visible behind the cloth are the hand, hair, and feet of a presumably nude woman. It was apparently painted to surprise Peale's wife. It is, however, saved from being a mere joke by the technical bravura of its execution, particularly evident in the crisply folded cloth and the play of light, sometimes dramatic, sometimes subtle.

Peale set a standard for still-life painting that was upheld throughout the 19th-century. His achievement in *trompe l'oeil* was not to be surpassed, however, until the emergence of WILLIAM MICHAEL HARNETT and JOHN FREDERICK PETO at the end of the century. Nonetheless, when he died, Peale was employed by a baker in Philadelphia, writing poems to decorate cakes. *Lit.: The Peale Family*, exhib. cat., Detroit Inst., 1967.

PEALE, REMBRANDT (1778–1860), a painter of portraits and historical subjects. Son of the famous painter, soldier, and naturalist CHARLES WILLSON PEALE, he was born in Bucks County, Pa. while his father was with Washington's army at Valley Forge. Reared in the intellectual, artistic milieu of the Peale household, Rembrandt was his father's favorite pupil. The elder Peale founded the first—though short-lived—art academy in America for the benefit of his son and, in 1795, persuaded Washington to sit for Rembrandt, who was then seventeen.

Rembrandt was in Baltimore with his brother Raphaelle in 1797, exhibiting objects from his father's Philadelphia museum. In 1801 he assisted in the legendary exhumation of the first American mastodon skeleton. Often entrusted with the management of his father's affairs, it was Rembrandt who took some of the mastodon bones on a tour of Europe. While in London in 1802–3, he painted portraits and attended classes at the Royal Acad., where he was impressed by the work of BENJAMIN WEST. On two visits to Paris, where he painted portraits for his father's gallery, he was equally taken with the French neoclassicists. The result of the last visit, in 1809–10, was that Rembrandt determined to be a history painter. He was actually invited to be a court painter to Napoleon, and an equestrian portrait of the emperor won wide acclaim. A classical subject, *The Roman Daughter* (1812, Peale Mus., Baltimore), was the object of sharp criticism, however, and Rembrandt, temporarily discouraged, returned to the United States.

In 1814 the artist, acting again for his father, established the Peale Mus. in Baltimore, which, like the one in Philadelphia, was intended to exhibit both art and natural history. Having neglected painting for a time in the pursuit of family business interests, Rembrandt achieved a belated success with *The Court of Death* (1824, Detroit Inst.), a large classical piece that combines the manner of West and Angelica Kauffmann in England with that of the followers of Jacques-Louis David in France. Busy and full of incident, the composition is anchored by a hideous seated figure at the center while others rush about in all directions in rhetorical gestures and in histrionic poses. Among the first American artists to make lithographs, Peale used them to publicize this work, which was enormously successful.

In his later years, Peale maintained studios in various cities and made several trips abroad. These were sometimes financed by making copies of old masters, upon which he freely elaborated. He wrote of his travels in *Notes on Italy* (1831) and published other literary and

didactic works. His achievement as a painter lies in his portraits. His "porthole" portrait of Washington (c. 1823, MMA), a prototype for many versions, was judged one of the best likenesses of the man, as was his *Thomas Jefferson* (1805, NYHS). His *Self-Portrait* (1828, Detroit Inst.), with its glowing light and intense examination of facial features, is clearly indebted to his father's portrait of James Peale (*Lamplight Portrait*) of 1822. Peale, a meticulous artist, has been overshadowed in recent years by his more original and flamboyant brother Raphaelle. *Lit.: The Peale Family*, exhib. cat., Detroit Inst., 1967.

PEALE, RUBENS (1784–1864), one of the artist-sons of CHARLES WILLSON PEALE. Born in Philadelphia, Rubens Peale, more than any of his brothers, was involved in the direction of some of America's earliest museums, following the interest of his father in bringing knowledge and inspiration in art and the natural sciences to the general public as part of a democratic culture. In this capacity, he first directed his father's Philadelphia museum and later similar institutions in Baltimore and New York City. It was only on his retirement in 1855 that Peale turned to creating art rather than exhibiting it, producing landscapes and, particularly, still-life paintings in the last decade of his life. Some of these were original compositions, whereas many others were copies of works by other members of the Peale family. Perhaps due in part to their varied sources, his still lifes vary greatly in quality, though almost all of them display a certain primitive charm. Unlike the other still-life artists of the Peale clan, he occasionally undertook floral subjects, which were just then finding popularity in America. Perhaps his best-known pictures, however, are a number of paintings of families of game birds in their natural settings, probably quite similar to and derived from the habitat groups of the museums he had earlier directed. An example, *Ruffed Grouse in*

*Underbrush*, of 1864, is in the Detroit Inst. *Lit.:* Charles Coleman Sellers, "Rubens Peale: A Painter's Decade," *Art Quarterly*, Summer, 1960.

PEALE, SARAH MIRIAM (1800–1885), one of the earliest and finest women painters of the 19th century. She was born in Philadelphia. Like her sisters MARGARETTA ANGELICA and ANNA CLAYPOOLE PEALE, she grew up painting in the studio of her father, JAMES PEALE. She specialized in portraiture, first in Philadelphia and, after 1831, in Baltimore, until she moved to St. Louis, Mo., in 1847. In Baltimore she worked with her well-known cousin REMBRANDT PEALE, and the solidly modelled forms and rather warm and flushed coloring of her portraits suggest the influence of his French neoclassical training. Sarah Peale was probably the leading portrait painter in Baltimore and the most successful woman portraitist in America in the first half of the 19th century. She was also a still-life painter of ability, choosing rather simple and formal fruit arrangements in the manner of her father and of her cousin RAPHAELLE PEALE. Here, too, Peale achieved success, and her work was acquired by the leading Baltimore collector of the age, Robert Gilmor. She may well have been a leading figure in the development of the arts in St. Louis also, but that phase of her history still awaits study and evaluation. *Lit.: Miss Sarah Miriam Peale, 1800–1885: Portraits and Still Life*, exhib. cat., Peale Mus., Baltimore, 1967.

PEARLSTEIN, PHILIP (b. 1924), a realist painter. From Pittsburgh, he studied art at the Carnegie Inst. of Technology, before moving to New York City in the 1950s. His paintings at the time (primarily landscapes) were created with a gestural technique reminiscent of Chaim Soutine's and of ABSTRACT EXPRESSIONISM. In 1962 he exhibited his first figural works but still used a loaded brush and a generally expressionist manner of creating forms. Shortly afterward, surface ac-

tivity in his paintings diminished to an even, flat covering, and his figures assumed a pale, anemic color. Whatever their race, their skin never glistens. Calling himself a "postabstract realist," Pearlstein considers his realistic figures "a constellation of still-life forms." To underscore the abstract elements of his compositions, he often lets the frame cut through a head or part of a body and arranges his models in contorted poses; he may also tip up the ground plane so that figures ascend the picture surface as well as recede into depth. He has juxtaposed male and female nudes in matter-of-fact poses that deny, or discourage inferences of, psychological or sexual interaction. Often, his figures are posed in a neutral, barely indicated studio environment. As a result, shapes created between two figures and shapes created between a figure and the canvas's edge are vitally significant parts of a composition. The effect is not unlike the abstract compositions of FRANZ KLINE. Pearlstein has also painted portraits, which add a contemporary note of anxiety to the underlying one of melancholy struck earlier, say, by MOSES SOYER. Representative examples of his work are *Two Nudes* (1964, Univ. of Texas) and *Reclining Nude on Tan and Purple Drapes* (1967). *Lit.:* Linda Nochlin, *Philip Pearlstein*, exhib. cat., Univ. of Georgia, 1970.

PÈNE DU BOIS, GUY (1884–1958), a painter and writer. Born in Brooklyn, N.Y., he studied in New York City with WILLIAM MERRITT CHASE, ROBERT HENRI, and KENNETH HAYES MILLER from 1899 to 1905. He travelled to Europe in 1905–6; in Paris he studied under Théophile Steinlen and became acquainted with the work of the painter-draftsman Jean-Louis Forain. On his return, Pène du Bois embarked upon a writing career that he would pursue together with painting throughout his life. He worked successively for the *New York American* as music and art critic; for the *New York Tribune* as an assistant to Royal Cortissoz; and as art critic for the *New York Evening Post*. He edited *Arts and Deco-*

*ration* for seven years, starting in 1913 with a special issue on the ARMORY SHOW, in which he himself exhibited. He returned to France, staying there from 1924 to 1930. He also authored monographs on JOHN SLOAN and WILLIAM GLACKENS (both 1931). Pène du Bois's earliest work, until about 1918, reflects the influence of Henri. Freely brushed and dark in tone, the paintings depict street scenes and other realistic subjects; however, he tended to avoid the seamy side of urban life, choosing his subjects more often from the middle or upper classes, depicting them dispassionately or with a hint of social satire that possibly reflects Forain. By 1920 Pène du Bois had hit upon a style he subsequently used with little variation. People still dominated the scene and were rendered in a minimally modelled, volumetric way, with smoothly applied paint accentuating the roundness of the forms. They are reminiscent of the rather wooden figures of Pène du Bois's teacher Miller and also of the tubular folk sculpture of his contemporary ELIE NADELMAN. In certain satirical works and studies of carnival life they became almost robotlike. In the carnival scenes, he employed a generally more strident palette than his normal cool color modulations. By the 1940s, Pène du Bois had loosened up the outlines of his figures slightly and set them against hazy rather than slick backgrounds; beyond that, his style remained essentially the same. Good examples are in MMA and WMAA. His autobiography, *Artists Say the Silliest Things*, was published in 1940.

PENNELL, JOSEPH (1857–1926), a printmaker, best known for his etchings. From Philadelphia, he began to study etching in the late 1870s and briefly attended the School of Industrial Design (Philadelphia Coll. of Art) and PAFA between 1878 and 1880. From 1884 to 1917, he lived abroad for the most part. He worked in a variety of graphic media and made prints of scenery in many parts of Europe. He also depicted buildings, interiors, and individuals. In style,

he was influenced by JAMES A. M. WHIS-
TLER and in technique by the pen-and-
ink drawings of the popular illustrator
Charles S. Reinhart. He also wrote and/
or illustrated about one hundred books.
A collection of his work is in the Library
of Congress.

PENNSYLVANIA ACADEMY OF THE FINE
ARTS, a society founded in 1805 to pro-
mote the cultivation of the fine arts and
to provide copies of paintings as well as
casts of sculpture for the use of local art-
ists. Like New York City and Boston,
Mass., Philadelphia was a center of artis-
tic activity in the late 18th and early
19th centuries. In 1791 CHARLES WILL-
SON PEALE started a short-lived School for
the Fine Arts and, in 1794, the equally
unsuccessful Columbianum, a cooperat-
ive society of thirty artists that sponsored
a single exhibition before its demise. Or-
ganized and run by local businessmen
and merchants, PAFA did not initially
consider exhibitions of contemporary art
and the establishment of an art school
among its priorities. In 1810 the Soc. of
Artists of the United States was founded
with those dual purposes in mind and
functioned cooperatively with PAFA. In
1824 the Artists' Fund Soc. of Philadel-
phia was formed for the same purpose.
In any event, a life class was instituted in
1812, at first on a temporary basis.
PAFA began to acquire major contem-
porary works about 1816 and, during the
succeeding decades, amassed a major
collection of American art. It is housed
in Frank Furness's High Victorian struc-
ture, which was completed in 1876. *Lit.:*
*In This Academy: The Pennsylvania
Academy of the Fine Arts, 1805–1976,*
exhib. cat., PAFA, 1976.

PEOPLE'S MURALS, a movement begun in
1967 to decorate the walls of buildings in
ghetto communities across the country,
most notably in black and Chicano
neighborhoods. Though trained artists
have joined the effort, many murals
have been created by amateurs. Artists
have also banded together into collec-
tives or cooperatives and have produced
group works. The first important mural
made was the now-destroyed *Wall of
Respect*, created in Chicago in 1967 by
the Organization for Black American
Culture. This was followed the next year
by the *Wall of Dignity*, also in Chicago,
designed by Eugene Eda and by Wil-
liam Walker, one of the major figures of
the movement. Soon, walls were painted
in communities from coast to coast. Sub-
ject matter is community-oriented and
reflects local social conditions. It may in-
clude ethnic history, culture heroes, local
housing problems, and aspirations for
the future. In addition to Walker, impor-
tant figures include John Weber and
Ray Patlán in Chicago, Dona Chandler
in the Boston, Mass., area, and the Artes
Guadalupaños de Aztlán in the Santa Fe
area. *Lit.:* Eva Cockroft, John Weber,
and James Cockroft, *Toward a People's
Art*, 1977.

PEREIRA, I(RENE) RICE (1907–1971), an
abstract painter. From Boston, Mass., she
studied at ASL from 1927 to 1930 with
Jan Matulka, and travelled to Europe
and Africa in 1931. During the mid-
1930s, she made paintings of machine
forms as well as of men and machines.
From 1935 to 1939, she worked for
WPA-FAP, primarily with the New
York Laboratory School of Design,
which helped direct her toward abstract
art and experimentation with materials.
By 1938 she was working with nonobjec-
tive shapes and a variety of materials,
most notably glass panels. Through the
early 1940s, she used layers of glass to
explore resonating light sources, which
she believed came from the depths of a
painting. An example is *Transversion*
(1946, Phillips Coll.). A romantic with a
geometrical style, she used rectangular
and trapezoidal shapes in conjunction
with linear grids to evoke mystical pre-
sences. After 1945 her forms grew more
complex, in part as images began to
overlap. During the 1950s and after, tex-
tures grew rich and rectilinear forms
were emphasized. These often floated on
what appear to be distant vistas of sea
and sky, which provide the geometrical

forms with a quality of mystery reflecting unknown, but felt, essences. Pereira wrote ten books after 1951 describing her interests in light, space, and mysticism. *Lit.:* John I. H. Baur, *I. Rice Pereira*, exhib. cat., WMAA, 1976.

PERFORMANCE ART, a development of the 1970s in which the artist's medium is his body. Based on sources such as HAPPENINGS and Yvonne Rainer's dance performances of the 1960s, it is a broadly encompassing art that includes the work of people who literally use themselves as their principal vehicle for presenting artistic ideas. Consequently, it is a confessional and self-involved art concerned with self-documentation and self-discovery. The artist is a kind of choreographer and the performance area is the workspace. The public may watch a performance, see documentation of it by means of videotape, motion pictures, and photographs, hear it on tape, receive verbal acknowledgment of it, or become part of a piece unknowingly. Presentations may include combined media effects. Particular pieces or events may or may not have narrative content or be planned or improvised. Perhaps the most notorious example of Performance Art was Vito Acconci's *Seedbed* (1972), in which he engaged in private sexual activity under a ramp supporting invited persons.

PERRY, ENOCH WOOD (1831–1915), a painter. From Boston, Mass., he lived in New Orleans from 1848 to 1852, before going to Düsseldorf, Germany, where he remained until 1854. He studied with Thomas Couture in Paris in 1854–55 and was consul in Venice from 1856 to about 1859. He returned to America, settling in Philadelphia and then in New Orleans, where he painted portraits between 1861 and 1863, including those of such leading figures as Senator John Slidell. He travelled to Hawaii and then settled in New York City after the Civil War. His sitters included King Kamehameha IV, Brigham Young, and Ulysses S. Grant. Although he is believed to have studied with EMANUEL GOTTLIEB LEUTZE

while in Düsseldorf, Perry largely escaped his influence, responding instead to Couture's manner of painting. Perry's portraits and many genre scenes are characterized by solid modelling, precisely defined forms, and sharply contrasting shadows and highlights. Through the middle years of his career, his use of detail grew so prolific that his works serve as records of American interiors of the time. Subsequently, Impressionist influences diffused once-sharp definitions, and patterns of light and shadow subordinated narrative to more formal interests. His *The True American* (c. 1875, MMA), showing men reading newspapers on a porch, reveals a humorous streak as well as an ability to catch the telling and characteristic gestures of his sitters.

PERSICO, LUIGI (1791–1860), an Italian sculptor from Naples, who arrived in America in 1818. For several years, he worked in Lancaster, Pa., Harrisburg, Pa., and Philadelphia, sustaining himself as an artist by teaching drawing and painting miniatures. He came to public attention when his bust of the Marquis de Lafayette was exhibited, probably in 1824, when the Frenchman made a farewell tour of America. Taking advantage of his newly won acclaim, he moved on to Washington, D.C., in 1825 and quickly made a number of political friends, including President John Quincy Adams, of whom he executed a portrait bust about 1825.

One of President Adams's last official acts was to sign the contract authorizing Persico to create colossal statues of War and Peace for the niches under the east portico of the U.S. Capitol. These allegorical figures (now in storage) were executed between 1829 and 1835. In addition, Persico received the commission to do the pedimental sculptures for the east front *(The Genius of America*, 1825–28). For the great stairs, the sculptor chose as his subject the discovery of America and showed Columbus striding forth holding an orb, flanked by a crouching, seminude Indian maiden.

*The Discovery* (1844), which was something less than a complete artistic success, has also been removed from its former position and placed in storage crates. These more ambitious sculptural projects for the Capitol, in the neoclassical style, were not as well conceived as Persico's portrait busts, and they drew a barrage of criticism. Nevertheless, it must be said in the sculptor's defense that he had to contend with, and was ultimately defeated by, three adverse factors in his adopted culture: a lack of understanding of the humanist tradition in art, a taste for scurrilous criticism, and xenophobia.

When *The Discovery* was unveiled in 1844, critical comment was so unfavorable that Persico lost any chance of receiving other government commissions. Furthermore, several congressmen thought it unjust that a foreigner should receive government commissions when American sculptors were at hand to do the work. Although Persico continued to exhibit at the Boston Athenaeum and the Artists' Fund Soc. of Philadelphia until 1855, he finally decided to return to Europe. He died in Marseilles. *Lit.:* Wayne Craven, *Sculpture in America*, 1968.

PETERDI, GABOR (b. 1915), a printmaker and painter. Born near Budapest, Hungary, he studied at the Hungarian Acad. of Fine Arts in 1929, the Accademia di Belle Arti, Rome, in 1930, and at the Académie Julian and Académie Scandinave, Paris, in 1931 and was associated with Stanley William Hayter's Atelier 17 from 1933 to 1939 in Paris and again in 1947 in New York City. Peterdi came to America in 1939. Although he has worked in all the graphic media, he is best known for his engravings and intaglio prints. His first color print, *Sign of the Lobster*, was made in 1947. He has been concerned with a variety of themes, which he has often developed in series. An early theme, concentrating on destruction, appeared in his Surrealist-influenced Black Bull series (1939) as well as in such later works as *The Vision of Fear*. He has also explored themes of

generation and nature's elemental forces, especially after 1947 *(Germination I*, 1951). Peterdi's images are very personal but not abstract, and they insinuate themselves into the viewer's consciousness. In the stylistic play between long arabesques and small strokes and dots characteristic of his technique, meaning is implicit and profound. He has said: "All miracles of nature and behind it all the lingering terror of the atomic age—I want to paint all this and say *A man was here.*" His book *Printmaking* was published in 1959. *Lit.*: Una Johnson, *Gabor Peterdi*, exhib. cat., Brooklyn Mus., 1959.

PETO, JOHN FREDERICK (1854–1907), a *trompe-l'oeil* still-life painter who labored most of his life in obscurity. Because he had almost no success as an artist in his lifetime, and due to the slight critical regard given to still-life painters in general in the 19th century, the details of Peto's biography remain sparse. He was born in Philadelphia and is recorded as a student at PAFA in 1878. By far the strongest influence on his work was that of WILLIAM MICHAEL HARNETT, who had studied at the academy a decade earlier, lived in New York City until 1876 and then returned to Philadelphia.

Peto worked first in Philadelphia, where he maintained a studio and exhibited at the academy. To augment his income he travelled often to Island Heights, N.J., where he played the cornet at camp meetings. In 1889 he settled there permanently. When the camp meetings were discontinued, he sold paintings to the genteel families that summered at Island Heights. He lost all touch with the major art centers and, although invitations came yearly, he never again exhibited at PAFA.

Peto worked laboriously; he often abandoned pictures that were near completion and often painted two or three pictures, one atop the other, on the same canvas. In 1905 a Philadelphia dealer unscrupulously acquired a number of Petos, and they began to appear on the Philadelphia art market bearing the sig-

nature of Harnett and fetching grand prices. The styles of the two artists, actually quite different, were thus confused for posterity until the late 1940s.

Peto, unlike Harnett, failed to attract a large audience, in part because he refused to prettify the objects in his paintings. Nineteenth-century America valued still life only insofar as the subject was appealing and evoked nostalgic sentiment. The objects Peto used over and over again in his works are homely and worn—very different from Harnett's shiny, elegant bric-a-brac—and his dark tonalities are more akin to the palettes of THOMAS EAKINS and ALBERT PINKHAM RYDER.

The classic *trompe l'oeil* painting shows objects cluttered on a shelf or fastened to a board or door. Peto was a master of the "rack picture," such as *Old Souvenirs* (1881), in which miscellaneous scraps of paper, a news clipping, envelopes, a photograph, and the like are attached to a wooden board by strips of tape. He began painting these in Philadelphia to decorate offices—as illusions of bulletin boards—and produced them during the rest of his life. Harnett, by contrast, painted few pictures of this type, although *Old Souvenirs* has a faked Harnett signature. Harnett's work is entirely literal in its fidelity to the texture and weight of each object, whereas Peto became increasingly concerned with the play of light over the object and with dramatic contrasts. In *Still Life with Lanterns* (1889), the effects of light are so emphasized as to deny the solidity of the objects and to defy the pull of gravity on them.

*Bowie Knife, Keyed Bugle, and Canteen* follows the pattern Harnett established for "door pictures" with his famous *After the Hunt*, of 1885. It is an exemplary work, but very different in effect from Harnett's bravura canvas, combining qualities of luminous light and muted color with a deep regard for the subject: battered objects brought back by Peto's father from the Civil War. The quality of pathos, of tenderness, even, in many of Peto's works, including the well-known *Poor Man's Store* (1885, MFAB), in which the array of simple wares in a battered storefront window are bathed in a soft yet direct light, also distinguishes Peto from his contemporaries. *Lit.*: Alfred V. Frankenstein, *After the Hunt: William Michael Harnett and Other American Still-Life Painters, 1870–1900*, 2d ed., 1969.

PHILLIPS, AMMI (1788–1865), a leading country portrait painter. From Colebrook, Conn., this self-taught artist crisscrossed the Connecticut, Massachusetts, and New York tristate region from at least 1811, the date of his earliest known pictures, until his last years. Initial formative influences on the artist were works by the itinerants REUBEN MOULTHROP, Nathaniel Wales, and Uriah Brown. In his first mature phase, the so-called Border Portrait period of 1812–19, Phillips painted portrait busts and three-quarter-length and full-length portraits. These works are characterized by flat, heavily outlined forms. *Harriet Leavens* (c. 1815, Fogg Mus.), Phillips's masterpiece, and other subjects of this period exude an otherworldly, dreamlike charm. Between 1820 and 1828, his work turned gravely realistic, probably as a result of contact with EZRA AMES. Backgrounds grew dark and pastel tints gave way to rich colors. Faces were modelled with great attention to plastic definition, as in the portrait of Gabriel Norton Phillips (c. 1824, Connecticut Hist. Soc., Hartford). Phillips's next phase, known as the Kent Portrait period, lasted until 1838. Typical works included women in languid poses. The earlier realism of treatment of features was diluted by a recurrent primitivism coupled with an extraordinary abstract quality of design. *Boy in Red* (1834, Princeton Univ.) is an excellent example. Phillips's work of the 1840s alternated between a realistic starkness and an emotional warmth. His later work was influenced by photography. About 300 paintings have been assigned to him. *Lit.*: Mary Black, Barbara C. Holdridge, and Laurence B. Holdridge, *Ami Phil-*

*lips: Portrait Painter, 1788–1865*, exhib. cat., Albany Inst., 1968.

PHOTOGRAPHY, a process whereby images are produced on a sensitive surface by the action of light, and then fixed by chemical means. The first camera, described as early as the 16th century, was a room *(camera obscura*, or "dark room") with an aperture in one wall. If a piece of paper were held a short distance away from the aperture, the scene outside would be projected on it and could be traced with great accuracy. This early device was later reduced to manipulable proportions and widely used by artists of the 17th and 18th centuries to increase the realism of their work. Ways to fix the camera's image chemically were invented by six different Europeans at approximately the same time: Louis J. M. Daguerre, Nicéphor Niepce, Hercules Florence, William H. Fox Talbot, Sir John Herschel, and Hippolyte Bayard; however, Daguerre's method, producing a positive image on silverplated copper, became the most popular. His announcement in January, 1839, preceded by seven months his revelation of the exact process. As early as March, 1839, the *Boston Mercantile Journal* printed a description of the finished result of Daguerre's process, comparing it to the rival "calotype" invented by the Englishman Talbot; this was reprinted in a number of other American newspapers, including the *Washington National Intelligencer* (March 7, 1839). These accounts, however, were received with skepticism by both scientists and the public. SAMUEL F. B. MORSE, who, as a student at Yale Coll., had tried similar experiments unsuccessfully, was in Paris at the time of the original announcement. He immediately went to visit Daguerre, then wrote a letter describing in detail the daguerreotypes he had seen; this was published in the *New York Observer* on April 20, 1839, and was given more credence. A description of the exact process arrived in New York City on September 20, 1839, about a month after it had been revealed to the French

Académie des Sciences; by September 25, the method had been published in other American cities. Immediately, "amateurs" attempted to duplicate Daguerre's invention. Though Morse himself succeeded in making a daguerreotype view from a window at New York's City Univ. late in September, the credit for making the first daguerreotype in America belongs to D. W. Seager, an Englishman living in New York City. His view of "St. Paul's church and the surrounding shrubbery and houses" was on display on the premises of Dr. James Chilton (another early daguerreotypist) and reported in the *Morning Herald* on September 30. A week later, Seager gave a public lecture and demonstration, quickly spreading knowledge of the technique. Other important early experimenters with the daguerreotype process were John William Draper in New York City, Joseph Saxton in Philadelphia, Edward Everett Hale in Boston, Mass., and Dr. Robert Peter in Lexington, Ky. Almost all these men were either amateur or trained scientists, though this did not exclude their interest in the possibilities daguerreotype held for art.

Though claims were made by many, including Morse and Draper, Alexander S. Wolcott of New York made the first successful daguerreotype portrait, probably on October 7, 1839. He was able to do this by means of an invention that reduced exposure time from five minutes to sixty-five seconds or less. It consisted of a concave reflector of relatively large diameter inserted into the camera, where it reflected light onto the smaller sensitized silver plate. He and his partner, John Johnson, also established the first "daguerrean gallery" to make portraits, using mirrors in the studio to increase the amount of light falling on the sitter. By 1841 improved lenses and chemical discoveries had reduced exposure time to about fifteen to twenty seconds in portrait studios and to as little as one-fifth of a second in outdoor work. Morse also opened a studio (at first with Draper) and supported himself for more

than a year by making photographic portraits and training other photographers, among them MATHEW BRADY and Albert Sands Southworth. By the 1840s, portrait galleries were operating in all the major east-coast cities. Most noted for their artistry and technical skill were the galleries of Robert Cornelius in Philadelphia; of Edward Anthony, Mathew Brady, and John Plumbe, Jr., in New York City; and of the partners Albert Sands Southworth and Josiah Johnson Hawes in Boston, Mass. Daguerreotypes were also used for making panoramic pictures (see PANORAMAS), such as Charles Fontayne's and William Southgate Porter's 1848 view of Cincinnati from the river, made in eight contiguous sections.

The calotype was a negative image produced on paper, from which, unlike the daguerreotype, any number of positive prints could be made. William and Frederick Langenheim of Philadelphia tried to popularize the calotype in America but failed, largely because Talbot had patented his process and photographers rebelled against paying a license fee but also because the paper negative needed a longer exposure time and could not give the extraordinary detail of the daguerreotype, which so delighted the public. In 1851 Frederick Scott Archer invented the collodion or "wet-plate" process in England and it very soon made both the daguerreotype and the calotype processes obsolete. From a negative image on glass, hundreds of paper prints could be made with nearly the clarity of the daguerreotype and with exposures reduced to from two to four seconds. Its drawbacks consisted in having to prepare the plate, expose it while it was still wet, and rush back to the darkroom (or tent) to develop it before it dried, the whole process taking about twenty minutes. The photographer was thus chained to an enormous amount of equipment, making it all the more remarkable that the process was used so successfully for all the pictures made of the Civil War and of the frontier for the geological surveys of the late 1860s and

1870s (see PHOTOGRAPHY, CIVIL WAR; PHOTOGRAPHY, FRONTIER). Archer also discovered that he could make the glass negative appear positive by backing it with black cloth or paint, creating the "ambrotype." The "tintype," a variation, consisted of a collodion negative on a black japanned metal plate. Both the ambrotype and the tintype, used mostly for portraiture, were especially popular in America until the 1860s and 1870s when the carte-de-visite and cabinet photograph—paper prints pasted onto cardboard mounts 4 by 2½ inches and 6½ by 4½ inches, respectively—gained ascendancy.

George Eastman's introduction in 1880 of the gelatin-coated dry plate made it possible to buy prepared plates, expose them at will, and develop them weeks later. His production in 1889 of flexible film was the final step in the direction of the "snapshot." These basic materials are still used in the 20th century, though there have been major developments in film speed (shorter exposures) and in film sensitivity, producing a greater range of colors in the final black-and-white image (panchromatic film). Color film was also a great innovation as was the Land, or Polaroid, camera, which develops film instantly.

PHOTOGRAPHY, CIVIL WAR. During the Civil War (1861–65), photographers were (often reluctantly) given official permission to enter the battle zones, bivouacs, hospitals, and supply camps of the Union Army to record with greater exactitude than had been possible before, the facts of war. The collodion or "wet-plate" process in use at the time was enormously cumbersome (see PHOTOGRAPHY). The relatively long exposure time required meant that it was nearly impossible to get action shots, though attempts to do so were made; and therefore subjects are usually battlefields after the battle, ruins of cities and bridges, supply camps, railroads, officers, men, and corpses.

MATHEW B. BRADY, who felt himself destined to be the pictorial historian of

his times, became one of the greatest, certainly the best known, of these intrepid and ingenious men. He and his employees took two wagons to Bull Run on July 21, 1861, the first battle of the war. In the confusion and panic of the ensuing rout, a good deal of Brady's equipment was damaged, but he safely returned to Washington, replaced everything at his own expense, and hurried back to the field of action. Such experiences became routine. Since they followed the armies so closely, the campaign photographers were frequently in danger. Their wagons were conspicuous targets, and often, even when they were not actually hit, their horses would bolt at the noise, spilling chemicals and breaking the fragile plates.

Brady spent his own money to hire assistants, who manned, at one time, twenty-two wagons dispersed among the Union armies. Since he considered all photographs taken by his employees to be "Brady" photographs, some discontent was created among his men. One of the best, Alexander Gardner (see PHOTOGRAPHY, FRONTIER), who had been in charge of Brady's Washington gallery since 1858 and whose emigration from Scotland Brady had financed, left in 1863 and formed his own photographic corps with some of Brady's best cameramen. When Gardner published his *Photographic Sketch Book of the War* (1865–66), including pictures made by all his employees, he was careful to record the names of the men who made the individual negatives and prints.

Timothy H. O'Sullivan (see PHOTOGRAPHY, FRONTIER) was responsible for some of the most evocative images of the war, including the famous "Harvest of Death" (1863), a view of the corpse-strewn battlefield at Gettysburg in the early morning mist; its poetic mood underscores the absurd wastefulness of the sacrifice. George N. Barnard made his most important series en route with General Sherman through Georgia; like O'Sullivan and Gardner, he usually transcended the merely documentary.

It has recently been demonstrated that Gardner's famous "Home of the Rebel Sharpshooter" (1863) was not taken as found; apparently, Gardner moved the body of a dead soldier to a picturesque spot and propped up his own rifle next to the body. Whether or not Gardner's colleagues also occasionally tampered with facts in order to express a larger truth, their photographic images may well have been too successful in evoking experiences of war in the minds of Americans eager to forget them. Gardner's *Sketch Book* sold very few copies, and both he and Brady were ruined financially, after trying unsuccessfully to sell pictures, many of which had been taken with stereoscopic cameras, with an eye to popular sales that never materialized. (Such cameras produce a double image the same distance apart as the eyes, and, when recombined by a stereopticon viewer, give a striking effect of three-dimensionality and heightened realism. They were extremely popular with the middle class, and most home parlors had a viewer and a basket of stereograph views, but no one wanted to be reminded of the War.)

Though many were mishandled, more than 6,000 glass negatives of Civil War photographs by Brady and those who worked for him are preserved in the Library of Congress and the National Archives in Washington, D.C. *Lit.:* Library of Congress, *Civil War Photographs 1861–1865: A Catalogue*, compiled by H. D. Milhollen and D. H. Mugridge, 1961.

**PHOTOGRAPHY, FRONTIER.** Between 1849, when Robert H. Vance followed the Gold Rush and recorded the miners as well as the California landscape with his daguerreotype camera, to 1885, when the "wet-plate" technique fell out of use, the West was explored and recorded in its freshest aspect by photographers as well as painters. In 1853 JOHN MIX STANLEY accompanied a government expedition seeking the best route for a railroad to the Pacific, and the same year S. N. Carvalho accompanied a private exploring party, making daguerreotypes of In-

dians, buffalo, the plains, and mountains from Missouri to Utah. Almost all of these early pictures, however, are lost, so it is impossible to discuss their quality.

Despite the usual disadvantages of the "wet-plate" or collodion process (see PHOTOGRAPHY), which were magnified by the need for extra equipment, glass plates, and chemicals on the long trips, its introduction in the mid-1850s precipitated a whole new wave of exploratory photography. CARLETON E. WATKINS gained international fame with the large 18-by-22-inch views of California's Yosemite he made in the 1860s. Andrew J. Russell, official photographer of the Union Pacific, recorded the construction of the railroad as it progressed westward from Omaha, Nebr., beginning in 1866. Alexander Gardner (see PHOTOGRAPHY, CIVIL WAR) photographed the construction of the company's eastern division in Kansas, at his own expense. Russell and Gardner made views of towns along the route, of striking geographical and geological features, of Indians, and of the landscape of the Great Plains—a fine record of frontier life in the late 1860s.

After the Civil War, which interrupted governmental exploration, numerous geological surveys were funded by Congress to explore the most inaccessible regions of the West. The first, in 1867, was the U.S. Geological Exploration of the Fortieth Parallel, and its photographer was Timothy H. O'Sullivan (see PHOTOGRAPHY, CIVIL WAR). Exploring Nevada, Utah, Wyoming, and Colorado, O'Sullivan made pictures of stark and strange landscapes with the classically restrained compositions and simply presented details of his Civil War style. On a survey of Arizona and New Mexico in 1873, he made what is considered his masterpiece, a view of the "ancient ruins in the Canyon de Chelly," in which the combined force of historical and geological past evoke the ageless grandeur and mysteriousness of the "new" continent.

William Henry Jackson joined the F. V. Hayden Survey (which included artists SANFORD ROBINSON GIFFORD and THOMAS MORAN) from 1870 to 1878 and became the most famous master of landscape photography. Initially more interested in panoramic views than in the landscape details that preoccupied O'Sullivan, Jackson made many a hazardous mountain climb to obtain pictures of a sweeping vastness. Later he focused more closely on features of unusual interest: His pictures of geysers and boiling mud pools brought the Yellowstone area to the attention of the public, and it was declared a national park in 1872. Jackson built himself the largest camera used in expeditionary photography, one that could produce 20-by-24-inch glass plates. Such large negatives enabled him to convey the magnitude and nobility of the western landscape with the highest degree of detail.

Plans to publish the photographs of the government surveys generally failed to materialize, but many of the photographs themselves survive. There are good collections in MOMA and GEH. *Lit.:* Weston J. Naef, *Era of Exploration*, 1975.

PHOTO-REALISM, primarily a movement in painting, though some sculptors are associated with it, that began after 1965 and reached its creative peak during the early 1970s. As artists once depended on plaster casts or ancient statuary for models, the Photo-Realists depend upon photographs of a scene, rather than the scene itself, as the source of their imagery and style. In this respect, Photo-Realism may be considered an extension or variant of POP ART, since an already extant image (here, a photograph rather than a cartoon, advertisement, or label) serves as the model. The image may be transformed by cropping, superimposition, and juxtaposition as well as by intensification or diminution of colors. Since a photographic source is often exactly reproduced in paint, the viewer occasionally cannot distinguish the painting from a photograph of the same scene. Artists transfer the photographic image to paper or canvas by means of slide projection or laboriously copy their models, some using a grid transfer sys-

tem. Subject matter is usually derived from contemporary life: leisure-time activities, street scenes, and the highway culture. People are rarely included, and the end-product recalls the dehumanized landscapes of PRECISIONISM. Quite often the picture plane seems to disappear not simply because forms appear in precise perspectival relationships but because textures and brushstrokes are suppressed. Pioneering Photo-Realists include Malcolm Morley, who, in the mid-1960s, carefully transcribed travel posters and postcard scenes. Some, like Don Eddy, Robert Cottingham, and RICHARD ESTES paint reflections on surfaces or include glass surfaces in their work, which creates interesting visual problems with regard to establishing the picture plane. CHUCK CLOSE concentrates on portraits. Robert Bechtle and Ralph Goings paint objects of our environment, and Audrey Flack has painted works based on statues. Sculptors John de Andrea and DUANE HANSON create fiberglass figures that are frighteningly lifelike. *Lit.*: Gregory Battcock (ed.), *Super Realism*, 1975.

PHOTO-SECESSION, a group of photographers formed in 1902 by ALFRED STIEGLITZ in opposition to the academic salon system and for the purpose of promoting photography as a fine art. Founders included EDWARD STEICHEN, Gertrude Käsebier, and Clarence H. White. The magazine *Camera Work* (1903–17), edited by Stieglitz, became the vehicle for both the ideas and the images of the group, and his LITTLE GALLERIES OF THE PHOTO-SECESSION, founded in 1905, presented the photographers' work. They were "pictorialists," who believed that photography could be a medium of personal expression and that any means taken to that end were justifiable. They defended manipulative techniques, such as combination printing, double exposure, soft focus, and staged subjects, as well as the use of the "painterly" gum-bichromate process, in which actual pigment forms the final image. They felt their work should be judged by the same aes-

thetic criteria applied to painting, and, from the beginning, their work paralleled the late 19th-century styles of Impressionism, Art Nouveau, and Symbolism.

Käsebier specialized in soft-focus images with a narrative or fictional basis, in the tradition of Julia Margaret Cameron. She concentrated on themes of motherhood and the lot of women, as for example in "The War Widow," depicting a mother with an infant, both dressed in white, in a darkened kitchen. White's pictures have a Whistlerian elegance and balance that bespeak a graceful world of people at leisure, whether in salons or in delicately lighted landscapes. He also collaborated with Stieglitz on a series of nudes with extraordinarily sensitive tonal values. Steichen did nudes in an Art Nouveau style, atmospheric landscapes, and interpretive portraits (best-known is the romantic "Rodin," a combination print of the sculptor next to his statue *The Thinker*). ALVIN LANGDON COBURN'S early work tended to abstraction, concentrating on reflections in water and strong compositional forms. Stieglitz, too, in his early work adhered to the group's basic principles but by 1914 had turned away from the art-for-art's-sake doctrine and ceased altering his photographs, having come to believe that he should seek only those qualities that are unique to the photographic medium. Thus, the concept of "straight" photography was established, and the group drifted apart. Steichen came to agree with Stieglitz, whereas Coburn, believing more than ever in the validity of manipulation as long as photography remained an avant-garde art form, went on to complete abstraction. Käsebier's strong commitment to the pictorial style led her to help form the Pictorial Photographers of America, a group whose low standards and out-of-date sentimentality eventually discredited their original ideas. MOMA has a good collection of the Photo-Secessionists' work. *Lit.*: Robert Doty, *Photo-Secession: Photography as a Fine Art*, 1960.

PICKETT, JOSEPH (1848–1918), a primitive painter. A self-taught artist, Pickett was discovered by the public only after his death. In his earlier years, he travelled with carnivals and ran a shooting gallery, decorating the sides of the booth with painted landscapes and circus motifs. Each winter he returned to his birthplace, New Hope, Pa. At the age of forty-five, Pickett married and settled down in New Hope. He opened a grocery store and painted a landscape containing a large maple tree on the facade. At first he used house paint and brushes made of cat hair, but later he adopted more conventional artist's supplies. Pickett worked on each painting for years, applying the pigments layer upon layer to achieve a raised, relief effect. To give the texture of the material represented, he often mixed sand, crushed shells, and other gritty substances with his paint. Pickett's style is naive, lacking scientific perspective and a sense of three-dimensional space. Instead, his perspective is a personal one, dependent upon the importance he attached to various buildings and objects. His compositions are flat with no shadows, yet they are alive with vivid colors. Very few of Pickett's paintings survive, but it appears he was fond of painting the Pennsylvania landscape, as seen in his *Manchester Valley* (c. 1914–18, MOMA), and local events of the American Revolution, as in *Coryells Ferry in 1776* (c. 1914–18, WMAA).

PINE, ROBERT EDGE (1730?–1788), a British artist working in America after the Revolution. Pine was born in London, a member of an artistic family and brother-in-law of Alexander Cozens, and was painting in London as early as 1749. During the 1760s, he was a serious rival to Sir Joshua Reynolds as a practitioner of grand-manner portraiture and creator of theatrical portraits. He painted George III in 1762 and was a founding member of the Royal Acad. in 1769. He also exhibited as a historical painter, which appears to have been his principal ambition, and toward that end he came to America in 1784 to paint a series of pictures on the theme of American independence. He worked principally in Philadelphia. Pine's only historical work, however, was *Congress Voting Independence* (Pennsylvania Hist. Soc.), left incomplete on his death and finished, rather ineptly, by EDWARD SAVAGE, who also engraved the painting. The picture has documentary value but is uninspired, with no dramatic presence. Pine's numerous American portraits also show little more than competence in likeness and even anatomical rendering, and they suggest a tremendous decline from the best of his English work.

PINNEY, EUNICE (1770–1849), a self-taught watercolorist, who was born and lived her life in Simsbury, Conn. Among the varied subjects of her paintings, many of which have survived, are landscapes, genre scenes, and works with religious and historical themes. All of Pinney's extant work can be dated between 1809 and 1826.

Somewhat primitive in style, her pictures are characterized by a sound sense of composition. Two-dimensional forms are often placed within a decorative setting to give an overall rhythmic effect. *Two Women* (c. 1815, NYHS) shows the artist's interest in design: Figures in perfect profile and the consistent use of a crisscross pattern are combined with a symmetrical layout to provide a stable, satisfying composition. The linear, decorative elements of Pinney's watercolors suggest that she modelled her works on 18th-century woodcuts and book illustrations. Most of her pictures are in private collections. *Lit.*: Jean Lipman, "Eunice Pinney: An Early Connecticut Watercolorist," *Art Quarterly*, Summer, 1943.

PIPPIN, HORACE (1888–1946), a primitive painter. From West Chester, Pa., he lived in New York State as a child, served with the U.S. Army in World War I, and then returned to his hometown in 1920. Although he made drawings as early as 1898, his first serious paintings date from 1930, when he also created designs on wood panels with a

hot poker. Pippin imaginatively interpreted religious and military subjects as well as domestic scenes of his own experience. The military works, such as *End of the War: Starting Home* (1931, Philadelphia Mus.), intimately involve the viewer in the psychological agonies of the scene, a startling occurrence in the field of primitive art, whose practitioners avoid psychological introspection. Perhaps because he was black, his paintings of John Brown on trial, reading his Bible, and going to his execution (1942, the last in PAFA) are filled with barely suppressed emotion, also rare in primitive art. Such feelings were controlled by sophisticated contrasts of detail, with large areas of canvas left relatively bare of forms. Pippin's work, consequently, approximates a 20th-century vision, in that he manipulated form, texture, and color as well as theme to psychological effect. His primitivism lay in his lack of modelling skills, in his inability to suggest atmospheric perspective, and in his use of simplified contours, rather than in his subject matter, which was not simplistic or naive. *Lit.*: Seldon Rodman, *Horace Pippin*, 1947.

PITTMAN, HOBSON (1900–1972), a painter. Born in Epworth, N.C., he studied at Woodstock, N.Y., during summers in the 1920s. He made the first of several trips abroad in 1928. Although primarily a painter, he began to work with linoleum cuts and woodcuts in 1930, completing about fifty blocks, and, in 1931, made the first of about twenty etchings. After exploring a variety of modernist styles, he developed, during the 1930s, a personal romantic realism in a series of small-scaled domestic interiors that evoked the slow-paced lifestyle of the southern middle class. Paintings like *The Widow* (1937, WMAA) suggest that Pittman was really a latter-day American Impressionist in style and choice of themes (see IMPRESSIONISM, AMERICAN). Through the 1950s, he made many still lifes and flower pieces (*Mantel Arrangement*, 1954, Butler Inst.). In his late style, Pittman's brushwork loosened considerably and, in occasional passages of superimposed, translucent images, dreamscapes were suggested. *Lit.*: *Hobson Pittman: Retrospective Exhibition from 1920*, exhib. cat., North Carolina Mus., 1963.

POLLOCK, JACKSON (1912–1956), probably the premier American painter of the century, whose importance and fame derive from the "drip" paintings he made between 1947 and 1951 rather than from a sustained decades-long production. Discounting a very few specific earlier achievements, such as *The Death of Wolfe* (1770) by BENJAMIN WEST, Pollock's paintings can be called the first American works of major consequence in the history of Western art. Born Paul Jackson Pollock, in Cody, Wyo., he grew up in Arizona and California. Two of his brothers, Charles Pollock and Sanford McCoy, also became artists. Pollock studied at ASL from 1930 to 1933 with JOHN SLOAN, ROBERT LAURENT, and THOMAS HART BENTON; the last had the greatest immediate effect on him. Between 1935 and 1943, he was sporadically employed by WPA-FAP. He worked with David Alfaro Siqueiros in 1938, when the latter experimented with spray guns and airbrushes. The following year, he received psychiatric treatment; in 1939 and 1941, he underwent Jungian analysis, a byproduct of which was a series of important drawings generated in part by Pollock's understanding of Jung's categories of archetypes. In the late 1930s, Pollock met JOHN GRAHAM, an influential figure in the early history of ABSTRACT EXPRESSIONISM, and, by 1942, Pollock had become acquainted with such other key figures in that movement, as ROBERT MOTHERWELL and with such Surrealists as Matta. These friendships undoubtedly increased Pollock's interest in the role of the unconscious in art and spurred his interest in the writing of automatic poetry. His first solo exhibition took place in 1943 at Peggy Guggenheim's Art of This Century, the major gallery, at that time, for the young Abstract Expressionists. (Pollock painted

a mural for Guggenheim in 1943–44, now in the Univ. of Iowa.) He worked steadily until 1954, when he began to question his creative vitality. He was killed in a single-car crash.

Pollock's earliest surviving works reveal the influence of Benton and AMERICAN SCENE PAINTING (virtually all of his roughly fifty recorded WPA–FAP paintings have been lost). Although Pollock subsequently repudiated Benton's style and point of view, the coarseness and rhythmic sweep of his later work probably reflects his teacher's expressionist attack, except that Benton's forms tended to coalesce around a central hub whereas Pollock's images pushed out toward the margins. His interest, in the late 1930s, in expressive pictorial effects at the expense of representation was also abetted by the influence of Pablo Picasso and José Clemente Orozco. Given Pollock's taste for subjective rumination, his favorite American artist was, not surprisingly, ALBERT PINKHAM RYDER.

As early as 1937, Pollock had painted completely nonobjective works composed of evenly distributed sequences of color dabs. By 1940 he was already exploring primitive imagery, evoking mythic auras if not specific rituals and forms. The European Surrealists who arrived in New York about 1940, and works by Picasso with which Pollock was already familiar, considerably facilitated his search for prelogical expression. Although the rough handling of pigment and what might be termed "violent automatism" were peculiar to Pollock as well as to other Americans, his *Moon Woman Cuts the Circle* (1943) revealed his knowledge of André Masson's work. Other graffiti-strewn and arabesque-filled paintings, such as *Guardians of the Secret* (1943, San Francisco Mus.) combined elements of Orozco's work with those of Paul Klee and Joan Miró. In addition, an atmosphere of ritual—as if Pollock were a priest performing in rites of his own invention and recording his presence by means of a free calligraphy—may also reflect his early familiarity with Navajo sand painting. Like his earlier pieces, these made passing references to Cubist space, but Pollock emphasized continuous fields of accented forms rather than interrelationships between figures and their backgrounds. Motor vigor and seemingly autonomous linear rhythms evoked compositional openness rather than judiciously arranged, balanced forms.

The great Wassily Kandinsky retrospective in 1945 at the Mus. of Non-Objective Painting (now the Guggenheim Mus.) was probably instrumental in helping Pollock formulate a new approach to painting, according to which the process of making forms, rather than the forms themselves, became the content. Conceptually, such works as *Sounds in the Grass: Shimmering Substance* (1946, MOMA) are intensely private and communicate nothing to the viewer but the immediate mood and associated physical activity of the artist. Among the most subjective works ever painted, they gain meaning through psychological, sociological, and general cultural associations. To a Marxist, they may reflect the total breakdown of communication in a bourgeois society lacking shared cultural assumptions. To a romantic, they may reveal the breakdown of barriers between the spectator and the artist since, without any distracting content between them, the artist can reveal his soul completely. Stylistically, these pictures are richly textured but not sculptural, for their evenly accented surfaces deny volume as well as sensuous appeal. They are the works of a draftsman rather than a colorist.

By 1947 Pollock had begun to pour and drip paint on canvas—now spread on the floor—to ease his task of self-revelation. Of this technique, he said, "I feel nearer, more a part of the painting, since this way I can walk around it, work from the four sides and literally be *in* the painting. ... When I am *in* my painting, I am not aware of what I'm doing." *Cathedral* (1947, Dallas Mus.), one of the first drip paintings, is composed of dense webs of pigment, flowing arabesques, and thickened splashes. Others

are more airy and can evoke lyrical or depressing emotions. Although Pollock was not the first to employ a drip technique, he became the first to build an oeuvre based on it, one that could reveal, with great seriousness of intent, profoundly personal feelings as well as combine the direct confrontation of accidental gesture with intellectual control. Those works revealing the greatest density and airlessness marked a significant development in post-Cubist space. Because of the solid buildup of pigment, but not of definable forms, figure-ground interactions all but disappeared. Lines no longer defined the edges of specific shapes, and centralized focal points vanished. As a result, space extended laterally but not in depth; despite their assertive textures, these drip paintings lacked tactility. With one of the most muscular and gestural styles ever invented, Pollock was able to create in these works a sense of spatial stasis. Consequently, they pointed the way toward post-Cubist, nontactile pictorial space. They also forced recognition of the canvas surface as an object rather than as a "window" through which one sees forms in simulated deep space. And, because they suggested the continuation of art-making activity beyond the edges of a canvas, they helped destroy the notion that art-making must be limited to the creation of definable shapes with definable borders.

Between 1950 and 1952, Pollock made many black paintings. Using thinned black Duco on raw canvas, he fused color and surface in this group of works. In them, he explored the problem of creating shapes that remain part of the canvas instead of pulling away from it in more traditional figure-ground relationships. In the later black paintings, however, such traditional relationships did reassert themselves, indicating that Pollock chose not to explore further the implications of his spatial breakthrough. This is also borne out by his late multicolored works, such as *Portrait and Dream* (1953, Dallas Mus.), which reverted to the mythic subjects of the 1940s. *Lit.*: Francis

O'Conner and Eugene Thaw, *Jackson Pollock*, 1979.

POOR, HENRY VARNUM (1888–1970), a painter and ceramist. From Chapman, Kans., he studied art at the Slade School, London, and the Académie Julian, Paris, in 1910–11. He made pottery decorated with figures during the 1920s and subsequently designed ceramic murals. In 1935 he painted murals in the Department of Justice and in 1937 in the Department of the Interior (both Washington, D.C.) for the Section of Painting and Sculpture (see FEDERAL ART PROJECTS). His portraits and landscapes ally him to the AMERICAN SCENE PAINTING movement, but, unlike THOMAS HART BENTON, Poor tended to paint individuals in quiet, even depressed, moments of their lives, as in *The Pink Tablecloth* (1933, Cleveland Mus.). His landscapes (*Grey Day*, 1932, MMA) reveal a similar austere view of the countryside. In general, his realistic forms were energized by expressive brushwork and bold colors. *Lit.*: Peyton Boswell, Jr., *Varnum Poor*, 1941.

POP ART, a term coined in the mid-1950s by critic Lawrence Alloway to describe products of the mass media. Soon after, the meaning of the term became confined to a fine-arts context and encompassed primarily handmade paintings, sculpture, and graphics whose sources lay in the products of the mass media and popular culture. Pop Art emerged in America during the 1961–62 exhibition season. Its central figures were ROY LICHTENSTEIN, CLAES OLDENBURG, JAMES ROSENQUIST, ANDY WARHOL, and TOM WESSELMANN. JAMES DINE, ROBERT INDIANA, GEORGE SEGAL, and WAYNE THIEBAUD played peripheral roles. BILLY AL BENGSTON, Joe Goode, Mel Ramos, and EDWARD RUSCHA formed a California-based group. Pop Art, together with MINIMAL ART, helped create the 1960s taste for hard-edged and brightly colored forms. In contrast and reaction to ABSTRACT EXPRESSIONISM, interest in process and personal revelation was down-

graded and hidden behind the impersonal mask of images derived from billboards, comic books, advertising illustrations, artifacts of mass culture, and even paintings by Pablo Picasso and Piet Mondrian that have become a part of mass culture.

Just as the public shared common assumptions and knowledge about religion and classical culture in earlier periods, so the contemporary public shares a familiarity with images produced by and for popular culture. These images, however, are not based on systems of thought or accumulated knowledge but rather on previously existing visual signs produced by modern communications systems pervasive in modern culture. Some artists, like Lichtenstein, took pains to transform their models; others, like Rosenquist, juxtaposed disparate images; still others seemed content to copy their models closely while presenting their results in an art context. Regardless of the degree of transformation, Pop Art images are clearly and cleanly rendered, and are invariably isolated from their original environments.

Perhaps because of their discomfort with Pop Art's obviously antielitist and nonintellectual subject matter, critics and historians have emphasized the movement's historical context. Copying preexisting objects has a long and distinguished history in American art, beginning with the pervasive use of English mezzotint models by colonial artists. Stylistic and attitudinal precedents can also be found in such works as the clean-surfaced, deadpan, *trompe l'oeil* canvases of vernacular subjects by WILLIAM MICHAEL HARNETT as well as in the hard-edged industrial subjects of PRECISIONISM. Marcel Duchamp's use of common artifacts as fine-arts images was contributory to the final configuration of the movement. ASSEMBLAGE and HAPPENINGS formed the immediate background for its emergence, since in New York City, at least, Pop artists knew and were sometimes associated with artists linked to those movements.

During the 1950s, ROBERT RAUSCHEN-

BERG and JASPER JOHNS worked with common objects and images, including photographs, stuffed animals, urban detritus, and simulated flags and targets. Other aspects and objects of the environment were introduced into art contexts in the Happenings of such figures as Allan Kaprow, Oldenburg, and RED GROOMS after 1959. By 1960, however, Lichtenstein, Warhol, and others began to move away from the more permissive and participatory aspects of these developments and no longer accepted an easy interchange between found object and art object, between art and life, or between the simple and the more complex reading of an object. They no longer used their models as parts of their works but as models instead, creating totally new works based on them. In this regard, Pop Art has firm links with traditional art forms, media, and techniques since the typical product is a hand-crafted object, whether it is, say, a painting, a silk screen, a sculpture, or a combination of any of these. As a movement with internal coherence, Pop Art existed until the late 1960s. *Lit.*: Lawrence Alloway, *American Pop Art*, exhib. cat., WMAA, 1974.

POPE, ALEXANDER (1829–1924), a popular painter of animal subjects and *trompe l'oeil* still lifes. He was born in Boston, Mass., and first studied sculpture with WILLIAM RIMMER (Pope was the one American still-life specialist to create a considerable body of sculpture). His earliest works were carved hunting trophies, both of live and of dead game birds in painted wood, and his dead-game sculptures are the works by him closest to the paintings of such contemporaries as GEORGE COPE. About 1887 he appears to have begun painting large *trompe l'oeil* still lifes, obviously inspired by the success of WILLIAM MICHAEL HARNETT's *After the Hunt* (1885); these include both hunting pictures and also arrangements of weapons, uniforms, and other military paraphernalia. They are usually extremely large pictures, compositionally based upon a very obvi-

ous geometrical framework. Pope's color is darkly rich, closer to Harnett's than to that of the other members of Harnett's school.

Pope was primarily known in his own time as a painter of animals, not only dead ones but live ones also. He was a successful animal portraitist, painting pictures of famous horses, champion dogs and cats, and similar subjects. And he also turned his hand to a related and very unusual kind of *trompe l'oeil* picture: animals—dogs or chickens for instance—in wooden crates, with chicken-wire netting over them. The chickens look furious and the dogs look wretched, but even more amusing is the simulation of wood and metal. Like the pictures of JOHN HABERLE, this is an example in the field of deceptive realism where a limited amount of painted illusionism is particularly effective. Boston responded appreciatively to Pope, who was one of the most successful followers of Harnett; even the Tsar of Russia owned several of his works. *Lit.*: Alfred V. Frankenstein, *After the Hunt: William Michael Harnett and Other American Still-Life Painters, 1870–1900*, 2d ed., 1969.

PORTER, FAIRFIELD (1907–1975), a realistic painter and a writer. From Winnetka, Ill., he studied at ASL from 1928 to 1930. His mature works, which date from the late 1940s, changed little in style over the succeeding years. He favored intimate themes, whether they were interiors or landscapes. His was a broad, placid stroke and a blond palette, that of a modernized American Impressionist or a follower of Pierre Bonnard. His light-dappled forms, as in *The Garden Road* (1962, WMAA), made up of both small and large planes of color, are usually arranged in shallow space. On occasion, richly painted passages compete as abstract shapes with Porter's realistic formats. The sun usually shines brightly in his paintings, even in interiors, where figures are placed near windows. His urban views reflect a similar calm presence. Porter's point of view was essentially that of an amiable coun-

try dweller, and was perhaps sharpened by his move to Southampton, Long Island, N.Y., in 1949. Porter also painted several portraits, including one of his fellow artist LARRY RIVERS (1951) and one of the poet John Ashbery (1970). Porter wrote art reviews throughout the 1950s and a monograph on THOMAS EAKINS (1959). *Lit.*: *Fairfield Porter: A Retrospective Exhibition*, exhib. cat., Hirschl and Adler Galleries, Inc., 1974.

PORTER, RUFUS (1792–1884), an itinerant painter and inventor. From Boxford, Mass., he is known to have worked as early as 1810 as a house painter and sign painter in Portland, Maine, and other nearby communities. After moving to New Haven, Conn., in 1816, he began to paint portraits and, during the next decade, continued to do so through New England and as far south as Virginia. His earliest known mural landscape was executed in 1824, the last in 1845 (Porter is credited with having made about 150 murals in all). These charming works, often painted over mantelpieces as well as completely around a room, were often done by formula. Colors and forms were arbitrarily simplified and leaves of trees were precisely emphasized. Many objects, for example, steamboats and barns, were copied from outline drawings or created by means of stencils. Invariably, the scenes are amiably rural. A writer and editor as well, Porter wrote an art manual, *A Select Collection of Valuable and Curious Arts, and Interesting Experiments*, that appeared in 1825–26. In 1840 he bought the *New York Mechanic* magazine, changing its name to the *American Mechanic*. He also edited *Scientific American* from 1845 to 1847. After 1845 he concentrated his talents on inventions, which included plans for building an airship. *Lit.*: Jean Lipman, *Rufus Porter: Yankee Pioneer*, 1968.

POUSETTE-DART, RICHARD (b. 1916), a lyrical Abstract Expressionist painter. From St. Paul, Minn., he was largely self-taught but did learn a considerable amount from his father, Nathaniel, an

artist and writer. In the late 1930s, Richard developed a clean-edged, neat style, combining Cubist spaces with odd but not disquieting Surrealist imagery contained within accented ornamental black lines. About 1940 he started embellishing his paintings with enriched surfaces and small jewellike forms and soon began producing biomorphic, often cluttered canvases (*Number 11: A Presence*, 1949, MOMA). Throughout the decade, a delicate, nervous line weaving across forms helped organize his compositions. Through the 1950s, his encrusted surfaces, now containing jewellike color clusters rather than identifiable forms, began to overwhelm the enframing linear webs and biomorphic shapes (*In the Forest*, 1957, AK). By 1960, form had largely dematerialized in a continuous skin of textured color touches suggesting a spatial stasis reminiscent of MARK TOBEY's painting. Often Pousette-Dart organized his compositions around broad circular motifs. His work is less an example of gestural ABSTRACT EXPRESSIONISM than it is an attempt to illuminate the hidden meaning of life. His thickened, dappled surfaces make one aware of the material pressure of reality, but also suggest the permeation of matter by spirit. They call attention to their presence and let one's eyes penetrate to infinite distances. *Lit.*: John Gordon, *Richard Pousette-Dart*, exhib. cat., WMAA, 1963.

POWERS, HIRAM (1805–1873), among the most highly esteemed American sculptors of the 19th century. Powers was born near Woodstock, Vt., but his family soon moved to Ohio, settling near Cincinnati. Fatherless, young Powers worked at various jobs including one at the Luman Watson clock and organ factory. He showed an early interest in sculpture and received some instruction from FREDERICK ECKSTEIN in Cincinnati. About 1828 Powers became supervisor of an exhibition of mechanical devices at Dorfeuille's Western Mus. There, he restored some damaged wax figures and inserted clockwork mechanisms into a tableau of *The Inferno*. This was so realistic that women are said to have fainted at the sight of it, and the exhibit had to be closed. Powers was now determined to be a sculptor. A projected trip to Italy in 1829 ended in New York City, where his funds ran out but where he was at least able to see the work of the leading sculptors of the day. In 1834, with the help of the wealthy Nicholas Longworth, Powers travelled to Washington, D.C., where he executed the marble bust of Andrew Jackson (c. 1835, MMA) that was to launch his career. Apart from its classic drapery, it is a strikingly lifelike portrait. Jackson had said, "Make me as I am, Mr. Powers, and be true to nature always . . . I have no desire to look young as long as I feel old." The weathered face of the sixty-eight-year-old soldier, with its wrinkled, sagging skin, is rendered with consummate skill and rare sympathy. This success brought a host of commissions from the great and famous of Washington, including John Marshall, John Calhoun, Daniel Webster, Martin Van Buren, and John Quincy Adams.

In 1837 Powers, with his wife and two children, left for Italy never to return. In Florence he experienced some difficulty in establishing himself though he had the help of HORATIO GREENOUGH, whom he had met in Boston, Mass. A bust of Greenough made at this time (1838, MFAB) shows the influence of that sculptor's style on Powers. He is shown in classical costume, very much the Boston patrician, idealized and slightly Byronic. It is a strong statement, if somewhat icy compared to the Jackson portrait. Powers returned, however, to a more matter-of-fact naturalism in the 150 portrait busts he completed between 1842 and 1855. These were greatly admired and commanded as much as $1000 each. Powers had earlier done his own marble carving, but he soon found a capable Italian assistant and would eventually employ a dozen to execute his designs.

With success came the means to try his hand at the ideal works without which no sculptor could prove himself a true artist by the standards of the day. In

1838 Powers produced his first life-size work, *Eve* (NCFA), after the most rudimentary training in anatomy. The statue was a success, perhaps as much because of the Victorian preoccupation with fallen women as because of the quality of the work. This was followed by *The Fisher Boy* (1841, MMA), which, coming close on the heels of THOMAS CRAWFORD's *Orpheus* (1839) was the second fully nude male figure designed by an American sculptor. Despite its Praxitelean contraposto, the sculptor denied any classical intent. The boy, holding a shell to his ear and leaning on a tiller with a fishnet over it, represented a contemporary Italian youth with the face and proportions of the boy who modelled for it. It was not considered neoclassical but modern genre, and quite original.

This mode was taken up again in 1843 with *The Greek Slave* (copies at Newark Mus., Corcoran Gall., NCFA, Brooklyn Mus. Yale Univ.), Powers's most famous work. The pose of the nude female figure is closely related to that of the *Medici Venus*, with the head turned to offer the viewer a classical profile. However, the limbs are naturalistic and the proportions uncanonical. It is an example of that peculiar blend of neoclassicism and naturalism that characterizes so much American sculpture in the 19th century. The subject refers to the Greek struggle for independence from the Turks, which had inspired Byron and Eugène Delacroix. Powers wrote a sentimental description to accompany the statue at exhibition: As the girl was a modern Christian and not a pagan idol, her nudity was innocent and part of her plight. After a success in London, where it was sold for $4,000, the statue toured America in 1847. Still hostile to nudity, Americans were at first undecided but were finally won over by the pathetic story and by the efforts of Powers's agent, a deft promoter who saw that a properly reverential mood was created at each showing. The tour was an unprecedented triumph, netting $23,000 and, for Powers, a reputation as the greatest of American sculptors.

Powers continued to make portraits and ideal figures until the end of his life. Sometimes he combined the two, as in a larger-than-life figure of John C. Calhoun (1850) in Roman senatorial garb. This statue was recovered after a shipwreck, only to be burned during the Civil War. Powers became the rival of Crawford for public commissions in Washington, D.C., most of which he lost; however, his statues of Benjamin Franklin (1862) and Thomas Jefferson (1859–63) for the U.S. Senate and House of Representatives are successful efforts with Jean-Antoine Houdon's works as a model for the unobtrusive 18th-century dress. In 1872 Powers completed his last full-length work, *The Last of the Tribe* (1873, NCFA), an Indian maiden, half nude, running and looking back. *Lit.*: Donald M. Reynolds, *Hiram Powers and His Ideal Sculpture*, 1977.

POZZATTI, RUDY (b. 1925), a printmaker, painter, and sculptor. From Telluride, Colo., he graduated in 1950 from the Univ. of Colorado, where he studied with Max Beckmann in 1949 and BEN SHAHN in 1950. He travelled to Italy for the first time in 1952 and since then has found many subjects in that country. He has worked in all the print media, but least often in serigraphy and wood engraving. His first lithographs were made at the Tamarind Workshop, Los Angeles, in 1963, as was his first sculpture, as well. Until 1956 he preferred bringing his graphic images to life through linear rather than tonal means. Afterward, he developed a rich, painterly approach in which velvety blacks easily blended into and merged with lighter tones, regardless of the medium used. He has also made multicolored works. In 1967 he began to undertake traditional line etchings, a technique then little used in contemporary printmaking. His subjects range from animal life, including his often reproduced *The Grasshopper* (1954), to Roman scenes (ancient and modern), to landscapes. His woodcuts, especially (*Saint Martin and the Beggar*, 1959), project a profound emotionality. *Lit.*:

Norman A. Geske, *Rudy Pozzatti: American Printmaker*, 1971.

PRANG, LOUIS (1824–1909), a publisher and lithographer. Born in Breslau, Germany, he was brought up in the European craft tradition. The son of a calico printer, he apprenticed himself to his father from the ages of thirteen to eighteen, then spent five years as a journeyman, acquiring a wider knowledge of printing and dyeing. Because of his liberal political opinions, Prang was placed under the ban of the Prussian government during the Revolution of 1848. Arriving in New York City in 1850, he went on to Boston, Mass., to establish himself as a publisher. Prang turned to lithography in 1856 in partnership with Julius Mayer. Four years later he founded Louis Prang & Co., and his industry and enterprise ensured its success. His company was the first to offer stiff competition to CURRIER & IVES. He continually introduced novelties to the public. During the Civil War, he published maps and plans of battles so that those at home could follow military maneuvers. He invented the Christmas card, putting it on the market in 1875. But in his lifetime he was already recognized for his great contribution: increasing popular appreciation of art. Educating the public in art was a three-part effort for Prang. He issued chromolithographs of the works of such living American artists as Carducius Ream, MARTIN JOHNSON HEADE, GEORGE COCHRAN LAMBDIN, and LILLY MARTIN SPENCER. By publishing drawing books for use in schools, he came to influence methods of teaching art in its elementary stages. Most important, perhaps, he began in 1864 to reproduce famous works of art as chromolithographs. At the time, skeptics were of the opinion that the American public would never pay the six dollars Prang charged for them. But Prang persisted and, largely through his efforts, popular knowledge of European masterpieces grew.

PRATT, MATTHEW (1734–1805), a significant though secondary portrait painter. Pratt was born in Philadelphia, serving an apprenticeship there under James Claypoole, Sr., a portraitist and house painter by whom no works are known today. Pratt began his professional career in 1758, when he must have met the young BENJAMIN WEST. This relationship proved of great significance for Pratt, who followed West to London in 1764, accompanying West's fiancée. He became West's first American pupil. This relationship is immortalized in Pratt's most famous painting, *The American School* (1765, MMA), in which, among the young men depicted, must appear Pratt himself and his fellow American ABRAHAM DELANOY. The picture is famous as an art-historical document, but it also reveals in its severe, geometrical precision, its sculpturesque figures, its stagelike space, its use of local color, and its severity and calm all the formal characteristics of neoclassicism, of which West was to become England's greatest practitioner. Linearism and austerity also characterize Pratt's portraiture, perhaps a heritage of the limner tradition.

Pratt remained with West for two years, but in 1766 began to practice professionally on his own in Bristol, England, which had been the home of West's own first teacher, WILLIAM WILLIAMS. Two years later he returned to Philadelphia, travelling at first between New York and Virginia. In 1773 he had an exhibition of his art in Williamsburg, where he exhibited not only portraits but also still lifes and copies after grand-manner paintings by his teacher. He had settled in his native Philadelphia by 1785, becoming increasingly involved with teaching and decorative painting. Eventually he became a sign painter of unusual distinction, creating works recognized as being far above the usual artisan level of craftsmanship. His later portraiture is not securely attributed; his work of the early 1770s appears to have remained austere, sometimes even grim and haunting, whereas his painting of

about 1790 is less inspired and individual but more sophisticated in its grace and sentimentality, suggesting a kinship with English painting of the period, or with that of the Philadelphia painter JAMES PEALE. *Lit.*: William Sawitzky, *Matthew Pratt, 1734–1805*, 1942.

**PRECISIONISM,** a development between World War I and World War II, also known as Cubist-Realism. Precisionism never was a coherent movement with a central program, a specific point of view, or a set of manifestos or group exhibitions. Instead, it encompassed a broad spectrum of subject matter and styles. Key figures, who were also known as the Immaculates, included CHARLES SHEELER, from whose work Precisionism derives its greatest definition, CHARLES DEMUTH, GEORGIA O'KEEFFE, PRESTON DICKINSON, RALSTON CRAWFORD, and NILES SPENCER. Its stylistic sources lay in the paintings made by the Europeans Francis Picabia and Albert Gleizes when they were in New York City at the time of World War I; in the dry, brittle and mechanistic late works of MORTON LIVINGSTON SCHAMBERG; in JOSEPH STELLA's industrial scenes of the 1915–20 period; in the photography of Sheeler and PAUL STRAND; in early American artifacts; and in Synthetic Cubism and Purism. Precisionist attitudes toward subject matter, somewhat influenced by NEW YORK DADA, echoed the contemporary critical (largely negative) comments about American culture by such literary figures as Harold Stearns, Van Wyck Brooks, and Lewis Mumford. The subject matter itself included industrial, but not always urban, landscapes, views of large towns and cities, American artifacts, and, in O'Keeffe's work, views of the Southwest. Responding to forms in the environment rather than to the environment itself, these artists avoided anecdotal themes. Human beings rarely appear in Precisionist paintings and weather conditions are seldom indicated. The solidity of objects often disappeared into a web of planar forms. Unlike artists of the previous generation (such as JOHN MARIN), the Precisionists did not exult in modern America or indicate in their work any sociological involvement with popular issues or problems. Nor did they choose to suggest the movement of forms. Precisionist images tend to be static. Edges are crisp and clearly defined. Colors tended to be stable rather than modulated and were used less for expressive purposes than as attributes of form. Textures were minimized in the even flow of pigment. Individual marks rarely appeared.

Precisionist paintings were most abstract in the 1920s and 1940s, most realistic in the 1930s. The movement's periods of greatest originality were first the early 1920s and then the late 1930s, when, perhaps influenced by the works of Europe-inspired artists such as STUART DAVIS and the AMERICAN ABSTRACT ARTISTS group, the Precisionists began to make abstract paintings based on the American scene. For example, in Ralston Crawford's works, there appeared at that time the beginning of the first genuinely American abstract style that took into account American subjects, an American sense of scale, and the dry handling of pigment, characteristic of much American art since the 17th century. *Lit.*: Martin Friedman, *The Precisionist View in American Art*, exhib. cat., Walker Art Center, 1960.

**PRENDERGAST, MAURICE** (1859–1924), an artist best known for his watercolors, though he also made oil paintings and monotypes. From St. John's, Newfoundland, he was brought in 1861 to Boston, Mass., where he lived with his brother Charles until 1914, when they moved to New York City. By 1883 he had become apprenticed to a card painter, and Prendergast attributed his lifelong taste for flat-patterned, boldly colored forms to his early lettering experience. He travelled abroad six times: to England in 1886; from 1891 to about 1895 to France, where he studied at the Académie Julian and the Académie Colarossi;

to Italy in 1898–99; to Paris in 1909–10; to Italy in 1911–12; and to Paris in 1914, a trip cut short by World War I. He made more than 200 monotypes between 1892 and 1905. Although he worked in oils throughout his career, he began to use the medium with ever greater frequency after 1904. Prendergast was one of America's first modernists to understand the importance of form and color in the expression of feelings. Not the first to become aware of the Post-Impressionists, he was the first to be influenced consistently by them. From 1895 until the return from Europe of such Americans as MAX WEBER (who came home in 1909), Prendergast was the most modern artist working in America. He became aware of contemporary movements when in Paris in the early 1890s under the tutelage of James Wilson Morrice, the Canadian painter. Initially, JAMES A. M. WHISTLER and Edouard Manet were the strongest influences upon him, but they were soon supplanted by the Nabis, especially Edouard Vuillard and Pierre Bonnard. Tonal, Whistlerian studies gave way to more coloristic works containing firmer, more patterned outlines. *Evening Shower, Paris* (1892) predates in style and subject Bonnard's series of lithographs *Rue le soir sous la parapluie*, published in 1895. Following the lead of the Nabis, he also designed screens with scenes, not of French streets but of the Boston suburbs. Like them, too, his figures also grew more diminutive as they assumed a more integral role in pictorial structure.

Prendergast's first trip to Italy was especially significant. His art acquired a solidity and assertiveness it had lacked in Paris. *Piazza di San Marco* (1898–99, MMA) and *Ponte della Paglia* (1899, Phillips Coll.) combine Neoimpressionist brushstrokes with flat areas of bold color and startlingly eccentric distortions of scale and perspective. In the succeeding years, he painted some of his most advanced pictures, such as *Summer in the Park* (1905–7), composed of bands rather than spots of color. In other, horizontal, works of this period, such as *The Mall,*

*Central Park* (1901) and *The Promenade* (1913, WMAA), he tended to unite foreground and background with flat areas of color, the brushstrokes of the background continuing over and through the figures in front. Yet he never eliminated spatial recession to the same extent as did the younger modernists.

After his trip abroad in 1909–10, Prendergast began to paint nudes that suggest he may have become acquainted with the work of Pierre Puvis de Chavannes, though Prendergast avoided all literary connotations. For a brief period of time after the ARMORY SHOW (in which he exhibited seven pictures), he painted Cézannesque still lifes but soon dropped his new interest in suggesting mass and bulk for his own idiosyncratic concerns for contour and decorative patterning. In his last stylistic phase, dating from about 1918, his figures grew large, and outlines constrained their movements. Surfaces appeared increasingly airless and coagulated with pigment. In these works, he achieved a tapestrylike effect.

From the beginning of his career, Prendergast's subject matter included idyllic scenes of people enjoying the pleasures of the seaside, the park, and the boulevard. Like some of the Nabis, he revelled in uncomplicated themes, enjoying the delights of times happily spent in innocent pleasures. Although he exhibited with The EIGHT, he shared no concerns with the other members of the group except the desire to see art move out of academic stagnation. A collection of his sketchbooks is at MFAB. *Lit.*: Eleanor Green, *Maurice Prendergast,* exhib. cat., Univ. of Maryland, 1976.

PRE-RAPHAELITISM, AMERICAN, a movement and style based on the ideas and works of the English Pre-Raphaelite Brotherhood, which flourished from 1848 until the mid-1850s and originally included John Everett Millais, Dante Gabriel Rossetti, William Holman Hunt, and Thomas Woolner. Finding Raphael's·art too conventional and artificial,

these English artists sought to emulate the 15th-century northern and Italian painters, whom they admired for their careful craftsmanship and serious purpose. The Pre-Raphaelites' examination of nature was meticulous and detailed (here, the aesthetician John Ruskin, who in *Modern Painters* [1843] suggested that artists should neither stress nor reject anything in nature, anticipated their point of view, and his book was widely read in America). The first American to meet the Pre-Raphaelites was THOMAS BUCHANAN READ, who met Rossetti in 1850, but it was William James Stillman, who, as founder and co-editor with John Durand of *The Crayon* (1855–61), became most influential in popularizing their ideas in America. Following the magazine's demise, the Soc. for the Advancement of Truth in Art was founded in 1863, and its journal, the *New Path* (1863–65), continued to spread the Brotherhood's gospel of conscientiousness, perfection of finish, and truth to nature. The periodical also emphasized the virtues of informal and humble still lifes and other scenes from nature. Its spiritually uplifting tone and message echoed and complemented the sentiments of the artists of the contemporary HUDSON RIVER SCHOOL. The English painter Thomas Charles Farrer, who lived in New York City from about 1860 to 1872, helped disseminate the Brotherhood's ideals and techniques. Important American disciples included John William Hill (see HILL, JOHN), who began sketching humble subjects from nature

(birds' nests and dead animals) about 1855, after reading Ruskin, and WILLIAM TROST RICHARDS, who painted intimate and meticulous studies of ferns and forest scenes from the mid-1850s through the mid-1860s, the years when the Brotherhood had the greatest influence on American art. *Lit.*: William H. Gerdts, "The Influence of Ruskin and Pre-Raphaelitism on American Still-Life Painting," *American Art Journal*, Fall, 1969.

PRIMARY STRUCTURES. See MINIMAL ART.

PRIOR, WILLIAM MATTHEW (1806–1873), a New England folk artist, portrait painter, landscapist, and painter on glass. From Bath, Maine, he began to paint professionally as early as 1824, moved to Portland about 1831, and settled in Boston, Mass., between 1837 and 1841. Prior worked in two styles, one primitive and flat, the other more sophisticated with better-modelled figures. (He advertised in 1831: "Persons wishing for a flat picture can have a likeness without shade or shadow at one-quarter price.") An example of his flat style is *Three Sisters of the Coplan Family* (1854, MFAB). In 1850 he copied GILBERT STUART's "Athenaeum" portrait of George Washington, of 1796, from which he then made many copies on glass. After 1834 he formed a partnership with his relations by marriage, the Hamblens. *Lit.*: Jean Lipman and Alice Winchester (eds.), *Primitive Painters in America, 1750–1950*, 1950.

# Q

QUIDOR, JOHN (1801–1881), a highly original painter of literary genre. Quidor and his art were largely forgotten in the latter part of the 19th century. Consequently, few details of his life and career have come down to us. He was born in Tappan, N.Y., and received his only training in a brief apprenticeship, probably between 1814 and 1822, under JOHN WESLEY JARVIS. Although he is listed in a New York directory of 1827 as a portrait painter, no portraits by his hand are known to exist. In fact, he made a living painting banners, and signs and panels for fire engines.

Quidor was always attracted to fantastic literature, and his most successful works illustrate scenes from the tales of Washington Irving and James Fenimore Cooper. *Ichabod Crane Pursued by the Headless Horseman* (1828, Yale Univ.) shows a horse and rider, both grotesquely proportioned, in full flight from the ghostly specter pursuing them through a forest of gnarled trees in lurid moonlight. *The Money Diggers* (1832, Brooklyn Mus.), from Irving's *Tales of a Traveller*, shows clearly some of Quidor's stylistic antecedents. The knobby-jointed figures caught in hair-raising fright by the appearance of "the drowned buccaneer" are derived from the broader strain of Dutch and Flemish genre painting of the 17th century as well as from the 18th-century English satirists William Hogarth and Thomas Rowlandson. In applying this style to subjects chosen from the most imaginative literature of the day, Quidor developed a romanticism that was without European precedent.

Unfortunately for Quidor, there was the growing tide of mid-century realism to combat as well as the fact that the exaggerations of writers like Irving were simply not acceptable at that time in the visual arts. It availed him nothing that in such a work as *A Battle Scene From Knickerbocker's History* (1838, MFAB) he could marshal a large composition with more sweep and drama than JOHN TRUMBULL, the most celebrated American painter of battle scenes.

In the 1840s, Quidor embarked upon a series of seven large canvases of religious subjects to rival those of BENJAMIN WEST. For these he was to be paid partly in cash and partly in real estate in Illinois. In 1847 three of the works were completed and the artist rented an exhibition room at NAD. As was consistent with Quidor's luck, however, HIRAM POWERS's *The Greek Slave*, then the most talked-about work of art in America, was on show in the next room. Quidor's paintings drew little notice and have since been lost. Furthermore, he was swindled out of his land and never received payment for his labors.

Quidor did not lose his sense of humor. *The Embarkation From Communipaw* (1861, Detroit Inst.) from Irving's Knickerbocker's *History of New York* is a deft paraphrase of the composition of Antoine Watteau's *A Pilgrimage to Cythera;* in it, rotund New Amsterdam burghers, Van Kortlandt in the center blowing on a conch shell, make their way lustily to the boat, in sly parody of Watteau's svelte, dreamy lovers.

Quidor's late works became increasingly calligraphic and monochromatic, with a gold tonality again recalling the late Dutch School and Rowlandson. He seems to have experienced a waning of energy, however, becoming more dependent on his stylistic sources; certain late tavern scenes contain direct quotations from Dutch treatments of the same subject.

Quidor retired finally to his daughter's house in New Jersey. His obituary, written by his children, mentioned that he was a once-noted painter in New York but that, "It is ten years since he

painted anything." What little success
the artist enjoyed came early and was
followed by a long eclipse. He had hard-
ly any influence excepting, perhaps, on
the young ALBERT PINKHAM RYDER. Only
after an important showing of his work
at the Brooklyn Mus. in 1942 did the wit
and imagination of this most American
of romantic painters come to be ad-
mired. *Lit.*: David Sokol, *John Quidor:
Painter of American Legend*, exhib.
cat., Wichita Art Mus., 1973.

# R

**RANGER, HENRY WARD** (1858–1916), a noted landscape painter. Born in Syracuse, N.Y., the son of a commercial photographer, Ranger attended Syracuse Univ. and studied art in the United States and abroad. He was most impressed with Dutch and French landscape painting, and his work consistently reflected the influence of the French Barbizon School. His most characteristic works show the interiors of dense woods in rich autumnal colors. Applying the paint thickly over damp varnish, Ranger carefully studied decorative patterns of light on leaves and the bark of trees. In composition, mottled texture, and somberness of mood, such works as *Bradbury's Mill Pond No. 2* (1903, NCFA) are evidence of the impact of Camille Corot's art on Ranger. He was also capable of bright, airy views (*Pastoral Landscape*, 1897).

Having established himself successfully in New York City in 1884, Ranger began about 1900 to spend half his time in Old Lyme, Conn. There, he founded an American Barbizon School, which, though it produced no major artists, had a strong effect on American landscape painting and photography in the early 20th century (see BARBIZON, AMERICAN). Ranger became the dean of American landscapists, winning numerous awards and honors. He left much of his estate to NAD for the purchase of paintings by living American artists. *Lit.*: Peter Bermingham, *American Art in the Barbizon Mood*, 1975.

**RANNEY, WILLIAM TYLEE** (1813–1857), a leading genre specialist. From Middletown, Conn., Ranney participated in the Texan war of independence against Mexico, in 1836. On his return, he set up a studio first in New York City and then across the Hudson River in Hoboken, N.J., which was, at mid-century, something of an artists' center, still rural in character and yet convenient to the art world of New York. Ranney's Hoboken studio was noted at the time for its abundance of western paraphernalia—costumes, guns, and saddles—and it was the life of the western trapper and guide that he made his primary subject matter. Some of these pictures are very spirited, the fast-moving riders gesticulating emphatically, and with exaggerated expressions; others are quiet views of daily life in the little-inhabited plains and among the early pioneers. Also popular were his sporting pictures of duck hunting and shooting in the Hoboken marshes so close to home (*Duck Shooting*, 1850, Corcoran Gall.), and in this specialty he preceded by a few years the better-known ARTHUR FITZWILLIAM TAIT. Ranney also painted a number of more ambitious historical subjects: scenes of the American Revolution and, appropriately enough, the exploits of Daniel Boone, who opened up the western lands; however, Ranney's historical pictures are romanticized, lacking both drama and historical accuracy. He was much liked by his fellow painters, who arranged for a memorial exhibition after his death to aid his improverished family. A number of his colleagues, including WILLIAM SIDNEY MOUNT, also completed pictures left unfinished at his death. *Lit.*: Francis Gruber, *William Ranney: Painter of the Early West*, exhib. cat., Corcoran Gall., 1962.

**RATTNER, ABRAHAM** (b. 1895), a painter. From Poughkeepsie, N.Y., he began his art studies at the Corcoran School of Art, Washington, D.C., in 1914 and then switched to PAFA in 1917. After serving as a camouflage specialist in World War I, he returned briefly to PAFA, only to depart for France, where he remained until 1940, studying at a number of academies and EBA, in Paris. Basically an expressionist, he has responded to

Cubist and Futurist influences throughout his career. Rattner is a provocative colorist, often keying up his palette to simulate the effects of stained-glass windows. Yet, through the small multifaceted planes or broad, swooping planes of multihued forms, a studied draftsmanship provides his works with structural integrity. His themes, ranging from crucifixions to landscapes, reflect Rattner's obviously rich emotional resources. His human figures, regardless of the style in which they are painted, and despite the many incrustations of pigment, invariably seem vulnerable, suggesting that the artist paints the human condition rather than the human comedy. He designed the stained-glass *And God Said Let There Be Light* in 1958 for the Chicago Loop Synagogue. *Lit.:* Allen Leepa, *Abraham Rattner*, n.d.

RAUSCHENBERG, ROBERT (b. 1925), an assemblage-maker and perhaps the major artist of his generation. Born Milton Rauschenberg, in Port Arthur, Tex., he adopted the name Bob in the late 1940s, and it subsequently became Robert. He attended the Kansas City Art Inst. in 1947–48 and the Académie Julian, in Paris, in 1948. He then studied at Black Mountain Coll., N.C., in 1948–49 under JOSEF ALBERS and Anni Albers, and at ASL until 1952 under MORRIS KANTOR and Vaclav Vytlacil. At Black Mountain Coll., he met composer John Cage, pianist David Tudor, and dancer-choreographer Merce Cunningham, with whom he developed a longstanding professional relationship as a designer, manager, and performer in Cunningham's dance company. In 1953 and in succeeding years, Rauschenberg also made designs for Paul Taylor's dance company.

As an artist, Rauschenberg belongs to the generation that includes LARRY RIVERS and JASPER JOHNS; the one that followed ABSTRACT EXPRESSIONISM and anticipated POP ART and MINIMAL ART. Rauschenberg may be considered one of the major figures in the ASSEMBLAGE movement, which became identifiable during the 1950s and was surveyed in the exhibition *Art of Assemblage* at

MOMA in 1961. His use of nonartistic materials, in part based on Dada but without the Dadaist irony and anticultural attitude, was seminal for artists of the 1950s and after. Also provocative has been his use of electronic systems, not as ends in themselves but in connection with painting and other media, such as silk screen and Plexiglas, to record and present images, especially as in *Soundings* (1968, Wallraf–Richartz/Mus., Cologne), an audience-stimulated environmental piece.

Rauschenberg's early works, done about 1950, announced many of the themes and attitudes that governed his subsequent efforts. He worked, for example, with blueprint paper to obtain images of the female nude, indicating his willingness to explore nontraditional materials. His collages of the period included double and multiple images and often dealt with sports-related subjects, and they influenced such artists as ANDY WARHOL. His *White Painting* (1951), composed of seven plain white panels, that served as a backdrop for John Cage's *Theater Piece #1* (1952) at Black Mountain Coll. (perhaps the first HAPPENING) best summarizes the complexity of his thought. It challenged the Abstract Expressionist credo of painting as autobiography. It neutralized the importance of the artist as a creator, for the panels responded to and interacted with their surroundings by capturing shadow images, thus making the artist more of a participant in than a creator of the piece. The painting denied traditional notions of a hierarchy of compositional units, since all elements were of equal importance. This work was followed by a series of black paintings (1951–52) and one of red paintings (four works, 1953), each with collage elements made up of newsprint and fabric. In 1953 Rauschenberg included an electric light in a collage, probably his earliest piece with this feature, and in the same year he packed seeded soil into chicken wire, thus working with nature as well as with modern technology.

*Collection* (1953–54, San Francisco Mus.) was among his first combine

paintings, which he continued to make into the 1960s. Composed of spattered paint, photographs, and small attached objects, these were organized into flexible vertical and horizontal compartments lacking centers of focus. Before 1955 the identifiable images evoked the past, Rauschenberg's own childhood, or a generalized nostalgia. After 1955 the images became more urban and impersonal, derived less from memory than from random encounters with the detritus of an urban street. Rauschenberg suggested that these combines were "unbiased documentations of what I observed, letting the area of feeling take care of itself." His engagement was with objects rather than with ideas or feelings, as if each work were merely chance marks set down in a visual rather than a written diary. He viewed art at this time "as reporting, as a vehicle that will report what you did and what happened to you." Although his combines were filled with splashes of pigment and reproduced images with obvious personal meaning, Rauschenberg refused to think of them as exercises in self-expression—thus assuming the role of an expressionist lacking a compulsion to express anything. As if to underline this idea, he painted *Factum I* and *Factum II* (both 1957), the latter a copy of the former down to the last paint spatter and image. Some combines, such as *Bed* (1955) and *Monogram* (1955–59, Moderna Museet, Stockholm, Sweden), a stuffed goat with a tire encircling its body placed on a collage field, seem less a manipulation than a coordination of materials, whose past histories remain an iradicable ingredient of the work.

Rauschenberg made his first lithographs and silk screens in 1962. Often using transfer drawings (solvent-softened printed paper transferred to other surfaces), he subsequently made a variety of works that, like the earlier combines, brought together disparate images. Now, however, subjects were more recognizable, if no more understandable. For instance, in *Retroactive* (1964, WA), an oil and silk-screen ink on canvas, he juxtaposed news-media pictures of astronauts and of President Kennedy (an image used on at least ten different occasions) with sections of pure paint. Such experimentation also extended to more technologically complex areas. In 1966 he helped engineer Billy Klüver found Experiments in Art and Technology, a collaboration of artists, scientists, and technicians to investigate the utilization of advanced technology in the arts. Nevertheless, Rauschenberg's work remains and looks resolutely handmade. Just as his combines suggest an alliance with the environment, so his more technological works indicate collaboration with rather than capitulation to technology.

In the 1970s, he has explored the use of cardboard and other fragile materials in delicately balanced relief and three-dimensional assemblages. Important series include the Jammer (1975–76), pieces composed of fabric and wood, and evocative of ship sails, and the Hoarfrost (1974–75), works composed of diaphanous veils of fabric often containing transferred images. His new lyricism, still environmentally based, points to a relocation of response—to a world more rural now than urban. *Lit.*: Lawrence Alloway, *Robert Rauschenberg*, exhib. cat., MOMA, 1976.

**RAY, MAN** (1890–1977), a Dada painter, photographer, and filmmaker (see NEW YORK DADA). Born Emmanuel Radensky, in Philadelphia, he grew up in the metropolitan New York area. Largely self-taught, he briefly worked for an engraving firm before studying, for a short period of time in 1911, at the Ferrer School. In that same year, he made *Tapestry* (Mus. Boymans-van-Beuningen, Rotterdam, the Netherlands), a collage of rectangular pieces of cloth, a remarkably early nonobjective work. He produced his first imaginative pictures during the following year. Within the next few years, he explored various aspects of Cubism, to which he was introduced by the work of Americans who had been abroad, such as MAX WEBER, and by paintings he saw at the LITTLE GALLERIES OF THE PHOTO-SECESSION. Pictures of this period include *Five Figures* (1911,

WMAA) and *Portrait of Stieglitz* (1913, Yale Univ.). After meeting Marcel Duchamp in 1915, he turned to Dadaist methods and speculations, creating some of the most sophisticated works ever done by an American. These included his collage self-portrait with electric bells and a pushbutton (1916) and painting *The Rope Dancer Accompanies Herself With Her Shadows* (1916, MOMA). Unlike some of his more notable contemporaries (JOHN MARIN, ARTHUR G. DOVE), Ray derived his forms from mental notations rather than from nature. By chance, in 1917, he invented the rayograph, in which light is applied to negative film without the use of a camera. A few years later, in 1919, he began to use an airbrush, making works with both imperceptible and abrupt tonal changes, as in the gouache, ink, and airbrush *Admiration of the Orchestrelle for the Cinematograph* (1919, MOMA). His explorations of materials led him to make hanging sculpture out of disassembled lampshades (*Lampshade*, 1919) as well as standing pieces, such as *Cadeau* (1921), from a flatiron and carpenter's nails. He helped found the Société Anonyme in 1920, the first American organization to promote modern art, before leaving, in 1921, for Paris, where he remained until 1940. He lived in southern California until 1951 and then returned to Europe, his true spiritual home. While abroad, he participated in Dada and Surrealist exhibitions and events and made four Surrealist films between 1923 and 1929, which contained erotic and automatist elements as well as brilliant passages of tonal variations, thus combining aspects of chance and precise control. *Lit.*: Arturo Schwarz, *Man Ray*, 1977.

READ, THOMAS BUCHANAN (1822–1872), a painter and poet. From Chester County, Pa., he travelled to Cincinnati in 1837 where, two years later, he became an assistant to the sculptor SHOBAL VAIL CLEVENGER. He also worked as a portraitist and sign painter before moving to Boston, Mass., in 1841. He lived in Philadelphia from 1846 to 1850, when he left for

Europe, returning there in 1853–54 and again after the Civil War. Although he spent most of his adult years in Italy, he was one of the first Americans to become friendly with the English Pre-Raphaelites. Also acquainted with American sculptors in Italy, Read, too, tended to choose subject matter that was religious and ideal. Thus, he is part of that line of painters, including WASHINGTON ALLSTON and ARTHUR B. DAVIES, whose art is lyrical rather than dramatic, reflective rather than dynamic. His *A Painter's Dream* (1869, Detroit Inst.) shows an artist dreaming of an ideal woman, a Venus who floats above him, ready to serve as his muse. *Lit.*: John R. Tait, "Reminiscences of a Poet-Painter," *Lippincott's Magazine*, Mar., 1877.

REAM, VINNIE (1847–1914), best known for her statue of Abraham Lincoln, this sculptress was born in Madison, Wis. She sketched Indians as a child. The family moved a great deal but ultimately settled in Washington, D. C., where Ream met and studied under CLARK MILLS and worked as a copyist in the Post Office Department. Ream earned fame in her early adulthood when she was commissioned by the federal government to do a full-length statue of Lincoln, which she completed in 1871. (She was the first woman to receive a government commission for sculpture.) In 1869 she travelled to Rome, where she studied under Clemente Majoli and executed a bust of Cardinal Antonelli. Then she went to Paris, studying under Léon Bonnat and carving portraits of Franz Liszt and Gustave Doré. She executed busts and medallions of many prominent personalities, including General Ulysses S. Grant, General George McClellan, and Horace Greeley. After her marriage in 1878 to Richard Hoxie, she ceased to work for a time but later completed the statue of Admiral David Farragut (1875–81) in Farragut Square, Washington, D.C. Her sculptures may be seen in the NCFA and the State Hist. Soc., Madison, Wis. Her statue of Lincoln is in the U.S. Capitol Rotunda. *Lit.*: Richard Hoxie, *Vinnie Ream*, 1908.

**REDFIELD, EDWARD WILLIS** (1869–1965), the leader of a group of popular Pennsylvania landscape painters. After studying at PAFA in the mid-1880s and going to Europe with ROBERT HENRI in 1887, Redfield returned to Pennsylvania, teaching at PAFA and making his home in Center Bridge. Redfield's landscapes are set in rural Pennsylvania and were recognized in their own time as expressive of the beauty of the American countryside. He was particularly adept at painting winter scenes, which he rendered in a joyous, exuberant manner, and was considered the greatest painter of winter of his time, a successor to JOHN HENRY TWACHTMAN. Unlike Twachtman, however, Redfield's approach was very matter-of-fact, without sentiment or poetry. His pictures are clean of air and bare of incident, light and colorful, with the paint laid on very broadly in thick, vigorous brushstrokes. Though in retrospect Redfield's landscapes appear to be the rural equivalent of the urban-realist pictures of Henri and other members of The EIGHT, contemporaries felt his art to be most closely related to Impressionism. Redfield attracted other artists to him, and he was acknowledged as the leader of a group of rural landscapists that included Daniel Garber, Walter Schofield, and Robert Spencer. These Pennsylvania "Impressionists" were considered unrefined and unartistic, but direct and democratic, by contrast with the figure painters in Boston, Mass., ED-MUND C. TARBELL and FRANK WESTON BENSON, who were thought excessively refined and aristocratic.

**REGIONALISM.** See AMERICAN SCENE PAINTING.

**REID, ROBERT** (1863–1929), a founding member of the TEN AMERICAN PAINTERS. Reid was primarily a muralist, though he also painted genre, figure pictures, and landscapes in the Impressionist manner. Born in Stockbridge, Mass., he studied at the MFAB school from 1880 to 1884 and then at ASL. From 1886 to 1889, he was enrolled at the Académie Julian, in Paris, under Gustave Boulanger and Jules Le-febvre, spending his summers painting in Normandy. Returning to the United States in 1889, he taught in New York City at Cooper Union and ASL and, in 1921, at the Broadmoor Art Acad. in Colorado Springs, Colo. His mural paintings, for the Liberal Arts Building at the WORLD'S COLUMBIAN EXPOSITION (1893), the Palace of Fine Arts at the Panama-Pacific Exposition (1915), the Boston State House (1901), and the north corridor of the Library of Congress, depict neoclassical female figures in the Beaux-Arts manner but with a sense of reality and a decorativeness that relate them to his Impressionist easel works. Such easel paintings as *Violet Kimono* and *The Mirror* (both c. 1910, NCFA) and *Fleur-de-Lys* (c. 1899, MMA) are notable for their rich color, bold design, and vigorous handling of paint, and in their decorativeness they are reminiscent of the works of FREDERICK CARL FRIESEKE and Edward Simmons. *Lit.*: Patricia Jobe Pierce, *The Ten*, 1976. .

**REINHARDT, AD** (1913–1967), a painter, whose visual works and writings reflect a consistently evolving ideological commitment to pure painting uncommon among American artists. Born Adolph Reinhardt, in Buffalo, he studied in New York City with abstractionists CARL HOLTY and Francis Criss in 1936, and with Karl Anderson at NAD at the same time. He joined the AMERICAN ABSTRACT ARTISTS in 1937 and worked for the WPA-FAP Easel Project from that year until 1941. During the 1940s, he made a number of cartoons, which included attacks on the art world, for the newspaper *PM*. More than a gadfly, however, Reinhardt adhered to an ideal by which painting, transcending movements, commercialism, even individual style, would achieve a rigorously impersonal purity of artistic statement, becoming an art concerned only with itself. His paintings and collages of the 1930s were composed of hard-edged, unmodulated, flat planes with both curved and sharply angled perimeters. Devoid of anecdotal reference, they were part of the international Cubist-Constructivist style that flourished

between the world wars. By 1940, using collage as his vehicle, he began to move beyond Cubist pattern and space (though, never leaving them entirely) by atomizing surfaces in all-over patterns in a manner reminiscent of Oriental art, which he studied between 1946 and 1950. These patterns minimized personal touches, meanings, and traditional compositional references so that works appeared to have a life independent of their maker. Although at times, particularly late in the decade, his pictures resembled those of MARK ROTHKO, Reinhardt severely controlled suggestions of biological processes (see BIOMORPHISM). By 1950 vestiges of atmospheric effects had been eliminated through the use of small color bars jammed together in dense juxtapositions. At the same time, Reinhardt began to experiment with large oblong shapes of close-valued colors arranged symmetrically, as in *Abstract Painting, Blue* (1952, Carnegie Inst.). As early as 1953, he made monochrome paintings, sometimes using black—actually very dark greens or blues—which became his preferred color after 1960. In the latter year, he developed his ultimate style in the so-called black paintings. On a five-foot-square surface, nine squares of equal size were painted in close-valued tones of nonreflecting black paint. These works were essentially nonrelational, monotonal, textureless, and devoid of any meaning other than that suggested by their mere presence. They fulfilled Reinhardt's desire for a pure artistic statement. As he said in 1962, "The one work for a fine artist, the one painting, is the painting of the one-size canvas—the single scheme, one formal device, one-color monochrome, one linear-division in each direction, one symmetry, one texture, one free-hand brushing, one rhythm, one working everything into one dissolution and one indivisibility." Nevertheless, the very slight tonal differences of each square in a black painting do suggest the shallowest three-dimensional movement. As a result, Reinhardt's paintings are not inert, illustrating instead the extent to which spatial stasis can be achieved within the Cubist style. *Lit.*: Lucy R. Lippard, *Ad Reinhardt: Paintings*, exhib. cat., Jewish Mus., New York, 1967.

REMINGTON, FREDERIC (1861–1909), the major artist of western subject matter at the turn of the century. From Canton, N.Y., he attended the newly formed Yale Univ. School of the Fine Arts from 1878 to 1880, and there he also demonstrated great interest in sports and outdoor activities. He also briefly studied at ASL in 1886. He first travelled to the West in 1881 and shortly after his return sold a sketch to *Harper's Weekly* (Feb. 25, 1882). Within a few years, he had become a successful illustrator, his work appearing in many magazines, including the *Century* and *Outing*. Not content with illustration, he enrolled in ASL in 1886 but remained there for only a few months. Nevertheless, he often submitted paintings to its annual exhibitions in hopes of being recognized in the field of fine arts as well as in that of illustration. It was as an illustrator, however, that he gained an extraordinary reputation as a delineator of western scenes. His subject matter included cowboys, Indians, cavalrymen, and settlers. He preferred the rough-and-tumble West to the settled West, painting war scenes, camp-outs and the westward migration rather than farming and town scenes. Through all of his work, the attitude that the West belongs to the white man is implicit, though he was able to imbue the Indian with a dignity and nobility. Individual works—for example, *A Cavalryman's Breakfast on the Plains* (c. 1890, Amon Carter Mus.) and *The Fight for the Waterhole* (c. 1895–1900, Houston Mus.) are filled with anecdotal information, while landscape features are subordinated and often barely sketched in. His paintings are a western American equivalent of those by such contemporary French military artists as Edouard Detaille and Alphonse de Neuville and recall their scenes of the Franco-Prussian War.

About 1905 Remington began to experiment with Impressionist techniques,

but, like other Americans attracted to the style, he never allowed the figure to be lost in a maze of brushstrokes (see IMPRESSIONISM, AMERICAN). In 1895 he created his first bronze sculpture, *The Bronco-Buster*. Exhibiting a virtuoso sense of movement, his bronzes became extremely popular and rank among the finest sculptures of western subject matter. They were reproduced in multiple series. Altogether, Remington produced about 2750 drawings and paintings and 25 bronzes. He also wrote eight books and many articles on western life. He travelled widely and was a war correspondent during the Spanish-American War in Cuba, where he painted many pictures of local scenes. Large collections of his work are at the Amon Carter Mus., the Remington Art Mus., Ogdensburg, N.Y., and the Buffalo Bill Memorial Assoc., Cody, Wyo. *Lit.*: Peter H. Hassrick, *Frederic Remington: Paintings, Drawings, and Sculpture in the Amon Carter Museum and the Sid W. Richardson Collections*, 1973.

REVERE, PAUL (1735–1818), a silversmith and engraver. Born in Boston, Mass., he learned silversmithing from his father. He turned to engraving about 1765 and, over the years, engraved bills, money, musical scores, title pages, political prints, portraits, and scenic views. His most famous graphic work, the multicolored *Boston Massacre* (1770) was probably based on Peter Pelham's depiction of the event. Revere printed Massachusetts paper currency and treasurer's notes in 1775–76, during the Revolutionary War. Many of his magazine illustrations are replicas of English prints, a practice common at the time. *Lit.*: Clarence Brigham, *Paul Revere's Engravings*, 1969.

RICHARDS, WILLIAM TROST (1833–1905), a draftsman and landscape and marine painter. His formal education ended at thirteen, when he was obliged to leave his native Philadelphia's Central High School to help support his family by designing ornamental metal fixtures. His early artistic education seems to have

consisted of private study, in the company of WILLIAM STANLEY HASELTINE, with Paul Weber, a German portrait and landscape painter who lived in Philadelphia. Richards may also have attended some classes at PAFA, where he exhibited his first work in 1852. By the 1850s, Richards had settled upon landscape as the favorite subject of his works, some of which were also inspired by literary themes. An example of the connection between Richards's work and prose and poetry is the 1853 series of romantic drawings the artist made to be engraved and collected into a portfolio entitled *The Landscape Feeling of American Poets*.

In 1855 Richards, Haseltine, and Alexander Lawrie, an artist with whom Richards shared a studio in Philadelphia, set off on a European tour. Richards, during this first of many European study trips, came into contact with HIRAM POWERS, THOMAS BALL, EMANUEL GOTTLIEB LEUTZE, and ALBERT BIERSTADT, among others. Richards found contemporary European landscape painting less inspiring than American, and he returned to this country in 1856 with renewed respect for the works of JOHN F. KENSETT and FREDERIC EDWIN CHURCH, both of whom he had met. The influence of Church on Richards's depiction of light and atmosphere can be seen especially clearly in Richards's paintings of the Adirondacks, of the late 1850s and early 1860s (*A View in the Adirondacks*, c. 1860, Univ. of Washington, Seattle). It is possible that Richards was influenced by AARON DRAPER SHATTUCK at this time, for he started to draw and paint plants with the same sort of meticulous accuracy he admired in Shattuck's work. Richards also seems to have beem impressed by the works of the English Pre-Raphaelite artists that were exhibited in Philadelphia in 1858 (see PRE-RAPHAELITISM, AMERICAN). After that time, Richards not only sketched but also painted out-of-doors, hoping to achieve a greater fidelity to nature in his finished works, some of which betray the problems of having in a single picture extremely detailed elements along with the overall atmo-

spheric and spatial qualities necessary in large landscape paintings.

After a trip abroad with his family in 1866–67, Richards turned to marine subjects, emphasizing coastal scenes (*Cove on Conanicut Island*, c. 1877, Cooper-Hewitt Mus.). Though at first he treated this subject matter with the same approach to detail he had taken in his scenes of woodland glades, Richards's technique eventually became broader. From the 1870s, the artist used watercolor as well as oil for his sketches and finished works. By the 1880s, he realized that his painting style was being supplanted in popular taste by the more suggestive work of artists like GEORGE INNESS, and through the 1890s he continued to travel in America and Europe, seeking new places to paint, as well as greater recognition and new markets for his work. *Lit.*: Linda S. Ferber, *William Trost Richards*, exhib. cat., Brooklyn Mus., 1973.

**RICKEY, GEORGE** (b. 1907), a creator of kinetic sculpture and author. Born in South Bend, Ind., Rickey grew up in Scotland, where he was taken in 1913. He studied at the Ruskin School of Drawing, Oxford, in 1928–29 and with André Lhote and at the Académie Moderne in Paris in 1929–30. He returned to America in 1930 but has made repeated trips abroad. He has taught painting at many American colleges. His first mobile dates from 1945 and his first kinetic works in glass from 1949, after which he experimented with a variety of materials. During the 1950s, he explored complex aspects of movement, rather than the shapes of moving parts of a particular piece, emphasizing equilibrium between elements rather than frantic, gravity-defying motion. About 1959 he began to simplify forms, preferring to work with thin blades in vertical and horizontal configurations driven by wind rather than by mechanical means (*Peristyle: Five Lines*, 1963–64, AK). Of these works, both freestanding and suspended, he has said, "I have worked for several years with the simple movement of straight lines, as they cut each other,

slice the intervening space, and divide time, responding to the greatest air currents." All of his pieces are precisely engineered. He has written *Constructivism: Origins and Evolution* (1967). *Lit.*: Nan Rosenthal, *George Rickey*, 1977.

**RIIS, JACOB A.** (1849–1914), a documentary photographer and social reformer. Born in Ribe, Denmark, Riis emigrated in 1870 to America, where he lived in semipoverty for a number of years, experiencing the misery of the majority of immigrants in this country at first hand. Though he was trained as a carpenter, Riis finally found work in 1877 as a police-court reporter for the *New York Tribune*. In 1887 he began a series of flashlight photographs of tenements, police-station lodging houses, and the hideaways that served as beds for "street Arabs," homeless slum children. In 1888 the *Evening Sun* published one of his articles with illustrations hand-drawn after his photographs, but the facsimile reproduction techniques of the time were inadequate and the reduction considerably reduced the effectiveness of his work. Riis's famous book *How the Other Half Lives* was published in 1890 (reprinted in 1971) with seventeen photographic halftone reproductions (the remaining nineteen were reproduced by the old method). The book was devastating in its impact and moved Theodore Roosevelt, then governor of New York, to undertake the social reforms necessary to wipe out the worst of the slums and establish needed building codes.

An avid social reformer, Riis had his era's prejudices concerning slum dwellers, believing that certain races and nationalities had inherent tendencies toward the conditions in which they found themselves. Yet his photographs seem entirely sympathetic with their subjects and have given rise to the general misunderstanding of the complex nature of his personal attitude. The extreme sophistication of his compositions and the merciless light of the flashlight powder he successfully experimented with make his pictures impressive even today after a century of brilliant

achievements in documentary photography. A collection of Riis's work is in MCNY.

RIMMER, WILLIAM (1816–1879), one of the most imaginative American painters and sculptors, often called the "American Michelangelo." Born in Liverpool, England, Rimmer grew up in Boston, Mass., and was inspired by WASHINGTON ALLSTON, the most original American artist of the previous generation. Rimmer was also a self-trained physician, which may account in part for his superb grasp of anatomy. He is particularly admired as an extremely original sculptor, but actually few sculptural works by him exist. Several are in granite, among them *Head of a Woman* (1858) and *Saint Stephen* (1860), and the rugged nature of the material and tortuous conception of the subject matter are in direct contrast with the smoothness of the prevailing neoclassical marble technique (see NEOCLASSICAL SCULPTURE). Rimmer's only public commission, the granite *Alexander Hamilton* (1864) on Boston's Commonwealth Avenue, is somewhat fussy and less successful, lacking the intensity of his finest work.

Rimmer's best-known sculptures were conceived as bronze pieces, the *Falling Gladiator* (1861, MFAB), *Fighting Lions* (1871, MMA), and *Dying Centaur* (1871, MFAB). Though the *Gladiator* and *Centaur* are classical in subject, they are not neoclassical in conception: The rippling musculature and Baroque movement and the expressive emotionality of their tortured forms are, indeed, antithetical to the tenets of that style. The *Lions* has been called the finest animal sculpture of the 19th century; it is far more furious and intense than the more scientific work of Rimmer's French contemporary the famous animal sculptor Antoine-Louis Barye. The interlocking forms and churning lines are grippingly expressive of struggle and ferocity. The *Dying Centaur* has been interpreted as a self-symbol, the human half vainly seeking heavenly salvation,

the animal half sinking back to the earth, defeated by overwhelming forces.

Rimmer's achievement as a sculptor has tended to overshadow his pictorial abilities. His paintings and drawings also embody a powerful anatomical sense, unique for the period in America, and some of his drawings are intense, tragic reflections of the fratricidal Civil War. His paintings tend to be more melodramatic and more exotic than his sculptures, and for this reason they are perhaps less effective, but the famous *Flight and Pursuit* (1872, MFAB) is one of the most haunting and enigmatic romantic evocations in American art. The weird, surrealistic space, the threatening shadows, and the dreamlike aura of mystery and duality have prompted many interpretations.

Rimmer was also one of the leading art teachers of the time, both in his native Boston and as director of the School of Design for Women at the Cooper Union in New York City. He was also the author of several important books on anatomy, illustrated with fascinating drawings by himself. Lit.: Truman H. Bartlett, *The Art Life of William Rimmer: Sculptor, Painter, and Physician*, 1890.

RINEHART, WILLIAM HENRY (1825–1874), a neoclassical sculptor. From Maryland, he worked in a quarry on the family farm before moving to Baltimore in 1844. Supporting himself as a stonecutter, he attended the Maryland Inst. of the Mechanic Arts, where he won a gold medal in 1851 for *The Smokers* (Peabody Inst., Baltimore), a genre scene. Rinehart went to Florence in 1855 and, after a brief return to America in 1857, settled permanently in Rome in 1858. His oeuvre included ideal figures, such as the reliefs *Morning* and *Evening* (1858, Peabody Inst., Baltimore) and classically inspired figures in the round, such as *Leander* (1859), considered by Rinehart's contemporaries to be the most beautiful American neoclassical male nude, and *Latona and Her Children* (1874, MMA), a rich and rather sensuous

multifigure composition. Rinehart's style was simple and not inclined to prettiness or affectation. Occasionally, he turned out sentimental pieces, most notably the approximately twenty versions of *Sleeping Children* done between 1861 and 1874 (examples in the Corcoran Gall., NCFA, and WA), a popular theme of the day. By contrast, his portrait busts tended toward naturalism (*Chief Justice Roger Brooke Tanney*, 1873, Peabody Inst., Baltimore). In 1863–65 Rinehart completed the door THOMAS CRAWFORD designed for the U.S. Senate in 1855 and completed one for the House of Representatives from his own designs in 1866 (cast in 1905). He also executed many statues for cemeteries and parks in the Baltimore area. To a greater degree than any other sculptor, he maintained the neoclassical style into the third quarter of the century at a time when the influence of the Parisian Beaux-Arts style was gaining ascendency. *Lit.*: William S. Rusk, *William Henry Rinehart, Sculptor,* 1939.

RINGGOLD, FAITH (b. 1934), a painter and sculptor. From New York City, she studied with YASUO KUNIYOSHI and ROBERT GWATHMEY in the 1950s. During the next decade, she often expressed rage in her work, as in *Die* (1967) and *Flag for the Moon: Die Nigger*, of about the same time, in which the American flag was used as a backdrop to record the oppression of blacks. These paintings are filled with flattened, stencillike shapes painted with bold colors. After 1967 Ringgold developed a "black-light" style in which the traditional dark-light tonal scale was replaced by one based on intensity of pigment. She then brought to her color style a polyrhythmical sense of space based on the African Kula motif (eight interlocked triangles), and the result is well represented in her mural at New York City's Riker's Island Women's House of Detention. In the early 1970s, Ringgold began to make wall hangings and soft sculpture based loosely on African forms, and these reflect her interest in black and feminist themes.

RIVERA, JOSÉ DE (b. 1904), a sculptor, born José A. Ruiz, in West Baton Rouge, La. He worked as a machinist, blacksmith and tool- and die-maker before studying art in Chicago's Studio School with painter John Norton from about 1928 to about 1931. In 1932 he travelled in Europe and Africa. Employed by the WPA-FAP in 1937–38, de Rivera made the aluminum *Flight* for the Newark, N.J., Airport. He was always a precise craftsman, and his earliest sculpture, dating from 1930, was smoothly surfaced, with elemental volumes emphasized. In 1938, with *Red and Black (Double Element)*, he opened up his solid-core style by counterposing two semicircular aluminum sheets. Until the early 1950s, de Rivera explored the space-defining and space-enveloping qualities of bent sheet-metal, the inner and outer surfaces often painted different colors. In the 1950s, he concentrated on forming twisting, round, stainless-steel tubes of varying thickness, which, when slowly rotated, could decisively alter in appearance. Their gleaming surfaces reflect light, which makes them seem to dematerialize in their passage through space. For de Rivera, "the content, beauty, and source of excitement [are] inherent in the interdependence . . . of the space, material, and light, [which are] the structure." *Lit.*: Thomas S. Tibbs, *José de Rivera*, exhib. cat., La Jolla Mus. of Contemporary Art, La Jolla, Calif., 1972.

RIVERS, LARRY (b. 1923), a painter, who was one of the first to work in a post-Abstract Expressionist figurative style during the 1950s. Born in New York City, he turned to painting in 1945, after studying music at the Julliard School and pursuing a career as a musician. In 1947–48, he studied with HANS HOFMANN and WILLIAM BAZIOTES. Becoming part of the avant-garde scene, Rivers designed sets for plays by Frank O'Hara in 1952 and by Imamu Amiri Baraka (LeRoi Jones) in 1964 and for Igor Stravinsky's *Oedipus Rex* in 1966. In the 1950s, Rivers developed a style that inhabited a middle ground between Ab-

stract Expressionist improvisation and realistic rendering. Blurred images and smears filled the same surfaces as precisely drawn detail, all often floating in ambiguous space. Areas of canvas were quite often left bare of color. His *Washington Crossing the Delaware* (1953, MOMA) pointed toward the growing Pop and realistic sensibilities that would emerge about 1960. *Double Portrait of Berdie* (1955, WMAA) prefigured the revival of interest in figurative painting. Works such as these, with their passages of "good" and "bad" taste, mixed-media effects, lettering, obvious quotations from well-known artistic or advertising sources, and deadpan humor, helped diffuse the self-conscious seriousness of AB-STRACT EXPRESSIONISM. Yet Rivers could be serious as well. *The History of the Russian Revolution: From Marx to Mayakovski* (1965, Hirshhorn Mus.), a kind of summation of his style, pictorializes the Revolution through random painted images, wood cutouts, actual weapons, and posterlike sections, forcing the viewer to concern himself with such problems as the storytelling properties of art, the processes of making art objects, the combined use of actual and simulated objects, and the enjoyment of art as pure visual display. In 1957 Rivers began to make welded metal sculpture and subsequently used Plexiglas and wood. *Lit.*: Sam Hunter, *Larry Rivers*, n.d.

ROBERTS, HOWARD (1843–1900), a sculptor. From Philadelphia, he studied at PAFA before leaving for Paris and EBA, where he worked under Dumont and Charles Guméry. He lived in Paris again in 1873–74. Roberts was one of the first artists to reflect the shift in taste from the Italian-based neoclassicism of the mid-century period to the Parisian Beaux-Arts manner, characterized by a greater realism, a refined sensualism, an increase in genre elements, and a technical mastery of complicated poses. Realism did not imply naturalism, however, but rather a greater attention to detail, which could even be focused on idealized heads. Perhaps reflecting the growing concern with the American past,

Roberts made a study of Hester Prynne, the heroine of Nathaniel Hawthorne's *The Scarlet Letter*, in 1869–71. But it was his *La Première Pose* (1873–76, Philadelphia Mus.), a study of a nude sitting in a chair, that dramatically announced the new style when it was shown at the CENTENNIAL EXPOSITION in Philadelphia. *Robert Fulton* (1883, U.S. Capitol, Washington, D.C.) reflects Roberts's great concern for correct detail and anatomical accuracy. He was considered the most accomplished American sculptor during the 1870s. *Lit.*: David Sellin, *The First Pose*, 1976.

ROBINSON, BOARDMAN (1876–1962), a painter and illustrator. Born in Nova Scotia, he grew up in Wales and came to Boston, Mass., in 1894. He studied art in that city the same year and in France from 1898 to 1899 and again from 1901 to 1904, at the Académie Julian and Académie Colarossi as well as at EBA. In and after 1906, he made illustrations for many magazines and newspapers, and books. He was art editor of *Vogue* in 1906–7 and a cartoonist for the *New York Tribune* from 1910 to 1914, and he contributed to the *Masses* in 1916–17. He taught at ASL from 1924 to 1930, and, with THOMAS HART BENTON, helped popularize mural painting, especially with the set he designed for Kaufmann's Department Store (Pittsburgh, 1927–29), considered the first modern American murals. Robinson subsequently painted murals for Rockefeller Center, New York City (1932) and the Department of Justice, Washington, D.C. (1937). After 1930 he settled in Colorado, where he served as director of art schools including the Broadmoor Art Acad. His subject matter ranged from religious images to landscapes. With the exception of his murals, which were painted with a controlled brush, he preferred sketchlike finishes with scumbled passages of pigment. He distorted forms for expressive purposes and often used thickened light areas of color rather than outlines for figural definition. Although he was capable of creating forceful expressionistic images, he never lost sight of their essen-

tial realism. *Lit.*: Albert Christ-Janer, *Boardman Robinson*, 1946.

**ROBINSON, THEODORE** (1852–1896), one of the most significant of the American Impressionist painters (see IMPRESSIONISM, AMERICAN). Robinson was born in Irasburg, Vt., a region to which he returned at the end of his life. In 1874 he sought art training in New York, where he met WINSLOW HOMER, and the rustic scenes upon which Homer was then concentrating may have influenced Robinson's choice of theme, though not his style or interpretation. In 1876 he was in Paris, studying with C. E. A. Carolus-Duran, and undoubtedly gained from his French teacher a respect for a fluid, painterly technique. For a while, he was part of the Anglo-American art colony in Paris, many of whose members, like JOHN SINGER SARGENT, were also students of Carolus-Duran. He also studied with Jean-Léon Gérôme and in 1879 was in Venice, where he formed a brief but significant friendship with JAMES A. M. WHISTLER.

Late that same year, Robinson returned to America, working for Harper Publications, teaching, and accepting decorative commissions, including designs for mosaic and stained glass. In 1884 he went back to France, remaining there for eight years, with the exception of several trips to America. This second French sojourn can be divided into two periods. Until 1887 Robinson's work was conservative. His landscapes and his Parisian figure pictures were painted in a dark palette, with the forms created in flat areas of tone. In 1887 Robinson went to Giverny, near Rouen, where Claude Monet had settled four years earlier. (Robinson was one of the earliest Americans to visit Giverny and, though he was not the first, he was the most significant of them.) Monet has been described as Robinson's teacher; this was not true, but Monet did have a tremendous influence upon the younger man, who also settled in Giverny. Robinson's painting after 1887 is allied to French Impressionism, and his particular style is closest to that of Camille Pissarro, whom he must have

met at Giverny. The high colorism, flickering light, and broken brushwork of Impressionism are combined in Robinson's art with firmer drawing and more solid structure, and some of his finest landscapes, through an emphasis upon repeated and parallel diagonal areas of mottled color, emphasize geometry in a manner that recalls the painting of Paul Cézanne. Robinson also often chose a high horizon line, which brought about a strong structural emphasis, but his color range was usually somewhat restricted compared to Monet's—his tonal emphasis being placed on varying greens combined with a strong blue-purple tone. He often chose to paint meditative peasant figures, in a tradition going back to Jean François Millet in France and continued among the French Impressionists in the art of Pissarro.

Robinson sent his paintings back for exhibition at the Soc. of American Artists in New York, where he won a prize in 1890 for the best landscape by a young American artist. At the time, the society was giving up the dark, dramatic Munich influence and becoming the major exponent of Impressionism in America, with which movement Robinson was increasingly identified. About 1891–92, Robinson became as fully involved with Impressionism as he was ever to be, creating a number of works in the manner of Monet—paintings of poplar trees and a series of landscapes of the valley of the Seine under different conditions of weather (Corcoran Gall.; Addison Gall.; Randolph-Macon Women's Coll., Lynchburg, Va.).

In the winter of 1892, he returned to America permanently, intending to paint local scenery. His American work, including a group of New York urban scenes done in the winter of 1894–95, often exhibit a return to more solid forms and a more pronounced emphasis upon drawing. Robinson was one of the American artists of the period most reliant upon photography. He was considered the first and the most consistent of the American Impressionists and was important as a direct link with the French Impressionist artists. *Lit.*: Sona Johnston,

*Theodore Robinson*, exhib. cat., Baltimore Mus., 1973.

ROBUS, HUGO (1885–1964), a sculptor. Born in Cleveland, Ohio, he studied from 1904 to 1908 at the Cleveland School of Art, in which he also was employed manufacturing jewelry, tableware, and ivories. He continued his studies at NAD in 1910–11 and with Antoine Bourdelle at the Académie de la Grande Chaumière, Paris, from 1912 to 1914. Primarily a painter until 1920, he created sophisticated Cubist studies of interiors, nudes, and backyard scenes. Dissatisfied with his work, he turned to sculpture but, rather than transpose Cubism to three dimensions, he developed a lyrical, expressionist style. People were his preferred subject matter, the parts of their bodies made round and bulbous so that the perimeters seemed bounded by continuous arcs, as in *Woman Combing Her Hair* (1927, Corcoran Gall.). The flow of volumes always lay at the base of his designs. Only briefly, in the late 1940s, did he investigate three-dimensional Cubism, using chunky, hollowed-out forms. He chose not to emphasize the properties of materials, believing that "they distort or destroy pure form optically much more frequently than they enhance it." *Lit.*: Lincoln Rothschild, *Hugo Robus*, exhib. cat., WMAA, 1960.

ROCKY MOUNTAIN SCHOOL, the name given by the art historian James Thomas Flexner to a group of artists whose only common interest was in painting scenes of the Rocky Mountains on large canvases. The principal figures in the group are ALBERT BIERSTADT, THOMAS HILL, WILLIAM KEITH, THOMAS MORAN, and CHARLES WIMAR. They were all foreign born and received different kinds of artistic training. Wimar and Bierstadt were the first to travel in the West, the former journeying up the Missouri River in 1858, the latter visiting the Rocky Mountains in 1859. Keith lived in California briefly in 1859 but did not settle in San Francisco until 1862. Hill moved to San Francisco in 1861. Moran came to the West in 1871.

Bierstadt was the first and most important popularizer of western scenes, which he exhibited in the East, beginning in 1860, at NAD. An example of his work from this period is *Thunderstorm in the Rocky Mountains* (1859, MFAB). Bierstadt's concern was for realistic detail; Moran, the second most important artist of the group, chose a more painterly style, in emulation of the English artist Joseph M. W. Turner (*The Mirage, Teton Chain, Idaho*, 1879, Kimbell Art Mus., Fort Worth, Tex.). Hill is now best known for his several views of the Yosemite Valley (an example from 1889 is in the Oakland Mus.). Keith, whose intimate views are particularly admired, also painted vast panoramic scenes encompassing whole mountain ranges, as in *California Pines* (1878, LACMA). Even before these artists arrived in the West, of course, others had already toured the area, among them James Madison Alden, the official artist of the United States-Canada Boundary Survey from 1857 to 1861. *Lit.*: James Thomas Flexner, *That Wilder Image*, 1962.

ROESEN, SEVERIN (active c. 1847–c. 1871), a painter of some of the most elaborate still lifes made in Victorian America. Roesen's early years in Germany are almost completely unknown, though he exhibited in 1847 in Cologne. Certainly, his art shows the influence of the masters of still life in the important nearby art center of Düsseldorf. He emigrated in 1848 to New York City, where he remained for about ten years before moving to rural Pennsylvania and settling in Williamsport. Roesen created very large and complex pictures, arrangements of literally hundreds of pieces of fruit, flowers, and bird's nests, complemented by ceramic, glass, and wicker containers, all bespeaking the mid-century optimism and taste for enumeration and lavish, accurate description of nature. There is a formularistic monotony and a good deal of carelessness in the rendering of form in some of

his pictures by comparison with the work of JOHN F. FRANCIS, GEORGE HALL, and MARTIN JOHNSON HEADE, yet none of his contemporaries attempted so much. Although there appears to have been little development in Roesen's painting, some of the finest pictures of his Williamsport years silhouette the display against a broad, mountainous landscape background. Roesen appears never to have adopted the popular device of showing his still life in a natural setting, invariably placing it on a gray or white marble tabletop, often so overflowing as to require a double tier (*Still Life: Flowers*, MMA). *Lit.*: William H. Gerdts and Russell Burke, *American Still-Life Painting*, 1971.

ROGERS, JOHN (1829–1904), the most successful genre sculptor in the mid-19th century. He was born in Salem, Mass., and spent his early life as a clerk in New England, New York City, and the Middle West. He began to model sculpture before 1850 and in 1858 went first to Paris and then to Rome for training. The ideals of neoclassicism, as practiced by both American and European sculptors in Italy (see NEOCLASSICAL SCULPTURE) did not inspire him, however, and he returned to Chicago. He was, however, persuaded to continue modelling small genre figures of a type that he had previously undertaken as a hobby, and he opened a studio in New York City in 1859. Rogers's facile talent and shrewd marketing practices, as well as a growing public demand for inexpensive statuary, quickly made the venture a success. His sculptures (known as Rogers Groups) were small, very detailed plaster pieces, built around a metal armature and painted a neutral earth color. The artist's successful grasp of anatomy and his sharp observation of details of costumes and accessories were combined with a flair for compositional massing of figures and a sympathetic expressiveness. Among his earliest works were some relating to the Civil War, and in these he appealed to patriotism and popular sentiments about the deprivation and hor-

rors of war and slavery (*"Wounded to the Rear"—One More Shot*, 1864). Civil War subjects were only one facet of Rogers's art. The majority of his sculptures featured scenes of everyday life, most often rural or small-town—in the schoolhouse, at the parsonage, in the home (*The Checker Players*, 1859; *Weighing the Baby*, 1876). Among his more ambitious works were scenes taken from literature, including three from Washington Irving's tale of Rip Van Winkle, some from Faust, and a number of Shakespearean interpretations; these also emphasized the anecdotal more than the dramatic. There were a few small portrait sculptures, too—of Abraham Lincoln, George Washington, and Henry Ward Beecher. As time went on, Rogers's compositions became looser and his scenes more active. In all, he made about eighty groups, of which about 80,000 replicas were made. Rogers developed a catalogue mail-order business, and his pieces were advertised and often purchased as wedding presents. They were very inexpensive, usually about ten or fifteen dollars each. Rogers did plan and execute a number of monumental sculptures, too, but these are far less significant than his plaster groups. His success represents one aspect of the reaction to the ideal marbles so popular in their time, though he also benefited from the wave of popularity of pictures of everyday life that crested in America at mid-century. His groups are, in subject, the sculptural equivalents of the painting of WILLIAM SIDNEY MOUNT, though their anecdotal sentimentalism brings them closer in feeling to the work of such painters as THOMAS WATERMAN WOOD, ENOCH WOOD PERRY, and JOHN GEORGE BROWN. Rogers's success encouraged numerous imitators but none achieved his renown. *Lit.*: David H. Wallace, *John Rogers: The People's Sculptor*, 1967.

ROGERS, RANDOLPH (1825–1892), a prolific sculptor. From Waterloo, N.Y., he grew up in Ann Arbor, Mich. His serious training began with Lorenzo Bartolini in Florence, Italy, in 1848. Three years lat-

er, he established a studio in Rome, where he remained, for the most part, until 1885, when he returned to Ann Arbor. His work combined neoclassical formulas—and sources—with naturalistic detail, the combination usually inhibiting it from assuming heroic scale. Early ideal pieces included *Ruth* (1853, Toledo Mus.) and *Nydia, the Blind Girl of Pompeii* (1855–56, MMA), of which roughly twenty and one hundred copies, respectively, were made. Between 1855 and 1858, he designed the "Columbus" doors for the U.S. Capitol Rotunda, in Washington, D.C. Based on Lorenzo Ghiberti's Renaissance "Gates of Paradise" in Florence, they were cast in 1860. After the Civil War, Rogers completed several large monuments, including the Michigan Soldiers' and Sailors' Monument, Detroit (1881), and THOMAS CRAWFORD'S unfinished Washington Monument, Richmond, Va. (1861), to which Rogers added two fine naturalistic works of his own: *Andrew Lewis* and *Thomas Nelson*, as well as allegorical figures and ornaments. Although he gave the Univ. of Michigan a virtually complete set of his plaster casts, only a few are extant. *Lit.*: Millard F. Rogers, Jr., *Randolph Rogers: American Sculptor in Rome*, 1971.

ROSENQUIST, JAMES (b. 1933), one of the original exponents of POP ART, whose pieces often defy immediate understanding as regards content and compositional strucure. From Grand Falls, N. Dak., he studied at the Minneapolis School of Art in 1948, at the Univ. of Minnesota, with Cameron Booth, from 1952 to 1954, and at ASL in 1955. Between 1954 and 1960, he worked as a billboard painter. In the latter year, he painted *Zone*, his first "fine-art" painting created by commercial techniques and with commercial subject matter (his earlier serious work was abstract). In 1963 he executed a mural for the New York World's Fair. Since the late 1960s, he has used Mylar sheets and has explored visual effects produced by film. A typical painting by Rosenquist consists of enlarged, overscaled, and juxtaposed

fragments of unrelated objects; the effect is that of random layers of paintings on a billboard or images interrupted by turning the dial of a television set. His work also can be likened to a realistic, hard-edged combine painting by ROBERT RAUSCHENBERG. Rosenquist's subject matter is drawn from mass culture and can range from a small comb to an enormous hair dryer. His pictures evoke no special messages nor do they convey particular meanings, except as they suggest a distracted reading of contemporary cultures. In the aluminized Mylar works, reflections dislocate even further one's perceptions of the already interrupted forms. A few works, such as *F-111* (1964–65), which is eighty-six feet wide and depicts the fuselage of an airplane interrupted by images of spaghetti, a child's face, and a lightbulb, also provoke an examination of one's perception of time intervals. As a result, Rosenquist's art, in avoiding some of the more light-hearted aspects of Pop, calls attention to our reading of recognizable objects, to our concern with perceptual problems as a type of content, and to the formal structures elaborated to contain them. *Lit.*: Marcia Tucker, *James Rosenquist*, exhib. cat., WMAA, 1972.

ROSSITER, THOMAS P. (1818–1871), a portraitist and painter of historical and religious pictures. Born in New Haven, Conn., he studied there with Nathaniel Jocelyn, before opening a portrait studio in 1838. He travelled to Europe in 1840 with JOHN F. KENSETT, ASHER B. DURAND, and JOHN W. CASILEAR, and, in 1841, with THOMAS COLE, visited Rome, where he remained for five years. He lived in Paris from 1853 to 1856 and received a gold medal at the exposition of 1855. In 1860 he moved to Cold Spring on the Hudson River, where he worked on a series of paintings of the life of Christ. His biblical paintings drew on both Old and New Testament sources (*Rebecca at the Well* 1852, Corcoran Gall.). On occasion, he painted genre scenes that ventured beyond anecdotal themes to social criticism. *Such Is Life, a*

*Scene in London During the Crimean War* (1855, Newark Mus.), painted with an almost Pre-Raphaelite elaboration of detail, critically contrasts the wealthy and the poor of London. *Lit.:* Edith Rossiter Bevan, *Thomas Pritchard Rossiter,* 1957.

ROSZAK, THEODORE (b. 1907), a sculptor, printmaker, and painter. Born in Poznan, Poland, he was brought to Chicago in 1909. In 1926 he studied at NAD, between sessions at AIC in 1922, 1925, and 1927. Initially a painter, he preferred traditional romantic-realist styles during that phase of his career. He became seriously aware of modern art during a trip abroad in 1929–30, especially those notions propagated by the Bauhaus concerning the integration of the artist into society and his cooperation with architects and planners. He lived primarily in Prague while abroad. It was not until 1936, however, that Roszak turned energetically to sculpture. Then he began to make three-dimensional constructions of brass, plastic, and wood within the strictures of a streamlined Constructivism (*Construction,* 1937, NCFA). But lurking beneath his abstract form was an insistent, if vaguely defined, content derived from Joan Miró's amoebalike configurations. Roszak's paintings of this period reflected equally severe modes of interwar abstraction (see AMERICAN ABSTRACT ARTISTS). In 1938 he worked under László Moholy-Nagy's direction, at the government-sponsored Design Laboratory in New York City, established to bring Bauhaus ideas and principles to American art. By 1945, realizing that art did not lead to idealistic solutions, Roszak had found the world to be "fundamentally and seriously disquieted." To explore his new vision, he began to use brazed alloys and welded metals in freer formations. These gave visual embodiment to themes of myth as well as of contemporary anguish. In these pitted and scratched sculptures brazed with bronze and brass, for which he is best known (*Spectre of Kitty Hawk,* 1946–47, MOMA; *Migrant,* 1950, Univ. of Illi-

nois), menacing projections seem to twist free from their cores. Thin members are combined with broader metallic sheets in open construction, as if Roszak were adding to a Constructivist armature a menacing and probing content. *Lit.:* H. H. Arnason, *Theodore Roszak,* exhib., cat., WMAA, 1956.

ROTHERMEL, PETER FREDERICK (1817–1895), a painter best known for his historical works. From Nescopeck, Pa., he was trained as a surveyor before studying art in Philadelphia with John Rubens Smith and Bass Otis. Although he also painted portraits, he gained recognition with *Discovery of the Mississippi by Hernando De Soto* in 1843. He toured Europe in 1856 and settled in Rome until 1859; there, he produced historical works. After removing to Philadelphia, Rothermel turned out paintings on religious themes, of historical pageants derived from literature (*The Last Sigh of the Moor,* 1864, PAFA, based on Washington Irving's *Chronicle of the Conquest of Granada* [1829]), as well as on such contemporary events as the Battle of Gettysburg (c. 1870, Pennsylvania State Capitol, Harrisburg). Rothermel's grandiose themes allowed him to interweave figures with complexity and to include both sharply detailed and hazy forms in a single painting. A fine colorist, Rothermel was compared to Eugène Delacroix in his use of pigment, if not in the totality of his achievements.

ROTHKO, MARK (1903–1970), a leading figure of the Abstract Expressionist generation. From Dvinsk, Russia, he was brought to Portland, Oreg., in 1913. He moved to New York City about 1925 and studied briefly at ASL with MAX WEBER. In 1935 he cofounded, with ADOLF GOTTLIEB, The Ten, a group that favored expressionist styles in contradistinction to the more abstract ones preferred by the AMERICAN ABSTRACT ARTISTS. In 1936–37 Rothko worked for WPA-FAP. In the summers of 1947 and 1949, he taught at CSFA, helping to popularize ABSTRACT EXPRESSIONISM on

the West Coast. Known primarily as an easel painter, he also created murals for a restaurant in New York City (now in the Tate Gall., London) in 1958 and for the Harvard Univ. Holyoke Center in 1961–63; and a set of fourteen panels for the Inst. of Religion and Human Development of the Texas Medical Center, Houston, dedicated in 1971.

During the 1930s, Rothko painted isolated figures in urban settings, but he had begun to reject realism as early as 1938. He began experimenting with automatic drawing, which, in 1940, became one of the main features of his emerging biomorphic style (see BIOMORPHISM). Rothko used this Surrealist technique not for its own sake but to invoke meanings and feelings common to all people. He studied Greco-Roman mythology and was evidently receptive to the ideas of Freud and Jung concerning both the individual and the collective unconscious. He sought, as he said, symbols that were tragic and timeless, that expressed "man's primitive fears and motivations no matter in which land or what time." These were painted neither with reference to particular tales nor with premeditation. Instead, Rothko put down forms and colors as if on an unknown adventure. "Ideas and plans that existed in the mind at the start were simply the doorway through which one left the world in which they occur[red]," he said. Unlike Gottlieb's contemporaneous images, which suggested religious and hieroglyphic objects, Rothko's resembled spiky, linear, underwater organisms or geological strata embedded with fossils (*Baptismal Scene*, 1945, WMAA). Although he was referring to *The Omen and The Eagle* (1942) when he said, "It involves a pantheism in which man, bird, beast, and tree—the known as well as the knowable—merge into a single tragic idea," his words describe his general intent at the time. His paintings of this period were often done in watercolor or gouache in order to achieve translucent luminosity unattainable with oils. Softly brushed, the forms float in indeterminate spaces.

About 1945 horizontal bands appeared, and by about 1947 Rothko had begun to omit references to nature, for even these hindered the close interaction he sought between himself and the idea, as well as between the idea and the viewer. He found that "the familiar identity of things has to be pulverized in order to destroy the finite association with which our society increasingly enshrouds every aspect of our environment." Such new paintings as *No. 18, 1948* (Vassar Coll.) were composed of amorphous shapes, arbitrary rather than organic in nature. By 1950 Rothko had simplified his art even further by enlarging the shapes into rectangles and reducing their number to two or three in each painting. These rectangles were then stacked horizontally within a painted border that acted as an internal frame. Edges, as in *Red, Brown and Black* (1958, MOMA), were purposely kept soft and frayed so that the rectangles were not set off from their surrounding fields by sharp lines, which would have broken the sense of continuity and the integration of forms. Within all of the color areas, imperceptible and continued changes in value and intensity, coupled with quite visible brushwork, suggest palpitating presences, as if the shapes, as Rothko once said, "had no direct association with any particular visible experience, but in them one recognize[d] the principles and passions of organisms."

Although shape, color, and value relationships were carefully calibrated, Rothko did not want his work to be viewed as mere formal exercises. He felt that a painting lived through companionship with the viewer. Many works were purposely made large, forcing the viewer into intimate contact with their many and subtle nuances of color. Some works suggest infinite depths; others seem to be composed of shapes and colors that hover at the picture's surface. In either case, they invite contemplation as much for their implied content as for their technical aspects. Subsequently, artists more concerned with the latter qualities used Rothko's paintings as a point of departure for studies of surface tensions, color relationships, and ways of

negating suggestions of depth. *Lit.:* Diane Waldman, *Mark Rothko,* exhib. cat., Guggenheim Mus., 1978.

RUSCHA, EDWARD (b. 1937), a West Coast painter, printmaker, photographer, and author of books, associated variously with POP ART, CONCEPTUAL ART, and Surrealist modes. From Omaha, Nebr., he studied at the Chouinard Art Inst. in Los Angeles from 1956 to 1960. Since that time, he has explored a variety of media. Initially, he painted common standard-brand objects, often with sinister overtones. The influence of Hollywood, especially its movie titles, determined the appearance of his most famous work, *Large Trademark with Eight Spotlights* (1962), which spells out "20th Century Fox" in bold diagonals. Infatuated by letters, Ruscha has created some paintings composed of letters alone, the more recent ones being painted on moiré silk with vegetable dyes. Unlike his earlier pieces, these are absolutely frontal. During the late 1960s, however, he painted letters as objects that seem to be in the process of emerging from or dissolving into the canvas surface. His books (about fifteen) contain photographs that document American gasoline stations, houses, and swimming pools, among other subjects. *Lit.:* Linda Cathcart, *Edward Ruscha,* 1976.

RUSH, WILLIAM (1756–1833), the most significant American sculptor to emerge from the folk-art and figurehead-carving tradition in the early years of the Republic. Rush was born in Philadelphia, and it is with that city that his entire career is associated. His father was a ship carpenter, and even as a boy William occupied himself with carving ship models. He was then apprenticed to Edward Cutbush, an artisan of London, to learn the trade of carving, probably before the Revolution; the earliest commissions that he is known to have received for figureheads date from about 1790. As time went on, Rush gained much fame, and his shop, where he employed a number of apprentices, was well known in Philadelphia. He was the only sculptor to be-

come one of the founders, in 1794, of the short-lived Columbianum, the first art organization in America, and he was also one of the first directors of the PENNSYLVANIA ACADEMY OF THE FINE ARTS.

Probably because of his superior skill at figurehead carving, Rush was able to advance beyond artisan work and received a number of important commissions in the realm of "pure" sculpture. His first such works of importance were the figures of Comedy and Tragedy done for the Chestnut Street Theater in 1808 (now at the Edwin Forrest Home for Aged Actors, Philadelphia). The following year he received the commission for what was probably the best-known sculpture he executed, the *Water Nymph and Bittern,* which was placed in front of the neoclassical Centre Square Water Works. In 1824, on the occasion of the Marquis de Lafayette's triumphal tour of the United States, Rush not only carved his portrait (PAFA) but also executed two monumental sculptures of Wisdom and Justice, which were placed atop the triumphal arch over Chestnut Street, erected in Lafayette's honor (now in the Water Works Assembly Room, Philadelphia). His last major works were two reclining figures representing *The Schuylkill River Chained* and *Freed,* done about 1828 (now in the Philadelphia Mus.). In addition to the bust of Lafayette, Rush created a number of portraits, his subjects being, among others, doctors Caspar Wistar, Philip Syng Physick, and Benjamin Rush, the latter a cousin of the artist; George Washington; Oliver Hazard Perry; Andrew Jackson; and Winfield Scott. Two of his finest works are the portraits of himself and of his daughter, Elizabeth (c. 1822, PAFA; c. 1816, Philadelphia Mus.). Rush was by training and inclination a woodcarver, and the deep undercutting, broad planes, and generally columnar form of many of his statues bear witness to his respect for his chosen medium. He never worked in marble. Some of his portrait busts exist in plaster and some in terra-cotta, a medium in which he was also proficient. Stylistically, Rush was closer to the decorative Rococo tra-

dition of the 18th century than to the prevailing neoclassicism of his time, though the strict adherence to the forms and spirit of the antique had not yet reached America when he began his career. There is an airiness and gaiety to the swirling, voluminous draperies of his wide-eyed, often smiling figures that indicate some familiarity with 18th-century art, probably learned through print sources, possibly also through decorative garden sculpture imported from Europe. Yet, Rush's allegories were not unlike those carved by European artists of his day, and such a work as his *Schuylkill River Chained* is certainly related to statues of classical river gods. Some critics have claimed for Rush the distinction of being the first American sculptor, but he really stands instead at the apogee of the artisan tradition of woodcarving. Sculpture in America was soon to turn and develop along the lines of European neoclassical marble carving. Many of Rush's works are in the Philadelphia Mus. *Lit.*: Henri Marceau, *William Rush, 1756–1833: The First Native American Sculptor*, exhib. cat., PAFA, 1937.

RUSSELL, ANDREW J. (1830–1902). See PHOTOGRAPHY, FRONTIER.

RUSSELL, CHARLES MARION (1864–1926), a leading artist of western subject matter in painting, the graphic media, and sculpture. Born in Oak Hill, Mo., Russell spent his early years, from 1880 to 1893, as a trapper and a cowboy and lived among the Indians of Canada. Largely self-taught, he began recording western scenes in the mid-1880s; his work was first reproduced in *Harper's Weekly* in 1888. It was not until the 20th century, however, that he gained significant success as an illustrator. In his paintings, he tended to portray the more adventurous aspects of western life—confrontations between Indians and invading whites, horse thieves and the law, sharpshooters and their quarry. His sculpture describes similar activities as well as offers acute realizations of animals. Russell's art and career are superficially comparable to FREDERIC REMINGTON'S, and it seems that Remington's success advanced Russell's career as well. But Russell always remained a cowboy as well as a cowboy artist. His work seldom suggests a consciousness of design or of contemporary art movements. Both artists gained their primary fame through their illustrations, but Russell's work is more purely reportorial in nature. With the rise of regional cultural pride, and with the establishment of increasing numbers of museums of western art, the demand for the work of both these painter-sculptors became tremendous. A very extensive collection of Russell material is in the Amon Carter Mus. *Lit.*: Harold McCracken, *The Charles M. Russell Book*, 1957.

RUSSELL, MORGAN (1886–1953), a painter and major figure in the development of SYNCHROMISM. From New York City, he briefly visited Europe in 1906 and then studied sculpture with James Earle Fraser at ASL. In the following year, he began to paint under ANDREW DASBURG and ROBERT HENRI before departing for Paris in 1908, where he may have joined Henri Matisse's art class. By 1910 he had begun to devote himself exclusively to painting, although sculpture, especially Michelangelo's sculptures of slaves in the Louvre Mus., Paris, and his *Pietà* in the Cathedral at Florence, were important sources of early Synchromist works. In 1911 Russell met STANTON MACDONALD-WRIGHT and began to study with the Canadian color theorist Ernest Tudor-Hart, who had developed color theories with analogies to musical patterns. By 1912 Russell had come to believe that he could create paintings on a flat surface equivalent to three-dimensional sculptural forms through the manipulation of planes of pigment that were related to each other by means of precise harmonic color coordinations. His first Synchromy, a figurative work, *Synchromie en vert* (1912–13), was a direct result of his investigations. In effect, he replaced the local colors of objects with specific and arbitrary color. The first abstract Synchromies (by Russell, not Macdonald-Wright) date from 1913 (study for

*Synchromy in Deep Blue-Violet*, 1913, LACMA) and were composed largely of unmodulated planes of color equal in intensity. During these years, Russell also explored the notion of creating a machine that would combine music with color and light—an extension of the ideas he was exploring in his paintings. After visiting America in 1916, he returned to France in the following year, and there he painted landscapes, nudes, classical themes, and occasional coloristically muted abstract Synchromies. These Synchromies he called *Eidos*. *Lit*.: Gail Levin, *Synchromism and American Color Abstraction: 1910-1925*, exhib. cat., WMAA, 1978.

RYDER, ALBERT PINKHAM (1847–1917), a romantic painter. Ryder was born into a seafaring family in New Bedford, Mass., the center of the whaling industry. Early in his youth, his sight was impaired, and as a result he received an abbreviated education. With no formal training in art, and relying on the advice of a local amateur artist, Ryder began painting landscapes of the countryside near his home. At some time between 1867 and 1870, Ryder moved with his family to New York City. At first, his only artistic instruction came from the portraitist William Edgar Marshall. Later, he attended classes at NAD, where he drew from life and from casts of antique sculpture. Ryder's travels were as fitful as his education. He went abroad, to London, in 1877 but stayed only a month. Five years later, he made a more conventional tour of Europe where, apparently, he was as unimpressed by the galleries of old masters as by modern European art. Subsequent trips abroad, in 1887 and 1896, were made for the pleasure of the sea voyage. If Ryder's development was singular, it was not solitary. He formed a close friendship with the painter JULIAN ALDEN WEIR, and the two men were among the twenty-two founders of the Soc. of American Artists (see NATIONAL ACADEMY OF DESIGN).

Ryder's earlier works, such as *Mending the Harness* (c. 1880, NGW), show scenes of rural life. Although their style is fundamentally naturalistic, some critics have seen in them an augury of the more personal, visionary qualities of his later efforts. In the 1880s, Ryder's interest turned increasingly to literary subject matter. Like many a romantic before him, he was attracted to the Bible, to Chaucer and Shakespeare, to Byron, Tennyson and Poe. He shared the passion of his contemporaries for the operas of Wagner, which inspired two paintings: *The Flying Dutchman* (1880s, NCFA) and *Siegfried and the Rhine Maidens* (1888–91, NGW). In the latter, the swaying forms of trees set darkly against a moonlit sky are echoed by the forms of the nude maidens silhouetted against the reflection of light on the water. This treatment of natural forms, though highly personal, is somewhat similar in effect to the work of the English landscape painter and follower of William Blake, Samuel Palmer. In his treatment of literary themes, Ryder was never merely illustrative; narrative was not his chief concern. Rather, he manipulated natural forms so as to create a visual metaphor for sublime events. In this response to literature, he was very much like his predecessor, the most instinctive of American romantic painters, JOHN QUIDOR.

Nature dominates all of Ryder's work, and his attitude to it was as religious as that of any 19th-century painter. Inevitably, however, so personal a response required an equally personal style. This was described by Ryder himself: "My colors are not those of nature. . . . There was no detail to vex the eye. Three solid masses of form and color—sky, foliage, and earth—the whole bathed in an atmosphere of golden luminosity." The result is as austerely simple as the artist's description of it. His seascapes, in particular, though usually small in size, deal with elemental forces on a heroic scale. In *Moonlight* (1885, NGW) a single, forlorn boat is encompassed by the dark, rolling forms of the sea; only a prickly mast and a ragged, useless sail pierce the serene, luminous sky. *Moonlight Marine* (1870–90, MMA) is composed of alternating light and dark bands of color re-

presenting sea, sky, and cloud—the prevailing horizontality broken only by the dark shapes of the sails of the apparently unmanned vessel. Although nature is completely dominant in these works, it is not necessarily threatening. Ryder could, however, with the same simple means, produce a more menacing view of nature. In *Under a Cloud*, the tilt of a boat's mast suggests a strong wind, and the dark mass above threatens peril if not destruction. As Ryder said, "What avails a storm cloud accurate in form and color if the storm is not therein?" In *The Flying Dutchman* sea and sky are as turbulent as in any work of Joseph M. W. Turner, with the spectral ship appearing in a blazing yellow-and-red sunset.

Ryder's approach to nature, and the deliberate archaisms in many of his religious and literary works, show him to be strongly linked in spirit, if not by direct influence, with such early 19th-century visionary artists as Blake and Palmer. His tendency to abstract natural forms, however, clearly looks forward to such early American moderns as his friend MARSDEN HARTLEY and to MORRIS GRAVES *(The Dead Bird*, 1890–1900, Phillips Coll.). The suggestion is unavoidable that Ryder's abstraction was due in part to his continually poor eyesight; he avoided detail that might "vex the eye." Still, his work was, in any sense, remarkably at odds with the prevailing taste of the time for naturalism and plein-air light and color. Such simplification of forms and of space was only practiced among Ryder's contemporaries, and never to the same degree, by WINSLOW HOMER. It is significant that Ryder was included in the famous ARMORY SHOW of 1913, the harbinger of modernism in America. By that time, Ryder had all but stopped painting and was living reclusively in New York City. He was always a laborious worker, but his output was small, some 165 pictures in all. He was not technically astute, and

his paintings have deteriorated markedly. Also, his growing fame in the 20th century, together with the relative simplicity of his style, has proven attractive to forgers, who have multiplied his actual production by five to one. *Lit.*: Lloyd Goodrich, *Albert P. Ryder*, 1959.

RYMAN, ROBERT (b. 1930), a painter of antiexpressionist abstraction. Born in Nashville, Tenn., Ryman studied at the Tennessee Polytechnical Inst., Cookville, in 1948–49. Since about 1964, he has restricted himself almost exclusively to the use of white pigments and a square format, exploring whatever visual products and aesthetic concepts can be gathered from the actual process of painting itself. Ryman continually varies the materials he paints on, employing such substances as plywood, canvas, paper, fiberglass, linen, steel, and wall surfaces. The primary visual incidents result from the changes in method of paint application: short strokes of thin paint, impasto dragged the full horizontal distance of the surface in one stroke, dry strokes of irregular translucency, patchworks of small strokes. Different types of white paint are exploited for their own visual qualities: oil, baked enamel coatings, and rich printing inks (in his aquatints), for example. The scale of the square format can change as well, ranging from tiny to quite large. Ryman's art thus bears down on the pure physical and conceptual basis of what a painting is, namely, pigment applied to a surface. By eliminating all other extraneous elements, he forces the viewer to examine the "bare bones" of painting—for example, how the edge of an expanse of paint looks next to the bit of exposed material supporting it. Personal artistic intention is replaced by a method akin to presentation of facts, and the viewer must extract from each painting its particular set of physical-visual data. *Lit.*: Phyllis Tuchman, "Interview with Robert Ryman," *Artforum*, May, 1971.

# S

**SAGE, KAY** (1898–1963), a painter. Born in Albany, N.Y., she had little formal art training. From 1900 to 1914, she lived in Europe, chiefly in Italy. The years from 1919 to 1937 she also spent in Italy. During a sojourn in Paris from 1937 to 1939, Sage met the Surrealist painter Yves Tanguy, whom she later married. When the Surrealists fled Europe at the beginning of World War II, Sage, with Tanguy, returned to the United States permanently, taking up residence in Woodbury, Conn., in 1941. Sage was strongly influenced by Tanguy, whose work characteristically depicts organic or bonelike entities in an eerie infinity of space. Though she drew on his forms and formats in many ways, Sage developed a personal set of objects to populate her landscape. Beyond rock outcroppings, whose content of minerals literally veins their exterior, Sage erected complex structures that mimicked buildings, towers, roadways, ramps, and even toy railroad tracks. She focused on multilayered walls, alternately smooth and irregular, which grew like crystals from the environment. Twisting lengths of drapery often cling to these objects, or energetically pop out of crannies, or gather themselves into an incredible mass standing stiffly in the landscape. Sage's independence of Tanguy resulted chiefly from her reliance on more realistic imagery: for example, recognizably architectural forms (*Tomorrow Is Never*, 1955, MMA), banners, and eggs. In the last few years of her life, Sage made small mixed-media constructions, which echo certain forms in her paintings. *Lit.*: Regine T. Krieger, *Kay Sage*, exhib. cat., Cornell Univ., 1977.

**SAINT-GAUDENS, AUGUSTUS** (1848–1907), one of the most famous and gifted American sculptors. Saint-Gaudens was born in Dublin, Ireland, but his father, a shoemaker, moved the family to New York City when Augustus was an infant. At the age of thirteen, Saint-Gaudens began a painful apprenticeship with a cameomaker named Avet and worked for him for three years. The next three years were spent in the employ of the more sympathetic Jules le Brethon and studying at Cooper Union and NAD. Saint-Gaudens drew from antique casts and the nude figure and also worked in clay. His earliest extant piece is a bust of his father, *Bernard Saint-Gaudens* (1867, the artist's studio, Cornish, N.H.). In 1867 the young artist departed for Paris and enrolled in EBA, the school that contributed most to the aesthetics of his generation. The spontaneous, naturalistic style taught there greatly impressed him. Saint-Gaudens studied in Paris for three years and then moved on to Italy, where he came under the influence of Renaissance sculpture, particularly the reliefs of the 15th-century Florentine master Donatello.

By 1872 Saint-Gaudens had returned to New York City, and his most important work of the years immediately following was a portrait of William M. Evarts (1874, bronze copy in the artist's studio, Cornish, N.H.), in which a new naturalism had its first expression. After two years, Saint-Gaudens returned to Europe, enjoying there some success with portraits and "fancy" subjects. In 1876 he received the commission that was to win him fame, a bronze monument to Admiral David Farragut (1881, Central Park, New York City), in which Saint-Gaudens proved he had mastered the selective naturalism of the Renaissance sculptors. With one flap of his coat blown back by the wind to reveal a forthright stance, the admiral seems to command a rolling deck as he gazes out to sea. The pose is probably based on Donatello's *Saint George* at Orsanmi-

chele, Florence. The statue, both powerful and straightforward, was, with JOHN QUINCY ADAMS WARD's *Henry Ward Beecher* (1891), among the very few successful attempts made by Americans at combining naturalism and noble monumentality in sculpture.

After a favorable showing of the Farragut Monument in Paris and a triumphant unveiling in New York, Saint-Gaudens divided his time between a New York studio and one in Cornish, N.H. In 1884 he began work on a large bronze memorial to Colonel Robert Gould Shaw (1884–96, Boston Common). Unusually large in size (fourteen by eleven feet), the relief occupied the sculptor for twelve years. It shows a mounted officer leading his troops into battle. The heads are all portraits of men Saint-Gaudens observed in the streets and bars of New York and Boston, and they are an impressive achievement in themselves. Though rich in naturalistic detail, the work achieves a heroic surge, particularly in its dramatic play of light and shadow, reminiscent of Roman military reliefs. The power of the work is only slightly lessened by the rather incongruous allegorical figure fluttering above.

These and other large memorial portraits established Saint-Gaudens at the forefront of his field. He did not, however, completely neglect ideal sculpture and produced his only nude statue, *Diana*, in 1892 (Philadelphia Mus.) for the summit of the architect Stanford White's Madison Square Garden. The colossal figure, made by the ancient technique of hammering bronze sheets, was originally eighteen feet high (when it was erected, Saint-Gaudens and White realized they had miscalculated and it was replaced by a second version, thirteen feet high). In the same busy period, Saint-Gaudens executed perhaps his most original work, the Adams Memorial (1886–91, Rock Creek Cemetery, Washington, D.C.). Against a simple stone stele sits a brooding bronze figure, shrouded in a magnificent sweep of drapery. The image is startlingly modern; its strength lies in stark simplicity and emotional understatement.

To the end of his life, Saint-Gaudens maintained his characteristic vigor of execution and invention. In Paris in 1897 he began work on an equestrian monument to General William Tecumseh Sherman (1903, Central Park, New York City). The result is a dynamic, surging composition, with a figure of Victory leading the horse and rider. The refinement of surface handling shows Saint-Gaudens's technical brilliance in that respect. The group marked another successful attempt—however improbable—at crossing the real with the ideal. While most of his late Victorian contemporaries in America and abroad were producing only empty rhetoric, particularly in large public monuments, Saint-Gaudens's genius was to make out of the prevailing hybrid style, compelling dramatic statements. The Saint-Gaudens National Historic Site is located in Cornish, N. H. *Lit.*: Louise Hall Tharp, *Saint-Gaudens and the Gilded Era*, 1969.

**SAINT-MÉMIN, CHARLES BALTHAZAR JULIEN FEVRET DE** (1770–1852), the finest European artist to come to the new republic in the late 18th century. Saint-Mémin was born in Dijon, France, but fled to America in 1793 in the wake of the French Revolution, landing in New York when a rebellion on the island of Hispaniola made it inadvisable for him to reclaim a plantation there. He had been an amateur landscapist and began creating engraved views and maps but found portraiture more lucrative. The typical Saint-Mémin portrait is a profile on paper tinted pink, or sometimes blue. The outline was taken quickly with the aid of a machine, the physiognotrace, invented in 1786 by Gilles-Louis Chrétien. The outline, and also the eyes and lips, were drawn in pencil, with details filled in in black and white chalk, and sometimes in gray wash. These likenesses are startlingly realistic, very three-dimensional despite their sharp outlines, and clearly in the neoclassical aesthetic.

Saint-Mémin's style did not change appreciably, though he exhibited increased delicacy and assurance in his later work in the early 1800s. He sometimes sold his drawings alone but more often engraved a small copperplate from them with the aid of another machine, the panotrace, which created a reduced, circular copy. He then usually sold the drawing, plate, and twelve prints for twenty-five dollars, for a male likeness, and for thirty-five dollars, for a female one. He also excelled in the watercolor medium. His family joined him in 1798 and they made Burlington, N.J., their home; however, the artist spent much time in nearby Philadelphia and travelled all the way from Charleston, S.C., to Niagara Falls. Many of his subjects were important government figures. Nevertheless, Saint-Mémin never thought of his art as more than a temporary occupation, and, after visiting France in 1810–12, returned in 1814 with the reestablishment of the Bourbon monarchy. Later, he became an innovative curator in the museum of his native Dijon. *Lit.: Works of Saint-Mémin*, exhib. cat., Valentine Mus., 1941.

**SALMON, ROBERT** (1775–c.1848/51), a marine and landscape painter. From St. James, Whitehaven, Cumberland, England, he spent the first half of his career in his native land. He lived in Liverpool from 1806 to 1811, in Greenock, Scotland, from 1811 to 1822, and again in Liverpool from 1822 to 1825. His style reflected 17th-century Dutch marine painting, with its preference for low horizons, emphasis on atmospheric effects, and crystalline lighting; his attention to detail also points to the influence of Antonio Canaletto, who visited London in the late 1740s. Salmon settled in Boston, Mass., in 1828 and quickly became the most distinguished marine painter in the area. Before his return to England in 1842, he influenced the development of a number of American marine artists, including FITZ HUGH LANE, with whom he worked in William S. Pendleton's lithographic studio. Painting usually small panels of large, panoramic views of Boston's inner harbors, wharves, and neighboring shorelines, he achieved renderings of sky, land, and water that are luminous and filled with minute detail. His thin glazes and fluid brushwork enabled him to capture both hazy and extremely clear atmospheric effects. Examples of his work include *Rainford's Island, Boston Harbor* (c. 1840, MFAB) and *Boston Harbor from Mr. Green's House, Pemberton* (1829, Soc. for the Preservation of New England Antiquities, Boston). *Lit.*: John Wilmerding, *Robert Salmon: Painter of Ship and Shore*, 1971.

**SAMARAS, LUCAS** (b. 1936), a multi media artist. Born in Kastoria, Greece, he was brought to America in 1948. He attended Rutgers Univ. from 1955 to 1959, and there he met George Segal as well as Allan Kaprow and Robert Whitman, both pioneers of HAPPENINGS. Between 1959 and 1962, he studied art history at Columbia Univ. Like other artists of his generation, he has brought to his work a vast knowledge of present and past art learned in academic circles. An archetypal post-Dadist, post-Surrealist, and post-Abstract-Expressionist, for whom all objects and all experiences are to be used in an art-making context, Samaras took part in the earliest Happenings in 1959, allowing his body also to become an instrument of the art of others. About 1960, working within the ASSEMBLAGE milieu, he created small figures from plaster and cloth, dinnerware, cutlery, tacks, mirrors, etc., as in *Untitled* (1960–61, MOMA), which is composed of plastered feathers, pins, nails, and screws. He made his first boxes in 1960. These were initially covered with pins, tacks, or wool and by the mid-decade had evolved into intricately cut-out forms, as in *Box #3* (1963, WMAA), made of wood, pins, rope, and a stuffed bird. Samaras has said of these objects that he felt he could rescue ruined and useless things and give them dignity. What dignity they acquired lay in the mysterious, often erotic imagery the materials sug-

gested. Effects were made more by associational references and shocking juxtapositions than by specific formal properties. In 1965 Samaras created his first mirrored room, in which reflections reach infinity in all directions. An example, *Mirrored Room* (1966), is in AK. Since 1963 he has used photographs of himself as part of his art production. Since the early 1970s, this has been the most important aspect of his work. He also made a film, *Self*, in 1969. His art, intensely autobiographical if not obsessive, also relates to earlier modern movements. In broad terms, it is an extended form of romanticism in which not only his imagination but his very being and the objects of his environment are considered part of his continuous art production. He does not live the life of an artist: His life is an art object. *Lit.*: Kim Levin, *Lucas Samaras*, 1975.

SARGENT, HENRY (1770–1845), a portrait, genre, and historical painter. From Gloucester, Mass., he studied with BENJAMIN WEST in London from 1793 to 1799, before returning to Boston, Mass., where he was active as a politician, military officer, and inventor as well as a painter. *The Tea Party* and *The Dinner Party* (c. 1821, c. 1821–25; both MFAB) are among the earliest genre paintings made in New England and provide insight into upper-class social activities of the period. *The Landing of the Pilgrims* (c. 1813, Pilgrim Hall, Plymouth, Mass.) is reminiscent of the type of historical documentation in art pioneered by West. As a portraitist, and like GILBERT STUART, by whom he was influenced, Sargent was able to capture a sense of immediacy and presence in his sitters, as he did in *John Turner Welles Sargent* (c. 1819, MFAB). *Lit.*: Julia Addison, "Henry Sargent: A Boston Painter," *Art in America*, Oct., 1929.

SARGENT, JOHN SINGER (1856–1925), a cosmopolitan and very successful American painter, best known for his portraits. Sargent's parents were Americans who lived abroad, travelling constantly with the social season between various European capitals and watering places. Sargent was born in Florence on one of these stops. He showed an interest in and talent for drawing, which were encouraged by his mother. While the family wintered in Rome in 1868–69, Sargent spent some time in the studio of Carl Welsch, a German-American artist. From there he went on to study at the Accademia di Belle Arti, Florence, in 1871–72 and, after travelling to Dresden and Venice, worked in the studio of C.E.A. Carolus-Duran, in Paris. Sargent was, at first, strongly influenced by the Impressionists then in Paris. A trip to the Normandy coast in 1874 inspired such works as *The Oyster Gatherers of Cancale* (1878, Corcoran Gall.). This beach scene, a bright, loosely brushed study in French pleinairism, appeared in the Salon of 1879, one of the first works Sargent showed at those annual exhibitions.

Like JAMES A.M. WHISTLER and Edouard Manet, Sargent was very impressed by the art of Diego Velázquez. After a trip to Spain, he produced what may be his first major work, a large group portrait, *The Daughters of Edward Darley Boit* (1882, MFAB). The four young girls are shown full-length in the dark interior of their home. Two of them stand facing the viewer directly, one stands in profile, and the youngest sits on a rug and plays with a doll. There are two blue-and-white vases of enormous size, which dwarf the girls and are so meticulously painted that one critic has suggested this is a portrait of the pots rather than of the children. The vases were, in fact, prized family possessions that had survived sixteen transatlantic crossings. The formality of the poses and the shadowy interior may recall Velázquez's *Las Meninas* (1656), for which Sargent had a special esteem; however, the asymmetry of the composition and lack of any natural interrelation among the figures suggests an acute understanding of the portraits of Edgar Degas and of Whistler.

Sargent's *The Breakfast Table* (1883–84, Fogg Mus.), a portrait of his sister

Violet seated, off center, behind a table in a cramped space, is a further example of Degas's influence; *El Jaleo* (1882, Isabella Stewart Gardner Mus., Boston), depicting a Spanish dance troupe in performance, must recall the Spanish subjects of Manet. Close to Manet also is one of Sargent's most striking likenesses, *Portrait of the Artist's Niece Rose Marie Ormond* ("*Nonchaloire*"; 1911, NGW), in which the woman reclines on a sofa, with her dress and the furnishings of the room painted in a tour-de-force of impressionistic brushwork. The strong tonal contrasts reflect Manet as does the picture on the wall behind the sitter, which is abruptly cut off to create a hard, geometrical play against the luxurious drapery below.

Certainly, the most talked-about of Sargent's portraits was *Madame X* (1884, MMA). Despite the mysterious title of the work, the sitter was well known. She was Sargent's cousin Virginie Avegno, the wife of Pierre Gautreau and a leading "professional beauty" of Paris who was called the "Madame Récamier of the Third Republic." Sargent declared himself fascinated by the lavender "blotting paper of her skin," for which she was famous. The figure is shown standing full-length against a blank wall in the tradition of Velázquez, Whistler, and Manet. She leans on a tabletop and, though posed frontally, turns her head in profile to the viewer. There seems to be no reason, apart from the notoriety of the sitter herself, for this picture to have caused the scandal it did at the Salon of 1884. There is, to be sure, a curious, pale cast to the lady's skin—she wears no distracting jewelry, though dressed for evening—particularly as it is set off against her dark gown. There may also be something provocative in the casual ease of her pose in this most formal of portrait types. Most probably the sheer hauteur of her crisply drawn profile, her air of aristocratic disdain, roused the ire of the audience. At any rate, the picture was a spectacular failure, the kind that helps rather than hinders an artist's career. Sargent kept it in his studio for fifteen years, then sold it to MMA for a thousand pounds.

Had Sargent stopped painting in 1885, posterity might well have accorded him a place among the finest portraitists of the 19th century. Unlike his compatriot Whistler, who was inclined to antagonize his patrons, Sargent flattered them shamelessly. He was too willing to be the fashionable society portrait painter. His friend Henry James noticed the "talent which, on the very threshold of its career, has nothing more to learn." Occasionally, as in *Asher Wertheimer* (1898, Tate Gall., London), Sargent could find some depth in his sitters, but he never consistently achieved either the psychological penetration of THOMAS EAKINS or the invention of Whistler. More typical of his late work is *The Wyndham Sisters* (1900, MMA), three gracious women posed graciously in a gracious interior.

Although his technique was somewhat impressionistic, Sargent's oils have mainly dark tonalities, and only in his watercolor landscapes is there the brightness and coloristic freedom of the French school. A major undertaking of his late years was a series of mural decorations for the Boston Public Library (elaborate, symbolical panels on the development of religion) and for MFAB. The latter are classical in theme, including *Apollo and the Nine Muses* and *Atlas and the Hesperides* (for which he used models from the Ziegfeld Follies), and executed in the curious, dreamy, classical style, which also attracted such artists in the late 19th century as Whistler and Albert Moore, in England, and, in France, Pierre Puvis de Chavannes, who also did murals for the Boston Public Library. *Lit.*: Richard Ormond, *John Singer Sargent: Paintings, Drawings, and Watercolors*, 1970.

**SARTAIN, JOHN** (1808–1897), **AND FAMILY.** John Sartain was a printmaker, miniaturist, and portraitist. Born in London, he was apprenticed to engraver John Swain before coming to America in 1830 and settling in Philadelphia. Accomplished in making mezzotints, he helped popularize the medium after copying

JOHN NEAGLE's *Patriotism and Age*. Sartain was also a prolific engraver, turning out hundreds of illustrations for magazines, including his own *Sartain's Magazine* (begun in 1848). In the late 1850s, he started to make large engravings of major imaginative and historical works, including those of BENJAMIN WEST and PETER F. ROTHERMEL. Sartain was the art director of the CENTENNIAL EXPOSITION at Philadelphia in 1876. Four of his children became painters or engravers: Samuel (1830–1906), Henry (1833–c. 1895), Emily (1841–1927), and William (1843–1924). His autobiography, *The Reminiscences of a Very Old Man*, was published in 1899.

**SAUL, PETER** (b. 1934), a painter. From San Francisco, he studied at CSFA from 1950 to 1952 and at Washington Univ. from 1952 to 1956, before travelling to Europe, where he remained until 1962. A parodist and an absurdist, he comments mordantly on aspects of contemporary life, ranging from art to politics to the current infatuation with the past. Using garish Day-Glo colors, he creates often crowded canvases filled with violently caricatured and grossly exaggerated forms, misspelled words, puns, and odd perspectives. His works both influenced and were influenced by the underground comic books of the early 1970s.

**SAVAGE, EDWARD** (1761–1817), a portrait painter, engraver, and gallery director. From Princeton, Mass., Savage was self-taught and began his artistic career in Boston, Mass., in the mid-1780s but was in New York City in 1789, when he received a commission from Harvard Univ. for a portrait of George Washington. Two years later, he went to London, presumably to study with BENJAMIN WEST but also to learn the art of engraving. Upon his return in 1795, he settled in Philadelphia and the following year opened the Columbian Gall. to display old and modern paintings and prints. Savage continued to run the gallery for the rest of his life but moved it twice,

first to New York City, where, in 1802, imitating CHARLES WILLSON PEALE, he added a natural-history display (which he later sold to a colleague, who in turn sold it to P. T. Barnum). In 1811–12 Savage opened a new Columbian Gall. in Boston, and its holdings were later incorporated into the New England Mus.

The highlight of Savage's career was his painting *The Washington Family* (1796, NGW), which he made to display in his first Columbian Gall. and which he engraved two years later, possibly with a great deal of assistance from the talented David Erwin, newly arrived from England. Savage's masterwork is not particularly inspired and is overly symmetrical, but in choosing as his subject the entire First Family (George, Martha, her grandchildren, George Washington Parke Curtis and Eleanor Custis, and even the servant Billy Lee), Savage went beyond what had already been done by most Federal portraitists and added to the Washington iconography an image that has endured.

**SAŸEN, H(ENRY) LYMAN** (1875–1918), a painter. Born in Philadelphia, he worked as an electrical engineer and invented a variety of devices for which he held patents. He began to study art in 1899 at PAFA and, in 1904, won a national competition for designs for four lunettes, placed in the House Wing of the U.S. Capitol (Room H-143). The designs were academic in style. While abroad in 1906, he met Leo and Gertrude Stein and, becoming enamored of modern art, joined Henri Matisse's first art class in 1907–8. His paintings, until he returned to Philadelphia in 1914, were strongly influenced by Matisse's bright colors, unmodelled forms, and rapid brushstrokes. After 1914 Saŷen's paintings, which were almost all landscapes, grew airless and more abstract but kept their improvised, ragged look. Just before his death, he attempted an American-styled modernism that contained elements of folk and American Indian art. His last paintings contained poster-bright, unmodelled forms with precise edges, not un-

like the kind of style STUART DAVIS subsequently developed. Saÿen, with MORTON L. SCHAMBERG, organized Philadelphia's First Exhibition of Advanced Modern Art in 1914. Like Schamberg, he died in 1918, thus inhibiting the development of a "Philadelphia School" of modernism. Most of his paintings are in NCFA. *Lit.:* Adelyn D. Breeskin, *H. Lyman Saÿen,* exhib. cat., NCFA, 1970.

**SCHAMBERG, MORTON LIVINGSTON** (1881–1918), an early 20th-century modernist painter. From Philadelphia, he received an architectural degree in 1903, before studying at PAFA from 1903 to 1906. By 1909, after many trips abroad, he had grown beyond the modern impressionism of his teacher WILLIAM MERRITT CHASE. In the next few years, he moved rapidly from Fauvism to an abstraction based on natural forms, to works inspired by SYNCHROMISM or Orphism. Schamberg and H. LYMAN SAŸEN, another Philadelphian, experimented with similar abstracted landscape forms between 1913 and 1915. In the latter year, Schamberg began to explore curvilinear shapes based on such common objects as telephones *(Mechanical Abstraction,* 1916, Philadelphia Mus.), revealing the influence of Marcel Duchamp and Francis Picabia, whom he had met through Walter Arensberg in New York City (see NEW YORK DADA). Schamberg's pictures grew increasingly abstract and hard-edged; their disembodied forms, based on industrial artifacts, looked forward to PRECISIONISM. Had he lived longer, Schamberg might have made important contributions to that movement. He created one of the first examples—perhaps also the best-known—of American Dada sculptures, an assemblage of plumbing pipes entitled *God* (1916, Philadelphia Mus.). Schamberg worked as a photographer after 1913 but concentrated on portraits rather than on experiments in abstract form. *Lit.:* Ben Wolf, *Morton Livingston Schamberg,* 1963.

**SCHREYVOGEL, CHARLES** (1861–1912), a painter of the American West. From New York City, he spent most of his life in Hoboken, N.J. He studied with H. August Schwabe at the Newark Art League in the late 1870s and, from 1886 to 1890, at the Royal Acad., Munich. In succeeding years, he painted portraits and miniatures on ivory. Fascinated with the West as a child, he made the first of several trips there in 1893. His most famous works include *My Bunkie* (1899) and *Custer's Demand* (1903). Like FREDERIC REMINGTON, Schreyvogel limited landscape references so that the subject would stand out clearly. His favorite theme was warfare between intruding whites and Indians defending their ancestral homelands. To his credit, Schreyvogel usually painted Indians with dignity rather than as "devilish redskins." Most of his nearly one hundred known paintings and few bronzes are either in the National Cowboy Hall of Fame, Oklahoma City, or in the Thomas Gilcrease Inst. of American History and Art, Tulsa. *Lit.:* James D. Horan, *The Life and Art of Charles Schreyvogel,* 1969.

**SCHUSSELE, CHRISTIAN** (1824/26–1879), a leading historical painter and teacher of art. Schussele came to America from Alsace, his birthplace, settling in Philadelphia, one of many artists of German and Central European background who emigrated at the time of the Revolution of 1848. He began his career in this country practicing the nascent art of chromolithography; he was one of the earliest artists to work with mechanical color-printing in America. He quickly turned to painting, however, first as a genre artist and then as a history painter. To both themes, he brought a tradition of sound figural construction, which he at times combined with an excess of sentimental expression. Ill health forced Schussele to retire early from the ranks of significant Philadelphia artists, but it did not prevent him from assuming the role of teacher of painting at PAFA. Although his course of instruction and his methodology were traditionally academic, he was much respected, and it was Schus-

sele who took on as an assistant the young THOMAS EAKINS in 1876. Eakins was to introduce radical innovations into the curriculum, but it was Schussele who laid the groundwork in establishing PAFA as the outstanding teaching institution in America at the time.

**SEAWRIGHT, JAMES** (b. 1936), creator of electronic sculpture. From Jackson, Miss., he studied at ASL with JOSÉ DE CREEFT in 1961–62 and worked as a stage technician with choreographer Alwin Nickolais in 1962–63. Since 1963 he has been a technician for the Columbia-Princeton Electronic Music Center. He began experimenting with electronic sculpture in 1963, wanting "to make valid art out of the materials that are shaping the world." Preferring control to chance, he creates works in which forms are fixed but patterns of movement can be flexible. He is less concerned with motors, lamps, and circuits in their own right than in ways to make them parts of functioning systems. He has made pieces, such as *Watcher* (c. 1967), in which a mix of electronically generated sounds is determined by light patterns produced by the sculpture itself and people who move about it.

**SEGAL, GEORGE** (b. 1924), a painter and sculptor, best known for his figures made from plaster-impregnated bandages. Born in New York City, he studied at Cooper Union in 1941 and Pratt Inst. of Design in 1947. He majored in art education at New York Univ., from which he graduated in 1950, and received the M.F.A. degree from Rutgers Univ. in 1963. Segal is a member of the generation that learned about modern art in American art schools and universities rather than in studios abroad. He abandoned a promising career (1958–61) as a painter of large-scaled, expressionistic nudes to pursue one as a sculptor. His first pieces, made of wire, burlap, and plaster, looked, as he said, as if they had stepped from one of his paintings. In 1960 a student provided him with plaster bandages used to set broken limbs,

and Segal has used this type of material ever since. With it he makes castings from the bodies of friends, and pieces them together, altering the exterior by adding or deleting plaster to suit his expressive and formal aims. His figures, therefore, are not actual copies of his models—whose reverse images, instead, are locked inside the hardened plaster, unviewable and unknowable—an ironic, sad commentary on modern alienation. They are often set in realistic environments for which actual (rather than artist-created) objects are used, and, since Segal frequently leaves them unpainted, their ghostly presence is effectively reinforced by the contrast with literal reality. Segal prefers to re-create situations with which he has been familiar and to use people with whom he is acquainted in order, as he has said, "to intensify my sense of encounter with the world outside of me." His subjects until 1970, when he began to make reliefs of partial figures, included people in gas stations, restaurants, stores, and intimate domestic situations (*Bus Riders*, 1962, Hirshhorn Mus.; *Girl in a Doorway*, 1969, WMAA).

Segal creates two complex sets of formal and psychological relationships—between figure and figure and between figure and surroundings. Tensions are generated by carefully constructed compositional arrangements of the realistic but slightly askew and often unpainted figures. In addition, though real objects are made part of the tightly knit organizational formats, they retain a sense of their own past history, whether it be as a countertop or dentist's equipment. Segal seems purposely to leave unreconciled the gamut of dualisms between reality and artifice. ROBERT RAUSCHENBERG once said that he liked to operate in the gap between art and life. Segal has literally occupied that gap. Although he was initially associated with POP ART, chiefly because his art directly incorporated objects from the real world, his humanistic sculpture has little in common with the bright, hard-edged, commercial-looking products based on advertising media

that fill ROY LICHTENSTEIN's work, for example. Segal's environments are closer to those of the ASSEMBLAGE movement of the late 1950s, in which found objects were organized by the artist into compositional units. Given the theatrical, hauntingly lifelike nature of his sculpture, it seems appropriate, and perhaps no coincidence, that the first outdoor HAPPENINGS occurred at his New Jersey home, in 1958. Since 1973 Segal has cast from the human body in such a way that he can reproduce the exact dimensions of his subjects. *Lit.:* William Seitz, *Segal,* 1972.

**SERIAL IMAGERY.** See MINIMAL ART.

**SERRA, RICHARD** (b. 1939), a sculptor. From San Francisco, he graduated from Yale Univ. in 1964. He was involved with the Italian *arte povera* movement in 1965–66 and afterward associated with such artists as EVA HESSE who were interested as much in the process of making works as in the works themselves. Concerned with the qualities of materials, Serra has, since 1967, used rubber belts, neon tubes, molten lead, and large metal slabs. In 1968 he made his first Splash-piece, in which molten lead was thrown against the point at which floor and wall meet. In 1969 he incorporated gravity into his work by leaning large lead sheets against each other in his Prop series. Subsequently, in cities and fields in Europe and America, as well as in gallery spaces, he has placed enormous plates of metal in various configurations to make three-dimensional designs out of the areas being used. The metal plates may be touching each other, placed several yards apart, or hung from ceilings. Serra's intention in these works and projects is to create a "field force . . . so that the space is discerned physically rather than optically." *Lit.:* Liza Béar (interview), "Richard Serra: Sight Point '71–75/Delineator '74–76," *Art in America,* May, 1976.

**SHAHN, BEN** (1898–1969), a major social-realist painter, printmaker, and photog-

rapher (see AMERICAN SCENE PAINTING). Born in Kovno, Lithuania, he came to Brooklyn, N.Y., in 1906. An apprenticed lithographer from 1913 to 1917, he pursued a career in that medium while studying art at NAD from 1919 to 1922. He travelled in Europe and North Africa in 1924 and 1925, and again from 1927 to 1929. His subject matter and style at the time were generically modernist— intimate landscapes in an exuberant expressionist style (*Little Church,* c. 1925, Newark Mus.). After his return to America in 1929, he took up social themes, initially concentrating on thematic cycles pertaining to such innocent victims of governmental and official abuse as Henri Dreyfus (1930), Sacco and Vanzetti (1931–32; studies in MOMA and WMAA), and Tom Mooney (1932–33). Early statements in a developing art of social criticism, these works played upon the viewer's feelings without indulging in ideological polemics. Subjects were developed in a social-humanitarian rather than propagandistic manner. Shahn developed a new style with these works, an expressive realism that combined an emphatic, wiry line with ragged brushmarks. His exploration of each subject in a number of studies prefigured the narrative cycles of the mural movement of the 1930s (see FEDERAL ART PROJECTS).

In 1933, Shahn assisted Diego Rivera with the Mexican artist's ill-fated mural *Man at the Crossroads,* destroyed in 1933 before it was completed for New York City's Rockefeller Center. Hired by the Public Works of Art Project in 1933–34, Shahn made studies for a mural cycle on Prohibition (MCNY). This was followed by another group of studies, for murals at New York's Rikers Island Penitentiary in which, assisted by Lou Block, Shahn contrasted old and enlightened systems of punishment and rehabilitation. Neither mural project was completed. Between 1935 and 1938, Shahn photographed rural scenes in Ohio and nearby states for the Farm Security Administration, documenting the effects of poverty on the lives of the rural poor (see FARM SECURITY ADMINISTRA-

TION PHOTOGRAPHS). He based a number
of paintings on these works, including
*Scotts Run, West Virginia* (1937,
WMAA). For the same governmental
agency, he completed his first mural, a
fresco, in 1937–38, for the Roosevelt,
N.J., community center. Perhaps the fin-
est social-realist mural of the 1930s, it
detailed union support for and success in
creating better educational and residen-
tial facilities for organized labor.

Like other artists of his generation,
Shahn began to feel in the late 1930s
that "the social dream . . . could no long-
er reconcile the view [the idea of public
art] with the private and inner objectives
of art." Disenchanted, no doubt, by sec-
tarian political interests, he wanted to
tap "symbols that would have some . . .
universal quality." As a result, his subse-
quent governmental murals—for the
Bronx, N.Y., Central Annex Post Office,
1938–39; the Jamaica, N.Y., Post Office,
1939–40; and the Social Security Build-
ing (now the Department of Health,
Education and Welfare, 1940–42)—
made more general statements about
American life. During the 1940s, Shahn
made posters for the Office of War In-
formation and, in 1945–46, he served as
director of the Graphic Arts Section of
the Congress of Industrial Organizations
(CIO). His first important group of
paintings reflecting his new interests de-
scribed Italian scenes during and after
World War II (*The Red Stairway*, 1944,
St. Louis Mus.; other examples in MFAB,
MOMA, and Walker Art Center). In sub-
sequent years, Shahn designed sets for
ballets and plays and created mural mo-
saics for synagogues, private homes, and,
in 1963–64, the New Jersey State Mus.,
Trenton. His style grew increasingly per-
sonal, occasionally approaching com-
plete abstraction. His thin, expressive
line came to dominate his even thinner
color washes. Shahn's themes also be-
came personal rather than political, even
when, in 1960, he painted a series of
gouaches based on the story of the *Lucky
Dragon*, the Japanese ship that had been
dusted with fallout from a hydrogen-
bomb test (examples in Norton Gall. and

School of Art, West Palm Beach, Fla.,
and NCFA). His *The Shape of Content*
was published in 1957. *Lit.*: John D.
Morse (ed.), *Ben Shahn*, 1972.

**SHAPED CANVASES.** See MINIMAL ART.

**SHARPLES, JAMES (1752–1811), AND FAM-
ILY.** Theirs was the finest pastel art cre-
ated in America after JOHN SINGLETON
COPLEY and before the renaissance of the
medium in the later 19th century. From
Lancashire, England, James Sharples
was a pupil of George Romney, the Eng-
lish portraitist. He worked in Bath, Bris-
tol, and London before travelling to
America about 1793 with his wife, the
former Ellen Wallace (1769–1849), who
had been his pupil, and three children,
Felix (c.1786–1825), James, Jr. (c.1788–
1839), and Rolinda (c.1793–1838). The
family spent four years in Philadelphia
and four in New York City. They re-
turned to Bath in 1801, but in 1806 Felix
and James, Jr., came back to America.
Three years later, the rest of the family
followed. When the father died, his
wife, his daughter, and James, Jr., re-
turned to Bristol, where they finally set-
tled.

The Sharpleses were specialsts in pas-
tel portraits of cabinet size, smaller than
life but larger than miniature. They are
usually on thick gray paper, the wooly
texture of which gives a soft, grainy ap-
pearance to the very sensitive drafts-
manship. The likenesses are sometimes
in the common three-quarter view but
many are in profile. The highlight of the
Sharpleses' work was the often-replicat-
ed likeness of George Washington, done
about 1796 or 1797. The various mem-
bers of the family worked together so
closely that it is impossible to distinguish
among their hands. Fine examples are
usually assigned to James, Sr., but his
wife was equally talented and, though
she seems often to have copied her hus-
band's pictures, she undoubtedly created
original examples as well. There is a
large collection of their work in Bristol.
*Lit.*: Katherine McCook Knox, *The
Sharples*, 1930.

SHATTUCK, AARON DRAPER (1832–1928), a landscape painter of the WHITE MOUNTAIN SCHOOL and an inventor. A native of Francestown, N.H., Shattuck first studied portrait and landscape painting in Boston, Mass., with portrait painter Alexander Ransom. In the following year, he and his teacher moved to New York City, where Shattuck enrolled in NAD. During the next few years, Shattuck, like a number of the other second-generation HUDSON RIVER SCHOOL artists he knew, established a routine of sketching in upstate New York and New England in the summer and painting in a New York City studio in the winter. Among the artists with whom he became friendly were ASHER B. DURAND, WILLIAM SIDNEY MOUNT, with whom he collaborated on a picture (*Indian Guide, Mt. Chocorua*, [1858]), JOHN F. KENSETT, and SAMUEL COLMAN. Most of Shattuck's works were small-scale and rather romantic views of mountainous terrain. Like those of his friend Kensett, Shattuck's early works are frequently quiet scenes of trees, rocks, and water. A taste for precise detail is obvious in the foregrounds of the artist's early drawings and paintings, whereas a more painterly treatment of natural objects prevails in his later works. In paintings of the 1870s, Shattuck tended to concentrate on the bucolic subject matter offered him on the farm on which he lived in Granby, Conn. An illness in the 1880s caused him to turn from painting to inventing. He gave his attention to such varied projects as the improvement of stretcher keys for artists' canvases and the development of more efficient ventilating systems for tobacco barns. At the time of his death, Shattuck, at the age of ninety-seven, was the oldest living member of NAD. Many of his works are still owned by members of his family in Connecticut. *Lit.*: Charles B. Ferguson, *Aaron Draper Shattuck, N.A.*, exhib. cat., New Britain Mus., 1970.

SHAW, JOSHUA (1776/77–1860), an Engish-born landscape painter and inventor from Bellingborough, Lincolnshire. Trained as a sign painter, Shaw had become an established painter of landscapes, still life, flowers, portraits, and livestock before emigrating to the United States in 1817. Settling in Philadelphia, Shaw concentrated on landscapes, seascapes, genre, and Indian scenes. He was one of the first artists to record American topographical views for reproduction and wide dissemination. In 1819 Shaw toured the eastern seaboard, making watercolor sketches that were etched and aquatinted by JOHN HILL and published in 1820–21 as *Picturesque Views of American Scenery*. This became the model for published American landscape views. Shaw was also well known for his artist's manual *A New and Original Drawing Book* (1816) and for his *United States Directory for the Use of Travellers and Merchants* (1822), which contains excellent examples of engraved American advertising art. Active in the art politics of Philadelphia, Shaw founded the Artists' Fund Soc. in 1835 and the Artists and Amateur Assoc. in 1837. Shaw also invented a percussion-wafer priming device for firearms. In 1843 he moved to Bordentown, N.J., where he continued to paint until stricken with paralysis in 1853.

Shaw's landscapes are picturesque, embodying the ideals of the beautiful and the sublime, yet they tend to be somewhat dry. Colorful flowers, fuzzy foliage, and a sensitive use of light are characteristic of his best works. He is represented in the Victoria and Albert Mus. in London and in the Karolik Collection at MFAB.

SHEELER, CHARLES (1883–1965), the major exponent of PRECISIONISM as well as an important photographer. Born in Philadelphia, he studied there at the School of Industrial Art in 1900–3 and then with WILLIAM MERRITT CHASE at PAFA from 1903 to 1906. He travelled to Europe at least three times in the next few years (twice with Chase), but only during his last trip, from 1908 to 1910 with his friend MORTON L. SCHAMBERG, did he respond to modernist art. After

this encounter, Sheeler said that it took the next ten years to shake Chase out of his system. Some four factors contributed to the emergence of Sheeler's mature style, which first appeared about 1917 in conté crayon studies like *Barn Abstraction* (1917, Philadelphia Mus.). First, he became enamored of the simple, unadorned forms of early American and Shaker artifacts. Second, he became a commercial photographer in 1912. His photographs, especially those done between 1912 and 1917 of his farmhouse, prefigure his mature paintings, which are abstract in composition, with the details of rooms and facades isolated from the spaces surrounding them. Sheeler also pioneered in the use of sharp-focus effects, in reaction to the pictorialism of contemporary photographers (see PHOTO-SECESSION), and this clarity is also evident in his paintings. Third, the ARMORY SHOW of 1913 allowed Sheeler once again to study the modern movement in place of local realist styles. Until roughly 1917, he made paintings composed of arc-like forms and flattened and interpenetrating planes in a Cubist manner. His interests brought him into contact with Walter Arensberg's circle, which included artists, poets, and dancers, among them Marcel Duchamp, William Carlos Williams, and Isadora Duncan. Fourth, least specific, but certainly influential was the intellectual despair that spread over the country after World War I and was recorded in works by EDWARD HOPPER and CHARLES BURCHFIELD, whose images and attitudes were in direct contrast to the optimistic ones associated with the slightly earlier figures of the ALFRED STIEGLITZ circle—JOHN MARIN and ARTHUR G. DOVE, for example. Part of this reaction included the rejection of European styles and motifs. Sheeler himself chose to substitute American objects for the guitars and wine bottles of European studios (*Interior*, 1926, WMAA) and American landscapes for European ones, and to deemphasize textures, square-off planes of color, work with timeless atmospheric conditions (scenes painted at high noon

on cloudless days), and eliminate human figures (and, of course, interactions between them). This art lay at the points of intersection between European Cubism and traditional American realism, the transcendental silences of HUDSON RIVER SCHOOL landscapes and American FOLK ART.

In 1920 Sheeler began to photograph and to paint urban scenes in which buildings were reduced, as in *Church Street El* (1920) and *Offices* (1922, Phillips Coll.), to a sequence of bright, razor-sharp facades and deep shadows. Of these works, he said that he had wanted to remove the method of painting from the viewer's attention, and, in great measure, therefore, the artist's personality. Despite occasional odd perspectives, which placed realistic objects in abstract spatial relationships, Sheeler's paintings of this period were usually static. As the decade progressed, his pictures grew more realistic, but, paradoxically, the arrangements of details and of objects grew more antic and abstract. Of this development he remarked that he wanted to conceive pictures realistically but provide them with an underlying abstract structure. Reasoning thus, he clearly distinguished his photographs from his paintings of this period since the former were the result of a single image seen from one vantage point at one moment in time, whereas the latter were composite views. Nevertheless, the same detached, alienated, sharp-focus vision informed works in both media, as is readily observed by comparing his photographs and his paintings of the Ford Motor Company plant in River Rouge, Mich. The former were completed in 1927–28, the latter in 1930–32 (*American Landscape*, 1930, MOMA).

Sheeler created his most realistic work during the 1930s, in both paintings and conté crayon studies. Still attracted to industrial scenes, he also devoted great energy to recording an older America, especially the one reflected in Colonial Williamsburg, between 1935 and 1937. Yet he did not see himself, during this decade of AMERICAN SCENE PAINTING, as

an archivist. Instead, he felt that he was responding "to intrinsic realities of forms and environment," and nothing more.

A seismic shift occurred in Sheeler's work during the mid-1940s, due perhaps to the presence in America of such European abstractionists as Piet Mondrian and his American followers, and perhaps to Sheeler's own exploration of multiple-image photography. (His position as photographer-in-residence at MMA from 1942 to 1945 was not consequential in this regard.) In any event, after spending a month as artist-in-residence at Phillips Acad., Andover, Mass., in 1946, he began to employ multiple viewpoints where he would previously have used one and to dematerialize objects into disembodied and superimposed planes. The new works ranged in subject from massive industrial forms, as in *Incantation* (1946, Brooklyn Mus.), to intimate handmade objects. All were as carefully painted as his earlier work, with a precise and controlled placement of forms. To arrange the different levels of transparent planes, he first made sketches on superimposed sheets of Plexiglas and plastic. As a group, these works seem strangely quiet hymns to the extraordinary development of American technology, if not to the American ability to deal with that technology in a credible psychological manner. *Lit.*: Martin Freedman, *Charles Sheeler*, 1975.

**SHEFFIELD, ISAAC** (1798–1845), an itinerant painter of portraits in miniature and full-scale. From Guilford, Conn., he settled in New London about 1833, and there he painted many sea captains and their families. The men invariably hold a telescope in one hand. Behind them, a red curtain is usually drawn back to reveal a seascape. The women sit in front of a red curtain partially obscuring a harbor scene, as in *Lady with Birthmark* (c. 1835, Mus. of American Folk Art, New York City). Like other itinerants, Sheffield delighted in multiplying detail upon detail, capturing very delicate needlework patterns of shawls or, as in *James Francis Smith* (1837, Lyman Al-

lyn Mus., New London), the patterns of a penguin-skin coat. Although Sheffield's figures often lack the vivacity usually associated with the itinerant style, they are imbued with an attractive introspection. *Lit.*: Frederick Sherman, "Unrecorded Early American Portrait Painters," *Art in America*, Dec., 1933.

**SHINN, EVERETT** (1876–1953), a painter and illustrator and member of The EIGHT. From Woodstown, N.J., he worked as a designer for a gas-fixtures company in Philadelphia from 1890 to 1893, after studying industrial design. After deciding that he preferred fine arts, he took courses at PAFA between 1893 and 1897, and, at the same time, worked as a reporter-artist for the *Philadelphia Press*. During these years, he met the future members of The Eight. He moved to New York City in 1897 and continued his career as an illustrator and an artist. Altogether, he illustrated twenty-eight books and ninety-four magazine stories in addition to making cartoons and newspaper illustrations. About 1899 he made the first of a series of murals and large panels for private houses and, in 1907, he painted eighteen panels for the Stuyvesant Theater. In 1911 he completed murals on local industrial themes in the Trenton, N.J., City Hall. From 1917 to about 1923, he worked for motion-picture companies as an art director. In his paintings, he found subject matter in the slums as well as in middle-class café society and in theatrical activities (*Theater Box*, 1906, AK). His theater scenes were usually done in oil, his slum and lower-class pictures in pastel. Unlike JOHN SLOAN, who felt a genuine reformer's commitment to lower-class urban themes, Shinn viewed the entire city as a bright, glittering spectacle to savor and to enjoy until the end of his life. His art reflects the influences of Honoré Daumier, Edgar Degas, and Jean-Louis Forain. *Lit.*: Edith De-Shazo, *Everett Shinn*, 1974.

**SHIRLAW, WALTER** (1838–1909), a painter. From Paisley, Scotland, he was

brought to America in 1841 and grew up in Hoboken, N.J. He worked as an engraver in Chicago in the 1860s but was a largely self-taught painter until, to develop his technique further, he went abroad to study art in 1870. Unable to enter Paris because of the Franco-Prussian War, he went instead to Munich, where he remained until 1877. While there, he mastered the Munich style and was among those who introduced it to America (see MUNICH SCHOOL). His *Toning the Bell* (1874, AIC) was one of the most popular paintings exhibited at the CENTENNIAL EXPOSITION in Philadelphia. A genre, portrait, and mural painter, Shirlaw is perhaps best known for his paintings of the nude. His models were invariably placed in outdoor settings, and the works were given poetic titles like *Spirit of Autumn Leaves* and *Water Lilies* (NCFA). Like the Flemish painter Peter Paul Rubens, Shirlaw preferred fleshy models, a characteristic commented upon during his lifetime. Shirlaw was among the first to help popularize mural painting in the late 19th century (see MURAL PAINTING MOVEMENT). His public murals include *The Sciences* in the Library of Congress, and he also helped decorate the dome of the Manufacturers and Liberal Arts Building at the WORLD'S COLUMBIAN EXPOSITION in Chicago in 1893. In 1889 he made drawings of Indian life on the Crow and Cheyenne reservations. A founder of the Soc. of American Artists (see NATIONAL ACADEMY OF DESIGN), he was its first president. *Lit.*: Dorothea A. Dreier, "Walter Shirlaw," *Art in America* 7, 1919.

SISKIND, AARON (b. 1903), a photographer known for his abstract close-ups of urban walls, who is frequently discussed in connection with the Abstract Expressionist painters (see ABSTRACT EXPRESSIONISM). Siskind was born in New York City. While teaching English in New York City, he became interested in photography, after seeing the exhibitions of the Photo League, which he soon joined. After 1936, in keeping with the principles of the league, he produced a social-

documentary series, including Dead End: The Bowery and Harlem Document. His 1941 "Tabernacle City" a study of a revivalist camp on Martha's Vineyard, offended other Photo League members because of its concern with the formal beauty of architecture. Siskind nevertheless continued to move in this direction, eliminating deep space, and in 1943 he began to work with the flat plane using organic objects in a geometrical setting. Finding that the emphasis shifted from the object to the picture itself, he explored close-up abstractions of the urban environment, almost always focusing on flat surfaces: billboards, stained walls, graffiti. He remained true to the "straight" tradition of ALFRED STIEGLITZ, however, transferring the latter's notion of "the equivalent" from natural subjects such as clouds to the more geometrical world of city life. In the late 1940s, he became acquainted with the Abstract Expressionists, discovering a mutual interest in the expressive potential of pure form and the resulting emphasis on the picture plane. BARNETT NEWMAN introduced him to the Egan Gall.—which also showed WILLEM DE KOONING, PHILIP GUSTON, and FRANZ KLINE—and there he had his first one-man show in 1947. In 1951 he taught with HARRY CALLAHAN at Black Mountain Coll. and the following year joined the faculty of the Chicago Inst. of Design. An important retrospective of his work was held at GEH in 1965. *Lit.*: Aaron Siskind, *Places*, 1976.

SLOAN, JOHN (1871–1951), a painter, printmaker, poster artist, teacher, and member of The EIGHT. Born in Lock Haven, Pa., he spent his early adult years in Philadelphia, where he studied at PAFA from 1892 to 1894 and worked as an artist-reporter for the *Inquirer* in 1892 and for the *Press* from 1895 to 1903. He was also a pioneer poster artist in the Art Nouveau style during the 1890s. His first serious oil paintings date from 1896, and his first urban scenes were made in the following year. An example is *East Entrance, City Hall,*

*Philadelphia* (1901, Columbus Gall.). These early works, reflecting the example of ROBERT HENRI, whom he had met in the early 1890s, were based on Sloan's direct observations rather than on the currently fashionable Impressionism or on conventional academic art. Derived in style from Frans Hals and Edouard Manet, these works were almost monochromatic and characterized by vigorous brushwork.

At the same time that he was exploring urban subject matter, Sloan prepared, between 1902 and 1905, fifty-four drawings and an equal number of etchings for a deluxe edition of Charles Paul de Kock's novels. After settling in New York City in 1904, he created a series of etchings entitled New York City Life that reached beyond generalized observation of city themes to intimate recordings of life styles, specific events, and anecdotes in the public and private lives of its inhabitants. They were probably the first such works ever made by an American artist and helped spark conservative critical reaction to his entire oeuvre. Until about 1910, Sloan painted city scenes as an artist-voyeur, making vignettes of backyards, restaurants, street corners, and parks. For Sloan, life was the prime motive for art, whether it was a beach scene (*South Street Bathers*, 1907–8, Walker Art Center) or one of women entering a tavern (*Haymarket*, 1907, Brooklyn Mus.). Believing that knowledge of life was best acquired by spending time with ordinary persons, Sloan indefatigably searched for his subject matter on the city streets.

The most political of the realists, Sloan joined the Socialist party in 1909, made drawings for Socialist organs, including The *Call* and The *Coming Nation*, became an editor of the *Masses* from 1912 to 1916, and ran for the New York State Assembly in 1910 and in 1915. Despite his strong beliefs, he tried to keep his art and his politics separate. His paintings seldom convey a particular point of view, and even his illustrations lack political bite, with a few exceptions (*Class War in Colorado*, in *Masses*, July, 1914).

Sloan's palette lightened after 1909 because of his experiments with Hardesty Maratta's color system (see ROBERT HENRI) and the influence of such modernists as Vincent van Gogh, whose work Sloan studied at the ARMORY SHOW in 1913. About the same time, he began to paint more landscapes and more interiors. When he did return to city scenes, he tended to concentrate on the spectacle of the city, as in *The City from Greenwich Village* (1922, NGW). In 1928 he began to impose a linear overlay of red lines upon his subjects (studio nudes, for the most part). He hoped that this would add to the tangibility.of their form, and during the remainder of his career he painted in this manner. In 1939 he completed a mural, *The First Mail Arrives at Bronxville, 1846*, for the Bronxville, N.Y., Post Office. His autobiographical *The Gist of Art* was published in the same year. He became president of the Soc. of Independent Artists in 1918, a position he held for life. The major collection of his work is housed in the John Sloan Trust, Wilmington, Del. *Lit.*: David Scott, *John Sloan*, 1975.

SMIBERT, JOHN (1688–1751), a leading painter in colonial America. Born in Edinburgh, Scotland, and apprenticed to a plasterer and house painter, he moved to London in 1709, attended Sir James Thornhill's academy, and worked as a coach painter and as a copyist for London dealers. His talent for copying the old masters was to stand him in good stead later in his career. In 1719 Smibert travelled to Italy, where he copied portraits by Raphael and Titian in order to perfect his own technique. Returning to London in 1722, he began a successful practice as a portrait painter. There was stiff competition, however, from the Kneller School, as well as from Michael Dahl and Thomas Hudson. Smibert, who was exceedingly ambitious, was not able to gain ascendancy over these artists.

At this time, the pivotal incident of Smibert's career occurred: He met Dean

Berkeley of Derry, who sat to him in London. Berkeley was about to embark for "the Bermudas," where he intended to establish a "Universal College of Science and the Arts," and to convert the savage native Americans. He persuaded Smibert to join the expedition as teacher of drawing, painting, and architecture. The group set sail in 1728, landing in Virginia and moving on to Newport, R.I. While they waited there in vain for funds from England, Smibert proceeded on to Boston, Mass., where he quickly found patrons for his portraits, including the wife of the governor of Massachusetts, Mrs. Hutchinson. In Boston, Smibert completed the work, probably begun in London, that was to make his reputation. *The Bermuda Group* (1728–29, Yale Univ.) shows Dean Berkeley and his entourage, including members of his family and the artist. The bishop stands to the right, apart from the others and facing the viewer—a pose establishing him as the authoritative figure. Barrel-chested and confident, he gazes dreamily upward in a manner suggesting the quixotic nature of his expedition, which must have been apparent to Smibert by the time the picture was finished. The balanced composition is standard for the late Baroque period, with a pyramidal seated group in the center and standing figures, including Smibert, at left and right. Though there is little penetration into character, the relatively subtle interactions and rhythms of the composition make it easily the most sophisticated group portrait painted in America to that date. Its influence was enormous, and it established Smibert as the leading portraitist in the colonies. A controversy continues to surround the work because an alternate version exists in Dublin, Ireland, that is considered by some to be the original.

Having hit upon a successful formula, Smibert varied it only slightly throughout his career. In his portraits *Francis Brinley* and *Mrs. Brinley with Her Son Francis* (both 1730, MMA), the artist used slight variants of primary colors, as was his typical procedure. Mrs. Brinley's pose is derived from Smibert's copies of Sir Peter Lely's work and of a Raphael *Madonna*. *Francis Brinley* has a picturesque view in the background that is indicative of Smibert's increasing interest in landscape, which he took up especially as his eyesight failed in later life and he was obliged to forsake portraiture. No landscapes from his hand survive, however. Perhaps because of his infirmities or his isolation from cosmopolitan centers, his later portraits grew stiff and wooden, as is his rare full-length *Sir William Pepperall* (1747, Essex Inst., Salem, Mass.).

Smibert married well and never lacked money, but the thrifty Scot turned his studio into a showplace for his old-master copies and also into an art-supply shop. His gallery of copies, prints, and casts of antique sculpture attracted many young artists and, in fact, served as a kind of a school of art in an era when few such resources existed. In a long and industrious life, which was not without personal misfortune—five of his nine children died in infancy—Smibert introduced advanced European technique into American portraiture and found time to design Boston's famous Faneuil Hall. He made almost three hundred portraits. *Lit.*: Henry Wilder Foote, *John Smibert, Painter*, 1950.

SMITH, DAVID (1906–1965), perhaps the major American sculptor. In his work exists the kind of wild energy and adventurousness associated with such figures as Walt Whitman and JACKSON POLLOCK. Born in Decatur, Ind., he revealed an interest in art in high school and took a correspondence course fom the Cleveland Art School. A few years later, during the summer of 1925, he worked at the Studebaker automobile plant in South Bend, where he learned machineshop procedures and techniques for handling and cutting metals. After moving to New York City in 1926, he began to study painting at ASL, where he remained, off and on, until 1931. Jan Matulka, the Czech abstractionist, was his most important teacher. Smith began

making constructions in 1931, first attaching found and shaped objects to his paintings and, during a trip to the Virgin Islands, using coral and wood in free-standing units. He started making welded-steel pieces in 1932 and in the following year rented space in the Terminal Iron Works factory in Brooklyn. In 1934 he was assigned to the mural program in the Treasury Relief Art Project (see FEDERAL ART PROJECTS). He also worked for WPA-FAP in 1937. Between these two years he travelled abroad, as far as Russia. As early as 1930, he had become acquainted with the ideas of the Parisian avant-garde through his friend the emigré artist JOHN GRAHAM, STUART DAVIS, and ARSHILE GORKY. Smith moved to Bolton Landing, N.Y., in 1940. During World War II, he worked in a factory, assembling locomotives and tanks.

Although Smith made many "independent" pieces, he often explored particular themes in series, creating over fifteen such groups during his career. They include the Medals for Dishonor, 1937–40 (example in the Hirshhorn Mus.); Spectre, begun 1944 (example in the Detroit Mus.); Agricola, begun 1951 (example in the Hirshhorn Mus.); Tank Totem, begun 1953 (example in AIC); Sentinel, begun 1957 (example in the Hirshhorn Mus.); Albany, begun 1959; Zig, begun 1960 (example in Lincoln Center, New York City); Voltri (example in the Hirshhorn Mus.) and Voltri-Bolton, begun 1962; and Cubi, begun 1963 (examples in MFAB, Dallas Mus., Detroit Mus.). The Cubi series has been considered the finest group of sculptures ever made by an American artist.

Smith's career can be divided into at least three major phases: first, from about 1930 to 1940, when he assimilated European styles; second, the 1940s, when he developed a personal symbolism; and third, after 1950, when, in the development of a monumental art, formal concerns dominated symbolic ones.

Inventive as well as responsive to modern styles, Smith incorporated Cubist, Surrealist, and Constructivist elements into his works as well as spatial elements associated with painting. At the same time, he retained a distinctive mode of interpreting such elements so that his work may better be considered parallel to these movements than part of them.

He turned to welding techniques, the first American sculptor to do so, after seeing illustrations of welded pieces by Pablo Picasso (about 1930) and by Julio Gonzales and Alberto Giacometti (before 1934) in such journals as *Cahiers d' Art* and *Formes*. Exploring both figurative and geometrical formats, he readily absorbed the transposition of Cubist forms into three dimensions as well as the suggestive imagery of Surrealism (*Aerial Construction*, 1936, Hirshhorn Mus.; *Suspended Figure*, 1935). However, many of his pieces of this first phase differ from their European prototypes in that Smith tended to eliminate the sense of a real or implied central core and its enclosing shapes. Instead, he emphasized movement at the peripheries of his pieces and, at times, his surfaces seemed to be disconnected from their centers. In thus disavowing the anthropomorphic core from which outer forms "grew" and to which they related, he challenged traditional notions of sculpture. As a result, traditional hieratic compositions, with dominant and subordinate elements, were replaced by balances of disjunctive units arranged along different levels of height and planes in depth.

The Medals for Dishonor, his first important series, done after his return from Europe, are composed of a mixture of images derived from earlier artists' work and from medical illustrations but also reflect a personal idiom, seen, for example, in such phallic shapes as cannons. These works comment on the social and political situation of the time. In succeeding years, Smith combined personal symbols with formal innovations, especially the introduction of rectangular space frames that encompassed interior forms. This mode links his work to painting because of its suggested flatness and frontality. It allowed him to eliminate the base, a further denial of anthropo-

morphic connections. A fine example in this style is *Hudson River Landscape* (1951, WMAA). Its open, linear forms suggest a controlled writing in space. Simultaneously, Smith explored personal symbolism in such works as *Pillar of Sunday* (1945, Indiana Univ.), a vertical work with a spine and a base that had attached to it forms invoking childhood memories.

During the 1950s, in the Agricola series, Smith explored further the space-frame idea as well as the displacement of energy from a work's center to its peripheries. For this series, Smith used found objects, but he transformed them enough to obliterate their past histories. By contrast, the steel beams that compose the Sentinels and the large, circular oil-tank caps that compose the Tank Totems retain their past associations, though the use of paint and the insistent frontality of the Tank Totems tend to deny any clear three-dimensional reading of their parts. Smith's Cubi series in great measure summarizes aspects of his earlier work. In these large stainless-steel pieces composed of rectangular and circular forms, he explored the formal possibilites of the space frame, the compositional implications of the central core (both present and absent), the differences between expansive and contractive formats, the interrelationships of surface effects and volumetric bulk—especially when highly polished surfaces suggest weightlessness rather than solidity—and the effects on designs of bases and of nonbases.

Smith's importance lies in his explorations of Cubist form in sculpture, of the dematerialization of volumes, of painted sculpture, and of welding techniques. As a result of his knowledge of European art, his work became a repository of information and stylistic clues for younger artists. *Lit.*: Rosalind E. Krauss, *Terminal Iron Works: The Sculpture of David Smith*, 1971.

**SMITH, THOMAS** (active second half of 17th century), the earliest painter in the North American colonies whose identity has been established with reasonable scholarly certitude. Smith was a sea captain who reached Boston, Mass., from Bermuda in 1650. He was paid by Harvard Coll. for a portrait of a Dr. Ames in 1680, a work now lost, but his *Self-Portrait* (c. 1690, Worcester Mus.) is a strong, very individualized likeness, far more Baroque in style than most of the other extant 17th-century New England portraits, which are characterized by flattened figures and space, a decorativeness on and a masklike presentation of the countenance—features that all suggest a derivation from the older Tudor and Elizabethan aesthetic. Smith's own likeness, on the other hand, is powerfully modelled and strongly, if crudely, individualized. The picture is also noteworthy for its accessories: a naval battle in the distance (to indicate the maritime occupation of the sitter) and a skull and a poem on the table, suggesting the mortality of man. (Such *vanitas* motifs were common in 17th-century Europe but exceedingly rare in America until the late 19th century, when they reappeared in the still-life pictures of WILLIAM MICHAEL HARNETT and his school.) On the basis of Smith's *Self-Portrait*, a number of other late 17th-century New England portraits have been attributed to him. *Lit.*: Louisa Dresser, *Seventeenth Century Painting in New England*, 1935.

**SMITH, TONY** (b. 1912), a sculptor from South Orange, N.J. After attending ASL from 1933 to 1936 and the New Bauhaus, Chicago, in 1937–38, he turned to architecture. He began to work for Frank Lloyd Wright in 1939, and, until 1960, also had his own architectural practice. Although he painted and sculpted during these years, he did not exhibit publicly until 1964. Smith believes that form can generate meaning and that it has emotional content, yet his designs are cool and complex geometrical schemes often based on modular tetrahedral and octahedral formats. His work, therefore, is spare and severe, but, unlike works by Minimalist DONALD

JUDD, Smith's pieces reach out in seemingly antic directions and affect three-dimensional movement. Pieces such as *Moses* (1968, Princeton Univ.) are resolutely space-conscious in that solids and voids are integrated into rigorously controlled compositions. His pieces are, for the most part, monochromatic. Like much Minimalist sculpture, Smith's pieces are executed commercially after careful planning in several stages by the artist (see MINIMAL ART). *Lit.*: Eleanor Greene, *Tony Smith: Painting and Sculpture*, exhib. cat., Univ. of Maryland, 1974.

SMITHSON, ROBERT (1938–1973), a sculptor. From Passaic, N.J., he studied at ASL in 1955–56 and at the Brooklyn Mus. school. During the mid-1960s, his work was associated with MINIMAL ART, but instead of exploring reductive or serial systems, he experimented with progressive ones in which measurements increased or decreased. His units also tended to alter their size according to the particular system of expansive or contractive measurement used. In addition, Smithson explored the "behavior" of forms when their placement was changed. In *Enantiomorphic Chambers* (1964), duplicated forms containing mirrors faced each other in such a way that they reflected each other. In 1966 Smithson began to make trips to rural areas, where he photographed sites that had been altered by man in some way. This led to the exhibitions of Non-Sites, which consisted of topographical maps and photographs as well as bins of rocks and dirt taken from the selected area. Smithson likened this activity to the retrieval of particles from the moon by astronauts—a comparison that brings to mind an infant using a toy steering wheel in the family car. On the other hand, these works also point to a variety of problems regarding the Non-Site as an entity in itself and as a representation of the original site and many visual and linguistic questions thus engendered. A few years later, Smithson began making EARTH ART at outdoor sites, pouring as-

phalt down a hill near Rome, Italy (1969), and designing earthen ramps in shallow water, the largest and most famous being *Spiral Jetty on the Great Salt Lake, Utah* (1970). His *Partially Buried Wood Shed* at Kent State Univ. (1970) was completed when a hill of mud broke the supporting timber of the shed. Smithson was killed in a plane crash while photographing his *Amarillo Ramp* (1973) in Texas. *Lit.*: Lawrence Alloway, "Robert Smithson's Development," *Artforum*, Nov., 1972.

SOCIAL REALISM. See AMERICAN SCENE PAINTING.

SOCIETY OF AMERICAN ARTISTS. See NATIONAL ACADEMY OF DESIGN.

SOYER, MOSES (1899–1975), a painter who, with his twin brother, RAPHAEL SOYER, and younger brother, Isaac Soyer, helped sustain into the present era the warm, expressive, and humanistic traditions of portraiture and studies of interiors that can be traced, in rough, from Rembrandt, Moses's favorite artist, through Gustave Courbet, Camille Corot, and THOMAS EAKINS. Brought to this country in 1912 from Russia (he was born in Tombov), Soyer studied in New York City at Cooper Union, NAD, the Educational Alliance, and the Ferrer School, all between 1916 and 1920. From the start of his career, he painted richly textured and softly expressionistic portraits such as *Three Brothers* (1963–64, Brooklyn Mus.). Like his brother Raphael, he did many self-portraits. During the 1930s, he depicted the effects of the Depression on the unemployed and the underprivileged (*Artists on WPA*, 1936, NCFA), and with his twin brother completed a mural for the WPA-FAP at Kingsessing Station Post Office, Philadelphia. He also wrote critical pieces defending social realism and attacking regionalism (see AMERICAN SCENE PAINTING). During the 1940s, he portrayed many dancers, often in poses reminiscent of Edgar Degas, but with the added measure of melancholy that often graced

his works. Through the succeeding decades, he completed numerous portraits of people who, like *Julie Arenal* (1971), seem to be preoccupied with a sad secret. *Lit.*: Charlotte Willard, *Moses Soyer*, 1962.

SOYER, RAPHAEL (b. 1899), a painter. Born in Tombov, Russia, he came to America in 1912 and studied art in New York City at Cooper Union from 1914 to 1917, at NAD from 1918 to 1922, and, intermittently, at ASL. Employed by WPA-FAP during the 1930s, he painted a mural with his twin brother, MOSES SOYER, for the Kingsessing Station, Philadelphia, Post Office. His favored themes are urban views, such as *Sixth Avenue* (c. 1930–35, WA), interiors, and quiet moments in the lives of people, as in *Mina* (1932, MMA). He also paints fellow artists, dancers, and bohemians. Until 1927 he tended toward a consciously primitive manner, using flattened forms, tipped-up spaces, and slightly caricatured figures. Later, he developed a warm, brushy style, tonal rather than coloristic, reminiscent of Edgar Degas, although he has eschewed the Frenchman's odd perspectives for usually eye-level, frontal views. During the 1930s, he turned to Depression subjects, painting derelicts and the unemployed (*Transients*, 1936, Univ. of Texas) as well as office workers and shoppers. *In the City Park* (c. 1934), a study of men out of work, is a major document of social realism (see AMERICAN SCENE PAINTING) in its less doctrinaire aspects (Soyer expresses his sympathies for the downtrodden without resorting to propagandistic finger-pointing). He also made many lithographs of these Depression scenes. After 1940 he began to concentrate on studies of women at work or posing in the studio. His technique grew more sketchlike during the 1950s, but in his large *Homage to Thomas Eakins* (1964–65, NPG; studies in Hirshhorn Mus.), containing twelve figures of contemporary realist artists and their museum and gallery supporters, he reverted to the tighter handling typical of his earlier work. Between 1953 and 1955, he edited *Reality*. He has written A *Painter's Pilgrimage* (1962), *Homage to Thomas Eakins* (1966), *Self-Revealment: A Memoir* (1969), and *Diary of an Artist* (1977). *Lit.*: Lloyd Goodrich, *Raphael Soyer*, 1972.

SPENCER, LILLY MARTIN (1822–1902), the best-known woman artist working in the middle decades of the 19th century. Born in Exeter, England, she came to America in 1830 and settled in Marietta, Ohio, in 1833, then moved to Cincinnati in 1841. Although Nicholas Longworth, the Cincinnati art patron, offered to send her abroad to study, she remained in Ohio, where she worked with John Insco Williams and became acquainted with JAMES BEARD, the animal and genre painter. She moved to New York City in 1849 and soon developed a special interest in genre, basing many paintings on aspects of her own family life. In spite of a moralizing tone, de rigueur at the time, her genre pictures are often quite amusing (*Reading the Legend*, 1852, Smith Coll.; *Shake Hands*, 1854, Ohio Hist. Soc., Columbus). Spencer also aspired to the higher branches of painting, and she considered her *Truth Unveiling Falsehood* (1869) her masterpiece. Exhibited at the CENTENNIAL EXPOSITION in Philadelphia, it gained her an increased audience, though the public was already familiar with her work through the distribution networks of the AMERICAN ART-UNION and the Western Art-Union. *Lit.*: Robin Bolton-Smith and William H. Truettner, *Lily* [sic] *Martin Spencer, 1822–1902: The Joys of Sentiment*, exhib. cat., NCFA, 1973.

SPENCER, NILES (1893–1952), a painter associated with PRECISIONISM. From Pawtucket, R.I., he studied initially at RISD, in 1913, and then with ROBERT HENRI in New York City, in 1916. His best-known work, *City Walls* (1921, MOMA), a study of flattened, disembodied planar surfaces of buildings, reveals Spencer's profound response to Cubism, which he absorbed at first hand while

abroad in 1921–22. It was also his most abstract work until the 1940s. Associated with Precisionism during the 1920s and after, he rendered interiors, still lifes, farm scenes, and urban views in that dry manner. Buildings and landscape forms, although often unmodelled, were given bulk by darkened planes that represented shadows. As a result, his forms appear less to represent real objects than to indicate simplified three-dimensional blocks placed in skewed spatial settings. After painting a mural for the Aliquippa, Pa., Post Office during the 1930s, he turned more frequently to industrial themes. Perhaps influenced by the increasingly abstract art of RALSTON CRAWFORD, STUART DAVIS, and CHARLES SHEELER, Spencer soon eliminated virtually all spatial references and logical architectural arrangements (*The Silver Tanks*, 1949, Northern Trust Co., Chicago). His forms, however, never assumed the impersonal elegance of those of the other Precisionists but always retained a handmade quality. *Lit.*: Richard B. Freeman, *Niles Spencer*, exhib. cat., Univ. of Kentucky, 1965.

STAMOS, THEODOROS (b. 1922), one of the youngest first-generation Abstract Expressionists, whose first solo exhibition was held in 1943 (see ABSTRACT EXPRESSIONISM). Born in New York City, Stamos studied sculpture there at the American Artists School from 1936 to 1939, before turning to painting, in which he is self-taught. His paintings of the 1940s (*Impulse of Remembrance*, 1947, Vassar Coll.) possess a family resemblance to the biomorphic works of MARK ROTHKO and WILLIAM BAZIOTES (see BIOMORPHISM). Combining wriggly linear forms with large amorphous shapes, Stamos evoked primordial images seemingly at the beginning of their genetic development. Some seemed to be bathed in water; others suggested rocklike outgrowths; still others extended thin tentacles into the air. Colors, congealed in tone clusters, seemed spongy and undifferentiated. In 1947 he introduced distinct bands of color into some works,

thus controlling the earlier evocations of primeval matter. The bands, usually black or very dark in color, seemed to hover in an infinite distance. This Teahouse series (*Teahouse VII*, 1952, Geigy Chemical Corp., Ardsley, N.Y.) was followed, in the late 1950s, by more violently brushed works in which space did not seem to recede into the canvas; thus, even small works assumed monumental qualities. In 1963 he commenced the Sun-Box series in which large, usually rectangular shapes float in fields bisected by a bar of dark color extending the width of each canvas (*Low Sun-Black Bar II* (1963, Michigan State Univ.). During the middle 1960s, the edges of these forms stiffened considerably, and some Sun-Boxes grew to enormous size, filling almost the entire surface of a painting. Because of Stamos's touch and the fact that the large shapes are composed of modulated rather than monotonal planes of color, his work invariably suggests expanding atmospheric light. Like his pictures of the 1940s, these, too, evoke the potentiality of organic growth. *Lit.*: Ralph Pomeroy, *Stamos*, 1971.

STANKIEWICZ, RICHARD (b. 1922), a sculptor most closely associated with ASSEMBLAGE. From Philadelphia, he studied with HANS HOFMANN between 1945 and 1949 and, in Europe, with Fernand Léger in 1950 and Ossip Zadkine in 1950–51. After his return, he began to create works from scrap metal and discarded mechanical and household equipment, integrating their forms into compositions that can be both formally elegant and witty (*Kabuki Dancer*, 1956, WMAA). Unlike some assemblage-makers, Stankiewicz does not transform the objects he uses. Despite the limitations imposed by the materials, he has developed a body of work noted for its intricate spatial relations and technical innovation.

STANLEY, JOHN MIX (1814–1872), a painter of America's West. From Canandaigua, N.Y., he was apprenticed to a

coachmaker in 1828 and, while in Detroit in 1834, worked as a sign painter, before studying with James Bowman in Philadelphia the following year. After returning to the Middle West, he travelled on to Minnesota in 1839 and there he began to paint Indian scenes. Until he finally settled in Detroit in 1864, Stanley moved about quite often—to California in 1846, to Hawaii in 1848, and in 1853 to the Pacific Northwest, where he made daguerreotypes of Indians in the Columbia River area. His collection of Indian portraits (152 pictures of forty-three different tribes), which he placed in the Smithsonian Institution in 1852, was almost entirely destroyed by the fire there in 1865. Some other paintings by him of Indian subjects were also destroyed by fire that year in P. T. Barnum's American Mus. One of the first artists to do so, Stanley painted vast, panoramic western landscapes, such as *Mountain Landscape with Indians* (Detroit Inst.), as well as intimately scaled works like *Prairie Indian Encampment* (c. 1870, Detroit Inst.). He tended to choose the quieter aspects of western life—village scenes, processions across the landscape, and lookouts—rather than the drama inherent in conflicts between the white invaders and the Indian defenders of the land, or in the continuous battle for survival against the elements shared by all. Also a photographer, Stanley relied on camera records for much of his work. *Lit.: John Mix Stanley: A Traveller in the West*, exhib. cat., Univ. of Michigan, 1969.

STEBBINS, EMMA (1815–1882), a neoclassical sculptor who worked in Rome, one of a number of contemporary women artists to do so (see WHITE MARMOREAN FLOCK). Born in New York City, she began her career as a painter, but at the age of forty-two she visited Rome and developed an interest in sculpture, studying with BENJAMIN PAUL AKERS and becoming friendly with HARRIET HOSMER. Through family connections, she received commissions for a statue of Columbus (1867) for New York

City's Central Park (now in the Brooklyn Civic Center) and of the health-giving Angel of the Waters (described in the Gospel of John) for the Bethesda Fountain there (1862; cast in 1870). Dominating the fountain, a bronze angel alights to stir the water, and allegorical figures of Health, Temperance, Purity, and Peace surround the base (these attributes were of much concern to Americans just after the Civil War). Stebbins made many Biblical sculptures, including an *Infant Samuel* (1868). She also sculpted the figure of Horace Mann, cast in 1864, for the Massachusetts State House, Boston. *Lit.:* William H. Gerdts, Jr., *The White Marmorean Flock*, exhib. cat., Vassar Coll., 1972.

STEICHEN, EDWARD (1879–1973), a photographer, whose long career spanned a founding membership in the PHOTO-SECESSION in 1902 and the organization of the influential Family of Man show at MOMA in 1955. Born Edouard Jean Steichen in Luxembourg, Steichen was brought to America in 1881, and grew up in Hancock, Mich. While working for a Milwaukee lithography company, from 1894 to 1898, he began to photograph. Works he exhibited in the Chicago Photographic Salon of 1900 brought him into contact with ALFRED STIEGLITZ and Clarence H. White, whom he joined as a member of the Photo-Secession along with Frank Eugene, GERTRUDE KÄSEBIER, and others. In 1902 his first one-man show of paintings and photographs in Paris, where he had gone two years earlier to study painting, brought him international recognition. His evocative photographs of the sculptor Auguste Rodin and the lyrical, unfocused landscapes, nudes, and portraits of this period were used by critics and photographers as the strongest proofs that photography could be a creative artistic medium, independent from, and not subordinate to, painting. In 1905 he joined Stieglitz in establishing the LITTLE GALLERIES OF THE PHOTO-SECESSION and, after returning to Europe in 1906, continued to send him works by modern Eu-

ropean and American artists for exhibition there.

During World War I, Steichen was chief of aerial photography for the American Expeditionary Forces. The experience of working with photographs in which detail is the all-important factor persuaded him to take a new direction in his own photography, emphasizing sharp-focus detail and clarity. PAUL STRAND'S work also suggested the possibility of exploring close-up abstractions of natural and man-made forms. He returned to the United States in 1923 and turned to fashion photography, heading the staffs of *Vogue* and *Vanity Fair*, making many brilliant portraits of famous personalities, and experimenting with unorthodox photographic techniques for interpretive effect. During World War II, he was the director of all combat photography for the navy.

The year 1947 initiated the third important phase of Steichen's career: He was made director of the photography department at MOMA. His most important "work" of this period was the 1955 Family of Man exhibition, an enormous show including pictures by photographers from all over the world on the theme of the common experience of humanity. The works were used not to represent the photographer, or even his country, but as metaphors for such universal themes as creation, maternal love, hunger, and death. Steichen was also important in introducing many younger photographers in group shows at MOMA, including HARRY CALLAHAN, ROBERT FRANK, and DIANE ARBUS. He published his autobiography, *A Life in Photography*, in 1963. MOMA has a comprehensive collection of his work. *Lit.: Steichen the Photographer*, exhib. cat., MOMA, 1961. *Edward Steichen*, 1978.

STEINBERG, SAUL (b. 1914), a cartoonist and painter. From Râmnicul-Sărat, Romania, he studied architecture from 1933 to 1940 at the Polytechnic Inst. in Milan, Italy, before coming to America in 1942. His earliest published cartoons date from 1936 (*Bertoldo* magazine, Milan) and his *New Yorker* magazine cartoons, for which he is most famous, first appeared in 1941. He has also published eleven books, beginning with *All in Line* in 1945, and he has designed two murals, including one for the U.S. Pavillion at the Brussels World's Fair in 1958. In 1949 Steinberg began to make drawings on such objects as boxes and chairs. During the 1960s, he made several collages and, in the 1970s, many tablelike assemblages. He has also created paintings in a postcard-like format complete with rubber-stamp images.

Steinberg has worked in several styles that parody both traditional and modern painting modes and he is capable of using both precise linear and gaudy painterly effects. Often several styles and effects are combined in a single work along with printed words, so that visual and verbal ideas are combined. Meaning is often elusive, but even the most easily understood pieces indicate Steinberg to be a serious observer of modern life, aware of the masks and roles people must assume to cope with contemporary conditions. His point of view is not that of a cartoonist illustrating one-liner jokes, but of a perceptive individual profoundly, and humorously, engaged in illuminating the corners of the modern mind. Examples of his works are in MOMA and NCFA. *Lit.*: Harold Rosenberg, *Saul Steinberg*, exhib. cat., WMAA, 1978.

STELLA, FRANK (b. 1936), a painter and major figure in the MINIMAL ART movement, whose works made the paradigmatic reductionist statement concerning the relationship between the canvas as object and the paint as subject. Born in Malden, Mass., he studied with STEPHEN GREENE at Princeton Univ. from 1954 to 1958. By the latter year, his artistic direction had been established, and in 1959 his first mature paintings appeared—works in which black stripes, three inches in width, created symmetrical horizontal and vertical patterns (*The Marriage of Reason and Squalor*, 1959,

MOMA). In effect, the width of the stretcher and the shape of the canvas helped determine the patterns and, therefore, the painting's content. The need to make decisions during the course of execution was minimal, and the statement was made with an impersonal brushstroke. Without imitating machine-like forms with machinelike precision, these works were among the most consciously impersonal works ever created. As such, they marked one of the extreme reactions to ABSTRACT EXPRESSIONISM; autographic emotionalism and also an extension of the color-field paintings of MARK ROTHKO and BARNETT NEWMAN. In them, Stella also translated and developed further in abstract terms the implications of JASPER JOHNS's spaceless images of targets and flags. In these early paintings, Stella apparently answered two problems he had set for himself: one spatial, the other methodological. In response to the former, he eliminated dominant and subordinate elements, until that time common in Western art, because such relational units suggested spatial interactions. Stella preferred symmetry and regulated pattern. In answer to the second problem, he used house-painter's tools and techniques. These devices helped insure the flatness of the picture surface, the neutrality of content, and the absence of "artiness." The structure of the canvas itself became Stella's content.

Until about 1966, he created works in series that revealed different relationships between the framing edges and the internal designs. These included the early monochromatic Aluminum and Copper series, painted in metallic paint, as well as his first group of color pictures, the Benjamin Moore series (1961). As early as 1960, Stella had begun to alter the shape of the canvas by indenting parts of the edge. These notches caused the stripes to change direction, providing each work in a series with a different overall configuration; thus, the pictorial shapes within each canvas varied according to the shape initially given to each canvas. In 1961 Stella began to paint on deep-stretcher canvases with L, T, H, and other shapes, including hollow polygons, thus incorporating parts of the walls into the configuration. Although each painting was a complete unit by itself, it could function like a sculpture in that it also acted as a "cut" in the space of the wall. The conclusions to be drawn from this—the wholeness of the artwork and its existence as part of a three-dimensional continuum—were seized upon not only by painters but particularly by the younger sculptors, especially CARL ANDRE. Although these works are contentless in the traditional sense, they can evoke impressions of mystery, nobility, and other qualities. Nevertheless, Stella insisted first and foremost on their literal flatness and objectness. "My painting," he said in 1966, "is based on the fact that only what can be seen there *is* there. It really is an object." As if to emphasize the point, he created works in nonrelational series. Individual works within a series did not relate to other works as if some were preliminary studies or developmental explorations of a given theme. Rather, each was a variation on a similar format. There were no first or last paintings, only permutations. Here, too, Stella proved prophetic: The simple forms and serial permutations of work by a host of younger sculptors like DONALD JUDD certainly are rooted in Stella's example.

The irregular polygons of 1966 (*Union I*, Detroit Inst.) marked a departure from Stella's more hermetic art. In these pieces, triangles, parallelograms, and other geometrical forms did not necessarily relate directly to the framing edges, and colors created varying relationships not always coordinated with the overall configurations. Yet, since planes were juxtaposed rather than superimposed, and the differing intensities and tones of colors were kept in immaculate balance, flatness of surface was maintained. In the next major series, the Protractor, of 1968, Stella only minimally coordinated internal shapes with the large circular and semi-circular edges, and began to allow some high-keyed col-

ors to pull forward, thus breaking the flat format that characterized his work until this time. Developing further his flamboyant gifts for color and form, Stella created one of the few viable post-Minimalist painting styles during the 1970s. Although shapes of forms and edges of pictures no longer coincided, forms remained essentially nonrelational and seemed to be composed of inseparable parts. Much of his later production is in the form of multimedia collages, and his control of his materials and forms has been highly inventive. *Lit.:* William S. Rubin, *Frank Stella*, 1970.

STELLA, JOSEPH (1877–1946), a Futurist and painter of symbolic scenes. Born in Muro Lucano, near Naples, Stella was brought to New York City in 1896. He enrolled at ASL the following year and at the New York School of Art about 1898. Despite his apparent familiarity with the realistic paintings of The EIGHT, Stella's early studies of slum life are Rembrandtesque in technique and attitude. Some were published in *Outlook* and *Survey*, including a series on industrial Pittsburgh (1908). No doubt, his visit to that city encouraged his interest in such scenes. Stella returned to Europe in 1909, spending time, at first, in Italy, where his study of Venetian techniques and his friendship with Impressionist Antonio Mancini reinforced an interest in sonorous and warm atmospheric colors. His first significant contact with modernist art took place after his arrival in Paris in 1911. His palette lightened considerably, though he preferred Paul Cézanne and Cubism to Henri Matisse's Fauvism. Arriving in New York City a few months before the ARMORY SHOW opened in February, 1913, he soon undertook his first Futurist work, *Battle of Lights, Mardi Gras, Coney Island* (1913–14, Yale Univ.). With MAX WEBER's views of New York City, also painted at that time, it is among the earliest Futurist works completed by an American artist. Though broken into a swirling mass of small colored planes, its basic units are carefully arranged and its faceted forms are clearly delineated in a manner reminiscent of Gino Severini, whose Italian Futurist pictures Stella probably saw in Paris. Stella's subsequent essays in Futurism, however, grew more dynamic, departing from Severini's suave elegance. This trend culminated in his famous *Brooklyn Bridge* (c. 1919, Yale Univ.), which shows the progressive stages of an automobile's passage across the roadway. The bridge itself appeared to Stella as a "towering imperative vision," a "shrine containing all the efforts of the new civilization of America." In the next few years, however, Stella's romantic ardor for modern America cooled somewhat and he began to paint more realistic views presented in calmer tonal rather than coloristic patterns. In addition to industrial views that prefigured PRECISIONISM, he created the series New York Interpreted (1920–22, Newark Mus.), which turned bridges and skyscrapers into decorative rather than dynamic emblems of the metropolis.

An artist of wide-ranging taste, Stella began to paint moody nature studies in 1916 in abstract and surreal styles. Meanings, as in *Tree of My Life* (1919, Iowa State Educational Assoc., Des Moines), range from the intensely personal to the allegorically banal. In the early 1920s, Stella created the first of about thirty collages, using discarded objects and pieces of cardboard. These are brilliantly original, reflecting an exquisite sense of color and design. At the same time, he painted women in archaizing styles laden with symbolic content. During the remainder of his career, Stella continued to work with themes that ranged from the mystical to the commonplace and which were set in tropical and urban locales. His style, too, moved from the surreal to the classically ideal (the latter a consequence of his interest in Renaissance art). An international figure, Stella reflected in his art international developments and a concern for ornament that bespoke his southern Italian heritage, as well as a keen response to the American industrial landscape and an intensely personal commitment to invent themes from his

own imagination. *Lit.:* Irma B. Jaffe, *Joseph Stella*, 1970.

STERNE, MAURICE (1878–1957), a prolific painter, sculptor, and graphic artist. Born in Libau, Latvia, Sterne emigrated to America in 1889. In the early 1890s, he worked in New York City in an engraving firm as a designer's helper and studied drawing at Cooper Union. He attended NAD from 1894 to 1899 and studied anatomy under THOMAS EAKINS. In 1904 Sterne began a period of wide travel, visiting Europe (1904–8), where he was influenced most by the early Renaissance masters as well as Edouard Manet and Paul Cézanne. In Greece (1908), classical sculpture especially interested him. He also travelled to Egypt, India, and Burma in 1911–12, and then to Bali, remaining there for two years. His Bali studies made him famous and are often considered his best works. Paintings such as *Bali Bazaar* (1913–14, WMAA) exhibit a flattened style, akin to Paul Gauguin's and Cézanne's, that shows Sterne's knowledge of design and control of form and space. Later, line became more important to him and he simplified his forms. Sterne returned to America in 1915, although he visited Italy again in later years. He received numerous awards during his career; in 1933 he was the first American artist honored with a one-man exhibition at MOMA. Two years later, the Department of Justice, for its building in Washington, D.C., commissioned a set of murals from him that demonstrate his intellectualism despite their conventionality. In 1945 Sterne began summering in Provincetown, Mass., painting luminous marinescapes in a much freer style than his earlier, more controlled manner. His sculpture, cold and conventional, is considered inferior to his paintings. *Lit.:* C. C. Mayerson, *Shadow and Light: Life, Friends, and Opinions of Maurice Sterne*, 1966.

STETTHEIMER, FLORINE (1871–1948), a painter. Born in Rochester, N.Y., she studied in the mid-1890s at ASL with KENYON COX. In 1906 Stettheimer moved with her mother and two sisters to Europe (as none of the Stettheimer sisters married, throughout her life the artist's ties to her family were strong and a personal world of family and friends figures prominently in her work). In Europe Stettheimer travelled to France, Switzerland, Italy, and Germany, studying art in the latter country. The Stettheimers returned to New York in 1914, and in 1916 Florine had her first exhibition. Though a shy and private person, she moved among many of the prominent cultural figures of the time, including Marcel Duchamp and Virgil Thomson, designing the stage settings for Thomson's *Four Saints in Three Acts* in 1934. Well aware of modern trends in art, Stettheimer was proficient in the slashing-brush portrait style of JOHN SINGER SARGENT and experimented with Post-Impressionist paint-handling techniques in images of a curiously Symbolist turn. By 1915 her mature style had emerged: These pictures have a freely brushed and impastoed surface as well adapted to highly personal visions of flowers and family portraits as to her good-natured satirical views of modern life and culture. Since she openly abandoned academic draftsmanship, the style has been called purposefully naive, because of its flattened forms, simplified shapes, bright colors, and a fanciful approach to subject matter. Flowers particularly attracted her, and she rendered them in an intensely imaginative manner that suggested essays in symbolism and prompted some critics to comparisons with Odilon Redon. Some of the odd and primitive qualities of her work are due to her initial buildup on the canvas of a virtual relief of white pigment, on top of which the image was applied. In her many portraits, in her pictures of outdoor gatherings sometimes sprinkled with well-known artistic personages, and in her elaborately designed satires, Stettheimer managed to create a style that looks genuinely and unaffectedly primitive, yet is informed by the excitement and amusement she said she exper-

ienced in New York City. Good examples of her work are *Spring Sale* (1922, Philadelphia Mus.) and *Shops* (1922, LACMA). *Lit.:* Parker Tyler, *Florine Stettheimer: A Life in Art*, 1963.

STEWART, JULIUS (1855–1919), a leading figure painter. Stewart was born in Philadelphia but, as son of the expatriate art collector William Stewart, spent almost his whole life in Paris. His style and choice of subject matter were greatly influenced by the collecting tastes of his father, who particularly patronized the contemporary Spanish-Roman school, the artists Eduardo Zamaçois, Federigo Madrazo, and Mariano Fortuny. The young Stewart studied with the first two of these painters in the 1880s as well as with the French academician Jean-Léon Gérôme. He was very much a part of Parisian high society, which he mirrored in vivid paintings of fashionable life often in elegant rooms, and it is significant that a number of his finest works are today in old American clubs (*The Hunt Ball*, Essex Club, Newark, N.J.; *The Hunt Supper*, 1889, Buffalo Club, Buffalo, N.Y.). The vivacious realism that was praised in these works when they were first exhibited was recognized at the time as peculiarly American. In the 1890s, Stewart developed a second theme, the female nude, alone and in groups, in the outdoors. The figures are academically rendered, but the light is richly saturated with color. The subject was not unusual in French art, and it was more successfully rendered by expatriate artists like Stewart and better accepted abroad than in more conservative America.

STIEGLITZ, ALFRED (1864–1946), a photographer and founder of the PHOTO-SECESSION group (1902), the magazine *Camera Work* (1903–17), and the LITTLE GALLERIES OF THE PHOTO-SECESSION, which from 1905 to 1917 showed the first modern European and American art in the United States. Born in Hoboken, N.J., Stieglitz was the son of a successful German immigrant businessman.

He was educated in New York City and, in 1881, was sent to the Berlin Polytechnic to study mechanical engineering, but he became interested in photography, working until 1890 with H. W. Vogel, a famous photochemist. He developed a brilliant technique and early became interested in the strong linear design and atmospheric mood characteristic of the new photography in Europe. By the time he returned to America, in 1890, he had an international reputation and was determined to create an American school of fine-art photography on a par with those of England and Germany. By 1896 he was vice-president of the Camera Club in New York and editor of its periodical, *Camera Notes* (1897–1903), which he tried to make a vehicle for creative—rather than amateur—photography. When this attempt was finally blocked, he founded the Photo-Secession, so named to ally it with European artistic movements that had earlier broken away from academicism. Exhibiting with EDWARD STEICHEN, ALVIN LANGDON COBURN, GERTRUDE KÄSEBIER, and others who he felt exploited the creative and aesthetic possibilities of photography, Stieglitz also published their work and that of their European colleagues in his magazine *Camera Work*, the voice of modern photography from 1903 to 1917.

In 1905, with Steichen, he opened the Little Galleries of the Photo-Secession—later known as "291"—where Photo-Secession photographers presented their work. In 1908 Steichen sent from Europe a group of drawings by Auguste Rodin, which became the first in a series of important bodies of work by European and American avant-garde painters and sculptors shown at 291—one of the few places such work was accessible to Americans until the 1913 ARMORY SHOW. Henri Matisse, Pablo Picasso, Paul Cézanne, and Constantin Brancusi were first exhibited there, as were the American artists ALFRED MAURER, JOHN MARIN, MARSDEN HARTLEY, ARTHUR G. DOVE, MAX WEBER, ABRAHAM WALKOWITZ, and, later, GEORGIA O'KEEFFE and STANTON

MACDONALD-WRIGHT. Stieglitz particularly admired Dove, Marin, and O'Keeffe, and enthusiastically supported them throughout their careers. He welcomed the opportunity to present a strong school of American art—painting and photography together—even though it eventually lost him the financial support of the *Camera Work* subscribers who wanted illustrated articles on photography exclusively. Stieglitz was certainly the unifying force in early modern American art. *Camera Work* ceased publication and 291 closed in 1917, but from 1925 to 1929 Stieglitz ran the Intimate Gall. and from 1929 until his death directed An American Place, both New York galleries dedicated to forcing consciousness on the public of a uniquely American artistic vision.

While publishing *Camera Work*, Stieglitz, who had previously championed the photographer's right to manipulate the medium in any way suited to his vision, came to believe that only the "pure" or "straight" unaltered print was worth making. He liked to record life as he found it. Of his most famous work, "Steerage" (1907), he said "I saw a picture of shapes and underlying that the feeling I had about life." This quote expresses simply his concept of the "equivalent," central to his work following World War I. Beginning in the early 1920s, he came to think of all his pictures as metaphors for his feelings. As a way of reducing the importance of subject matter and emphasizing the evocative, he photographed clouds and gave his pictures musical titles such as "Composition" or "Symphony." These works, however, were never wholly abstract, and he continued to make portraits, landscapes, and cityscapes, feeling that they, too, were vehicles for his perceptions and emotions.

Stieglitz's modernism, like that of the American painters he supported most warmly, was deeply personal and steeped in both natural landscape and the romance of the modern city. The Stieglitz collection of art—largely those works shown at 291—was split up, but the bulk went to MMA. NGW received the set of Stieglitz's best prints, which he had kept together. Fifty-thousand letters, as well as manuscripts, catalogues, portraits, and clippings were given to Yale Univ. *Lit.:* Dorothy Norman, *Alfred Stieglitz: An American Seer*, 1973. Jonathan Green, ed., *Camera Work: A Critical Anthology*, 1973.

STILL, CLYFFORD (b. 1904), a major exponent of ABSTRACT EXPRESSIONISM. From Grandin, N. Dak., he grew up in Spokane, Wash., and southern Alberta, Canada. Interested in art as a youth, Still studied and taught himself from reproductions. He visited New York City in 1925, attended ASL for less than one hour, rejected, as he said, most of what he saw, and returned to the West to work out his own destiny as an artist. This version of the artist's youth and early maturity is, at least, in keeping with the strong position of absolute moral and artistic integrity that characterizes Still, whose decisions seem to have been reached because of his own deepest needs and feelings about the entire artistic enterprise rather than because of what was or is fashionable. In 1933 he graduated from Spokane Univ., where he had studied art, and then he taught at Washington State Univ. During a fellowship year at the Trask Foundation, Saratoga Springs, N.Y., in 1934–35, he completed a group of figure studies, some on green window shades, which, he says, marked the birth of "his concept of painting as an instrument of inner comprehension." By 1940 he had come to feel that he had rid himself of European tradition and contemporary fashions and embraced an art reflective of his own being and choices as an artist.

Through the 1930s, Still's painting style changed from expressionist realism to expressionist abstraction. In the early years of the decade, gaunt, hieratic figures stalked a seared, burnt-out landscape. Broad and quick brushstrokes, scumbled pigment, and rich textures provided his canvases with a profound emotionality. By the mid-1930s, the cen-

tral images had begun to grow abstract. Large in scale, they rose up mightily from the lower edge of the canvas to become great totemic icons. Some were set against combinations of blue and white, suggestive of the vast reaches of the prairie skies. These abstract presences, some as stark and as brutal as Aztec sculpture, are evocative of that landscape and of human feelings in the face of it. But, at the same time, the thick textural buildups and loaded-brush techniques prevented them from becoming mere exercises in landscape. Still, in effect, brought down to the size of the canvas the awesome and mysterious experience of measuring objects of ordinary scale against the vastness of western space.

In the early 1940s, he added a new set of images to his repertory. Space was reduced virtually to the canvas surface itself. Thin, wiry, energetic lines coursed through and over forms, which now seemed drawn from the Surrealist vocabulary of fecund biological images. It was as if Still had abandoned mountains for amoebas, the mysteries of great spaces for those of slender filaments. Abrupt tonal contrasts of light and dark were brought under strict control as colors assumed a middle ground of contrast. Nevertheless, occasional intensely bright spots of color appeared, setting off the remaining colors. These works were given no names other than numbers or letters. Still made twenty-one lithographs between 1943 and 1945 while teaching in Virginia. These paralleled yet were independent of his paintings. (At the same time, he made a number of watercolors and pieces of sculpture.) Many of his paintings were shown at Peggy Guggenheim's Art of This Century Gall. in 1946 and became major documents of BIOMORPHISM. MARK ROTHKO, who had met Still, felt his paintings had gone beyond genre and formal arrangements to tap tragic religious mysteries that imbued all myths at all times. Aware of the universal implications in his work, Still had indicated in 1944 that "one simply tries to remove the load of educational negatives which inhibit a student's mind,

so that he may comprehend or come in contact with forces he has within him. . . . To those who discover [the forces], is born no competition, but a beautiful wonder and affinity with the creation."

Still returned to the West in 1946 and taught until 1950 at CSFA, where he was influential in popularizing Abstract Expressionism. In San Francisco he developed his mature style, in large measure a combination of his two abstract modes, spatially suggestive of both flatness and depth. Jagged-edged forms, disposed all over a canvas's surface, refused to coalesce around a central focal point. Occasionally, if the forms were large and few enough, it appeared as though three or four had been jigsawed together to create the rectangle of the canvas. As a result, the enormous forms did not become spatially dominant images set against a receding landscape of other forms but tended to remain on the same plane in depth. In this way, Still's paintings could be read as combining, or reconciling, both an open expansiveness with respect for the flat surfaces of a canvas; or, they could be read as a continuous field of differently colored forms stretched across the canvas surface rather than as a series of forms establishing advancing or receding spaces. Occasional rents in the brightly colored patches, or linear elements, served to set off the continuity of the surface skin of a canvas. Spatially complex, these works both suggested and denied depth.

Since the 1950s, Still's textures have remained vigorous. In the past decade, however, edges have grown insistently jagged. Throughout the years, his usual format has been a vertical one, the major movements supporting upward-downward rather than lateral thrusts. Although these works are akin to Still's paintings of the 1930s with suggestions of western space, Still insists that he alone is the sole source of their imagery. In 1961 he stated that "each painting is an episode in a personal history, an entry in a journal. . . . No painting stops with itself, is complete of itself. It is a continuation of previous paintings and is re-

newed in successive ones." In 1964 he gave thirty-one works to AK and, in 1975, twenty-eight paintings to the San Francisco Mus. *Lit.: Clyfford Still,* exhib. cat., San Francisco Mus., 1976.

**STOCK, JOSEPH WHITING** (1815–1855), a largely self-taught painter of portraits, miniatures, landscapes, and marines. From Springfield, Mass., he turned to art in 1832, after a disabling accident. He received some instruction from Francis White, a pupil of CHESTER HARDING. Stock lived most of his life in Springfield, although he travelled to parts of southern New England and was in New Bedford, Mass., from 1842 to 1844. Altogether, he made over 900 portraits. Early in his career, he enjoyed copying works depicting such famous people as Napoleon and Andrew Jackson. A painter in the FOLK ART tradition, Stock was unusual in experimenting with various compositional schemes; the explanation may be that because he occasionally shared a studio after 1844 with photographer O. H. Cooley he based paintings on photographic sources. A characteristic example of Stock's work is *The Fisherman With His Dog* (c. 1850, Springfield Mus.). Stock was able to suggest deep space, but he never learned to free his forms from the picture surface or to envelop them in a convincing atmosphere. His figures were tautly outlined and their volumes were minimally modelled. His colors tended to be raw and brilliant, yet he could imbue the human countenance with a quality of softness and reflectiveness. *Lit.:* Jean Lipman and Alice Winchester, eds., *Primitive Painters in America, 1750–1950,* 1950.

**STORRS, JOHN** (1885–1956), a sculptor. Storrs spent most of his adult years in France. From Chicago, he chose his profession while abroad in 1907–08. After his return, he studied with Lorado Taft at AIC and then with Charles Grafly at PAFA. He went back to France in 1912 and was a favorite pupil of Auguste Rodin until his death in 1917. Storrs abandoned traditional representation for Cubist and machinelike forms in 1920. In a few years, he turned to vertically oriented, nonobjective forms resembling architectural schemes, with setbacks at various levels. Toward the end of the decade, curvilinear forms were admitted, though strictly contained within a geometrical framework (*Composition Around Two Voids,* 1932, WMAA). Some works were polychromed. In 1930 he designed the 33-foot-high aluminum statue of Ceres placed atop the Board of Trade Building in Chicago. Storrs was a pioneer modernist, attracted to the impersonal precision of machine forms, who nevertheless admitted occasional antic patterns into his controlled formats. Unlike many modernists who allowed air-filled voids to lighten their works, Storrs never lost sight of the solid core of a sculptured piece. *Lit.:* Abraham Davidson, "John Storrs," *Artforum,* Nov., 1974.

**STORY, WILLIAM WETMORE** (1819–1895), a prominent sculptor of classical subjects. The son of a Supreme Court Justice, Story was born in Boston, Mass., and educated at Harvard Univ. He had begun a successful career as a lawyer and had written several important books on law when his father died in 1845. A memorial statue of the famous jurist was planned, and the commission granted it to his son, although the younger Story was at best an amateur artist. He travelled to Europe to prepare himself for the endeavor and worked on the model in Rome in 1848–49. Completed in 1853, it is now in Cambridge's Mount Auburn Cemetery. The experience encouraged Story to give up the law and turn to sculpture. Such early works as *Arcadian Shepherd Boy* (1852, Boston Public Library, Boston, Mass.) are in a dreamy, sentimentalized classical mode. Story moved with his wife to Rome in 1851 and took apartments in the Palazzo Barberini. His circle of acquaintances included the Robert Brownings, Nathaniel Hawthorne, and William Makepeace Thackeray. Reflecting his literary interests, Story's works of the 1860s are

strongly anecdotal in character. His series of heroic women from antiquity, including *Cleopatra* (1858, replica of 1869 in MMA), *The Libyan Sibyl* (1861, replica of 1868 in the Smithsonian Institution, Washington, D.C.), and *Medea* (1864, replica of 1868 in MMA), were well received, for, as Henry James remarked, Story's interpretations captured "the imagination of his public as no one else just then could have done." *Medea*, whose model was the Italian actress Ristoni, a close friend, in fact has a brooding dramatic quality that is still quite effective. However, Story's works seem generally marred today by a profound literalness, an emotional sterility, and a dependence on numerous props in an attempt to extend the narrative beyond what the statuary will bear.

Unlike many other American sculptors, Story was not obliged to make portrait busts for a living. A rare example of such a work is *Elizabeth Barrett Browning* (1861, replica of 1866 in the Boston Athenaeum, Boston, Mass.) made, after her death, for her husband and showing a sensitivity for the modelled face absent in the artist's other works. *Lit.:* William H. Gerdts, Jr., "William Wetmore Story," *American Art Journal*, Nov., 1972.

**Strand, Paul** (1890–1976), a pioneer photographer. Born in New York City, Strand learned his craft from Lewis Wickes Hine in 1907 and later became a commercial photographer. The last two issues of Alfred Stieglitz's magazine *Camera Work* (1916 and 1917) were devoted to two prophetic aspects of his recent work: people photographed unaware with a hand-held Graflex camera and abstractions based on close-up views of objects (the latter, dating from 1915, were the first of their kind). He made use of natural, man-made, and architectural forms and was one of the first to find beauty in machinery. Strand made his living as a freelance cinematographer between 1922 and 1932. In 1933–34 he made *The Wave*, a film about fishermen, for the Mexican Ministry of Education. Returning to the U.S. in 1935, he worked on documentary films through World War II. In 1945 Strand had a one-man show at MOMA. In 1948 he moved permanently to France. During the 1950s and 1960s, he worked in Europe, making pictures for his own books.

Strand's most important photographic work was his earliest: his extremely simplified close-up views of such things as bowls, porch shadows, and rocks. These had an immediate impact not only on photographers but also on painters in the Stieglitz circle, notably Arthur G. Dove after 1915. Adhering firmly to the position that a camera should only record, he was opposed to those who manipulated the photographic image to imitate painting, as members of the Photo-Secession had done. Strand thus contributed significantly to the establishment of the "straight" aesthetic soon favored by Stieglitz and Edward Steichen, the two most important Photo-Secession photographers (see also Edward Weston). In his later work, he concentrated on architectural and human subjects characteristic of a particular locale. Though he continued to spurn photographic "manipulation," Strand eventually felt free to choose and pose the people he found most "typical" for his purposes. Collections of his work are in MOMA and GEH. His books include *Photographs of Mexico* (1920); *Time in New England*, ed. N. Newhall (1950); *La France de Profil* (1952); *Un Paese* (1954); and *Tir-A'Mhurain* (1962). *Lit.:* Paul Strand, *A Retrospective Monograph*, 1971.

**Stuart, Gilbert** (1755–1828), one of the leading portrait painters of his day in England and America. Born in North Kingstown, R.I., Stuart was baptised Gilbert Stewart but always used the Jacobite spelling and occasionally even styled himself Gilbert Charles Stuart. He was, in fact, of Scottish ancestry; his father had emigrated to work in the snuff mill of a Scottish doctor. The mill failed in 1761 and the family moved to Newport, where Stuart received some early instruction from the local portraitist Samuel King. An itinerant Scottish painter,

Cosmo Alexander, who arrived in Newport in 1769, took an interest in the fourteen-year-old Stuart, who was already demonstrating artistic talent, and accepted him as an apprentice. Together, they made a tour of the southern colonies and, in 1771, left for Edinburgh. This might have been the start of a promising career had not Alexander died suddenly in 1772, leaving his young pupil destitute. Stuart tried briefly and unsuccessfully to make a living in Edinburgh, then worked his way home to Newport as a sailor.

The details of Stuart's early life have been obscured by adulatory biographers with the help of Stuart himself, who, later on, told elaborately embroidered tales of the events of this period. He did, at any rate, paint portraits in Newport upon his return. *Francis Malbone and His Brother Saunders* (c. 1773–75), showing the two boys seated at a writing desk, is rendered in the flat, linear style typical of colonial painting, with the assiduously modelled heads and high luminosity of JOHN SINGLETON COPLEY's Boston portraits. Though still awkwardly proportioned, *John Bannister and Mrs. Bannister and Her Son* (both 1774, Redwood Library and Athenaeum, Newport, R.I.), show Stuart gradually developing a more integrated manner.

Stuart sailed from Boston, Mass., for England in 1775, literally, as legend would have it, on the eve of the Battle of Bunker Hill. His political sympathies were only mildly Loyalist but, with his eye on the main chance, he could see that there would be scant opportunity for a fledgling portrait painter during the war to come. In London he was obliged to support himself as a church organist. When he managed to gain portrait commissions, he often left them unfulfilled as was consistent with his always unpredictable temperament. Finally, in 1777, he entered the studio of BENJAMIN WEST and for five years worked on that artist's large history pictures and state portraits. The invaluable technical training he received with West is apparent in his small *Self-Portrait*

(1778, Redwood Library and Athenaeum, Newport, R.I.), in which the artist is depicted in 17th-century Dutch costume with his face emerging, in intense light, from a tenebrous background. The portrait reflects the Rembrandtian revival prevalent in Europe at that time, seen in the work of such disparate artists as Sir Joshua Reynolds and Jean-Honoré Fragonard.

Blessed with abundant, not to say brash, self-confidence, Stuart began to produce ambitious portraits of a consistently high caliber. These included one of his master *Benjamin West* (1780–81, National Portrait Gall., London), in which the artist is shown seated at his desk with weighty tomes and a scroll before him, emphasizing the high degree of learning deemed necessary for an artist of the day. One of the products of such learning, West's history painting *Moses Receiving the Laws on Mount Sinai*, is visible at the right. West is shown not in the Quaker garb he is popularly believed to have worn but dressed in the current fashion, with only his stern expression betraying his religious background.

Stuart excelled primarily as a face painter. He worked painstakingly on the face, bringing it to a high degree of finish before even sketching in the rest of the figure. It was said early in his career that he "made a tolerable likeness of the face, but as to the figure he could not get below the fifth button." Perhaps to quash this kind of criticism, Stuart painted his first great success, *The Skater* (1782, NGW). This full-length portrait of a Scottish gentleman, William Grant, was conceived after painter and sitter decided to spend a fine morning on the Serpentine in Hyde Park. There, Stuart was inspired to paint Grant as a skater in a winter landscape. The picture was much admired when exhibited at the Royal Acad., and it made Stuart's reputation, though, in the end, it seems to prove that the critics were right; the upper half of the figure is far more satisfying than the lower half. In two years' time, Stuart was the busiest portraitist in

London, commanding prices third only to Reynolds and Thomas Gainsborough. Ironically, a century later, when he had been utterly forgotten in London, this picture was variously attributed to George Romney, Sir Henry Raeburn, and others. Certainly, Stuart learned something from both Romney and Raeburn. His virtuoso handling of paint is particularly reminiscent of the latter.

Spectacular as was his success, Stuart still managed to live well beyond his means. Burdened by debts and unexecuted commissions for which he had already received payment, in 1787 he removed his portrait practice to Dublin, Ireland, where he again collected advance fees for portraits he had not the slightest intention of completing. In 1792 he sailed for America, where, by virtue of arriving safely, he became the finest portrait painter on the continent. Stuart's extraordinary ability to paint true likeness, tempered by the sober elegance of the idealized portraiture he learned from Reynolds and Romney, made his work far more attractive than the simple naturalism of native American painters. His loose, virtuoso brushwork created dazzlingly animated surfaces such as Americans had not seen. He thoroughly captured American taste, and practically everyone of note in Federalist America sat to him. Posterity has Stuart to thank for strong evocations of the characters of Thomas Jefferson, John Adams, James Madison, James Monroe, and other luminaries of the young republic. Perhaps the subject most closely associated with Stuart is George Washington; three of his portraits of the first president, the *"Vaughan" Portrait* (1795, NGW), the *"Athenaeum" Portrait* (1796, MFAB), and the full-length *"Lansdowne" Portrait* (1796, PAFA) became the prototypes for countless copies, reproductions, and imitations.

Moving from New York to Philadelphia, to Washington, D.C., and finally to Boston, where he died, Stuart never changed, but his erratic behavior was taken as a sign of genius. Characteristically, his famous *"Athenaeum" Portrait*

and a companion portrait of Mrs. Washington, though partly paid for, were left unfinished. *Lit.: Gilbert Stuart: Portraitist of the Young Republic,* exhib. cat., NGW, 1967.

SULLY, THOMAS (1783–1872), the leading portraitist of his generation in Philadelphia. Born in Lincolnshire, England, he was brought to Charleston, S.C., by his actor-parents in 1792. He received early instruction from his brother-in-law Jean Belzone and his brother Lawrence Sully, the miniaturist. Sully began his career in 1801 in Norfolk and Richmond, Va., before moving to New York City in 1805, where he may have worked for JOHN WESLEY JARVIS briefly. He visited and received criticism from GILBERT STUART in Boston, Mass., in 1807 and then settled permanently in Philadelphia in 1808. In 1809–10 he travelled to London, where he took a studio with CHARLES BIRD KING and studied with BENJAMIN WEST and Sir Thomas Lawrence, who influenced Sully considerably.

After returning to Philadelphia, he became a major portrait painter, helping to create the romantic portrait of mood. Although best remembered for somewhat simpering likenesses, such as *Sarah Annis Sully* (1832, MMA), his oeuvre reflected feelings ranging widely from the saccharine and melancholic to the vigorous and aggressive. He portrayed many of the famous people of the 19th century, including Thomas Jefferson (1821, American Philosophical Soc., Philadelphia), Andrew Jackson (1845, Corcoran Gall.), and Abraham Lincoln (1869). Common to virtually all of his portraits is a fluency of brushstroke and absence of extraneous background detail. He painted over two thousand portraits and more than five hundred subject pictures; their titles are listed in a register he maintained, now in the Pennsylvania Hist. Soc. He also completed at least twenty self-portraits, a unique achievement in American art at the time.

In 1838 he went to London to paint the new queen, Victoria, whose portrait he presented to the St. George Soc. in

Philadelphia (the original oil study is in MMA). Less well known as a history painter, he was commissioned by the federal government to paint *Washington at the Passage of the Delaware* in 1819, a work then too large for any existing building and now in MFAB. He prepared for publication *Hints to Young Painters* in 1851, but it was not printed until 1873. In it, he described his methods of painting, which, surprisingly in one whose forms were usually soft and pliant, included laying on an initial carefully wrought drawing of the sitter. All six of his surviving children became professional or amateur painters. Sully is well represented in MFAB, MMA, and the Philadelphia Mus. *Lit.*: Edward Biddle and Mantle Fielding, *Life and Works of Thomas Sully*, 1921.

SUYDAM, JAMES (1819–1865), a landscape painter. From New York City, he was in business before turning to art in the mid-1850s. He studied with Minor Kellogg and travelled with him in Greece. Suydam's favorite haunts were the New England and Long Island coastlines and the White Mountains. In style, he was an exponent of LUMINISM, painting low-horizoned panoramas small in both size and scale (*Paradise Rocks, Newport,* NAD). Friendly with JOHN F. KENSETT, he explored a similar range of subtle and imperceptibly changing tones. Suydam's landscapes were especially idyllic and serene and often included small figures engaged in farm tasks. He also articulated vast spatial recessions in fractions of inches. Unlike MARTIN JOHNSON HEADE, a Luminist who worked with a wide range of atmospheric conditions, Suydam preferred to paint the even light of high noon on a clear day. *Lit.*: John I. H. Baur, "A Tonal Realist: James Suydam," *Art Quarterly*, Summer, 1950.

SYNCHROMISM, the only modern movement developed by American artists before World War I. The originators, STANTON MACDONALD-WRIGHT and MORGAN RUSSELL, formulated it in 1913 in Paris. Major exhibitions of the style took place at the Neue Kunstsalon, Munich, and the Bernheim-Jeune Gall., Paris, in June and October, 1913, and at the Carroll Gall., New York City, in March, 1914. Synchromism attained its greatest influence in America between 1915 and 1918. Part of a broad trend in modernist art noted especially by the French poet Guillaume Apollinaire in 1912, Synchromism was concerned with the use of color to generate form, meaning, and composition. Its sources were varied and included such writings of scientists in the field of optics as *De la loi du contraste simultané des couleurs* by Michel Eugène Chevreul (1839), *Grammaire des arts du dessin* by Charles Blanc (1867; republished as the *Student's Textbook of Color*, 1881), and *Modern Chromatics* by Ogden Rood (1879), and paintings by Neoimpressionists Georges Seurat and Paul Signac as well as by Cubists and Fauvists who had relieved form and color from the function of recording images in a realistic manner. Frantisek Kupka and Robert Delauney, whose paintings had been dubbed Orphist by Apollinaire, were the most important precursors of Synchromism. Morgan Russell appears initially to have been more conversant with the functions of color than Macdonald-Wright. As early as 1908, he had already realized that the "natural movement of the world . . . was conditioned by the tones of the spectrum," and by 1910, he had remarked that he wanted to "create form through light to convey mass and solidity." Russell was studying with Ernest Tudor-Hart, a Canadian color theorist and artist, when he met Macdonald-Wright in 1910 or 1911. Tudor-Hart was especially helpful in developing spectral charts in disc form. Following Rood's analyses, he arranged colors in such a way as to elucidate color pairs and triads, which, like musical chords, were thought to possess harmonious rapport. When applied to painting, these color chords were supposed to insure harmonious balances of forms both as two-dimensional objects and as figures in three-dimensional space. Compared to other color painters, Russell and Mac-

donald-Wright were unusually scientific in their choice of colors, relying less on intuition and inspiration than on predetermined scales of color (it was as if works could be composed in—say—a certain key of yellow or blue-green, with appropriate major, minor, tonic, and dominant chords struck throughout).

Russell invented the term Synchromy ("with color") for a work he submitted to the Salon des Indépendents in 1913, *Synchromie en vert.* (His *Synchromy in Orange*, 1913–14, is in AK). Although he had previously wanted to create pictures solely by means of color, *Synchromie en vert* included a reference to one of Michelangelo's *Slaves* in the Louvre. Though it was Russell who had been trained as a sculptor, this statue served as an important point of departure for early Synchromist works by both young artists. It was not until the exhibition at the Bernheim-Jeune Gall. that Russell painted a totally abstract Synchromist work, *Synchromie en bleu-violacé.* Macdonald-Wright, then still working withMichelangelo's *Slave*, continued to display rhythms in his work suggestive of the human body in space. Both men, however, proposed to differentiate forms by color (blue, green, red, etc.) rather than by tone (dark blue, light blue). In this way, local colors would be destroyed and space suggested not by logical perspectival systems but by the projection of warm colors and the recession of cool ones. (Unlike abstract painters of the 1960s, the Synchromists wanted to maintain a sense of the third dimension. See MINIMAL ART.) Both Russell and Mac-

donald-Wright hoped that their works might be read as musical compositions, not only because of their use of color "chords" but also because the viewer would observe the development of related motifs over a period of time. There were at least two significant differences between the two artists. Macdonald-Wright to a greater extent maintained contact with natural forms, including the human body, and he allowed himself more tonal differences than Russell. In his *Synchromy in Green and Orange* (1916, Walker Art Center), a male body is clearly discernible.

About 1915, the artists went separate ways. Early in the next decade, Macdonald-Wright abandoned Synchromism, and Russell adhered to its rigid strictures only occasionally. Between 1915 and 1918, Synchromism influenced THOMAS HART BENTON, PATRICK HENRY BRUCE, ANDREW DASBURG, James Daugherty, ARTHUR BURDETT FROST, JR., and MORTON L. SCHAMBERG. It provided an alternative mode for artists who, for one reason or another, were not attracted to the nature-inspired modernist manner of the artists associated with ALFRED STIEGLITZ, including JOHN MARIN and ARTHUR G. DOVE. The movement probably also helped to make the intellectual works of Marcel Duchamp and Francis Picabia, who were in America during World War I, more understandable to those artists who had not travelled abroad and to the public. *Lit.:* Gail Levin, *Synchromism and American Color Abstraction: 1910–1925*, exhib. cat., WMAA, 1978.

# T

TACK, AUGUSTUS VINCENT (1870–1949), a painter of portraits, murals, and abstractions. From Pittsburgh, he developed his talent so quickly that a painting he sent to the Soc. of American Artists in 1889 received the highest rating and a place of honor. Study with JOHN LA FARGE was followed by a trip to France in the early 1890s. Beginning in the 1920s, he painted fifteen murals for various Catholic churches and government buildings, including the New Parliament Building, Winnipeg, Canada (1920), and the Nebraska State Capitol, at Lincoln (1928). After World War II, he painted many of the significant participants in the struggle, including General George C. Marshall, (c. 1949, Phillips Coll.). His portraits and murals were traditional in style, but during the interwar years, he also painted a number of mystical landscapes and abstract works on the themes of religion and creation. They evoke, through faceted slabs of color, suggestions of timelessness and spirituality in the tradition of ALBERT PINKHAM RYDER, GEORGE O'KEEFFE, and CLYFFORD STILL. Many of these works, for which he is best remembered, are housed in the Phillips Coll. *Lit.*: The American Studies Group, *Augustus Vincent Tack, 1870–1949.* 1968.

TAIT, ARTHUR FITZWILLIAM (1819–1905), a painter of sporting, hunting, and western scenes. Born near Liverpool, England, he taught himself to draw by copying paintings at the Royal Inst., Manchester, before coming to this country in 1850 as a full-fledged artist. Although he lived in New York City and spent considerable time in upper New York State, he painted western scenes, including *Trappers at Fault: Looking for the Trail* (1852, Denver Mus.), and anecdotal scenes set in frontier settlements (*Arguing the Point: Settling the Presidency*, 1854, R. W. Norton Art Gall., Shreveport, La.). Many of these pictures, and his sporting pictures, as well, were reproduced by CURRIER & IVES, so that Tait's work, at least in reproduction, was seen perhaps by more people than that of any other artist of the period. In his genre pictures Tait captured moments of tension, conflict, and drama without indulging in theatrics, and the appropriate backgrounds with detail that was neither too schematic nor overwhelming. He was a good storyteller in paint. He is as well known for his still lifes—primarily pictures of dead game hanging against a wall, which scholars have called an influence on the dead-game still lifes of WILLIAM MICHAEL HARNETT and his school a quarter-century after Tait's introduction of the theme to America. During the 1850s and 1860s, he also depicted numerous domestic and barnyard scenes. *Lit.*: Patricia C. F. Mandel, "The Animal Kingdom of Arthur Fitszwilliam Tait," *Antiques*, Oct., 1975.

TANNER, HENRY OSSAWA (1859–1937), a black painter of landscape, genre, and religious subjects, who was born into the family of a bishop in the African Methodist Episcopal Church in Pittsburgh. In 1866 the family moved to Philadelphia, where Tanner commenced his art studies. In 1880 he enrolled at PAFA to study for two years with THOMAS EAKINS. Tanner developed a close friendship with his teacher, who painted his portrait in 1902 (Hyde Collection, Glens Falls, N.Y.). Eakins's influence is obvious in the early realistic and somber-toned works by Tanner, who tried to establish himself as a painter of animals, genre scenes, and landscapes in Philadelphia. In 1888 he moved to Atlanta, Ga., opened a photography studio, and taught classes at Clark Coll. By 1891

Tanner had attracted the attention of several patrons, who helped to send him abroad for further study. Although he orginally intended to go to Rome, Tanner stayed in Paris to study with Jean Paul Laurens and Benjamin Constant. In 1893 Tanner spent some time painting in Brittany and turned to religious subject matter. His *Daniel in the Lions' Den* (1895, LACMA), *Annunciation* (1898, Philadelphia Mus.), and *Raising of Lazarus* (1897) were favorably received by visitors to the Paris salons and by the French government, which purchased the *Lazarus*. A patron, Rodman Wanamaker of Philadelphia, sent Tanner to the Holy Land in the late 1890s to gather material for more works in this vein. In later years, the artist returned to Palestine and also travelled in Egypt and Morocco.

After the turn of the century, Tanner concentrated on religious subject matter and landscape. His later works tended to emphasize the inspirational, miraculous, and unearthly aspects of biblical subjects. They were more broadly painted and showed great interest in the manipulation of light and shadow for dramatic effect. Tanner had his first one-man exhibition in this country in 1908. In the following year, he was elected to NAD, the first black artist to be so honored. Tanner died in Paris, where he had made his home. A collection of his work is in the Mus. of African Art, Frederick Douglass Inst., Washington, D.C. *Lit.:* Marcia Mathews, *Henry Ossawa Tanner*, 1969.

**TANNING, DOROTHEA** (b. 1913), a painter and, recently, a sculptor. Born in Galesburg, Ill., Tanning enrolled in classes at AIC at the age of twenty. She has produced what may be considered one of the most individual oeuvres in Surrealism by any artist who was not one of its European founders. Early acquaintance with the works of Edgar Allan Poe (and Aubrey Beardsley's illustrations for an edition of Poe), Emily Dickinson, Katherine Mansfield, Stendhal, and James Joyce helped to shape her sensibilities.

She had begun to show her work in the Julien Levy Gall. in New York City by 1942, and there she met the important European Surrealist Max Ernst, whom she married in 1946. They divided their time in the United States between New York and Arizona, before leaving permanently for Paris, where Tanning has lived since the 1950s. Tanning's art shows virtually no influence from her famous husband. Maintaining a precise realism throughout the 1940s, she presented an intensely personal, miraculous world of childhood and adolescence with women taking the principal roles. Using her favorite imagery of young women floating, rumpled fabrics, smoke, flowers, and empty or furnished interiors, she painted the fears and joys of childhood and womanhood, with surrealistically disguised yet very frank sexual references (*Palaestra*, c. 1947). Tanning's style changed somewhat in the 1950s, as objects were obscured in lambent atmospheres. Yet the same underlying ideas remained. They appeared also in her sculpture of the 1970s: weird yet finely crafted objects in which recognizable elements like furniture and female legs interpenetrate and mingle with strange forms and materials, including lumps and fur. *Lit.:* Alain Bosquet, *Dorothea Tanning*, 1966.

**TAOS COLONY,** a loose group of artists whose roots can be traced to 1897, when ERNEST L. BLUMENSCHEIN and Bert Phillips first visited and settled in that New Mexico community. Unlike the popular illustrators of western subject matter FREDERIC REMINGTON and CHARLES RUSSELL, the Taos artists were sympathetic to the culture of the Indians and recorded them without bias. They also painted landscapes, still lifes, and figure studies. No particular style is associated with the society or the area since at various times conservative and progressive artists have lived there. MAURICE STERNE moved to the Taos region in 1916 and ANDREW DASBURG visited often, settling there in 1930. In the 1920s, JOHN SLOAN and MARSDEN HARTLEY visited the area,

drawn, like all the artists, by the magnificent scenery and attractive local culture. *Lit.*: Pat Trenton, *Picturesque Images from Taos and Santa Fe,* exhib. cat., Denver Mus., 1974.

**TARBELL, EDMUND CHARLES** (1862–1938), leader of the Boston, Mass., Impressionist painters. A native of West Groton, Mass., he studied in 1879 at the school of MFAB, where he was later to become an extremely influential teacher himself. During the 1880s, the decade when Impressionism was at its peak in Paris, Tarbell studied at the Académie Julian with Gustave Boulanger and Jules Lefebvre. He returned to the United States in 1889 and was acknowledged as a leader among Boston artists at the turn of the century, a successor to WILLIAM MORRIS HUNT and later to DENNIS MILLER BUNKER. Critics acknowledged particularly his sensitivity to "vibrations" of color, and, especially in his outdoor figure paintings, he combined solid construction with a bright palette. In such works, Tarbell concentrated upon the female figure, presenting society women wearing the latest fashions at lawn fetes. Light in Tarbell's outdoor paintings is warm but usually shaded, a heritage from the Impressionist period of Bunker's mentor JOHN SINGER SARGENT. Tarbell also painted a good many indoor pictures, also usually of young women, engaged in sedentary and often solitary occupations—reading, sewing, or conversing languidly with one or two others. These interior pictures seem to have been valued even more highly by his contemporaries, and in their subtle modulations of light and atmosphere, as well as because of their subject matter, they suggest a homage to the Dutch 17th-century artist Jan Vermeer, then only recently "rediscovered." Recent scholarship has pointed out the emphasis in Tarbell's art on the hermetic world of upper-class women, who were excluded from the bustle of life and usually isolated from male companionship. Their ambience is usually austere but undeniably elegant: They may sew and read, but

they do not sew shirts, and their books are beautifully bound. One of the TEN AMERICAN PAINTERS, Tarbell was so influential in Boston that his followers were labelled "Tarbellites." *Lit.*: Lucien Price and Frederick W. Coburn, *Frank W. Benson, Edmund C. Tarbell,* exhib. cat., MFAB, 1938.

**TAYLOR, HENRY FITCH** (1853–1925), a late convert to modernist painting. From Cincinnati, he studied at the Académie Julian, in Paris, in the early 1880s. He returned to America in 1888. His work reflected Barbizon and Impressionist influences until the early years of the new century. Then, becoming a supporter of modernist art, he was a key figure in the development of the ARMORY SHOW. By 1914 his painting reflected a knowledge of virtually all the latest styles although he was particularly partial to Cubist organizational devices. He devised the Taylor System of Organized Color, in which psychical and psychological aspects of color were explored.

**TEN AMERICAN PAINTERS,** a group of artists in New York City and Boston, Mass., active from 1898 to 1919. Their name came from a sign used for their first exhibition in 1898, Show of Ten American Painters. Led primarily by CHILDE HASSAM, with JOHN HENRY TWACHTMAN and JULIAN ALDEN WEIR, a number of painters resigned from the Soc. of American Artists (see NATIONAL ACADEMY OF DESIGN) in 1897 because of the size and quality of its exhibitions as well as its conservative policies. In addition to Hassam, Twachtman, and Weir, the group included FRANK WESTON BENSON, JOSEPH R. DE CAMP, THOMAS WILMER DEWING, WILLARD LEROY METCALF, ROBERT REID, Edward E. Simmons, and EDMUND CHARLES TARBELL. ABBOTT THAYER and WINSLOW HOMER were invited to join the secessionists but declined. When Twachtman died in 1902, WILLIAM MERRITT CHASE replaced him. The Ten preferred small exhibitions and eschewed the trappings of a conventional organization, doing without officers and juries.

Their stylistic range extended from
Dewing's TONALISM to Hassam's Impres-
sionism, though most of the artists fa-
vored versions of Impressionism (see IM-
PRESSIONISM, AMERICAN). The group was
among the first in modern times to es-
tablish the tradition of setting up an or-
ganization independent of larger "offi-
cial" bodies of artists. Although the
radicalism of the Ten American Painters
was, in the 1890s, rather tame, their ex-
ample helped set the stage for the AR-
MORY SHOW. *Lit.:* Richard Boyle, *Ameri-
can Impressionism,* 1974. Patricia Jobe
Pierce, *The Ten,* 1976.

THAYER, ABBOTT HENDERSON (1849–
1921), a leading idealist painter. From
Boston, Mass., Thayer, like GEORGE DE
FOREST BRUSH, with whom he is often
compared, studied under the French
academic Jean-Léon Gérôme, becoming
a celebrated figure painter. He was the
arch-idealist of his time, creating from
about 1890 on a series of images of an-
gels and Madonnas—generalized reli-
gious imagery featuring young women
in flowing robes, often virginal white.
Thayer strove for the generalized and
timeless, but somehow his young women
remain very much of their period and
their nationality. Theirs is a distinctly
American female beauty, yet strangely
sexless. As idealized as Brush's, Thayer's
figures were more youthful, and his rich
and thick painterly manner was quite
different from the smooth illusionistic
surfaces of his contemporary Brush and
his teacher Gérôme. A good example is
*Young Woman* (1898, MMA). In Dub-
lin, N.H., where he settled at the begin-
ning of the 20th century, Thayer painted
a series of broad, brilliantly colored
landscapes, extremely sparse and free
and allied to the dominant Impressionist
movement of the period. His concern
with color led him to study and publish
on the principles of protective coloration
in nature, and these were adapted to
camouflage techniques in World War I.
Thayer's art remains among the most
dated of his period, but it was extremely
well received in its own time. *Lit.:* Nel-

son C. White, *Abbott H. Thayer, Paint-
er and Naturalist,* 1951.

THEÜS, JEREMIAH (c. 1719–1774), the
most significant colonial artist in
Charleston, S.C. Theüs was Swiss, and
came to South Carolina about 1735. The
majority of his works are still preserved
in Charleston and in Savannah, Ga. His
likenesses are strongly modelled and ex-
pressions intense and individual. His fig-
ures are invariably posed in a ramrod-
stiff manner. An artist of the Rococo pe-
riod, Theüs reflected the growing con-
cern with style and with fashion, empha-
sizing almost metallic highlights on the
satin costumes and draperies of his sub-
jects. Theüs did not meet any serious
competition during his long years of
dominance in his adopted city's artistic
life and he numbered among his sitters
members of such leading families as the
Rothmahlers and Manigaults. The ma-
jority of his paintings are busts. He ap-
pears to have been less secure in his full-
length portraiture, though his *Mrs. Peter
Manigault* (1757, Joseph Manigault
House, Charleston), which had to bear
comparison with a companion piece
done in London by Allan Ramsay, has a
sense of style and a real suggestion of
movement; the accompanying floral still
life is lovingly rendered, a fitting allu-
sion to feminine beauty. *Lit.:* Margaret
S. Middleton, *Jeremiah Theüs: Colonial
Artist of Charles Town,* 1953.

THIEBAUD, WAYNE (b. 1920), a painter.
From Mesa, Ariz., he received the M.A.
degree from Sacramento State Coll. in
1941. Throughout the 1940s, he worked
as a cartoonist and designer, and also
served as an artist in the U.S. Army from
1942 to 1946. Using an Abstract Expres-
sionist style in the early and mid-1950s,
he painted images of such common ob-
jects as gumball machines. Later in the
decade, he increasingly emphasized the
integrity of objects at the expense of his
earlier flashing brushwork and began to
set them against a blue horizon. His ma-
ture style appeared in 1961, when he
first celebrated the gustatory pleasures

of the country by portraying cakes, soups, ice-cream cones, etc. These were often arranged in neat rows. His bright, posterlike colors allied his work to POP ART, but Thiebaud maintained a thick, juicy sense of texture that had little in common with the smooth, media-derived style of Pop. By 1963 he had begun to paint figures and then landscapes in his mature manner. His surfaces are invariably uncluttered and each object is easy to read and arranged on a neutral surface. Examples include *Boston Creams* (1962, Crocker Gall.) and *Bikini* (1964, Nelson Gall.). *Lit.:* John Coplans, *Wayne Thiebaud*, exhib. cat., Norton Simon Mus., 1968.

THOMPSON, JEROME B. (1814–1886), a landscape and genre painter. Born in Middleboro, Mass., he was the son of Cephas Thompson, the portraitist, and brother of Cephas G. Thompson, a portrait and landscape painter. Jerome worked as a portraitist, too, on Cape Cod, Mass., while still in his teens. He moved to New York City in 1835 and in 1852 travelled to England, where he studied art for a few years. On his return, he lived on Long Island, N.Y. and in New Jersey. His work was most popular and perhaps most important during the 1850s, when he exhibited such paintings combining rural genre and landscape elements as *Apple Gatherers* (1858, Brooklyn Mus.). In these works, activities take place in the foreground while distant vistas sometimes sweep away to mountainous terrain. Whether the subject was toiling haymakers or picnickers, Thompson's vision was essentially a happy and sentimental one. People seem glad to cooperate with each other, and back-breaking labor is done with a smile in clean, dry clothing. Thompson paid careful attention to detail and at the same time to the luminous atmosphere of upland mountains, as in *The Haymakers, Mount Mansfield, Vermont* (1859).

TOBEY, MARK (1890–1976), a modernist whose work was deeply influenced by his nontraditional religious beliefs. Born in Centerville, Wis., he grew up in the Middle West. After taking a few art classes at AIC as a teenager and working as a commercial artist in Chicago, where he drew faces for catalogue illustrations, he left for New York City in 1911. He worked there as a fashion artist and caricaturist until 1922. About 1918, he was converted to the Bahá'i World Faith. Between 1923 and 1931, he lived in Seattle, Paris, New York City, and Chicago, before settling, between 1931 and 1938, at the English progressive school Darlington Hall as resident artist. In 1934 he traveled to the Orient and studied calligraphy and painting in Kyoto, Japan. (He had already studied Chinese brushwork techniques briefly with Teng Kuei in Seattle in 1923–24.) Tobey lived in Seattle until 1960, when he moved to Basel, Switzerland.

Although Tobey painted portraits and genre scenes after 1935, he developed his "white writing" technique in that year and henceforth turned progressively toward abstraction. Composed of a tangle of thin, continuous linear strokes, the white writing subsequently became central to his work. Of *Broadway Norm* (1935), his first painting in that vein, he said, "the calligraphic impulse I had received in China enabled me to convey, without being bound by forms, the motion of people and the cars and the whole vitality of the scene" (another early example is *Broadway*, 1935, MOMA). Whatever the specific subject, these works reflected Tobey's religious beliefs. For him, the white lines symbolized "light as a unifying idea which flows through the compartmental units of life." To break down these compartments, he deemphasized precise focal points, preferring to allow the lines to blur the particular centers of a composition. A canvas, therefore, became the symbol of the unity of forms and movements in the universe rather than an example of traditional organizational hierarchies in which dominant elements brought lesser ones into subordination. Tobey's white-line paintings lack the

sense of velocity characteristic of JACK-SON POLLOCK's drip paintings, the lines suggesting stationary strokes, which vibrate and fill the void rather than dart across it. Tobey's linear masses have substance, but lack solidity. Reflecting Bahá'i attitudes, Tobey's work invokes a sense of cosmic wholeness, suggesting the identification of matter with nonmatter, space with nonspace, and individual stroke with the totality of the pictorial field. Tobey was perhaps least dependent on European art of any American abstractionist, and his association with the Pacific Northwest painters MORRIS GRAVES and KENNETH CALLAHAN served to underline his isolation from the New York-Paris artistic axis. *Lit.:* William C. Seitz, *Mark Tobey*, exhib. cat., MOMA, 1962.

TOMLIN, BRADLEY WALKER (1899–1953), best known as a lyrical exponent of ABSTRACT EXPRESSIONISM. He studied art at the university of his native city, Syracuse, from which he graduated in 1921. Arriving in New York City the following year, he supported himself as a commercial illustrator, especially for Condé Nast publications, until 1929. He travelled abroad in 1923–24, 1926–27, and 1928, studying at the Académie Colarossi and Académie de la Grande Chaumière during his first trip. His early work runs a gamut from sentimental realism (*Young Girl*, 1925, Newark Mus.) to crisp Art-Deco-like arrangements. In the late 1930s, he turned toward abstraction, experimenting with Surrealist vegetative forms and Cubist spatial constructions. By 1939 he had begun to juxtapose disparate objects (for example, a human head and a cat's body) within Cubist planes. These works, such as *Inward Preoccupation* (1939, WMAA), often invoked melancholy states of mind. By 1947 Tomlin had begun to produce totally abstract works in which writhing, thickened lines that burst the Cubist grid, floated in indeterminate, darkened fields. Some recall ADOLPH GOTTLIEB's pictographs. Within two years, the linear contours had hardened into angular

dashes, dots, crosses, and T shapes and assumed an even emphasis over the entire canvas surface (*Number 9: In Praise of Gertrude Stein*, 1950, MOMA). In his very late works, Tomlin experimented with enlarged-dot shapes, which suggested falling snow or blizzards of blossoms, as in *Number 7* (1952–53, Baltimore Mus.). Like PHILIP GUSTON's work of the 1950s, Tomlin's reduced the bombast of JACKSON POLLOCK's and WILLEM de KOONING's works to living-room scale. *Lit.:* Jeanne Chenault, *Bradley Walker Tomlin*, exhib. cat., Hofstra Univ., 1975.

TONALISM, a stylistic trend in painting from the 1880s to the 1910s. Exponents included the major painters GEORGE INNESS and JAMES A. M. WHISTLER, the less important THOMAS WILMER DEWING, DWIGHT TRYON, and ALEXANDER HELWIG WYANT and also the PHOTO-SECESSION photographers EDWARD STEICHEN, CLARENCE H. WHITE, and GERTRUDE KÄSEBIER. Tonalism developed out of Barbizon painting (see BARBIZON, AMERICAN) and was related to American Impressionism (see IMPRESSIONISM, AMERICAN). Although it was not a movement with clear contours, and is perhaps largely a designation of convenience for scholars, Tonalism does have certain definable characteristics. Tonalists preferred poetic truth to scientific fact, intimate scenes, and meditative qualities in a subject or a theme. Initially, most Tonalists ignored urban themes, preferring sylvan settings or middle-class interiors. Their subjects hardly ever seemed to move, but sat or stood gazing off into space. Forms were softened, as if seen through a veil or a blurred, out-of-focus lens. Moods ranged from nostalgia to reverie, though occasionally more mysterious feelings might be aroused, but not to the point of animating a subject or giving a viewer any shock. These moods were communicated less by specific facts than by manipulation of colors and shapes. Scenes were often set at dusk or were shrouded in mist. Colors, therefore, were muted and unified within a controlled tonal range. Tonalists did not especially care for

French Impressionism because its analytical and brightly colored surfaces destroyed a sense of mood. At the other extreme, Tonalists also eschewed the often weak-minded attraction of academically inclined artists for sentiment. They tried to capture both a mood in nature and their own mood as it was affected by nature. *Lit.:* Wanda Corn, *The Color of Mood: American Tonalism, 1880–1900,* exhib. cat., de Young Mus., 1972.

TOOKER, GEORGE (b. 1920), a painter. From New York City, he studied at ASL from 1943 to 1944 under REGINALD MARSH, PAUL CADMUS, and KENNETH HAYES MILLER. By the late 1940s, Tooker had settled upon his basic approach, using a scrupulously disciplined technique that harks back to the Italian Renaissance and preferring the egg-tempera medium above all others. His methods, which he shares with Cadmus and Jared French, are, in part, the legacy of Miller. Tooker's subject matter is the human condition as seen in the context of contemporary society. Many of his works are allegorical. In *Subway* (1950, WMAA), the tiled walls and geometrical passageways of a subway system become a cold, antiseptic, modern Hell. The many people in this work, apprehensive and fearful, are similar enough to be considered repeated units of the same person rather than separate individuals. The theme of people in close physical proximity but psychologically distant from each other was continued in such works as *Sleepers* (1959, MOMA). Tooker's vision of a depersonalized world has been linked to that of the writer Franz Kafka as well as to Existentialism. Tooker has also painted works dealing with life's brevity and the inevitability of death. His paintings of young women peering hypnotically into mirrors overlooked by wizened elders are reminiscent of the related "Death and the Young Woman" theme in the art of previous centuries. *Lit.:* Thomas H. Garver, *George Tooker: Paintings, 1947–73,* exhib. cat., CPLH, 1974.

TROTT, BENJAMIN (c. 1770–1843), a miniaturist. From Boston, Mass., he began his career about 1791 and within two years had settled in New York City. After copying some of GILBERT STUART's portraits, he followed Stuart to Philadelphia, which remained the center of his activity until 1819, although he made visits to New York City in 1798–99 and Albany, N.Y., and Kentucky in 1805. Between 1819 and 1841, he travelled the Atlantic seaboard, staying for various lengths of time in major communities between Boston and Charleston, S.C. Although many of Trott's miniatures are completely finished, he often left backgrounds partially painted. Less thorough than EDWARD GREENE MALBONE, Trott also left visible his hatch and wash marks. These marks often provided his sitters with an extra measure of dash and liveliness, which usually complimented their alert glances and poses.

TROVA, ERNEST (b. 1927), a self-taught sculptor and painter. Born in St. Louis, Mo., he was, through the 1940s and 1950s, primarily a painter and influenced profoundly by WILLEM DE KOONING and, to a lesser extent, by Matta and Francis Bacon. Trova has preferred to depict the male figure. Between 1959 and 1963, he created assemblages and collages from urban detritus. Most works of this period were given anthropomorphic overtones, and by 1961 they had been metamorphosed into paintings of the Falling Man, a theme Trova pursued for over a decade. He usually entitled these works *Study: Falling Man* (example in Guggenheim Mus.). The Man was desexed and shown in profile with a flat chest and slightly protruding stomach. Invariably, his knees were locked, whether standing erect or lying down. By 1963 the subject had appeared in polished sculptural form, sometimes reproduced in multiple images. He might have attachments on his chest or other parts of his body, or he might be mounted on wheels—a modern Frankenstein-like android. In the early 1970s, in a series entitled The Profile Cantos, Trova

took apart the Falling Man to such an extent that many versions, composed of flattened arcs and circles, appear to be completely abstract. *Lit.*: Udo Kultermann, *Trova*, 1978.

TROYE, EDWARD (1808–1874), an animal and figure painter. Born near Geneva, Switzerland, the son of a painter, he lived in England as a youth, before emigrating to the West Indies about 1828 and then moving on to Philadelphia soon after. He became a specialist in painting racehorses, especially after making several sketching trips through the southern and border states. After 1835 he lived in Kentucky most of the time. Examples of his work include *Richard Singleton* (c. 1830), a racehorse (despite the name), and his own self-portrait, which included two horses (1852, Yale Univ.). Troye also painted equestrian portraits, including one of General Winfield Scott (U.S. Capitol). In the 1850s, Troye visited the Middle East and painted several exotic scenes, duplicates of which were presented to Bethany Coll., W. Va.

TRUMBULL, JOHN (1756–1843), a history painter and portraitist. Born in Lebanon, Conn., son of the governor of the state, Trumbull was graduated from Harvard Coll. in 1773. There, he decided on an artistic career and visited JOHN SINGLETON COPLEY for criticism and advice but at the outbreak of the War of Independence he entered the military as a colonel and drew maps for Washington and General Horatio Gates. In 1777 he resigned his commission to study art in Boston, Mass., where he occupied the studio that had belonged to JOHN SMIBERT. He left for London in 1780 but, with hostilities still raging between the two countries, he was promptly arrested as a spy. Only after the war was he able to establish himself in the London studio of BENJAMIN WEST and, under the tutelage of that American expatriate, begin his serious work.

In 1785, with the encouragement of John Adams and Thomas Jefferson as well as Jacques-Louis David and West,

Trumbull embarked upon a series of paintings depicting the great events of the war. His *Death of General Warren at the Battle of Bunker's Hill, 17 June 1775* (1786, Yale Univ.) is in the tradition of modern history painting established by West's famous *Death of Wolfe* of 1770. The composition, the brilliant red uniforms, the stormy sky with fluttering Baroque flags, and the heroic poses all reflect West and West's sources. In this work and in *The Death of General Montgomery in the Attack on Quebec, 31 Dec. 1775* (1786, Yale Univ.), Trumbull demonstrated a histrionic fury akin to the spirit of Copley's *Death of Major Peirson* of 1784.

In drawing on these examples of his predecessors, Trumbull exploited the patriotic temper of the times and sought to achieve the high moral tone that had made such heroic death scenes so popular in the late 18th century. His vigorous brushwork and emotional intensity (which acknowledged the new taste for passion and the sublime in art) places him at a transitional moment between neoclassicism and romanticism.

In 1789 Trumbull returned to the United States, where he painted portraits and arranged for the sale of engravings of his pictures. He travelled through the country and twice to London (1794, 1808) and encountered considerable professional difficulty as well as fame. In 1817 he was commissioned by act of Congress to decorate the rotunda of the Capitol with four historical murals, and he completed them in 1824. No longer under the direct influence of West, however, his style had become stiff and bombastic. His history subjects, as evidenced by these murals (*The Declaration of Independence; The Surrender of General Burgoyne at Saratoga; The Surrender of Lord Cornwallis at Yorktown;* and *The Resignation of General Washington at Annapolis*), were increasingly encumbered by portraits, so that their composition was reduced effectively to the marshalling of rows of heads. With the exception of his miniature studies, Trumbull's single and family portraits,

though precisely rendered, suffer from the artist's aloofness of personality.

Trumbull was elected president of the AMERICAN ACADEMY OF THE FINE ARTS in 1817. His dictatorial rule brought about the collapse of that organization and the founding, by dissident students, of the NATIONAL ACADEMY OF DESIGN. Among his later artistic works are views of Niagara Falls, which look forward to the prevailing interest of the next generation of American painters in landscape (example in WA of c. 1807). Trumbull also made architectural designs. His only surviving building is the Congregational Church in Lebanon, Conn. His autobiography appeared in 1841, the first of its kind published in the United States. Trumbull, particularly in his earlier works, remains the most impressive chronicler of the American Revolution. *Lit.:* Irma B. Jaffe, *John Trumbull*, 1975.

TRYON, DWIGHT WILLIAM (1849–1925), primarily a painter of landscapes and seascapes in an intimate, contemplative manner with muted tones, and low-key colors. Tryon has been called a quietist and a Tonalist (see TONALISM). Born in Hartford, Conn., in 1876 he went to Paris, where he studied with Jacquesson de la Chevreuse and worked briefly with the Barbizon painter Charles François Daubigny and with Henri Harpignies and Antoine Guillemet. From 1877 to 1881, he spent summers with the figure painter ABBOTT THAYER and in 1881 moved to New York City. Tryon's characteristic approach to landscape was through subtle nuances of atmosphere and mood rather than an empirical attack on light and color. A typical scene by Tryon, such as *Morning Mist* (1914 Freer Gall. of Art, Washington, D.C.) or *Before Sunrise* (1906–07, Washington Univ., St. Louis) depicts a woodland evenly balanced by horizontal divisions of grass and shrubs and verticals of tall trees aligned with precision, with the leafage evaporating into a misty atmosphere. Primarily influenced by the Barbizonist Camille Corot and JAMES A. M.

WHISTLER, Tryon preferred the serenity and stillness of nature clothed in luminous, soft color. Charles Lang Freer was an avid patron of Tryon, and many of the latter's paintings are in the Freer Gall. of Art in Washington, D.C. In his lyrical, poetic approach to landscape and his interest in quiet corners of the world, Tryon may be compared to such contemporaries as ALEXANDER HELWIG WYANT, Birge Harrison, and JOHN FRANCIS MURPHY. *Lit.:* Henry White, *The Life and Art of Dwight William Tryon*, 1930.

TUTTLE, RICHARD (b. 1941), a mixed-media artist. From Rahway, N.J., he gained the B.F.A. degree from Trinity Coll., Hartford, Conn., in 1963. From 1962 to 1964, he studied at Cooper Union in New York City. Since 1963 he has explored states of dematerialization and, since about 1970, the relationship of objects and their environment. He has worked with three-inch paper cubes, wires, string, plywood, and other materials of varying permanency. Many pieces are very small but nevertheless energize the spaces in which they have been placed. They may lie on the floor or be attached to a wall. Octagonally-shaped paper and cloth forms may even be stapled to surfaces. As a result, many pieces are not self-contained in the traditional sense but depend upon their surroundings to provide full realization of their aesthetic potential. *Lit.:* Marcia Tucker, *Richard Tuttle*, exhib. cat., WMAA 1975.

TWACHTMAN, JOHN HENRY (1853–1902), a painter of landscapes in the Impressionist style and a founding member of the TEN AMERICAN PAINTERS (see IMPRESSIONISM, AMERICAN). Twachtman was noted for his highly personal interpretations of a range of atmospheric conditions. Born in Cincinnati, the artist studied there first at the Ohio Mechanics Inst. In 1874 he met and continued his studies with FRANK DUVENECK, a painter of the MUNICH SCHOOL, who influenced his early style, which is characterized by

direct, spontaneous brushwork with thick impasto in rich paint often in the brown range. In 1875 the artist left for Europe, where he studied with Ludwig Loefftz at the Royal Acad. in Munich, and in 1877 accompanied Duveneck and WILLIAM MERRITT CHASE to Venice, where there was a colony of American artists painting in the Munich style. The following year, Twachtman returned to America but in 1880 was again in Europe, teaching at Duveneck's school in Florence and in 1881 accompanying JULIAN ALDEN WEIR and JOHN FERGUSON WEIR to Holland.

A decisive change in his artistic style took place during Twachtman's trip in 1883 to Paris, where he studied at the Académie Julian with Jules Lefebvre and Louis Boulanger. During his three-year stay in France, he fell under the influence of JAMES A. M. WHISTLER and the French Impressionists and initiated friendships with the American Impressionists CHILDE HASSAM and THEODORE ROBINSON. *Arques-la-Bataille* (1885, MMA) and *Springtime* (1880–85, Cincinnati Mus.) are early examples of Twachtman's Impressionist style. Characterized by low-key harmonies of gray and green, an almost monochrome palette, smoother paint texture, and a tendency towards abstraction, they often call to mind Whistler's muted and delicate compositions. Twachtman's use of broad, flat areas of color also suggests the influence of Japanese prints.

The paintings of the 1890s are in a still lighter, Impressionist palette. *Meadow Flowers* (c. 1890–1902, Brooklyn, Mus.), *Winter Harmony* (c. 1900, NGW), and *Snowbound* (c. 1895, AIC) are all highly subjective interpretations of nature. In 1889 Twachtman purchased a farm in Greenwich, Conn., which was to serve as the inspiration for many canvases. In these paintings, Twachtman was concerned with poetic vision and not with the visual reality, though his blurred forms resemble those of the French Impressionist Claude Monet. Rarely dated, they do not deal with a particular time or place but with the essence of nature.

In this quality, he resembled such painters as ALBERT PINKHAM RYDER. Like the American Impressionist Birge Harrison, Twachtman had a fondness for winter scenes, though his are more contemplative and intimate. He often painted the same subject frequently, though not so much to capture the different effects of light as to elicit varying emotional responses. During his last years, Twachtman painted even more quickly and directly, using brighter colors. His surfaces became more alive and more impressionistic than before. *Waterfront Scene-Gloucester* (1901) and *Sailing in the Mist* (1900, PAFA) exemplify this late style. They are not unlike the idyllic landscapes of his friend Julian Alden Weir. *Lit.:* Richard J. Boyle, *A Retrospective Exhibition: John Henry Twachtman,* exhib. cat., Cincinnati Mus., 1966.

**TWOMBLY, CY** (b. 1929), a painter. From Lexington, Va., he studied at the school of MFAB in 1948–49, at ASL in 1950–51, and at Black Mountain Coll. in 1951–52. He settled permanently in Rome in 1957. Twombly developed his characteristic calligraphic, or "doodle," style of painting during the 1950s. On canvas or paper, he makes a variety of marks and squiggles that are often charged with erotic content, as is *The Italians* (1961, MOMA). This gesturalism grew out of Surrealist improvisation, but Twombly generally keeps his forms from coalescing into patterns with obvious thematic meaning. *Lit.: Cy Twombly,* exhib. cat., Inst. of Contemp. Art, Univ. of Pennsylvania, 1975.

**291** (Gallery). See LITTLE GALLERIES OF THE PHOTO-SECESSION.

**TWORKOV, JACK** (1900–1977), a painter. Born in Biala, Poland, he was brought to America in 1913. From 1923 to 1926, he studied at NAD and ASL. From 1934 to 1941, he was supported by various FEDERAL ART PROJECTS. He did not paint from 1942 to 1945. Through friendship with LEE GATCH and KARL KNATHS in the

late 1920s, he absorbed European modernism, although, during the 1930s, he tried, as he said, "to salve my social conscience at the expense of my aesthetic instincts." After 1945 he began to reject European modernism for one of his own invention (a studio adjoining WILLEM DE KOONING's from 1948 to 1953 was a factor here). Tworkov's works of the period resemble de Kooning's, but he imposed a gridlike restraint on his forms. By 1955 the grid had become his paramount subject. At first it was casually applied, in large textured brushstrokes and colors evocative of the late work of Claude Mo-

net as in *Crest* (1958, Cleveland Mus.). During the 1960s, in works such as *West 23rd* (1963, MOMA), the vertical and horizontal elements grew enormous relative to the canvas. In the 1970s, the grid became rigid. Elements appeared to be measured; certainly they were regularized. The improvisational gestures of the two previous decades were now transformed into a consistent, seemingly planned series of movements. Nevertheless, the earlier surface shimmer of colors was maintained throughout Tworkov's later work. *Lit.:* Edward Bryant, *Jack Tworkov*, exhib. cat., WMAA, 1964.

# U

**UELSMANN, JERRY N.** (b. 1934), a photographer important in reestablishing the validity of the manipulation of the photographic image. Born in Detroit, he studied photography with Ralph Hattersley and MINOR WHITE at the Rochester Inst. of Technology and with Henry Holmes Smith at Indiana Univ., where he received an M.F.A. degree in 1960. Like White, he was interested in the kinds of meanings evoked by juxtaposing images but unlike White he began experimenting with printing negatives together, producing multiple images in a single print. He soon became extraordinarily proficient in combining as many as twelve negatives, always playing against the learned responses of the spectator to the realistic basis of the medium. In the 1960s, when he began working, this technique was unconventional and it presented a challenge to EDWARD WESTON's "purist" approach. Although CLARENCE JOHN LAUGHLIN and Frederick Sommer had been working with it consistently since the late 1930s, Uelsmann attracted considerably more attention to this type of photography with a major one-man exhibition at the Jacksonville Art Mus., Jacksonville, Fla., in 1963 and another at MOMA in 1967. With his creative roots in Surrealism, Uelsmann continues to juxtapose ordinary images to create evocations of the unconscious and archetypal in human experience. Many of his photographs are in MOMA. *Lit.:* Jerry N. Uelsmann, *Jerry N. Uelsmann,* 1971.

**ULRICH, CHARLES FREDERIC** (1858–1908), a painter. Born in New York City, he studied at NAD and then went to Munich in the early 1880s. In 1884 he became the first recipient of the Clark Prize at NAD. After a brief stay in the United States, Ulrich returned to Europe, living in Venice for several years. Despite his training in Munich with Ludwig Loefftz and Wilhelm Lindenschmidt (see MUNICH SCHOOL), he preferred a style notable for its precision and control. In his work, tonal changes were carefully regulated and outlines were sharp. Although his pictures have a photographic look, his compositions were carefully attuned to his subject matter. Thus, in *The Village Print Shop* (c. 1885), forms were placed to emphasize the impersonality of working conditions; in *In the Land of Promise—Castle Garden* (1884, Corcoran Gall.), a painting of immigrants at Ellis Island, figures are cut off at the canvas's edges to suggest the immensity of the room in which the subjects sit and stand. These working-class scenes are among the few produced in the late 19th century.

# V

VANDERLYN, JOHN (1775–1852), an important figure in American romantic painting. Vanderlyn was born in Kingston, N.Y., a descendant of Pieter Vanderlyn, a portraitist active in the Hudson Valley in the 1730s (see PATROON PAINTERS). At the age of fourteen, Vanderlyn was making drawings after Dutch prints and at sixteen he produced a "drawing book" with studies after Charles Lebrun. He was then apprenticed to Thomas Barrow, an art dealer in New York City, and had lessons there at the Columbian Acad. of Painting. A copy Vanderlyn made of GILBERT STUART's portrait of Aaron Burr, which had been left at Barrow's for framing, attracted the attention of Burr, who offered him the opportunity to assist Stuart in Philadelphia for a year.

In 1796 Vanderlyn was sent by Burr to study in Paris, thus breaking the umbilical ties between American artists and the studio of BENJAMIN WEST in London. Except for brief return visits to America, he remained in Europe until 1815. Departing from the tradition of British history painting, Vanderlyn learned a romantic neoclassicism in the manner of Jacques-Louis David and Jean-Auguste Dominique Ingres. His *Death of Jane McCrea* (1804, WA) illustrates a contemporary poem about a woman shot and scalped during the Revolutionary War and was thus an example of modern history painting as practiced by West and David. The distraught woman is seen kneeling between two muscular savages; one seizes her by the hair while the other raises an ax. The woman's dress is in disarray, a concession to popular appeal. In the dark, brooding landscape background a would-be rescuer arrives too late. With this work, Vanderlyn served notice that American history painting was to be emotional and dramatic, as opposed to the heroic but stagy death scenes of the European tradition.

*Marius Amid the Ruins of Carthage* (1807, de Young Mus.), painted in Rome, shows the Roman general, as the artist expressed it, "sitting in somber melancholy, reflecting the mutability of Fortune." Vanderlyn may have had in mind here the fortune of his friend Burr, who, after the disastrous Hamilton duel, was standing trial for treason. The still, contemplative mood of the work suggests David's *Lictors Returning to Brutus the Bodies of His Sons* (1789). The figure and the setting are scrupulously derived from classical models, and the work won a gold medal from Napoleon in 1808, making the artist's reputation in France.

In an attempt to create an ideal picture of female beauty comparable to his *Marius*, Vanderlyn painted *Ariadne Asleep on the Island of Naxos* (1812–14, PAFA). Based on Renaissance masterpieces—Correggio's *Antiope* in Paris, Giorgione's *Sleeping Venus* in Dresden, and Titian's *Venus d'Urbino* in Florence—Vanderlyn's softly modelled, sensually posed nude lies in the virgin landscape of America rather than on the cultivated hillsides of Europe. Vanderlyn's motive in painting *Ariadne* was partly financial: A female nude exhibited in Philadelphia some years before brought the painter, ADOLPH-ULRICH WERTMÜLLER, notoriety and a considerable income. But when the *Ariadne* was placed on exhibit in 1819 it only created a scandal.

With the *Ariadne* and some other works, Vanderlyn exhibited his *Palace and Gardens of Versailles* (1815, MMA) in a special rotunda in City Hall Park in New York City, but the work was some years in advance of the popular taste for PANORAMAS. In 1829 the city cancelled Vanderlyn's lease, and the debt-ridden artist retired in discouragement to Kingston. Later his *Niagara* (1842–43, Senate House Mus., Kingston) was to

achieve a freshness and sweep that had some influence on the emerging HUDSON RIVER SCHOOL (early versions dated from 1804 and c. 1827). But Vanderlyn, feuding with JOHN TRUMBULL over commissions and producing stiff, rhetorical works when he won them (*The Landing of Columbus*, ordered in 1837 by Congress for the U.S. Capitol Rotunda), never succeeded in his goal to become the great American history painter. For all his talent and energy, he died frustrated and destitute. His extremely fine *Portrait of the Artist*, of about 1814, is in MMA. *Lit.*: Kenneth C. Lindsay, *The Works of John Vanderlyn*, 1970.

**VEDDER, ELIHU** (1836–1923), a leading symbolistic painter. Born in New York City, Vedder studied at an early age with Tompkins Harrison Matteson in Sherburne, N.Y., and, in 1856, went to Paris and Italy, returning to New York in 1861. What are probably his most haunting works were done in the immediately succeeding years. These paintings, which prefigure European Symbolism by more than twenty years and reflect the mood of anxiety and uncertainty that swept the country after the trauma of the Civil War, include *The Questioner of the Sphinx* (1863, MFAB), *The Lair of the Sea Serpent* (1864, MFAB), and *The Lost Mind* (1864–65, MMA). The sense of isolation, the vast, desolate wastes that comprise the settings of these paintings create an intense sense of melancholy and tragedy that is heightened by an almost surreal naturalism; Vedder's contemporaries, however, were puzzled by their unfamiliar allegory (the hooded female figure of *The Lost Mind*, however, became a popular symbolic form in the late 19th century). In 1866 Vedder left America and settled in Rome, one of the last major American artists to reside there, for Rome was being supplanted by Paris and Munich as a magnet for American expatriates. With the exception of some charming and free sketchlike landscapes of the Italian countryside (example of 1875 in AIC), Vedder's work in Italy remained allegorical and symbolistic,

though his figures became more generalized and stylized, taking on overtones of the old masters, particularly Michelangelo, and approaching the work of such contemporary European painters as Anselm Feuerbach, Frederic Lord Leighton, and Edward Burne-Jones. His stylized, sinuous drapery and whiplike linearism may also have been related to the Aesthetic Movement and the "rediscovery" of Botticelli. Such qualities made Vedder's style particularly appropriate to mural painting as it was revived at the end of the century (see MURAL PAINTING MOVEMENT), and he painted significant though mannered murals at Bowdoin Coll. in 1894 and in the Library of Congress in 1896–97. The finest work of his late years is his series of exquisitely linear and decorative illustrations for the *Rubáiyát of Omar Khayyam* (1884). Vedder's own book, *The Digressions of V.*, was published in 1910. *Lit.*: Regina Soria, *Elihu Vedder: American Visionary Artist in Rome*, 1970.

**VONNOH, BESSIE POTTER** (1872–1955), a sculptor noted for her figurines and fountains depicting dancing children and tender visions of mother and child. Born Bessie Potter, in St. Louis, Mo., she moved to Chicago as a child and began to study with Lorado Taft at AIC about 1890. She assisted Taft with the works he created for the WORLD'S COLUMBIAN EXPOSITION of 1893. At the fair, she fell under the spell of the Russian sculptor Paul Troubetzkoy, whose bronze statuettes exerted the greatest influence upon her work. Although she travelled to Paris and Florence, she had no foreign training, though it has been observed that her sculpture reflects an awareness of the tender domestic subjects treated by Pierre Auguste Renoir and MARY CASSATT (whose work she could also have seen at the Columbian Exposition). In 1899 she married the painter ROBERT WILLIAM VONNOH and thereafter lived in New York City. Vonnoh's figurines (*The Young Mother*, 1896, MMA; *Dancing Figure*, c. 1900) and her bronze birdbath fountain in the children's garden in Cen-

tral Park, New York City, display the artist's delight in spontaneity and picturesque observation. *Dancing Figure*, though delicate and fragile physically, gains an almost monumental quality through its acute perception of mood. A versatile artist, Vonnoh also sculpted the more rugged, forthright portrait bust of Dr. Frank M. Chapman at the American Mus. of Natural History, New York City. Other works by this artist may be seen at the Brooklyn Mus., Newark Mus., Corcoran Gall., and AIC.

VONNOH, ROBERT WILLIAM (1858–1933), best known for his portraits and landscapes, which are among the earliest American Impressionist paintings (see IMPRESSIONISM, AMERICAN). Vonnoh was born in Hartford, Conn., but moved to Boston, Mass., as a child. He studied from 1875 to 1877 at the Massachusetts Normal Art School and from 1881 to 1883 in Paris with Gustave Boulanger and Jules Lefebvre and at the Académie Julian. Upon his return to America, he became a noted portrait painter, executing sober, realistic likenesses of such personalities as Alexander N. Fullerton (Chicago Hist. Soc.) and DANIEL CHESTER FRENCH. In 1887 Vonnoh departed for Paris again, and studied there for the next four years. He worked with Jules Bastien-Lepage and encountered Claude Monet and French Impressionism, which radically altered his style. Vonnoh returned to America in 1891, bringing Impressionism to PAFA where he was an instructor until 1896. In 1899 he married the sculptor Bessie Potter (see VONNOH, BESSIE POTTER). In such characteristic works as *Winter Sun and Shadow* (1890, North Carolina Mus.), *November* (1890, PAFA), and *Picking Poppies* (1913, Corcoran Gall.), Vonnoh reflected the influence of Bastien-Lepage in his muted color and realistic observation of nature. His spontaneous execution and underlying classical composition are reminiscent of the early Camille Pissarro. In *Poppies* (1888, Indianapolis Mus.), the influence

of Monet is evident in the close-up, worm's-eye view, absence of horizon, and bright red dashes of paint. *Lit.:* Eliot Clark, "The Art of Robert Vonnoh," *Art in America*, Aug., 1928.

VOULKOS, PETER (b. 1924), a ceramist, sculptor, and painter, whose example has helped eliminate the distinction between craftsperson and artist. From Bozeman, Mont., he received the M.F.A. degree from the California Coll. of Arts and Crafts, Oakland, in 1952. He lived in Los Angeles from 1954 to 1959 and then settled in Berkeley. He contributed to a redefinition and redirection of the field of ceramics after 1955 by adding collage elements to plates and to pottery, by stacking forms, by combining thrown and slab elements, by cutting deeply into surfaces, and by experimenting with coloring materials, including epoxy paints. By the late 1950s, he had made several large ceramic sculptures, some as high as sixty-five inches, that emphasized rough textures and seemingly improvised combinations of additive units. Examples include *Sculpture, 5000 Feet* (1958, LACMA). The influence of the Austrian sculptor Fritz Wotruba is evident in many of these pieces. About 1960 Voulkos began to experiment with the lost-wax bronze casting process. By 1965 his vocabulary of forms was established and included "the cylinder, the elbow, the dome, the flat sheet, and the rectangular cube," all amazingly smooth in surface and sleekly industrial in appearance in comparision with his ceramic sculpture. Voulkos prefabricates these forms and then creates works from them. He is thus able to compose with startling rapidity. His major commissions have included a thirty-foot-high monument for San Francisco's Hall of Justice (1971) and a smaller one for the Federal Building in Honolulu (1977). Voulkos has been a highly influential teacher at the Otis Art Inst., Los Angeles, and in Berkeley. *Lit.:* Rose Slivka, *Peter Voulkos*, 1978.

# W

**WALDO & JEWETT,** a successful portrait-painting firm in New York City from 1812 to 1854. Samuel Lovett Waldo (1783–1861), born in Windham, Conn., first studied in Hartford and painted portraits in his native state and in South Carolina. Later, he went to London to work with BENJAMIN WEST at the Royal Acad. from 1806 to 1808, returning to New York City the following year to become one of the finest portrait specialists of the time. In 1812 the young William Jewett (1789/90–1874) from East Haddam, Conn., joined Waldo as an assistant or apprentice, and in 1818 the two formed a partnership that lasted until 1854, when Jewett retired. The portraits that came out of the studio of Waldo & Jewett, often so signed, either in script or in stencil, are among the strongest and most solid and three-dimensional of the period, characterized by a broad painterliness and an optimistic, confident expression. The artists appear most assured in single likenesses, being rather more awkward in their relatively rare group portraits. Since Waldo was the established master, it has generally been assumed that he was usually responsible for the overall design of a portrait and for the execution of the principal areas of head and hands. Certainly, the works he painted before his association with Jewett, such as the *Self-Portrait* (1817, MMA) and several likenesses of Andrew Jackson (c. 1817, version in MMA), are very accomplished, professional performances. But, though relatively few in number, the known works by Jewett alone are also very competent portraits, and it would not seem probable that, for almost forty years, the younger artist contented himself with the role of drapery and accessory painter. In all likelihood, the partners shared the commissions in such a complicated manner that their individual contributions are indistinguishable. Several joint portraits are in MMA.

**WALKER, WILLIAM AIKEN** (1838–1921), a southern genre painter. From Charleston, S.C., he was largely self-taught, though he spent some time during the 1860s studying in Düsseldorf, Germany. He lived at various times in Charleston, Baltimore, New Orleans, and other communities and wandered all over the Deep South recording post-Civil War genre scenes. His preferred subject matter was rural blacks at work—on the docks, in the fields, or at home around their plain and simple cabins. Although he often showed blacks in tattered clothing, he seems not to have emphasized the economic oppression they suffered or their poverty; nor did he make their labors heroic. As a result, his paintings, mostly small studies lacking in insight and telling observation, qualify as competent examples of local-color painting. In the larger plantation scenes, showing as many as twenty-five people working in the fields, Walker's style approached that of FOLK ART. Yet he provided these works with as much detail as the smaller ones, in part because he used the camera as a means to stimulate his memory. Two lithographs published in 1884 by CURRIER & IVES brought him into prominence as a genre painter. He also painted game and fish studies (example of 1860 in MFAB), especially in the 1860s and again after 1900. He favored landscapes after 1890. *Lit.:* August P. Trovaioli and Roulhac D. Toledano, *William Aiken Walker: Southern Genre Painter,* 1972.

**WALKOWITZ, ABRAHAM** (1878–1965), a modernist painter. From Tyumen (Siberia), Russia, he was brought to New York City in 1889. He studied art briefly in 1894 and again at NAD in 1898. He began to make etchings in 1899 and during

the next ten years produced many monotypes. His earliest studies of urban streets and river views were blurred by a concern for tone and mood reminiscent of JAMES A. M. WHISTLER's. After travelling to Europe in 1906–7 and studying at the Académie Julian, he became a modernist, responding most strongly to Fauvism and to Auguste Rodin's late wash drawings. At this time, he started to draw images of the dancer Isadora Duncan. Eventually, he made thousands of drawings of her, perhaps because her ideas about spontaneity and freedom coincided with his. After his return to New York, in 1910, Walkowitz became an important figure in the small modernist art world, exhibiting at the LITTLE GALLERIES OF THE PHOTO-SECESSION in 1912, the ARMORY SHOW in 1913, and the Forum Exhibition in 1916 (see INDEPENDENT EXHIBITIONS). He was also active in forming the People's Art Guild, the first artists' cooperative in this country, with John Weichsel in 1915. During these years, he restlessly experimented with different styles and subjects but often painted New York City in a Cubo-Futurist manner (Metropolis No. 2, 1923, Hirshhorn Mus.) In all these works, he tried, as he said, to find visual equivalents for his experiences. In the 1920s, he painted realistic views in response to changing tastes, and in the 1930s he added social themes to his repertory. Lit.: Sheldon Reich, "Abraham Walkowitz, Pioneer," American Art Journal 3, 1971.

WARD, JOHN QUINCY ADAMS (1830–1910), one of the greatest of the naturalistic sculptors of the 19th century. Born near Urbana, Ohio, Ward began his career as an assistant to HENRY KIRKE BROWN from 1849 to 1856, working with Brown in Brooklyn, N.Y., on the great equestrian statue of George Washington (1853–56) for Union Square in New York City. Undoubtedly, it was Brown who inclined Ward toward naturalism rather than the waning but still dominant neoclassical aesthetic. After two years of portrait work in Washington, D.C., Ward opened his own studio in New York. His first major independent sculptural achievement was Indian Hunter (original bronze statuette, 1864, NYHS; enlarged version, Central Park, New York City, installed 1868). The young Indian and his dog make a well-integrated group, with a suggestion of movement and real dramatic presence, and the statue's realism was, and is, much admired. For the first time in many years, an American sculptor had avoided the traditional repertory of poses and anatomical and facial types derived from antique statues and honored actual aboriginal appearance. Unlike most neoclassical sculpture, the Indian Hunter is meant to be seen in the round rather than from a frontal position.

Ward continued to live and work in New York, and most of his major sculpture was done in bronze for public monuments in that city, as was the Washington of 1883, at the Federal Hall National Memorial. As usual, the face was derived from Jean-Antoine Houdon's famous statue in Richmond, Va., but Ward interpreted his subject very independently, forthrightly understating details of costume and utilizing Washington's cloak for an effect of expansiveness. A cloak again effects a sense of monumentality in what may be Ward's greatest achievement, Henry Ward Beecher, of 1891, in Borough Hall Square, Brooklyn. The somewhat rougher, more generalized treatment creates an impression of rugged, uncompromising character and intellectual honesty. Beecher's role as a fiery abolitionist was emphasized, not only in the resolute likeness but in the secondary figures at the side of the large pedestal, subordinated to the towering subject. This two-level figural conception was not infrequent in late 19th-century monuments, and Ward's use of it is particularly effective. In his commitment to realism and a native American art Ward was perhaps the most solidly satisfying sculptor of his generation; however, his treatment of surface tended to be rather dry and unexciting as compared to the more ani-

mated work of the French-trained masters of the next generation, AUGUSTUS SAINT-GAUDENS and DANIEL CHESTER FRENCH. *Lit.:* Adeline Adams, *John Quincy Adams Ward: An Appreciation,* 1912.

WARHOL, ANDY (b. 1928), a figure central to POP ART. From McKeesport, Pa., he studied art at the Carnegie Inst. of Technology, Pittsburgh, from 1945 to 1949, before coming to New York City, where he worked as an illustrator and commercial artist until 1960. In 1960 he began to make paintings based on comic-strip characters, including Popeye, Superman, and Dick Tracy, on which paint was splattered and dripped. During the following year, he rejected expressionist devices of paint handling for the smooth, impersonal finishes he then applied to a broad range of images, including Campbell soup cans, newspaper pages, dance-step diagrams, and multiple images of dollar bills, stamps, and Coca Cola bottles. Examples include *Green Coca-Cola Bottles* (1962, WMAA) and *Campbell's Soup Can* (1965, MOMA). Initially handpainted, these were soon reproduced in quantity by silk-screen techniques. Many were single images; some were done as multiples, in allusion to modern industrial techniques of reproduction. (There are 112 bottles in *Green Coca-Cola Bottles.*) All of these works were based on preexistent images taken from the mass-communications and advertising media. Simultaneously, Warhol made multiple-image paintings from photographs of celebrities and motion-picture stars (*Marilyn Monroe's Lips,* 1962, Hirshhorn Mus.). Some of these images are superimposed as if seen in an unsynchronized film clip. Others, like *Mona Lisa* (1965, MMA), are simply juxtaposed. In many of his silk-screen works, Warhol pursued his interest in painterly processes by varying the intensities and areas of pigment from section to section so that no two faces in a single work had to be identical.

Unlike the paintings of ABSTRACT EXPRESSIONISM, these works conceal the artist's feelings despite the patent interest in process and pigment manipulation. Warhol also disavowed the previous generation's search for myth and archetypes by choosing to work with the most common images of his own time. These he manipulated freely within the limitations of the silk-screen process. Although the images are realistic, they do not suggest bulk and depth, since they are based on reproductions of the originals. Probably influenced by the example of JASPER JOHNS, Warhol set about to employ recognizable subject matter but maintain the integrity of the flat picture surface, an approach keenly admired through the 1950s and 1960s. In some of his multiples of car crashes and baseball players (*Baseball,* 1962, Nelson Gall.), the configuration of forms and colors even allows one to read the surface as an all-over pattern rather than as a display of repeated individual units. Perhaps through these works Warhol was exploring a much larger problem—that of the conflict between immediacy and detachment, of allowing the repetition of an image to dull one's response to it. If so, then these works reflect the concern with alienation common in the 1960s and 1970s. As if to emphasize the ambivalence between emotional and visual responses, Warhol has said that his "image is a statement of the symbols of the harsh, impersonal products and harsh materialistic objects on which America is built. It is a projection of everything that can be bought and sold, the practical but impermanent symbols that sustain us." He has also said that he thinks "everybody should be a machine," and that anybody "should be able to do all my paintings for me." Yet, with the exception of a relatively few works, such as the impersonal soup-can paintings, changing intensities of colors suggest a deeply romantic temperament. Of all Pop artists, he is probably the most paradoxical and the most emotionally susceptible.

In 1964 Warhol turned to sculpture, making boxes painted with the labels of items sold in supermarkets. In 1966 he

exhibited helium-filled balloons. The apparent simplicity of these sculptural forms gave them a family resemblance to the modular and serial works of MINIMAL ART. More important has been Warhol's interest in film, to which he turned in 1963. Initially, the images were largely static, as in the eight-hour film of the Empire State Building (1964), but soon movement and even plot were added, as in *Lonesome Cowboys* (1968). Through the 1970s, he has concentrated on portraits. His book *From A to B and Back Again* appeared in 1975. *Lit.:* John Coplans, *Andy Warhol,* 1970.

WARNER, OLIN LEVI (1844–1896), a sculptor. Born in Suffield, Conn., he went abroad in 1869 and studied at EBA. In Paris he assisted Jean Baptiste Carpeaux on a fountain at the Luxembourg Palace. When Warner returned to America in 1872, he was among the first to bring back the new Beaux-Arts style, which soon replaced the neoclassicism of the mid-century period as the leading sculptural mode. His bust of JULIAN ALDEN WEIR (1880, copies in MMA and the Corcoran Gall.), with its combination of naturalism and idealism couched in a style that takes advantage of the reflecting qualities of bronze, is a good example of the Beaux-Arts style. In the late 1870s, Warner helped popularize the low-relief portrait. During the 1880s, he began to receive commissions for monumental works (*William Lloyd Garrison,* 1885, Boston, Mass.). On a two-year tour of the Northwest Territory, from 1889 to 1891, he made exquisite medallion portraits of many Indian chiefs, now in the collection of MMA (an example is *Joseph, Chief of the Nez Percê,* 1889). Warner also did full-lengths and ideal figures, such as the graceful and refined *Diana* (1887, MMA). The latter is closer to the neoclassical style than are Warner's portraits. After creating works for the WORLD'S COLUMBIAN EXPOSITION in 1893, he began a set of bronze doors for the Library of Congress, but was killed in an accident before completing them.

*Lit.:* W. C. Brownell, "The Sculpture of Olin Warner," *Scribner's Magazine,* Oct., 1896.

WATKINS, CARLETON E. (1829–1916), a photographer of the West. From Oneonta, N.Y., he moved to San Francisco about 1850 and took up photography in 1854. Initially, he worked for Robert H. Vance, a daguerrean photographer. In 1856 Watkins became one of the first to photograph the western landscape in its pristine condition. By 1861 he had established the standard against which other landscape photographers were measured, especially in his mammoth-plate (over a foot by nearly two feet in size) and stereographic views of the Yosemite region. His publication *Yo-Semite Valley* attracted wide interest and thus indirectly led to federal legislation in 1864 to preserve the valley as a state park. He photographed the area during the rest of the decade and in the early 1870s, and from these years about 60 mammoth plates, out of some 115 he made in all, survive. Of his many stereographic photographs of the region, only a relatively few are known to exist. In 1868 he photographed in Oregon and in the Columbia River area; in 1870 in the Cascade Mountains of northern California; in 1873 in Utah; and in 1880 he did studies of southern California missions. Because he lost his early photographs in bankruptcy proceedings, he rephotographed many early views after 1874. Unfortunately, much of his earlier and later work was lost in the San Francisco earthquake and fire of 1906. Always attracted to trees as subjects, Watkins made a number of notable "tree portraits," the most famous of which is probably "Grizzly Giant" (c.1864). These are unusually early photographic essays in pure form. Watkins's early style tended toward the picturesque, but after 1866 he developed a sense of classical restraint evident particularly in his ability to balance large forms and to contrast delicately small masses of trees against enormous mountains. *Lit.: Carleton E. Watkins: Pioneer*

*Photographer,* intro. Richard Rudigill, 1978. Weston J. Naef, *Era of Exploration,* 1975.

**WATKINS, FRANKLIN C.** (b. 1894), a painter born in New York City but associated with Philadelphia. He studied art at PAFA from 1913 to 1918, with brief interruptions, and taught there after 1943 for many years. His personal brand of dramatic realism emerged in the mid-1920s and is characterized by surging diagonals, expressionistic distortions and, despite a brushy facture, insistent wiry outlines. He was catapulted to prominence by winning first prize at the Carnegie International Exhibition in 1931 with *Suicide in Costume* (1931, Philadelphia Mus.), an extravagantly emotional picture of a costumed figure holding a smoking gun. By the late 1930s, Watkins had subdued his emotionalism in a more restrained lyricism (*The Studio,* 1940, AK). After World War II, he began to investigate religious themes (*Angel,* 1948, Detroit Inst.), perhaps to balance his reputation as a portraitist. Some of the religious pieces appear to have been influenced by poet William Blake's paintings. *Lit.:* Andrew Carnduff Ritchie, *Franklin C. Watkins,* exhib. cat., MOMA, 1950.

**WATSON, JOHN** (1685–1768), one of the earliest professional artists working in the New York-New Jersey area. Watson grew up in Edinburgh, Scotland, and in 1714 settled in Perth Amboy, N.J., where he remained, except for a return visit to Scotland in 1730. Despite his relative prominence (which was recalled years later by the artist and historian WILLIAM DUNLAP, who grew up in Perth Amboy), very few paintings can be securely attributed to Watson, despite his longevity. The few oil portraits we have by him are large, monumental images, painted in a broad dramatic style in a simplified, provincial interpretation of late Baroque portraiture as practiced in England by Sir Godfrey Kneller and in Scotland by Sir John Medina, works by both of whom are presumed to have influenced Watson. Despite his strategic position in New Jersey and close to New York City, Watson seems to have had to resort to enterprises in real estate, as a merchant, and as a moneylender, to supplement the proceeds from his painting. Though his oil portraits are few, the New Jersey Hist. Soc. has a large collection of his wash and plumbago (graphite on vellum) drawings, and these are more delicate and sure than his oils. Some of these drawings are portraits, some are of classical and other ideal subjects; the latter may echo the classical pictures he painted on the shutters of his Perth Amboy studio, recalled as an artistic wonder by local inhabitants for many years. *Lit.:* John Hill Morgan, *John Watson: Painter, Merchant, and Capitalist of New Jersey,* 1941.

**WEBER, MAX** (1881–1961), perhaps the most stylistically adventurous of the early modernists. He was a watercolorist, a printmaker, a sculptor, and a poet as well as a painter in oils. From Bialystok, Russia, he settled in Brooklyn, N.Y., in 1891. There, at Pratt Inst., he studied with ARTHUR WESLEY DOW, one of the most innovative art teachers of the time, from 1898 to 1900. From Dow, Weber learned to see forms in terms of visual relationships rather than as objects. Given a sympathetic regard for mystical states of being, the inheritance of his devoutly religious Jewish background, Weber probably found readily comprehensible the strong spiritual components of early 20th-century modernism, as well as its emphasis on abstract forms. Before travelling abroad in 1905, he taught in the public schools of Lynchburg, Va. (from 1901 to 1903), and in the State Normal School, Duluth, Minn. (from 1903 to 1905).

In Paris he studied at the Académie Julian and Académie Colarossi until 1906 and at the Académie de la Grande Chaumière in 1906. He became acquainted with the avant-garde artists Georges Braque and Pablo Picasso and

the primitive painter Henri Rousseau soon after his arrival. In 1907 he helped to organize a class under Henri Matisse's direction. Weber returned to New York City in 1909. During the next several years, he experimented with a variety of modern styles, some of which he could have encountered only after leaving Europe. He was among the first Americans attracted to primitive art—in his case, especially that of the American Indians of the Southwest. In 1910, he helped put together an exhibition of Rousseau's paintings at the LITTLE GALLERIES OF THE PHOTO-SECESSION and was given a solo show there himself in 1911. His one-man show at the Newark Mus. in 1913 was the first accorded to a modern artist in an American museum.

After his return from Europe, Weber first employed a bright Fauve palette and simplified his figures in primitivistic fashion (*The Geraniums*, 1911, MOMA). About 1910 he also began to emphasize solid volumes, as if painting sculptural versions of proto-Cubist forms (*Composition with Three Figures*, 1910, Univ. of North Carolina, Chapel Hill). By 1912 or 1913, he was making Futurist views of New York City (*Rush Hour, New York*, 1915, NGWA). In contrast with the static nudes and amiable landscapes of his Cézannesque-Cubist work, these paintings exulted in the dynamism of modern life. By 1915 Weber had added Synthetic Cubist elements to his repertory of forms (*Seated Woman*, 1917, Brandeis Univ.). His sculptures of this period, also recapitulating the different modern styles, were among the most advanced American works of their time. Weber's contemporary woodcuts, because of their abrupt black-and-white contrasts and angular rhythms, also evoked suggestions of German Expressionism. His *Essays on Art* (1916), a major statement of early modernist aesthetics, described his approach to the creation and the execution of art objects. Filled with references to the interaction of the artist's spirit with that of the work being created, it reflected a broad spectrum of European artistic thought, ranging from

that of Henri Bergson, the French philosopher, to that of Wassily Kandinsky, the Russo-German abstractionist.

About 1919 Weber eliminated the more abstract elements from his art. In a series of multifigure pictures, often of female nudes, he returned to Cézanne in a monumental style in which bulky forms were invested with a solidity not present in his work after 1913. *Composition with Nude Figures* (c. 1923, Vassar Coll.) is an example. These figures also reflected a new mood of melancholy. At the same time, Weber also began to paint Jewish themes, and these formed an important component of his subject matter in later years. About 1930 his figures began to grow insubstantial as the planes defining the parts of the body became caught in linear webs. Weber, who in the 1910s was concerned with the spirituality of matter and in the 1920s with the physical substance of objects, seems to have become interested in human spirituality in the following decades. Perhaps the rise of Nazism also prompted his turn to such subjects as *Students of the Torah* (c. 1940, Phillips Coll.) and *Discourse* (1940, Univ. of Rochester), in which he memorialized a culture then being ruthlessly destroyed. In this phase of his career, the insubstantial but often heavily outlined forms appear as though seen through transparent glass. Weber's personal expressionism, barely controlled early in his career, was now given free rein, and it transformed all of his work, religious and secular.

Though a dedicated modernist, Weber painted some "proletarian" factory scenes during the 1930s. He also served, in 1937, as national chairman of the AMERICAN ARTISTS CONGRESS, the most powerful left-wing artists' organization of the period. Perhaps more than that of any other early modernist, Weber's art reflects the problems faced by Americans whose modernism was an acquired taste. In the absence of a strong native tradition of stylistic experimentation, Weber tried many modernist styles, perhaps losing sight, at times, of his own emotional predispositions and stylistic

preferences. His early work is, therefore, a series of brilliant recapitulations of styles established by others. Not until the 1920s did he begin to paint profoundly of himself, about twenty years after he became a modernist. *Lit.:* Lloyd Goodrich, *Max Weber*, exhib. cat., WMAA, 1949.

WEIR, JOHN FERGUSON (1841–1926), a painter and important teacher. Weir was the son of a professor of drawing at West Point, ROBERT W. WEIR, and brother of the Impressionist painter JULIAN ALDEN WEIR. As such, Weir was overshadowed by both his relatives in his own time and ours. Born at West Point, N.Y., he achieved fame early in his career, in the 1860s, with *The Gun Foundry* (1866, Putnam County Hist. Soc., Cold Spring, N.Y.) and its companion, *Forging the Shaft* (1867, destroyed; replica of 1877 at MMA). These are among the earliest industrial scenes painted in America, and their monumental size and drama of chiaroscuro are in tremendous contrast with the small dynamic figures of workmen shown in cavernous industrial interiors. These paintings gained Weir an international reputation, but he was never again to equal them, either with quiet HUDSON RIVER SCHOOL style landscapes or, later, with Impressionist scenes and still lifes, similar to but more tentative and less sensitive than those of his more famous brother. In any case, Weir's creative artistic efforts were overshadowed by his activities as director of the Yale School of Fine Arts, a post he held between 1869 and 1913. His "official" position in the late 19th-century art world was confirmed when he was chosen to be a commissioner of the art exhibition at the CENTENNIAL EXPOSITION in Philadelphia. *Lit.:* Theodore Sizer, ed., *The Recollections of John Ferguson Weir*, 1957.

WEIR, JULIAN ALDEN (1852–1919), a painter and one of the chief exponents of Impressionism (see IMPRESSIONISM, AMERICAN). Born at West Point, N.Y., he was a son of the drawing teacher and professor at the U.S. Military Acad., ROBERT W.

WEIR, from whom he received his earliest training. In the winter of 1867–68, Weir went to New York City to study at NAD and then in 1873 to Paris. There he began to work with the great French academician Jean-Léon Gérôme; even then, Weir was torn between the demands of drawing, emphasized by his teacher, and his own concern with color. In Paris Weir was particularly impressed by and became close to the French plein-air painter of peasant subjects Jules Bastien-Lepage. In 1875 he exhibited his first major work, *A Brittany Interior* (1875), a dark, dramatic peasant subject, at the Paris Salon.

Weir's reaction to Impressionism, which he encountered in Paris in 1877, was one of revulsion at its lack of drawing and form, and, on meeting JAMES A. M. WHISTLER in London in that year, on his way back to America, he described that master's art as only "commencements." Back in New York, where he settled for good in 1883, Weir participated actively in the Soc. of American Artists while supporting himself painting portraits and teaching. His finest paintings of the 1880s are his still lifes, usually flower paintings featuring roses, with the natural objects often juxtaposed with elegant silver goblets and other bric-a-brac in an exquisite contrast of natural and man-made objects. In the poetry of his still lifes, he was seen as heir to JOHN LA FARGE, and also as an artist in the tradition of the recently "rediscovered" French master Jean–Baptiste Siméon Chardin.

Weir's figure and portrait paintings of this decade remained dark and dramatic, but in 1886 he was struck by the Impressionist paintings on exhibition in New York City and soon thereafter he turned increasingly to landscape painting and the development of a more personal style. He adopted the broken brushwork and heightened colorism of Impressionism; however, his tonal range remained relatively limited, featuring, for instance, a preponderance of different greens and blues rather than a complete range of colors. The paint in his

outdoor scenes was often laid on in broad, "stitchlike" strokes that frequently create an even patterning of texture throughout a canvas.

Many of Weir's paintings were done in and around Windham, Conn., where he had a summer home beginning in 1883. Occasionally, he would incorporate the thread factories of nearby Willimantic into his paintings, finding beauty in modern and industrial subjects as well as in nature. One of his finest and best-known Impressionist paintings is *The Red Bridge* (1895, MMA), where a newly painted vermillion iron bridge is contrasted with a gently tonal, green landscape setting. Weir's figure paintings, however, remained darker and more conservative throughout his career, though here, too, a poetic mood developed and the brushwork gradually loosened.

Weir was early recognized as a knowledgeable force in the modern art world. He was a major advisor to such American collectors as Erwin Davis, encouraging them to buy the works of the controversial modernists Edouard Manet and Gustave Courbet. He was a major figure in the TEN AMERICAN PAINTERS, an Impressionist group formed in 1898. Among his closest artist-friends were JOHN H. TWACHTMAN and ALBERT PINKHAM RYDER. He was one of the artists commissioned to paint murals in the Liberal Arts Building at the WORLD'S COLUMBIAN EXPOSITION and, though he was untried in this area, his were deemed among the most successful. He early supported the organization of the ARMORY SHOW and became president of NAD in 1915. Though his art is quiet and unassuming, Weir was a strong force for progressivism in American art, perhaps more as a personality than as a painter. He was much championed by American writers and critics, above all, by Duncan Phillips. *Lit.:* Dorothy Weir Young, *The Life & Letters of J. Alden Weir,* 1960.

**WEIR, ROBERT W.** (1803–1889), a painter of historical, religious, and genre scenes as well as portraits. His sons, JULIAN ALDEN WEIR and JOHN FERGUSON WEIR were also artists. Born in New York City, Weir was befriended as a youth by the portraitist HENRY INMAN. He studied with Robert Cooke, a British heraldic painter, in 1820 or 1821. At that time, Weir also drew from casts at AAFA. An aspiring history painter, he went to Italy in 1824, one of the first Americans to do so, and studied with Pietro Benvenuti, a Florentine neoclassicist. He returned to America in 1827 and soon after painted a portrait of the Seneca Indian chief Red Jacket (1829, NYHS). In 1834 he began to teach art at the U.S. Military Acad., West Point, where he remained until 1876, and because he lived along the Hudson River, he knew most of the artists who played a significant role in the development of the HUDSON RIVER SCHOOL. In addition to painting scenes from the novels and stories of such writers as Washington Irving, James Fenimore Cooper, and Sir Walter Scott, he completed many history paintings. Christopher Columbus, a favorite figure, was the subject of paintings made in 1823, 1837, 1844, 1858, and 1877 (the third is at West Point). Weir's *Embarkation of the Pilgrims* (1837–43) is among the finer paintings in the U.S. Capitol Rotunda, Washington, D.C. His style varied from a tight, dry realism to a soft, brushy mode (based on the style of Titian, whom he admired). Weir has been considered one of the most representative figures of mid-19th century art because of his connections with literary figures and the range of his subject matter. *Lit.:* William Gerdts, *Robert Weir: Artist and Teacher of West Point,* exhib. cat., West Point Mus., West Point, N.Y. 1976.

**WENGENROTH, STOW** (b. 1906), a lithographer. Born in New York City, but associated with New England, especially with Maine, he studied at ASL and the Grand Central School of Art from 1923 to 1927. He turned to printmaking in 1929 and, during the succeeding decades, created realistic views of harbors,

coves, lighthouses, buildings, and the flora and fauna of the Northeast. Before working on a lithographic stone, Wengenroth makes very precise dry-brush drawings. His style is characterized by velvety but also slightly grainy finishes. His early works, until about 1935, were usually darkly colored and the forms precisely rendered. Through the 1940s, he occasionally indulged in an almost Pre-Raphaelite effusion of woodland detail. At the same time, he printed a tint stone over the black stone to render brilliantly sharp atmospheric effects or dense fog. Although he has made intimate close-ups of birds, he has, especially after 1960, concentrated on capturing the crystalline light of the New England coast as in the style of LUMINISM a century before. A large collection of his work is in the Boston Public Library, Boston, Mass. *Lit.:* Ronald and Joan Stuckey, *The Lithographs of Stow Wengenroth*, 1974.

WERTMÜLLER, ADOLPH-ULRICH (1751–1811), a painter. From Stockholm, he studied sculpture and painting in Sweden and in 1772 went to Paris, where he worked under the neoclassical painter Joseph-Marie Vien and also attended the Académie Royale from 1772 to 1774. He then went with Vien to Rome, where he remained until 1779. He subsequently became first painter to Gustavus III, king of Sweden, for whom he executed his most famous work, *Danaë and the Golden Rain* (1787, National Museet, Stockholm). After travelling in Spain from 1790 to 1794, he came to Philadelphia. He lived again in Europe from 1796 to 1800 but soon came back to Philadelphia, and, in 1803, settled in Delaware. In America he painted many portraits, including one of George Washington, in 1794, but his high prices hindered the progress of his career. Wertmüller's figures had a Rococo grace and delicacy, and his colors tended toward pastel shades. Immaculately finished surfaces were a hallmark of his style. He gained considerable notoriety and a good deal of money when his, then,

quite shockingly nude *Danaë* was put on public exhibition in New York City from 1806 to 1811. *Lit.:* Franklin D. Scott, *Wertmüller*, 1963.

WESSELMANN, TOM (b. 1931), a painter. From Cincinnati, he studied art at the Art Acad. of Cincinnati and at Cooper Union in New York City in the late 1950s. In 1959 he began to make collages, which in style showed the influence of such disparate artists as WILLEM DE KOONING and Henri Matisse. Usually domestic interior scenes, they often included nude females, a subject to which Wesselmann would return with obsessive regularity. In the early 1960s, caught up in the wave of POP ART, he began to compose large multimedia tableaux of similar interiors, some of which included freestanding forms. Female nudes often figured in these, (*Bathtub Nude Number 3*, 1963, Wallraf-Richartz Mus., Cologne). At the same time, Wesselmann also made collages composed of reproductions of packaged foods, reflecting the contemporary interest in food themes manifested by ANDY WARHOL, CLAES OLDENBURG, and WAYNE THIEBAUD. During the mid-1960s and after, Wesselmann concentrated on paintings and reliefs (some in plastic) of nudes as part of a continuing Great American Nude series, in which women are shown as sex objects. He emphasized breasts, mouths, and genitalia, often reducing a body to a few enlarged details. *Lit.:* J. A. Abramson, "Tom Wesselmann and the Gates of Horn," *Arts Magazine*, May, 1966.

WEST, BENJAMIN (1738–1820), a successful expatriate painter, born near Springfield, Pa., who had a profound influence on his colleagues at home. West probably learned the rudiments of painting from WILLIAM WILLIAMS, a portrait painter from Bristol, England, who had settled in Philadelphia in the 1740s. Williams was able to lend to West copies of Charles Alphonse du Fresnoy's *De Arte Graphica* and a book of aesthetic theory by Jonathan Richardson, so the young

American absorbed something of the latest European theoretical writings on art. West visited Italy from 1760 to 1763, stopping at Rome, Florence, Bologna, and Venice. In Rome he was introduced to the circle of Anton Raphael Mengs and Gavin Hamilton, the leading artists among the group of expatriates gathering at the Villa Albani. He was thus imbued with the classical taste that was then prevailing in Europe. It must be stated that West's success abroad was due in part to his being considered a phenomenon from the frontier of the civilized world. Cardinal Albani, who was blind, was particularly taken with him, and decided he must be an American Indian.

In 1763 West set up practice in London as a portrait painter and, though he was not an Indian, played his role as an American exotic to good effect. For the Archbishop of York, West painted *Agrippina Landing at Brundisium with the Ashes of Germanicus* (1768, Yale Univ.), which was exhibited to wide acclaim and brought a royal commission, the first in a long and profitable association with the Crown. The picture shows the bereft widow at the center carrying an urn with the remains of her heroic spouse. The central, friezelike group was derived from the Ara Pacis. West here demonstrated the knowledge of antique art and literature that was deemed essential for a history painter of that day.

In 1771 West brought about what has been called a revolution in history painting. His *Death of Wolfe* (1770, versions in Royal Coll., London, and National Gall. of Canada, Ottawa), showed General Wolfe, killed at the battle of Quebec, surrounded by grieving soldiers and an Indian, all in the clothing they might actually have worn. Against all academic tradition, and the advice of Sir Joshua Reynolds and the king, West had painted a history picture in modern dress instead of classical garb. While this was not the first such attempt, it was the most dramatically successful and led the way to such "modern history" pieces as Copley's *Death of the Earl of Chatham*

(1779–80) and Jacques Louis David's *Death of Marat* (1793) and *The Tennis Court Oath* (1794). The painting, for all the furor it caused, is actually quite a conventional Baroque composition, with Wolfe at the center in a Christlike pose borrowed from Anthony Van Dyck. The groups of mourners, few of whom had actually been present at the scene, display the range of "passions" as prescribed by the French academician Charles Lebrun in the previous century.

West was not, by nature, a revolutionary spirit but as an American he was perhaps more disposed than his European contemporaries to break with an academic tradition that was not, after all, his own. Furthermore, as an American, he was more likely to get away with it. As an impartial observer, West was shrewd enough to perceive a nationalistic spirit in England and had good reason to believe that the celebration of a military victory would be well received by the public. The sale of the engravings of *The Death of Wolfe* brought the publisher the astonishing sum of fifteen thousand pounds. West may also have noticed that when the English history plays of Shakespeare were produced they were now, in this nationalistic vein, beginning to be given in accurate period costume, as is shown by William Hogarth's portrait of Garrick as Richard III. What is often forgotten in discussing the historical importance of *The Death of Wolfe* is that it is quite a satisfying painting and may well represent the apex of West's art.

In the wake of this success, West was commissioned by King George III to do two more heroic death scenes, one Greek, one medieval; the subjects, chosen by West, were depicted in appropriate historical garb. In this same busy period West produced one of his most popular works, *William Penn's Treaty with the Indians* (1772, PAFA), another historical subject from the exotic New World that was bound to please London society. Some of the figures, including the Indians and rustic American types, were derived from Raphael's Vatican

Stanze frescoes, while the circular composition of the central group was taken from Masaccio's *Tribute Money*, which displayed the sort of "learning" advocated by Reynolds in his *Discourses*.

In his early years, West was content to produce history pictures on the modest scale of Nicolas Poussin, but increasingly his works were grand in scale and grandiose in treatment. *Saul and the Witch of Endor* (1777, WA), with its eerie light and bizarre figures, seems to reflect both the influence of Edmund Burke's writings on the Sublime and the art of Henry Fuseli, James Barry, and others who were then working in a romantic mode. *Death on a Pale Horse* (1787, PAFA), which West painted in several versions between 1787 and 1817, with its grotesque subject and swirling movement is a fully operatic example of the artist's late, very romantic, style.

West was a charter member of the Royal Acad. and became its second president, succeeding Sir Joshua Reynolds in 1792. Like all presidents, West had severe critics then, and has had ever since. To his wittier contemporaries Fuseli, Barry, and Blake, he was an object of ridicule; Byron called him a "flattering, feeble dotard." A modern critic has suggested that the simpleminded George III found in him a kindred spirit. It must be admitted that West was not an imaginative artist but persisted in a proven formula. He had little sense of color and less feeling for the texture of paint. However, his place in the history of art is secure. The example of his career and that of his compatriot JOHN SINGLETON COPLEY attracted numerous American artists to Europe after the War of Independence, many of whom passed through West's studio in London, receiving their first sophisticated training from him, as well as a highly serious and ambitious view of the mission and purposes of art. *Lit.:* Robert C. Alberts, *Benjamin West*, 1978.

**WESTERMANN, H(ORACE) C(LIFFORD), JR.** (b. 1922), a sculptor. From Los Angeles, he turned to art in the mid-1950s, when he was studying at AIC. His first independent efforts date from 1955. His works resemble those of the so-called Chicago Monster School, with large, ungainly human forms, as in the paintings of LEON GOLUB, as well as, more remotely, of the Surrealists. His images are often taken from the American vernacular. An excellent craftsman, Westermann often brings together disparate forms or, as in *Memorial to the Idea of Man If He Was an Idea* (1958), ludicrously transforms familiar ones. In *Memorial to the Idea*, a human body has become a vertical, locked box surmounted by another vertical box, dominated by a cyclopean eye. The severity of his surfaces and the preciseness of his outlines link Westermann both with primitive artists, with whom he shares an antic inclination to juxtapose odd images and forms, as well as with the Minimalists of the 1960s, with whom he shares a rigorous formalism. Laminated wood is his favored medium. *Lit.:* Max Kozloff, *H. C. Westermann*, exhib. cat., LACMA, 1968.

**WESTON, EDWARD** (1886–1958), a photographer known for his extremely clear and detailed pictures of natural forms. Born in Highland Park, Ill., he began his career as an itinerant photographer in California. In 1911 he opened a portrait studio in Glendale, where he also made pictorial photographs for local exhibitions. In the early 1920s, he turned to sharp-focus realism and became the most adamant supporter of "straight" photography (see ALFRED STIEGLITZ). Feeling that the camera's primary ability to record visual facts should not be interfered with, Weston made only contact prints from 8-by-10-inch negatives, which he did not tamper with in any way. The restriction made the creative act of "previsualizing" the final image before exposure of the utmost importance. Weston followed through at every stage of the development process with an unfailing technical perfection. He used the smallest aperture (f.64) to achieve extreme detail throughout the entire depth of the picture, whether it was a

nude, a landscape, or a still life, believing that only perfect clarity could reveal "the life force of the form."

While in Mexico from 1923 to 1926, Weston photographed nudes, clouds, and even occasional industrial forms that are reminiscent of PAUL STRAND'S and CHARLES SHEELER'S work. His best-known pictures were taken about 1930: a series of pristine close-up images of nautilus shells and vegetables that includes his famous "Pepper No. 30." In the late 1930s, he repeatedly recorded the white dunes at Oceano, Calif., with an extraordinarily heightened sense of texture and form. In 1932 he helped found the F.64 GROUP and in 1937 was the first photographer to receive a Guggenheim Fellowship, one result of which was his book *California and the West* (1940). Weston's last photographs were made in 1948 on Point Lobos, a coastal area of eroded rock rich in unusual forms. Good collections of his work are in MOMA and GEH. *Lit.*: N. Newhall, *The Photographs of Edward Weston*, 1946.

WHISTLER, JAMES ABBOTT MCNEILL (1834–1903), among the most influential of the 19th-century painters. Whistler was born in Lowell, Mass., and was raised partly in New England and partly in Russia, where his father, an engineer, was involved in railroad construction. After his father's death in 1849, the family returned to the United States where, in 1851, Whistler entered the U.S. Military Acad. at West Point. An inability to do chemistry, he said later, put an end to his military career after three years. At West Point, he made illustrations for student publications and afterward worked in the U.S. Coast and Geodetic Survey as a surveyor and cartographer, receiving valuable training in drawing and etching.

In 1855, decided upon an artistic career, Whistler sailed for Europe never to return. In Paris he studied briefly with the academician Charles-Gabriel Gleyre, but soon the gregarious American found his way into bohemian circles. Whistler's flamboyant manner and ready wit made

him an accepted denizen of the cafes. With the painters Henri Fantin-Latour and Alphonse Legros he formed a "society of three." He knew the painters Gustave Courbet, Edouard Manet and Edgar Degas—the only man whose wit intimidated Whistler—and such poets and critics as Charles Baudelaire, Théophile Gautier, and Stéphane Mallarmé. In short, Whistler had stumbled into the avant-garde of European art.

Whistler first demonstrated his skill in *At the Piano* (1859, Taft Mus.), a work owing much to the realist spirit of Fantin-Latour and Degas. But Whistler was not a realist, and his first declaration of intellectual independence, *Symphony in White No. 1: The White Girl* (1862, NGW), made a spectacular appearance at the notorious Salon des Refusés in 1863. The most startling feature of this full-length portrait of the artist's Irish mistress, Joanna Heffernan, was its subtly orchestrated tonal variations, deriving perhaps from the portraits of Diego Velázquez, which greatly attracted the artist—as they did Manet—at this time. Although the musical part of the title was added later, some critics found the work an enigmatic one. In England, where Whistler had settled in 1859, it was associated with Wilkie Collins's mystery novel *The Woman in White*, while the French critic Jules-Antoine Castagnary concocted an elaborate allegory of the "morning after the wedding night" and compared the picture to Jean Baptiste Greuze's *La Cruche Cassée*. In fact, the wistful figure of the girl is close in spirit to the dreamy, asexual heroines of Pre-Raphaelite portraiture and undoubtedly owes something to the influence of Dante Gabriel Rossetti and his followers. Courbet called the work "an apparition" and so it remains to this day, among the most intriguing portraits of the century.

Whistler moved to London perhaps to avoid the stiffer competition in Paris or because he could not share the realist interests of his French contemporaries, but he crossed the Channel often and maintained close ties with the Parisian artistic community. He believed devoutly in the

*l'art pour l'art* credo of Gautier and the other French writers. This most French of notions was not likely to sit well with the English, who believed the only justification for art was a moral purpose. It was inevitable that the brash young painter would come in conflict with the greatest of all moral apologists for art, John Ruskin. In 1877 Whistler exhibited his *Nocturne in Black and Gold: The Falling Rocket* (1874, Detroit Inst.), deliberately choosing a musical title—used earlier by Chopin and later by Fauré and Debussy—to remove the work from any possible narrative context. With its varying tones of blue and black and bright touches of gold and white, the picture is possibly the most abstract one painted up to that time. Whistler's technique was singular: He mixed the tones to be used in a watery "sauce," a preparatory step that often took longer than the application of the paint to the canvas. Then the picture was laid flat to dry, and as the paint saturated the canvas it created a woven, tapestried effect. Ruskin, in his publication *Fors Clavigera*, accused Whistler of "cockney impudence" and of "asking two hundred guineas for flinging a pot of paint in the public's face." Whistler sued him for damages, and the issue came to trial in 1878. Whistler thus joined the select company that included Paolo Veronese and Francisco de Goya, of artists who were obliged to defend their works in a court of law. The artist was brilliant throughout the ludicrous proceedings as his methods were placed before public scrutiny. When the opposing attorney taunted him for asking so much money for the work of a few hours, Whistler countered with his famous riposte, "I ask it for the knowledge of a lifetime." But the British would only pay for labor. Whistler was awarded a farthing, which left him financially broken and much embittered. The affair ended tragically for Ruskin as well. The great critic who had recognized the imaginative elements in Joseph M. W. Turner's landscapes could not see them in Whistler's. He suffered one of his periodic mental breakdowns and never fully recovered. Worst of all, the development of art in England was virtually frozen until the end of the century.

Despite this setback, Whistler gained a large measure of renown. His *Arrangement in Grey and Black No. 1: The Artist's Mother* (1872, Louvre Mus. Paris), was sought and finally acquired by the Louvre, and he was made a *Chevalier de la Légion d'honneur*, a rare honor for a foreigner. He remained extraordinarily receptive to a range of stylistic influences. Although he rejected Impressionism, he shared with that school an interest in Japanese art (to which he was introduced in the early 1860s), as is apparent in *Symphony in White No. 2: The Little White Girl*, part of his decoration for the Peacock Room (1876–77, Freer Gall. of Art, Washington, D.C.) to hold the Oriental porcelains of his friend Frederick R. Leyland. These designs also anticipate the Symbolists and Art Nouveau. He also shared with Pierre Puvis de Chavannes and the English academicians an interest in late Hellenism, inspired by the Tanagra statuettes unearthed in 1870.

After receiving a commission for a series of etchings, Whistler left for Venice in 1879. Thereafter, he turned more and more frequently to the graphic media and to pastel and watercolor. The studies in these media of streets and harbors he made during extended travels in Europe and North Africa embody all the refinements of tone and nuances of effect he sought. Many of these are monotypes or poissards (small wood panels). Most notable are his etchings, among the most skillful and sensitive ever made, where a few strokes describe a cityscape or ships at a dock, and blank paper stands for light and atmosphere. Whistler was a most literate artist, as his "Ten O'Clock" lecture and his book *The Gentle Art of Making Enemies* (1890) amply illustrate. His work had a powerful impact on generations of artists in America and Europe (see TONALISM). He died, his dandified pose and combative character intact. *Lit.:* Denys Sutton, *James*

*McNeill Whistler: Paintings, Etchings, Pastels, and Watercolours,* 1966.

WHITE, CLARENCE H. (1871–1925). See PHOTO-SECESSION.

WHITE, JOHN (active 1570s–1593), an English artist and watercolorist. Very little is known about White's life before his association with the expeditions to Roanoke colony in Virginia in the 1580s. He may have accompanied Sir Martin Frobisher to Canada in 1577 and Philip Amadas and Arthur Barlowe to the Carolina Outer Banks in 1584, working as a recording artist. In 1585 he travelled to Virginia with a group sponsored by Sir Walter Raleigh to explore the possibility of English settlement at Roanoke. White recorded the flora, fauna, and inhabitants of the area in careful watercolor drawings, while an observer, Thomas Hariot, took detailed notes. The party returned to England in 1586. White's drawings and enthusiasm for permanent settlement prompted Raleigh to name him governor and principal agent for the enterprise. In 1587 the artist and a group of settlers, including White's daughter and her husband, the future parents of Virginia Dare, the first English child born in America, sailed to Virginia. Later that year White was obliged to return to England to secure additional supplies for the settlement. Because of England's war with Spain, White was unable to return to Roanoke until 1590, when he could find no trace of his family or the rest of what became known as the "Lost Colony." White chronicled his efforts to locate the group in a letter of 1593 written in Ireland; nothing of his later life is known.

Twenty-three of White's watercolors of 1585–86 were engraved by Théodore de Bry as illustrations for his *America* (1590). The original, larger, set owned by the British Mus., consists in large part of drawings of Indians, reptiles, fish, birds, and some plants. The absence of mammals and the scarcity of plants has led to speculation as to the completeness of the set. In his role as the expedition's recording artist, White sought to document the natural forms of previously unexplored regions in a precise and scientific manner. Although he did not understand perspective and did employ a number of recognized conventions in his work, his watercolors seem quite free in approach to subject matter and technique when compared with the few similar surviving works of the period. *Lit.:* Paul Hulton and David Beers Quinn, *The American Drawings of John White,* 1964.

WHITE, MINOR (1908–1976), a photographer, and editor of *Aperture* from 1952 to 1976. Born in Minneapolis, Minn., White received a B.S. degree in botany from the Univ. of Minnesota in 1933. He became seriously interested in photography in 1937 but did not receive real encouragement until he met ALFRED STIEGLITZ after World War II. Beaumont and Nancy Newhall—curators of photography and critics—urged him to undertake graduate work at Columbia Univ. in art history and aesthetics, and this study enlarged his approach to the medium. While in San Francisco teaching at CSFA (from 1946 to 1952), he came under the influence of EDWARD WESTON and ANSEL ADAMS, who helped him achieve a mastery of photographic techniques. In 1952 he became curator of photography at GEH and founded, with the Newhalls and DOROTHEA LANGE, *Aperture,* a serious magazine devoted to photography and criticism. From 1955 to 1964, he lectured on photography at the Rochester Inst. of Technology, and continued to organize shows at GEH. He became professor of photography at M.I.T. in 1965, retiring in 1974.

In his own photography, White embraced the idea of "equivalence" expressed in Stieglitz's late work. He wanted to bring the magical impulses of the origins of art to photography. He concentrated on close-ups of natural objects, which are usually ambiguous in terms of space and form and suggest metaphorical meanings. He advocated "reading" photographs for such content to enrich

the experience of looking. White was as creative, on a larger scale, in his group shows, and these are as important as his own photography. Assembling works by many photographers, he would create a new context in which to view them, suggesting through juxtapositions mystical meanings often foreign to the photographers' original intent. Such shows as Sequence 13: Return to the Bud (GEH, 1959), Light[7] (M.I.T., 1968), and Celebrations (M.I.T., 1974) may therefore be seen as large-scale metaphorical works by White rather than as exhibitions on a theme. Collections of his work are in MOMA and GEH. *Lit.:* Minor White, *Mirrors, Messages, Manifestations,* 1969.

**WHITE MARMOREAN FLOCK,** an epithet coined by Henry James in his essay of 1903 *William Wetmore Story and His Friends* to describe a group of women sculptors who settled in Rome in the 1850s and 1860s ("that strange sisterhood of American 'lady sculptors' who at one time settled upon the Seven Hills in a white marmorean flock"). Their years of greatest activity extended through the 1870s, after which their cool, restrained style (see NEOCLASSICAL SCULPTURE) was supplanted by newer modes emanating from Paris, in which a dexterous naturalism was emphasized. Their moment of greatest popularity was perhaps reached in 1876, when several of them exhibited works in the CENTENNIAL EXPOSITION in Philadelphia. These artists' work was highly esteemed and, in concept and scale, did not differ from that of their male colleagues. They, too, executed heroic, full-length statues of national heroes and allegorical and ideal figures as well as traditional portrait busts and medallions. The first American woman who is known to have gone to Rome and worked as a sculptor was Sarah Fisher Ames, now remembered for her portraits. She was followed in 1852 by HARRIET HOSMER, probably the most famous of all, whose small sculptural conceit *Puck* (1856, NCFA) was often replicated. Louisa Lander made her appearance

in the Italian capital in 1855. EMMA STEBBINS, best known for her *Angel of the Waters* (1862), part of New York City's Bethesda Fountain in Central Park, arrived in 1857. This first wave was followed by a second, including MARGARET FOLEY about 1860, Florence Freeman in 1861, and ANNE WHITNEY in 1867. EDMONIA LEWIS, half Chippewa Indian and half black, whose ethnic background is felt in such works as *Forever Free* (1867, Howard Univ.), may have arrived the same year. VINNIE REAM, who is known for her standing *Lincoln* (1866–71) in the Rotunda of the U. S. Capitol, was a late arrival, settling in Rome only in 1870. Many of these women, including Hosmer, Stebbins, and Lewis, were closely associated with the actress Charlotte Cushman and her expatriate circle in Rome. *Lit.:* William H. Gerdts, Jr., *The White Marmorean Flock,* exhib. cat., Vassar Coll., 1972.

**WHITE MOUNTAIN SCHOOL,** not a true school but a loose grouping of artists who preferred to paint or painted a number of significant and characteristic pictures in New Hampshire's White Mountains during the second half of the 19th century. Like the Hudson River Valley before it and the Rockies afterward, the untamed, epic grandeur of the scenery served as a source of inspiration for many of the most prominent landscape painters of the mid-19th century. Interestingly, one of the earliest artists to paint there was the founder of the HUDSON RIVER SCHOOL, THOMAS COLE. Proof of the impact these awesome vistas had on his work is *A View of the White Mountains* (1827, WA), in which a lone figure, surrounded by the heavily forested peaks, stands awestruck by nature's splendor. In the 1850s, BENJAMIN CHAMPNEY visited the area for the first time, and he returned to paint in the North Conway region during the summers for more than fifty years. He is the artist most often identified with the region. Champney delighted in pastoral and picturesque views, as is evident in his *Saco River: North Conway* (New Hampshire

Hist. Soc., Durham), a painting that seems to owe a great deal to the mid-19th-century group of French landscape artists called the Barbizon School after the little town that was the center of their activities (see BARBIZON, AMERICAN). In fact, the White Mountain colony was often referred to as an "American Barbizon" since many of Champney's Boston colleagues joined him there in the summers, as did the Hudson River School artists JOHN F. KENSETT and JOHN W. CASILEAR. Kensett, in *An October Day in the White Mountains* (1854, Cleveland Mus.), depicted the mist-shrouded mountains of New Hampshire in a manner that anticipates his later Luminist paintings. Casilear, a New York-based artist, persuaded many painters of that state to come to New Hampshire, including his teacher ASHER B. DURAND. Like Cole before him, Durand sought to re-create the towering grandeur of the mountains in works such as *Franconia Notch* (1855, NYHS). The mountains also figured in the work of ALBERT BIERSTADT and JASPER F. CROPSEY. The latter painted a spacious, romantic vista called *Indian Summer Morning in the White Mountains* (1857, Currier Gall. of Art, Manchester, N.H.), in the gold and crimson colors of autumn to which he was so partial. For many artists, the White Mountains were a place to visit rather than live. During the 1850s, the views they chose most often emphasized the mountains' awesome majesty; later artists like Champney were inspired to paint the region's more tranquil aspects. *Lit.:* *A Century of Art in the White Mountains*, exhib. cat., North Conway Library Assoc., 1965.

**WHITNEY, ANNE** (1821–1915), a sculptor. Born in Waterloo, Mass., she received little formal training, studying only briefly with WILLIAM RIMMER in 1862. Whitney joined the colony of American artists in Rome in 1867 (see WHITE MARMOREAN FLOCK). Her major works date from about 1870. Her reputation was made abroad with such neoclassical works as the *Lotus Eater* (plaster copy in Newark

Mus.). At the time of her return to America in 1871, she was considered a leading New England sculptor of portraits and ideal groups. She was commissioned in 1873 to complete a full-length portrait of Samuel Adams for the U.S. Capitol in Washington, D.C. The Adams portrait shows a rejection of the neoclassical style in a combination of naturalism and monumentality that can also be seen in Whitney's seated figure of William Lloyd Garrison (1880, Smith Coll.). Other works by Whitney include *Le Modèle* (1875, MFAB), an impressionistically rendered bronze bust of a dozing woman, and a bronze statue of Charles Sumner (1900, Harvard Univ.). The portrait of Sumner was Whitney's last major work. *Lit.:* E. P. Payne, "Anne Whitney, Sculptor," *Art Quarterly*, Autumn, 1962.

**WHITTREDGE, THOMAS WORTHINGTON** (1820–1910), a landscape painter. Born near Springfield, Ohio, he lived in Cincinnati, for the most part, from 1837 to 1849, working as a house and sign painter, a daguerreotypist, a portraitist, and finally a landscapist. He departed for Europe in 1849 and, after visiting London, the Low Countries, and Paris, settled in Düsseldorf, Germany, living for a year in the house of the artist Andreas Achenbach. Whittredge moved to Rome in 1855 and returned to America in 1859, making his home in New York City. He travelled to the West in 1866, 1870, and 1877 and to Mexico in 1893 and 1896. Although he worked primarily in oils, he made several watercolors late in his career. His autobiography was published in 1905.

Whittredge's early works painted in America (*The Hawk's Nest*, 1848, Cincinnati Mus.) glorify nature's majesty in emotional and painterly terms in the romantic manner of THOMAS COLE. He is known for the fine detail of his landscapes, a trait already apparent in his early *View of Cincinnati* (c. 1845, Worcester Mus.), as well as his feathery treatment of branches and leaves, a technique acquired abroad (*Old Hunting Ground*, Reynolda House, Winston-Sa-

lem, N.C.). While in Düsseldorf, he developed further his meticulous technique and acquired an interest in irregular landscape forms that also characterized the work of contemporary German artists. After returning home, he renounced his European stylisms, depicting America's virgin forests and streams in quiet, gentle paintings that tended to broadness and openness. But even though he became an important member of the HUDSON RIVER SCHOOL, he brought to his landscapes and seascapes a precision, compositional balance, and tonal harmony that set off his work from that of his peers. His western scenes, such as *On the Plains, Colorado* (1877, St. Johnsbury Athenaeum, St. Johnsbury, Vt.), are characterized by a crisp handling of both foreground details and distant mountain ranges that, nevertheless, succeeds in conveying the vast spaces of those regions. Late in his career, about 1885, his style softened, and a developing interest in golden, flickering light suggests a more advanced aesthetic not unrelated to the growing French Barbizon influence in America (see BARBIZON, AMERICAN). These works *(Millburn, New Jersey*, Newark Mus.) are also more intimate in scale. *Lit.:* "The Autobiography of Worthington Whittredge, 1820–1910," ed. John I. H. Baur, *Brooklyn Museum Journal*, 1942 (reprint, 1969).

WILLIAMS, MICAH (active c. 1810–c. 1830), a portraitist. This little-known folk artist worked primarily in the Monmouth and Middlesex counties of New Jersey. About sixty portraits, mostly in pastel, have been associated with his name, and they date from 1814 to 1827. In most, the background is keyed to the color of the sitter's eyes. Hands are often stiffly folded across the lap or chest, and the hair of male subjects usually rises to a triangular peak. The neutral backgrounds serve as a foil for the delicately lined eyes, which give the sitters an alertness that their simply modelled features and slightly grim expressions do not prepare one for. A characteristic example is *John G. Vanderveer* (Abby Aldrich Rockefeller Folk Art Collection, Williamsburg, Va.). *Lit.:* Irwin F. Cortelyou, "A Mysterious Pastellist Identified," *Antiques*, Aug., 1954.

WILLIAMS, WILLIAM (1727–1791), a painter and author, who had a varied career in England and America. Born in Bristol, England, Williams, the son of a sailor, was apprenticed as a seaman. Although it is not known where he received his artistic training, he appeared in Philadelphia about 1747, and there he is thought to have been the first teacher of BENJAMIN WEST. He also worked in New York and, in the West Indies, in Jamaica.

Williams's style was a lively, personal version of the English Rococo, as also practiced in America by JOHN WOLLASTON and JOSEPH BLACKBURN. His *Conversation Piece* (1775, Winterthur Mus., Winterthur, Del.) shows a man and woman stiffly posed in a park setting that is almost theatrical in its artificiality. In addition to many portraits, Williams produced such stylized works as *Woman with a Book* (1767, Deerfield Acad., Deerfield, Mass.), showing an Old Testament Sibyl in vaguely Oriental costume in a rocky landscape, with the tower of a synagogue in the background. A companion piece, *Woman with Hour Glass and Skull* (1767), is a traditional Penitent Magdalen. Another rarity among his works is *Imaginary Landscape* (1772, Newark Mus.) with ships off a rocky coast dominated by a castle, reminiscent of the early efforts of Benjamin West. Although Williams spent thirty years in America, only about a dozen works are securely attributed to him. He also wrote a novel about seafaring. He died in his birthplace, Bristol. *Lit.:* William Gerdts, "William Williams: New American Discoveries," *Winterthur Portfolio* 4, 1968.

WIMAR, CHARLES (1828–1862), a painter of frontier subjects. Born Karl Wimar in Siegburg, Germany, he was brought in 1843 to St. Louis, Mo., where he grew up

and made many Indian friends. He studied from about 1846 to about 1850 with Leon de Pomarede, an artist-decorator, who encouraged him to paint Indian and western scenes. After receiving further training from 1852 to 1856 in Düsseldorf, Germany, where he worked under EMANUEL GOTTLIEB LEUTZE, Wimar settled in St. Louis. In the late 1850s, he journeyed several times up the Missouri River in search of interesting subject matter. Abroad, he had favored the tight, linear Düsseldorf style (*Indians Pursued by American Dragoons*, 1853, Noonday Club, St. Louis); in later works, however, Wimar softened his technique and adopted a panoramic viewpoint when appropriate, as in the wide-focus *Indians Approaching Fort Benton* (1859, Washington Univ., St. Louis). Wimar's scrupulous concern for correct detail extended to a variety of themes. He portrayed hunting and war scenes as well as Indian ceremonies and buffalo—grazing, resting, and migrating. He photographed many Indians as well. About fifty of his finished works have been identified, and of these seventeen were made abroad. Four of his American sketchbooks have been preserved. His murals for the dome of the old St. Louis Courthouse, completed in 1861, have been largely destroyed.

WINSTANLEY, WILLIAM (active c. 1793–after 1806), a landscape painter and portraitist. He came to the United States from England before April, 1793. At that time, he is known to have sold two Hudson River views to President Washington. These works, *Morning, Hudson River* and *Evening, Hudson River* (both 1792–93, Mount Vernon Ladies' Assoc., Mount Vernon, Va.) are carefully balanced compositions with the hazy light of the landscape style ultimately derived from Claude Lorrain and practiced in England by Richard Wilson.

Winstanley next visited the newly established District of Columbia, where he painted several views of the Potomac River. Two of these were also bought by the president. At this time he produced *Genesee Falls, New York* and *Grotto Scene by Moonlight* (both 1792–93, Smithsonian Institution, Washington, D.C.). The latter is in a more picturesque manner perhaps inspired by the Neapolitan grotto scenes of the English artist Joseph Wright of Derby.

For some years, Winstanley was based in New York City, where he exhibited PANORAMAS of London and Charleston, S.C. He also painted portraits and made copies of a portrait of Washington by GILBERT STUART, which, according to some sources, he tried to sell as originals. A portrait now in the White House is thought to be one of these copies.

Winstanley published a play, *The Hypocrite Unmask't*, in 1801 and is last recorded in America in a notice in a Boston, Mass., newspaper of that year. Nothing is known of his later career except that he returned to London, where he exhibited landscapes at the British Institution in 1806. *Lit.:* Jacob Hall Pleasants, *Four Late Eighteenth Century Anglo-American Landscape Painters*, 1970 (reprint).

WOLLASTON, JOHN (active c. 1734–1767), one of the most prolific painters of colonial America (about 300 American portraits by him survive). Probably from London, the son of a British painter of the same name, Wollaston was making portraits in England as early as 1734 (series in the Bodleian Library, Oxford). We know more about his life abroad than we do of the pre-American careers of most British artists who visited colonial America. His early *George Whitefield Preaching* (1742) is an interesting picture in that it is a portrait with genre overtones—the congregation grouped below the famous Methodist minister reacts to his oration. Wollaston was active in New York City from 1749 to 1752—the first significant painter to reside there—but his style had already been formed in England by 1744. He, like JOSEPH BLACKBURN, was a "drapery painter," relying on formulas for poses and expressions and emphasizing the shimmer of satin and silk, pretty colors,

and attractive accessories. His male figures are large and ruddy-complexioned, often with a disturbing unnatural tilt to the head and body and a complacent smile. His women are prim and upright and are often dressed in identical outfits, even to a double-pointed mobcap enframing the head. The features of men and women are also very similar, and almost all have the almond-shaped eyes for which Wollaston was well known. Though—perhaps because—he relied so heavily upon formulas, Wollaston was extremely successful; his emphasis upon stylish Rococo costume must have added to the appeal. He travelled through colonial America from New York City south, working in Maryland (1753–54) and in Virginia (1755–57). Then he probably returned to England, before going to the West Indies and then visiting Charleston, S.C., in 1767, after which he went home to England and obscurity. (Some confusion exists, however, between Wollaston and an artist of the same name who spent some time in India, and the facts of his life are by no means unquestioned.) Wollaston's style does not seem to have changed appreciably during his American years, though his Maryland and Virginia canvases are nearly all large three-quarter-length portraits, often featuring an outdoor setting. Wollaston's ability to attract commissions may account for his strong influence upon a number of young American painters, including BENJAMIN WEST and JOHN HESSELIUS. *Lit.:* George C. Groce, "John Wollaston: A Cosmopolitan Painter in the British Colonies," *Art Quarterly*, Summer, 1952.

**WOOD, GRANT** (1892–1942), a painter. Wood was born in Anamosa, Iowa, and grew up in Cedar Rapids. Associated with AMERICAN SCENE PAINTING, he was largely self-taught. In the summers of 1910 and 1911, he attended the Minneapolis School of Design and Handicraft and Normal Art, studying under Ernest Batchelder, a leading advocate of the English Arts and Crafts movement. There followed short periods of study at

Iowa State Univ. and AIC. Wood travelled abroad in 1920, 1923, 1926, and 1928, enrolling at the Académie Julian, in Paris, in 1923. In 1932 he cofounded and taught at the Stone City Art Colony and Art School. During the Depression (1933–34), he was named director of the Public Works of Art Project in Iowa and, in the same period, became an Associate Professor of Fine Arts at the Univ. of Iowa.

Wood's work can be divided into two major periods. The first consists largely of views of Cedar Rapids, landscapes, oil sketches of European scenery, some portraits, and a few public commissions executed in a vaguely impressionistic yet traditionally picturesque style. The major turning point in his career occurred in 1928, when Wood travelled to Munich to supervise the final stages of the execution of a stained-glass window for the Cedar Rapids Veterans Memorial Building commissioned by the Daughters of the American Revolution. Immediately after this trip, Wood turned to ordinary subjects, which he treated in a highly polished, realistic style. The impulse behind this new departure possibly came from Late Gothic and Northern Renaissance art as well as the severe and austere "new objectivity" of the contemporary painting Wood saw in Munich. *American Gothic* (1930, AIC), Wood's first masterpiece, also included a measure of satire and caricature mixed with his own brand of midwestern regionalism. In the same year, Wood also produced his first major landscape painting, *Stone City* (1930, Joslyn Art Mus., Omaha, Nebr.), revealing a new, open sweep of countryside and exaggerated elevation not found in his landscape panels of the 1920s. His landscapes of the 1930s often combine a homey innocence with a fantasy of forms that takes the viewer into another world, where, for example, Paul Revere rides a rocking horse over a road out of a dream in *The Midnight Ride of Paul Revere* (1931, MMA).

Wood's most controversial paintings reflect his ability to transform his feelings about social standards and provin-

cial complacency into an effective form of satire. Offended by a local D.A.R. chapter that had denounced his having his Cedar Rapids war memorial window executed in Germany, Wood retaliated by creating *Daughters of Revolution* (1932, Cincinnati Mus.). In this work, he portrayed three conceited old women before EMANUEL GOTTLIEB LEUTZE's picture *Washington Crossing the Delaware* (1851), presumably to emphasize the snobbery, insincerity, and closed-mindedness of the membership of that organization.

His satire could also take a good-natured and comic turn, as it did in one of his last major paintings, *Parson Weem's Fable* (1939, Amon Carter Mus.), an insight into sentimental American folklore. The largest single collection of Wood's work belongs to the Cedar Rapids Art Center. *Lit.*: James Dennis, *Grant Wood: A Study in American Art and Culture*, 1975.

**WOOD, THOMAS WATERMAN** (1823–1903), a genre specialist. From Montpelier, Vt., he studied in Boston, Mass., with CHESTER HARDING before moving in 1852 to New York City, where he worked as a portraitist. He also lived in Quebec, Canada, and Washington, D.C., before settling briefly in Baltimore, where he began to paint genre scenes. He travelled abroad from 1859 to 1861 and, during the Civil War, through the American South, where he painted several pictures with war themes. He settled permanently in New York City in 1867. Although he was a sensitive portraitist, his fame nevertheless rests upon his sharply detailed, anecdotal genre paintings. A number of these contain the single figures of picturesque blacks, sympathetically rendered and brightly colored. His most ambitious works are *Yankee Peddler* (1872) and *The Village Post Office* (1873, New York State Hist. Assoc.). These are among the most traditional of all subjects in American genre painting; in fact, Wood's work was more characteristic in style and subject matter of the mid-century than of his own period. His

pictures, which describe a rural way of life fast disappearing, often contain many figures of all ages, happily content. Yet, a certain nostalgia crept in: Whereas the Yankee peddlers of mid-century genre were young, vigorous hucksters, Wood's is an elderly man who would have known those "better days." His finest paintings are quite restrained and, though never satirical, are usually free of sentimentality; a certain cloying emotionality, however, does affect his later work. Wood was a much respected artist in his time and became president of NAD. A gallery devoted to his work is in his native Montpelier.

**WOODRUFF, HALE** (b. 1900), a painter and printmaker. From Cairo, Ill., he attended the John Herron Art Inst., Indianapolis, and the Fogg Mus. school before travelling abroad for further study in Paris at the Académie Scandinave and Académie Moderne as well as with HENRY OSSAWA TANNER (about 1931). He studied mural painting in Mexico with Diego Rivera in 1936. During the 1930s, he painted realistic scenes of life in the rural black South, portraying the poverty and the few joys of life in a depressed and segregated society. In 1938 he completed a set of murals depicting the mutiny of slaves aboard the *Amistad* in 1839 (Talladega Coll.) in a style suggestive of both Rivera and THOMAS HART BENTON. His woodcuts of this period show the expressive use of abrupt light-and-dark contrasts. From 1931 to 1945, he taught at Atlanta Univ., where he helped develop the talent of many black artists. By the 1950s, abstraction and free invention had replaced social commentary in his work. Occasionally, he used hieroglyphics as if to suggest a private language, but generally his interest in open brushwork, spare contours, and flattened spaces reflected a desire to explore the decorative possibilities of picture making rather than its ritualistic aspects.

**WOODVILLE, RICHARD CATON** (1825–1855), a genre painter. He received his

earliest art instruction in the 1830s from the drawing masters at his school, St. Mary's Coll., in his native Baltimore, and possibly from ALFRED JACOB MILLER. Woodville undoubtedly had access to a local private collection that contained examples of Dutch and Flemish genre paintings as well as canvases by WILLIAM SIDNEY MOUNT. While briefly enrolled (1842–43) as a medical student at the Univ. of Maryland, Woodville executed a series of sketches of his colleagues and the inmates of an almshouse. In regard to their precise, controlled draftsmanship and high degree of finish, these drawings, twenty-five of which were preserved in an album by a friend, have been compared to work by the great French master of line Jean Auguste Dominique Ingres. A work of 1844 in watercolor and pencil entitled *Soldier's Experience* (Walters Gall.) is the earliest known genre painting by Woodville. The artist later took the composition of this piece for a more elaborate oil, *Old '76 and Young '48* (1849, Walters Gall.) after he had studied in Europe. In 1845 Woodville exhibited his first work at NAD and then went abroad to study art. After a year at the academy in Düsseldorf, Germany, he became a private student of portraitist Karl Ferdinand Sohn. Some academic pencil-and-chalk studies on tinted paper date from this time. Woodville studied with Sohn for five years and then lived in France and England from 1851 to 1855. He died at the age of thirty of an overdose of morphine.

Although Woodville spent most of his brief career in Europe, he is remembered chiefly for his contemporary American genre scenes. He also produced historical and literary genre pieces and a few portraits. Two of his best-known works, *War News from Mexico* (NAD) and *Politics in an Oyster House* (Walters Gall.), were painted in 1848. Both followed Woodville's most successful compositional formula: the modestly scaled depiction of two or more figures involved in a discussion and arranged in relatively shallow, stagelike space. Woodville frequently incorporated likenesses of members of his own family and precisely rendered still-life passages into his conversation pictures. Although his compositions became less contrived and his style more suggestive as he matured, Woodville's works are generally meticulous in detail and finish—characteristics of his training in Düsseldorf. He seems to have acquired his eye for detail and his subtle sense of color and chiaroscuro from Dutch 17th-century works in particular. In contrast to the paintings of his slightly older contemporary William Sidney Mount, Woodville's works appear urbane and sophisticated, and, of course, they are also distinguished by the flavor of Woodville's native city, Baltimore. The majority of the small number of works by Woodville remains in museums and private collections in Baltimore and Washington, D.C. *Lit.*: Francis Grubar, *Richard Caton Woodville*, exhib. cat., Corcoran Gall., 1967.

WORKS PROGRESS ADMINISTRATION-FEDERAL ART PROJECT (WPA-FAP). See FEDERAL ART PROJECTS.

WORLD'S COLUMBIAN EXPOSITION, Chicago, 1893, the fifteenth world's fair and the second major American one (see CENTENNIAL EXPOSITION). An enormous undertaking, it displayed American achievements in the arts, in industry, in technology, and in agriculture. Most important American artists of the period participated, either as decorators of the buildings or as exhibitors in the various art shows. Francis D. Millet supervised the lavish mural and sculptural decorative program. Major sculptural works included DANIEL CHESTER FRENCH's *Columbus Quadriga*, a multifigure group featuring Columbus in a chariot placed atop the triumphal arch of the fair's peristyle. At opposite ends of the Great Basin, a body of water around which a number of buildings were situated, were French's *The Republic* and FREDERICK MACMONNIES's Columbian Fountain. Other major sculptural works included Karl Bitter's decorations for the Administration Building and Lorado Taft's

work for the Horticultural Building. Murals decorating the largest structure at the fair, the Manufacturers and Liberal Arts Building, provided a cross-section of contemporary taste and included works by classicist KENYON COX, by WALTER SHIRLAW (see MUNICH SCHOOL), and by the Impressionist-influenced J. ALDEN WEIR and ROBERT REID. MARY CASSATT painted a mural for the Women's Building. For the most part, subject matter tended toward the symbolic and the allegorical, with such typical titles as "Abundance," "The Arts of Peace," and "The Modern Woman" proliferating.

Of the ten thousand oil paintings on display in the enormous Arts Palace, more than a thousand were by Americans. Although the most popular of these was THOMAS HOVENDEN's conservative *Breaking Home Ties* (1890), avant-garde Tonalist and Impressionist works were also on view (see TONALISM; IMPRESSIONISM, AMERICAN). A few artists had solo exhibitions (JAMES A. M. WHISTLER showed fifty-nine etchings). In addition, a survey of American art provided historical background for contemporary developments.

Even though the exposition provided impetus for the formation of the National Sculpture Soc. in 1894 and the Mural Painters Soc. in 1895, it did not spark a renaissance of the arts as had been hoped. Instead, it recorded a high point of conservative artistic taste as well as of cooperation between architects, painters, sculptors, and decorators in the adornment of public, religious, and private buildings in the country. *Lit.*: David Burg, *Chicago's White City of 1893*, 1975.

WRIGHT, JOSEPH (1756–1793), a portraitist in oils and in wax and a medalist. Born in Bordentown, N.J., the son of PATIENCE WRIGHT, he moved as a boy to New York City and then in 1772 to England. There he studied art with his mother as well as with BENJAMIN WEST and John Hoppner. He travelled to Paris in 1782, just before returning to America. He lived in Philadelphia from 1783 to 1786, in New York City until 1790, and, again, in Philadelphia until his death. He is best known for his portraits of George Washington, of which two main types exist—a three-quarter-length bust dating from about 1784 (examples in the Massachusetts Hist. Soc. and the Pennsylvania Hist. Soc.) and a profile bust of about 1790 based on an etching made at that time (example in the Cleveland Mus.). Wright was also the first to model a three-dimensional bust of Washington. In 1792 he became a designer and die-sinker for the U.S. Mint and designed a cent piece, which was probably not executed. His oil portraits include one of his own family (1793, PAFA). *Lit.*: Fiske Kimball, "Joseph Wright and His Portraits of Washington," *Antiques*, May, 1929, and Jan., 1930.

WRIGHT, PATIENCE LOWELL (1725–1786), a modeller in wax. Born Patience Lowell in Bordentown, N.J., Wright had no formal training and began modelling initially in breaddough, turning to wax in 1769, after the death of her husband. After moving to New York City, where her small bas-relief portraits soon became popular, she exhibited wax figures in her home. In 1772 she left for England, where she became famous for her profile relief portraits modelled on oval panels. In 1785 she executed a wax miniature of George Washington from a bust done of him by her son, JOSEPH WRIGHT. She also did miniatures of Benjamin Franklin, whom she knew well, and of Charles James Fox. The only surviving work by Mrs. Wright is the wax sculpture of William Pitt in the museum at Westminster Abbey, London, for which she modelled the hands and face. *Lit.*: Everett Parker Lesley, "Patience Lowell Wright, America's First Sculptor," *Art in America*, Oct., 1936.

WYANT, ALEXANDER HELWIG (1836–1892), a landscape painter in the style of TONALISM. Wyant was born in Evans Creek, Ohio. In 1857 he saw paintings by GEORGE INNESS in Cincinnati and was

so attracted by their moody expressiveness and atmospheric suggestiveness that he went to New York City to meet him. Encouraged by Inness and supported by the patron of artists in Cincinnati, Nicholas Longworth, Wyant attended NAD for a year and went to Karlsruhe, Germany, in 1865 to study under Hans Fredrik Gude, a Norwegian artist of the Düsseldorf school. From Gude he learned form and construction, but he was influenced more by Joseph M. W. Turner and John Constable, whose landscapes he saw upon visiting England, before returning to New York City in 1866. In *Early Spring* (Montclair Mus.), with its silvery greens, one can certainly see the influence of Constable and of the French Barbizon masters Camille Corot and Théodore Rousseau, as well. *An Old Clearing* (1881, MMA), *Moonlight and Frost* (Brooklyn Mus.), and *The Pool* (Toledo Mus.) all exhibit Wyant's characteristic fairly free brushwork, low-key colors, and subtle contrasts of light and dark. Wyant had a fondness for painting in the Adirondack Mountains. His atmospheric, personal views of nature recall the work of HOMER DODGE MARTIN and of Inness. *Lit.: Alexander Helwig Wyant*, exhib. cat., Univ. of Utah, 1968.

WYETH, ANDREW (b. 1917), one of the most popular artists in the country's history; his *Christina's World* (1948, MOMA) is perhaps the best-known 20th-century American painting. From Chadds Ford, Pa., he studied with his father, N. C. Wyeth, the illustrator. His preferred media are watercolor and tempera. He also uses a dry-brush technique with watercolors. Before 1942 his style was painterly; afterward, he developed a linear, precise, realistic mode. His subject matter is drawn from his environment—his home in Chadds Ford and his summer residence in Maine—and he has often included members of the Kuerner family in the former and of the Olson family in the latter. Such modern objects as automobiles rarely disturb the bucolic quiet of his landscapes. In his portraits, often of socially disadvantaged persons, figures are frequently isolated against expanses of black wall (*That Gentleman*, 1960, Dallas Mus.). Muted browns and ambers are Wyeth's favored colors. Altogether, the effect of his work, even sunlit scenes, is somber. During the 1940s, when *Christina's World* was painted, a sense of disquiet pervaded ostensibly pleasant pictures. Although his detail is explicit, Wyeth accents the abstract basis of his designs by placing forms in unusual positions. To achieve the haunting quality that imbues many of his figures, he may accent the textures of skin and hair but diminish the color intensities of garments and the immediately surrounding space. Not unexpectedly in a member of the Abstract Expressionist generation, Wyeth provides his landscapes and interiors with a greater expansiveness and openness than did earlier realists like EDWARD HOPPER. His vision is more panoramic and his compositions are not as frontal but they include more diagonal recessions. In 1976 he became the first living American-born painter to receive a retrospective exhibition at MMA. *Lit.*: Wanda Corn, *The Art of Andrew Wyeth*, exhib. cat., de Young Mus., 1973.

# Y

YOUNG, MAHONRI MACKINTOSH (1877–1957), a sculptor and painter. From Salt Lake City, with which he never lost contact, Young studied at ASL in 1899 and then, early in the next decade, at the Académie Julian, Académie Colarossi, and Académie Delacluze, in Paris. He made additional trips abroad, including a long stay during the mid-1920s. Regardless of medium, his works were naturalistic in the tradition of Jean François Millet and Honoré Daumier. His sculpture was the plastic equivalent of the painting of The EIGHT, as is evident in his choice of themes and unpretentious realism (*Stevedore*, 1904, MMA). Young sculpted athletes, laborers, and such unusual and colorful city dwellers as organ grinders. His favorite material was bronze. In his paintings, he depicted the urban poor as well as a host of rural and leisure-time activities— harness racing, for example. His studies of the Southwest, made during a trip in 1912, are among the earliest modern works of that region. The largest collection of his oeuvre is at Brigham Young Univ. *Lit.*: Frank Jewett Mather, Jr., *Mahonri Young*, exhib. cat., Addison Gall., 1940.

# Z

ZORACH, MARGUERITE THOMPSON (1887–
1968), a leading modernist in the years
just preceding and just following the AR-
MORY SHOW. Born Marguerite Thompson
in Santa Rosa, Calif., she spent four
years (1908–12) in Paris, where she met
Pablo Picasso, Gertrude Stein, and Ossip
Zadkine and studied at the La Palette
School. Broadly brushed areas of saturat-
ed color in her early paintings suggest
the influence of the Fauves and the Ger-
man Expressionists. In 1911 her works
were shown at the Société des Artistes
Indépendants and the Salon d'Automne
in Paris. The finest paintings of her artis-
tic career were produced in India and
Palestine during the following months
and in the Sierra Mountains shortly after
her return to California in 1912. *Windy
Day in the Sierras* and *Waterfall* (both
1912) continued to reflect her strongly
emotional response to the beauty of na-
ture and to suggest a personal identifica-
tion with the spiritual forces she discov-
ered in solitude. During the same period,
she was reading essays by Ralph Waldo
Emerson and writing poetry about her
feelings and experiences in nature. Her
mastery of bold colors and skillful use of
a Fauve palette were indications of the
great potential of this artist already in
the forefront of vanguard developments
in America before World War I. But her
capabilities as a modernist painter were
never full realized. Shortly after her first
solo exhibition, held in Los Angeles in
1912, she left for New York and mar-
riage to WILLIAM ZORACH.

In subsequent years, she began to in-
troduce motifs from modernist paintings
into needlework and textile designs, be-
coming one of the first Americans to use
vanguard artistic developments in the
applied arts. Her paintings were exhibit-
ed at the Armory Show in 1913 and in
the famous Forum Exhibition of Modern
American Painters in 1916 (see INDEPEN-
DENT EXHIBITIONS).

Reflecting the influence of many of
their contemporaries in New York, par-
ticularly MAX WEBER, whom they met in
1915, the Zorachs began to experiment
with the Cubist idiom. Marguerite de-
veloped a new awkwardness of manner
and a somber palette that marked a radi-
cal departure from her earlier Fauve-in-
spired works. In 1916 she began to ex-
hibit her "tapestry paintings," in which
the rigorous fragmentation of forms of
her Cubist work was replaced by stylized
Arcadian landscapes of brightly colored
threads. These tapestries were to become
her major artistic interest during the
next four decades of her life, though she
continued to paint till her death.

By the 1920s, William Zorach had
turned seriously to sculpture, and Mar-
guerite often collaborated in his major
commissions. She sought no personal rec-
ognition, but her husband depended on
her mastery of design and she produced
many of the preliminary drawings for
his sculptures. For example, Zorach's fa-
mous *Spirit of the Dance*, created in
1932 for Radio City Music Hall, New
York City, was based on an original
sketch by his wife. Representative exam-
ples of her work are to be found in the
NCFA and WMAA. *Lit.*: Roberta Tar-
bell, *Marguerite Zorach: The Early
Years, 1908–1920*, exhib. cat., NCFA,
1973.

ZORACH, WILLIAM (1887–1966), a sculp-
tor and painter. From Eurburg, Lithua-
nia, in 1891 he came to Cleveland, Ohio,
with his family and there he was appren-
ticed to a lithographer as a youth. He
studied briefly at ASL and NAD in 1907
before settling from 1909 to 1911 in Par-
is, where he attended classes at the La
Palette School. Though aware of mod-
ernist developments, he did not begin to
work in the newer styles until 1912,
probably under the influence of Margue-
rite Thompson, who married him in 1912

(see MARGUERITE THOMPSON ZORACH). From 1912 to 1916, his paintings were predominantly Fauve, often of nudes in landscape settings. Subsequent paintings revealed Cubist qualities, including a group done in California's Yosemite Valley in 1920. Throughout all the phases of his painting career, Zorach was attracted to mother-and-child themes and also to primitive stylistic features; given foresight, this would have made predictable his ultimate abandonment of oil painting, which took place in 1922, because the medium could not convey the kinds of human values and feelings he wanted to communicate. By 1917 he had turned to carving, creating his first bas-relief wood piece, and, in 1919, his first wooden figure in the round. In 1918, he used clay for the first time. After 1922 his sculpted figures, no longer angular and Cubist, grew round, volumetric, and monumental. Modern influences grew remote as he increasingly responded to other artistic sources. "I owe most," he said, "to the great periods of primitive carving in the past—not to the modern or to the classical Greeks, but to the Africans, the Persians, the Mesopotamians, the archaic Greeks and of course to the Egyptians." Early examples include *Floating Figure* (1922, AK) and *Child With Cat* (1926, MOMA). In these and other carved works, the peculiar quality of the material—wood or stone—often dictated the shapes of the completed sculptures. By the late 1920s, his mature style—large, simple volumes and generalized forms—was set, achieved by a technique sensitive to the possibilities inherent in each medium he used. Most works were composed of broad rhythmic sequences around solid cores. As at the beginning of his career, Zorach chose themes centering upon mothers and children (*The Future Generation*, 1942–47, WMAA). He also executed man-and-woman groups, dancers, and animals, done either in the round or in relief. *Lit.*: John I. H. Baur, *William Zorach*, 1959.